Other
Things

Other Things

Bill Brown

The University of Chicago Press

Chicago and London

The University of Chicago Press, Chicago 60637
The University of Chicago Press, Ltd., London
Published 2015
Paperback edition 2019
Printed in the United States of America

28 27 26 25 24 23 22 21 20 19 1 2 3 4 5

ISBN-13: 978-0-226-07665-2 (cloth)
ISBN-13: 978-0-226-28302-9 (paper)
ISBN-13: 978-0-226-28316-6 (e-book)
DOI: https://doi.org/10.7208/chicago/9780226283166.001.0001

The University of Chicago Press gratefully
acknowledges the generous support of the Office of
the Provost at the University of Chicago toward the
publication of this book.

Library of Congress Cataloging-in-Publication Data
Brown, Bill, 1958– author.
Other things / Bill Brown.
pages cm
Includes bibliographical references and index.
ISBN 978-0-226-07665-2 (cloth : alk. paper)—
ISBN 978-0-226-28316-6 (e-book) 1. Object
(Philosophy). 2. Material culture. 3. Object
(Philosophy) in literature. 4. Material culture
in literature. 5. Material culture in art. I. Title.
BD220.B76 2015
814′.6—dc23
2015014453

♾ This paper meets the requirements of ANSI/NISO
Z39.48-1992 (Permanence of Paper).

To Short, in thanks for the gift of culture

Contents

III
Kitsch Kulchur

Illustrations

Figures

Acknowledgments

When you take a very long while to complete a book, it's hard to sense that time as coinciding with the time in which life is lived, and in which some cherished lives come to an end. Jay Fliegelman possessed a materialism all his own, but his fascination with objects was contagious, and his excitement about my materialism, and his questions about it, always proved catalytic. Miriam Hansen and I taught together ("Modernity and the Sense of Things"), we wrestled over ways to make sense of one or another paragraph in Kracauer or William James, and we thought together so comfortably as to complete each other's sentences, in class or on the page. John Hofstra, while never ceasing to ask, "Why things?," always expressed an unbridled certainty about the project; he also introduced me to the work of Harold Searles. More than I am willing to say, I miss these interlocutors for whom I continue to write.

Three deans at the University of Chicago — Janel Mueller, John Boyer, and Martha Roth — provided the time and the resources for me to pursue my research to the best of my ability. A year as the Los Angeles Times Distinguished Scholar at the Huntington Library (in 2012–13) proved essential to the completion of the book's most difficult chapters; Roy Ritchie made that fellowship possible, and the wonderful staff at the Library made it fruitful. A series of remarkable research assistants — Thomas Kim, Nicholas Yablon, Paul Durica, and Christopher Dingwall — amplified my abilities with patience, efficiency, and enthusiasm. Chris in particular — tracking down images and citations, establishing deadlines, helping to prepare the manuscript — made sure that the project would

become a product, the object it turned out to be. At the University of Chicago, the Object Cultures Project (housed within the Chicago Center for Contemporary Theory) has been an environment in which to sense (and to make sense of) different disciplinary investments in materiality and the object world. Anwen Tormey and Amanda Davis make the Project work. I continue to learn from my graduate students at Chicago, who have been adept at thinking collectively on behalf of giving form to passing insights, and no less adept at articulating both fascination and frustration with the current thinking about objects and things, matter and materiality. At the University of Chicago Press, I continue to benefit from the diligence, patience, and keen intelligence of Alan Thomas; his reputation as an editor continues to grow precisely because he has always been so much more than an editor.

In the opening notes to the relevant chapters, I credit journals that have published previous versions of the material, and I thank specific audiences and individuals whose observations, questions, and suggestions helped to turn a talk into something worth reading. Other friends and colleagues have been engaged across the long haul, responding to chapters, recommending further reading, talking at length about the many topics I run into across the following pages. It is a better book—much better—thanks to the attention of Marie Krane Bergman, Lauren Berlant, Theodore Brown, Andrew Cole, Leela Gandhi, Elizabeth Helsinger, Gregory Jackson, Patrick Jagoda, W. J. T. Mitchell, Anne Munly, Richard Neer, Deborah Nelson, Jay Schleusener, and Eric Slauter. With other folks—David Alworth, Jessica Burstein, Dipesh Chakrabarty, Heather Keenleyside, Jonathan Lamb, Jennifer Roberts, Jane Taylor, and Babette Bärbel Tischleder—I have had the pleasure of sharing conceptual and historical questions in the midst of working to give new subfields the shape they deserve. With M. L. Fraser Brown I have enjoyed the satisfactions of figuring out when and why prose seems to work. Daily, in many dimensions and with delight, I share the topic of things with Diana Young, whose fascinations and fixations typically prompt my own.

Frances Ferguson has become an ideal reader, profoundly generous, imaginative, and serenely sensitive to problems of form and function. My intellectual friendship with Bradin Cormack (vertiginous at times, at times just intense) has buoyantly sustained my commitment to the project. I continue to depend, above all, on the animating critical acumen of Dr. Jim Chandler, who has read portions of this project so many times that he might be able to recite them. In an era in which time has become increasingly scarce and precious, I recognize such generosities as the remarkable gifts that they are.

Overture (The Shield of Achilles)

Western literature's most magnificent object, Achilles' Shield, enacts a drama of animate matter. Although Homer depicts Hephaestus— hammer in one hand, tongs in the other—crafting the Shield from bronze and tin, silver and gold, the poet describes the object's design in full resolution:[1]

> He pictured on it earth, heaven, and sea,
> unwearied sun, moon waxing, all the stars
> that heaven bears for garland: Plêïadês,
> Hyadês, Oríôn in his might. (18.557–60)

But even as the account of what the god has "pictured" achieves scenic stability—"two cities, noble scenes" (18.564)—those scenes themselves famously come to life. In the City of Peace, there are wedding feasts, where brides make their way

> through town by torchlight from their chambers
> amid chorales, amid the young men turning
> round and round in dances. (18.566–68)

In the City of War, "all the figures clashed and fought/like living men, and pulled their dead away" (18.620–21). Moreover, at this turning point of the epic, when Achilles is at last about to enter combat to avenge the death of his friend Patroklos, the Shield manifests the cost of war by pre-

senting the quotidian (yet astonishing) agricultural life in fields, pastures, and vineyards:

> Lighthearted boys and girls
> were harvesting the grapes in woven baskets,
> while on a resonant harp a boy among them
> played a tune of longing, singing low
> with delicate voice a summer dirge. The others,
> breaking out in song for the joy of it,
> kept time together as they skipped along. (18.654–60)

This is the exuberant life—the life outside of epic action—that the clashing armies, Trojan and Achaean, have had to leave behind.

At such moments of heightened activity, the poem is quick to remind its audience that this life resides within a crafted object—that the activity amounts to activated metal:

> The *artisan made next* a herd of longhorns,
> *fashioned in gold and tin*: away they shambled,
> lowing, from byre to pasture by a stream
> that sang in ripples, and by reeds a-sway.
> Four cowherds *all of gold* were plodding after
> With nine little dogs beside them. (18.661–66, my emphasis)

The poem repeatedly clarifies that Achilles' Shield is at once a static object and a living thing, just as it marks and celebrates the phantasmagoric oscillation among forms and materials: the furrowed earth behind the plowmen may be "black," but it is also "gold,/all gold—a wonder of the artist's craft" (18.631–33). Homer's distribution of vitality extends beyond the immortal and the mortal—to the artifactual. This "wonder of the artist's craft" would seem to insist, then, on a kind of indeterminate ontology, in which the being of the object world cannot so readily be distinguished from the being of animals, say, or the being we call human being.[2]

Yet, for all the centuries of commentary on the Shield, such a speculation has hardly been broached. The ontological ambiguity has been elided in behalf of rhetorical analysis, above all the analysis of ekphrasis, specified most clearly as "*the verbal representation of visual representation.*"[3] Achilles' Shield has served as the archetypal instance of ekphrastic poetry. In that service animate matter has been fettered into immobility, fixed between the pictorial and the verbal, the image and the word. Objection has been raised to the poet's failure to sustain "a picture-like

representation," his indulgence in "a thoroughly youthful pleasure in animated narration."[4] More often, though, that animation has been esteemed. And since G. E. Lessing published his commentary in *Laokoon* (1766), the Shield of Achilles has served to stage the distinction (often dramatized as a dispute) between the visual and the verbal—that is, by Lessing's light, the distinction between the spatial and the temporal, between stasis and kinesis, between pictures and stories. Homer triumphantly deploys the signal advantage afforded by the verbal medium, "the liberty to extend his description over that which preceded and that which followed the single moment represented in the work of art," an extension which that work of art itself "must leave to the imagination."[5] Lessing is hardly alone in curiously reifying the referent, as though Homer bore witness to the Shield itself, as though the poet himself—the poetry itself—were not producing the object.[6] Nor, despite various objections to his analysis, is he alone in effectively displacing the object with an image; the story of the Shield gets told as "the translation of image into story."[7] And the story of the Shield gets told as a foundational story because "ekphrastic literature reveals again and again this narrative response to pictorial stasis, the story telling impulse that language by its very nature seems to release and stimulate."[8] Though much of the animation hardly conforms to anything recognizable as a plot—

> The others,
> breaking out in song for the joy of it,
> kept time together as they skipped along

—readers retain their emphasis on narrative. Even efforts to argue beyond such an understanding of ekphrasis by regarding the Shield as an "imagetext" do not bring the represented object—as object—into focus: "Homer's whole point seems to be to undermine the oppositions of movement and stasis, narrative action and descriptive scene, and the false identifications of medium with message."[9] But what if Homer's whole point, undermining the opposition of movement and stasis, has nothing to do with literary modes (description and narration), and less to do with linguistic and pictorial media than with the medium of metal? What if Homer's point is instead to undermine the opposition between the organic and inorganic, the vibrant and the inert?

Or, rather: what if that point is strikingly beside the point, precisely because the poem does not acknowledge our more modern convictions about the difference between the animate and inanimate, subject and object, persons and things? In a universe where deities appear on the battlefield, how disorienting could it be as an ancient auditor to encounter

vitalized matter? Indeed, when Hephaestus limps out of his workshop
to speak to Thetis, he does so supported by fully animate and intelligent
artifactual creations:

> maids of gold, like living girls:
> intelligences, voices, power of motion
> these maids have, and skills learnt from the immortals. (18.482–84)

Yet even these automata—distant ancestors of E. T. A. Hoffmann's Olym-
pia, Fritz Lang's Maria, Philip K. Dick's androids, and Pixar's Wall-E—
have hardly convinced readers that the Shield might possess a vitality
of its own.[10] We're assured that there is "no suggestion in the Shield of
Achilles that Hephaestus himself made the images on the Shield live and
move and speak; rather, the type of description that is characteristic of
the *Iliad* makes the images of the Shield into stories."[11] The commanding
role that the Shield has played in the history of modern ekphrastic criti-
cism has all but denied it any role in the history of animate matter.

And yet, when George Chapman published his translation of *Achilles
Shield* (the same year, 1598, in which he published *Seaven Bookes of The
Iliades of Homere, Prince of Poets*), his dedicatory epistle to the Earl of Sus-
sex all but began by highlighting such a role: the heavens, the earth, the
sea, the two cities—these are "so lively" that readers "in times past have
believed that all these thinges have in them a kind of voluntarie motion."
Such a belief, Chapman then asserts, continues to make good sense, "for
so are all things here described by our divinest Poet, as if they consisted
not of hard and solid metals but of a truly living and moving soule."[12]
This Homeric vitalism, as Chapman describes it, might be considered the
ancient anticipation of more modern (modernist or avant-garde) percep-
tions of material vitality. Georg Simmel celebrates the "sensation of be-
coming" in Auguste Rodin's work, for instance: the "movement [that] in-
vades every domain," which the sculptor expresses "by giving the surface
a new mode of being, a new vibration."[13] Just as his contact with Henri
Bergson (the philosopher and the philosophy) lies behind Simmel's par-
ticular appreciation of Rodin's work, so too Bergson (along with Lucre-
tius, Spinoza, and Nietzsche) lies behind the more recent effort, by Gilles
Deleuze and Félix Guattari, to disclose an "energetic materiality."[14] In
Mille Plateaux (1980) they pay particular attention to metal: "What metal
and metallurgy bring to light is a life proper to matter, a vital state of
matter as such, a material vitalism that doubtless exists everywhere but
is ordinarily hidden or covered, rendered unrecognizable." The "inven-
tion, the intuition of metallurgy," they argue, is the "prodigious idea of

Nonorganic Life" (454). In Homer's epic it is not the metallurgist but the immortal "artisan," who, fashioning a shield from bronze and tin, silver and gold, gives form to that prodigious idea. Or, as Deleuze and Guattari would say, the material vitality of the Shield "overspills the form" (410); it consists of a "matter-movement" or "matter-energy" that manifests a "*corporeality*" that is neither some essence nor "a sensible, formed and perceived, thinghood" ["choséité sensible, formée et perçue"] (407).[15]

Which is to say—in the terms that I develop and deploy throughout the present book—that it is precisely the Shield's *thingness*, as opposed to its sensible (formed and perceived) *objecthood*, that registers such vitality. The matter-movement transposes the object into some *other thing* that *is* (the being of which is) in excess of any manifest object. Insofar as sculpture becomes aware of itself as "a medium peculiarly located at the juncture between stillness and motion, time arrested and time passing," it may be the art form singularly suited to expose the thingness of the object world, what the sculptor Henry Moore considered to be the vital state of matter as such.[16] More recently, within the first stage of minimalism, Tony Smith explained that he was "interested in the inscrutability and mysteriousness of the thing"—the thing that fits nowhere on the grid of intelligibility, the thing that names our encounter with a restless object world where things ("presences of a sort") don't quite behave the way they "should."[17] Such strange behavior has preoccupied other art forms as well, from epic poetry to surrealist film. And thingness and object-hood have been distinguished resolutely—above all, by Martin Heidegger in his pursuit of *das Ding*. But I mean to dislodge the binary from philosophy (compromising its specificity and its grandiosity) in order to disclose what literature and the visual and plastic arts have been trying to teach us about our everyday object world: about the thingness that inheres as a potentiality within any object, about the object-event that precipitates the thing.[18] This is a pedagogy that repeatedly points to the uncanniness of the ordinary, the oscillations between the animate and inanimate, for instance, which Homer renders extraordinary.[19]

More simply, the worlds made manifest by Achilles' Shield might be said to figure those worlds out of which weaponry as such is forged: to figure those ordinary lives that lie behind the extraordinary actions and objects of war. In this sense, such worlds and lives are not *on* the Shield so much as they are *within* it (like the labor congealed by the commodity, as Marx describes it).[20] In his later translation of book 18 (in 1611, part of *The Iliads of Homer*, all twenty-four books) Chapman suggests such a way of considering the Shield's component figures:[21]

For *in it* he presented earth, *in it*, the sea and skie,
In it, the never-wearied Sunne, the Moone exactly round
And all those stares with which the browes of ample heaven are
 crownd— (18.557–59, my emphasis)

Extending Chapman's prepositional insistence—translating *en* not as "on" but as "in"—would be a way toward apprehending the thingness of the Shield, given how etymologies of *thing* (*chose, Ding, causa, res*) retrieve the notion of a gathering or an assembly: the Shield is a thing insofar as it gathers singers and soldiers, earth and sky.[22] It is a way toward imagining the Shield not only as an adumbrating emblem of the neo-vitalist thought of the late twentieth century, but also as an allegorizing precursor of the hybrid assemblages and "quasi-objects" charted most energetically by Bruno Latour, who insists that we think beyond (or, more precisely, before) the distinction between subject and object, human and nonhuman.[23] He repeatedly exposes the human drama within the nonhuman, and the animation and agency of the artifactual, to the point where a subject-object binary no longer makes sense and the object world comes to life, like the Shield, vivified by the human aspiration, frustration, and aggression it has gathered.[24] In Latour's own case studies of the human life that resides within objects, shedding light on that "blind spot in which society and matter exchange properties," weaponry proves a rich resource (*PH*, 190).[25] People and things cannot be disaggregated; agency must be distributed among multiple actants; and thus one must say that "B-52s do not fly, the U.S. Air Force flies" (*PH*, 182). The Air Force—its pilots and procedures, its ambitions, ranks, and regulations—already inheres within the object. From this point of view, the Shield's ploughing and dancing, for instance, cannot be thought of as distinct from the epic action; rather, this life—these lives—appear *there* on the battlefield, albeit only as congealed by this object form.

Latour has repeatedly argued that sociologists must learn from artists when it comes to recasting "solid objects" into "the fluid states where their connections with humans may make sense."[26] He encourages the social sciences all told to learn—from "novels, plays, and films from classical tragedy to comics"—that the "social" cannot be reduced to humans, that society cannot be fathomed as "an object-less social world" (54–55, 82). Clifford Geertz once lamented that "social scientific theory" had "been virtually untouched" by Kenneth Burke's account of "symbolic action," as by the literary criticism of William Empson, R. P. Blackmur, and Eric Auerbach (among others). Social analysis remains impoverished, he believed, without an appreciation for the functions of figurative language ("metaphor, analogy, irony, ambiguity, pun, paradox, hyper-

bole").[27] Geertz was invested in literary explication as a model for interpreting what and how specific practices *mean*—that is, *why* a given practice is meaningful and *how* it conveys that meaning. Latour instead expects sociologists to learn (from novels, plays, and films) how to identify the constituent and mutually constitutive, mutually empowering and constraining, participants (or actants) of any practice. Not what a practice means, but how the practitioners operate.

This, as the literary-critical engagement with Achilles' Shield should make clear, is hardly to say that literary history or literary theory always teaches the lesson that Latour has learned. On the one hand, you can now read a political scientist relishing the vitality of matter and a historian of science describing ("without resorting to ventriloquism or projection") the eloquence of obdurate objects.[28] On the other, you can read a literary theorist dismissively (albeit jovially) insisting that "attributing intentions and language to various bits and pieces of the world," making "'all kinds of unexpected things' speak," depends on the "vis amatoria" and the shared projections of "amateurs."[29] Such a formulation insists that the "professional" must speak within, and in behalf of, the modern. (All but needless to add, the amateur-professional distinction is itself modern). It also disregards how an individual's experience of ontological ambiguity can provoke, or be provoked by, anxiety or fear, not love and affection. The restless "quasi-object" is hardly welcomed by the characters in a gothic novel, a Kafka story, a horror film, or those episodes of daily life when your computer, toaster, or phone suddenly seems to have a will of its own. The experience of object agency can't be ascribed to any one disposition.

The ontological ambiguity (or homogeneity) that Latour himself proposes is part of a project that is differently and productively normative: the effort to establish new epistemological norms for making better sense of the "social"; to establish new narratological norms for telling more accurate stories about the history of science and technology; and thus to establish the means of "speak[ing] of democracy again, but of a democracy extended to things themselves."[30] The arts, however, disclose the complications, equivocations, mediations, and possible destinations of any such democracy, present, past, and future. Literature may indeed be the place where, in Latour's words "the freedom of agency"—that is, the distribution of agency beyond the human—"can be regained," but it is also the place where such freedom can be lost—or, most precisely, the place where the dynamics of gaining and losing are especially legible.[31] In other words, literature also portrays the resistances to that freedom and the ramifications of it, be they phenomenological or ontological, psychological or cultural.

Such freedom was arrested within the "Homeric" world that W. H. Auden redescribed in a deadening, administrative tone. In "The Shield of Achilles" (1952), which begins by effectively devitalizing Homer's animated object, he casts Thetis as the figure repeatedly disappointed because Hephaestus has failed to craft the life she anticipates:[32]

> She looked over his shoulder
> For vines and olive trees,
> Marble well-governed cities
> And ships upon untamed seas,
> But there on the shining metal
> His hands had put instead
> An artificial wilderness
> And a sky like lead.
>
> A plain without a feature, bare and brown,
> No blade of grass, no sign of neighborhood,
> Nothing to eat and nowhere to sit down, . . . (1–8)

There may be some degree of motion in the modern military system, but Auden keeps it to a minimum:

> Barbed wire enclosed an arbitrary spot
> Where bored officials lounged (one cracked a joke)
> And sentries sweated for the day was hot:
> A crowd of ordinary decent folk
> Watched from without and neither moved nor spoke (31–35)

He clearly means to produce an image of modern war—or simply of war—as a stultifying phenomenon without passion or heroism, without the "ritual pieties" that Thetis looks for, without "athletes at their games" or "men and women in a dance," without a feature to relieve the overarching impression of sterility: "His hands had set no dancing-floor/But a weed-choked field" (47–48). Auden conveys the disenchantment of military operations through a disenchanted object. If Homer's Shield can be said both to manifest a vital state of matter and to disclose the imbrication of human and nonhuman, then Auden's Shield must be said to portray the devitalized object world of modernity and to stage the difficulty of recuperating its vitality.

The book in hand tracks efforts to effect that recuperation in visual, plastic, and literary works of the long twentieth century (1890–2010).

My title, *Other Things*, is meant to identify two topics that remain intertwined throughout the following pages. First, *other things* designates those things that we routinely differentiate from persons; experiencing personhood remains inseparable from that routine. But such routine can find itself challenged (dramatically or inconspicuously) either because, enmeshed as we are in the object world, we can't at times differentiate ourselves from things, or because those things (however actively or passively) have somehow come to resemble us.[33] I end up contemplating a rather odd assortment of things—beach glass and plate glass, mechanical banks, skyscrapers, cell phones, plastic chairs, pottery, sneakers, Charlie McCarthy dolls, fluorescent lights, masks of the Northwest Coast, and metronomes, for instance. But I focus on a familiar assortment of human behaviors (such as collecting, fetishizing, and memorializing) and of emotional states (such as shock, melancholy, thrill, and nostalgia). My critical mode can be described as a materialist explication that marshals historical fragments (including fragments of our historical present) to make sense of the questions this work seems to ask, however inadvertently. The arts seem to have a material unconscious, by which I mean (most simply) that they *register* transformations of the material world that they do not necessarily *represent* or intentionally express. Marcel Duchamp was not expressing his admiration of the urinal when he submitted *Fountain* to the jury for the Society of Independent Artists exhibit in 1917, but the piece nonetheless registers (and has as its precondition) the European infatuation with the new plumbing technologies developed in the United States.[34] Conceptually, *Fountain* exposes the arbitrariness of the art object (its indeterminate material and form), the boundaries of the art system (its adjudication of what will count as art), and the authority of the artist. Physically (in the photographic record we have), *Fountain* also might be said to stage the aesthetics of everyday life and a new era of functional design, even as it intimates how the one-to-oneness of art spectatorship (which has its own history) has come to correlate with the modern privatization (the serial individuation) of urinating in public, a privatization mediated by (regimented by) the object world.[35] In addition, insofar as you glimpse the humanoid outline of the tipped urinal, you sense (in excess of the object's utility, its cultural novelty and its anti-aesthetic function) some other thing. It is that thing—that kind of thing—that I wish to bring into view.

My first chapter, "Things—in Theory," provides an account of how I myself understand the object-thing dialectic and then tracks the object-thing distinction as it appears in the work of Heidegger and Jacques Lacan. Neither discussion provides an analytic for understanding the force of inanimate objects in human experience, but both make it clear

why a focus on objects alone will not disclose the potency of the object qua thing. The subsequent chapters most often proceed by isolating individual works (a short story by Virginia Woolf, a photograph by Man Ray, a film by Spike Lee, for instance) and responding to their organization of the inanimate object world and the place of the human within it. I have clustered the chapters under three headings. "The Matter of Modernism" points out how a particular material (glass), a particular artistic practice (assemblage), and a generic material form (the pot) came to materialize ambitions and anxieties about the subject-object relation within modernity and to dramatize what André Breton called "the crisis of the object"—what I read as his intuition about the other thing. The chapters in "Unhuman History" focus, first, on the human-unhuman binary (in Hannah Arendt's political ontology and in Latour's political ecology); then on a fictional and a psychoanalytic account of the attractions of the nonhuman environment; and finally on an art practice, responding to the history of ethnology, meant to shock our historical sensibility into recognizing some extrahuman temporality, a history not of the world, but of the earth. Finally, "Kitch Kulchur" (for which I borrow the spelling from Ezra Pound's last-ditch effort to "preserve some of the values that make life worth living") follows Walter Benjamin's (and, ultimately, Theodor Adorno's) logic, perceiving kitsch not just as the most degraded of cultural forms but also as the site—there, where the object becomes another thing—through which an aspiration for some alternative to the status quo can be perceived.[36] My gambit is to work somewhere between the registers of history and literature, criticism and theory, convinced that to think meaningfully about objects, things, and thingness necessitates thinking not only about the surrealist assemblage but also about plastic and leather, about buildings and toys, and indeed about production, distribution, and consumption. You can read the book as an account of modernism and the afterlife of its investment in disclosing, despite modernity's disenchantment, an object world that (in one corner or another) has retained its enchantment or been enchanted anew.[37] My brief coda juxtaposes Dan Flavin's first fluorescent light sculpture with Gaston Bachelard's nostalgic last book, *The Flame of a Candle*, in the effort to expand the notion of materiality and to derive, from light, a poetics of thingness.[38]

The conceptual investments of these chapters are wide-ranging, but my interest in things has been sustained above all by two assertions: Georg Lukács's claim (cited like a mantra in the chapters to come) that the culture of rationalization and calculability, effected by the commodity form's abstraction of the object, conceals "above all the immediate—qualitative and material—character of things as things"; and

Georges Bataille's claim that because capitalism is "an unreserved surrender to *things*," capitalist cultures "place what is essential" beyond or outside "the world of *things*."[39] Like Heidegger, the art of the long twentieth century has worked—through various acts of redemptive reification, as I call them—to reveal that character and to disclose its unanticipated role in human life. Bruno Latour can ask the social sciences to learn about things from art and literature because that is, first off, where the character of things has been preserved, awaiting its excavation. In the process of excavating, though, you sometimes find things you never bargained for. You end up confronting the character of *other* things when some other thing finds you.

Many of the chapters gathered here were once essays, some of which have enjoyed autonomous lives for some time. The essays were once talks, often prompted by generous invitations to participate in interdisciplinary conferences, seminars, and colloquia: "Material Powers," "Thing[s] Matter," "Theories and Things: Re-Evaluating Material Culture," "Real Things: Matter, Materiality, Representation, 1880 to the Present," "Waste and Want: The Cultural Politics of Value," "The Pathos of Authenticity: American Passions for the Real," "Curious Things," "Rethinking the Real," "Thing/Theory," "One More Thing: History, Objects, Writing, and Everyday Life," "What Is an Object? Thing Theory in Interdisciplinary Perspective," "Seeing Things," "Materiality," "Materiality and Art History." As such a list (though partial) suggests, this book emerges from a conversation that gained considerable momentum in the first decade of the current century, a conversation that takes things seriously in different registers: with an emphasis on materiality, on objects, on the real, on things, on the Thing, none of which are equivalents but all of which, at times, summon each other.

The book is also part of a long conversation I've been having with myself. In *The Material Unconscious* (1996) I worked to show how changes in the material culture of the American 1890s, even when they played no evident role within the diegesis of prose fiction, worked their way into the literary imagination, often as lexical, figurative, or formal novelties.[40] In *A Sense of Things: The Object Matter of American Literature* (2003), I tried instead to show how the mechanics of narrative prose fiction get deployed to convince readers of the materiality of the represented object world, to infuse that world with significance, and to exhibit how objects organize our desires, knowledges, and fantasies in a way that can hardly be explained by the cultural logic of capitalism. Indeed, thinking tangentially to the homogenizing accounts of the culture of consumption, I worked with the assumption, as I do in the present book, that *the doubleness of the commodity (divided into use value and exchange value) conceals a*

more rudimentary distinction between the object and itself, or the object and the thing, which in fact sustains the success of the commodity (in other words, the success of capitalism). Value derives from the appropriation of a preexisting surplus, the material object's own excessiveness.[41] Between those books, recognizing that the inanimate object world was slowly returning as a legitimate object of attention across several fields, I edited a special issue of *Critical Inquiry, Things* (2001, 2004), which brought together scholars from a range of disciplines. My introduction to the volume, "Thing Theory," gestured toward conceptualizing things, the thing, and thingness (work that I pick up in my first chapter here) but also pointed to prior conceptualizations in the twentieth century. As I asked then, "what decade of the century didn't have its own thing about things?"[42] Taking things seriously ought to include bringing the history of such thinking back into focus.

Still, who could have predicted, twenty years ago, that the phenomenological object world (or indeed the material world, the real world, and things themselves) would return with a kind of vengeance, having been marginalized or elided for so long by, say, structuralism and deconstruction, various theories of the subject, and the emphasis on discursive or social construction, as by the critical fixation on the *image* and the *text*, and by the materialism named Marxism (in its Althusserian mode)? And how should we understand the broad spotlight now turned on the object world within various disciplinary dramas? Where had things gone? Within different disciplines, different blockades had established the quarantine. Art History had disengaged the image from its material support; Anthropology transformed objects into goods or into signs; History felt most secure with words, not things, as the source of evidence; Philosophy privileged language or *Dasein* to the point of rendering the being of objects secondary, if not beside the point.[43]

But to ask seriously, "What is this thing about things?" is to imagine dramas that transcend these effectively parochial, intradisciplinary disputes. One drama no doubt consists of the perceived threat posed by the digitization of the world we once knew. Describing the "dematerialization of material culture" with particular anguish, the archaeologist Colin Renfrew laments the current separation "between communication and substance." Because "the electronic impulse is replacing whatever remained of the material element in the images to which we became accustomed," the "engagement with the material world where the material object was the repository of meaning is being threatened." All told, by his light, "physical, palpable material reality is disappearing, leaving nothing but the smile on the face of the Cheshire Cat."[44] The quest for some new engagement with the object (be it archaeological, historical,

or philosophical) could be understood as an effort to forestall such a disappearance, or to cling to a world where objects remain repositories of semantic plenitude.

No less reasonably, though, the quest could be provoked by the appearance of new objects, in particular those objects that are displacing the role of humans, those products of technologies that have caught up with science fiction and for which the battlefield provides another apt illustration. The Unmanned Combat Air Vehicle (UCAV) has now been programmed not just to be commanded remotely but also—in the case of the Boeing X-45, say, or the X-47 Pegasus—to fight autonomously, detecting and destroying enemy targets.[45] As P. W. Singer has made clear, in *Wired for War* (2009), our new century—wherein, by 2008, U.S. forces in Iraq already included twelve thousand robotic units—is in the process of witnessing war unmanned.[46] No matter how agential we theorize objects to be and to have always been, we should be poised to assess a novel distribution of agency outside the confines of theory.

Finally, it may be that scholars have turned their attention to the object world because our most precious object, the earth, seems to be dying, and it has thus become a global object (it has been produced as an object) within international political and legal discourse.[47] All told, then, if one can a posit a material unconscious that has provoked this thing about things, I suspect it is troubled by a "dematerialization" of the world, a proliferation of newly agential objects, and a recognition that our most familiar object, our planet, has become uncanny. Such changes make it clear that those who long to exclude objects from the ethical imagination (somehow convinced that "forces are conspiring" against the intellectual engagement with things) seem determined to render the humanities obsolete.[48] Rather, as one historian put it, "Things are back. After the turn to discourse and signs in the late twentieth century, there is a new fascination with the material stuff of life."[49]

That fascination has been no less obvious within today's art world. As more than one critic has said, *Documenta XIII* (2012), for instance, clearly meant to align itself with today's "object-oriented philosophy" as with "thing theory."[50] But before the turn of the century, in 1992, Klara Sax (at age seventy-two) had already reached the final stages of her immense desert installation of B-52 bombers. From atop a sandstone ledge, you could see the "broad formation across the bleached bottom of the world": "two hundred and thirty planes, swept-winged, fanned like bottom creatures, some painted in part, some nearly completed, many not yet touched by the paint machines."[51] In a work meant to be seen as "a single mass, not a collection of objects" (83), Sax achieved the scale of the great earthwork projects, something on the order of the two vast trenches that

Michael Heizer had cut into the Nevada desert, *Double Negative* (1969–70), or his vast *City* (begun in 1972, once scheduled for completion in 2010). But this is a woman who, rather than reenact the heroics of transforming the earth, had long ago abandoned painting to devote herself, like Louise Nevelson or Louise Bontecou, to assemblage, working with bits and pieces—scraps—and then "saving" the artifacts of the Cold War "from the cutter's torch," seeming to ask whether art could ever achieve the dimensions of war. "I am painting airplanes that are a hundred and sixty feet long with wingspans even longer and total weight operating on full tanks maybe half a million pounds." In her 1992 interview she was willing to say, "This is an art project, not a peace project. This is a landscape painting in which we use the landscape itself. The Desert is central to this piece. It's the surround. It's the framing device" (70). But she also said (too hastily), "Power meant something thirty, forty years ago. It was stable, it was focused, it was a tangible thing. . . . You could measure things" (76).[52]

Don DeLillo has become both critic and poet of the late-century American object world—its buildings and dumps, its baseballs and radios, its station wagons, computer screens, toxins, and art. In *Underworld* (1997), the man with whom Klara Sax once had a brief yet intense affair, Nick Shay, has become a waste-management executive, overseeing an organization of "waste handlers, waste traders, cosmologists of waste," and making sure that other residues of the Cold War remain out of sight, "entomb[ing] contaminated waste with a sense of reverence and dread" (88). Nick's chess-obsessed brother Matt has grown up to work on classified projects in remote locations; he is a "bombhead" living life in the Pocket, "somewhere under the gypsum hills of New Mexico," a "self-enclosed and self-referring" region that is "inaccessible to others" (403, 401, 412). Working on the desert, not beneath it, Klara Sax developed a project that inspired a new nomadism, attracting "teachers on leave and nomads and runaways . . . burnt-out hackers looking for the unwired world" (65). It may well be the case that subject and object, human and nonhuman, are inextricable, and that human life already resides within the weapon, be it shield or B-52 or drone. But Sax conjures a very different imbroglio of persons and things: "See, we're painting, hand-painting in some cases, putting our puny hands to great weapon systems . . . we're trying to unrepeat, to find an element of felt life, and maybe there's sort of a survival instinct here, a graffiti instinct—to trespass and declare ourselves, show who we are" (77). It is an imbroglio nonetheless: a haptic engagement that, fully recognizing the importance of the object world, struggles to preserve the importance of the human within it. It is an effort to reanimate, differently, Auden's "artificial wilderness." Will-

ing to admit, in *Mille Plateaux* (as translated), that an "art movement can be a war machine" (422), Deleuze and Guattari never sensed how such a movement might begin with objects of war for which war is no longer the object—how the art of war might be refunctioned as art's own war to provoke a different state of unrest.

One

Things—in Theory

In the opening pages of *Falling Man*, an unidentified consciousness
struggles to apprehend the devastation of lower Manhattan, "a time
and space of falling ash and near night," of "seismic tides of smoke, with
office paper flashing past," of "people running . . . holding towels to their
faces," of "otherwordly things in the morning pall." The man himself
does not run. Glass in his hair, glass in his face, he walks. He walks slowly
enough and consciously enough to encounter, consciously, the altered
object world he inhabits—the things that the novelist, Don DeLillo, in-
sistently tags as *things*: "In time he heard the sound of the second fall.
He crossed Canal Street and began to see things, somehow, differently.
Things did not seem charged in the usual ways, the cobbled street, the
cast-iron buildings. There was something critically missing from the
things around him. They were unfinished, whatever that means. They
were unseen, whatever that means, shop windows, loading platforms,
paint-sprayed walls. Maybe this is what things look like when there is no
one here to see them."[1] The animation of the passage derives from the
relays between some things and others: from a dynamic that moves—
under the sign of *things*—from general to particular, abstract to concrete,
vague to precise. Things are critically different. The cast-iron buildings
and the loading platforms—those things are different. Something is
wrong. What's wrong is manifest there, in those things—shop windows
and paint-sprayed walls—but the thing that is wrong, everywhere, looms
both within and beyond those things.

DeLillo exploits the ambiguity of things and an ambiguity in *things*—

what Martin Heidegger referred to simply as the word's broader and narrower sense. For *thing* (*Ding, chose,* &c.) can designate merely something (*ein Etwas*) as opposed to nothing; it can refer to actions or conditions ("Let's get those things done now"; "things have been pretty shitty"); and it can name any quotidian object—a rock, a knife, or a watch, as he says. Heidegger himself persistently isolates and concentrates on the present-at-hand (*das Vorhandene*), "what is most immediate, most capable of being grasped."[2] The scale of DeLillo's concrete things—walls and windows and streets—renders them less graspable. And they can hardly be extracted from (grasped out from) their condition; they thus dramatize how things remain tangled among other things, including the least graspable things, like the thing that is missing—"something critically missing"—the thing whose absence is nonetheless present *there*.

Not knowing his way, the man vacillates between the thoughtless and the thoughtful. His passing speculation that this state of things may be their state—their state in the absence of human perception, the way things look in the absence of looking—seems to engage traditional questions: whether, for instance, a falling object makes any sound in the absence of an auditor. The speculation might very well bring to mind, chillingly, Jean-Paul Sartre's analogous point that destruction is only a human experience. Storms, for example, "merely modify the distribution of masses of beings. There is no *less* after the storm than before. There is *something else*." In the absence of a human witness, "there is being before as after the storm—that is all."[3] But most precisely, the man's speculation entertains the prospect that this event has simply disclosed things as they are: the being of the Kantian thing-in-itself (*Ding an sich*) outside the spatiotemporal grid of experience, the perceptual apparatus that can only provide apprehension of the thing-for-us (*Ding für uns*). Perhaps the perceptual apparatus itself has succumbed to the wave of destruction. More likely, the passing thought insists that perception is irreducible to seeing, that it is always a matter of corporeal involvement, never some purified, pristine spectatorship. This is why, objecting to how Kant overlooks "the phenomenon of the body and that of the thing," Maurice Merleau-Ponty concludes that we "must say that my experience breaks forth into things and transcends itself in them, because it always comes into being within the framework of a certain setting in relation to the world which is the definition of my body."[4] The definition of *this* man's body—a passing driver sees "a man scaled in ash, in pulverized matter" (DeLillo, *Falling Man*, 6)—provides the framework within which he stumbles into one and another question about things and our access to them. All but aimlessly, he stumbles back out.

In the course of the following chapters (the last of which returns to

Falling Man), I describe how specific examples from the literary, visual, and plastic arts fashion questions about the object world and our relation to it, about the mutual constitution and mutual animation of subject and object, and about a kind of thingness provoked by the object that remains irreducible to any object form. Within the current chapter, I mean to anticipate those questions and to dilate them, exposing their conceptual infrastructure and providing a genealogy for the distinction to which I repeatedly refer, between objects and things—or the object and its thingness. This is a distinction that, within my subsequent cases, will be reinflected in response to the matter at hand. Here my concern is how things have drawn a more formalized thinking about them and our orientation to them: our life in the midst of things, their lives in our midst.

I retain some version of the much-disparaged subject-object distinction in behalf of apprehending an object-thing distinction whose explanatory power lies in the cultural field (and not, that is, in the field of metaphysics or psychoanalysis). After providing a chart of my scheme for describing the thingness of objects—the thing that is the other thing, understood in either a physical or a metaphysical register—I track Heidegger's repeated approach to the question of the thing (in its autonomous being). In his final approach (delivered as a lecture, "Das Ding," in 1950), he develops a version of the object-thing distinction that Lacan takes up in what I read as his inadvertent theory of objects: an account of how the making of the artifact fashions the difference on which signification as such depends. My exposition of their texts and the links between them provides the conceptual historical core of the chapter; this is thought that continues to merit rethinking and that remains at the center of thinking about things. I pursue this genealogy to make sense of the intuition that sustains this book as a whole: that attention to physical *objects* (material culture) and to *thingness* (material or immaterial) can productively converge. Because that convergence, in my subsequent cases, is so often mediated by literature, photography, and film ("Why not, if you care so much about material objects, give some thought to that coffee mug sitting right there on the table?"), I conclude the present chapter by pointing to various definitions of materiality per se that argue against one or another fantasy of immediate access to the material world, definitions that suggest instead how the *mediation* of objects can make their materiality (let alone their thingness) sensible, if not in the last instance fully apprehensible. It would be possible to curate the thinking I track within a material and materialist history—a history of technology and of corporate capital and mass consumption. That is not my aim within the confines of this chapter, however. I want rather to share a feel for things, then and now, in theory.

1. Object-Thing

Insofar as *Other Things* leaves the subject-object binary in place (while re-peatedly discovering it disoriented or displaced), you might want to en-gage the book as a retrospective inquiry. I look backward from the twenty-first century to some earlier "remedial work on our relation with things," a phrase by which John Mullarkey characterizes Henri Bergson's *Intro-duction to Metaphysics* (1903), where Bergson insists, against the philo-sophical tradition, on the mind's capacity to follow "reality in all sinu-osities and of adopting the very movement of the inward life of things."[5] Above all, though, I look back into a modernity where the animation of the object world, the voice of things, or the indistinction of object and subject does not constitute a general (or generalizable, theorizable) con-dition but irrupts as a discrete event, the aesthetic effects of which range from the uncanny to the sublime. Nonetheless, as Alfred North White-head emphasized, the subject-object relation may pattern experience, but "subject and object are relative terms," and the relation must not be regarded as the structure of knower to known. This is because "experi-ence is an activity" and the "basis of experience is emotional": "The occa-sion as subject has a 'concern' for the object," he argues; "the 'concern' at once places the object as a component in the experience of the subject."[6]

If the perennially demonized subject-object distinction was a defining feature of modern thought (the thought of Descartes, say), then it re-mains difficult not to admit (however reluctantly) that this is a moder-nity that we continue to inhabit. The difficulty might be measured by the story that Jean Piaget tells of the ontogenetic development of the object concept itself, where the human infant achieves the distinction between object and subject as a kind of triumph—the triumph of overcoming the "egocentrism" of radical undifferentiation, where there is neither self nor "objectivity."[7] Only gradually does the infant assimilate the envi-ronment as external (xi–xii). This externality may be the basis for—but cannot be equated with—the epistemologist's idea of a world outside the subject. Rather, it precipitates as a realist metaphysics in which the ob-ject seen and grasped and sucked is the object (itself) now apprehended as object.[8] Externality designates the emerging consciousness of an ob-ject world and spatial relations; it designates the gradual organization of "reality," which occurs "to the extent that the self is freed from itself by finding itself and so assigns itself a place as a thing among things, an event among events." This is a "transition from chaos to cosmos" (xiii): a trajectory from the child's "adualistic consciousness" (that knows no binary) to the production of objects, the coordination of a relationship

to those objects, the faith in object conservation (between eight and ten months), and the internalization of those schemata (5, 45, 96). Conferring stability on the object world (on the otherness of the object) stabilizes the objecthood of the self. This is the psychological transition (the denouement of the infant adventure) on which an understanding (such as Hannah Arendt's) of the stability of the artifactual world depends. But no one has ever experienced such stability as wholly secure: sometimes the same table at which you sit everyday just isn't the same. It has become something else.

When Piaget moves from his preface to the body of his book, he transposes the "thing among things" into the "object among other objects": the child, we're told, eventually "places himself as an object among other objects," thus becoming "a part of the universe he has constructed by freeing himself of his personal perspective" (97–98). It is as though the psychologist, before rendering this scene of confidence, has registered the way that objects, even in their originary differentiation (as mere things among things) are not yet quite distinct—as objects. Which is to suppose that, however inadvertently and vaguely, he registers some distinction between the object and the thing. This is the distinction that I mean to dilate.

The first chart formalizes the dynamics out of which the distinction between the object and the thing (between an object and its thingness) should become clear.

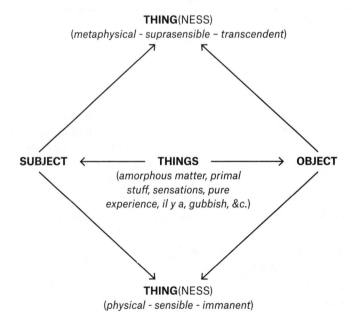

The arrows designate relations. *Things* (plural) designates some under-organized material field or some unorganized amalgam or mass: a field of sensations before they are organized into discrete objects; or a more general field of objects before any one object (a stone, a city, a chair, a can of diet coke) becomes distinct; or that field of "material . . . of which everything is composed," the "primal stuff" that William James called "pure experience," one of whose "terms" becomes the subject, another the object.[9] Indeed, the field of things should be understood to include the pre-emergent subject as a thing entangled in things—*this is a field of things from which both subject and object precipitate in and as their relation.* More traditionally, you would find a different horizontal axis (second chart):

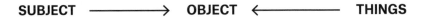

SUBJECT ⟶ OBJECT ⟵ THINGS

That axis describes a dynamic wherein the object emerges from an interaction between the perceiving or apperceiving subject and things. But such a formulation stabilizes the subject before the emergence of an object, neglecting the way that the subject, too, emerges from things.

The diagonal arrows in the first chart point out how some thing, by which I will always mean the thingness of the constituted object, is the outcome of an interaction (beyond their mutual constitution) between subject and object. The thing thus names a subject-object relation. The corollary of this point is that any object can become a thing—or, more precisely, that thingness inheres (as a latency) within any manifest object. Of course, the subject can be an individual or a group—a family, a club, a gang, a subculture, a nation, &c.; group identity can be fortified by the thingness of some object: ritual food, a totem animal, a national flag. And an object can appear in the subject position; indeed the dynamic can be understood most readily through an interobjective relation. Imagine a toy truck beside a magnet that suddenly affixes itself to the truck. From the magnet's point of view (if you will) the object qua object is beside the point: it doesn't matter that the truck is yellow and blue, that it is three inches tall, that its wheels are black, that the girl playing with it calls it a truck. What matters is the iron in the truck (or the iron of the truck): that is the thing that compels the magnet—the thing that does not in any sense destroy the object but that renders the object superfluous (except insofar as it provides the source of the thing).

How is it that an object becomes a thing for one or another (individuated) human subject? Such thingness can seem to be the result of subjective response, something akin to what Roland Barthes called the *punctum* of the photograph: what captivates you, however minor or inadvertent

the detail. An "intense mutation of my interest," he calls it; with his eyes shut, he will find the "detail" continuing to "rise of its own accord into affective consciousness."[10] He calls it the "partial object" as opposed to the "total object" produced by the photographer's intention (43, 47). The faint stain on the lampshade here recalls (calls back into being) the faint stain you kept staring at, there, in the lower corner of your family's dining room drapes.

But such thingness can result as well from the object's insistence, what Alfonso Lingis calls the *imperative* that forces the subject's attention: as fact, as interruption, as summons. "Things are attractions" that "draw our perceptual movements to themselves and hold them"; an object "lures and concentrates the current of feeling in us"; it makes demands: the armchair "calls for composure in the midst of agitation," and "the worktable calls for devotion to craft."[11] The curiously bulbous ball-point pen compels you (however much you want or need to write) to keep rolling it between your thumb and fingers. Rolling it. And rolling it.

In any case—physical or metaphysical, with the thing provoked as *punctum* or as *imperative*, or both, the two often indistinguishable—the thingness of the object, just as it is irreducible to the object form (be that thingness physical or metaphysical), threatens the coherence of the object. If the thingness of the table resides in the remarkable patina of the bird's-eye maple (the thing thus emerging from the physical register), the isolation of that property undoes the integrity of the object; it disaggregates what Hegel calls the "community (*Gemeinschaft*)" of the "objective entity."[12] If the thingness of the chair resides in its historicity— its historical value, its having been sat in by Hegel—the solid object has given itself over to the role of medium, the access it gives to what transcends it.[13] My concern is not with an object's withdrawal from its properties, but with the adamant presence of a thingness that is fully (even exuberantly or aggressively) manifest in those very properties, so long as *properties* also names metaphysical characteristics (say, the symbolic valence of the wine and bread that makes them other things). When you say that there is some thing about that bust of Balzac that creeps you out, the thing is present and potent, even if it can't immediately be named or known.[14]

All this may clarify what I mean by the other thing, by the distinction between object and thing, but such clarity comes, of course, at the expense of the local detail where any thing occurs. Totalizing in its simplicity, the scheme cannot be comprehensive because in itself it cannot disclose the density of the thing as affect or effect. Suffice it to say that my concern is not with whether you succeed or fail to grasp things-in-themselves, objects as they are. My concern is how objects grasp you: how

they elicit your attention, interrupt your concentration, assault your sensorium. My descriptions are ontical—addressing the world we inhabit, the what and where and how and why of objects therein; my questions are not ontological in the sense of struggling (vainly) to answer the question of the being of things tout court. Which is not to deny that there are times when such questions, however initially absent, resurface—as the return of the suppressed. (In a less palatable, more august parlance: the ontic study of history slips into the ontological study of the historicity of Being.) The slippage between the two—between the ontic and the ontological—might be said to participate in a variety of oscillations, including the overarching ambiguity that animates thing theory as I've described it before. For my original chart introduces a false dilation—a temporality that the thingness of things often refuses: the temporality obscures the fact that, at the same time, the thing can seem to name the object just as it is, even as it names something else.

2. Heidegger

Such a formalization of the thing—more exactly, a heuristic conceptualization of thingness—reanimates and reorients an object-thing distinction that appears most saliently in the work of Heidegger and Lacan, the latter drafting off the former while decidedly shifting the destination of the inquiry. However anthropocentric Heidegger's concern with *Dasein* may be (specifically designating human-being), his originality lies not least in his insistence that we cannot begin to appreciate what being human means without recognizing that such being is thrown (has been thrown) into a world of things. And no one so patiently faces the disorienting fact that the most familiar things are those we know least. Moreover, if Lucien Goldmann is right to believe that, in *Being and Time* (1927), Heidegger was responding to Lukács's account of reification (*Versachlichung*) in *History and Class Consciousness* (1922)—responding by trying to generate an account of "what we are to understand *positively* when we think of the unreified *Being* of the subject," as Heidegger himself puts it—then it surely makes sense to understand his ongoing effort (1925–50) to describe the thingness of things as a response to Lukács's claim (following Marx) that the "character of things as things" has been destroyed by the hegemony of the commodity form.[15] This is to suppose that, with Lukács as his unacknowledged interlocutor, Heidegger was asking: How might we characterize the character of things as things? There is much to be learned from tracking Heidegger's persistent question—a question that everywhere and always means to stage his effort to think beyond

Kant. But my sense is that he ultimately provides, in his 1950 lecture "Das Ding," a riposte to Marx: the thing there figured has powers that are comparable to those of the commodity object that Marx describes (in the first chapter of *Capital*), but the thing there is no commodity. Nor is it an object.

From the first, Heidegger's phenomenological ontology is an effort to move beyond (more precisely, beneath) Husserl's phenomenology, itself a return to the problem of "the things themselves" that accounts for how objects present themselves to consciousness. For Heidegger, positing such a distinction between subject and object amounts to a philosophical retreat from the fundamental question of the Being (*das Sein*) of a being (*das Seiende*) or beings, from the "more primordial" task of characterizing "the meaning of Being in general" (*BT*, 31). He dismisses attention to the ontic—the merely phenomenal, this distinct being or that one—in behalf of attending to the ontological: an analysis of the structures of Being. (The ontic level of inquiry, which separates the subject and the object, also names the domain of positive knowledge.) Husserl brackets off the world to study a particularized subject-object dynamic. Heidegger lets the world back in. He does so by positing *Dasein* as his topic of inquiry, the there-being (*Etre-là*) that is a being-here-in-the-world. Thus, insofar as fundamental ontology unfolds as an analytic of *Dasein*, Heidegger must ask after the ontological structure of the world; he must determine the "*worldhood*," the worldliness (*Weltlichkeit*), of the world, the fundamental constitution of which is unequivocal: "The entities within the world are Things" (*BT*, 78, 91). Frustrating as Heidegger's dismissal of phenomena (this chair or that table) may be, his commitment to the "average everydayness" of *Dasein* and his description of *Dasein* as a being in the midst of what is (*inmitten des Seienden*) render things absolutely adhesive: there is no human-being without them—they are never not within Being. (This is why he singles out Descartes for extended censure [*BT*, 125–34]).[16] Yet this very adhesiveness presents an immediate problem, for "that which is ontically closest and well known, is ontologically the farthest and not known at all" (*BT*, 69).[17]

Insofar as being-in-the-world consists of the quotidian engagement with things, understanding *those* things responds to the forgotten question of Being. The things most engaged by (or in) *Dasein* Heidegger terms "equipment" (*das Zeug*), his translation of the Greek *pragamata*, "entities which we encounter in concern," with which we involve ourselves everyday—"equipment for writing, sewing, working, transportation, measurement," for instance, but also the equipment used for unconscious tasks: "When I open the door, for instance, I use the latch" (*BT*, 96–97).[18] Our very involvement with such things, which entails concentrating on the

task rather than the tools, means that their essential characteristic—their equipmental being, their instrumentality, their "ready-to-handness"—remains inconspicuous; but should we stop to observe them, we necessarily fall into a secondary mode of encounter, wherein only their "presence-at-hand" becomes apparent. Heidegger's famous case is the hammer: should you simply look at the hammer, its readiness-to-hand (*Zuhandenheit*), its specific "Thingly character" cannot be "grasped theoretically at all" (*BT*, 98, 99). Indeed, "the less we just stare at the hammer-Thing, and the more we seize hold of it and use it, the more primordial does our relationship to it become, and the more unveiledly is it encountered as that which it is—as equipment" (*BT*, 98). But within that encounter (that *praxis*) the thing effectively disappears from our conceptual view.[19] "The peculiarity of what is proximally ready-to-hand is that, in its readiness-to-hand, it must, as it were, withdraw in order to be ready-to-hand quite authentically" (*BT*, 99).[20] Our closest theoretical approach to this equipmental being occurs when the hammer breaks or when it has gone missing; then "the characteristic of the presence-at-hand in what is ready-to hand" becomes apparent. But Heidegger's emphasis falls on the dynamic wherein the "entities we encounter in concern are proximally hidden" (*BT*, 96), on how readiness-to-hand withdraws and withholds itself; "and it is in this that the Being-in-itself of entities which are ready-to-hand has its phenomenal structure constituted" (*BT*, 106).

Such a conclusion from the early part of *Being and Time* (1927) does not prevent Heidegger from continuing to pursue one or another effort to grant the thing "a free field to display its thingly character directly," as he puts it in the subsequent decade ("WA," 25). When he publishes his Freiburg lectures of 1935–36, originally titled "Basic Questions of Metaphysics," he titles the book *The Question of the Thing* (*Die Frage nach dem Ding*, 1962).[21] He divides the book into two parts, "Various Ways of Questioning about the Thing," and the great bulk of the book, "Kant's Manner of Asking about the Thing," where he reads *The Critique of Pure Reason* to show how the question of the thing is not Kant's question. This is not so much because "Kant does not pose the question of the thingness that surrounds us," concerned as he is with the "thing as an object of mathematical-physical science," but because he addresses the thing as an appearance (*Erscheinung*), which is to say as an object: "Objects are things as they appear" (*WT*, 128, 214). Yet Heidegger begins with a kind of longing: an interest in the "realm of things immediately around us" that can grant us access to "thingness" (*Dingheit*) itself, which means asking for "something unconditioned (*un-bedingtes*)" (*WT*, 8–9). The lesson learned from Kant is a lesson in how elaborately one must consider those condi-

tions, but Heidegger remains dedicated to an interrogation that means to catalyze the disclosure of thingness from things that are close at hand.

In the first part of *The Question of the Thing*, he reviews traditional answers, above all the idea that the "essence of the thingness of things" is the unchangeable bearer of changeable properties (this chair can be painted, sanded down, stained, recaned, &c., all the while remaining this same chair), grammatically figured as the subject to which properties can be predicated ("this chair is wood"; "this chair has a cane seat"), the clarity and simplicity of which ought to make it clear that "the question is obviously no longer a question" (*WT*, 34–35). And yet this supposedly natural, self-evident answer is in fact historical, based on certain presuppositions and thus leaving the answer unsettled: it could be that "things actually encounter us quite differently" (*WT*, 40). So, too, the question must be historical, and thus the question of the thing, responsibly asked, would require the "transformation of the hitherto existing position toward things, a change of questioning and evaluation, of seeing and deciding; in short of the being there (*Da-sein*) in the midst of what is (*inmitten des Seienden*)." This is the task not of one argument but "of an entire historical period" (*WT*, 50). Within his own argument, Heidegger can only hope to demonstrate that "the definition of the thing and the way it is set up include fundamental presuppositions which extend over the whole of being and to the meaning of being in general"; this is a demonstration of the inadequacy not just of common sense but also of the reigning scientific conception of the thing as "material, a point of mass in motion in the pure space-time order, or an appropriate combination of such points," taken then as the substructure of all things (*WT*, 129, 51). The demonstration means to challenge the regime of reason: not just the limits of scientific reason (Kant's own demonstration of what cannot be known in itself), but also the capacity of philosophical reason to find what it is looking for. This is why he emphasizes other modes of apprehension: as he puts it in the "Work of Art" essay, "what we call feeling or mood" ("*Befindlichkeit*"—affect, sensitivities, experiential feeling, kinds of care [*Sorge*]) "is more reasonable—that is, more intelligently perceptive—because more open to Being" than reason ("WA," 24–25).

You can read *The Question of the Thing*, then, as an extended account of why the question must be postponed, a postponement reenacted the same year when Heidegger sets out to address "The Origin of the Work of Art" and provisionally accepts the familiar notion that works of art have a "thingly character," which then necessitates knowing with "sufficient clarity what a thing is" ("WA," 19–20). "What in truth is the thing, so far as it is a thing?" he asks, aiming "to know the thing-being (thingness) of

the thing," to "discover the thingly character of the thing" ("WA," 20). He again reviews the efforts that have grounded both philosophical thinking and common sense: the "three modes of defining thingness conceive of the thing as a bearer of traits [sometimes understood as the substance of a thing and its accidents, or what can be predicated of it], as the unity of a manifold of sensations, as formed matter" ("WA," 30). None "lay hold of the thing as it is in its own being"; each is an "assault" on the thing ("WA,"25). The stubborn evasion of the thing from our thought begins to seem like a fundamental characteristic: "Can it be that this self-refusal of the mere thing, this self-contained independence, belongs precisely to the nature of things?" Because it is so familiar (being man-made), equipment once again seems like the best place to start; it requires working to discover the "equipmental character of equipment" ("WA," 31). But in this instance, the task proves successful because Heidegger turns to "a common sort of equipment—a pair of peasant shoes"—and then to a Van Gogh painting of such shoes, displacing the query (about the particularized but unspecified shoes) onto (or into) the (particularized but unspecified) work of art ("WA," 32–35). It turns out that "the art work lets us know what shoes are in truth" because art "opens up in its own way the Being of beings" ("WA," 35, 38).[22]

But his most general question about "thing-being" gets left behind, for it turns out that the artwork's "work-character cannot be defined in terms of its thingly character" ("WA," 31, 67). Heidegger remains willing to say that "anticipating a meaningful and weighty interpretation of the thingly character of things, we must aim at the thing's belonging to the earth." But given that the nature of the earth reveals itself only in opposition to the world, and given that this "conflict is fixed in the figure of the work and becomes manifest by it" (the work that sets up a world and sets forth the earth), it is only through the work—the work of art—that we come to know "the thingly character of the thing" ("WA," 67). We can "never know thingness directly," "only vaguely" and only through the work. Such an outcome is hardly surprising, given that his consideration of the artwork's origin "(German *Ursprung*, literally, primal leap)" becomes an account of *what* the work of art effectively originates: earth and world, nation, a people ("WA," 75). Professor Heidegger's Art History 101 is a lesson in how Art inaugurates History as such.

And yet, after these repeated efforts to discover the thingness of things—efforts rigorously pursued and differently abandoned—his "Das Ding" lecture (1950) finally accomplishes the task: thingness discloses itself; the philosopher is "called by the thing."[23] He provides two historical contexts for the inquiry: the first, with which the lecture opens, is the technological, mass-mediated abolition of distance, which has the effect

not of bringing the remote near but of eradicating both remoteness and nearness; the second is the explosion of the atom bomb, but only as an event, "the grossest of all gross confirmations of the long-since-accomplished annihilation of the thing," which is to say the scientific annihilation of the thing in behalf of the sphere of objects. The "thing as thing remains proscribed, nil" ("T," 168). In his initial effort to apprehend the "nature of nearness," Heidegger attends to "what is near," which turns out to be "what we usually call things"; such attention, though, faces a familiar challenge: "But what is a thing? Man has so far given no more thought to the thing as a thing than he has to nearness." In this version of the exercise, he turns not to a painting but to a jug (*Krug*), which importantly "stands on its own"; in its independence "the jug differs from an object" ("T," 164); it could become an object, but its "thingly character" cannot "be defined in any way in terms of the objectness, the over-againstness of the object" ("T," 164–65). (For Hannah Arendt, who makes no distinction between object and thing, this over-againstness gives "the things of this world their relative independence," their "objectivity," which is their endurance—implied, as she says, "in the German word for object, *Gegenstand*.")[24] This names the kind of relation, and thus the condition, that Heidegger is determined to think beyond; only beyond the *Ding für uns* can we locate the thing's self-sameness. He fabricates a little scene in which a potter throws the jug—a story about the (ontic) creation of the jug that may tell us something about the "objectness of the object" even as it fails to respond to those fundamental (by now familiar) questions about the "thingness of things": "What in the thing is thingly? What is the thing in itself? We shall not reach the thing in itself until our thinking has first reached the thing as a thing" ("T," 165).

Notable not least for suppressing the sort of questions—about the nature of equipment, work, and world—that had previously distracted attention away from the thing, here the lecture concentrates on what you could call the force of the jug's form. "From start to finish the potter takes hold of the impalpable void," bringing "it forth as the container in the shape of a containing vessel"; its thingness lies in the "void that holds" ("T," 167). This is a capacity not just to hold, but also to gather and to give. And because the poured gift (the "giving of the outpouring") is either spring water or wine, each dependent on sky and earth, Heidegger is led to say that "in the jugness of the jug, sky and earth dwell" ("T," 170). Because this gift could serve mortals or, as a libation, the immortal gods, he is led to say that "in the gift of the outpouring earth and sky, divinities and mortals dwell *together all at once*" ("T," 171). And because the word *Ding* (*dinc* in Old High German) originally meant a gathering (an assembly) for deliberation, Heidegger can say (as a way of recaptioning how

the jug makes the "simple-manifold" present) that "the thing things" (*das Ding dingt*): a predication that (crucially) does not distribute properties of the thing, but lets it be in its Being, as though we said not that the chair sits in the corner, or the chair is worn, or that the chair is wood, but exclusively that *the chair chairs*. In its self-sameness the thinging thing gathers. The jug is no "object" or "*res*" or "*ens*": "The jug is a thing insofar as it things." "The thing things. In thinging it stays earth and sky, divinities and mortals" ("T," 175). Moreover, it brings near what is distant, preserving both distance and nearness, the onefold of the fourfold, which is the "onefold of worlding." While, in the "Work of Art" essay, the artwork assumes the potency of originating world and earth in their relation, in "Das Ding," the Thing has a no less august role to play, making the world manifest: "The thing things world. Each thing stays the fourfold into a happening of the simple onehood of the world" ("T," 178). This culminates Heidegger's strategy for thinking beyond the Subject, beyond Kant, for whom "that which is becomes the object of representing that runs its course in the self-consciousness of the human ego" ("T," 174). It concludes his strategy, in search of the Thing, for overcoming the merely ontic and the merely phenomenological: for overcoming the subject and thus any subject-object divide.

Without perceiving thingness in "Das Ding" as the outcome of a decades-long, serial interrogation, it is impossible to appreciate the radical break that the lecture stages—the way it abruptly severs the world from human-being to enable the thing to dramatize both its autonomy and its potency. No less, Heidegger certainly means to have a final word in the specifically German engagement with this primitive form. In a meditation on the competing aesthetic and utilitarian values of the vase, "Der Henkel" (1911), for instance, Georg Simmel isolates the handle as the point of connection that must contribute to the sovereign artwork while connecting it to the "world outside art." And thus the object ("so unpretentious a phenomenon") serves as a "superficial symbol" of the simultaneity wherein the individual is utterly self-contained and yet beholden to "political, professional, social, and familial" environments.[25] Ernst Bloch went on to evacuate such a meditation of any interest in symbolism and the notion of Art. He begins his *Spirit of Utopia*, published just after World War I, with a lament about the cultural enervation and the "stink" and "corruption" of Germany, but then he turns to a pitcher (*Krug*) on the table and describes a "self-encounter," an "intensifying fullness," as he becomes "richer, more present"—"cultivated further toward myself by this artifact that participates in me."[26] "I am by the pitcher. Thus it leads inside, stands before the wall in the room," he writes, and the pitcher grants him access not only to the organic and agricultural, but to color

and form, and to the imbrication of subject and object: "Things"—some things—"become like the inhabitants of one's own interior . . . an influx and reflux of things, . . . a pansubjectivism within the object, beyond the object, as object itself" (Spirit, 9, 32). Theodor Adorno's exquisite recollection of reading Bloch's book (at the age of seventeen, in 1921) becomes (at Simmel's expense) an intensifying exposition: "What the hollow depths of the pot (Krug) express is not a metaphor; to be in those depths, Bloch suggests, would be to be in the thing-in-itself, in what it is in the nature of the human being that eludes introspection. Physically and spiritually, in its unfathomable interior the artifact embodies for those who made it what they have neglected and missed out on."[27] In Heidegger's rewriting of the episode, such concern for the human being and human beings is effectively beside the point, except insofar as they are assembled (gathered) by the thing.[28]

In the redramatization that Heidegger stages, he has excised any meditating (thus mediating) subject. And he has removed any handle, which constitutes an initial strategy for thinking about the object without having to think through the conundrum of equipment (which, when most essentially itself, withdraws). He has cast the potter as the sole human actor to emphasize the production of the object rather than, say, its consumption or its use. And once the potter exits, the objectness of the object (its relation to a subject) can give way to the thingness of the thing. Yet thingness here, whether it be the gathering of the fourfold or the (indissociable) thinging of the world, names an activity, a productive function—but an activity animated by no human aim (which is why the thingness of the thing need not disappear in praxis, into the object of praxis). You could say that the jug has a use value that has nothing to do with (its) use (by humans): it is not man who grabs the jug but the jug that gathers man.[29] Indeed, precisely insofar as the jug performs a task that it has not been given, you might describe its value as a kind of misuse value (a term on which I'll rely in subsequent chapters). Only by casting a useful object that is in no way beholden to its use can Heidegger theatricalize the other thing, the eventfulness of the thing.

"Thinking in this way, we are called by the thing as the thing" ("T," 178). Ray Brassier (among others) understands such a call, and the kind of drama enacted within those closing pages of Heidegger's lecture, as the "thinly disguised exaltations of mystico-religious illumination over conceptual reality." He does so while reminding his readers that Kant meant to show that religious hypotheses about reality could not be discounted because reason, as it turns out, "has no absolute jurisdiction over reality"; by defining the limits of science, Kant "leaves room for faith."[30] You could say, then, that Heidegger's lecture (where he himself points out how "Sci-

ence's Knowledge . . . [has] annihilated things as thing" ["T," 168]) simply fills up that room.

I'm inclined, however, to point to a non-Kantian context for assessing the mystico-religious dimension of Heidegger's inquiry. For if, as I've argued, Heidegger's lecture responds to Lukács's claim that the "character of things as things" has been destroyed by the hegemony of the commodity form, then the lecture can also be read as a response to Marx's account of commodity fetishism, from which Lukács developed his theory of reification. (As will become clear in chapter 5, Hannah Arendt, while pointing to Marx, addresses Kant; Heidegger, pointing to Kant, addresses Marx.) In contrast to what Marx calls the "metaphysical subtleties and theological niceties" of the commodity—the analysis of which shows that an apparently "trivial thing" is a "very strange thing," some *other thing*—Heidegger means to demonstrate, through the ontological analytic, how very strange a trivial thing (the thingness of that thing) *always is*, long before it has been subjected to (abstracted by) the commodity form.[31] (Jacques Derrida fairly well restages this drama, with a different mystical overtone, in *Specters of Marx*.)[32] The thing, thinging, has independent agency and voice before commodification generates the illusion of such agency and voice. This is to suppose that Heidegger means to rewrite (or unwrite) "Commodity Fetishism and the Secret Thereof": to fashion an episode in Western thought in which the bell clangs, the jug jugs, the thing calls, *das Ding dingt*, outside the commodity form. There may be a "mystical character of the commodity" (Marx, *Capital*, 164), but the object as such, appropriately addressed, discloses its own mystical character—as thing. Granting agency to the thingness of the object (it gathers and it calls), Heidegger enables the appreciation of a more ubiquitous potency, what (for instance) Alfonso Lingis refers to, in his anthropological phenomenology, as "the imperatives in things, the imperatives things are."[33]

In Heidegger's landscape, it is only a vigilant passivity that will enable the other thing, the thingness of things, to disclose itself; in the landscapes on which Lingis focuses, and on which I focus, you have no choice. Tripping over the dog's water dish, touching a glazed jug that doesn't feel the way it looks, using your paperback copy of *The Imperative* as a flyswatter to nail an angry wasp: these are momentary encounters—scenes of accident, confusion, emergency, contingency—wherein thingness irrupts. In other words: don't stay up all night at the kitchen table waiting for the jug to do its thing; just turn off the lights and start to feel your way to bed in the dark.[34]

3. Lacan

For Heidegger, the absence (around which the object forms) comes to specify a primordial yet ongoing event: the gathering (there) of the terrestrial and celestial, the mortal and immortal. For Lacan, the Thing still designates an absence, but this remains unspecified and obscure, "characterized by the fact that it is impossible for us to imagine it."[35] Surfacing in a range of texts, the concept receives it fullest attention in book 7 of the seminar (1959–60), *The Ethics of Psychoanalysis*, where Lacan complicates "the question of ethics" by tracking the two great transgressions that Freud mapped—against the father and against the principle of pleasure—and by showing how the death instinct (the "instinct de mort," more primitive than any "drive") challenges our capacity to accept Kant's understanding of the good, as does the more straightforward query into the meaning of human action, given how action can never be fully disentangled from desire. The seminar reaches its climax in Lacan's reading of *Antigone*; it begins, over the course of the first five weeks, with an "Introduction of the Thing."

Within that introduction, the concept is clearest when rendered most abstract: when Lacan restricts himself to the axiom *"Das Ding* is that which I will call the beyond-of-the-signified." This is a "beyond" from which the subject (by definition) keeps its distance, however "constituted in a kind of relationship characterized by primary affect, prior to any repression" (54). The Thing is a gap at the center of the real to which the subject has no access and against which it develops the signifying process itself: *"Das Ding* is something that presents and isolates itself as the strange feature around which the whole movement of the *Vorstellung* turns," around which "the whole adaptive development revolves" (57). In this regard, then, it is structural and not substantial. Yet Lacan goes on to substantialize it variously, for the Thing, eluding representation, gets represented nonetheless. Pointedly and polymorphously. Lacan speaks of "the Other as a *Ding*" (56), of "the burning bush [as] Moses's Thing" (174), of the unapproachable Lady within courtly poetry as having "the value of representing the Thing." *Das Ding* is the mother, "the Sovereign Good" that is "also the object of incest" and thus "a forbidden good" (70). These are objects transposed to the value of the Thing. He will substitute the Thing for sin, as for jouissance, as for evil, given that the "question of *das Ding* is still attached to whatever is open, lacking, or gaping at the center of our desire," whatever comes to seem radically enigmatic or opaque (55, 84 [quote]). Unrepresentable and unimaginable though it may be, the Thing repeatedly "affirms itself," "oblig[ing] us . . . [to] encircle it or bypass it in order to conceive it" (118).[36]

Even such a brief account makes it clear that *das Ding* should not be conceived as *das Ding an sich*. It may not be phenomenal, but it cannot be said to reside outside the subject. Because it "is there in a beyond," the Thing may seem transcendental, but it is part of "psychic reality" (21); it must "be posited as exterior," yet "it is at the heart of me" and is that around which "the signifying relations of the unconscious are organized" (71). An "intimate exteriority or 'extimacy'" — "that is the Thing" (139), the beyond that is nonetheless within. As he explains elsewhere (silently transposing Heidegger's basic dynamic of proximity and withdrawal), the Thing "in and of itself is what is closest" to the subject "while escaping him more than anything else."[37]

And for Lacan (despite the echo of Heidegger), the Thing has nothing to do with things. Throughout the seminar he repeats this point, most sharply in response to a seminar participant's basic question about things: for given Freud's distinction between *Wortvorstellungen* (word-presentations) and *Sachvorstellungen* (thing-presentations), and given Freud's insistence that the unconscious operates through the latter alone, how can we make any sense of Lacan's linguistic emphases and his overarching notion that the unconscious is structured like a language (44)?[38] Lacan responds to the question most immediately by distinguishing between two German words denoting "the thing," *das Ding* and *die Sache*; by pointing out how Freud restricts himself to the latter, "the *Sache* [that] is clearly the thing, a product of industry and of human action as governed by language"; and by asserting that "it is obvious that the things of the human world are things in a universe structured by words, that language, symbolic processes, dominate and govern all" (45). Thing and word, *Sache und Wort*, "form a couple": "*Das Ding* is found somewhere else" (45).[39]

Where else? As it turns out, somewhat closer to things than Lacan would at first lead his audience to believe. The Thing may have nothing to do with the object world and object-presentations, yet these lure him into an elaborate engagement. They do so once he has completed his "Introduction to the Thing" and begins the new year with "The Problem of Sublimation." In the English language, you get to say that Lacan had a thing about things: he was a collector like Freud. ("And if some of you like to think that it is in imitation of Freud, so be it" [113].) Across his writing, too, he collects everyday objects — a sardine can, a honey pot, a telephone, a lectern, a mustard pot, &c.; these serve as pedagogical props, often to help demonstrate how words create things. He offers a more elaborate prop at the close of one week's lecture (January 20, 1960) when he finishes the day by providing his auditors with "a little fable," prefaced by the assertion that he will not be addressing the "psychology of collect-

ing" and by the reminder that of course "what is called an object in the domain of collecting should be strictly distinguished from the meaning of object in psychoanalysis," where it "is a point of imaginary fixation which gives satisfaction to a drive in any register whatsoever" (113). (In psychoanalysis, inanimate objects rarely achieve the status of objects.)[40]

The fable concerns a brief autobiographical episode in which, during the Pétain era, Lacan visited Jacques Prévert's flat, where he saw the poet's elaborately displayed collection of matchboxes.

> It was the kind of collection that it was easy to afford at that time; it was perhaps the only kind of collection possible. Only the match boxes appeared as follows: they were all the same and were laid out in an extremely agreeable way that involved each one being so close to the one next to it that the little drawer was slightly displaced. As a result, they were all threaded together so as to form a continuous ribbon that ran along the mantelpiece, climbed the wall, extended to the molding, and climbed down again next to a door. I don't say that it went on to infinity, but it was extremely satisfying from an ornamental point of view. (114)

What Lacan reports as the "shock of novelty" resolves into a particular effect: into the recognition that "a box of matches is not simply an object, but that, in the form of an *Erscheinung* [occurrence] as it appeared in its truly imposing multiplicity, it may be a Thing" (116). Decidedly drifting toward a psychological account of the poet's collecting, Lacan imagines that Prévert's "satisfaction" and his "motive" concern "less the match box than the Thing that subsists in a match box." And he finally suggests that "the picture drawn" by Prévert's presentation was meant to disclose the "copulatory force" of the boxes. When he then summarizes his fable by saying that "the revelation of the Thing beyond the object shows one of the most innocent forms of sublimation," you can begin to sense something less than innocent (114). For of course the Thing is not "beyond" the object; it is within the object—indeed it is the object—except insofar as the "pouvoir copulatoire" quickly renders the scene as a kind of object orgy, say, with the objects genitalized (as hermaphrodites) to show how the collection at once hides and dramatizes a libidinal thrust.

In the subsequent week, Lacan returns to the episode and "the question of what we call the Thing"—to "the transformation of an object into a thing, the sudden elevation of the matchbox to a dignity that it did not possess before" (117–18). But the significance of the fable (the moral of the story) deflates when Lacan interrupts to say, "It is a thing that is not, of course, the Thing" (118) ("*c'est une chose qui n'est point pour autant la Chose*" [142]). This is because "the Thing is that which in the real, the primordial

real, I will say, suffers from the signifier," the dynamics of signification
serving to protect the subject from the real. The question of the Thing
thus becomes the question of signification: most simply, "the question of
what man does when he makes a signifier" (119). To answer that question,
Lacan reformulates Heidegger's lecture and provides a mythic (though
premythical) rendition of *homo faber*: for if "the signifier as such [not
language as such, not words] is constituted of oppositional structures,"
it comes as no surprise (except to the doctrinaire Lacanian) that "those
signifiers in their individuality are *fashioned* by man, and probably more
by his hands than by his spirit" (119, my emphasis). Lacan then turns to a
primordial physical act of making, to "the most primitive of artistic ac-
tivities, that of the potter," and to the vase (or vessel: *le vase*, his substitu-
tion for Heidegger's primitivist jug [*Krug*], with an echo of André Breton's
Les vases communicants [1932]). The moral of *this* story is simple, for the
act of throwing the pot ("perhaps the most primordial feature of human
industry") appears as the very fashioning of the signifier that introduces
"a gap or hole in the real" (119, 121). The vase—subject of myth, parable,
and metaphor, as Lacan writes—may have served to reveal for Heideg-
ger "what he calls Being," but for Lacan, the crafting of the object, around
an absence that becomes its center, reveals instead a "notion of creation"
that points at once to originary signification and to the Thing it is not,
indeed to nothing. For if, Lacan continues, "you consider the vase . . . as
an object made to represent the existence of the emptiness at the center
of the real that is called the Thing, this emptiness as represented in the
representation presents itself as a *nihil*, as nothing" (121). The nothing
around which the vase is thrown becomes nothing only in its relation to
the something that the vase itself becomes.

Elsewhere and insistently for Lacan, words make things—"It is the
world of words that creates the world of things."[41] But for a moment, here
in the *Ethics*, the other thing makes words. Rather, the making of the ob-
ject (by hand) is the making of signification, the instantiation of oppo-
sitional structure that will enable language to enter the world. What is
especially important about this story of "the first of such signifiers fash-
ioned by the human hand" is that the object "is in its signifying essence
a signifier of nothing other than of signifying as such" (120). The object
"creates the void and thereby introduces the possibility of filling it," which
is to say it creates both emptiness and fullness, absence and presence, the
oppositional structure on which language depends. The Lacanian myth
of creation doesn't stop with the vase, however; the myth describes the
basic function of art, which, "to a certain extent . . . always involves cir-
cling the Thing" (141). "The object," Lacan maintains, "is established in a
certain relationship to the Thing and is intended to encircle and to render

it both present and absent" (141). The world of art, then, teaches us that things in fact have everything to do with the Thing.

"Why the image has suddenly resurfaced in my memory, I cannot tell," Lacan writes of his matchbox fable (114). But can't you tell that it resurfaces there as the return of the repressed object world, an object world effectively elided, throughout psychoanalysis, by the priority of the human subject, and elided, throughout Lacan's work, by the priority of the word? If, in the terms established by Alfred North Whitehead and Hannah Arendt, this appears as the familiar flight from the world into the subject, it is also a flight from the postwar accumulation of stuff as registered, say, in the opening pages of Georges Perec's *Les Choses* (1960).[42] It is as though Lacan, despite himself, wants to speak about objects; he wants to teach us how an object can be both itself and some thing (some other thing) more or less than itself. In this detour taken by the text (as he would say of Freud's work), Lacan makes it possible to view Prévert's collection as an assemblage, an installation, a work of art. . . .

Les boîtes d'allumettes recycles and refunctions the detritus of the everyday, dignifying quotidian, utilitarian form through repetition (the way a word repeated over and over becomes mere sound) even while offering the faintest record of cigarettes lit, or of lamps lit, or simply a memory of the match struck in the night to see your face. The work transposes modernity's seriality (the train tracks that don't quite go on to infinity) into a sweeping, serpentine concatenation, extended like the fossilized vertebrae of some extinct creature that reappears as the living behemoth of mass production, domesticated *there* in the poet's salon. Given Prévert's close association with Duchamp, an art historian might emphasize the place of *Les boîtes d'allumettes* within the history of readymades and *les objets trouvé*, if not its relation to Duchamp's playful deployment of match sticks, a penchant he shared with Francis Picabia, Tristan Tzara, and Man Ray.[43] No less important, Prévert's work aligns with Giorgio Morandi's serially painted bottles and jars (those paintings and prints that have "subject matter in the most classical sense," as Robert Irwin put it, though "those same bottles and jars that he painted continuously . . . lost their identification as bottles"), just as it foreshadows a fascination with the dialectic of quantity and quality that eventuates in Andy Warhol's soup cans or Tara Donovan's massive accumulation of toothpicks or of styrofoam cups that, whatever else, mean to disclose some thing about the objects, some significance emerging from the insignificant and ephemeral, that you cannot sense within the habits of the everyday.[44] When Lacan first asserts that the "collection pointed to its thingness as matchbox," he himself draws attention to a thing (in fact, a structure) that makes it clear that Prévert has selected no random ob-

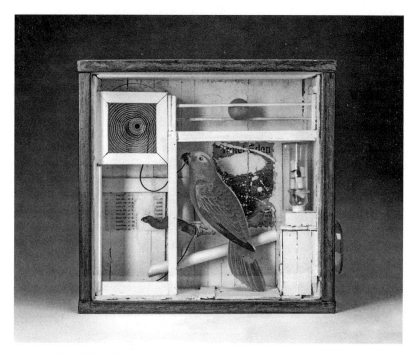

1.1 Joseph Cornell, *Untitled ("Hotel Eden")* (c. 1945). © The Joseph and Robert Cornell Memorial Foundation/Licensed by VAGA, New York. Assemblage with music box, 38.3 × 39.7 × 12.1 cm. Photograph: National Gallery of Canada, Ottawa.

ject but "a mutant form [une forme vagabonde] of something that has so much importance for us that it can occasionally take on a moral meaning; it is what we call a drawer" (114). The meaning that Gaston Bachelard had attributed to drawers—the year before Lacan's seminar on ethics, in *The Poetics of Space*—is not exactly moral, but it is precisely to the point: for drawers (like chests) are, Bachelard writes, "veritable organs of the secret psychological life"; they are "hybrid objects, subject objects" that become the models of "inner space [that] is also intimate space."[45] Fashioning the drawer, we figure the psyche itself: interiority, the most interior of which came to be named, in the twentieth century, the *unconscious*. This is why the constellations within Joseph Cornell's boxes can be recognized so readily as the materialized object-presentations (*Sachvorstellungen*) of the unconscious itself (fig. 1.1).

4. Materiality, Mediation, and the Meta-object

Heidegger concentrates on an object that discloses the thingness of things in its unconditioned autonomy: standing alone and standing forth, the thing things. Lacan excavates the Thing that names, for an individuated subject, the abyss of the real. Not in a genealogical relation to one another, but at some provoked intersection we can begin to glimpse—in theory—how thingness might emerge both outside the subject and at the center of the subject (so far within and beyond as to render *within* and *beyond* nonsensical, at times: to render experience infantile—in Piaget's sense—without the distinction between environment and self). Nonetheless, a commitment to material culture (and the materiality of culture) could claim that they leave things far behind. And yet, within a different frame (that which I understand thing theory to construct and adopt) they dramatize how attention to the object world can assume unexpected dimensions. Attending to the ontic should not foreclose the psychological, or indeed the ontological. Theodor Adorno's much-invoked assertion that "we are not to philosophize about concrete things; we are to philosophize, rather, out of those things"—has been read as Critical Theory's version of American Modernism's "no ideas but in things."[46] But the emphasis can be recast to assert the need to *philosophize* out of those concrete things, and not just to historicize them (say) or to curate them into a scene of cultural coherence. Concrete things— pots, computers, tables, and chairs—have a vitality that can quickly disturb any such coherence. If that vitality can be captioned as a kind of thingness, this is not some overarching, overwhelming singular Thing (*das Ding*), but a more quotidian and rambunctious (less august and thus more significant) thing. There's some *thing* about this place that gets you (that you find enchanting) and some *thing* that drives you nuts. The enchanting *thing* about the place (let's call it a modest loft in lower Manhattan) might be the look and feel of the worn ebonized floorboards, or the size and shape of the windows; the thing that drives you nuts might be the lingering presence of a strange smell. One limit of today's philosophical interest in the "permanent strangeness of objects" is that it stabilizes both objects and strangeness and thus can hardly hope to tell you what is strange here, strange now, or what was strange there and then.[47] The task of dramatizing the thingness of objects—here and now, there and then— is rarely the task of theory, let alone of philosophy. It is the task of art.

In his "Work of Art" essay, Heidegger writes that we "never know thingness directly," "only vaguely"; only art can disclose "the thingly character of the thing" ("WA," 35, 38, 67). In his own effort to think beyond the "impasse" of the distinction between "figurative and so-called

abstract art," Lacan, in his *Ethics*, contends that when works of art "imitate" objects, they only pretend to do so, for in fact they "make something different out of that object" (141) ("En donnant l'imitation de l'objet, elles font de cet objet autre chose" [169]). They make of the object some *other thing*. Art also alerts us, more simply, to how media give us access to materiality. So too the literary arts. By introducing the concept of *la coupure épistémologique*, Bachelard provided Louis Althusser, Michel Foucault, and Alexandre Koyré with the means of characterizing eventful change; by casting science as "projective" (rather than "objective") within his historical epistemology, he paved the way for what became Science Studies, enabling Bruno Latour (for one) to see multiple participants (material and conceptual, human and nonhuman) at work in the production of facts;[48] but when it came to understanding *matter*, Bachelard drifted away from the scientific fields and preferred to think with literature, as he did in his five great books on the elements, written (1938–43) while he continued to write about science. He preferred literature because he recognized that "literary expression enjoys an existence independent of perception"; literature helped him to adopt a "material psychoanalysis" that could explain, for instance, how "the resistant world elevates one to a level of dynamic existence, an existence of active becoming."[49]

It is possible, of course, to argue that any medium (by definition) denies immediate (unmediated) access to materiality. But a more robust line of reasoning has insisted that media disclose an otherwise inapprehensible materiality. For instance, André Bazin, in his "Ontology of the Photographic Image" (1945), argues that "the photographic lens gives us an image of the object that is capable of relieving, out of the depths of our unconscious, our need . . . [for] the object itself, but liberated from its temporal contingencies." He concentrates on the aesthetic potential of photography to "reveal[] reality": "only the impassive lens, in stripping the object of habits and preconceived notions . . . can offer it up unsullied to my attention."[50] The claim can be read as a version of Walter Benjamin's belief that photographic and filmic media provide access to an "optical unconscious," both in their visualization of otherwise imperceptible physical details of everyday life and in their revelation of how modernity constitutes the human subject.[51] Incorporating insights from both Bazin and Benjamin, Kracauer's *Theory of Film: The Redemption of Physical Reality* (1960) asserts the medium's unique ability "to record and reveal physical reality," toward which it thus "gravitates." The point is not just that techniques like the close-up "reveal[] new and unsuspected formations of matter" but that film tout court can prevent us "from shutting our eyes to the 'blind drive of things.'"[52] By contextualizing this publication between Kracauer's copious notes for the volume (the Marseille

notebooks), and his subsequent *History: The Last Things before the Last*, Miriam Hansen is able to elucidate this "drive" and to dilate Kracauer's concept of realism, making it clear that redeeming reality is no "realist" project in any familiar sense of that word. For film, as he writes in his notebooks, "brings the whole material world in to play, . . . push[ing] toward the bottom, to gather and carry along even the dregs. It is interested in refuse, in what is just there—both in and outside the human being."[53] He is interested in those contingencies that escape our "habits of seeing," which are, as Hansen specifies, "shaped by language and circulation, by social, cultural, and representational regimes" (268).

In what amounts to much the same logic, when Emmanuel Levinas addresses the cinema, he points to how it "lay[s] bare what the visible universe and the play of its normal proportions tone down and conceal." But this claim on behalf of cinema appears within a much broader account of art and the aesthetic—an account in which objects, things, and materiality are the catalyzing terms. The "inwardness of things," he argues, "acquires personality" in the work of art,[54] and "the forms and colors of a painting do not cover over but uncover the things in themselves, precisely because they preserve the exteriority of those things" (46). Theory, when it comes to the topic of things in the twentieth century—to the topic of the thing understood ontologically, psychoanalytically, or materially—keeps pointing to the visual, plastic, and discursive arts. Those arts advance a speculative realism that ignores the discrepancy between the phenomenal and the material in order to lay bare the phenomenon of materiality, the *materiality effect* that is the end result of the process whereby you are convinced of the materiality of some thing (over and against any traditionally realist aesthetic). They then ask about the other thing. For Heidegger, Van Gogh's peasant shoes reveal the equipmental being of equipment. For Levinas, painting uncovers things in themselves by preserving their exteriority. The worldly object produced by the artist offers itself as a *meta-object* that addresses or discloses the question of the object and of the thing.

Don DeLillo develops the dimensions of the meta-object when he portrays two paintings by Giorgio Morandi hanging in a mother's Upper East Side apartment, part of the background in a space that is "serenely self-possessed."[55] The still lifes hang there as though in citation of the Morandi hanging in Steiner's salon in Frederico Fellini's *La Dolce Vita* (1960). But in some sense they hang there simply as a sign of wealth and sophistication (Morandi's importance within the New York art scene having been established by Lionelli Venturi's exhibition in the late 1950s).[56] They hang there simply. *La natura morta di* Morandi, one or another, consists

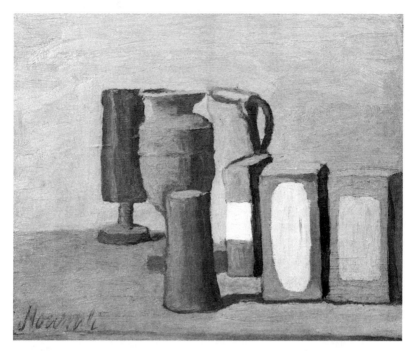

1.2 Giorgio Morandi, *Still Life* (1949). © 2015 Artists Rights Society, New York/SIAE, Rome. Oil on canvas, 36 × 43.7 cm. Photograph: James Thrall Soby Bequest. Museum of Modern Art/Licensed by SCALA/Art Resource, New York.

of "groupings of bottles, jugs, biscuit tins, that was all" (12) (fig. 1.2). But that is not all.

Mother and daughter certainly ignore the still lifes while arguing about other things:

> "You liked asking questions as a child. Insistently digging. But you were curious about the wrong things."
>
> "They were my things, not yours."
>
> "Keith wanted a woman who'd regret what she did with him. . . . And the thing you did wasn't just a night or a weekend. He was built for weekends. The thing you did." (12)

Under the sign of things, the relay (somewhat comic, somewhat desperate) between confusion and certainty, particularity and specificity, speeds up, with only the Morandi paintings hovering there in the background as though to provide some sanctuary—the "groupings of bottles, jugs, biscuit tins"—from the semantic vertigo provoked by the word *thing*, its capacity to designate both acts and objects, the abstract and the concrete, the known and unknown. (As Lacan says, "each language has

its advantages," and an advantage of English is the robust promiscuity of this word.)[57] But the daughter, Lianne, has already granted the still lifes something beyond their simplicity: "There was something in the brushstrokes that held a mystery she could not name, or in the irregular edges of the vases and jars, some reconnoiter inward"; these are dimensions of the artwork "she hadn't talked about with her mother" (12). And yet what she does talk about with her mother ("the wrong things," "my things," "the thing you did") reilluminates the things in Morandi's paintings, as though drawing attention to the fact that the painter painted and repainted the same "bottles" and "jugs" (or "vases and jars") as though to prove that they are never the same. That the same things can be, somehow, other things. "Three days after the planes" (8), the two women address the matter of Keith, the ex-husband, the man who had been covered in ash and had begun "to see things, somehow, differently." DeLillo asks you to recognize how even the most serene and simple work of art is at work provoking you to see things differently, far from such catastrophe.

I

The Matter of Modernism

The task of art, Emmanuel Levinas argued, is a matter of "extracting the thing from the perspective of the world": presenting things in their "real nakedness," uncovering "things in themselves."[1] He thus assigns to art the role of overcoming the epistemological limits established by Kant (that is, the role of evading the spatiotemporal grid and causal logic that determine human perception), but not, it may seem, without specifying art's function in the context of a degraded twentieth century. A Lithuanian Jew who had been naturalized as a French citizen and had fought against Germany in World War II, Levinas began to draft *Existence and Existents* (1947) during his years of internment in Hanover; from there he imagined that the "common intention" of "modern painting and poetry" was "to present reality as it is in itself, after the world has come to an end." But "the end of the world" did not mean for him the destruction perpetrated by two wars; it meant, rather, the "destruction of representation," of "realism," and of the "continuity of the universe" (*Existence*, 50). Indeed, even if Levinas could glimpse such an end (and thus the emergence of being), it was, rather, the world's persistence (exacerbated by two wars) that proved to be an intractable problem: that's why the thing must be *extracted* from the world.[2] And that's why so much of modernism (visual, plastic, and discursive) can be understood to name aesthetic events meant to provoke that other thing—or thingness—from the fetters of modernity.

By what means—within the modern world—can that other thing be extracted? Martin Heidegger (whose impact on Levinas is clearly audible)

pursued "the question of the thing" throughout his career, as I tracked in chapter 1. No matter how obsessive he may thus seem, modernism can appear no less obsessed. In chapter 2, "The Secret Life of Things," I briefly describe the lyric effort to resuscitate things (to extract them from the world) but concentrate on Virginia Woolf's "Solid Objects," a story in which a man's casual discovery of a piece of beach glass provokes a kind of obsessive collecting. Because the practice obliquely mirrors the recycling demands that World War I placed on European populations, it seems to embed the story in a history that the plot of the story elides. But the practice also shows how a banal object (indeed, the fragment of an object) can become another thing, itself a catalyst for a subject's transformation.

"The Modernist Object and Another Thing," chapter 3, points out how, in the 1960s, a mission to defeat the object operated on two fronts: conceptual art's effort to supplant the object-form of art through ideation, and Michael Fried's designation of "objecthood" as the condition against which modernist art must define itself in order to maintain its status as art. Through the access point of one of his targets (Donald Judd) and one of his own footnotes (on surrealism), I jump back (to provide the backstory, if you will) to André Breton's "crisis of the object," a concept he developed over the course of two years (1934–36). My own concept of the other thing—the thingness of objects—is clearly indebted to Breton, just as it is indebted to Heidegger, whose first lectures on the thing— *The Question of the Thing*—were delivered in 1935. (These dates leave little doubt that historical, material conditions—severe and widespread scarcity—prompted the century's most ambitious thinking about things.) Because Breton derived his understanding of the "surrealist object" not least from Man Ray's assemblages, photographs, and rayographs, the chapter concludes with attention to Man Ray sustained across two sections, the first focusing on the genre of the object-portrait, the second developing an account of *Object to Be Destroyed*, his metronome with an eye affixed to the spindle, an image with which the chapter also begins.

Chapter 4, "Concepts and Objects, Words and Things," focuses on the fiction of Philip K. Dick, a body of work that depicts a postapocalyptic world of detritus and repeatedly entertains the possibility that reality is an illusion, but a body of work that also rescues (repeatedly) one object form—the pot—from those conditions. I use his attention as an aperture through which to make visible the preponderance of pottery in Hebert Read's art criticism: his own attention to the concrete-abstract form (beginning in the 1920s) that both preceded and sustained his appreciation of modernist sculpture. This is an attention, nourished by Henri Bergson's vitalism, that the historiography of modernism has effectively erased in its (conscious and unconscious) effort to exclude craft from art.

I conclude by addressing a dystopian novel of Dick's in which crafted objects (pieces of jewelry) compete with crafted words (a novel) as access points to some less horrific reality.

Within this opening section of the book, then, I move from the power of the fragment to that of the assemblage, to that of a self-contained object-form (the vitality of which exceeds that containment). My chapter on Woolf locates her story quite precisely within the history of wartime London, within the aesthetic aspirations of the Bloomsbury group, and within the context of modernity. The other two chapters noticeably linger in the afterlife of modernism. They do so to reframe the modernist dynamics of extracting the thing from the world and to draw attention to the persistence of those dynamics. Such reframing enables a new materialism to achieve the ambition of being empirical without succumbing to any temptation to be, all too simply, empiricist.

Two

The Secret Life of Things (Virginia Woolf)

For Miriam Bratu Hansen

You should be reading this with something in your hands besides this book. And something, really, besides a pencil or pen. Something like an empty glass, a rubber band, a paper clip that you can rub between your fingers, that you can twist and bend back and forth. For the idea is to wonder whether—while concerning ourselves with one or another crisis of the subject in the late twentieth century—we weren't also in the midst of some effort to think about the object, if not indeed to liberate material objects. The comic version of such an effort would resemble a scene from the old *Mork and Mindy* television show: when asked what could have happened to all the sponges in the kitchen, the alien (Robin Williams) proudly announces, "I took them to the river and set them free."

A somewhat more serious version can be found in the work of Jean Baudrillard, who came to denounce the way that the object, because it is considered "only the alienated, accursed part of the subject," had been rendered unintelligible, "shamed, obscene, passive." Undoing the privilege of the subject is not for him a matter of attending to the subject's fraught, fragile, and divisive constitution. It is a matter of imagining how the "destiny of the subject passes into the object," of naming the object "sovereign," of celebrating the crystal's revenge, indeed "crystal revenge."[1] And yet, of course, the luminous transparency of the crystalline object, its auratic singularity, can only impoverish other objects, material objects, or material understood as itself an object—not shimmering, exquisite crystal, let us say, but glass that is nothing but glass.

Is it not the very splendor of the object that allows objects to disappear so readily in Baudrillard's subsequent work, evaporating into one or another version of the hyperreal?

No less than the tradition he writes against, Baudrillard seems to suffer from what Theodor Adorno called the familiar "allergies to entity," a chief symptom of which is the failure to recognize that there can be no "primeval history of the object," only a history "dealing with specific objects." The passage into materialism, as Adorno came to describe it, requires acknowledging "things" outside the subject-object trajectory, which means thinking sensation in its distinction from cognition. For the "dignity of physicality" is indissoluble in, and not exhausted by, the subject-object relation, epistemologically or phenomenologically understood.[2] Still, if "things" are indeed not exhausted by that relation, it is only in the subject-object nexus where they occur, or where they can be *narrated* as the *effect* (not the ground) of an interaction at once physical and psychological, at once intimate and alienating. To the degree that the *thing* registers the undignified mutability of objects, and thus the excess of the object (a capacity to be other than it is), the *thing* names a mutual mediation (and a slide between objective and subjective predication) that appears as the vivacity of the object's difference from itself: the object and the other thing. What happens, should you drop the crystal, should it shatter, and should you glance at the bits of glass that, though they are nothing but glass, captivate your attention? What happens when you de-auraticize *the* object (that is identifiable only within a fundamentally static structure) and begin again with the vertiginous banality of things—with some sense of the curious thingness of those objects you incessantly if unconsciously touch, the objects you see without ever looking? What if you looked?

In fact, *things* achieved a new discursive visibility in the closing two decades of the twentieth century. From the disciplines of anthropology and history, as from the interdiscipline of "material culture studies," important anthologies summoned us to attend to things: *The Social Life of Things* (1986), *Material Cultures: Why Some Things Matter* (1998), *History from Things* (1993), *The Sex of Things* (1996). These volumes assumed the task of denaturalizing consumer practices, of tracing (both within and between cultures) the *work* of exchange and consumption: the way economic value is created in specific social formations, the way cultural values become objectified in specific material forms, the way that people shape, code, and recode the material object world, the way they make things meaningful and valuable. Just as such analysis exposes the politics that underwrite our most daily acts of exchange, as Arjun Appadurai would have it, so too, in Victoria de Grazia's words, this type of analysis

"responds to the imperative to know about material needs, wants, and desires."[3]

But is it *things* that these volumes constitute as the object of their address? For the degree to which the essays trace generalizable circuits of exchange and consumption is the degree to which they can address *no thing at all*, but only objects, if you will allow me to pursue my axiomatic distinction. The sort of objectification that takes place during those operations that produce use value, sign value, cultural capital will never produce a thing. Producing a thing—effecting thingness—depends, instead, on a fetishistic overvaluation or misappropriation, on an irregular if not unreasonable reobjectification of the object that dislodges it from the circuits through which it is what it typically is. Thingness is precipitated as a kind of misuse value. By *misuse value* I mean to name the aspects of an object—sensuous, aesthetic, semiotic—that become palpable, legible, audible when the object is experienced in whatever time it takes (in whatever time it is) for an object to become another thing.

This distinction brings a kind of instability into focus wherein the thing becomes manifest between multiple objectifications. Within the shimmering splinters of glass, glass can become something else. Or, to offer another narrative example (of what can be exemplified only syntactically, only in time): in the process of using a knife as a screwdriver, of dislocating it from one routinized objectification and deploying it otherwise, you have the chance (if just a chance) to sense its presence (its thinness . . . its sharpness and flatness . . . the peculiarity of its scalloped handle, slightly loose . . . its knifeness and what exceeds that knifeness) inadvertently and as though for the first time. For the first time, perhaps, you thus also sense the norms by which we customarily deploy both knife and screwdriver. My concern, then, is not to unveil the meaning of things in their proper thingness, nor to describe the fate of the essential object abstracted from its interactions, and neither is it to privilege the thing (*das Ding*) over things (*die Sachen*). For the life of things made manifest in the time of misuse is, should you look, a secret in plain sight—not a life behind or beneath the object but a life that is its fluctuating shape and substance and surface, a life that the subject can catalyze but cannot contain.[4]

The title of my chapter, "The Secret Life of Things," no doubt brings to mind a line from William Wordsworth or Percy Shelley, or one of E. T. A. Hoffmann's uncanny tales, or one of several surrealist images—if not Tristan Tzara's "the knives are on their feet," then perhaps Louis Aragon's "bunch of keys [humming] to themselves jingling a song of the good old days."[5] Though such animation is not my concern in the following pages,

I will in fact be preoccupied by the 1920s, the decade when things emerge as the object of profound theoretical engagement in the work of Georg Lukács, Heidegger, and Walter Benjamin; the 1920s is also the decade after objects and things were newly engaged by (or *as*) the work of art by Ezra Pound, Marcel Duchamp, William Carlos Williams, and Gertrude Stein, among others.

The idiom of modernist poetry most clearly focuses attention on isolated objects to enchant them by other (noncommercial) means, above all through a kind of lyricization (or, say, a lyric technology) in which the object, not the subject, appears in the foreground. When Francis Ponge published a collection of prose poems, *Le parti pris de choses*, in 1942, he was perpetuating an impulse—"taking the side of things"—that had been voiced since the first years of the century.[6] Rainer Maria Rilke, in the "thing-poems" (*Dinggedichte*) that he published in *New Poems* (1908), began to express what he reports elsewhere as his lifelong devotion to objects. Rodin and Cézanne had offered him an education, he said repeatedly, in *things*. In 1903, the year after his first meeting with Rodin, he writes of his sense of being forsaken as a child. "But then," he adds, "when people remained alien to me, I was drawn to things, and from them a joy breathed upon me."[7] In his lecture on the sculptor in 1907, he begins by insisting that "it is not people about whom I have to speak, but things." "You still need things," he tells his audience, "things" await "your confidence, your love, your dedication."[8] The second of his *Duino Elegies* (1922) makes it clear how fleeting and insubstantial human-being is in contrast to the being-of-things—at once stable and agential:

> Look: the trees exist; the houses
> That we live in still stand. We alone
> Fly past all things, as fugitive as the wind.
> And all things conspire to keep silent about us, half
> Out of shame, perhaps, half as unutterable hope.[9]

In *One-Way Street* (1928), Benjamin can begin to sound like Rilke—"warmth is ebbing from things," he writes—but he presents an antagonism between the human and the object world that proves more difficult to overcome: "Objects of daily use gently but insistently repel us. Day by day, in overcoming the sum of resistances—not only the overt ones—that they put in our way, we have an immense labor to perform. We must compensate for their coldness with our warmth if they are not to freeze us to death."[10]

Modernist poets often felt the need to rescue them—to extract them in their "real nakedness," as Levinas puts it—not just from consumer cul-

ture but also from rationalism, symbolism, and language itself.[11] Hannah
Arendt was right to say that "for Rilke, things have a higher rank in exis-
tence than do human beings,"[12] but Rilke retained faith in the capacity of
language to intensify the object world: in the ninth of the *Duino Elegies*,
he asks a rhetorical question:

> What if we're only *here* to say *house*,
> bridge, fountain, gate, jug, fruit, tree, window?

Nonetheless, such a role confers on things a new ontological amplitude:

> but for *saying*, understand,
> oh for such saying as the things themselves
> never dreamt so intensely to be. (57)

Fernando Pessoa insists on an ascetic alternative. In 1914 he invented
a poet (one of what he called his "heteronyms"), Alberto Caeiro da Silva,
who is said to have recorded *The Keeper of Sheep* between 1910 and 1912.
Stridently antimetaphysical, antirational, and antireligious, the lyrics
amount to a meditative argument against the significance of things.

> Because the only hidden meaning of things
> Is that they have no meaning at all.
> This is stranger than all the strangenesses,
> And the dreams of all the poets,
> And the thoughts of all the philosophers—
> That things really are what they appear to be
> And that there is nothing to understand.[13]

The recognition of things depends on our capacity to "unlearn"—on
"Knowing how to see without thinking" (KS, 65). A chief impediment to
that recognition is language itself—

> the language of men
> Which gives personality to things,
> And imposes a name on things. (KS, 71)

Whereas, for Rilke, the act of naming confers greater being, for Pes-
soa that act prevents things from being what they are, for "things have
neither name nor personality" (KS, 71).

And yet, for all Caeiro's repudiation of language and the "dreams of
poets," his objects of fascination—sky, trees, grass, wind, rivers—seem

paradigmatically "poetic," as does his self-appellation as a shepherd, "a keeper of sheep," despite the fact that he does not keep sheep:

> I never kept sheep
> But it's as if I'd done so. (*KS*, 32, 3)

However resistant to analogy or metaphor, Caeiro frames his endeavor metaphorically. Sharing many of Pessoa's concerns, William Carlos Williams nonetheless produced very different lyric results. He recognized the need to "escape from crude symbolism, the annihilation of strained associations."[14] And he was appalled by the way that "categories" trap things within "corners of understanding"—by the fact that, "reinforced by tradition, every common thing has been nailed down."[15] But his eye was drawn not just to such pastoral objects as the famous "red wheelbarrow"; it was drawn as well to the quotidian artifacts of domestic life.

> The red paper box
> hinged with cloth
> is lined
> inside and out
> with imitation leather[16]

It is the *imitation leather* that affirms the status of this object beyond the realm of the "poetic," just as it affirms the prospect that any object might be redeemed by the right kind of attention. His playful allusion to Rodin in the title of "The Thinker" similarly deflates the grandiosity of art while the poem expands its purview:

> My wife's new pink slippers
> have gay pompons.
> There is not a spot or a stain
> on their satin toes or their sides.
> All night they lie together
> under her bed's edge. (*Collected Poems*, 220)

In such poems, Williams enacts a kind of redemptive reification, resignifying the mundane (indeed, the silly) not through rhetorical inflation but through an untoward engagement:

> I talk to them
> in my secret mind
> out of pure happiness. (*Collected Poems*, 220)

Such engagement might be said to compensate for the coldness of things with human warmth, but a warmth that is meant to leave things raw, not cooked. Although, as I detailed in chapter 1, Heidegger is concerned with an ontological amplitude (Being) that is irreducible to the ontic (mere beings), and Levinas is particularly fixated on a "paroxysm of materiality" that exceeds any recognizable object form, for modernist poetry the object form of things, and the human relation to them, remains the more explicit topic of both thematic and formal attention.

The record of Virginia Woolf's more idiosyncratic engagement surfaces in a very short story she titled "Solid Objects." It is in fact a story not about solidity, but about the fluidity of objects, about how they decompose and recompose themselves as the object of a new fascination. It is about the materials that make up the material object world, about the transvaluation of those materials into less and more than their familiar properties. It is about dislocating material—nothing but glass—from an instrumentalist teleology and into an aesthetic scene, though not one authorized by the dictates outlined in Pierre Bourdieu's *Distinction* or Baudrillard's *System of Objects*, but content instead with intensely private, inconspicuous display.

Woolf began to write the story in November 1918, at the close of World War I, and she published it in *Athenaeum* in 1920. The story concerns a man named John, who, discovering a smooth lump of glass on the beach, brings it home and places it on the mantle, using it as a paperweight. The discovery incites him to seek out other objects that remind "him of the lump of glass," anything "so long [as] it [is] an object of some kind, more or less round . . . anything—china, glass, amber, rock, marble," the paradigmatic shape and size in fact bringing the specificity of the material into question.[17] At first, studying the objects displayed in the windows of curiosity shops, he becomes increasingly obsessed and finally roams London with "a bag and a long stick," ransacking "all deposits of earth," searching "all alleys and spaces between walls" in his quest for discarded objects that might become for him "specimens" (*HH*, 85). As he discovers other remnants—pieces of broken china, a bit of iron—his collecting impulse becomes, from his friends' perspective, pathological. Before long he abandons the life he has led as a politician on "the brink of a brilliant career," a man standing for Parliament (*HH*, 82). Indeed, in most respects he abandons his life, "devot[ing] himself more and more resolutely to the search," suffering "fatigue and derision" but still "consumed by [the] ambition" to add to his little collection (*HH*, 85).

The story has not fascinated Woolf's readers, who have been far more captivated by the life of the subject, the fate of individuality, and the vicis-

situdes of consciousness in her fiction. A small, critical consensus, however, reads "Solid Objects" as a cautionary tale warning against aesthetic absorption at the expense of the practical, the ethical, and the political.[18] Woolf, let us say, managed not to succumb to what Clive Bell disparaged as his contemporaries' "metaphysical-moral doctrines concerning the cowiness of cows and the thing in itself."[19] But her own boredom with politics-as-usual, what she called her "natural disposition to think Parliament ridiculous," would suggest that the moral of the story might not be read so unequivocally.[20] She herself stopped accompanying her husband Leonard on his political campaigns in 1919. At the end of the war, she wrote of the war that "the whole thing [was] too remote and meaningless to come home to one either in action or in ceasing to act" (D, 215). She also was eager to eschew conversation about the "bitter, impatient, powerful" lower classes (D, 220). Such comments suggest that one might say of the story what Bell said of art more generally, that "no one could be much worse placed than the political moralist for seeing whatever there may be to be seen in what is, at once, strange and subtle."[21]

What is strange and subtle in Woolf's story, however, is the way it bears witness, however unconsciously, to the political economy of Great Britain during and immediately after World War I. In other words, I want to point out how John's encounter with these material fragments—a piece of glass, of broken china, and of iron—is not just embedded within a trajectory of English aesthetics (John Ruskin to Roger Fry) or a genealogy of modernism (say, T. E. Hulme's "poetics of sensual immediacy and fragmentary vision"), but also embedded between the domestic crisis of wartime scarcity in London and the postwar industrial crisis provoked by the British commitment to free trade.[22] Though the fragments may thus be thought of as souvenirs of the unreal city, their very collection erases that context from the narrative as such.[23] But elsewhere, Woolf makes it clear how the war impinged on the material practice of art. She writes to Vanessa Bell about the problem of securing her paint: "The difficulty about paints is that they're made with oil, 'Now you may not know [a merchant has explained to Woolf] that every gun when it's first cast has to be dipped in a bath of oil.'"[24] She records in her diary the physical threat to art posed by the raids on London: "The Academy is storing its precious pictures, only 18 in number, in some Tube. They are told to expect immense bombs at the end of the month, which will dig 20 feet deep, & then explode" (D, 138). Yet "Solid Objects," without ever invoking the war, provides instead an account of the aesthetic—or an account of what we might call the relation between aesthetics and politics, between art and the economy—that is a history of the senses fundamentally altered by the facts of wartime scarcity and postwar depression. You

might argue that the story's displacement of the psychological with the *materiological* is Woolf's uncharacteristic exploration of the antihumanist modernism advanced by Hulme. But her capacity to narrate a new subject-object dynamic seems catalyzed instead by the transgression of economic habits, both domestic and international—in a word, by the Western world's misuse of material for martial ends, by the transposition of material into *matériel*.

As literary criticism wrestled itself out of the homogenizing habits of new historicism and the heterogenizing habits of cultural studies, one version of a new materialism asked how material culture impresses itself on the literary imagination. Another asked how literature itself works to imagine materiality, how it renders a life of things that is tangential to our narratives of modern production, distribution, and consumption; how it can contribute to a materialist phenomenology that does not bracket history but asks both *how*, in history (how, in one cultural formation), human subjects and nonhuman objects constitute one another, and *what* remains outside the regularities of that constitution that can disrupt the cultural memory of modernity and modernism.[25] If Georg Simmel was right to argue, circa 1900, that money, while giving us an increased access to things and power over them, increasingly mediates that relation so that we lose any "direct contact with things," then we should recognize how various aesthetic practices (and today's critical practices) struggle to compensate for that loss.[26] Indeed, as I suggested in my overture, it would be perfectly reasonable to account for the recent scholarly attention to objects (not to say things) as a reaction against the declaration of—if not some compensatory response to the fact of—the further disappearance of the object within an increasingly mediated (indeed digitally mediated) universe.

Woolf's story might thus be read as moralizing against such materialist fascinations, if it does not rather, as I'll suggest, investigate a different kind of fascination, indeed a kind of fetishism that seems like an alternative mode of inhabiting modern culture. By consecrating the valueless material object, such fetishism confounds political economy's account of value, alienates itself from any enlightenment horror of waste, and settles happily into an unhuman (not antihumanist) history. "Solid Objects" manages to revise the question of the object and the question of things while clarifying the risk of that revision, which is always a risk to what Woolf's story narrates as the aesthetic subject. "One day," the narrator explains, "starting from his rooms in the Temple to catch a train in order to address his constituents, his eyes rested upon a remarkable object lying half-hidden in one of those borders of grass which edge the bases of vast legal buildings. . . . [He] drew the piece of [broken] china

within reach of his hands. As he seized hold of it he exclaimed in triumph," missing his train (*HH*, 82–83). Such exhilaration, staged in relation to the emblems of modernity (the train, the legal buildings, parliamentary democracy, commuter temporality) is irreducible to consumer desire or the structure of cathexis described by psychoanalysis; it instead testifies to the enigmatic excess that characterizes the physical world, especially its bits and pieces, the discarded remains of modern objects. Insofar as the aestheticization of this refuse leaves John in a condition of social sclerosis, however, "aesthetic autonomy" manifests itself here not as the object's distance from consumer culture but as the utter isolation of the individual (the aesthetic subject). Some other reading of the story might indeed argue that John's obsession with inorganic objects is in fact inseparable from what Freud described, in his own postwar text, *Beyond the Pleasure Principle* (1920), as the drive toward the inorganic that is the drive toward death.

Let me turn now to a clarifying disjuncture in William James's psychology—clarifying because it temporalizes, *narrating* the interaction between the somatic and the cognitive—to offer some handle on the object-thing distinction that I advanced schematically in chapter 1. Working within and against the associationist tradition, James points out, in his chapter on the perception of space, how the coalescence of our sensations in and as a thing depends on habit. This means that we grant to objects that we merely see (without touching) their full physicality because we are accustomed to doing so. Real form, what Edmund Husserl came to call the inauthentic image as opposed to the authentic image we actually see, is *habitually* conjured up. In his somewhat prescient understanding of mind as matter (with which he works to refine the Humean position), James argues that habitual objects "plough deep grooves in the nervous system," so that there is a path of least resistance through which, for instance, our sensations of grayness and thinness and length become the apperception of a knife.[27]

In his chapter on the "perception of things," however, he tells the story of what happens when our habits are broken, when for instance we look at a landscape with our head upside down or when we turn a painting bottom up: "The colors grow richer and more varied, we don't understand the meaning of the painting, but, to compensate for the loss, we feel more freshly the value of the mere tints and shadings." James understands perception and "naked sensation" as different cerebral conditions that cannot take place at the same time, since sensations in themselves do not add up (*P*, 727). One might say, rather, that we need to understand

two distinct, dynamic, intertwined materializations: one in which we seem to begin with sensations, which precipitate perception; and one in which the proximate sensuous engagement lies between one and another perceptual horizon. The viewer's perceptual "failure" (as in the case of nonfigurative painting) prompts a different kind of attention; but, in the routine of daily life, perception perpetually forecloses sensuous experience in order to render the material world phenomenal, which means rendering it habitable. What I want to underscore is how in James the difference between the apperceptive constitution of the thing, in what I would call its *objecthood*, and the experience of the thing, in what I would call its *thingness*, emerges in the moment (and no doubt only as a moment) of reobjectification that is a kind of misuse—turning the picture bottom up, standing on one's head. The point may be less that "sensation is one thing and perception another," and more that the experience of sensation depends on disorientation, both habit and its disruption (P, 727).

In the case of Woolf's story, the point is not that the familiar object has been defamiliarized into unreconstituted fragments (which is to say discrete, fragmented sensations), but rather that literal fragments become objects without any of the coherence or familiarity we associate with objects. Peripatetic though he is, John resembles less modernity's flâneur than the bricoleur, "speak[ing] not only *with* things . . . but also through the medium of things," reordering debris the way a kaleidoscope, to borrow Lévi-Strauss's figure, transforms bits of glass into a "new type of entity."[28] But though John perceives new structural patterns, he manages along the way to experience texture and shape in a mode where materials themselves, unchanneled through the habitual object, become the objects of his fantasy. Familiar materials—glass, china, iron—are debanalized, appearing all but magical: "It was impossible to say whether it had been bottle, tumbler, or window-pane; it was nothing but glass; it was almost a precious stone" (HH, 80). Not objects, but materials—"nothing but glass"—have been released from any readiness-to-hand. Free from their incorporation into the familiar object world, they seem to assume lives of their own as John grants them a kind of agency. The piece of broken china "looked like a creature from another world—freakish and fantastic as a harlequin. It seemed to be pirouetting through space, winking like a fitful star. The contrast between the china so vivid and alert, and the glass so mute and contemplative, fascinated him, and wondering and amazed he asked himself how the two came to exist in the same world, let alone to stand upon the same narrow strip of marble in the same room. The question remained unanswered" (HH, 83). By not answering the

question, both John and the narratorial voice grant the materials their sovereignty, but they do so not, as Baudrillard would have it, from a state of abjection, but in a state of wonder.

Woolf's story might thus be located within a continuum of modernist attention to materials, from, say, Otto Wagner's 1895 vision of a future architecture dominated by "the prominent use of materials in a pure state," to F. T. Marinetti's futurist cult of metals and Ernst Jünger's "poems of steel," to Donald Judd's 1965 description of the "aggressive" specificity of materials and the "objectivity" that inheres in the "obdurate identity of a material."[29] In closer proximity to Woolf, her friend Roger Fry, in the manner of Ruskin, repeatedly argued for the aesthetic importance of compositional substance, singling out the fate of china. He objected to Wedgwood (a cornerstone in accounts of eighteenth-century consumer society) because it set "a standard of mechanical perfection which to this day prevents the trade from accepting any work in which the natural beauties of the material are not carefully obliterated by mechanical means."[30] Whereas Fry's answer to the problem was replacing mechanical production with craftsmanship, "Solid Objects" answers the problem of mechanical perfection by introducing the imperfection wrought by accident—by engaging the shard. At times, Woolf clearly shares Fry's fundamental aesthetic judgment. In *Orlando*, the men of genius whom Orlando accompanies in the eighteenth century (Joseph Addison, Alexander Pope, Jonathan Swift) collect "little bits of coloured glass," demonstrating a kind of restrained appreciation for material that stands in contrast to the monumental accumulation of Victorian clutter—"crystal palaces, bassinettes, military helmets, memorial wreaths . . . telescopes, extinct monsters, globes, maps, elephants, and mathematical instruments"—a rubbish heap of Victorian history, a pile of "heterogeneous, ill-sorted objects" perceived by Orlando as a "garish erection."[31] "Solid Objects," however, suggests that the residues of such clutter, the object decomposed into little bits, as it were, can still compel us in their rudimentary substantiality, conveying both the natural and unnatural beauties of material.

Writing in *Athenaeum* the year before Woolf's story appeared there, Fry laments the fate of materials within the Victorian object. Describing the inappropriate use of material to fashion all the Victorian *objets* that "gratify fatuous curiosity" and appeal to "social emotions" rather than "aesthetic feelings," he concludes that "the use of material at this period seems to be the least discriminating, and the sense of quality feebler, than at any previous period of world history."[32] The familiar Bloomsbury dismissal of Victoriana here achieves a materialist specificity inherited from the likes of William Morris, but Fry stops short of wondering what

might in fact be learned about "social emotions" from the ill-suited use of materials. His role as artist and art critic no doubt prevented his taking an interest in the kind of disjuncture between material and form that captivated Benjamin as a legible sign of utopian longing. With a logic learned from *The Eighteenth Brumaire*, Benjamin imagines that the decorative (mis)use of iron, rather than its structural deployment, marks the way novelty first emerges in and depends on residual form, which is the way social dissatisfaction with the present expresses itself in a citational longing for the future, a longing that cites a past that is anterior to the recent past: "These tendencies deflect the imagination (which is given impetus by the new) back upon the primal past."[33] Whereas Ruskin believed the "constant use of cast-iron ornaments" marked the "degradation of our national feeling," Benjamin read it retrospectively as marking an otherwise unexpressed desire to abandon a degraded present.[34]

Whereas for Benjamin the point of considering such disjuncture is to imagine how a collective unconscious "thinks" forward by thinking back to a classless society, for Woolf the point is more the way that attention to the substance of iron, for instance, can provide access to a "primeval history" that is no longer anthropocentric. The story begins to answer the question of how we could bring materials into history as something other than the history of their use, in industry or art. When John, perpetually scouring the crannies of London in his quest to add to his collection, finds a piece of iron under a furze bush in Barnes Common, his sense of time becomes cosmological: "It was almost identical with the glass in shape, massy and globular, but so cold and heavy, so black and metallic, that it was evidently alien to the earth and had its origin in one of the dead stars or was itself the cinder of the moon. It weighed his pocket down; it weighed the mantelpiece down; it radiated cold. And yet the meteorite stood upon the same ledge with the lump of glass and the star-shaped china" (*HH*, 84–85). The passage is mobilized by a dialectic of proximity and distance, familiarity and alterity, that is at once spatial and temporal. The utterly ordinary, which is also otherworldly, can be pocketed and domestically displayed without ever being domesticated. Woolf records not only what it would feel like to desire material per se as a personal possession, but also how such a possession might change the scale of one's historical imagination, how the cosmological might insinuate itself into the daily. To name the scrap of modern iron a "meteorite" is to dislodge it from the homogeneous structure of time, and to insist not that the distant past lingers within the present, but that this past is present as a kind of surface with which we can make intimate contact, as though touching one history in and as another.[35] If the story's temporality seems somewhat abstract or confused—"Day after day passed. He

was no longer young" (*HH*, 85)—this is because John's archaeology of the modern, his engagement with material as an end (not a means), has dislodged him from the temporal dictates of modern life. The *vie privée* of things becomes something other than the history of the object's production and exchange, and something other than its representation in, or transformation into, the work of art.

With James's help, you can redescribe the modernity that Simmel renders—where the ability to dominate things is coupled with the inability to establish contact with things—as the intensification of a basic perceptual process, or as a perceptual process that has become fixed as a social condition. In the 1920s this sociopsychological, sociosensual problematic achieved its full theorization. On the one hand, Lukács asserts that reification "conceals above all the immediate—qualitative and material—character of things as things." On the other, Heidegger, without ever specifying Lukács, complains that such arguments always fail to describe for us what "we are to understand *positively* when we think of unreified *Being*." (See chapter 1.) And Benjamin, in a much-quoted passage from *One-Way Street* (providing a non-Heideggerian response to such a complaint) describes how children's engagement with the material world reveals the capacity to transform things, bits of cultural detritus, into new things—a kind of recycling that never replicates the world as it is, but rather reminds us, in the mode of spontaneous assemblage, that things might be other than they are.[36]

"Any object," Woolf writes, "mixes itself so profoundly with the stuff of thought that it loses its actual form and recomposes itself a little differently in an ideal shape which haunts the brain" (*HH*, 82). This activity of recomposition, which moves John's encounter from the sensuous and material to the phenomenal and the psychological, returns to the material by granting him a different mode of engagement with the city. That is, just as John mediates the transformation of the lump of glass into a "precious gem," so too the glass transforms his relation to urban space. It provokes him to walk through London with "his eyes upon the ground," especially attracted to the alleys where "such objects often occurred"— "thrown away, of no use to anybody, shapeless, discarded" (*HH*, 82). To say that objects *occur* is to suggest that objects have a temporality; they don't happen to be there so much as they happen. And the way that they happen distorts John's pedestrian quest to match the shape of the smooth lump of glass; instead, he seems propelled only by a new responsiveness to form as such. The broken piece of china "as nearly resembl[es] a starfish as anything—shaped, or broken accidentally, into five irregular but unmistakable points" (*HH*, 83). His new optical and tactile consciousness

will not permit him to leave a curious object behind; he misses a meeting in order to secure the shard. John may exhibit the typical passions of the new collector, but you can't quite say exactly what it is that he collects. And he makes no effort to express himself in his exhibition; rather, the lives of these things—the glass contemplative, the china vivid, fitful, surreal—overwhelm his life.

Benjamin, in his essay on surrealism, confidently proclaims that the writer, too, perceives the immense force, the revolutionary energy, that resides within discarded artifacts, those "enslaved and enslaving objects." But in the more telegraphic and enigmatic "Dream Kitsch" ("Traumkitsch"), where he imagines a history of dreams, the unconscious seems severely limited; the dreams of today, he writes, are a "shortcut to banality"; in our dreams "there is a gray coating of dust on things," and in dreams we touch objects "where they are most threadbare and timeworn," where they are "worn through by habit." The dreamwork fails to recapacitate us as children, who never (according to habit) "clasp a glass but [instead] snatch it up."[37] It is a kind of misapprehension, an untoward reobjectification, a kind of misuse that clears the dust away.

It was with the "impulse of a child," Woolf writes, that John slipped the lump of glass inside his pocket "promising it a life of warmth and security" (*HH*, 81). When on the beach, and having left off a political argument with his friend Charles ("Politics be damned!"), John distracts himself by "burrow[ing] his fingers down, down into the sand," his eyes becoming "clear transparent surface[s] . . . expressing nothing but wonder, which the eyes of young children display" (*HH*, 80). Roger Fry rhetorically deploys the child to much the same effect in "The Artist's Vision," an essay that taxonomizes the "economy" of the senses (in his phrase) and differentiates looking from mere seeing. Though it is children who genuinely "look at things with some passion," the adult nonetheless retains "something of this unbiological, disinterested vision," the testimony to which he finds in those collections of objects (like John's) that are otherwise unremarkable but "which have some marked peculiarity of appearance that catches his eye."[38] This essay, also published in *Athenaeum* in 1919, provides the simplest conceptualization of what Woolf is up to in her story. It is as though Fry has translated James's psychological point (which originally stumbled onto the aesthetic, onto questions of landscape and painting) and transformed it into a point about the aesthetic and nonaesthetic subject. "We were given our eyes to see things, not to look at them," a fact that he takes to be a biological necessity since the "very considerable ignorance of visual appearances" becomes a practical matter (594). When, in "The Cinema," Woolf writes about film—which, according to the surrealists, disclosed in the photogenic object the fact

that things have lives of their own—she describes its ability to provide audiences with a new field of sensation. She reiterates Fry's point, but she also nationalizes it, describing "the English unaesthetic eye" as "a simple mechanism which takes care that the body does not fall down coal-holes."[39]

If the unhabituated child perpetually appears in contrast as the engaged aesthetic subject (although Benjamin calls attention not to a disinterested appreciation of the material world, but to an interested, spontaneous reconfiguration of that world), this is not a reinstallation of the Wordsworthian subject, for whom nature and not the detritus of culture exists as the fully engaging aesthetic object. Still, Woolf's story, because the child appears only as a vehicle for describing John's reactions, poses a complex of inescapable questions. Is John's response childlike in the profundity of its willingness to see and to feel the material world anew, or is his behavior a lamentable, childish retreat? Is this an inspired act of transgression or simply a regression? Is this a regrettable withdrawal from politics or the recognition that politics needs to begin elsewhere, with some experience of the profound otherness that lies within the everyday?

The story's ambiguity has everything to do with the proximity or specularity of, on the one hand, the life of things and, on the other, commodity culture as usual. For you would recognize John as being in the throes of consumer desire—"The determination to possess objects that even surpassed these tormented the young man"—were that determination to have appeared in Emile Zola's *Au bonheur des dames* or Theodore Dreiser's *Sister Carrie* (*HH*, 85). His desire anticipates a later moment in the history of bourgeois consumerism when consumption and collection seem increasingly conflated. Any newly purchased object, not just the Hummel figurine but also the bottle cap, the Beanie Baby, the 9/11 Christmas ornament—is declared by the manufacturer to be *collectible*. Whereas, writing of the early-nineteenth-century interior, Benjamin could imagine that the collector's responsibility was "the Sisyphean task of divesting things of their commodity character" and of freeing things from the "drudgery of being useful," by the late twentieth century, the fantasy of such a task became one more means of increasing consumer desire.[40]

So, too, of course, the secret life of things—whether it is the fitfulness of a piece of broken china, or knives standing on their feet, or sponges swimming free at last on the river—might be declared a literalization of our alienation as Simmel described it, where, "by their independent, impersonal mobility," objects "complete the final stage of their separation from people" (*PM*, 460). And yet, it is precisely by giving in to—

thinking or working through—reification and alienation, and by identi-
fying a profounder separation (not of objects but of things), that Adorno
came to re-identify ethical possibility: "If a man looks upon thingness
as a radical evil . . . he tends to be hostile to otherness, to the alien thing
that has lent its name to alienation, and not in vain" (*ND*, 191). For Sim-
mel, the problem of modernity can be characterized by the fact that "ob-
jects and people have become separated from one another," that objects
can no longer be "assimilated by the individual" (*PM*, 460). For Adorno,
the problem has become the very will-to-assimilation. He designates the
happiness of philosophy, over and against the "imperialism of annex-
ing the alien," as residing "in the fact that the alien, in the proximity it
is granted, remains what is distant and different" (*ND*, 191). Were we to
grant "Solid Objects" a place between Simmel's sociology and Adorno's
philosophy, we would read it as a narrative of things accumulated but
not arranged, intimate but unassimilated, *extimate* in their simultaneous
proximity and distance, accreted as vivacious fragments belonging to
no whole. The ethics of the story thus reside in Woolf's depiction of an
experience—of experience—that activates for the fragment a life of its
own.

Though "Solid Objects" narratively and ambivalently engages topics con-
ceptualized elsewhere, Woolf's diary during these years hardly records
any consistent concern for material objects. We read other diarists, after
all, to hear about things. She writes about reading and thinking and talk-
ing and writing. Just as, in *Orlando*, the young nobleman's "disease of
reading" can temporarily turn all his riches—"carpets, sofas, trappings,
china, plate, cruets, chafing dishes and other movables often of beaten
gold"—into mist, so too in Woolf's own daily record, her reading and
writing tend to obscure any encounter with the physical world (*Orlando*,
75, 74). If she writes about objects, she tends to write about them as signs,
in the effort to determine how possessions characterize those who pos-
sess them: "art lamps and iridescent plates," for instance, seem to dem-
onstrate the gentility of one "farmer husband" (*D*, 248).

In her stories, however, material objects seem a condition of narrat-
ability. "Moments of Being" records the thoughts of a woman in search of
a lost pin, the finding of which puts a stop to the story. "The New Dress"
records the way social anxiety is most keenly mediated by material pos-
sessions. The point of "The Lady in the Looking Glass" is that possessions
that apparently reveal a life in fact keep it concealed from view. An ex-
traordinary dangling modifier in the story suddenly shifts the burden
from the unnamed narrator to the possessions themselves, as though
they spent their time contemplating the woman who possesses them:

"Under the stress of thinking about Isabella, her room became more shadowy and symbolic; the corners seemed darker, the legs of chairs and tables more spindly and hieroglyphic."[41] It is as though the object world, by concerning itself with human subjects, becomes both more and less legible, clearly significant but indecipherable.

Though the novels never think through artifacts so exclusively, they continue to foreground the way objects mediate human relations, including the self's relation to itself. Orlando's past returns to her in the twentieth century through her former possessions, housed in a museum. In *Night and Day*, when Mrs. Hilbery exclaims, "Dear things! Dear chairs and tables! How like old friends they are," the dearness resides in the family history that the objects express, in the objects' august legibility, a result of the fact that "We live in things," as Mrs. Swithin explains to the man who "fingers sensations" in *Between the Acts*.[42] Those novels construct a universe where, as Benjamin would have it, interiors are legible in the traces left by their occupants, and where collected objects contain for the collector elaborate narratives of their collection. In Woolf's version of the argument, within our houses, within our rooms, we are "surrounded by objects which perpetually express the oddity of our own temperaments and enforce the memories of our own experience." Thus a whole morning spent in Italy, the iron table and the breeze and the vines and the pillars—these "rise up in a cloud from the china bowl on the mantelpiece," a bowl purchased during an Italian holiday.[43]

But the fragments collected in "Solid Objects"—which, the more you read Woolf, seems itself to be an unrepresentative fragment—have only a fantasized and fantastic provenance: perhaps the lump of glass is a gem "worn by a dark Princess," or perhaps it is from an Elizabethan treasure chest (*HH*, 80–81). The fragments express the oddity of someone else's temperament: John imagines that the shape of the china shard depends on the "conjunction [of] a very high house, and a woman of such reckless impulse and passionate prejudice that she flings her jar or pot straight from the window without thought of who is below" (*HH*, 84). As compellingly as this scene may describe a woman's frustration with the objects that materialize her domestic confinement, the scene results from John's mere conjecture. In other words, the difference that "Solid Objects" insists on is a difference that comes from dislodging objects from a history of their proximity to subjects, from liberating artifacts from their status as determinate signs, from rendering a life of things that is irreducible to the history of human subjects.

Yet the pathos of *Jacob's Room*, among other novels, depends precisely on that reduction, on the symbolic and metonymic power of objects. The novel displays the evanescence of the protagonist's life as a relation to

the material object world. Woolf's poetics of space is in fact a poetics of the object. We first read about the boy climbing on a rock, "one of those tremendously solid brown, or rather black, rocks which emerge from the sand like something primitive," and then about him lost at the beach and "sobbing, but absent-mindedly" running "farther and farther" to discover just what it is that he has glimpsed "among the black sticks and straw."[44] Despite his family's insistence, he refuses to give up the sheep's skull, whitened by water and wind; he sleeps with it at the foot of the bed. The boy's attachment to the natural object that most readily suggests permanence, rock, becomes instead an attachment to bone, the quintessential memento mori that expresses the proximity of the animate and inanimate.

A child's fascination with the natural world—children collecting beetles and butterflies in chapter 2—devolves into more mundane arrangements, such as Jacob's room at Cambridge, which has a "round table and two low chairs," along with "yellow flags in a jar on the mantelpiece" (*JR*, 38). The novel gradually taxonomizes the adult fascination with objects. Consumer desire keeps Fanny captivated by "Evelina's shop off Shaftsbury Avenue," where "the parts of a woman were shown separate," skirts and boas and hats and shoes displayed without the logic of the ensemble (*JR*, 121). Indian philosophy prompts Jinny Carslake to cherish "a little jeweler's box containing ordinary pebbles picked off the road. But if you look at them steadily, she says, multiplicity becomes unity" (*JR*, 131). A recognizably romantic sensibility compels Jacob himself to cherish the Acropolis. In the midst of these competing modes of cathexis, the narrator offers a fully thematizing, ambiguating account of the relation between things of the world (actions) and things in the world (mere things) as Jacob begins to think seriously about his future, about going into Parliament, perhaps, about the question of the British Empire, the question of Home Rule in Ireland: "For he had grown to be a man, and was about to be immersed in things—as indeed the chambermaid, emptying his basin upstairs, fingering keys, studs, pencils, and bottles of tabloids strewn on the dressing-table, was aware" (*JR*, 139). Once immersed in mere things, Jacob is about to immerse himself in things, as his new possessions testify. He is cut off from aspiring to the political life and the sense of political economy that John willfully abandons in "Solid Objects." The concluding tableau of the novel, then, evolves less from the idea of absence (Jacob's death in the war), and more from a lingering presence, all the unburied remains, those possessions no longer possessed. A room lived in and permanently left is not haunted, but uncanny: "One fibre in the wicker arm-chair creaks, though no one sits there." The overwhelming question for those left is what to do with the objects that linger: hold-

ing out a pair of Jacob's old shoes, his mother asks "What am I to do with these?" (*JR*, 176). If, as Baudrillard would maintain, the subject's destiny passes into the object, what is the object's destiny beyond the life of the subject? What sort of obsolescence is this?

The affective power of the novel's close demonstrates the metonymic potency of material objects, which is inseparable from their potency to convey the realism of the novelistic universe, not just in the work of Charles Dickens or Honoré de Balzac, say, but also in experimental fiction. Woolf came to believe that the birth of the English novel as we know it, *Robinson Crusoe*, must be thought through the figure of the "large earthenware pot" that she posits as an emblem of Daniel Defoe's authority, which is fiction's authority to overwhelm the reader with the wholeness of an imagined world and to interrupt romantic fantasy with novelistic fact. "By believing fixedly in the solidity of the pot and its earthiness, he has subdued every other element to his design; he has roped the universe into a harmony."[45] In the power of the earthenware pot as Woolf imagines it, which is Defoe's capacity to novelize the universe, there is something of Stevens's jar on a hill in Tennessee, transforming the landscape around it, if not something of Heidegger's jug, the thing that things the world.[46] When solid objects become the explicit object of Woolf's address, however, the coherence of the solid object that makes the world cohere gives way to the solidity of fragments; there is no earthenware pot, but simply "a piece of china of the most remarkable shape . . . shaped, or broken accidentally, into five irregular but unmistakable points" (*HH*, 83). Though the emphasis on the accidental shape of the china fragment might be said to ally the story with the Dadaist and surrealist faith in the irrational and the contingent, the point is more that reevaluating the material world seems to depend on its reuse and on some violence that violates the coherence of the object. Whereas John imagines this violence as the act of an angry woman (hurling a "jar or a pot" out the window), the violence that the story nowhere imagines but everywhere intimates is the violence of war.

As John hunts in "the neighborhood of waste land where the household refuse is thrown away" and then comes to "haunt the places which are most prolific of broken china, such as pieces of waste land between railway lines, sites of demolished houses, and commons in the neighborhood of London," it is hard not to envision him as a character roaming the city streets and rat's alley of *The Waste Land*, the poem the Woolfs published two years later (*HH*, 82, 83–84; fig. 2.1). But such a convergence, itself part of a more widespread representation of postwar London as the unreal city, foregrounds a crucial contrast.[47] In place of the

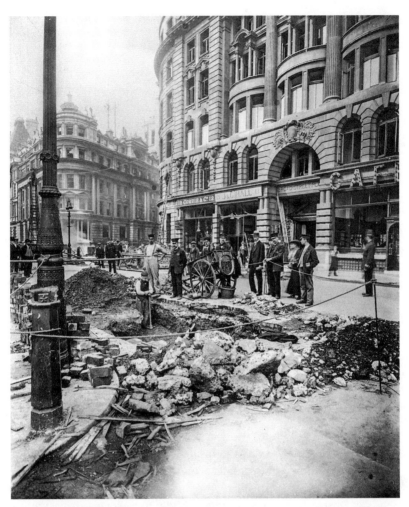

2.1 Damage to Liverpool Street in London following the Zeppelin raid on the night of September 8–9, 1915. Messrs Nules and Kaye, London, 1915. LC 32. Corporation of the City of London Collection, Imperial War Museum, London.

dolorous psyche of *The Waste Land*, shoring cultural fragments against the spiritual ruin of the cityscape, John serendipitously accretes material fragments within which he finds all the spirit he needs.

If war-traumatized London makes sense as the (underspecified) setting for the story, that trauma would seem to be specifically material, not spiritual. Though Woolf could dismiss the war as "remote and meaningless," she also lamented that "one has come to notice the war everywhere," meaning that "everything is skimped," that butcher shops are closed, that cards are required for "most foods," that other shops display "tins, or cardboard boxes" that are empty (*D*, 100).[48] Given the facts

of wartime scarcity, the point is less that her diaries seem so evacuated of material objects and more that the world they describe has been so evacuated: "If you see a plum, it is invariably a decoy plum" (*D*, 112). Though the accounts of the raids on London, the mattresses dragged to the cellar, are the more obvious reminder of the presence of the war in her diaries and letters, there is a subtle yet ubiquitous sense of how the things of the world, such as paper and paint, have become the materials of war. In this context, then, the intermittent material fascinations of her 1918 summer diary attain more significance: "I think it was on Friday that I was given my green glass jar by the chemist—for nothing! It's a jar I've always coveted; since glass is the best of all decorations, holding the light & changing it" (*D*, 170).[49]

If Woolf's pleasure in this green glass jar resurfaces in John's pleasure in the green lump of glass found on the beach, it does so embedded in a culture of scarcity that precipitates a different quality of cathexis. Glass had become the focus of national concern as glass manufacturers transformed major plants into munitions factories.[50] Moreover, the arrested import of Jena glass from Germany and Austria and of chemical glass from Bohemia had created a so-called glass famine in Britain, especially severe in the production of microscopic and photographic lenses.[51] As the *Geographic Journal* explained in its review of the reports from the Ministry of Munitions, there was hope that "British glass sands" would support domestic production needs. But if to the ministry it seemed as though these sands had sufficient silica content and the right grain, in fact the postwar search for the best sand led British crystal manufacturers back to Fontainebleau and to Loch Aline, Scotland.[52] For the iron in the English sand gave indigenous glass a green hue; it was *verre de fougère*.[53] The image of John "burrowing his fingers down, down, into the sand" and discovering there "a large irregular lump" of green glass might thus be read as an image less of discovery than of productivity, a production of glass out of the domestic glass sands of Britain and a recognition of its particular beauty. Still, it is not material as such (neither the sand nor the glass), but the whole process of retrieving and reanimating the ambiguous remnant that sustains John's fascination.

Between 1912 and 1930 Francis Bakley published some six books and dozens of articles on English glass; in retrospect, this looks like an act of mourning, composed as it was in the midst of general doubts about the longevity of the English production. The problem was not simply that glass manufacturers had been making lightbulbs, rods, and tubes for wartime industry, but also that, once the war was over, free trade made cheap imports a perpetual threat to the financial success of domestic stemware. The Society for Glass Technology was organized in 1916, as

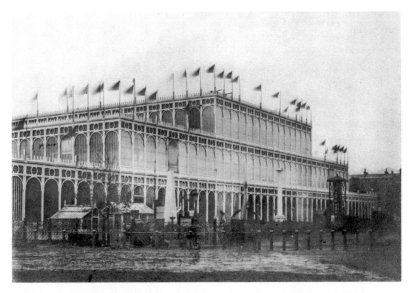

2.2 Claude-Marie Ferrier or Hugh Owen, Crystal Palace (view of west end of building) (1851). Salted paper photoprint. Prints and Photographs Division, Library of Congress, Washington, DC.

was a Department of Glass Technology at Sheffield, in the specific effort to sustain the nation's importance in the history of glass manufacture. But by 1924, 70 percent of the British market was supplied by imports, factories closed, and glassmakers were left unemployed in the face of continental competition.[54]

If the wartime and postwar history of glass in Britain can help to re-frame "Solid Objects" as a story about the modern fate of materials, then the history of iron extends and intensifies the point. The history of iron *and* glass, as instantiated by the Crystal Palace, chronicled the serial and international prospects of modernity (fig. 2.2).[55] Still, the story of Great Britain's iron trade was perpetually felt as a national tragedy, a narrative of decline from the Industrial Revolution and the thriving imperial economy. In standard histories, the vast iron and coal resources of England were understood as the necessary condition of the eighteenth-century Industrial Revolution. As Leonard Woolf revised this history, the Industrial Revolution and empire converged as an "intense preoccupation with material things," a demand for raw materials, coupled with production technologies, that resulted in "the whole world [being] ransacked for mines and metals," and in international competition for the control of resources.[56] The globalization that culminates in war, and in the compression of time and space that has been said to constitute modernity, originates with what we might call a passion for materials. When Virginia Woolf begins to write a story about accumulating materials in the

month of the war's close, she thus writes an allegory of that war's origin, but an allegory with a difference—the difference marked by a bricoleur's confusion of ends and means, by an alternative economy where value results from a noninstrumental passion for other things.

During the war, the need for scrap in the production of bombs led the military to search the English countryside and to return to major battle-fields to recover metal.[57] The imperial passion for materials had become a warring Europe's obsession with iron and steel. In an article titled "Coal and Iron in War," the *Fortnightly Review* stressed the industrial, economic rationale of Germany's aggression by publishing excerpts of a confidential memorandum, submitted to the chancellor from leading industrial and agriculture societies in May 1915, that underscored the importance of the long-term weakening of enemy nations, using iron as a case in point. The *Review* itself proclaimed that the current British supply of pig iron and steel was utterly "inadequate to our needs."[58] The problem of this war of attrition, as we have come to call it, was understood to have boiled down to the "essential question," in Sir John French's words, of "munitions, more munitions, always more munitions," and after the Ministry of Munitions was organized (with Lloyd George appointed minister), the ministry took over such crucial production centers as the Cumberland and Lancashire Iron mines.[59]

In the history of English iron, 1882 marks the record year for exports, dominated by the sale of railroad iron to colonial markets. By the close of the century, because of the McKinley tariff of 1890 and the British policy of free trade, Great Britain lost those markets (the United States supplying Canada with 70 percent of its iron and steel requirements) and had its domestic market flooded with "iron dumping" from Belgium, Germany, and the United States.[60] Though the war secured the domestic market for British manufacturers, other nations increased their own producing capacity, making 1921–31 the "Black Decade" of the British iron industry.[61] While the price of bar iron had been controlled during the war, the control was removed in 1919; by 1921 the price of such rudimentary objects as nuts and bolts had risen to five times that before the war.[62] When, in his obsessive search, John discovers "a very remarkable piece of iron" under a furze bush, he encounters the element that had become the focus of national and international obsession.

All this is to say that if John's "serious ambitions" are met with a "lack of understanding" that is repeated in the critical consensus about the story, we might nonetheless begin to understand his behavior as an alternative mode of experiencing scarcity (*HH*, 85). In Europe, more than in the United States, the war intensified a Taylorist horror of waste, not just of time but of substances. This was the war in which all citizens were

summoned to participate as national subjects, "each one of us"—"you and each one of you."[63] In their effort to involve civilians in the military project, governments took out ads and relied on posters as the new medium for communicating with the masses, for bringing the war into the civilian everyday. Saving fat for use in explosives, collecting the metal needed for scrap in the making of bombs—these activities amounted to a new kind of materialism, a requisite bricolage, a recognition that the materials of everyday objects could have another life (figs. 2.3, 2.4). As Aragon came to put it,

> Aha! That tinkling silver-plating was false
> The teaspoons are made of lead just like those bullets.[64]

Indeed, if the engagement Woolf narrates in "Solid Objects" can be understood as registering and aestheticizing (however inversely or perversely) the newly stipulated attention to materials throughout Europe, then the story can grant us a different access to familiar accounts of modernism and the object. Whether one assumes that the readymade was meant to attack the world of art, to foreground the role of the artist, or to dislodge common objects from the tyranny of use, Duchamp first promoted his readymades when the making of any common object—a urinal, a bottle rack, a snow shovel—was threatened all over Europe by the requirements of martial manufacturing. The various governmental demands to rethink the material world, and to revise the notion of waste toward a notion of recomposition, might lurk behind what Benjamin called the "materialistic, anthropological inspiration" that provoked the surrealists to discover some revolutionary potential in discarded objects.[65] As for anthropological inspiration as such, we can describe the fetishism Woolf portrays as an alternative economy, an intensely private and privatizing reorientation of value, that offers a specular image of the alternative economies that anthropologists made visible in the 1920s. In *Argonauts of the Pacific*, based on fieldwork done in New Guinea and North Melanesia during the war, Bronislaw Malinowski introduces "law and order into what seemed chaotic and freakish" by describing the function of apparently meaningless objects in the Kula.[66] When Marcel Mauss revises those conclusions to emphasize the irrationality of such practices, he deliberately juxtaposes "irrational expenditure" with the Western image of *homo oeconomicus* as "a calculating machine" devoted to "frigid utilitarian calculation."[67] Though Georges Bataille went on to celebrate various modes of *dépense* as such, Mauss's own ethical conclusions, argued in explicit relation to the European war, emphasize how a stable sociality, a kind of solidarity that depends on competition, can

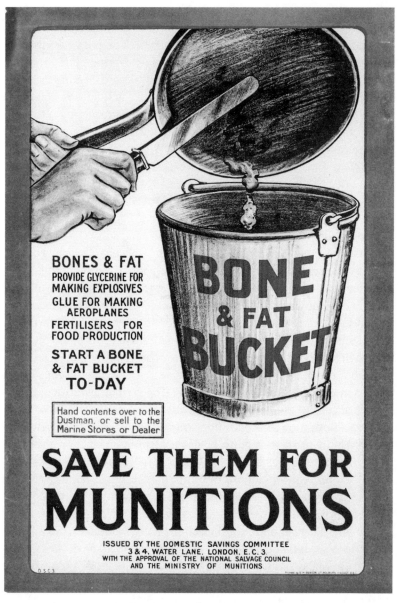

2.3 *Bone & fat bucket: Save them for munitions.* London: Issued by the Domestic Savings Committee with the approval of the National Salvage Council and the Ministry of Munitions (between 1914 and 1918). Printed by S. H. Benson, London. Call number: Folio-2 Gray A-58. Photograph: Bowman Gray Collection, Rare Book Collection, Wilson Library, University of North Carolina at Chapel Hill.

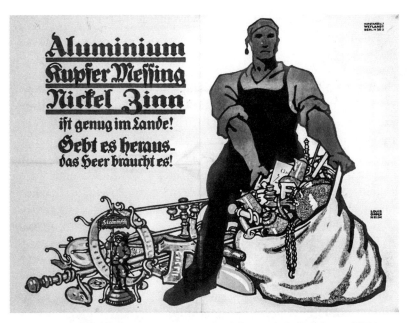

2.4 [Louis Oppenheim,] German conservation poster (1917). Photograph: Poster Collection, GE 183, Hoover Institution Archives.

emerge out of the respect and reciprocity of "the gift." The intense isolation of the individual in "Solid Objects" would be anathema to Mauss. But Woolf's image of reappropriating, valorizing, and aestheticizing waste, no less than his own image of wasting valuable property, is underwritten by the sense that the economic reason of the West has been exhausted.[68] Which is to say that the history of objects as we know it (the history of objects as we know them) will never challenge the Enlightenment's history of itself. The challenge comes from the history of other things, and from the histories in them.

"Solid Objects" begins with a narratorial consciousness that registers, as though through binoculars or through a zoom lens, a barely perceptible detail that slowly comes into focus as two human bodies. Woolf thus manages to record, in this gradually clarifying perception, something like the momentary development of sensation into perception:[69]

> The only thing that moved upon the vast semicircle of the beach was one small black dot. As it came nearer to the ribs and spine of the stranded pilchard boat, it became apparent from a certain tenuity in its blackness that this spot possessed four legs. . . . [The] mouths, noses, chins, and check stockings of the two speakers became clearer and clearer; the smoke of their pipes went up into the air; nothing was so solid, so living, so hard,

red, hirsute and virile as these two bodies for miles and miles of sea and
sandhill. (*HH*, 79)

These bodies, rendered as body parts and as parts that help designate the
form of the pilchard boat, achieve their solidity in the context of the sea-
scape. But once they settle into their wholeness (once they assume, let
us say, the phantasmatic image of the coherent human body), the "only
thing" that can mark such solidity is some other thing. As he burrows
into the sand, John's fingers finally curl "round something hard—a full
drop of solid matter," which turns out to be a "green tint," a lump of glass,
smoothed by the water into a veritable green gem (*HH*, 80). "It pleased
him; it puzzled him; it was so hard, so concentrated, so definite an object
compared with the vague sea and the hazy shore" (*HH*, 81). The definite-
ness of the solid object seems rather to expose the vagueness of politics
("Politics be damned!"), pushing politics into the background, as objects
sometimes do in Woolf's diary: "I have bought another glass jar for 2/-.
These things are in the foreground. It is partly due to them . . . that I don't
write first & foremost of the German offer of peace" (*D*, 199). If we grant
"Solid Objects" a (specifically) peripheral place in the British literature of
World War I, and even grant Virginia Woolf's shortest fiction some re-
lation to Leonard Woolf's tireless work for the League of Nations, then
this story will assume a very different role—to demonstrate how utterly
pedestrian passions can be understood as a longing for the fragments of
the West not to be reassembled as they were.

Though the solidity of human bodies in the story gives way to the so-
lidity of glass, solidity as such certainly gives way to a kind of fluidity—
"the green thinned and thickened slightly as it was held against the sky or
against the body" (*HH*, 81)—just as it gives way to elaborate fantasy: "Per-
haps after all it was really a gem; something worn by a dark Princess trail-
ing her finger in the water as she sat in the stern of the boat and listened
to the slaves singing as they rowed her across the Bay" (*HH*, 80–81). What
prevents solidity from becoming the point, what capacitates the imagi-
native encounter, is the incoherence of the fragment. John does not quite
succumb to what Simmel described as "the present vividly felt charm of
the fragment" that distances us "from things" because "reality is touched
not with direct confidence but with fingertips that are immediately with-
drawn" (*PM*, 474). Rather, John's tactile engagement gives him license
to explore some other unhuman reality: "John turned it in his hands; he
held it to the light; he held it so that its irregular mass blotted out the
body and extended right arm of his friend" (*HH*, 81). The fragment ap-
pears in "Solid Objects" as the figure of the material metonym whose
metonymic function has been arrested—the unconsummated metonym,

as it were. The unconsummated metonym is the figure, or the conceptual image, that Woolf offers us to think the object-thing dialectic, to think the world anew. John collects broken parts that are not really parts *of* anything determinable: "It was impossible to say whether it had been bottle, tumbler, or window-pane; it was nothing but glass." His materialism, where parts are related not to wholes but to other parts, enacts a kind of redemption that refuses the (Heideggerian) temporality of recuperation.

John's fetishism does not depend on substitution, but merely dynamizes the excess that characterizes any object, even the paper clip, the rubber band, the empty glass. If the work on objects (consumer objects, museal objects, ethnographic objects) "responds to the imperative to know about material needs, wants, and desires," then work on things should assume the task of discovering (in the history of objects) material desires, or the desire for material, that can only be lost in the histories of consumer society or ethnographies of cultural exchange. At the very close of the story, John's friend Charles, depressed by the disarray of the room and utterly confused by his friend, asks "What made you give it up," meaning to ask just what prevented John from pursuing his political career. When John answers "I've not given it up," he means that he has not abandoned his unbridled search (*HH*, 85). He could hardly give it up. His passion has become irrepressible. In addition, he refuses to feel guilt about his new pleasure because rather than discovering one solid object or another, he has in fact discovered some other desire. The desire to historicize this desire cannot help but limit its potential to overcome the specificities of time and of place, its potential to sense multiple histories materialized in (or by) the discarded remnant, the curious remainder. The war precipitated a national fixation on materials that may have prompted Woolf to imagine some more challenging, exhilarating material fixations. But we repeat the error she remonstrates against if, accumulating bits and pieces of this history, we believe that they form anything like the whole story.

Three

The Modernist Object and Another Thing (Man Ray)

In the long conversation he held with Man Ray in 1970, Pierre Bourgeade, a friend and fellow photographer, put the matter bluntly: "Votre métronome, avec un oeil au bout du battant, on le voit partout."[1] One sees it everywhere, the metronome with an eye affixed to its spindle: not just in the form of such exquisite photographs (fig. 3.1)—the mise en scène so precisely vague, the shadow crafted to help suspend the object just above its support, the attitude of the eye elusive—but also in previous and subsequent versions of the little assemblage, and in Man Ray's photographs of these, and in reproductions of those. Sir Roland Penrose, in the book that accompanied the Man Ray retrospective he organized in 1975 (he had, with André Breton, organized the *London International Surrealist Exhibit* in 1936), also remarked on the preponderance of this particular object. As part of its campaign in 1974, the Social Democratic Party of Hamburg had used the image for a huge poster. And the New York Cultural Center, in its version of the Man Ray retrospective that year, set the artist's monumental replica at the exhibition's entrance.[2] Few artworks from the twentieth century have had such a buoyant social life—nourished by reproduction and remediation, appropriation and distribution. That vitality would seem to confirm a suspicion that the image simply yet insistently records: the possibility that, all the time, objects spend their time looking. You may think that you see this metronome everywhere, but in fact, everywhere—"it's everywhere"—the metronome sees you.

If anything, Man Ray's *Object to Be Destroyed* (1932; fig. 3.1) has become the more iconic because, in the twenty-first century, surrealism—

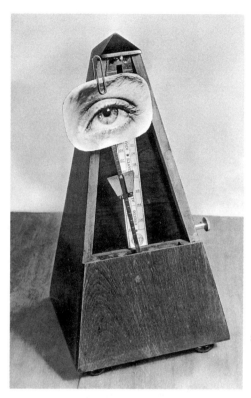

3.1 Man Ray, *Object to Be Destroyed* (1932). © 2015 Man Ray Trust/ Artists Rights Society, New York/ADAGP, Paris. Photograph: Telimage (2011).

specifically the surrealist object—has become increasingly fetishized, able to draw crowds to exhibitions, to draw scholars from both sides of the Atlantic, to draw attention from cartoonists, manufacturers, and advertising agencies.[3] Surrealist objects—Man Ray's flatiron with tacks (*Le cadeau*, 1921), Meret Oppenheim's fur-covered cup, saucer, and spoon (*Le déjeuner en fourrure*, 1936), Salvador Dalí's lobster phone (*White Aphrodisiac Telephone*, 1936), any number of surrealist mannequins photographed by Man Ray or boxes confected by Joseph Cornell—these have been firmly lodged in the *Wunderkammer* of the Western imaginary. However fraught the surrealist movement may have been (qua movement) the surrealists certainly got something right.

Or something wrong. For surely the commodity-object forms of surrealism—Magritte coffee mugs, Dalí magnets, Max Ernst T-shirts—provide exclamation marks for the surmise that surrealism is, well, "too easy!"—in contrast, say, to the "pictorial nominalism" of Duchamp, or the "subject-less" suprematism of Malevich, or the satiric bile of German expressionism. Simply enough, you could dub the ubiquity of these surrealist objects as the latest episode in what Adorno called "the false afterlife of surrealism," his most concrete example of how the "shock-laden

contents [*Inhalte*]" of the modernist work are absorbed by a world that "gives a cozy reception to unsublimated material as soon as the thorn is removed." But the damage they suffer in "their peace with the world" does not fully deplete their poignancy.[4] The questions posed by Magritte's *La trahison des images* ("Ceci n'est pas une pipe") (1928–29) have yet to become obsolete—questions about image, word, and object, as about reference and representation.

But the more challenging task is to grasp some "truth" within the "false afterlife of surrealism": the prospect that its objects continue to mesmerize (even if they no longer startle) not because any hope remains for "winning the energies of intoxication for the revolution" (in Benjamin's memorable phrase) but because they channel twenty-first-century anxieties and aspirations structured across two poles: on the one hand, the atrophy of the object world (its *soi-disant* dematerialization) effected by digital technologies and, on the other, the hypertrophy of the object world in the form of proliferation (including robots and drones) and in the form of waste (which precipitates as the world's jeopardization of the earth).[5] Who in his or her right mind does not long, however subconsciously, for something akin to what Breton termed a "total revolution of the object"?[6]

That revolution depends on escaping those habits of reason that, in the 1920s and 1930s, so offended the likes of Breton and Gaston Bachelard. The latter's invention of historical epistemology (in *Le nouvel esprit scientifique* [1934]) provided Breton with the substance (he already had the spirit, along with the phrase) to articulate a "crisis of the object." Published in *Cahiers d'art* in 1936, Breton's "Crisis of the Object" appeared as a conceptual complement to the 1936 *Exposition surréaliste d'objets* at the Galerie Charles Ratton (in Paris), which included work by surrealists (Arp, Calder, Dalí, Miro, Oppenheim, Giacometti, Tanguy, among others) and fellow travelers (Picasso, Duchamp, and Man Ray, among others), along with mathematical models from the 1870s, along with "primitive objects."[7] We should be embarrassed about the widespread attraction to surrealism only insofar as it registers the persistence of that crisis—or, more precisely, the ongoing limit of that crisis: the fact that the crisis has yet to be realized. For if, as Maurice Blanchot once put it, "surrealism is always of our time"—and "no longer here or there," but "everywhere"—that is because neither his time nor ours can yet distinguish itself from the time of the Surrealist Object.[8]

But here, after a historically and culturally confined chapter on Virginia Woolf, I want to approach the story of Man Ray's metronome not just within the frame of surrealism, but also in a more general context (visual, plastic, and literary) of the Modernist Object. (The no-less-salient

context of conceptual work from the first decades of the twentieth cen-
tury—work by Bloch, Lukács, Heidegger, Bataille—appears in other chap-
ters of this book.) By the Modernist Object I mean to designate not one
object or another, but the problematic of the object as such within mod-
ernism: the questions posed about objects, and about the object status of
the artwork itself over and against any task of representation, thus about
objectivity, abstraction, and objecthood, along with what Breton called
"the generally limiting factor of the object's manifest existence." Surreal-
ism strives to exceed that limit through a different "will to objectifica-
tion" (*Surrealism*, 279), which provides the most sustained access to what
I call in this book the *other thing*: some thing catalyzed in the encounter
of subject and object. To convey the contours of that problematic, I begin
with two kinds of objection to the object in the 1960s—one from concep-
tual artists who hoped to render the object-form of art obsolete, and the
other from Michael Fried, who came to recognize objecthood as a phe-
nomenon against which art, to be art, had to define itself (and for whom
the "modernist object" would be an oxymoron). Both help to highlight a
schematic understanding of the tension between art and objects, which
can recode the difference between modernism and the avant-garde. The
center of the chapter then focuses on the ways in which André Breton de-
veloped his concept of the "crisis of the object." Finally, the last two sec-
tions of the chapter provide an extended engagement with Man Ray—
on the one hand describing his object-portraits (portraits of objects) and
on the other describing his machine portraiture (portraits of machines,
and mechanomorphic portraits of people), both of which anticipate his
assemblage of the eye and the metronome. Art history has by now pro-
vided such astute microhistories of modernism and the avant-garde (not
least of Dada and surrealism) that it seems time to pull the camera back
(sacrificing focus on specificities of time and place, medium and form,
aesthetics and politics) in order to begin sensing how Man Ray's plastic
poetry—"une sorte de poésie plastique," as he said to Bourgeade (*Bonsoir,
Man Ray*, 59)—might contribute to our understanding of the modernist
object tout court, as to an understanding, asserted by Man Ray's *Object
to Be Destroyed*, of how the thingness of an object can persist beyond the
object's destruction.

1. Objecthood

In February 1968, addressing the most recent wave of conceptual art,
Lucy Lippard and John Chandler described how the studio was "be-
coming a study": "Such a trend," they wrote, "appears to be provoking

a profound dematerialization of art, especially of art as object, and if it continues to prevail, it may result in the object's becoming wholly obsolete."[9] *The obsolescence of the object*. That was a striking possibility, if not a strident actuality, in the work of George Brecht or Sol LeWitt, Lawrence Weiner or Robert Barry. One of Barry's printed texts—*Something That Is Hardly Anything at All* (1969)—quietly intimates that art, distinguished from aesthetics, deserves its own ontology. It's the idea; it's not the sensory experience.[10]

Of course, dematerialization, depending on how you understand it, was not such a novelty. You could call it a perverse realization of what one commentator calls the "progressive obliteration of the object" in Kant's Third Critique, where *noesis* (thought) trumps *aesthesis* (perception) to the point of rendering the work of art superfluous; or a version of art's task, within the Chinese tradition, to deontologize objects in behalf of disclosing not things but the foundations of things; or as a complement to art history's subjugation (at the hands of Edwin Panofsky) of "the entire history of the concept of art to the authority of the [Platonic] Idea"; or as the American instantiation of what Yves Klein had called, in a lecture at the Sorbonne in 1959, "the evolution of art toward the immaterial" (anticipating his exhibition, the next year, of *The Void*, and his proclamation "My paintings are now invisible").[11] And though Pop, in Warhol's words, was "a way of liking things," its advent provoked a particular kind of dematerialization that Arthur Danto voiced repeatedly: for when the difference between art "and mere real objects" can no longer be determined perceptually (Warhol's Brillo box looks just like a Brillo box) then it becomes "imperative to quit a materialist aesthetics in favor of an aesthetics of meaning."[12] The matter just doesn't matter. In his Hegelian mode of describing the advent of the posthistorical period of art (in which philosophy effectively supplants art), "the objects approach zero as their theory approaches infinity," art "having finally become vaporized in a dazzle of pure thought about itself, and remaining, as it were, solely as the object of its own theoretical consciousness."[13]

Then again, this so-called dematerialization of art was just one impulse among many in the 1960s, including its more preponderant dialectical inverse, made manifest in any number of Fluxkits, specific objects, minimalist situations, and monumental earthworks, as in the *Assemblage* exhibition that the Museum of Modern Art (MoMA) held in 1961. In an interview with Ellen Johnson, Mel Bochner explained, "During the early sixties when I began to think about art, the formulation was really 'art=object.'" He goes on to say, "[The] Johns and the Rauschenbergs and the Stellas were formative things to my thinking"—formative things, that is, insofar as they provoked him to do away with "physicality," with

3.2 Mel Bochner, *Portrait of Dan Flavin* (1966). © Mel Bochner. Ink on graph paper (cut out), 4.5 × 8.5 in. Photograph: Courtesy of Peter Freeman Inc., New York.

"surface" and "support," and with "found objects." His concluding point, a point repeatedly expressed by conceptual artists, maintains that once you "begin to reconstruct the artist's intention . . . you've obviated the need for the continuance of the object."[14] He himself was busy making number drawings and word portraits, not only of artists who stood for the concept (Duchamp, LeWitt), but also of those who stood for the object (Flavin, Smithson), as though their work could be remediated in discursive form (fig. 3.2).

Bochner's sense of the scene in the 1960s—"art = object"—had been conceptualized most forcefully and telegraphically by Donald Judd, whose "Specific Objects" (published in the *Arts Yearbook* in 1965) described a diverse range of "new three-dimensional work" that had evaded the effectively exhausted "set forms" of painting and sculpture: "Because the nature of three dimensions isn't set, given beforehand, something credible can be made."[15] The new work was proving itself more powerful than painting because "actual space is intrinsically more powerful and specific than paint on a flat surface." And beyond the specificity of the object itself—its irreducibility to any "inherited format"—the work foregrounded the specificity of its materials in an "unusually aggressive" manner. "There is," Judd writes, "an objectivity to the obdurate identity of a material," which does not disappear in favor of the object (because, say, in the case of Carl Andre's arrangements of brick, lead, or steel, the material effectively *is* the object: the object isn't made from bricks; it simply is bricks). Although he recognized the diversity among the artists he named (and he named more than forty, while singling out John Chamberlain, Claes Oldenburg, and Lee Bontecou for particular atten-

tion), the power of the essay resides in Judd's ability to generalize and thus to assert a full-scale rupture: something like a general strike against inherited media.

His fundamental definitions have been imbedded within the discipline of art history and the practice of art criticism, the more so because Michael Fried took them up in his defense of modernist painting and sculpture against this "new work." What Judd lists as the "insufficiencies of painting"—its flatness and rectangularity—Fried recognizes as the challenge posed by the medium, but a challenge successfully marked and met by Jules Olitiski, Kenneth Noland, and Frank Stella. Moreover and more pointedly, he understands the task of contemporary paintings—working against the "literalist art" that had become "the expression of a general and pervasive condition"—as the effort to maintain "their identity as *painting*" rather than being "experienced as nothing more than objects," which is a matter of "confronting the identity that they hold as shapes."[16] Thus, he argues that "modernist painting has come to find it imperative that it defeat or suspend its own objecthood": imperative that it remain "pictorial, not, or not merely literal," over and against the literalist works that mean, as Judd might have said, to "discover and project objecthood as such." Fried presses on to insist that (from the "perspective of recent modernist painting") objecthood is "antithetical to art" (153). This "negation of art" ensues from the work's theatricality: its attention to the encounter with the embodied, spectating subject, and thus its concern with space and the situational context. Facing the same art world that Bochner described, Fried asserted a different formula: art ≠ object.

But what the essay dramatizes as the antagonism between two artistic modes had appeared—the previous year, in Fried's essay on Stella—as an agonism *within* the art practices he admired most, activated by the "explicit relation between depicted and literal shape."[17] Rather than the flatness that Clement Greenberg had isolated, it was shape that had (for the first time) become the conspicuous determinant of the painted canvas.[18] For Noland, Olitski, and Stella, this meant acknowledging "the literal character of the picture support" (*AO*, 78) and working through (working on, or working at) the relation between visual illusion and literal shape. By concentrating on that relation, Fried brings the potency of objecthood—for painting—into view, while pointing out that the "literalness isolated and hypostatized" by other artists (Donald Judd, Larry Bell) plays no role in what he regards as the most advanced art of the moment (*AO*, 88). In his subsequent (1998) account of "Art and Objecthood" (originally written for *Artforum*'s special issue on sculpture in 1967), he describes the experience that provoked the essay, which was his recognition, in the New York galleries of the midsixties, of "literalism's singular effec-

tiveness as mise-en-scène ([Robert] Morris and Carl Andre were masters at this)," their installations soliciting the beholder "in a way that was fundamentally antithetical to the expressive and presentational mode of the recent painting and sculpture I most admired" (*AO*, 40–41). The essay has often been read as the modernist agenda's last gasp, and Fried himself hardly contradicts such a reading: "I don't seem to have imagined the possibility that within a few years the art I admired would be all but submerged under an avalanche of more or less openly theatrical productions and practices" (*AO*, 43), practices extending far beyond the minimalist work, which he deemed worthy of discussion, to unacknowledgeable fields such as Pop. The aesthetic autobiography contributes to Fried's effort to restrict his argument to a precise historical moment, as he does in the essay itself by repeatedly explaining that "objecthood [had] become an issue for modernist painting only within the past several years"; before 1960 (or thereabouts), the "risk, even the possibility of seeing works of art as nothing more than objects did not exist." Looking back at the essay's fate, he voices particular concern that his criticism in the 1960s and his subsequent art history not be fused in a way that makes him seem to be arguing that a "war" between "the theatrical and the pictorial" (*AO*, 160) informs the Western tradition of painting from the eighteenth century to the second half of the twentieth.

And yet, granting Fried his frustration with the art scene in the early sixties, and granting the newness of the problem faced by modernist painting, such historical specificity hardly works in reverse . . . by which I mean, of course, that objecthood (in various manifestations) had been deployed again and again in behalf of defeating painting, and of defeating art, since the second decade of the twentieth century. This is why a host of other critics—Rosalind Krauss and Hal Foster, among others—were able to write counterhistories to that modernism understood (in Krauss's words) as "the history of an ever more abstract and abstracting opticality."[19] Given the precision with which Judd points to significant precursors—the Jasper Johns of the cast objects, the Robert Rauschenberg of the combines, Arp's sculpture, Duchamp's readymades—there is something peculiar about Fried's elision of the potency of objecthood, more precisely of objects, from earlier decades.[20]

But pointing to the effort to defeat art (or opticality) by means of the object (by means, say, of Duchamp's bottle rack or snow shovel) can itself obscure the tension between that effort and the extraordinary (and extraordinarily accelerated) trajectory whereby, moving from Cézanne to cubism to abstract painting and sculpture, art's task of representing objects gave way to the work of establishing itself as an object on its own. Kazimir Malevich casts the transition as a move away from objectivity:

"When in the year, 1913, in my desperate attempt to free art from the ballast of objectivity, I took refuge in the square form and exhibited a picture which consisted of nothing more than a black square on a white field, the critics and, along with them, the public, sighed, 'Everything which we loved is lost.'"[21] Given this familiar trajectory, it may not seem surprising that Stella, who, by Fried's light, "sought to undo or neutralize objecthood" (AO, 41), had ended up, by Judd's light, in the specific-object camp. And it's not so surprising that Stella himself, in a 1966 interview, seems to "hypostatize objecthood" (to borrow Fried's phrase [AO, 41]): "My painting is based on the fact that only what can be seen there *is* there. It really is an object. Any painting is an object and anyone who gets involved enough in this finally has to face up to the objectness of whatever he's doing. He's making a thing."[22]

Supposing neither that Fried gets Stella wrong, nor that Stella gets his own practice wrong, I simply mean to show how specifying objecthood as a problem faced by recent modernist art diminishes the problematic of the object as it informed and transformed a longer trajectory of modernism. William Carlos Williams, in his antipathy to realism (what he dubbed "France's 'lie'"), declared that the artist is: "AT WORK MAKING OBJECTS."[23] Though he was explaining the work of Juan Gris, Williams also recognized how Gertrude Stein interrupted the transparency of language (which enables representation) to confer on words, sentences, and paragraphs their own status as objects. And though she herself understood her experiments as a kind of verbal cubism, Williams locates the effects of her writing within a literary tradition whose origin can be found in Laurence Sterne: "The feeling is of words themselves, a curious immediate quality quite apart from their meaning."[24] Unlike her formalist contemporaries (such as Victor Khlebnikov), Stein remained unwilling to eradicate sense altogether. But in the "Objects" section of *Tender Buttons* (1914), her miniature compositions enigmatically play with (in and around) referentiality, evading full sense while promoting sound to the point of turning the pieces into aural objects. Thus, in "Dirt and Not Copper":

> Dirt and not copper makes a color darker. It makes the shape so heavy and makes no melody harder.
> It makes mercy and relaxation and even a strength to spread a table fuller. There are more places not empty. They see cover.[25]

Not only does the cumulative semantic obscurity of the prose enable the composition itself to emerge as an object, but it does so at the specified expense of objects—what Malevich termed "the ballast of objectivity."

Although Stein influenced her contemporaries, it is the language art-
ists of the 1960s who expanded the radicality of her experimentation. She
is invoked as a crucial reference by Carl Andre, for one, whose *One Hun-
dred Sonnets (I . . . Flower)* abandons grammar and adopts an altogether
different mode of organizing words: "the kind of grid," as he explained
to Liz Kotz, "that a typewriter produce[s] in a very machine-like way."[26]
He understood his poetry not as an act of self-expression, but as an ex-
periment related to Stein's—"She wanted . . . to find out what *language
says*"—a strategy of promoting the obdurate identity of *this* material.[27]
No less than sharing a studio with Frank Stella, and no less than his work
as a brakeman on the Pennsylvania Railroad, Andre's experiments with
concrete poetry—square blocks on the page that consist of one repeated
word—provide a paradigm for his subsequent materialist arrange-
ments, when he abandons language and turns his attention to objects
(plates 1, 2).[28]

2. Art History

Even such a hasty genealogical gesture points out how visual and literary
artists were thinking with (or through) the object form. More straightfor-
wardly and more familiarly, everyday objects have a long history of being
summoned in behalf of defeating art—art understood as a (bourgeois)
institution, as an autonomous sphere, as a grandiose ideology. They were
summoned by the avant-garde in the effort to interrupt modernist aes-
theticism, which is why Peter Bürger makes much of collage technique
when he's describing how the avant-garde meant to break free of the self-
enclosed work (and world) of art and to intervene in social reality.[29] In
contrast, the modernist work, according to its most renowned champion,
"must try, in principle, to avoid any order of experience not inherent in
the most literally and essentially construed nature of its medium."[30] On
the one hand, Clement Greenberg recognized the threat that had been
posed by Dada's rejection of the aesthetic: a threat "to compromise all of
modernism and deprive it of its rightful place" within art's august conti-
nuity.[31] On the other, he was always willing to dismiss avant-garde work
on the grounds that the "look of non-art" is "aesthetically extraneous,"
as he puts it in "Recentness of Sculpture" (1967), where he belittles mini-
malism by captioning it "Good Design"—design as opposed to art.[32]

Duchamp's first (fully) readymade (the bottle rack he purchased in
1914) established the role of everyday objects within the history of the
anti-aesthetic, but that role, however differently inflected, had hardly
diminished by the 1960s.[33] When Claes Oldenburg opened The Store in

1961, the pastiche of consumerism did not diminish his sense that he was providing a way to display art outside the frame of the gallery and the museum. As he makes patent in his *Documents from the Store* (1961), the mission was aggressively anti-aesthetic: "If only I could forget art entirely. I don't really think you can win. Duchamp is labeled art too." Despite the conundrum, he was bent on producing things that could evade the status of art: "Assuming I wanted to create a thing what would that thing be? Just a thing, an object. Art would not enter into it."[34] However familiar much of this sentiment is—the artist is at work making objects (Williams), the artist making a thing (Stella)—Oldenburg more specifically longs to defeat or neutralize art. But though he may exclude *Art* from his idea of production, he nonetheless provides an extensive credo in behalf of some entity that newly conceives "art":

> I am for an art . . . that does something other than sit on its ass in a museum. I am for an art that grows up not knowing it is art at all. . . . I am for an art that involves itself with everyday crap and still comes out on top. . . . I am for an art that you can pick your nose with or stub your toes on. . . . I am for the art of bright blue factory columns and blinking biscuit signs. . . . I am for the art of underwear and the art of taxi-cabs. (39–42)

Taxicabs and biscuit signs and underwear—the quotidian object world ("everyday crap") is summoned not in behalf of rejuvenating art (which had been the role of ethnological artifacts in the first decade of the century) but in behalf of defeating art into something unrecognizable.

This history, in which objects and art are at odds (if not at war), hovers in the margins of "Art and Objecthood." It is also a history that helps to schematize the distinction between modernism and the avant-garde, the latter deploying things (plural) in behalf of interrupting the concept of art to which modernism remains beholden. At the close of "Specific Objects," Judd contributes to this schematization by offering a simple and certain response to any account of modernism (Greenberg's) that imagines a history of art that amounts to sloughing off superfluous elements: "If changes in art are compared backwards, there always seems to be reduction, since only old attributes are counted and these are always fewer. But obviously new things are more, such as Oldenburg's techniques and materials." Judd commits himself to describing avant-garde amplitude— a newness fostered by new things.[35] Any number of juxtapositions illustrate this schematized history, but few make the point more clearly than the relation between Jackson Pollock's *Full Fathom Five* (1947; plate 3) and Rauschenberg's *Bed* (1955; plate 4). Pollock has incorporated cigarette butts, coins, matches, tacks, a key, and nails into his painting, but

the skein of paint effectively obscures the objects; the work remains fully legible as the large abstract painting it is. Rauschenberg makes use of a drip technique while aggressively disrupting abstraction, replacing stretched canvas with his bedclothes (never not recognizable as the bedclothes they are), replicating the scale of large abstract painting while displacing its grandiosity with the most domestic of large-scale objects.[36] On the one hand, painting appears to triumph over the object world; on the other, the object world appears to triumph over painting. In Leo Steinberg's words, Rauschenberg produced a "pictorial surface that let the world back in again."[37] Rauschenberg provides Steinberg with the most explicit examples of a reorientation of the picture plane in the 1950s, from vertical to horizontal, where the "painted surface is no longer the analogue of a visual experience of nature" (as it remains in abstract expressionism) but alludes to "hard surfaces such as tabletops, studio floors, . . . any surface on which objects are scattered" (84). Such allusions amount to granting Rauschenberg's work its context in the everyday object world; "flatness" is thus "no more of a problem than the flatness of a disordered desk or an unswept floor" (88).

The conflict between objects and painting (if not that between art and objecthood) extends beyond the frame established by Judd's and Fried's essays. But even as those essays generate the coordinates for charting that extension, they also record an affective encounter not with objects or things, so much as with some other thing—which is the thingness of particular objects. Indeed, it is as though Fried struggles to voice such a point by quoting—twice—one line from Tony Smith: "I'm interested," the sculptor says, "in the inscrutability and mysteriousness of the thing" (AO, 156, 165). What is this thing?

As his example, Smith points to a "Bennington earthenware jar," which "has subtlety of color, largeness of form, a general suggestion of substance," and which is "calm and reassuring—qualities that take it beyond pure utility. It continues to nourish us time and time again. We can't see it in a second, we continue to read it" (AO, 166). Smith's apprehension of the thingness of the jar (which could be read productively in the context of both Bloch's and Heidegger's meditations on the Krug, described in chapter 1) amounts to a simple recognition that the object is what it is while becoming some thing else—some thing in excess of its manifest form, however dependent on that form. In Fried's own experience, such a recognition arises with (or as) a very different affect. After describing how the literalist object "makes the beholder a subject," he goes on to say that the subject's experience of the object is akin to being "crowded," as though "by the silent presence of another person" (AO, 154–55). Continuing the account, he foregrounds the uncanniness of the encounter:

"The experience of coming upon literalist objects unexpectedly—for example, in somewhat darkened rooms—can be strongly, if momentarily disquieting" (*AO*, 155). Literalist work is singularly disquieting insofar as it is "biomorphic," if not "blatantly anthropomorphic," an effect, Fried argues, of the object seeming to have an inside: "It is . . . as though the work in question has an inner, even secret, life" (*AO*, 151). In his retrospective account of the essay, he explains, as though more fully inhabiting the genre of the sixties' horror film, "There is, I might have said, something vaguely *monstrous* about the body in literalism" (*AO*, 42), not quite clarifying whether this is the body of the beholding subject or that of the literalist object. Such ambiguity is indeed a hallmark of the thingness he tracks—the unresolved doubleness, the ambiguous ontology (somehow animate and inanimate, somehow person and thing), the inexplicable secrecy. The conundrum cannot be captioned adequately by "objecthood," of course, because what disquiets and crowds—what seems monstrous—is precisely the way that the object refuses to behave as a mere object. For Fried, these details contribute to a demonstration of how the literalist sensibility has been "corrupted or perverted by theater" (*AO*, 161). But his experience testifies more provocatively to the presence of a thing that by definition names a subject-object relation, a phenomenological case where the object cannot be arrested into stability, into the structure of knower and known.

However untoward such a reading of "Art and Objecthood" may seem—a reading wherein the critic's anxiety over thingness ("the inscrutability and mysteriousness of the thing") takes precedence over the adjudication of what counts as art, and how—it seems to align with an extensive note in which Fried names a historical analog for literalism, *surrealism*, abruptly opening the floodgates to an earlier twentieth-century moment that he has studiously excluded: "There is, in fact, a deep affinity between literalist and Surrealist sensibility" (*AO*, 176).[38] The affinity resides in the fact, for instance, that "both resort to similar anthropomorphizing of objects or conglomeration of objects (in Surrealism the use of dolls and mannikins makes that explicit"); that "both tend to deploy and isolate objects and persons in 'situations'"; and that both exhibit "remarkable effects of 'presence'" (*AO*, 171).[39] While Fried, unlike Greenberg, effectively suppresses surrealism, here it returns, however momentarily, in behalf of explaining what is wrong with contemporary art.[40]

And yet, while the peripheral attention to surrealism may help to make sense of the disquiet Fried feels confronting the thingness of objects, it doesn't quite explain what could be so alarming about Donald Judd's Plexiglas stacks or Robert Morris's polyhedrons or Tony Smith's black modules (no matter how suddenly you happen to come upon them). You

might feel more threatened by the aggressive oddity of Oldenburg's giant and flaccid light switch, the kind of object that Judd describes as "grossly anthropomorphized," arguing that Oldenburg takes "anthropomorphism to an extreme" and exaggerates any "accepted or chosen form" in order to equate the "biopsychological" ("emotive form") with the shape of the object itself. The work (the ice-cream cone, the hamburger, the chocolate cake) is uncanny because it dramatizes the monstrosity of the material shapes that shape American life. Of course, Oldenburg's work remains unacknowledgeable by Fried, as does the work of Lee Bontecou, which Judd describes as "explicit and aggressive"—and which he finds daunting, if not frightening: "The abatised orifice is like a strange and dangerous object. The quality is intense and narrow and obsessive" ("Specific Objects," 188). Indeed, no American art from the sixties appears so disquieting, so biomorphic, so surrealist and monstrous as Bontecou's angular constructions made of canvas that has been wired to welded metal, the aggressive inscrutability of which depends on the presence of an overwhelming absence: the black hole. Moreover, few artists of the day enjoyed such a vibrant career. Bontecou appeared in solo and group shows (including solo shows at the Leo Castelli gallery in 1960, 1962, and 1966; including *Documenta III*, MoMA, and the Whitney annual sculpture exhibit in 1961, 1963, 1964, and 1966); and her monumental, twenty-one-foot-wide, winglike construction was permanently installed in the new Lincoln Center for the Performing Arts (designed by Philip Johnson) in 1964 (plates 5, 6). She had also become a celebrity both in art journals and in the popular press: *Cosmopolitan, Vogue, Time, Life*.[41] Unacknowledged as Bontecou may have been by the likes of Greenberg and Fried, she had achieved a kind of hyperpresence within the art scene of the sixties. Thus, though her work bears no affinity to the minimalism that Fried does acknowledge and attack, it is as though "Art and Obejcthood" were a screen essay (functioning like a screen memory) behind which lies an antipathy to those unacknowledgeable objects that Judd had described (utterly disquieting, biomorphic, monstrous objects), which provoke a kind of horror. Which is not to say that Bontecou's assemblages can readily be understood as specific objects.

The brief essay that Judd published on Bontecou (in *Arts Magazine* in 1965), written after "Specific Objects," clearly shows how much of an impact she had had on his conceptualization of that phenomenon, though she does not so clearly illustrate his argument. He begins: "Lee Bontecou was one of the first to use a three-dimensional form that was neither painting nor sculpture. Her work is explicit and powerful."[42] Her work exhibits the singleness of specific objects because the work's structure is "coextensive" with its shape and with the image it generates. But that

image itself—"the image is an object, a grim, abyssal one"—proves difficult for Judd to assess. On the one hand, he rightly insists that "the black hole does not allude to a black hole; it is one"; on the other, he acknowledges that "the image does suggest other things, but by analogy; the image is one thing among similar things." But those similar things seem to be irrepressibly evoked. At least commentators on Bontecou, including Judd, cannot resist an analogical litany: "This possibly threatening and possibly functioning object is at eye level. The image cannot be contemplated; it has to be dealt with as an object, at least viewed with puzzlement and wariness, as would any strange object, and at most seen with terror, as would be a beached mine or a well hidden in the grass. The image extends from something as social as war to something as private as sex, making one an aspect of the other." The object may have specificity in its aggressive and complex distinction from painting—because Bontecou is both working in canvas and producing works to be hung in the manner of paintings—but the object-image oscillates in and out of analogical referentiality. (The residue of indexical referentiality in Chamberlain's work—vehicular crisis—can produce a milder version of the same effect.) Although the "work asserts its own existence, form and power, . . . becom[ing] an object in its own right," the "image also extends from bellicosity, both martial and psychological—aspects which do not equate—to invitation, erotic and psychological, and deathly as well." As Judd says of her work in "Specific Objects," "internal and external references, such as violence and war, have been added. The additions are somewhat pictorial, but the image is essentially new and surprising." From Judd's point of view (but in Fried's vocabulary), you would say that it is imperative that the work remain literal (as object), and not, or not merely, pictorial (as image).[43]

Not only does the work oscillate between the literal and the pictorial, the abstract and the figurative, object and image, specificity and referentiality; also, within the referential register it convokes competing domains, the natural and the mechanical, the prehistoric and futuristic, the sexual and the militaristic. And while the palette and the angled, cut forms seem cubist, the biomorphism (at once ocular and vaginal, oral and rectal) and the (armored) hostility locate the work, without the humor, within the surrealist tradition (among those "bad objects," such as Man Ray's *Cadeau*, Giacometti's *Disagreeable Object*, and the more startling of the surrealist mannequins, say André Masson's [1938], which went undressed save for the bird cage surrounding its head). Indeed, Judd's critical encounter with Bontecou helps clarify the way in which surrealism tended to produce what you might call inspecific objects. Judd was adamant about his assertion that the "primitive, oppressive and unmitigated

individuality" of Bontecou's works "excludes grand interpretations." Subsequent critics have repeated the claim while nonetheless marshaling a host of possible (indeed probable) cultural referents, from television (as an object and as a medium) to the Cold War to the science fiction of H. G. Wells and Philip K. Dick; elusive as she herself was about interpretation, she mentions Sputnik, and expresses her anger about war.[44] (The objects she includes in the work—rivets, washers, saw blades, shrapnel, iron keyholes—contribute to the vertiginous signifying energy.) Though their pictoriality excludes them from what Fried called literalist work, they are of course (as he himself would emphasize) utterly theatrical, insisting on the presence of a beholder and indeed the beholder's interaction with the object, stepping toward it, peering in, stepping back, and back one step again. They not only *seem* to have an inside; they have one, and thus seem to have "an inner, even secret, life" (*AO*, 151). A Lacanian reading of Bontecou's best-known work would read one or another orifice as the materialization of the Thing in object form: as an emptiness representing what cannot be represented. But the thingness that this work dramatizes most simply is the refusal of the object to be one thing or another; the black void can't help but overwhelm the most casual beholder with the sense that there is something essential about the object (or the inside of the object) that remains elusive. The object doesn't have specificity insofar as it draws your attention to something other than object it is. In the world of Lee Bontecou, art = thing.

3. Crises of the Object

However fleetingly, Fried's note locates a prehistory of the object's instability within surrealism. It can hardly begin to suggest the centrality of the object within surrealist theory, fiction, poetry, and exhibition practice from 1924 to 1936, when the *Exposition surréaliste d'objets* at Galerie Charles Ratton marked the culmination of the intensifying interest in the object world—or, say, in the world rethought or reimagined through the object.[45] Not that such instability was confined to surrealism per se. *Ulysses* (1922), for instance, provides its own untoward and exuberant animation of *embodied* objects that can be read as a kind of protosurrealist flamboyance, especially given that Joyce wrote the Circe episode while living in Paris in 1920, the year when Breton and Philippe Soupault published *Les champs magnétique*. Although Breton went to some pains to segregate Joyce outside the surrealist project, the behavior of objects within the episode anticipates his call to release objects from the habits of quotidian perception.[46] And although, by 1953, Breton retreated into a

historical overview insisting that the "'prime matter'" of surrealism "(in the alchemical sense)" had always been "language," even the first *Manifesto of Surrealism* (1924), which concentrates on poetry, literary antecedents, and verbal techniques (automatic writing, "random assemblage"), all but begins with an account of the problem posed by the object world: "Man, that inveterate dreamer, daily more discontent with his destiny, has trouble assessing the objects he has been led to use, objects that his nonchalance has brought his way, or that he has earned through his own efforts."[47] In other words, those very objects serve as the measure for assessing man's discontent.

Soluble Fish (1924) exhibits such an inveterate dreamer at full liberty to interact differently with objects and to witness their correlatively idiosyncratic behavior: "Someone took it into his head one day to gather the fuzz of fruits in a white earthenware bowl; he coated several mirrors with this vapor and came back long after: the mirrors had disappeared. The mirrors had got up one after the other and left, trembling."[48] Although nothing restricts the animation of the object world—among other phenomena, a traveling lamppost indulges in monologue (78)—it is the transpositions in and out of the quotidian that convey what would become the more precise surrealist adventure of moving between the ordinary and extraordinary, the enigmatic and the panoramic, channeled through quotidian objects (and the leap from object to object) that, say, have been reassessed:

> At the bottom of the fourth page of the newspaper an unusual fold that I can describe as follows: it looks as if it has been wrapped around a metallic object, judging by a rusty spot that might be a forest, and this metallic object might be a weapon of an unfamiliar shape, akin to the dawn and a large Empire bed. The writer signing the fashion column, near the aforementioned forest, speaks a most obscure language in which I nonetheless believe that I can make out that the negligee of the young bride will be ordered this season at the Partridge Company, a new department store that has just opened up in the Glacière district. The author, who seems to be particularly interested in the trousseaus of young women, emphasizes that these latter are free to change their body linen for soul linen in the event of divorce. (60–61)

The passage has those hallmarks of surrealism—interest in the outmoded, proximity to fashion, engagement with the phantasmagoria of consumer culture—that fascinated Benjamin. "The father of Surrealism was Dada," he explained in his genesis myth; "its mother was an arcade." By that he means to refer not just to Breton's meetings with Louis Aragon

in the Passage de l'Opéra, nor just to Aragon's *Paysan de Paris* (that "requiem" for the arcade wiped out by the Boulevard Haussmann), but also to the object world tout court on display in Paris. This is why the nine muses who appear as midwives "at the birth of Surrealism" include not just Lenin and Freud, but Citroën.[49]

Benjamin lived in Paris for several months in 1927 (joining the Sacco and Vanzetti demonstrations in August), where he confirmed his sense that surrealism was not psychoanalytic (the analogue Breton himself declared) so much as it was archaeological and anthropological.[50] The first part of his major essay on surrealism (published in three installments in 1929) focuses on Breton's *Nadja* (1928) to make the case for what he had already asserted in "Dream Kitsch" (1925): the surrealists "are less on the trail of the psyche than on the track of things."[51] What he comes to call the *"profane illumination"* of the surrealists is "a materialistic, anthropological inspiration."[52] In *Nadja* (1928), Breton had settled into a less oneiric mode—incorporating photographs to affirm the autobiographical reality of his text—while conveying the dreamlike character of the urban everyday, which includes not an animate object world but his inexplicable cathexes on objects found as he wanders through the *marché aux puces* at Saint-Ouen: "I go there often, searching for objects that can be found nowhere else: old-fashioned, broken, useless, almost incomprehensible, even perverse—at least in the sense I give to the word and which I prefer—like, for example, that kind of irregular, white, shellacked half-cylinder covered with reliefs and depressions that are meaningless to me."[53] The lady, as Benjamin explains about Breton's record of erotic longing, "matters least," as in Provençal poetry (210). What matters, rather, is Breton's claim that "when I am near her I am nearer things which are near her" (90). Benjamin (having repeated the line without quoting) asks, "What are these things?"

His own adamant yet elusive answer characterizes *Paysan de Paris* as much as (or more than) *Nadja*, even as it anticipates the mode of thinking through which he himself would develop his *Arcades* project, begun in 1927: "He was," Benjamin writes, "the first to perceive the revolutionary energies that appear in the 'outmoded.'"[54] The surrealists are the first to recognize that "enslaved and enslaving objects" can be "suddenly transformed into revolutionary nihilism." Both Breton and Aragon "bring the immense forces of 'atmosphere' concealed in these things to the point of explosion." The passionate elaboration bespeaks the degree to which Benjamin was fashioning a methodological program for his own work, the articulation of which reaches a characteristically epigrammatic pitch: "The trick by which this world of things is mastered—it is more proper to speak of a trick than a method—consists in the substitution of a politi-

cal for a historical view of the past" (210). Certainly, for Benjamin, as for Aragon and Breton, "at the center of the world of things stands the most dreamed-about of their objects: the city of Paris itself" (211).

Which is certainly not to diminish Breton's own attraction to objects, expressed very concretely in the next decade when he began to produce "poème-objets," assemblages of both objects and words (plate 7). Sharing the desire that he found in Apollinaire's *Calligrammes*—to express one-self "in a form that would be poetic and plastic at the same time"—he comments at some length (without reference to his own work) on the experimental strategy "of incorporating objects, ordinary or not, within a poem, or more exactly of composing a poem in which visual elements take their place between the words without ever duplicating them." The idea was to provoke "a novel sensation, one that is exceptionally disturbing and complex." Invoking Rimbaud's claim in behalf of the "systematic derangement of all the senses," he situates the practice within his own understanding of surrealism's fundamental dictum: "We must not hesitate to *bewilder sensation*."[55] Octavio Paz offers a more poetic apprehension of the practice that focuses specifically on the fate of the object within these hybrid fabrications: "Snatched out of context, the objects are diverted from their normal use and significance. They are no longer really objects and they are not quite signs. So what are they? Silent things that speak. To see them is to hear them. What do they say? They whisper riddles, puzzles."[56] For Paz, the accomplishment rests in Breton's capacity to render the objects vocal, which begins with their dislocation, subjecting them to productive misuse, staging their misuse value.

It is in the thirties when Breton himself centralizes the object as a topic for polemical attention.[57] Lecturing in Brussels under the title "What Is Surrealism?" in 1934, he charts a history of the movement whose initial stages "seemed only to involve poetic language exclusively," whose spirit then "spread like wildfire," and whose future cannot yet be predicted. But he asks his audience (and the readers of the subsequent pamphlet) to recognize that its "most recent advance is producing a *fundamental crisis of the 'object'*": "It is essentially on the object that surrealism has thrown most light in recent years. Only the very close examination of the many recent speculations to which the object has publicly given rise (the oneiric object, the object functioning symbolically, the real and virtual object, the moving but silent object, the phantom object, the found object, etc.), can give one a proper grasp of the experiments that surrealism is engaged in now. In order to continue to understand the movement, it is indispensable to focus one's attention on this point."[58] But he himself shifts focus as he moves from this penultimate claim to a concluding concern with the "overthrow of capitalist society," hence with the task of

correlating artistic innovation with the "interest of the working class" (186–87). The shift in attention leaves an obvious gap between the object experiments and political praxis.

Breton might have used his subsequent lecture, "Surrealist Situation of the Object," delivered in Prague the following year, as an occasion to bridge that gap, effecting some transition between the "fundamental crisis of the object" and the material and sociopolitical crises that ravaged Eastern and Western Europe. Instead, he begins by pointing out a particular problem with the "situation of the Surrealist object," a problem precipitated by surrealism's "sudden and rapid spread" and the resulting "vulgar abuses" wherein any "type of little non-sculptural object" has been proclaimed to be surrealist. (He seems oblivious to the barb within the "recent proposal by Man Ray" to authenticate surrealists objects with "a sort of hallmark or seal";[59] in this case as in others, Man Ray had no truck with Breton's petulant exclusions.) While Breton points out how Duchamp, designating a ready-made object as a work of art, paved the way for the surrealist object, the latter relies on fashioning something else, what Max Ernst described as "the coupling of two realities which apparently cannot be coupled on a plane which apparently is not appropriate to them" (275). Having quoted Ernst, Breton then goes on at some length about his own call, from *Introduction au discours sur le peu de réalité* (1927), to produce and circulate objects from dreams, including useless machines, maps of nonexistent cities, and "absurd, highly perfected automata" that would become "responsible for giving us a correct idea of action"—each and all of these meant to discredit "'reasonable' beings and objects" (277). But he insists that the subjective production of objects— "the organization of perceptions with an objective tendency around subjective elements"—should be understood not only as "bewildering," but also as "revolutionary, in the sense that they urgently call for something to answer them in outer reality" (278). The *real* object—*the object realized by the surrealist*—means to conjure an altogether new reality.

Breton then pursued the "crisis of the object" in the issue of *Cahiers d'Art* titled *L'Objet*—the special issue accompanying the *Exposition surréaliste d'objets* that he helped to organize at Galerie Charles Ratton, which included "Objets mathematiques. Objets naturelles. Objets sauvages. Objets trouvés. Objets irrationnels. Objets ready made. Objets interpretea. Objets incorpores. Objets mobiles" (the curious orthography appearing in the original). Christian Zervos commissioned Duchamp to produce a cover for the issue, and he included essays, art, and photographs by Breton, Éluard, Man Ray, Hans Bellmer, Max Ernst, Salvador Dalí ("Honneur à l'objet!"), and Claude Cahun ("Prenez garde aux objets domestique"), among others.[60] Breton used the occasion to develop a sig-

nificant shift in his thinking, for here, thanks to having read Bachelard's *La nouvelle esprit scientifique* (1934), he could focus on the "parallel development" of scientific and literary revolutions and declare a unified attack on reason. He describes the historical correspondence, in 1830, between the discovery of a non-Euclidian geometry that "'opened up' rationalism" and the height of romanticism; and the way that, in 1870, a new "generalized geometry" (encompassing both the Euclidian and non-Euclidian) required "the same kind of *transcended contradiction*" that one finds in Lautréamont and Rimbaud: "These duplications of the geometric image and the poetic image were accomplished simultaneously."[61] That history prompts him to say that it is necessary to deconcretize (*déconcrétiser*) "various geometries" and to break down (*rompre*) "the barriers in art which divide familiar sights from possible visions"; indeed, modern art and science present the same structure, in which the "real," confused for too long with the given, "splinters in every direction possible and tends to become a component of the possible" ("CO," 276). The scientific psychology that Bachelard had described does not simply offer Breton an analogue; it establishes the ground for resituating surrealism as the very access point to the real. He wrote of the essay later that year (in his contribution to Herbert Read's book on surrealism), "I have endeavored to show how the *open rationalism* which defines the present position of scholars (as a sequel to the conception of non-euclidean—a generalized geometry, non-newtonian mechanics, non-maxwellian physics, etc.) cannot fail to correspond with the *open realism* or *Surrealism* which involves the ruin of the edifice of Descartes and Kant"—that edifice which Heidegger, at the same time but in a very different key, was also bent on ruining to gain access to the thingness obscured by objects.[62]

Above all, Bachelard adamantly objected to the image of science as the progress of reason. He insists that genuine discovery has had an altogether different psychological foundation: "Psychologically, the modern physicist is aware that the rational habits acquired from immediate knowledge and practical activity are crippling impediments of mind that must be overcome in order to regain the unfettered movement of discovery." The creative imagination has to break through "epistemological obstacles" in order to gain new knowledge. Such imagination had enabled the development of non-Maxwellian physics and non-Euclidian geometries; that liberation required "engaging in what one might call a kind of psychoanalysis," by which he meant a search for some truth that lay behind (or within) manifest existence.[63] Only "a nonrealist mode of thought, a mode of thought sustained by its own dynamic thrust" is capable of moving from the given "scientific object" to the constitution of a "new reality," such as that described by Einstein (133–34).

As Gavin Parkinson has shown at length, Breton "adheres closely—slavishly even" to Bachelard's text.[64] He does so because historical epistemology as such, and Bachelard's credentials as chair of philosophy at the University of Dijon, authorize him to expand the relevance of surrealism far beyond the sphere of art. He can declare the need for "*surrealism* to be accompanied by a *surrationalism* which will act simultaneously as a stimulant and a restraining influence," the latter term (from Bachelard's "vocabulary," as Breton says) at once marking the need for both empirical experimentation and imagination, and adding "immediacy" and relevance to the former—indeed, providing "ample proof of the unity and depth of feeling animating all human speculation in our times" ("CO," 276).[65] Always willing to reinflect his intellectual autobiography, he re-presents his call for the manufacture of "dream-engendered objects" (1924) as the means to depreciate "those objects often dubiously accepted as *useful* which clutter up the so-called real world," and thus to provide the "prerequisite for the unleashing of the *powers of invention*" ("CO," 277).

L'objet, then, names a problem and a possibility. It names a battleground. "Common sense," Breton argues, "cannot prevent the world of concrete objects, upon which it founds its hateful regime, from remaining inadequately guarded" against the attack from poets, artists, and scholars who mean to disrupt "the generally limiting factor of the object's manifest existence." Within that disruption, "the same object, however complete it may seem, reverts to an infinite series of *latent possibilities* which . . . entail its transformation" ("CO," 279).

Had Breton appropriated and seriously refunctioned a distinction that Heidegger pursued in these same years (1934–36)—the distinction between the object and the thing—he might have argued that each of those latencies can precipitate as the other thing: the thingness of the object uncontained yet obscured by its manifest existence.[66] Breton designates such thingness by contrasting the "object's conventional value" to its subsequent "dramatic value"—its august theatricality: not a mode by which the object produces the subject (in Fried's scene of spectatorship) but a mode by which the thingness of the object produces: *new subjects* ("CO," 279). Whereas Heidegger performs a vigilant passivity in behalf of waiting for the thing to disclose itself, Breton insists on aggression, the "surrealist aim of bringing about *a total revolution of the object*," an attack on the object in order to render it other than it is ("CO," 280). Both share with Bachelard the conviction that the object cloaks or screens a reality within it; Breton quotes and italicizes Bachelard's assertion that "*one will discover more in the reality concealed within the entity than in the immediate data surrounding it*" ("CO," 279–80). But he alone has faith that this revolution of

the object might precipitate revolution as such in an untoward, transforming reification that means to explode the reification effected by even "the best organized systems—including social systems—[that] seem to have become petrified," stubborn, and as adamantine as the manifest objects themselves ("CO," 277). This is why the "crisis of the object" must be thought of not as a crisis to be overcome, like the material crisis suffered in Paris and elsewhere. For it is a crisis that needs to be intensified, amplified, expanded beyond the arts and sciences. The other thing names the possibility that things—including the material structures of the social— might be reimagined, might be, in fact, transformed.

4. Object-Portraits and Things That Dream

It is not Bachelard alone who enabled Breton to imagine a crisis of the object beyond the sphere of art. For the mathematical objects on display in the surrealist exhibition—pedagogical models from the 1870s that had been used to illustrate the surfaces generated by algebraic equations— provided concrete access to a reality undisclosed by the object forms of daily life. Christian Zervos commissioned Man Ray to photograph those models, publishing twelve full-page plates in *Cahiers d'Art*, which Breton captioned with enigmatic, quasi-allegorical titles (*The Rose Penitents*, for instance), further displacing them from their pedagogical role (fig. 3.3). To make the photographs, Man Ray returned to the "dusty cases" in the Institut Henri Poincaré, where he had already photographed the bizarre constructions (mostly wood, but also plaster, metal, and wire) meant to manifest what was thinkable but heretofore unvisualizable.[67] As he writes in his *Self-Portrait*, the math meant nothing to him, but he found the forms "as varied and authentic as any in nature"—"complete microcosms." Moreover, "they could not be considered abstract as Breton [had] feared" (*S-P*, 368)—the exhibition needing to mark, for Breton, a triumph over contemporary abstract art ("l'art contemporain [abstractivisme]"), a chapter in the art-object antagonism.[68] Indeed, Breton could write of the forms that "the thoughts that brought them into being carried themselves, due to an impulse we can no longer understand, from the abstract to the concrete" ("CO," 280). The models certainly served Breton as "souvenirs of an epistemological revolution," in Parkinson's words (*Surrealism*, 72), but they also served as overwhelming (concrete) testimony to the "unprecedented *desire to objectify*" ("une *volonté d'objectivation* sans précédent") shared by science and art. They licensed Breton to declare that "the whole pathos of modern intellectual life resides in this unremitting quest for objectification" ("CO," 280).

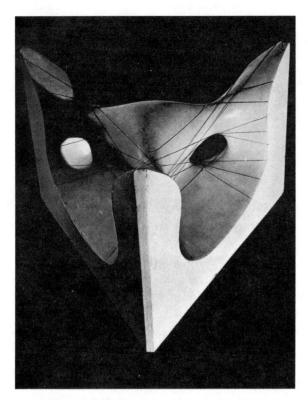

3.3 Man Ray, *Mathematical Object*, from *Cahiers d'Art* 11.1–2 (1936).
© Man Ray Trust/Artists Rights Society, New York/ADAGP, Paris.
Photograph: Telimage (2011).

Max Ernst, the first of the surrealists to be attracted to the objects, had
exhibited them in 1919 (and went on to include drawings of them in later
collages), but it was Man Ray's photographs through which the objects
enjoyed sufficient fame to have a lasting impact on other artists.[69] This
is because Man Ray had taught himself how to produce what should be
recognized as the object-portrait—meant not just to formalize spatial re-
lations (in the manner, say, of Paul Strand) but to bestow some mystery
or personality on the inorganic (which then appears not as the *bestowed*,
but as the *revealed*). In the photographs, he isolates the objects and re-
moves their labels; he also provides, within his studio, dark backgrounds
and dramatic, multi-angled illumination; and he shoots them from idio-
syncratic points of view, close up, distancing the models not just from the
dusty cabinets but also from the brightly lit lecture hall (and thus, say,
activating their misuse value). Finally, by cropping the image in order to
grant the object the freedom to hover in a space all its own, he illustrates
the medium's capacity to rematerialize the object as some other thing.[70]

Though there was a time when Man Ray seemed like a marginal figure in the history of surrealism—Maurice Nadeau hardly mentions him in his two-volume *Histoire du surréalism* (1944)—his significance is now taken for granted, and that significance resides foremost in his photographic portraiture, of nudes and of objects. The object portraiture began in New York, when he purchased a camera to document his own work. The cover image he went on to provide for the inaugural issue of *La révolution surréaliste* (1924) was a photograph of a construction he had made in 1920, two years before he left for Paris. *L'énigme d'Isidore Ducasse* (fig. 3.4)—a sewing machine wrapped up in a wool blanket and then tied up with string—was inspired by a trope from the final canto of Lautréamont's *Chants de Maldoror* (1869), which came to circulate as a kind of bible among the surrealists, the line quoted like a mantra.[71] The narrator describes a sixteen-year-old English boy, wearing a Scottish tartan, who stands at an abandoned corner of Rue Vivienne, "display[ing] his silhouette and direct[ing] his light step toward the boulevards." To convey the boy's beauty, the narrator relies on a sequence of perverse similes, the last of which provides the incongruous juxtaposition on which the surrealists fixated: "He is as handsome . . . as the fortuitous encounter upon a dissecting-table of a sewing-machine and an umbrella!"[72] This is the line that unequivocally centralizes objects within the surrealist en-

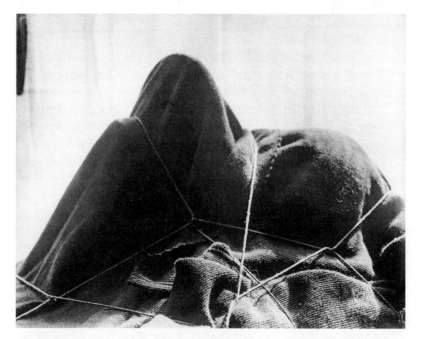

3.4 Man Ray, *L'énigme d'Isidore Ducasse* (1920). © Man Ray Trust/Artists Rights Society, New York/ ADAPG, Paris. Photograph: Telimage.

deavor. Max Ernst abstracts the line in that definition of the surrealist object which Breton quotes as authoritative: "the coupling of two realities which apparently cannot be coupled on a plane which is apparently not appropriate to them."[73] And in "The Object as Revealed in Surrealist Experimentation" (1932), Salvador Dalí testifies to the fascination of Man Ray's photographic interpretation: "This suggested other wrapped-up objects which one wanted to identify by touch but finally found could not be identified; their invention, however, came later."[74]

In step with Ernst and Dalí, critics clearly recognize the inspiration for *L'énigme* in the line from *Maldoror,* and they recount the profound impact that Lautréamont's fantastic imagery and exuberant nihilism had on the surrealists. They don't pause, however, to see how Man Ray has also engaged the plot of the final, irrepressibly gothic episode of *Les chants,* where Maldoror kidnaps the English youth and stuffs him, bones broken, into a sack, before tying up the sack and handing it to a butcher to be destroyed as a mangy dog. The enigma—for the group of butchers about to destroy the dog—is whether the struggling contents of the sack might be . . . some other thing.[75] Insofar as the photograph of the assemblage (and indeed the assemblage itself) illustrates the novel's plot, it adheres to the literary and abandons the kind of medium-specificity by which modernism came to be defined.[76] That phrase by which Man Ray came to characterize his work in assemblage—"une sorte de poésie plastique"—foregrounds not the literal but the literary. Man Ray's photograph, because it renders scale ambiguous, convokes the trope *and* the violent, preposterous plot. The construction appears as an act of condensation, where plot and trope are wrapped up in each other. Identification is a more enigmatic mystery than Dalí ever dreams.

Man Ray's other early constructions more simply anticipate (and help to crystalize) the formula for the (unspecific) surrealist object. When he arrived in Paris—met by his friend Duchamp at Gare St. Lazare on July 22, 1921—he stepped into *"l'époque floue,"* the transition period between Dada and surrealism (variously dated as 1919 or 1922, to 1924). That afternoon, embraced as the New York Dadaist trumpeted by Duchamp and Francis Picabia, he met the writers who became central to the formation of surrealism—Breton, Aragon, Éluard, and Soupault. Shortly thereafter Soupault offered him the inaugural show at his new bookshop and gallery (Librairie Six); the show opened in December as a Dada affair. On the day of the opening, Man Ray made his "first Dada object in France, similar to assemblages [he] had made in New York" (*S-P,* 115). Recognizing his discomfort with the cold and the large crowd's French, Eric Satie took his new acquaintance to a café, where they drank "grogs" to warm up, then stopped at a hardware store on the way back to Librairie Six. Man Ray

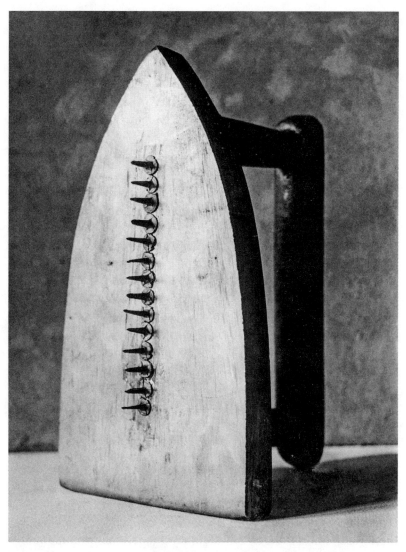

3.5 Man Ray, *Cadeau* (1921). © Man Ray Trust/Artists Rights Society, New York/ADAGP, Paris.
Photograph: Telimage.

purchased an iron, a tube of glue, and tacks, fourteen of which, back at
the gallery, he glued to the surface of the iron, before adding the work,
now called *Cadeau*, to the exhibition (fig. 3.5). As he explained to Arturo
Schwarz, explicitly differentiating his practice from his friend Duchamp's
(as he did routinely), he required "two factors that are not related in any
way. The creative act for me rests in the coupling of these two different
factors in order to produce a plastic poem."[77] While the readymade had
opened up the everyday object world as a source of irreverent inspira-

tion, only its alteration could eventuate in what would become known as the surrealist object. Indeed, insofar as you are persuaded by Theirry de Duve's important argument that the Duchampian readymade belongs (as Duchamp himself believed) to the history of painting, you are prepared to appreciate Man Ray's very different, ongoing struggle against painting (waged while, on and off, he continued to paint).[78]

But Man Ray also creates, in the *Cadeau*, a scene of impending violence, the icon of domestic labor transformed into a weapon, the gift transformed into a terrorist joke. However comically, this object manifests the aggression of gift-giving: the cycle of obligatory exchange that, removed though it may be from the market, remains a system nonetheless, indeed a more public drama of commitment and obligation. This had been the topic of Marcel Mauss's research since before the start of World War I. That research came to fruition in his *Essai sur le don* (1925), which not only tracks those customs in which "persons and things merge," but also (engaging early Roman and German law) seeks to reconceptualize things tout court: "Originally—so much is sure—things themselves had a personality and an inherent power." "Things," Mauss goes on to say, "are not the objects that the law of Justinian and our own legal systems conceive them to be." His use of the present-tense negative ("are not") bespeaks his effort to attack the contemporary reduction of man to an "economic animal."[79] It is as though, in behalf of imagining some alternative socioeconomic system, Mauss recounts a different crisis of the object—its instability *as* object—yet to be realized in the West. While his explicit impact on surrealism is to be found in the political economy of Georges Bataille, he shares with Breton, Bachelard, and Heidegger a frustration located (and yet, perhaps, still to be overcome) at the point of the object.[80]

Le cadeau, meant as a gift for Soupault, disappeared from the exhibition. But, as with so many of Man Ray's constructions, the photograph served very well in its stead. You might say of the *Cadeau*, as of the mathematical models, that the photograph is less a reproduction, more a production, an object in its own right. Moreover, photographic reproduction seems to have licensed Man Ray's lack of scruple in reconstructing his objects—often made just in order to be photographed. "I have no compunction about this," he writes plainly in his memoir: "an important book or musical score is not destroyed by burning" (S-P, 97). He reconstructed the flatiron assemblage many times. In the terminology established by Nelson Goodman, Man Ray would shift the entirety of his work from the autographic to the allographic regime; reproducibility was no threat to the artistic endeavor.[81] He went on to justify the practice proudly: "Créer est divin, reproduire est humaine."[82]

Because he needed to earn a living (as many of his compatriots did not), his camera became his most precious tool: "I was going to make money—not wait for recognition" (*S-P*, 119). Celebrated as his show had been at Librairie Six, no work sold. And it was not by becoming the "official recorder of events and personalities" that he made money, since he didn't charge for the portraits he made of the celebrated writers and artists who came to Paris—the portraits that, for instance, came to decorate Sylvia Beach's bookstore (*S-P*, 118). He made money by taking pictures of objects—works of art—commissioned by his sympathetic friend Picabia to document his bourgeoning collection. Picabia's wife Gabrielle, in a parallel effort, introduced Man Ray to the celebrated fashion designer Paul Poiret, who was willing to see what the photographer might be able to do for him.

While that introduction eventually launched Man Ray into a career as the most sought-after fashion photographer in Paris (by 1926 he was commissioned to photograph the couture section of the decorative arts exhibition), it also inadvertently launched him into a very different graphic pursuit. At work in his makeshift darkroom (his small bathroom), trying to satisfy Poiret's expectation of "something original," he made a mistake that, as recounted in his *Self-Portrait*, has become the most celebrated episode in the history of cameraless photography. With an unexposed sheet of paper mistakenly left in his developing tray, he "mechanically placed a small glass funnel, the graduate, and the thermometer in the tray on the wetted paper": "I turned on the light; before my eyes an image began to form, not quite a simple silhouette of the objects as in a straight photograph, but distorted and refracted by the glass more or less in contact with the paper and standing out against a black background, the part directly exposed to light" (*S-P*, 128–29). Enthralled by the results, he put aside the work for Poiret ("using up my precious paper") and pursued the new escapade, "taking whatever objects came to hand—my hotel room key, a handkerchief, some pencils, a brush, a candle, a piece of twine." His own excitement was soon shared by Tzara, his upstairs neighbor in the boarding hotel, who declared the prints to be "pure Dada creations" (*S-P*, 128–29; figs. 3.6, 3.7).[83]

Thanks to Tzara's spreading the news, "writers, painters, and musicians" came to see the work, bringing Man Ray "books and sketches" and inviting him "to concerts of modern music"; Jean Cocteau asked for one of the "meaningless masterpieces" as a frontispiece for his new book of poetry (*S-P*, 131).[84] Well-known as Man Ray might have been within a small circle, the new experiments turned him into a Parisian celebrity. He was not the first to make photograms, but he achieved in them (through a simplicity of arrangement and the addition of motion) an

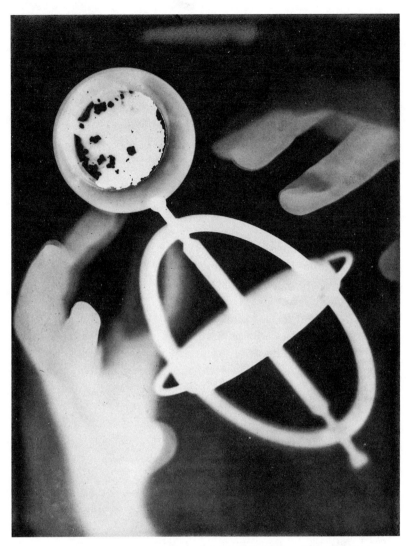

3.6 Man Ray, *Untitled*, from *Champs Délicieux, Paris* (1922). © Man Ray Trust/Artists Rights Society, New York/ADAGP, Paris. Gelatin silver photogram, 22.9 × 17.1 cm., Julien Levy Collection, Special Photography Acquisition Fund, Art Institute of Chicago. Photograph: © The Art Institute of Chicago.

effect that seemed to bring quotidian objects to life.[85] He had anticipated the basic strategy back in New York, where he began to use "odd miscellaneous objects lying about"—the constellation of a key and two triangles, for instance—as stencils for his airbrush paintings, the aerographs that relieved him from the tedium of painting and that had often been mistaken for strange photographs (*S-P*, 73, 145). "It was thrilling," he came to recall, "to be able to paint a picture without touching the surface—a

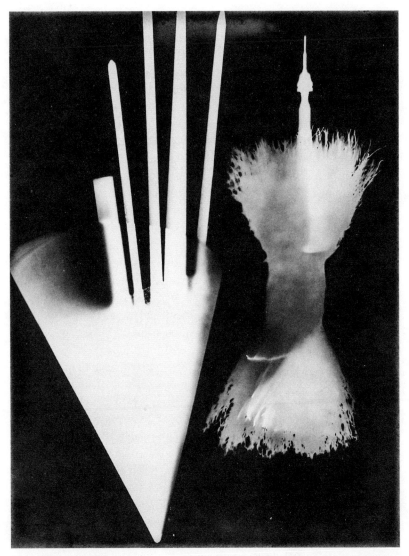

3.7 Man Ray, *Untitled*, from *Champs Délicieux, Paris* (1922). © Man Ray Trust/Artists Rights Society, New York/ADAGP, Paris. Gelatin silver photogram, 22.9 × 17.1 cm., Julien Levy Collection, Special Photography Acquisition Fund, Art Institute of Chicago. Photograph: © The Art Institute of Chicago.

purely cerebral act" (*S-P*, *73*). Moreover, despite the fun he was having with the photogrammic method, he took the results seriously straight off. In one letter he reported not only that he had freed himself from "the sticky medium of paint" to work "directly with light itself," but also that his "subjects" were "never so completely translated into the medium."[86] And he explained to Poiret that he "was trying to do with photography what painters were doing, but with light and chemicals, instead of pig-

ment, and without the optical help of the camera" (S-P, 130).[87] Man Ray's fellow artists were enthralled by the perplexing images, much to his delight: "I saw Picasso here on his knees before a photogram," he said in an interview in 1929; "He allowed that in many years he had not experienced as great a sensation of art as from it. Painting is dead, finished."[88]

He soon made a photo album, publishing it as *Champs délicieux* (1922) in a limited edition with an accompanying preface by Tzara, "La photographie à l'envers" (often recast as "When Objects Dream"), that has become the canonical account of the poetics of Man Ray's new work.[89] These were "things," Tzara writes, "to touch, to hear, to crunch, to apply to the eye, to the skin . . . things of days or nights which absorb through our pores the greater part of our life, that which expresses itself unnoticed." The importance of his further account, despite the emphasis here on *our* lives, lies in the ultimate emphasis on the objects themselves — not, say, on the formal composition, not on the photographer, not on the conjunction of the contingent and the technological. He submits to the rayographs as "projections surprised into transparence, by the light of tenderness, of things that dream and talk in their sleep" ("des objets quie rêvent et qui parlent dans leur sommeil").[90]

Although, in the first decades of our century, philosophy has begun to reassess the merits of panpsychism, to entertain the idea of granting inanimate objects a kind of consciousness, Man Ray had inspired Tzara to grant them an unconscious. Not the objects in dreams, but the dreams of objects. Like the spirit photography deployed again and again to confirm the existence of ghosts, no body of work so powerfully intimated how objects might be living secret lives of their own, the life of other things obscured by "concrete objects" (in Breton's subsequent terminology), objects in their manifest form. Georges Ribemont-Dessaignes described the images as "fantas[ies]" that "mingled these mysterious silhouettes in a space that must surely have escaped from some new field of gravity."[91] "Like the undisturbed ashes of an object consumed by flames," Man Ray himself wrote, "these images are oxidized residues fixed by light and chemical elements of an experience," an experience of the object's own.[92]

In 1922, two years before the surrealists appropriated Man Ray's photograms as their own, a "Rayograph" appeared in the *Little Review* (where the term first saw print), and four rayographs appeared in *Vanity Fair*, Condé Nast's magazine that had emerged from *Dress*, the men's fashion magazine he had purchased in 1913.[93] The publication devoted a full page to Man Ray — "the well-known American painter now living in Paris and closely allied with the modern school of French art" — pictured in the center of the page, surrounded by four rayographs, each captioned (fig. 3.8). (One caption — "Imitation of the Gyroscope by the Magnifying

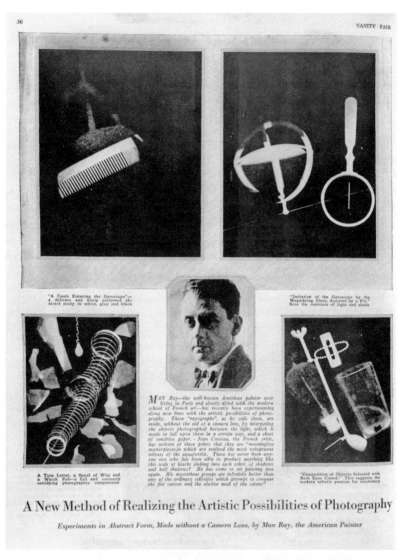

3.8 Man Ray, *A New Method of Realizing the Possibilities of the Photograph* (1922). © Man Ray Trust/ Artists Rights Society, New York/ADAGP, Paris. From *Vanity Fair* 19 (November 1922): 50.

Glass, Assisted by a Pin"—does a fair job of remarking the curious ani-mation and agency the objects seem to possess.) Edited by Frank Crown-inshield—a regular visitor in Paris, one of the organizers of the Armory Show in 1913, and a subsequent founding board member of MoMA— *Vanity Fair* had quickly become the premiere magazine that combined fashion and art. Overriding objections made by both his advertisers and his publisher, Crowninshield committed himself to knowing and repro-ducing the latest work and news from the arts: work by Picasso, Matisse,

Gertrude Stein, T. S. Eliot, F. Scott Fitzgerald, Edward Steichen, Imogen Cunningham, Cecil Beaton, and Cocteau, among many others.[94] On the page facing the reproduction of the rayographs, Tzara's "News of the Seven Arts from Europe" (subtitled "A New Comic Opera by Stravinksky and the Latest Fermentations of Dada" only in its fifth year of existence), provided an account of *Marva*, an appreciation of Le Douanier Rousseau, a report on the recent exhibition of Max Ernst, brief reviews of two "dadaist books" (one by Soupault, one by Éluard), and a lively record of his own belligerent pamphlet attack (with Satie, Soupault, and others) on a dogmatic convention devoted to modern art.[95] But the magazine was also a premiere advertising venue, containing *full-page* ads for cars, tires, hats, handkerchiefs, collars, ascots, Whitman chocolates, phonographs, pianos, and long underwear. On the second page of Tzara's report, he describes the pamphlet that the Dadaists produced: "The paper on which it was printed was of a vulgar pink: a housewife would not hesitate to wrap a camembert in *Le Coeur à Barbe*. The cover looked like a rebus, but was only a haphazard mixture of pictures from catalogues of 30 years ago" (88). The report faces a full-page ad for Campbell's Soup. Indeed, along with Edmund Wilson's reviews of Fitzgerald and Eugene O'Neill, Clive Bell's "Art and Cinema," Djuna Barnes's account of Joyce, and along with such articles as "Expressionism in the German Theatre" and "The Sculpture of Aristide Maillol," *Vanity Fair* provided a regular New York "Shoppers' and Buyers' Guide" and monthly columns including *The Well Dressed Man*, *The Financial Situation*, and *Fashions and Pleasures of New York*.

Vanity Fair situates the rayographs within a world of objects—indeed a world of commodities, sex appeal, and luxury—that, *avant la lettre* (*avant le surréalisme*), entangles these glimpses of the surrealist object within the hyperproductivity and hypervisibility of the 1920s market in personal goods, a somewhat disorienting object world in its own right. Indeed, it is difficult to resist reading *Vanity Fair* according to the Bretonian script wherein new objects are meant to produce new subjects, albeit, in this case, new subjects commensurable with a new lifestyle. The print context of the rayographs dramatizes the proximity (at first by accident, then by design) of Man Ray's experimental temperament and his work for the fashion industry. You could say that *Vanity Fair* participated in the avant-garde effort to break down the wall between art and society, but only insofar as it recognized how art could generate the frisson of the daring and the thrill of the new.[96] Illustrating Benjamin's frustration that "the most advanced and daring products of the avant-garde" only ever had a public made up of the wealthy, the magazine would also seem to document that what Adorno named the "false after-life of sur-

realism"—the "cozy reception" of "shock-laden contents"—was in fact a life lived before the movement ever began.[97] But this would be to imagine that *Vanity Fair* was a typical magazine, which it was not; by the time of the "Crisis of the Object," the magazine had lost so much advertising revenue that it was folded into another Nast publication, *Vogue*, which, like *Harper's Bazaar*, printed any number of Man Ray's exquisite fashion spreads but had no commitment to publicizing the avant-garde—or, say, only a commitment to the avant-garde as this had been absorbed by the fashion industry.

In the previous decade, Poiret was not alone in his willingness to elicit aesthetic novelty through photographic innovation. For its ad in the November 1922 issue of *Vanity Fair*, the Ide collar company employed Paul Outerbridge, whose formally precise close-up still lifes (resembling those of his mentor Paul Strand) had appeared in the magazine as full-page art photographs (for example, *The Kitchen Table: A Study in Ellipses*— an image of brown eggs, a bowl, and a milk bottle arranged on a white table—in the July issue).[98] For Ide—and in dramatic contrast to other collar ads, which invariably portrayed a well-dressed man elegantly suited and collared—Outerbridge shot a collar alone, extremely close up and tightly cropped, against a checkerboard (or, let us say, a chessboard) pattern, the surface on which it rests, but slightly above which it seems to float (fig. 3.9). Neither the personification of objects that Marx describes, nor what Benjamin called the sex appeal of the inorganic quite explains the curious animation conferred on the collar in this portrait, the pristine white form portrayed as a kind of gesture. When Duchamp saw the image in *Vanity Fair*, he tore out the page and pinned it up in his studio.[99] If that fact alone reminds us that the avant-garde engaged everyday consumer culture, the ad itself testifies to what Benjamin came to call, in his *Arcades Project*, the "eccentric, revolutionary, and surrealist possibilities of fashion."[100] Indeed, it is hard not to believe that Outerbridge's enchanted object inspired Man Ray to produce the dance-of-the-collar in *Emak-Bakia* (1926; figs. 3.10, 3.11, 3.12), his second film, the *cinépoème* that integrates rayography, stop-frame animation, reverse motion, and double exposure, along with narrative fragments. In one of those fragments, a well-dressed man is dropped off at a house and walks in with his valise, which turns out to contain collars. He starts to rip them up, one by one, then rips off his own collar and tosses it away. The film cuts to an animated object portrait: a single collar, balanced on its back, twirls and twirls against a black background; it does so until it begins to dissolve in double exposure, then into dancing bars of light. The sudden juxtaposition of the two seems to divulge a secret: much as the man longs to free himself of his collar, that collar longs for its freedom—to be some other

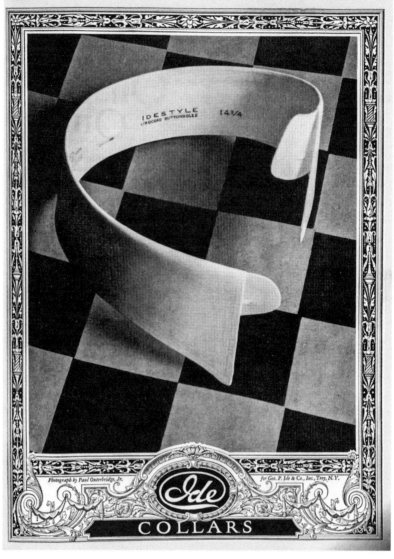

3.9 Paul Outerbridge, photograph for Ide Collars (1922). From *Vanity Fair* 19 (November 1922): 5.

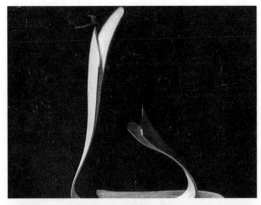

3.10 Still from *Emak-Bakia* (1926),
Man Ray, dir. (1926; New
York: Kino on Video, 2005).
© Man Ray Trust/Artists
Rights Society, New York/
ADAGP, Paris.

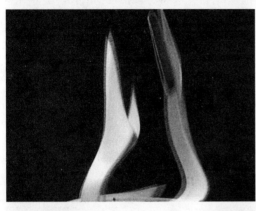

3.11 Still from *Emak-Bakia* (1926),
Man Ray, dir. (1926; New
York: Kino on Video, 2005).
© Man Ray Trust/Artists
Rights Society, New York/
ADAGP, Paris.

3.12 Still from *Emak-Bakia* (1926),
Man Ray, dir. (1926; New
York: Kino on Video, 2005).
© Man Ray Trust/Artists
Rights Society, New York/
ADAGP, Paris.

thing that is irreducible to the manifest sartorial object. By effectively animating Outerbridge's still life, Man Ray points to where consumer culture can begin to disclose an object's life and longing, which is a longing not least to leave that culture behind.

5. Another Thing

As described by Breton, the crisis of the object was no recent event—it had begun in the 1830s. By the 1930s the crisis had intersected with the new physics, with the aggression against abstraction by Dada and surrealism, but also with a certain triumph of the object registered by the *Machine Art* (1934) exhibit in New York—dramatizing the aesthetics of cocktail shakers and propellers and ball bearings. Curated by Philip Johnson for the Museum of Modern Art, the show touted the aesthetic dimension of the very rationality that Breton deplored.[101] The machine art of the avant-garde, at times playful and at times bombastic, had its origins with the appearance of Duchamp and Picabia in New York, where they arrived in the hope of enjoying the *succès de scandale* provoked by their work in the *Armory Show* of 1913. The infatuation with the machine was no more evident than in *291*, the journal (published for a single year, in 1915–16) named for Alfred Stieglitz's gallery, where Man Ray had been able to keep abreast of the new European work, and where he met Duchamp and Picabia that year. In its inaugural issue, Agnes Ernst Meyer proclaimed, "The scientific influence has at last invaded the field of art," and shortly thereafter Paul B. Haviland declared, "WE ARE LIVING IN THE AGE OF THE MACHINE. . . . MAN MADE THE MACHINE IN HIS OWN IMAGE." Thus it is, he goes on to say, that the ideal human has become "MACHINO-MORPHIC."[102] While Rilke had bemoaned the new "empty, indifferent things, sham things" intruding from America, Duchamp and Picabia embraced them.[103] In his interview with the *New York Tribune* in 1915, Picabia announced a "revolution in my methods of work": "Almost immediately upon coming to America it flashed upon me that the genius of the modern world is machinery. . . . I have enlisted the machinery of the modern world, and brought it into my studio."[104] He did so most simply and provocatively in his machine portraits for the July–August issue of *291* (nos. 5–6), the cover of which displayed his portrait of Stieglitz as a camera, followed by other full-page portraits, of Haviland, Marius De Zayas, of himself, and, most audaciously, *Portrait d'une jeune fille americaine dans l'état de nudité*—the nude American girl represented as a spark plug. The mechanomorphic portraits have been interpreted at great length and with great ingenuity, the *jeune fille* understood as a comment on the an-

drogynous look of young American women or on the perpetual charge that the girl gives to the artistic and erotic passions.[105] More simply, the portraits illustrate the point that Henri Bergson had shouted from his book *Laughter* (1900): "THE ATTITUDES, GESTURES AND MOVEMENTS OF THE HUMAN BODY ARE LAUGHABLE IN EXACT PROPORTION AS THAT BODY REMINDS US OF A MERE MACHINE."[106] Picabia makes it clear that such a reminder does not always depend on motion.

Man Ray participated in this mechanomorphic portraiture by constructing assemblages and photographing them, by photographing existing objects in isolation, and by photographing still-life arrangements, his camera so omnipresent that Breton came to dub him "THE MAN WITH A MAGIC LANTERN FOR A HEAD"—a caption that constitutes a mechanomorphic portrait in itself.[107] In 1916 he made a mixed-media assemblage, *Self-Portrait*, which he added to his second one-man show at the Daniel Gallery: a painted board with the cups of two bells in the place of eyes (thus resembling owl eyes), and with a (nonfunctioning) door bell attached to the lower center right. In 1920 he made a portrait of Katherine Dreier, *Catherine Barometer*: a washboard nestled in steel wool, from which a long glass tube rises against a color chart. He was typically attracted to an older technology, his camera rendering the old technology new. His early photograph of an eggbeater distinguishes itself from the close-ups of Paul Strand by its title, *Man* (1918), meant to caption the phallic contours of the eggbeater's shadow (though this did not prevent him from retitling the image *Woman*). As Mason Klein puts it, the image amounts to "the photographic animation of the readymade."[108] As Man Ray said of Duchamp's *Fountain*—having retracted his own work from the Society of Independent Artists's exhibition in 1917 once the directors had rejected the urinal, signed R. Mutt—"R. Mutt took an ordinary article of life, placed it so that its useful significance disappeared under the new title and point of view." He "created a new thought for that object."[109] But when Man Ray produces a new thought for his object, he is not (like Picabia) simply reifying persons; he is personifying things, with the same techniques through which he produced his erotically charged nudes. In *Object to Be Destroyed*, the mechanomorphized human is, no less, the anthropomorphized machine.

Before committing himself more seriously to photography, he had worked to animate objects in paint, as in *Percolator* (1917, fig. 3.13). Although the percolator was first patented in France in 1818, the first American patent was taken out in 1865; after the turn of the century, new percolators, one after the other, were proclaimed to "revolutionize" the making of coffee, and new patents continued to be filed. Electric percolators, the success of which depended on the safety of domestic

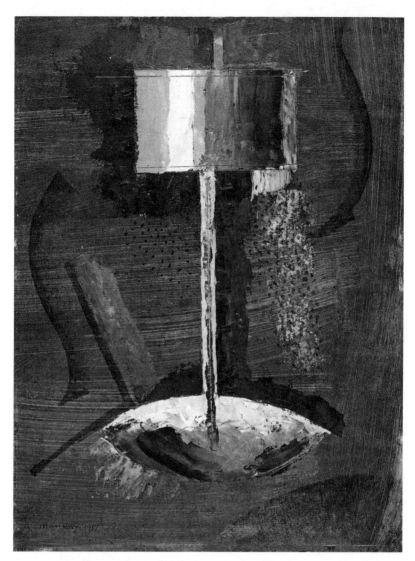

3.13 Man Ray, *Percolator* (1917). © Man Ray Trust/Artists Rights Society, New York/ADAGP, Paris. Oil on board, 16 × 12 in. Photograph: Through prior gift of the Albert Kunstadter Family Foundation, Art Institute of Chicago.

electricity (including the invention of the fuse) granted the percolator a new kind of autonomy; by the end of the war, ads show how the coffee maker could live free from the confines of the kitchen, allowing the homemaker to serve coffee anywhere. Of course Man Ray paints not the coffee maker, not the pot, but the percolator basket, the filter—where the action is, as it were—and he does so with a kind of shading and gestural stroke of the palette knife that makes the object seem to vibrate, even as coffee grounds or coffee drops descend (somewhat awkwardly) from

the shining metal basket. As becomes characteristic of Man Ray's object portraiture, the object, isolated against a dark background, appears to be lit from more than one angle.[110]

The percolator has an affinity with Duchamp's series of chocolate grinders (though they are painted in an impersonal, precisionist mode). He originally saw one of these objects in a confectioner's shop window, and he deployed its form over and over again (most famously in the lower section of the Large Glass), toying with its erotic connotations.[111] As with the human figure (*Nude Descending Staircase*, 1912), so with the everyday object, Duchamp was working to determine how objects at rest (paintings) could depict objects in motion (his *Coffee Mill* of 1911 being a particularly crude example). Man Ray, shortly after his own attempt to convey human motion through its effects in *The Rope Dancer Accompanies Herself with Her Shadows* (1916), used a comparable strategy with the filter, focusing attention on the discharge, thus too on the effaced hydraulics—the boiling water forced through the stem. *Percolator* can thus be understood as an effort to disclose the ejaculatory dynamics of the object's own animation, its own operation, overlooked in everyday use.

All this is to say that *Object to Be Destroyed* evolves from the widespread interest in the mechanomorphic portrait and from the interest Man Ray shared with Duchamp in domestic machines and their motion, just as it shares paradigmatic surrealist fascinations. After originally constructing the work in 1923 and calling it *Object of Destruction*, he reconstructed and photographed the assemblage in 1932. Whereas *Cadeau* appeared as a violent object, the composite in *Object to Be Destroyed* is readily legible as the *result* of violence, not just the ontological violence of conflating human subject and inanimate object, but also that of disfiguring the human body in pursuit of ludic novelty, which has a well-known biographical source. For the eye is the eye of Lee Miller, who became Man Ray's new darkroom assistant, receptionist, and lover in 1929. Always volatile, the relationship deteriorated as Miller became an increasingly impressive photographer in her own right, enjoying her own clientele and spending more time with other men, leaving Man Ray in a jealous rage. In 1932 she left for good.[112]

He had photographed Miller's face and her nude body, and he had isolated portions of it (buttocks, breasts, lips) many times, cropping the image to produce a portrait of the body part. Over and over again he had photographed her eyes (plate 8). When he drew a prototype for the assemblage in the special surrealist issue of a new magazine, *This Quarter*, it showed a metronome with an eye on the spindle, entitled *Object of Destruction* and accompanied by these instructions (fig. 3.14): "Cut out the eye from a photograph of one who has been loved but is seen no more.

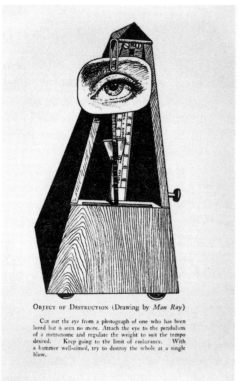

OBJECT OF DESTRUCTION (Drawing by *Man Ray*)

Cut out the eye from a photograph of one who has been loved but is seen no more. Attach the eye to the pendulum of a metronome and regulate the weight to suit the tempo desired. Keep going to the limit of endurance. With a hammer well-aimed, try to destroy the whole at a single blow.

3.14 Man Ray, *Object of Destruction* (1932). From *This Quarter* 5.1 (September 1932): 55. © Man Ray Trust/Artists Rights Society, New York/ADAGP, Paris. Photograph: Special Collections Research Center, University of Chicago Library.

Attach the eye to the pendulum of a metronome and regulate the weight to suit the tempo desired. Keep going to the limit of endurance. With a hammer well-aimed, try to destroy the whole at a single blow."[113] The instructions inhabit the genre of what you might call the Dadaist recipe, as in Tzara's 1920 formula for the Dadaist poem: "Take a newspaper. Take some scissors. . . . Cut out each of the words that make up the article and put them into a bag. Shake gently. Then remove each cutting one after the other. Copy them carefully in the order they leave the bag. The poem will resemble you."[114] Breton provided such a recipe in the first manifesto, under the heading "Secrets of the Magical Surrealist Art."[115] Man Ray's instructions, coupled with our biographical knowledge, make it clear how this image exemplifies the surrealist fascination with and symbolic violence toward women—the fragmentation of the woman's body (in a tradition, one should add, that goes back to Petrarch). The image can also be read from the perspective of object-relations theory, which emerges in Freud's account of the fort/da game in *Beyond the Pleasure Principle* (1920) and expands in Melanie Klein's psychoanalysis of children in the 1920s and 1930s (which I address in chapter 6). The initial point is simply that

children manipulate objects—they exert their power over objects—in a way that compensates for their lack of power in the adult world.

But what if Man Ray's recipe from *This Quarter* served as a kind of screen, behind which lies another story: a story about objects and their power over us. In this scenario, it is our complex relation to objects that ends up sublimated, as it were, by being transposed into the more familiar script of erotic desire. Man Ray shared a version of that complex relation when he provided Arturo Schwarz with a very different account of the object's original construction and fate:

> I had a metronome in my studio which I set going when I painted. . . . The faster it went, the faster I painted; and if the metronome stopped then I knew I had painted too long. . . . A painter needs an audience, so I also clipped the photo of an eye to the metronome's swinging arm to create the illusion of being watched as I painted. One day I did not accept the metronome's verdict. The silence was unbearable and since I had called it, with a certain premonition, *Object of destruction*, I smashed it to pieces.[116]

Needless to say, the object in the story does serve as a substitute (for the missing audience); so too it serves to externalize anxiety. But should you read *Object to Be Destroyed* only as a case of surrealist aggression against women, you can't recognize it as an illustration of the object's own aggression and, say, its place in the history of modern painting. For Man Ray provides a case in which an object (the modulated metronome) is made into a two-dimensional image (a photograph) after mythically serving as a regulator for the act of painting; it too is a modernist object worked out in an interface with painting.

But it is as though the object will not behave the way it should, refusing to serve Man Ray as a mere object. He may have destroyed the silent object in order to persevere with his painting, but he compulsively recreates the object, as object and image both. The composite—Man Ray always needed two things—convokes the act of seeing and the passage of time.

Along with most surrealists, Man Ray had an obsessive fascination with eyes and the isolated eye, evident long before his association with the group, as in *The Eye That Sees Everything* (1919), an aerograph (in fact, airbrush and gouache on wood-pulp laminate board) that portrays a floating transparent eyeball, at once evoking Emerson and Odilon Redon's many ocular drawings, such as the charcoal *Eye-Balloon* (1878).[117] In *Emak-Bakia* (1926) eyes appear as camera lenses within headlights; and eyes are painted on eyelids that open to reveal the eyes beneath. Man Ray constructed his first *Boule sans neige* (1932) with a cutout of Lee Miller's

eye within the globe. The eye persists throughout his career and across different media. An exchange he had with René Magritte provides some sense of the predominance of ocular imagery among the surrealists: "He admired a photographic enlargement I had made of a single eye, offered me a painting in exchange, which I received later: a large eye in which clouds and blue sky filled the whites" (S-P, 253). (Magritte made several versions of *Le faux miroir* [1928].)

What did they see in the eye? However distinct Man Ray's photograph is from the world of Rilke's thing-poems, it is clear from Rilke's occularization of the statue of Apollo—

> there is no place therein
> that does not see you

—how granting sight to the object world grants it, at least, a kind of excessiveness.[118] And that excessiveness is what Hegel understood to be the very definition of art. In his chapter on the ideal of art, in the *Aesthetics*, he moves from the banal idea that "in the eye the soul is concentrated and the soul does not merely see through it but is also seen in it," to the claim that art must "convert every shape in all points of its visible surface into an eye, which is the seat of the soul and brings the spirit into appearance." Art, he concludes, "makes every one of its productions into a thousand-eyed Argus."[119] In this respect, the supreme joke of *Object to Be Destroyed* might amount to its literalization of Hegel's claim, with art (and something like art as such) emerging from the mundane artifice of a paper eye (the soul) attached with a paper clip. A corollary to the joke would engage Benjamin's understanding of how photography destroyed the object's aura, which he defines not just as the object's uniqueness in time and space, but also as its ability to return our gaze.[120] Man Ray, you might argue, sets out to show how photography capacitates the object to look back, even an object that one might call singularly unauratic in the sense of figuring—by embodying and enabling—the regularity and routinization of modern life. It is a reauraticizing stunt that can be tirelessly reproduced, endlessly photographed.

Which is to say that Man Ray's medium itself contributes to the duration implied by the image. Rosalind Krauss has underscored the temporal, specifically narrative dimension of surrealist objects, pointing out that the "coupling of disparate entities," in work such as Man Ray's *Le cadeau* and Oppenheim's *Le déjeuner en fourrure*, shrouds the object "in the temporality of fantasy," prolonging a viewer's experience by summoning up a repressed internal narrative.[121] The metronome in the *Ob-*

ject to Be Destroyed thematizes temporality, even as the *Object* fascinates to the degree that you internalize a narrative of being stared at, and stared at, over time. It is this kind of temporal duration that, for Michael Fried, renders literalist work theatrical. In contrast to the "instantane-ousness" of modernist painting and sculpture (experienced completely all at once), objecthood amounts to "a presentment of endless or indefi-nite *duration*" — "as though theater confronts the beholder, and thereby isolates him, with the endlessness not just of objecthood but of *time*" (*AO*, 167). And it is this topic of time (on which emotional states such as "dread, anxiety, presentiment" depend) that provokes the note wherein surrealism appears as the antecedent of current literalist work: where surrealism appears (as though from nowhere) to dilate the moment of Fried's critique, the tightly framed present, into the duration known as the avant-garde.[122]

Of course this object you see isn't an object at all, but the image of an object, and an image almost more legible as a film still, given that the object is legible only as an object in motion, its spindle not centered and at rest. The irony of its stasis — in relation to the title — lies in the fact that the *Object to Be Destroyed* becomes an object perpetually preserved, an object very much in time, and marking time, yet suspended out of time (just as it is suspended somewhat awkwardly in space). The metronome, a means of regulating rhythm, becomes instead a means of steady sur-veillance, at once the eye of the pyramid, the eye of god, and the manifes-tation of the field of vision (it's everywhere) in which the subject is con-stituted — that is, the way in which inanimate objects and not just human subjects hold us in their gaze.

Man Ray produced a new version of the assemblage for the Julie Levi Gallery in New York in 1945, the piece to be titled *Lost Object*, but retitled, thanks to a printer's error, as *Last Object*, a revision to which Man Ray assented. Part of the point — part of the project — was to submit to the accidental (as Duchamp had done, accepting the shattering of the Large Glass); it was a way to evade the "apartness from the praxis of life" that constituted the institutional status of art.[123] For the exhibition catalog, Man Ray wrote: "Last Object or Object of destruction. It is still my earnest desire, someday, while the eye is ticking away during a conversation, to lift my hammer, and with one well-aimed blow to completely demolish the metronome."[124] When the piece was exhibited at the Dada retrospec-tive at Galerie d'Institut in Paris in 1957, a group of protestors destroyed the object. But the next year, prompted by Daniel Spoerri, Man Ray made an edition of one hundred metronomes, now titled *Indestructible Object*, believing that "it would be very difficult to destroy all hundred metro-

nomes now," difficult to destroy the thing's many manifestations.[125] Perpetuity had always been something of the point, the work not "done," not given over, not declared distinct from its maker.

So the moral of my story might be said to have a Lacanian twist. Like stiff wire, it will twist back. Predictably enough, the first twist derives from the much-recounted anecdote of the sardine can, wherein Lacan the "young intellectual" was unpredictably at sea, on a small boat with fishermen: He reports, "[Petit-Jean] pointed out to me something floating on the surface of the waves. It was a small can, a sardine can. It floated there in the sun, a witness to the canning industry, which we, in fact, were supposed to supply. It glittered in the sun. And Petit-Jean said to me— *You see that can? Well, it doesn't see you!*" Amused as Petit-Jean was, Lacan explains, "In a sense it was looking at me, all the same. It was looking at me at the level of the point of light, the point at which everything that looks at me is situated—and I am not speaking metaphorically."[126] Because Lacan felt out of place among the fishermen, his story serves as an account of sudden self-consciousness. On these grounds (and despite his general antipathy) he applauds Sartre's account of shame—in the midst of a hypothetical act of voyeurism—sensed as a gaze from elsewhere (being watched watching), thus a "gaze imagined in the field of the Other" that has nothing to do with an "organ of sight," and thus is specifically not the Sartrean look (*Seminar*, 84). In a characteristically de-ontologizing gesture, Lacan has reduced the sardine can to a point of light.

And yet, if the sardine looked at Lacan, it did so *not* from the point of light, but from its own point of view. Indeed, adjudicating the discrepancy between Lacan and Petit-Jean, you might side with Petit-Jean—not to say that the sardine can doesn't see Lacan, but to say, rather, that *it sees right through him*.[127] It does so looking for some other surrealist, or looking for some other moment of surrealism before Lacan (and Breton) ceded priority to the word, if not looking forward to some moment when the object world might return as the object of attention, some moment when the object would be felt to have outlived its obsolescence in a return of the suppressed and repressed. Of course, it is really Man Ray's metronome that has been looking: looking aggressively, looking "everywhere," while knowing full well that by destroying the object you can in fact preserve some other thing—the thingness of the object. Able to sense how the surrealists were tracking not the psyche but things, Benjamin concludes his essay about them with an appropriately concrete trope: "They exchange, to a man, the play of human features for the face of an alarm clock that in each minute rings for sixty seconds."[128] The metronome watches to see whether we really can wake up.

Four

Concepts and Objects, Words and Things (Philip K. Dick)

for Fredric Jameson

The mind . . . has perpetually to revise, or rather to recast,
all its categories. But in this way it will attain to fluid concepts,
capable of following reality in all its sinuosities and of adopting
the very movement of the inward life of things.

HENRI BERGSON

The ultimate in paranoia is not when every*one* is against you but
when every*thing* is against you. Instead of "My *boss* is plotting
against me," it would be "My boss's *phone* is plotting against me."

PHILIP K. DICK

Why, how, and at what cost does Philip K. Dick—over and against the
wreckage piled up in his postapocalyptic environments, and despite
any number of threats posed by the inanimate object world, as by that
world's dissipation into so many reality effects—how does he nonethe-
less preserve some faith in the "good object": the good object that I want
to read, across those pages that have helped to define postmodernism, as
the remnant of some high-modernist aspiration? For within the socially
and ontologically distressed surroundings that have made this fiction so
famous, there remains something like "object possibility": the chance
that some thing about an object might mediate persons differently, that
difference might glimmer within the object world as though in a crys-
tal ball. Along with their account of reification-as-usual—of present and
future worlds commodified and rationalized to the point of transforming
persons into things, and of denying things their thingness—the novels

enact a redemptive reification, conferring on particular and particular-
ized objects some value outside the regimes of use and exchange, objects
that can irrupt as object-events . . . that have, you might say, eventfulness
within them . . . that can, it seems, catalyze some crack in time's homo-
geneity, some break through the continuum we know as human history
. . . most recently known as modernity and postmodernity.

Such objects have been difficult for readers to bring into sharp focus.
This is not least because Philip K. Dick—variously inspired by Heraclitus,
Plato, Berkeley, Kant, Norbert Weiner, amphetamines, or LSD—found
it difficult *not* to believe that "the empirical world was epiphenomenal,"
difficult *not* to believe, for instance, that objects are "really informa-
tion and information processing which we substantialize."[1] The novel-
ist thus shares with that intellectual event of the 1960s—the impact of
structuralism and cybernetics—an investment in system at the expense
of empirical objects, objects newly relegated to the status of mere surface
phenomena. Nonetheless, in the following pages I draw attention to the
paradox of a particular object cathexis that decidedly tangles the informa-
tion loop. I then turn to those damaged (at times deranged) object worlds
that seem to register a more widespread exasperation with the object cul-
ture of the postwar era, circa 1960. But any effort to curate Philip K. Dick
within a historical exhibition (under the sign of structuralism, cybernet-
ics, Cold War containment, consumer culture, counterculture, or tech-
nological advance) should be unsettled by the wildly uncertain status of
time, history, and contemporaneity in his fiction—a point that Fredric
Jameson has made (despite his own will-to-historicize) with audible con-
tempt: "We may expect future scholarship to yield a volume of informa-
tion about current events in the American 1950s and early 1960s which
threaten our appreciation of Dick's inventiveness and 'thinking.'"[2] My
own appreciation has been prompted by Dick's reinvention of a certain
modernist sentiment that conjures up the under-acknowledged place of
pottery in a kind of transcultural and transhistorical "vernacular mod-
ernism" where the pot had emerged, thanks to the art critic and art his-
torian Herbert Read, as the epitome of plastic formalism.[3] Finally, then, I
offer a reading of the concrete abstractions that appear in *The Man in the
High Castle* (1962), where words, in the form of a book, and things, in the
form of handcrafted jewelry, seem to compete for the role of providing
some egress from the claustrophobia of historicism, historicity, and his-
tory, here rendered as a postwar environment where the Allies have lost
World War II and the formerly united United States has been divided be-
tween Japan and Nazi Germany. My argument most simply tells a story
about the significance of the genre of science fiction for apprehending
past, present, and future object worlds. But the chapter also pursues a

chiasmic trajectory that moves from abstractions that are designated as concrete (in the work of Louis Althusser) to concrete objects that are considered abstract (in the work of Read). And it demonstrates how popular culture, mass culture, or postmodernist culture can retrieve for us the remnants of a plastic modernism that has been effectively elided while the *word* and the *image* have so profoundly dominated our accounts of the twentieth century. This dynamic could be understood—thanks to Henri Bergson—as the actualization of the virtuality of modernism's past.

1. Concepts and Objects, Systems and Things

Although the mise en scène of this redemptive reification must be, in some sense, the American objectscape of the 1960s, I would like to begin elsewhere—at first, elsewhere in place—with the preface that Louis Althusser published for a translation of *Capital*, volume one, in 1969. It is the well-known preface in which, posing the question "What is *Capital*?," Althusser sharply differentiates Marx's "greatest work" from the early works—those quasi-existentialist, or idealist, or humanist texts— after which comes the "theoretical event," the "epistemological break" (the notion borrowed from Gaston Bachelard's conceptual history of science and subsequently refunctioned by Foucault). The "break," according to Althusser, is announced in the eleventh thesis on Feuerbach; it is made manifest in *Capital*; it "opens up to scientific knowledge what can be called the 'Continent of History.'" He argues that the human and social sciences (history and sociology and psychology and political economy, &c.) have provided no more than "preliminary knowledges," whereas Marx provides the "theory which 'opens up' to scientific knowledge the 'continent' in which they work." All those disciplines are, and have been, in the grip of "the illusions in which they live and to whose maintenance they contribute." The "theoretical *revolution*" provoked by *Capital* (not by Marx, but by *Capital*) offers nothing less than the "theory which is indispensable to every science"—indispensable because it can turn preliminary knowledge into scientific knowledge. The theory, like any theory, Althusser writes, is "*a system of basic scientific concepts.*" And, he claims, in an arch yet profound tautology: "These concepts are concepts." In other words, he emphasizes, they are "*abstract* notions."[4]

But the paradoxical point about such notions is that they "are not at all 'abstract'[;] quite the contrary." The point is—when it comes, say, to "total surplus value," or "socially necessary labour," or "exchange value"—that these "notions" name phenomena that simultaneously remain intangible and invisible *and* designate "actually existing realities." Abstraction

is said to be scientific insofar as it specifies "a concrete reality which certainly exists but which it is impossible to 'touch with one's hands' or 'see with one's eyes.'" Indeed, the conceptualized object is "infinitely more concrete, more effective than the objects one can 'touch with one's hands' or 'see with one's eyes.'" ("Cet objet est terriblement concret en ce qu'il est infiniment plus concret, plus efficace, que les objets qu'on peut 'toucher avec les mains' ou 'voir avec les yeux.'")[5] And indeed, to those readers of Marx who would point (in contrast) to the considerable empirical history that he surveys in the three volumes of *Capital*, Althusser insists, in his preface, that you "must not imagine that [he] is analyzing the concrete situation in England when he discusses it. He only discusses it in order to 'illustrate' his (abstract) theory of the capitalist mode of production" (77). Although Althusser is known for overcoming the infrastructural-superstructural divide with the concept of structural causality, there's no denying that, here, he distinguishes between epiphenomena, "objects," and those other phenomena—which is not to say concepts, exactly, but a more fundamental, objective reality that becomes perceptible and intelligible through the act of conceptualization.

At the risk of sounding unabashedly tendentious, I want to suppose that Althusser provides us, in this preface to *Capital*, with the opportunity to code Marx's mature work as a kind of *alternate history*—presented as the real history, the scientific history, that lingers beneath (or within) lived life, the empirical everyday. This is to imagine reading Althusser's Marx as occupying a literary subgenre of historical fiction, sometimes designated "allohistory," that becomes manifest as parallel worlds in H. G. Wells's *Men Like Gods* (1923) and has, as one of its best known examples, Phillip K. Dick's *Man in the High Castle* (1962), his account of a postwar United States enduring conquest by the Axis powers.[6] But in this case as in others, it turns out that there are simultaneous histories, rival realities occurring within the same temporal coordinates. In "Precious Artifact" (1964), a colonist returning from Mars to Terra (after the total war) endures the prototypical PKD (Phillip K. Dick) dilemma: "Would they ever show him the substance beneath the illusion?"[7] In *Time Out of Joint* (1959), Ragle Gumm's daily success with a newspaper puzzle in a fabricated small town of 1958 in fact sustains the defense of a 1998 earth against lunar attacks. At times, momentarily, the fabrication unravels: "The sides of the bus became transparent. He saw out into the street, the sidewalk and stones."[8] As the novelist himself put it, he kept writing versions of this story "over and over again"—in *The Three Stigmata of Palmer Eldrich* (1965), in *Ubik* (1969), in other novels from the decade, where the characters are "mass hallucinating a world" while experiencing strange symptoms of some rival reality.[9] Given Dick's antipathy to

corporate America and his own feeling that Marxist readings of his work made sense, it is tempting to read that "mass wish-fulfillment hallucination shared by everyone" as the illusion of the quotidian itself, behind which lies the system of capital, a "totally untenable reality"; at times the menace—say, a government-owned corporation with the new "idea of creating an entire fake alternate world"—proves more severe than anything perpetrated by the Culture Industry.[10] But Marx the historical materialist never made it onto the reading list (Plato, Hume, Kant) from which Dick learned that "in a certain sense the empirical world was not truly real."[11] Thus my point is only that, circa 1960, both Louis Althusser and Philip K. Dick were at work imaging the simultaneous existence of two realities—one fully perceptible, and the other imperceptible but no less real (or indeed simply real).

Such science-fictional bifurcation might be said to enact a kind of structuralism, with empirical phenomena at once disguising and disclosing some other reality. In *VALIS* (1981), Horselover Fat finds the point in Heraclitus: "Latent structure is master of obvious structure" (39). Of course, science fiction anticipated, then drew inspiration from, the work of Hugh Everett, whose "'Relative State' Formulation of Quantum Mechanics" (1957) explained that the multiplicities of the quantum world could resolve themselves into empirical phenomena only as parallel universes, only through a "many worlds interpretation" of the universe.[12] The plot of *Flow My Tears, the Policeman Said* (1974) depends on a drug that inhibits the "brain's ability to exclude one unit of space from another," thus enabling "alternative spatial vectors" to appear, opening "up the entire range of spatial variation" so that a "whole new universe appears to the brain to be in the process of creation."[13] But the novelist was especially attracted to a linguistic model. In *Time Out of Joint* (1959) Ragle Gumm speculates: "Our reality, among words not things. No such thing as a thing anyhow; a gestalt in the mind. Thingness ... sense of substance. An illusion. Word is more real than the object it represents."[14] At his most insistent—in *VALIS*—the point is far from speculative: "All creation is a language and nothing but a language." Indeed, Horselover Fat is obsessed by the idea that the physical universe "is really information which we substantialize. ... The linking and relinking of objects by the Brain is actually a language, but not a language like ours (since it is addressing itself and not someone or something outside itself)." In other words, the physical universe amounts to "information and information processing" (23) within an autopoetic and self-sustaining system, making it clear, as Katherine Hayles has argued, that the discourse of cybernetics nurtured Dick's "persistent suspicion that the objects surrounding us—and indeed reality itself—are fakes."[15] References to cybernetics appear in his earli-

est stories. But all of this is to say, for my argument here, that just as the object was threatened with obsolescence in the world of conceptual art (as I recounted in chapter 3), so too, what we might consider the reality of the object world comes under new kinds of suspicion in the postwar decades, extending to the work of systems theory, the sociocybernetics where the habit of granting things reality remains (at best) a nuisance. With characteristically august irritability, Niklas Luhmann writes, "One of the worst aspects of language . . . is that predication is forced on the subjects of sentences; this suggests the idea, and reinforces the old habit of thinking, that we deal with 'things,' to which any qualities, relations, activities, or surprises must be ascribed. But the thing schema (and correspondingly the interpretation of the world as 'reality') offers only a simplified version of the fact dimension."[16]

Somewhat less tendentiously, now, I want to imagine that Althusser's notion of the "epistemological break" (understood as a rupture within intellectual biography, not as a depersonalized paradigm shift) can be deployed to caption those moments of revelation when characters see through "reality," or indeed that event that took place in Philip K. Dick's biography (known in the PKD world as "2-3-74,"), the psychotic break he experienced in February–March 1974 as a vision that he spent eight thousand pages of a journal (the *Exegesis*) and much of the rest of his life thinking through. In the profoundly autobiographical *VALIS* (an acronym for "Vast Active Living Intelligence System"), this gets called a "theophany . . . a self-disclosure of the divine" (37), experienced during "eight hours of lurid phosphene activity" (106), which, Horselover Fat explains to his friends, was a matter of God "fir[ing] a beam of pink light directly at him, at his head, his eyes" (20). It is within this break that he discovers that "the phenomenal world does not exist; it is a hypostasis of the information processed by the Mind" (39).

But such discoveries in the novel are curiously complicated (compromised, contradicted, or congested) by the persistent attention to a pot: "Stephanie brought Horselover Fat to God . . . by means of a little clay pot which she threw on her kickwheel, a kickwheel which Fat had helped her pay for, as a present on her eighteenth birthday." The pot accrues mystery and apparent potency as the plot develops, but right from the start the reader is told that "the pot was unusual in one way": "In it slumbered God. He slumbered in the pot for a long time, for almost too long" (19). As a friend explains later in the novel, "Fat says God was sleeping in the pot and came out in March 1974—the theophany" (154). While the "self-disclosure of the divine" ramifies as the further disclosure that the object world is mere hypostasis, the disclosure itself originates within that object world—indeed, within a specifically artifactual withinness.

Fat himself calls the pot "Oh Ho because it seemed like a Chinese pot to him" (45), an act of naming that suggests that the pot—this pot—had already appeared in *Deus Irae*, a novel Dick began in the 1960s and completed and published, with Robert Zelazny, in 1976. In the twenty-first-century, postapocalyptic world, Peter Sands concocts various cocktails from the amphetamines left over from the nuclear war, "tripping out on drugs," "seeking something," striving, "via the medication, to lift the membrane, the curtain."[17] When he succeeds in achieving his epistemological break, at first he sees a "flaxen-haired youth" whom he takes to be Christ, wearing a toga, "built like a blacksmith," holding an open book, its pages composed in Greek. Then, turning, he "ma[kes] out the bobbing, floating image of a small clay pot, a modest object, fired but without glaze; merely hardened" (30). Although this is "a utilitarian object, from the soil of the ground," the pot talks to him: "It was lecturing him against being awed—which he had been—and he appreciated it. 'I'll tell you my name,' the pot said, 'I'm Oh Ho'" (30–31). Over the course of the exchange (the pot explaining that the previous figure had come from "Sumerian times"), this name changes to "Ho Oh," and finally to "Ho On," before the object shimmers into disappearance. Later, a priest explains that the name is not Chinese but Greek, "a name God gave himself in the Bible The Most Holy? The On High? The Ultimate Power?" (41). But rather than any kind of grandiosity, it is the pot's ordinariness and its humility that makes it significant. "We are alike, you and I, equals in a certain real way, made from the same stuff" (31). On the one hand, this sounds banally biblical; on the other, it sounds like an object's version of the constructivist conviction that "things . . . must be equals, comrades."[18] This is not a relation of knowing subject to known object, but a freshly disclosed ontological intimacy and a thingness that becomes a politics of the ordinary expressed by the "little clay pot which came from the earth and can, like you, be smashed into bits and return to the earth, which lives only as long as your kind does" (31).

Both pots would appear to have their biographical origin in a pot that was given to Dick by a student at Mills College. Breaking news for the PKD world in July 2008 reported that Tessa Dick (the novelist's fifth wife) had decided to sell "Oh Ho" on eBay. In fact, she was selling two pots, the one Phil identified as Oh Ho and another, more likely made by the student (Tess wrote), that is a pitcher.[19] The comment suggests that she hadn't recently reread *VALIS*, where the object's precise form remains ambiguous. In the eponymous film *VALIS*, which the characters view within the novel, the pot mysteriously reappears (144), showing up in different places and at different moments, at times just subliminally, and at times in different forms: sometimes the pot appears as a pot and some-

times—as Fat's friend Kevin explains—the pot appears as a pitcher: "'Did you notice the pot?' Kevin said, 'The little clay pot—like the one you have. . . . It also appears as a pitcher'" (144–45). In Fat's subsequent travels, as he reports to his friends, he finds "the pot" in a museum in Athens, a twenty-four-hundred-year-old poros krater that shares with the pot in the film the mark of "Crick and Watson's double helix model" (for DNA), here inscribed as the "intertwined snakes of the caduceus" (223). The pot thus serves as a kind of centripetal force, constellating (if not conflating) the filmic and nonfilmic, the ancient and the contemporary ("the super-imposition of ancient Rome and modern California," for instance [209]), the virtual and the actual, . . . earth and heaven, . . . deities and mortals. God may project the object world, but he also resides within it; the clue to the information system resides both within and beyond the system: "Who or what is [the] V[ast] A[ctive] L[iving] I[ntelligence] S[ystem]? The clue is the ceramic pot or ceramic pitcher; same thing" (152).

To summarize, then: On the one hand, as reported in Horselover Fat's *tractate* (a version of Dick's *Exegesis*), "the universe is information and we are stationary in it, not three-dimensional and not in space or time. The information fed to us we hypostatize into the phenomenal world" ("Entry 14," 110). On the other, the narrator (Phil) explains that "Fat's en-counter with God—the true God—had come through the little pot Oh Ho," a three-dimensional object, "which Stephanie had thrown for him on her kickwheel" (65). But *Deus Irae* would seem to establish the fact that objects can possess value, power, and meaning (for instance) with-out possessing that thing we call objectivity. Rather than the questions that have come to make Philip K. Dick so famous—What is real? What is human? What is posthuman?—other questions intrigue me: questions about what role objects play in human life, what kind of knowledge they congeal, what kinds of agency they assume. And as for reality, the sim-plest way of understanding Dick's fixation on pottery is to sense how, in the 1967 scenario for a novel (never completed) that uncharacteristically assuages the central ambiguity, he posits potting as a figure for hypos-tasizing: "If this half-completed ersatz world is capable of answering Joe Protagoras' needs, *then it is real*—in the sense that it provides material out of which he can fashion a reasonably tolerable life. . . . The ersatz, half-completed world . . . gives Joe Protagoras a field in which to work creatively" as "an artist, and this ersatz world is the lump of clay out of which he will fashion his own idiosyncratic reality."[20] This is to suppose that Dick could imagine a little clay pot not so much *in* the real world but *as* the "real world" thrown by the human psyche.

2. Object Cultures

In what Kristin Ross calls a "prehistory of postmodernism in France" she has explained how the structuralist, antihumanist Marxism of Althusser and his followers could hardly square with anticolonial thought.[21] While "no serious French intellectual could invoke 'man' without blushing," the most eloquent subjects of colonization—Fanon, Césaire, Memmi—"did nothing but claim for themselves the status of man" (163). Among other, less obviously charged, casualties of structuralism, Ross charts the fate of history, of the everyday, and of objects.[22] "Structural man takes the real, decomposes it, then recomposes it in view of creating the general intelligibility underlying the object; he creates the object's simulacrum" (161). Thus, after his "sociohistorical analysis of the object world" in *Mythologies* (1957), Barthes comes to "abandon nonverbal materials and limits himself to analyzing only 'language objects'" (182) in *Eléments de sémiologie* (1964) and, more paradoxically, in *Le système de la mode* (1967).[23] On such grounds, a similar tale could be told of Jean Baudrillard, whose first book, *Le système des objets* (1967), unfolds as a sequence of materialist investigations into the practical or signifying function of objects within everyday life, but who soon establishes his reputation as the theorist of the hyperreal, deploying the fiction of Philip K. Dick (such as *The Simulacrum* [1964]) as a paradigmatic marker of the derealization of the "so-called real word."[24] Ross situates this forsaking of nonverbal materials in the material context of the era's profound change in the production and distribution of objects, and in the object-mediation of the social and the political, which she describes as a kind of Americanization: "modernity" gets "measured against American standards"; American imports ("stainless steel, Formica, and plastic") are championed "as modern and as clean" (90); the economy enters "more and more into collaboration, or fusion with, American capitalism" (7); "American-style mass culture" begins to take hold (10); and "daily life . . . increasingly appear[s] to unfold in a space where objects tend[] to dictate to people their gestures and movements—gestures . . . that for the most part ha[ve] to be learned from watching American films" (5). The French elision of the inanimate object world accompanies an Americanization of that world.

But the Americanization of France and regions elsewhere (Germany, Japan, the UK) occurs simultaneously with, as it were, *the Americanization of the United States*, where new scales of production and distribution prompt new object ideologies. Nixon iconically defines freedom, in his 1959 debate with Khrushchev, as the consumer's freedom of choice: "Diversity, the right to chose is the most important thing. . . . We have many different manufacturers and many different kinds of wash-

ing machines so that housewives have a choice."²⁵ American superiority lay in the consumerist security of a suburban domestic lifestyle. The most fundamental ideological change within postwar consumerism, Lizabeth Cohen has argued, lies in the solidification of a consumer nationalism. "Mass consumption in postwar America would not be a personal indulgence, but rather a civic responsibility designed [as *Life* put it] to provide 'full employment and improved living standards for the rest of the nation.'"²⁶ Such a nexus between citizenship and consumption, locally manifest in the new shopping centers that were promoted as community centers, reenergized the faith in the insatiability of consumer desire. By 1965, Jack Strauss, the chairman of Macy's, could review the recent past and declare that the nation's "economy keeps growing because our ability to consume is endless. The consumer goes on spending regardless of how many possessions he has."²⁷

But while historians have charted this shift in how objects were meant to mediate individual and group identity (the citizen, the housewife, the community), they have been less attentive to those high-cultural and mass-cultural efforts to represent or register a quotidian object culture that's run amuck: say, Thomas Pynchon's self-propelled can of hair spray uncontrollably atomizing, "hissing malignantly . . . bounc[ing] off the toilet seat collid[ing] with a mirror zoom[ing] over to the enclosed shower . . . around three tile walls, up to the ceiling, past the light"; or Vladimir Nabokov's Pnin, his life "a constant war with insensate objects that fell apart," a war in which the "frame of his spectacles would snap in mid-bridge," in which the "zipper a gentleman depends on most would come loose in his puzzled hand"; the new art's refabrication, reproduction, and gigantic replication of consumer object culture, from cars (John Chamberlain) to soup and soap (Warhol) to plugs and light switches (Claes Oldenburg); or Lucille Ball's ritual wrestling match with oven and toaster, or any number of episodes from the first four seasons of *The Twilight Zone* (1959–63) in which characters are terrified by an inanimate object world that's come to life.²⁸ Philip K. Dick, beyond his homogenizing images of postwar detritus, intensifies this portrait of an object culture (way) beyond human control. In "Colony" (1953), an early story describing a planet considered good for colonizing, objects turn out to be animated by an evil force: "The towel wrapped around his wrist, yanking him against the wall. Rough cloth pressed over his mouth and nose. He fought wildly, pulling away."²⁹ In *Ubik* (1969) an apartment's automatic door, refusing to admit Joe Chip until it gets paid, waxes legalistic: "Look in the purchase contract you signed when you bought this conapt."³⁰

The challenge that androids pose to the ontological stability of the

human in Dick's fiction has (quite reasonably) obscured the more casual and ubiquitous permeability between the animate and inanimate, the vocal and the voiceless, the agential and the passive, so that passengers have conversations not with a cab driver but with the "autonomic cab" itself, as in the final lines of Now Wait for Last Year (1966): "'I can see what you mean, sir,' the cab broke in. 'It would mean no other life for you beyond caring for her.'"[31] Indeed, when Dick is not charting "the tyranny of an object," as one character calls it in Do Androids Dream of Electric Sheep? (1968), his animate object world seems to prefigure Bruno Latour's conceptualization of a sociality that includes both persons and things.[32] For Latour, "the extension of speech to nonhumans" amounts to a preliminary step toward interrupting the "cold war between objects and subjects," a cold war whose ramifications he has variously charted, not least with the idea of imagining some new political ecology. "As soon as we stop taking nonhumans as objects," he asserts, in his ongoing effort to disclose the agency of the nonhuman, "as soon as we allow them to enter the collective in the form of new entities with uncertain boundaries, entities that hesitate, quake, and induce perplexity, it is not hard to see that we can grant them the designation of actors."[33] All this is to suppose, then, that even as certain intellectual currents of the 1960s seemed to wash things away, an undertow not only preserved them but in fact animated them in a way that anticipates not a poststructuralism that amounts to "materialism without matter" (in Derrida's phrase) but a postsociological effort to distribute agency beyond the human.[34] The loquacious pot in Deus Irae makes it clear—"We are alike you and I . . . made from the same stuff"—that such distribution does not depend on high technology.

But such a point might amount to the platitude that time—in the world of Philip K. Dick—is always time out of joint. Indeed, just when, in Ubik, the novelist seems most attentive to his contemporary American object culture—toasters and deodorant and long-line bras and bottled Italian dressing—the very notion of the contemporary (of contemporaneity) gives way. This is the story of human half-lifers (living beyond their death in cryonic suspension), about precogs who can picture the future, about telepaths, about "heteropsychic infusion"; it is the story of a corporate battle unfolding in the form of deadly serious mind games. But for all the cognitive theatrics, the drama still unfolds within—or as—the inanimate object world undergoing mysterious and momentous change. Each chapter opens with an epigraph that reads like an advertisement:

Pop tasty Ubik into your toaster, made only from fresh fruit and healthful all-vegetable shortening. Ubik makes breakfast a feast, puts zing into your thing! Safe when handled as directed. (748)

But no ad has any apparent relation to the events or the scene of the chapter itself, and each has only an opaque relation to the previous and subsequent ads:

> Perk up pouting household surfaces with new miracle Ubik, the easy-to-apply, extra-shiny, nonstick plastic coating. Entirely harmless if used as directed. Saves endless scrubbing, glides you right out of the kitchen. (676)

Nonetheless, this comic mismatch between one epigraph and another, as between epigraph and chapter, squares with the intensifying disjunctions within the plot, above all the noncontemporaneity of the object world itself: the reversion of matter to earlier forms, a series of "metamorphoses" that amount to devolution, the object world of 1939 insinuating itself into 1992: "I can't keep objects from regressing," as Joe Chip puts it. "Prior forms . . . must carry on an invisible, residual life in every object. The past is latent, is submerged, but still there, capable of rising to the surface once the later imprinting unfortunately—and against ordinary experience—vanished" (725). The TV set reverts to an "oldtime AM radio, complete with antenna and ground wires" (724). This is not entropy ("the entire planet . . . disintegrat[ing] into junk," as it does in *Androids* [497]) but a "retrograde force," with "archaic forms . . . moving toward domination" (712). As Joe Chip approaches a "retail home-art outlet" a "computer-controlled . . . self-service enterprise selling ten-thousand commodities for the modern conapt," he recognizes a "shimmer, an unsteadiness," an "oscillation" of the building as though it were "alive"; "at the amplitude of instability, it resolved itself into a tiny, anachronistic drugstore with rococo ornamentation," displaying "hernia belts, rows of correction eyeglasses, a mortar and pestle, jars of assorted tablets" (752). An afterimage of the past becomes newly present in object form.

It might make sense to say that there is something Proustian about the amplitude of the past's return. (In *Flow My Tears*, a copy of *Remembrance of Things Past* sits on a wicker table, although it sits there unread [35].) But in fact the pressure of the past, dislodged from any individuated memory, seems more strictly Bergsonian: "In reality, the past is preserved by itself, automatically. In its entirety, probably, it follows us at every instant . . . leaning over the present which it is about to join, pressing against the portals of consciousness that would fain leave it outside."[35] As Deleuze has emphasized, for Bergson the unconscious is not psychological, but ontological.[36] This is why Benjamin could draw on Bergson to imagine a materialist historiography that depends on a "method of receiving the things [of the past] into our space. We don't displace our being

into theirs; they step into our life."[37] In *Ubik*, the "past is latent, is submerged, but still there, capable of rising to the surface"; for Benjamin, too, object agency entails the power of things past to assert their present presence.

Of course, Dick deploys temporal disjuncture as a standard plot device, and in *Martian Time-Slip* (1964), among other novels, he understands the disjuncture cognitively: he considers the basis of schizophrenia, as of autism, to be a "fundamental disturbance in time-sense."[38] Indeed, in "Schizophrenia and *The Book of Changes*," he not only develops the point that "what distinguishes schizophrenic existence from that which the rest of us like to imagine we enjoy is the element of time"; he goes on to assert that "the schizophrenic is engulfed in an endless now" and that the LSD trip amounts to a "vertical opening forth of synchronicity."[39] But as Deleuze would say of Bergson, in *Ubik* "the past is pure ontology" (56). Nonetheless, given that Joe Chip experiences the hypostasis of the anachronistic drugstore while he's alone, there remains some doubt about whether to consider the event ontological or psychological, collective or individual. The oscillation between the two registers is what Benjamin works to resolve from Proust's understanding of experience: experience (*Erfahrung*) in "the strict sense of the word" combines "certain contents of the individual past" with "material from the collective past." To explain his point, he relies on two tropes, shifting, however slightly, from the verbal to the plastic, the aural to the tactile: a story does not "convey an event per se" but "embeds the event in the life of the storyteller in order to pass it on as experience to those listening. It thus bears the trace of the storyteller, much the way an earthen vessel bears the trace of the potter's hand."[40]

3. The Mass Ponderability of the Object

Science fiction is the literary subgenre most concerned with the object world—with, say, environment as opposed to character. Philip K. Dick agreed with other writers and readers of science fiction "that the true protagonist of an SF story or novel is an idea and not a person," but the magnetism of that idea, as he himself acknowledged, generally assumes object form: "the doorknob that winks at the protagonist," for instance, in the opening of Henry Kuttner's *Fairy Chessmen*.[41] If, as Jacques Rancière has repeatedly argued, Balzac's and Flaubert's disregard "for any hierarchy between foreground and background, and ultimately between men and things" constituted a politics of literature—"the hallmark of democracy"—then you could say that science fiction tends to assert a

new hierarchy, things having been foregrounded to the point of enacting some new tyranny.[42] Science fiction is also the literary, filmic, televisual, and digital genre that has had a distinct impact on our physical environment, from *Star Trek*'s design prototype for cell phones to the novelistic contribution to new battlefield technologies, such as drones. This is why, in P. W. Singer's *Wired for War* (2009), an account of the faith that war will be conducted without men, he devotes a chapter to the role science fiction has played in the military imagination: Robert Heinlein's *Starship Troopers* (1959) inspired the idea of global positioning systems, of surgical strikes, of powered armor exoskeletons; Orson Scott Card's *Ender's Game* (1985) provided the military with the idea of extensive virtual training, and Card became a military consultant. Such an impact has not been confined to the United States. But Japanese science fiction, no less inspirational, generally heroizes the robot and autonomous technology. According to one robotics professor from Waseda University, "The machine is a friend of humans in Japan"—not least, Singer argues, because within Shintoism "both animate and inanimate objects, from rocks to trees to robots, have spirit or soul just like a person."[43]

The machine (as opposed to the pot) is more often a soulless threat in the world of Philip K. Dick. Thus, in "Autofac" (1955), which depicts a world "seared flat, cauterized by repeated H-bomb blasts," the network of underground factories, which have been "rigged" by the "Cyberneticists" in "the early days of the Total Global Conflict," fail to recognize that humans are willing to "resume control of industrial production" in the postwar moment.[44] An automatic truck cannot be interrupted: "The truck regarded them calmly, its receptors blank and impassive. It was doing its job" (204). Recognizing that the factories are on the brink of depleting the earth's resources, the men successfully explode one of the underground outfits. But in its death throes, the factory "spurt[s] out [a] torrent of metal seeds"—seeds that contain microscopic machines that assume the task of starting to build miniature "replica[s] of the demolished factories" (226, 225). The tyranny of things, indeed.

Philip K. Dick came to distinguish himself, among science fiction writers, precisely because he devoted himself to questions posed not by technology but by his own version of cybernetics, informatics, and game and system theory, and to a cornucopia of psy phenomena. Nonetheless, Fredric Jameson has drawn attention to the tarnished and toxic object worlds in the work: not to the mechanical-organic unhuman-human axes that have fascinated cybercriticism, but to the damaged, dislodged, and disintegrating objects that populate so much of this fiction. In his memorial tribute to the "Shakespeare of Science Fiction" (1982), Jameson described Dick's concept of "kipple": his "personal vision of entropy in a

late twentieth-century object world . . . that tends to disintegrate under its own momentum, disengaging films of dust over all its surfaces, growing spongy, tearing apart like rotten cloth or becoming as unreliable as a floorboard you put your foot through."[45] In *Do Androids Dream of Electric Sheep* (1968), J. R. Isidore explains to a new inhabitant of an all-but-abandoned apartment building in the post–World War III era that "kipple is useless objects, like junk mail or match folders after you use the last match or gum wrappers. . . . When nobody's around, kipple reproduces itself. For instance, if you go to bed leaving any kipple around your apartment, when you wake up the next morning there's twice as much of it. It always gets more and more. . . . The entire universe is moving toward a final state of total, absolute kipple-ization" (480–81). As in "Autofac," the inorganic object world overwhelms the human because it reproduces itself.

But things represent not only problems—the object world gone amuck. They also offer possibilities. "The post-catastrophic perspective may explain," Jameson writes, "why in Dick's novels, as in other kinds of populism, handicraft skill (especially potting) becomes the privileged form of productive labor" (361). This is what he terms, in the *Postmodernism* book, "the 'petit bourgeois' valorization of small craftsmanship."[46] But as I've already tried make clear, it is not just potting as a form of work, but the form of the pot as such—not just the process but also the product—that commands the novelist's attention.

Which is not to deny the frequency with which potters appear in Dick's novels, generally cast as minor heroes. Despite its interplanetary travel and autonomic cabs and homeopapes and "thermosealed interbuilding commute cars" and "psychiatric suitcases," *The Three Stigmata of Palmer Eldritch* (1964) all but begins with a domestic scene of craftsmanship, a man watching his wife throw and decorate pots: "In the living room his wife sat in her blue smock, painstakingly painting an unfired ceramic piece with glaze; her tongue protruded and her eyes glowed . . . the brush moved expertly and he could see already that this was going to be a good one" (240). Despite her success at the "most exclusive art-object shops" in New Orleans and San Francisco (249), Emily's work is rejected by the Perky Pat market, which miniaturizes objects for the domestic environments psychically inhabited by the colonists on Mars, who have been "transported [thanks to the drug Can-D] out of local time and local space" and into the doll layouts. Emily's failure distinguishes her work from such goods as the "Werner simulated-handwrought living [neck]tie" (its "colors . . . a primitive life form") as from Palmer Eldritch's overproduction of "consumer goods . . . piled up in unlikely places where no colonists existed. . . . Mountains of debris, they had become, as the weather

corroded them bit by bit" (242–43). Her failure secures that utopian cele-
bration of the "conscious sensuous pleasure in the work itself," as William
Morris had put it.[47]

The potter enjoys a kind of revenge on the market in *Flow My Tears,
the Policeman Said* (1974). Mary Anne Dominic appears late in the
novel—a potter on her way to ship a couple of her pieces—but she is
the one who helps the protagonist to escape the police and to reestab-
lish his identity. Subsequently resisting his multimedia scheme to propel
her career, she expresses satisfaction with her own sense of craft: "I'm
very happy. I know I'm a good potter; I know that the stores, the good
ones, like what I do" (184). Then, in an uncharacteristically closural epi-
logue, the narrator reports that Dominic eventually "won a major inter-
national prize for her ceramic kitchenware" (228); indeed, in the closing
lines of the novel, we're told that a blue vase of hers "wound up in a col-
lection of modern pottery. It remains there to this day, and is much trea-
sured. And, in fact, by a number of people who know ceramics, openly
and genuinely cherished. And loved" (231).[48] Just as the woman herself,
"young, heavy-set, but with beautiful auburn hair" (168), helps to settle
the protagonist, so the modern vase serves to settle the two competing
realities—"two space corridors," one "an actuality; one . . . a latent pos-
sibility among many" (211–12). And the modern vase distinguishes itself
not only from the world of mass culture but also from the private world
of antique-collecting (from guns and stamps and vinyl records to medi-
eval chess sets and Tarot cards). Indeed, the affection and admiration
accorded the blue vase in the novel's final sentences suggests that Dick
means to accomplish more than privileging "handicraft skill" or valoriz-
ing "small craftsmanship"; the accomplishment occurs in an era when
the new popularity of crafts coincided with their effective dismissal from
art history.

When, in *The Galactic Pot-Healer* (1969), the novelist finally fashions
the potter as a primary protagonist, he does so with characteristic perver-
sity, but also with clarity. Like his father before him, Joe Fenwright is an
incomparable restoration artist—"a ceramic pot was a wonderful thing,
and each that he healed became an object which he loved"—but he lives
in a totalitarian United States of 2040, where there is no longer any pot-
tery to restore. There is no ceramic, only plastic. It is a world where any
number of crafts have become obsolete, a world where the "dignity of
work" no longer makes sense, a world where unemployment is the famil-
iar fate: "Along the sidewalks of the city the vast animallike gasping entity
which was the mass of Cleveland's unemployed—and unemployable—
gathered and stood, stood and waited, waited and fused into a lump
both unstable and sad."[49] Summoned to another planet to restore the

pottery that sank beneath the sea with an ancient cathedral, Fenwright achieves a kind of existential rejuvenation, confronted with cartons of potsherds and provided with extraordinary equipment. But the novel's attention to this scene of craftsmanship (which is merely a scene, given that the work is interrupted before it begins) pales beside its attention to his mesmerizing discovery, underwater, of an enormous pot:[50] "'It's a volute krater,' Joe said. 'Very large.' Already he could distinguish colors emanating from it toward him, the colors which bound him more firmly to this spot than all the cords and seaweed, all the other snares. . . . 'It's superb,' he said simply" (120–21). Fenwright's aesthetic encounter with the krater, like his elaborate knowledge ("a flambé glaze . . . of reduced copper," while in "places" looking "almost like 'dead leaf' glaze" [122]), cautions against domesticating Dick's attention to pottery into "popu-lism" and the California craft culture of the 1960s (which would include his wife's handcrafted jewelry business, for which he himself worked in 1961).[51] That movement did imagine establishing "a new domestic order where mundane aspects of life might be elevated and transformed into meaningful artistic expression," over and against the routines solidified by the new postwar object culture.[52] But such high aspirations coincided with a "nadir" within art history: "craft" had been utterly disaggregated from "art"; as one curator quipped, "Ceramics is occasionally the subject of art history, but more often is its victim."[53]

Philip K. Dick's pottery seems more recognizable within the light cast by a broader twentieth-century perspective, such as that provided in my first chapter. This included Ernst Bloch's postwar *Spirit of Utopia* (1918), which begins with the "intensifying fullness" he experiences in his "self-encounter" with a pitcher (*Krug*), and Martin Heidegger's postwar, postatomic lecture "Das Ding" (1950), which focuses on a potter and the thrown jug (*Krug*) as way of gaining access to the thingness of things. (He shared with Dick the Heraclitan belief that "the nature of things is in the habit of concealing itself" [*VALIS*, 39].) In a word: pottery (so timeless as to be essential both to *Gilgamesh* and to *Robinson Crusoe*) surfaces as an object of postwar fascination, a means of gaining access—through the object at hand—to whatever relief from modernity might be.

But that familiar fascination should not distract attention away from the history of the conceptualization of the pot in modernism, a history that makes particular sense of Dick's own fixation—not just on pots but also on abstract material forms. This history had its unanticipated origins in *English Pottery* (1924), coauthored by Bernard Rackham and Herbert Read, the poet and literary critic who, following his military service in the war and subsequent service at the Treasury, was transferred to the post of assistant keeper of ceramics at the Victoria and Albert Museum in

1922. Their book on *pottery* (not ceramics) abruptly interrupted the many English histories that narrated a steady progress in ceramic art from the coarse to the elegant, from "mere peasant work" to the work of Wedgwood, with no "account of the nature of pottery"—which, in their understanding, had been steadily compromised since the eighteenth century. Drawing attention to very early work, and objecting to much of the subsequent painted decoration, they pronounced that "pottery is, at its best, an abstract art," which should be recognized as "plastic art in its most abstract form."[54] Pottery (and what we would now call the medium specificity of pottery) soon became a cause célèbre within the English press (the *Times*, the *Observer*, the *Spectator*, the *Manchester Guardian*, &c.).[55] And for Read, on his way to becoming one of the century's first great expositors of modern sculpture, pottery catalyzed (or, say, materialized) a new conceptualization of art. "Pottery is pure art," he goes on to write, in *The Meaning of Art* (1931); "it is freed from any imitative function."[56] In this historical survey committed to understanding "all art" as "the development of formal relations," and to understanding "aesthetic sensibility" as that which "corresponds to the element of form in art," modernist abstract art enjoys special attention. But not at the expense of pottery: "Pottery is at once the simplest and the most difficult of all arts. It is the simplest because it is the most elemental; it is the most difficult because it is the most abstract" (40–41).

In *The Meaning of Art*, Read also refuses to distinguish between the artist and the artisan—"The distinction between the 'fine' and 'applied' arts is a pernicious one" (49)—and that refusal becomes the argumentative force of *Art and Industry* (1934), his manifesto in behalf of industrial design. In an argument that resonates more with Walter Gropius than with William Morris, he argues that once we "recognize the abstract nature of the essential element in art," we can appreciate how industrially produced useful objects can "appeal to the aesthetic sensibility as *abstract art*," with an "appeal" that is "rational and irrational," which is to say "appreciated by intuitional modes of apprehension."[57] Predictably, pottery not only receives extensive attention (58–61, 96); the "simple industry of pottery" also becomes the closing, paradigmatic case for "the industrial production of objects of use" (117). For Read, then, pottery exemplifies the resolution not only of artist and artisan, but also of art and industry, all the while epitomizing "pure art" not on the grounds of some autonomy from the regimes of use and exchange but on the grounds of its autonomy from mimetic representation. He differentiates his argument from Morris's vilification of machinery, and it should be differentiated from Heidegger's technophobia, despite Read's own anarchist antipathy

to modern society and culture. The concept of handicraft is unimportant to Read; what matters is the status of the object as a concrete abstraction.

It is not the craft of potting, though, but the craft of welding that achieves that ideal in *The Man in the High Castle* (1962), still Dick's best-known novel, where the results of the work—strange, handcrafted jewelry that is at once exquisitely formed and unformed, amorphous—prove far more compelling than the work of production itself. They are the source of an incomparable aesthetic and spiritual satisfaction, the site of a modernist, indeed high-modernist, all-but-Heideggerian apprecia-tion. The "cultured, educated," and "elite" Japanese man Paul Kasoura ob-serves of the strange handcrafted jewelry, "Here is a piece of metal which has been melted until it has become shapeless. It represents nothing. Nor does it have design, of any intentional sort. It is merely amorphous. One might say, it is mere content, deprived of form."[58] Read might say that the jewelry is "plastic art in its most abstract form." Deleuze and Guattari might say that the vital "matter-movement" of the metal "overspills the form."[59] And you might say of the "piece of metal" that it is a thing, not an object, or a thing resisting certain object form, with its "substance," contra Aristotle, residing in matter. The object, in other words, has the form of no form; it is a kind of formless form, having taken the shape of shapelessness; it is more sublime than beautiful, in the sense that it lies beyond comprehension and yet is neither threatening nor terrifying but very simply soothing.[60]

Though it is plain how this attention to the handcrafted jewelry ad-umbrates Dick's subsequent attention to pottery (pot or pitcher: same thing), the amorphous pieces of metal also bear a relation to those scenes of formlessness in his other novels, from the grimy and cluttered apart-ments to the more pervasively entropic: "He heard the kipple coming, the final disorder of all forms, the absence of which would win out" (*Androids*, 585). The point about the jewelry—indeed, you might say the point about abstract art—is its capacity to resist the figurative and evade the familiar without succumbing to the entropic. On the one hand, "Eventually every-thing within the building would merge, would be faceless and identical, mere pudding-like kipple piled to the ceiling of each apartment. And, after that, the uncared-for building itself would settle into shapelessness" (*Androids*, 448). On the other, the very fact that the piece of jewelry "is a miserable, small, worthless blob contributes to its possessing wu. . . . an entire new world is pointed to by this" (*Man*, 156). The crafted object—as the abstract other thing—manifests an energetic release from mimetic form; so doing, it serves as a kind of conduit to a world that is not this world, which is to say that, by Kasoura's light, it is the source of some

kind of immanent transcendence. Within a plastic register, this is something like the difference between the work of Claes Oldenburg and that of Henry Moore; while the soft objects of the former (light switches, toilets, fans) express the lassitude of things and the weight of their having-to-be in a human world, the latter's rounded and abstract carvings seem to incarnate the vitality of material itself, what the artist called "a pent-up energy, an intense life of its own, independent of the object it may represent."[61] The effort to access this energy is the effort to disclose a dynamic thingness that exceeds the object form (on which it nonetheless depends).

The novel itself, though, does not juxtapose forms of formlessness. Rather, it juxtaposes abstract art to the abstractions of ideology, and it does so early in the novel, in an exchange between Mr. Baynes, posing as a Swedish businessman, and the German artist Alex Lotze, traveling to San Francisco for an exhibition of his work "arranged by Dr. Goebbels' office" (36). Baynes expresses his taste for the "old prewar cubists and abstractionists"; the artist insists that such art "represented a period of spiritual decadence, of spiritual chaos," supported by "Jewish and capitalist millionaires" (34). In his subsequent meditation on the "psychotic world we live in," Baynes (who is in fact a German working against the Reich) concludes that the source of the "frenzied and demented" psyche of the Nazis lies in the ability—and in the will—to believe that abstractions are concrete: "Their view; it is cosmic. Not of a man here, a child there, but an abstraction: race, land. *Volk. Land. Blut. Ehre* The abstract is real, the actual is invisible to them. *Die Güte*, but not good men, this good man" (38). The novel deploys the actual abstract thing as a node through which to evade the work of reified abstractions.

You could hear in Kasoura's account of the jewelry something of the modernist sculptural aspiration for the nonfigurative, conveyed in 1928, when Constantin Brancusi told Isamu Noguchi how lucky he was to be in a generation that "could look forward to uninhibited and true abstractions," and when Noguchi himself was "interested in getting a certain plasticity of form, like something alive."[62] The jewelry—like the small organic abstractions of Jean Arp—expresses what Read came to conceptualize as "vitalism." When Barbara Hepworth visited Arp's studio in Paris in 1932, she wrote that "the idea—the imaginative concept—actually is the giving of life and vitality to material. . . . Vitality is not a physical, organic attribute of sculpture—it is a spiritual inner life."[63] A vitalist like Henry Moore, Read writes in *The Philosophy of Modern Art*, "believes that behind the appearance of things there is some kind of spiritual essence, a force of immanent being which is only partially revealed in actual living forms."[64] Formless form might thus be said to disclose a different dis-

crepancy between illusion and reality, between the object forms that our world has assumed and the forms to which materials themselves may aspire. The material genealogy of this vitalism would most obviously locate some point of origin in the work of Rodin; a conceptual genealogy would point to Bergson, who understood *concepts* to be what prevents philosophers from engaging with *objects*—what prevents the human intellect from "represent[ing] the *relations of external things among themselves*—in short, to think matter." The "intellect feels at home among inanimate objects, more especially among solids, where our action finds its fulcrum and our industry its tools."[65]

Just as the jewelry in Dick's novel anticipates his subsequent fixation on the pot, so Read's early attention to pottery anticipates his appreciation of abstract sculpture, above all the work of Moore and Hepworth, with whom he concludes *The Meaning of Art*. Yet Read's engagement with pottery as "plastic art in its most abstract form" disappears from the historiography of the 1960s. In *Beyond Modern Sculpture* (1968), an important history widely adopted as a textbook, Jack Burnham pays considerable attention to vitalist sculpture, to the impact of Bergson, who served as "the high priest of a new cult," and to the importance of Read, whose criticism he surveys across twelve pages. But he argues that Read only "provided a *post facto* intellectual justification for vitalism's existence," an aesthetic that had originated with "the sculptors themselves"; he argues that the "notion of vitalism" doesn't explicitly appear in Read's work until *The Philosophy of Modern Art* (1952).[66] But such an account overlooks Read's prewar association with T. E. Hulme, for one, the translator of Bergson who helped to inspire a surge of British materialist anticapitalism that Leela Gandhi has captioned "a type of *philophusika* or love for things"—the effort, "*a la* Henri Bergson, to bring the human into reparative fellowship with things," thus "laying claim to an updated metaphysical empiricism" that could rectify the "spiritual impoverishment of the objective world."[67] In *An Introduction to Metaphysics* (1903, translated by Hulme in 1913), Bergson insists that "progressive philosophy" must recognize that the mind is capable of "adopting the very movement of the life of things."[68] This *Introduction* paves the way for what became fully recognizable as vitalism in *Creative Evolution* (1907), the book that became a kind of bible for the later generation of sculptors who sought to liberate the latent vitality within their material, a life force that animates apparently inanimate matter. Two years after rereading *Creative Evolution* in 1922, Read himself argued, in *English Pottery*, that "a good vessel possesses *vitality*": "The eye registers and the mind experiences in the contemplation of energetic lines and masses a sense of movement, rhythm, or harmony which may indeed be the prime cause of all aes-

thetic pleasure."[69] He repeats the point, quoting the earlier text, in *Art and Industry*. But those books appear nowhere in Burnham's account. The potter as artisan, the pot itself, pottery understood as "the simplest and most difficult of all the arts"—these have been erased from the story of modern sculpture. Yet even as the popularity of pottery (part of the craft movements of the 1960s) lay behind its displacement from the field of art, the literary register nonetheless reanimates the vitality of craft as vernacular modernism.[70]

Or, you might say that retrieving that erased history clarifies how "handicraft" in the fiction of Philip K. Dick can in fact be understood as "modernism," with all its utopian longing. Moreover, to recognize Herbert Read as an "unregenerate Bergsonian" (his words) is to recall the impact of Bergson's metaphysical empiricism in the first decades of the century: its impact not on conceptions of the image or the moving image, but on conceptions of the static object . . . or, rather, the moving object . . . the object in stasis that nonetheless moves.[71] For Read, the task of thinking matter (as Bergson put it) resulted in formulations that have remained enigmatic, such as his assertion—in *The Art of Sculpture* (1956) and elsewhere—that plastic sensibility depends on "a synthetic realization of the mass ponderability of the object."[72] By this he surely means to confuse (or, say, to integrate) thought and thing, to formalize substance without reducing it to form, and to caption some non-Cartesian mode of embodied contemplation in which thinking occurs as a kind of holding. (It is the sort of formulation that appalled Clement Greenberg, who dismissed the Englishman as an "incompetent art critic" not least because Read believed that sculpture foregrounds the tactile sensations, whereas Greenberg himself insists that sculptural works provide "their decisive satisfaction through the eyes," and that "actual visibility" gives rise to a merely "virtual tactility.")[73] But by the time Read wrote his *Concise History of Modern Sculpture* (1964), he came to recognize that what he had been calling "vitalism" could be understood as "the quality the Chinese call *ch'i*, the universal force that flows through all things, and which the artist must transmit through his creation to other people."[74] Admiring the jewelry, Paul Kasoura explains to Robert Childan that "the hands of the artificer . . . had wu, and allowed that wu to flow into this piece," and thus by "contemplating we gain wu ourselves" (Dick, *Man*, 155).[75]

4. Words and Things

American Art Handcrafts, the name of the ritzy shop on San Francisco's Montgomery Street, is in fact a misnomer. For Robert Childan actually

sells Americana—posters, signed framed photographs, old guns, comics, shaving mugs, ties—"taking advantage of the ever-growing Japanese craze" (26). Having previously operated "a small rather dimly lighted secondhand bookshop on Geary," he has abandoned the traffic in words for the traffic in things because he's learned, from an "elderly Japanese ex-army man," a man "particularly addicted to the collecting of old magazines dealing with U.S. brass buttons," that wealthy Japanese customers have developed an insatiable taste for "historic objects of American popular civilization" (25). Of course, here in *The Man in the High Castle* (1962), American popular civilization tout court has become merely historical. The alternate history tells the story (like Philip Roth's subsequent *Plot against America*) of life in postwar America with Germany in control of the East, Japan in control of the Pacific States of America (having installed a puppet white government in Sacramento), and the Rocky Mountain States enjoying relatively benign neglect and superfluity. In the postwar era, the Reich has relocated or exterminated the Jews from New York, had the "Slavs rolled back two thousand years' worth, to their heartland in Asia," conducted an African genocide, drained the Mediterranean for farmland, and developed an aggressive economic and technological program, with "a world monopoly in plastics" and a space program well on its ways to colonizing the planets (23–24, 20). Not only has the Japanese empire failed to keep up; the Reich also seems to be developing a secret plan for a nuclear attack on the Home Islands.

Despite the claustrophobia of this grotesque world, there are two modes through which to envision some egress, one textual and one, say, phenomenological; over the course of the novel, an almost imperceptible alternate reality—within or beyond the lived empirical reality—is sometimes disclosed by a book, sometimes disclosed by a thing.[76] Fulfilling that role, the strange amorphous jewelry appears as a decidedly good object, although it is not quite good enough, thus marking the impossibility of the residual modernist aspiration.

Several of the characters (American, Japanese, and German) have gotten their hands on a book entitled *The Grasshopper Lies Heavy*, itself an alternate history, "one of those banned-in-Boston books" written by the "eponymous man in the high castle" (58) who has sequestered himself with fortress-like protection north of Denver (somewhat comparable to Dick's own seclusion in Point Reyes). "Another fad," "another mass craze" (59), this book is a novel in which Roosevelt, not assassinated in 1933, pulls America out of the Depression, arms the country, and refuses to tolerate Germany's attack on Poland, France, England. "And after the war," as one character explains to another, "the U.S. and Britain divide the world. Exactly like Germany and Japan did in reality" (74). The novel

fascinates a full range of characters. Paul Kasoura considers the novel generically, as an "interesting form of fiction possibly within the genre of science fiction" (97). Freiherr Hugo Reiss, the Reichs Consul in San Francisco, finds himself mesmerized: "Amazing the power of fiction, even cheap popular fiction. . . . No wonder it's banned within Reich territory. I'd ban it myself. Sorry I started it. But too late; must finish, now" (112). Robert Childan, proprietor of the San Francisco shop, views any alternative to current global politics with suspicion: "Communism would rule everywhere," he thinks; "If Germany and Japan had lost the war," the "Jews would be running the world today" (100, 102).

Childan's shop becomes the site through which the story of things, as opposed to any story of books, or the story of the cherished novel, begins to unfold, thanks to the Japanese collecting habit, prompted by the impulse to make some contact with a lost culture that has come to seem idyllic.[77] When Mr. Tagomi, a senior representative of the Japanese Trade Mission in San Francisco, presents a Mickey Mouse watch to the dignitary Baynes, he calls it "this most authentic of dying old U.S. culture, a rare retained artifact carrying flavor of bygone halcyon day" (40). The recipient is merely bemused. But Childan finds his enterprise threatened when it turns out that a gun he has sold, a "Colt revolver of the Frontier period" (43), is fake, however exquisitely replicated. Childan phones his supplier and barks at him, and he barks at the manufacturer, who himself erupts in front of his girlfriend: "This whole damn historicity business is nonsense. The Japs are bats. I'll prove it." Handing her two Zippo lighters, "one carried by Roosevelt when he was assassinated," he explains to her that "'One has historicity, a hell of a lot of it. As much as any object ever had. And one has nothing. Can you feel it?' He nudged her. "You can't. You can't tell which is which. There's no 'mystical plasmic presence,' no 'aura' around it'" (57). "Historicity" does not reside in the object. It is this dilemma of historicity—and indeed, the dilemma of history—that the amorphous object, the jewelry, seems to resolve.

Two workers from the replica factory, one of them recently fired, agree to strike out on their own in the jewelry business even though, as one says, "nobody wants contemporary American; there isn't any such thing, not since the war" (42). But Ed McCarthy and Frank Frink set up shop, purchase equipment, and set to work making jewelry that the text initially describes as something . . . describable, something recognizable: "Cuff bracelets made of brass, copper, bronze, and even hot-forged black iron. Pendants, mostly of brass, with a little silver ornamentation. Earrings of silver. Pins of silver or brass" (117). In subsequent descriptions, though, the objects appear less distinct: "Most of the pieces were abstract, whirls of wire, loops, designs which to some extent the molten

metals had taken on their own. Some had spider web delicacy, an airiness; others had a massive powerful, almost barbaric heaviness. There was an amazing range of shape" (118). Although the mercenary and manipulative Childan adopts a dismissive attitude toward the jewelry, he senses its appeal—"Custom originals. Small sculptures. Wear a work of art"—and accepts a few pieces on consignment, anticipating a problem in the antiques market. "*With these, there's no problem of authenticity.* And that problem may someday wreck the American artifacts industry.... If I quietly build up a stock of nonhistoric objects, contemporary work with no historicity either real or imagined, I might find I have the edge over the competition" (132). Thus begin the dynamics of the object culture that Philip K. Dick will stage over and over again: the contemporary crafted artwork in competition both with antiques and with the mass market. Indeed, Childan himself surprisingly resists the chance to pitch a wider market to the artists, to have their work "mass-produced" by the thousands as "a line of amulets to be peddled all over Latin America and the Orient" (158). He resists on nationalist grounds, the grounds that Americans, despite all appearances, can be "proud artists" who fashion more than "models for junky good-luck charms" (162, 161).

But it is neither any romance of restricted distribution nor a romance of production that the novel details at length. Rather, it is the romance of reception—something other than consumption, indeed the act of contemplation in which the object becomes another thing. Kasoura, who lives in one of the exquisite modern buildings in San Francisco, built where there had been "nothing but rubble from the war," goes on and on: "Here is a piece of metal which has been melted until it has become shapeless. It represents nothing. . . . [It] somehow partakes of Tao. It is balanced. The forces within this piece are stabilized. . . . The name for it is neither art, for it has no form, nor religion. What is it? I have pondered this pin unceasingly, yet cannot fathom it. We evidently lack the word for an object like this" (155–56). In contrast to the word—the *narrative* of some other history that provokes fascination, anxiety, aspiration, and controversy—the thing inspires blissful stupefaction, bounded by neither shape nor word.

But at one point in the novel, an Edfrank piece provokes a wholly different reaction. Having been sold a "squiggle of silver," one of the "shapes that merely hinted rather than were," Tagomi sits on a bench in the sun by Kearney Street inspecting his new possession in search of some "compression of understanding" (199, 201). After fifteen minutes, frustrated because, despite Childan's promises, the object seems merely inert, he shakes the squiggle—"You are empty, he thought": "Tried everything, he realized. Pleaded, contemplated, threatened, philosophized at length.

What else can be done." He listens to it, smells it, tastes it: "No meaning, only bitter hard cold thing." But he finally shifts to a mode of contemplation: "Metal is from the earth . . . from that realm which is the lowest, the most dense And yet . . . it reflected light. . . . Not heavy, weary, but pulsing with life. . . . Yes that is the artist's job: takes mineral rock from dark silent earth, transforms it into shining light-reflecting form from sky" (202). But when Tagomi believes that his experience with the squiggle—"microcosmos in my palm . . . can't look away. Spellbound by mesmerizing shimmering surface"—has come to an end, he has in fact entered a hynagogic state, and sees, from the park, a world of auto traffic (not pedicabs) and a "hideous misshapen thing on the skyline. Like nightmare roller coaster suspended blotting out view. Enormous construction of metal and cement" (203–4). By asking a passerby, he finds out it is the Embarcadero Freeway, which is to say he has momentarily entered the San Francisco of 1962, neither the diegetic alternate reality of the novel, nor the alternate reality to that reality, which is the story provided by *When the Grasshopper Lies Heavy*, but the object world of the American 1960s in which Phillip K. Dick himself lived. In this case, then, an object has provoked the epistemological break, after which an alternate present becomes fully present, with no dilation—in effect, without narrativity.

An alternate story, the narrative history (of what one character calls "utopia") can't be materialized beyond the pages of the novel, but matter, the formless forms, serves as no ground for narrative dilation. This discrepancy—a symptom of what Jameson would call the "structural impossibility" of utopia—can be extended within the novel (and beyond the novel) as a host of binaries: object (book) versus amorphous thing; mass culture (the alternate history appears on the shelves in drugstores) versus modernism; historicity versus presence; hermeneutics versus epiphanics; the gnostic versus the drastic; politics versus poetry.[78] It is the gap between these that prevents the characters from imagining change.

But it would be unfair to the novel not to point to a certain synthesis of word and thing mediated by the *Book of Changes*, the *I Ching*, consulted by several characters who throw coins or yarrow stalks and look to the chart of hexagrams and the commentary for an assessment of their situation and some recommended action. The *I Ching* generates the present of the characters (who follow its decisions) even as it generated the past of textual production, if we're to believe Dick that he used the *I Ching* to determine his plot just as the man in the high castle claims to have used it.[79] This synthesis, though, points to the marked and unmanaged enigma in the novel, the hyperpresence and diminished existence of China: on the one hand, the "book created by the sages of China over a period of five thousand years, winnowed, perfected" (14) and, on the other, the

Chinese population fully subdued by Japan in the diegetic present, working as pedicab drivers who bike their passengers up and down the hills of San Francisco. The alternate history renders China led by its great democratic President Chiang Kai-shek into the modern world as a market that sustains the American workingman's "highest standard of living in the world" (141).[80] The novel thus elides the epiphanic understood politically—call it revolution—even while it anticipates (in the contemporary artifact, the now that opposes historicity) a Cultural Revolution against the "Four Olds"—old ideas, old culture, old customs, old habit—accompanied by the Red Guard's infamous destruction of precious bourgeois antiques.[81]

But that elision is no doubt necessitated by a point that the novel makes formally—in its free indirect discourse, its various streams of consciousness, and the narrator's own voice. The Japanese characters, those who appreciate both American antiques and modernist forms, not only speak, they also think, in broken English: "*Sic!* Mr. Tagomi thought, using high-place Latin word. . . . Looks askance at merely military" (17). But the so-called whites of the novel think the same way: "Taking it all day from Japs such as Mr. Tagomi. By merest inflection manage to rub my nose in it, make my life miserable" (128). Even as the Japanese characters explain of some concepts—wu—that they cannot be thought in English, Dick's own diction and syntax, in this novel alone, keep evading idiomatic English. You could read this as his way of marking, circa 1960, that no transformative object relation was to be realized through Western thought.

Unhuman History

The two most renowned earthworks, Michael Heizer's *Double Negative* (1969–70) and Robert Smithson's *Spiral Jetty* (1970), locate the human artifact within unhuman history. On a sixty-acre site in Nevada's Moapa Valley, Heizer constructed *Double Negative* by digging two 30-foot-wide and 50-foot-deep trenches on either side of a canyon, creating a 1,500-foot-long expanse. Smithson constructed *Spiral Jetty* from mud, stones, and basalt rocks: the 1,500-foot-long, 15-foot-wide coil extends from the shore of the Great Salt Lake into the water, which submerges the work in years when the snowpack runoff is heavy. Both works are difficult to find and to access, but photography and film quickly made them iconic, within and beyond the art world.

Both *Double Negative* and *Spiral Jetty* inhabit the process of erosion and thus collapse the distinction between the artifactual world and the earth. Both dwarf the human body in the context of the earth. Collaborating with earth, their works succumbing to it, both artists constructed countermonuments (monumental in scale yet dramatically subject to time) at what the artists understood to be the edge of the world. However sensationally spatial, they highlight the temporal dimension: they dilate the phenomenological present to provide some access to geological time. The idea of *unhuman history* makes audible what is inaudible (however present) in "geological time." It does not fully exclude the human. It displaces the human from the center of its story. It subordinates the species as one actor (or one actant) among many within time framed by the before-and-after of the human, while recognizing nonetheless that *time*

and *history* remain human concepts (even when they are deployed, very reasonably, to name unhuman concerns). The idea of unhuman history becomes awkward now that geologists give credence to the *Anthropocene* as a new epochal designation for the era dominated by the human impact on the systems that constitute the earth, not least its climate.[1] While the designation names the most stridently human era within unhuman history, it more saliently serves as a kind of twenty-first-century nickname for the dedifferentiation of world and earth, of artifact and of merely terrestrial fact. "Interested in collaborating with entropy," Smithson wanted to make something that would, "in a sense, interact with the climate and its changes."[2]

The following three chapters engage four modes of thought—philosophy and science studies, psychoanalysis, and ethnology—that differently bring the unhuman into focus. In chapter 5 I begin with Hannah Arendt, who establishes coordinates for the human condition as it had been known and experienced, and as it was being threatened in the postwar era. I concentrate on her objection to philosophy's retreat into the subject before I point to more recent versions of that objection and the full-bore effort to reengage the object world beyond (or without) the subject and without the human—what threatens to become (by my light) a retreat into the object. Chapter 6 tracks such a retreat in Myla Goldberg's *Bee Season* (2000), a novel I read with the help of Harold Searles, whose book *The Nonhuman Environment* (1960) remains the most serious effort within the history of psychoanalytic thinking to extend the theory of object relations beyond the bounds of the human. Chapter 7 examines the work of Brian Jungen, the contemporary First Nation artist whose extraordinary refabrications, defamiliarizing the materials from which our daily lives are fashioned, stage the intersection of two histories (human and unhuman) on display in the natural history museum. The chapters noticeably return to topics that emerged in my reading of Virginia Woolf's "Solid Objects" in chapter 2—collecting, display, waste, and cosmological time, for instance; they do so, however, with a particular emphasis on how, within our recent past and our present, the other thing can compel you to consider the unhuman dimension within which humanity takes place.

Five

The Unhuman Condition (Hannah Arendt/ Bruno Latour)

Toward the close of the 1950s, Philip K. Dick began to publish stories in which human beings have become obsolete—in which human-being has thus begun to make less sense. These are stories in which the species survives on some other planet (not Terra), or technology has obviated human participation in the world of manufacture, or defense systems have become both autonomous from and oblivious to human interests. The stories anticipate his more wildly imaginative and elaborately plotted novels (such as those I discussed in chapter 4), but they generally do so in a different key: characters simply experience, within the everyday, the effective obsolescence of the human.[1]

In those same years, Hannah Arendt delivered a series of lectures on the human condition: the conditions by which she understood the human as such to be philosophically recognizable. As she describes it, that recognition entails a very particular relation to things and a guarantee from them. She does not differentiate things from objects, as her former teacher Heidegger had; and she grants the artifactual world the very stability that the likes of André Breton, Gaston Bachelard, and Man Ray had sought to undo. She posits such stability over and against the instabilities—registered likewise by the artifactual object world—that were pointing to the limit of the human.

In the subsequent decades of the twentieth century, that object world disappeared into the margins of philosophical and scholarly attention, increasingly preoccupied as it was with language, the subject, and the mind. Within the last decade of the century, though, the object rather

suddenly returned to the spotlight across a wide range of thought. When the object returned with particular panache, in the work of Bruno Latour, it did so at the expense of the subject: at the expense of the subject-object relation. As I made clear in chapter 1, Heidegger had already worked to circumvent that relation by defining Being itself, *Dasein*, as a being-in-the-midst-of-things, which cannot be disaggregated by a subject-object structure. Latour shares Heidegger's frustration with Descartes and Kant, though not an ounce of his patience for working through Kant. Indeed, he has little more patience for Heidegger, given that *Dasein* names human-being; for Latour the human, like the subject, impedes a productive description of sociality. Moreover, he impatiently refuses to indulge in metaphysics because he has come to understand himself (as Arendt understood herself) to be thinking in a state of emergency.[2]

Whereas Arendt addressed the emergency by asserting, specifying, and elaborating terms she inherited above all from the Greeks, Latour addresses it by insisting that his readers dismiss inherited terms and concepts in order to sense—and to make sense of—the conditions we now face. Those are not the conditions (the conceptual or political preconditions) that add up to the human condition, but those that challenge (as Arendt anticipates) the efficacy of the *human* as a concept and as a term. This chapter unfolds as an engagement with Arendt's conceptual investment in things (the artifactual *world* as distinct from the *earth*); as a glimpse at some recent thinking, above all Latour's, that privileges objects and things; and as an account of Latour's further efforts to think without the human, and to posit Gaia in a thought experiment that means to give us some conceptual purchase on ecological crisis. Latour's more recent work helps to situate the twenty-first-century attention to objects, including his own, within a history of the present. As Heidegger insisted, ontology has a history, and ontological questions reside within history, even if, at times, it is only ontological questions that seem to make history visible.

1. Earth/World

In *The Human Condition* (1958) Arendt begins not with humans per se but with a human creation: an object, Sputnik, launched October 4, 1957. The success of Sputnik, the first artificial satellite to orbit earth, intensified the Cold War, prompted nation-states to revamp their science programs, and provoked what soon became known as the space race. Arendt herself leaves the satellite unnamed. "In 1957," her prologue begins, "an earth-born object made by man was launched into the universe, where for some

weeks it circled the earth according to the same laws of gravitation that swing and keep in motion the celestial bodies—the sun, the moon, and the stars."[3] You might say that, given the notoriety of the event, there was no need to name the earth-born object. Yet the anonymity is baldly strategic—deployed to displace this object from the politics and new trepidations of the Cold War that were already evident, the morning after the launch, on the front page of the *New York Times*: "Soviet Fires Earth Satellite Into Space ... Sphere Tracked in 4 Crossings over U.S."[4] Arendt means to situate the event within a different story.

First off, this is a story about the confusion of the terrestrial and the celestial: the "earth-born object," as she puts it, "dwelt and moved in the proximity of the heavenly bodies" (1). The "human artifice of the world" (the world as differentiated from the earth) is thus no longer earth-bound; a part of the world has left the earth. This becomes, then, a story about the "wish to escape the human condition" insofar as "the earth is the very quintessence of that condition.". Whatever the international political fallout of the launch may be, it all amounts to local politics in the context of, and in contrast to, the "rebellion against human existence as it has been given" (2). Which is why "this event" is "second in importance to no other, not even to the splitting of the atom" (1).

But the point is not simply that we are "earth-bound creatures" who "have begun to act as though we were dwellers in the universe." For this new object also serves as an emblem of how thought cannot keep up with "know-how"—a sign of how language fails to apprehend technology (3). Arendt thus situates the event within a second story: the story of how words have lost their power because the mathematical statements that inform scientific knowledge "can in no way be translated back into speech" (4). Of course, the threat of technological complexity was an ongoing topic in the twentieth century: at the century's outset, Georg Simmel, for one, described the uneven development of subjects and objects, the discrepancy "between objective and subjective culture," by which he meant to summarize how the subject becomes estranged from increasingly specialized products.[5] Having insisted that "the culture of things" is "nothing but a culture of people, so that we develop ourselves only by developing things," he sensed the corollary conundrum: "What does that development, elaboration and intellectualization of objects mean, which seems to evolve out of those objects' own powers and norms without correspondingly developing the individual's mind?" (*Philosophy*, 449). What this means from Arendt's perspective—as she charts not the sociopsychological but, first, the linguistic ramifications of "scientific achievement"—is that meaning itself has been challenged: we can no longer make sense of the world we have created, given that "whatever

men do or know or experience can make sense only to the extent that it can be spoken about" (4). Moreover, given that speech is the ground of political being, our failure to transpose scientific statements "back into speech"—or to translate things into words—challenges our capacity to remain political. Thus, when it comes to the earth-born object circling the earth, the eventfulness of the event lies nowhere within the spectrum of international politics. It lies beyond politics—or on some horizon beyond which the political as such must be said to disappear.

Whether or not this was the most convincing way to begin to describe a diminished public sphere, I simply mean to draw attention to how Arendt focuses on a particularized if unnamed object to appropriate the alarm attending the object-event, and to infuse her topic—the *vita activa*, the life of engaged action among others—with a comparable sense of currency and crisis.[6] Yet even as, by Arendt's light, this artificial thing threatens to foreclose the sphere of politics and to destabilize the very condition within which we attain our humanity, it is nonetheless things, she argues, that provide the stability by which we may be said to withstand the perpetual change of life itself, the "never-resting stream of the life process" (33). For the "artificial world of things, distinctly different from all natural surroundings," constitutes the signal "human artifact" of the world as such, and that artifact "bestow[s] a measure of permanence and durability upon the futility of mortal life and the fleeting character of human time" (7–8). Distinguishing humans as human, things also confer individual identity. The "things of the world," she goes on to write, "have the function of stabilizing human life, and their objectivity lies in the fact that—in contradistinction to the Heraclitan saying that the same man can never enter the same stream—men, their ever-changing nature notwithstanding, can retrieve their sameness, that is, their identity, by being related to the same chair and the same table" (137).[7]

Can a chair and a table be the source of identity? More traditionally, consciousness (and no thing) has been posited as the ground for establishing the sameness on which identity depends—the ground by which, in Locke's words, "a thinking intelligent being" can "consider itself as itself, the same thinking thing, in different times and places." "Consciousness always accompanies thinking," he writes, and "continued *consciousness*" unifies different states with "the present thinking being": "By this everyone is to himself what he calls *self*."[8] When, for William James, the object world comes to contribute to the "consciousness of self," it does so through the dynamics of possession. In contrast to Locke's "immaterial thinking thing," what James calls "the empirical self or me" becomes an aggregate that includes not only body and mind but also possessions: my "clothes and [my] house."[9] Now, although Arendt may adopt an em-

pirical resolution to the question of self-sameness, within her argument a psychology of possession plays no part. Still, the minimal identity that things grant (the stability of self) might be said to undergird—*to be the precondition for*—those practices of consumption, possession, and display through which objects mediate our relation to ourselves and to other human subjects, and through which (as sociologists, anthropologists, historians, and political scientists have variously explained) individuals express their individuality, their personality, their status—through which they mean to form and transform themselves.[10]

Which is why it makes sense to situate Arendt's investment in things, her studiously conceptualized account of the constitutive human investment, within the context of—and as the precondition for—the postwar object world: not only the proliferation of gadgets, the advance of mass manufacturing and mass marketing, and the international distribution of U.S. consumer goods, but also the incorporation of everyday objects within works of art (say, Robert Rauschenberg's "combines"), or the new status proclaimed for objects in poetry and fiction. *"Les choses sont là,"* Robbe-Grillet writes of the *nouveau roman* in 1956, insisting that photographic and filmic media have taught the novel about the sheer presence of things, which will now "renounce their pseudo-mystery."[11] Arendt can be recognized as responding to new phenomena within different cultural dimensions, much of which she comes to synthesize as the "relentless . . . *depreciation* of all worldly things" that constitutes "the waste economy in which we now live" (252–53, my emphasis). Just as the success of the satellite in 1957 represents a decisive step in man's alienation from his "immediate earthly surroundings," so too the postwar economy represents a decisive step in man's alienation from the world. If the former manifests the desire to "escape from man's imprisonment to earth" (1–2), to flee the boundaries of space, then the latter implicitly marks an unwitting (yet utter) capitulation to time.

Arendt's own *appreciation* of those "worldly things" informs her most general account of work—"fabrication, the work of *homo faber*, consists in reification"—and it informs her signal definition of art as the reification that, because of its permanence, serves as "the most intensely worldly of all tangible things" (139, 167). Without reference to Lukács, she aggressively retrieves the concept of reification from the Western Marxist tradition; and while, from her point of view, the character of things as things may be lost within the field of consumption, that character—the stable and stabilizing force of things—remains evident, clearly, within the field of art.[12]

Such an appreciation for things is also registered, however fleetingly, in her postwar correspondence with Karl Jaspers—whom she had

not seen since 1933, and who had remained in Germany while she fled, first to Paris, then (in 1941) to New York. Writing in 1945, recounting his thoughts of her "moving on constantly from one room to another" since her departure from Germany, Jaspers describes the rooms in Heidelberg where he has continued to live: "the same rooms, as if nothing had happened. You could sit in the chair at my desk again the way you used to as a doctoral candidate."[13] She responds by saying, "What you wrote does indeed create that 'bright room' in which things once again fall into their proper place": "I think about your study . . . with the chair at the desk and the armchair across from it where you tied your legs in marvelous knots and then untied them again."[14] It is as though, in order to preserve Jaspers's identity, she must picture him in relation to (bound up with) the same chair and the same table: "things" in "their proper place." Whatever the risk of sentimentalizing a profoundly unsentimental thinker, it is hard not to sense the pathos of Arendt as a Jew in exile, "still a stateless person," who cleaves to no state but to a mise en scène—the same chair and the same table—as though the scene could preserve durability itself in the midst of momentous change.[15]

The realm of change, as depicted by *The Human Condition*, is most fundamentally the realm of natural forces and biological processes, those "devouring processes of life" against which the human artifice of the world provides some haven. But of course, by 1945, it was the world and not the earth, the man-made as opposed to the given, that stood out more dramatically, more tragically, as the scene of mutability. Jaspers writes that "everything is different" and that the bright room with the same chair and the same table amounts to "a ghostly continuation of externals from the past into this transformed world." "What," he asks, "can we rebuild out of this chaos?" He may be "optimistic," but only "provided world history does not just roll over and destroy us."[16] Arendt herself was not an optimist. Her very use of "man" to designate all humans could well be underwritten by the fact that (as she put it before delivering the lectures that became *The Human Condition*) atomic war had transformed "the individual mortal man into a conscious member of the human race" because it has left "*everybody* . . . frightened."[17] Indeed, though she goes on to cast the artificial satellite as an event that is "second in importance to no other, not even the splitting of the atom," she nonetheless grants that it was the "first atomic explosions" that created "this modern world" (6). Not only does nuclear technology have the capacity to "destroy all organic life on earth"; it has already undone the relation between world and earth, and that between earth and cosmos (150). For "instead of carefully surrounding the human artifice with defenses against nature's elementary forces, keeping them as far as possible outside the man-made

world, we have channeled those forces, along with their elementary power, into the world itself" (150). And this has meant concocting—on earth—"forces such as occur only outside the earth," "energy processes that ordinarily go on only in the sun"; it adumbrates a "future technology [that] may yet consist of channeling the universal forces of the cosmos around us into the nature of the earth," and thus in fact altering what any of us could ever mean by *earth* (150, 262, 150). Presented with this case, as with the case of Sputnik, Arendt discloses her basic experiment in political ontology: the effort to determine whether the distinctions marked by terrestrial and celestial, natural and artificial, earth and world can still be heard to characterize human existence—and thus to summon humanity back to its existence. Or whether her "description of the fundamental articulations of the *vita activa*"—derived from the Western tradition, and singularly from ancient Greece—has simply become anachronistic.

In the twenty-first century, we have become accustomed to the fact that (in Arendt's terms) the world—quietly, at times, however certainly—is destroying the earth, and no less accustomed to the idea that the earth, however given, is subject to our making, an extension of the human artifice. As Arendt herself argues elsewhere, it has become all but impossible for man to "encounter anything in the world around him that is not man-made and hence is not, in the last analysis, he himself in a different disguise."[18] Some future struggle within and against this toxic reification, this anthropocentric worlding of earth into some thing other than earth, will no doubt be viewed (by some) as the planet's effort to regain its autonomy. It is hardly surprising, then, that the object world seems to have commanded a new kind of attention—that its imperatives have been felt as newly imperative across a spectrum of fields and disciplines. This is not to assert (or to suppose) that such efforts routinely include—as Arendt's own effort does—any consciousness of their setting, of their contemporaneous world, of the things that compose that world or that threaten that world's composition. Since *The Human Condition* appeared, though, it has been a familiar resource when, in different realms of scholarship, our relationship with things appears *at one and the same time* to be a problem and a possibility. In *The Meaning of Things*—an ethnographic effort to analyze how urban Americans understand the "role of objects in people's definition of who they are"—Mihaly Csikszentmihalyi and Eugene Rochberg-Halton framed their argument with the question of human survival and the specific dilemma posed by the energy crisis of the 1970s, which was for them the most recent evidence of the "vicious circle in which [humanity's] unlimited appetite devours the world on which its life depends."[19] It is their hope that mankind can develop and deploy the "symbolic energy" of things before the very

possibility of a "meaningful relation to objects" has been fully foreclosed by "rampant materialism" (247). The basis of that meaningful relation they find expressed in Arendt's conviction, simple and august, that "the things of the world have the function of stabilizing human life" (137).

2. Subject-Object

You can read *The Human Condition*, then, for its radical appreciation of things—its grasp of the object world as the human artifice "relied upon to house the unstable and mortal creature which is man." But you can't really argue that it's a book about things. It is, as Arendt reported to Jaspers, a book about "labor—work—action in their political implications."[20] It is a book about the indignity of labor, and the profundity of work, with the work of art so adamantly extricated from the means-end logic of a productivist rationality that it appears (in the book's most awkwardly subtle formulation) not as the product of thought, but as the interruption of thought (170). More simply, it is not a book about things because it does not ask *the question of the thing*, as Heidegger does. Indeed, given how readily Arendt adopts her former teacher's distinction between earth and world, for instance, her elision of the question seems even willful. Political theory, you might assert, can't afford to indulge in metaphysics. Indeed, though she patiently retrieves and revivifies fundamental Greek formulations (above all the difference between *oikos* and *polis*), she never focuses on Aristotle's "discovery of things," as Wolfgang-Rainer Mann captions it: that momentous interruption of the Platonic account of reality that had not "recognize[d] things as things," the Platonic ontology that grants sensible things only "*ersatz* being."[21] Aristotle himself does not present his thinking (in the *Categories*) as such an interruption or as a discovery. As Mann explains, the novelty of his realist metaphysics has gone unappreciated because those metaphysics soon became common sense.

Of course, such *common sense* has been repeatedly challenged, abandoned, or reconfigured—in ways that compromise Arendt's overarching claims for what things do for us. For if you "retrieve" your sameness (that is, your identity) through your relation to the same chair and the same table, then by what means do you retrieve the sameness of the chair, the sameness of the table?[22] How do you recognize them as chair and table? How do you see and re-see them as what they are? Things may seem to stabilize human identity, but they themselves have been distinctly desta-bilized in the Western tradition.

It may be, in fact, that Arendt forecloses (in haste) this nagging ques-

tion of the thing while she argues against Marx, against his failure to differentiate between labor and work, and his corollary failure to imagine a thing's worth, before or beyond its value. For even if the concept of use value can be deployed to preserve some sense of the object's concreteness over and against the abstracting power of exchange, she notes, it nonetheless dissolves "every tangible thing . . . into mere function" (160). Marx has no truck with "the instrinsick natural worth" of a thing that Locke contrasts to mere value; he is unable, Arendt specifies further, "to summon up the 'intrinsick' objective worth of the thing in itself" (165). By phrasing the matter this way, she voices objection not just to Marx but also, from a different angle, to Kant, who relegates the thing-in-itself (*das Ding an sich*) to the noumenal realm that remains inapprehensible to the subject, who, given the spatiotemporal and causal structuring of experience, has access only to the phenomenal realm of appearances, the realm of constituted objects from which things-in-themselves remain elusive. Such a distinction, from Arendt's point of view, has crippled the philosophical endeavor.

It is not Kant, though, but Descartes whom she singles out (along with "the most persistent trends in modern philosophy since Descartes") as the party responsible for "world alienation," in which men share "not the world but the structure of their minds" (254, 283). Those trends in philosophy have provoked the second half of the "twofold flight from the earth into the universe and from the world into the self" (6), what José Ortega y Gasset called (in 1914) the "subjectivism" that should be recognized as "the original sin of the modern epoch."[23] Arendt herself cites Alfred North Whitehead's conviction that "the assumption that the mind can only know that which it has itself produced and retains in some sense within itself" amounts to the "retreat" of "common sense."[24] Common sense, in Mann's understanding of Aristotle, may thus be said to remain very much the point. From Arendt's perspective, however, the point is that, because of this retreat, "philosophy suffered more from modernity than any other field of human endeavor" (294). It has suffered because it so profoundly limits its field of legitimate inquiry: the "disappearance of the sensually given world" turns philosophy into a "theory of cognition and psychology"; it turns philosophers into "epistemologists" (288, 293, 294). The skeptical tradition effectively prohibits access to the world: far from believing in the world's immortality, the philosopher remains unsure that it is "real" (320). Meanwhile, science has had no trouble pressing on, daunted neither by philosophical skepticism nor by the conceptual acrobatics (say, the positing of a transcendental subject) by which that skepticism is supposedly overcome. By abandoning the world as it has been given to the senses, philosophy capitulates authority to science.

But philosophy has more recently deployed the authority of science in the explicit effort to shake off the Kantian hangover, to escape the subject, to release itself from what Arendt calls the "shackles of finitude" (265), and to abandon epistemology in behalf of ontology.[25] Quentin Meillassoux points very simply, in *After Finitude*, to the perplexity that science poses with the "arche-fossil": those scientific statements about events that precede human presence on earth, and indeed the fossil-record of life on earth.[26] For on the one hand, in this account of the Kantian tradition, our apprehension remains confined to "the correlation between thinking and being"; no object can be fathomed as an autonomous, self-subsisting entity, because the act of thinking cannot be adequately separated from its content; we can only engage what is given to thought. And yet, on the other, science repeatedly thinks what is independent of thought, what precedes givenness. To borrow Don DeLillo's line from *Falling Man* (with which my first chapter began), science has no difficulty telling us "what things look like when there is no one here to see them," no difficulty speaking about things that are independent of and indifferent to human perception and cognition, about things lying outside the correlationist scheme. Science has no misgivings about teaching us history without the human. The point, Meillassoux insists, is not about the realism of science, but "rather that science deploys a process whereby we are able to *know* what may be while we are not"—a process of rationalizing and mathematizing questions about what occurs in the before-and-after of humanity (114–15).[27]

He historicizes the point with melodramatic flair: while Kant (in his preface to the second edition of the *Critique of Pure Reason*) understood his exposé of the limits of reason as a Copernican revolution, Meillassoux recasts this event as a "Ptolemaic counter-revolution" that relocates mankind as the stable center of the known universe, making "the object conform to our thought," and thus effectively reversing "the Galilean-Copernican decentering wrought by science": just when "thought realized for the first time that it possessed in modern science the capacity to actually uncover knowledge of a world that is indifferent to any relation to the world, transcendental philosophy insisted that the condition for the conceivability of physical science consisted in revoking all non-correlational knowledge of this same world" (*AF*, 118). While science has succeeded in telling us more and more about the earth in our absence, philosophers—as Arendt had lamented—have been "remorselessly exposing the bounds of knowledge ever more stringently within the limits of humanity's present situation" (*AF*, 121). Meillassoux concludes his manifesto by pointing toward new philosophical objectives: on the one hand, to determine why it has been possible to assert knowledge outside the

correlationist scheme, and, on the other, "*to get out of ourselves*, to grasp the in-itself, to know what is whether we are or not" (*AF*, 121). In a phrase: to get over the subject. Though he describes his inquiry as "resolutely *precritical*" (*AF*, 3), Meillassoux adopts not a naive realism but what he calls "speculative materialism," which retains respect for the rigors of correlationism and insists on contingency, the possibility that things could be (could yet prove to be) other than they are.

Through an altogether different engagement with science—through the anthropology and sociology of science, and what has come to be called science studies—Bruno Latour had already drawn attention to objects in a demand that we overcome the subject-object divide: what he repeatedly designates as modernity's stubborn phantasm.[28] Only the "extraordinary form of radical realism" that characterizes science studies can begin to assuage that "catastrophe from which we are only now beginning to extricate ourselves": the catastrophe that unfolded under the banner marked Kant, which was only exacerbated when "society" took the place of the transcendental ego: "Instead of a mythical Mind giving shape to reality, carving it, cutting it, ordering it, it was now the prejudices, categories, and paradigms of a group of people living together that determined the representations of every one of those people."[29] In his effort not just to grant objects their manifest reality but also to demonstrate their role as participants—actants—in sociality, Latour has repeatedly specified that his objective is not to grant things subjectivity "but *to avoid using* the subject-object distinction *at all* in order to talk about the folding of humans and nonhumans" within one or another actor network (*PH*, 194).[30] Despite sharing an attraction to Whitehead, then, Latour's political ecology must object to Arendt's political ontology: he must object to her distinction between earth and world, for instance, her segregation of nature, her technophobia, and her humanism.

However devastating Latour means to be to the subject, it is from the object's point of view (if you will) that Graham Harman distinguishes his own exuberant object oriented philosophy from Latour's "flat ontology," where all human subjects and nonhuman objects have been recast as actants, the relations among them (and the enfolding of human and nonhuman) taking precedence over any discrete entity. The "more we define a thing by its relations," Harman writes, "the more we strip it of autonomous reality."[31] He had confronted much the same problem in Whitehead, who "ends up devouring" the "integrity of individual objects" within a "total system of relations."[32] What must remain elided, then, is what you could call the object's relation to itself (a relation *within* rather than a relation *between*), indeed the tension (at times quite a classical tension, the tension that Heidegger always found insufficient) be-

tween the object and its properties.[33] Heidegger, in his essay on the work of art, had extended a point he made about equipment in *Being and Time*, explaining not only that the "unpretentious thing evades thought most stubbornly," but also that such "self-contained independence" may well belong "precisely to the nature of the thing."[34] It is the nature of the thing to be evasive. Harman transposes the claim into an account of the *real* object, which (as opposed to its qualities, accidents, relations, moments, &c.) always withdraws, both from humans and from other objects. While Latour considers an object to be "nothing more than its sum total of perturbations of other entities," Harman focuses on the "mysterious residue in the things hiding behind their relations with other things" (*Bruno Latour*, 158), the residue that amounts to the intrinsic object itself, which (like the Heideggerian thing if not indeed like the thing-in-itself), always "stands apart" (*Bruno Latour*, 208).

While Latour works within and against a sociological tradition, Harman works within and against a phenomenological tradition, taking the study of the object's manifestation to human consciousness and effectively extending this to a study of the manifestation of objects to one another (independent of us), which remains a study of what, in those relations, remains withheld. His world is "filled with a single genre of reality known as objects"; this is a world characterized by its own ontological flattening, between what we commonsensically call the material and the immaterial, the real and the imaginary (including centaurs, literary characters, and concepts).[35] In an Arendtian mode, you might call this a retreat into objects—or into the object—that can provide no purchase on ontological history, or on the historical question of how a nonhuman object world forms and transforms the human. Indeed, he is willing to risk the conceptual danger of panpsychism (granting the powers of thought to everything), because it is "greatly outweighed by the truly perilous risk of preserving the dominance of the human-world split" (*Bruno Latour*, 212). Object Studies has been willing to assert that "flat ontology is an ideal."[36] Insofar as the field achieves that ideal, it compromises any contribution it might have made to the study of the inanimate object world, of material culture, of the artifactual, of the nonhuman, all of which that achievement would effectively conceptualize out of existence. The greater risk, in any dash to do away with Kant, amounts to epistemological hubris: reinstalling dogmatic claims to all kinds of knowledge untempered by any diffident recognition of the bounds of *human* knowing, the forms of *human* intuition, the limits of the all-too-human subject. This is why Andrew Cole has explained that the energy of this so-called realist project plainly derives from idealism and mysticism.[37]

Where does this leave us—leave you, leave me? Refreshing as such

thinking has been in its attention to objects—objects anterior or ulterior to human thought (Meillassoux), objects undifferentiated from subjects within a network (Latour), objects whose mysterious depths are comparable to the depths of human objects (Harman)—there are any number of ways in which we might plead against the retreat into the object, and plead in behalf of not yet abandoning the subject so simply or quickly. Indeed, there are ways in which we might be said to be stuck with, or *stuck to*, certain subjects (you, me) no matter what twenty-first-century solvents can now be downloaded. But the subject-object dichotomy and the dynamics of that dichotomy need not compromise a realist metaphysics and need not be scripted by the authority of Kant, Hegel, or Husserl, as Alfred North Whitehead showed at length. He makes it clear that subject-object is not a permanent installation, that the terms themselves are relative and emerge within an occasion: "An occasion is a subject in respect to its special activity concerning an object; and anything is an object in respect to its provocation of some special activity within a subject."[38]

More bluntly, the anthropologist Daniel Miller (trained as an archaeologist) has argued that because anthropology begins with an "empathic encounter with the least abstracted and most fully engaged practices of the various peoples of the world," it cannot afford philosophy's effort to overcome familiar dualisms. By this he means that the anthropologist is stuck with the subject-object duality and must in fact "strive for the vulgarity that philosophy necessarily eschews."[39] In what sometimes feels like an era of irresponsible interdisciplinarity, such a division ought to make good sense: distinct disciplines constitute their objects of analysis distinctly, after all, and each has its own protocols for generating knowledge effects (for constituting what will count as knowledge). Nonetheless, within the collection that Miller introduces, *Materiality*, the contributors themselves don't adopt the vulgarity he espouses. Lynn Meskell, for one, by focusing on the agential force of ancient Egyptian statuary, explains how the boundaries between subject and object collapse in an ontology that may "impinge upon our own contemporary and profound debates about subjects and objects," including Latour's debate with the subject-object binary.[40] Whether Meskell expects her readers to appreciate the idiosyncrasy of ancient Egypt, or to appreciate how the ancient Egyptians got it right (transculturally and transhistorically) by extending agency to the object world, she makes it clear that archaeology need not (or must not) leave the subject-object binary in place. Indeed, you could say that the anthropologist's and the historian's attention to "the practices of various peoples" has traditionally exposed the insularity of modern, Western thought: Haïda spoons, like Kwakwaka'wakw dishes, are "animate things"; the legendary Nine Tripods of ancient China were

considered to be animate and to possess consciousness; in medieval Europe, wooden figures "moved, wept, sweated blood."[41] The history of anthropology, as Alfred Gell emphasized, is a history of defamiliarizing the concept of "persons" and of charting how "things" achieve a kind of personhood.[42] Anthropology, like history, is a field that makes the very idea of not-being-modern make sense.

Yet a residual commitment to such binary thinking can be sustained on other grounds than the anthropologist's. While abandoning the subject-object dichotomy—or, indeed, abandoning the subject—has the distinct advantage of foregrounding the object world, it has the disadvantage of making it impossible to locate individual human agency. And when Latour writes, trenchantly, of "democracy extended to things themselves," of a new democracy of persons and things, those claims can't help but be haunted by the fact that we don't yet enjoy democracy among persons.[43] And even as the combination of science, organization, and industry render nonhuman entities articulate—"Nonhumans are endowed with speech, however primitive, with intelligence, foresight, self-control, and discipline, in fashion both large-scale and intimate"— so too that very combination has a history of rendering human entities mute (PH, 204).[44] More simply, the homogenizing ontology seems to square not so much with Marx's understanding of how capital reifies persons and personifies things, but with the more recent chapter of Capital where maximizing profit has meant minimizing human participation to the point of threatening to render the human obsolete: where phone trees, automated tellers and checkers, robotic mechanics, drones, and additive manufacturing (3-D printing) challenge (if I may put it this way) the human right to labor—or, more eloquently, "the practical realization of labor as value."[45] If it is true that "sociology is not the science of human beings alone—that it can welcome crowds of nonhumans with open arms, just as it welcomed the working masses in the nineteenth century," then the question of the nonworking masses of the twenty-first century remains loudly absent.[46]

But such ethical and political quandaries (which are not quandaries I mean to pursue) have more recently been leavened by Latour himself as he argues that the "Subject/Object opposition is troublesome only if we take these two terms as distinct ontological regions"; for once we grant that each names a composite, "it ought to be possible to relocalize," to "mitigate this major issue of subjectivity and objectivity" that the "Moderns merely exaggerated," and to recognize the descriptive "convenience" of the binary.[47] Besides, those quandaries in no way diminish the trenchant validity of Latour's "pragmatogony": a time line on which he charts how the once-comfortable distinction between subjects and ob-

jects, humans and nonhumans, has given way, and will continue to give way, to "an ever greater level of intimacy and on an ever greater scale" (*PH*, 200–201). And yet that very time line—which is to say that history, which is an ontological history—also points to two obvious questions that loom over object oriented thinking as a whole. First: By showing how we have become, say, increasingly nonmodern, does this trajectory reinstall the kinds of periodization that Latour once eschewed by declaring that we have never been modern? Second: Given this trajectory, should we understand Latour's analytic as the mode by which to assess this increasing intimacy, or should we understand it, rather, as a *symptom* of that intimacy? Or both?

3. Human-Unhuman

To a question that came to be asked with increasing eloquence and urgency—"Why has the physical and 'thingly' component of our past and present being become forgotten or ignored to such an extent in contemporary social research?"—Latour provided acerbic answers.[48] "To become a social scientist," he wrote in *We Have Never Been Modern* (1991), "is to realize that the inner properties of objects do not count, that they are mere receptacles for human categories."[49] The problem derives from the tautological constitution of the social sciences themselves, the conviction that society provides its own infrastructure: "As soon as you believe social aggregates can hold their own being propped up by 'social forces,' then objects vanish from view and the magical and tautological force of society is enough to hold *every thing* with, literally, *no thing*."[50] The very idea of the social (let alone social construction) effaces the object world from (and far beyond) the social sciences. Most simply, Latour defines modernity itself as the project that established different "ontological zones," radically distinguishing—despite their ongoing interdependence, their de facto imbrication—the human from the nonhuman.[51] This is why my opening chapters provoke the conclusion that modernism always knew that we have never been modern. Whether you consider the constructivist effort to overcome the "rupture between things and people" by "dynamiz[ing]" the thing into something "connected like a co-worker with human practice," or you confront the objects that act and speak on their own in the Circe episode of *Ulysses*, or you linger in front of Man Ray's *Object to Be Destroyed*, you experience modernism's persistent effort to blur (or expunge) the lines of modernity's ontological map.[52]

Indeed, in his effort to lead a "Copernican counter-revolution" that refuses to acknowledge the gap between "things-in-themselves" and

"humans-among-themselves," Latour contends that "sociologists need as much variety in 'drawing' actors as there are debates about figuration in modern and contemporary art."[53] This is a counterrevolution that means to have political, specifically democratic results, with democracy newly conceived by "adding a series of new voices to the discussion, voices that have been inaudible up to now": *"the voices of nonhumans."*[54] Idiosyncratic as such a claim may seem, it is a version of the democracy that alarmed Flaubert's original readers, whom Jacques Rancière credits for perceiving what more recent readers (notably Sartre) failed to see—a literary regime in which "material things" and "human beings" enjoy the same importance: "Flaubert's disregard for any difference between high and low subject matters, for any hierarchy between foreground and background, and ultimately between men and things, was the hall mark of democracy."[55] This is a regime in which "mute things speak better than any orator," things like the conglomeration of objects ("furnishings, inventions, fashions, works of art and relics") in the antique shop at the opening of Balzac's *La peau de chagrin* (1831), all adding up to "an endless poem" ("Politics," 18–19). Rancière insists, moreover, that the "Balzacian paradigm of the shop as a poem had to exist first, to allow for the analysis of the commodity as a phantasmagoria"; "Marx's commodity"—arguably now the most famous of all speaking inorganic forms—"stems from the Balzacian shop" ("Politics," 21).

Rancière's literary history can provoke two further points. For of course previous literary-object orators were anything but mute: indeed, if those objects that voice the Anglo-Saxon riddles of the tenth-century *Exeter Book* (a loom, a shield, a plow, a bucket, a helmet, &c.) can be described as garrulous, then those that narrate the object autobiographies (or it-narratives) of the eighteenth century (a coat, a slipper, a pen, a hackney coach, several coins, &c.) must be considered verbose.[56] Prefaced by an epigraph from Lucretius's *De rerum natura* (a perennial source, then as now, for conceptualizing the life of matter), *The Adventures of a Rupee* (1783) begins with its own material vitalism:[57] "The sun saw me in the mountains of Tibet an ignoble lump of earth. I was then undistinguished from the clods that surrounded me by the splendor of my appearance, or by the ductility of my substance; but I contained within myself the principles of my future form, and . . . by degrees I assumed color and other qualities which I had not before." As for Lucretius himself, George Santayana made the relevant point in 1910: "The great thing about this genius is its power of losing itself in the object": "We seem to be reading not the poetry of a poet about things, but the poetry of things themselves"—of "their own movement and life."[58] Such articulate objects would seem to pose a particular question to the regime Rancière addresses: for has it

not in fact muted the object world while compensating with an exten-sive sign language that preserves the mere *legibility* of objects? Further, even if Marx could hear the voice of things in Balzac, did he not recog-nize that such a voice was being drowned out by the voices of commodi-ties—that the enchantment of the object world had come to depend on the structure of the commodity? Just as inhabiting modernity has meant living in a world where, epistemologically, knowledge of things has been disaggregated from people and power, so too it has meant enduring the power of things in commodity form. This is why, throughout the book in hand, I find myself unable to focus on a particular potency of objects (named the *other thing*) without drawing attention to the field of con-sumer culture that perpetually obscures that potency.

Latour concerns himself neither with literary history nor with the his-tory of commodity fetishism (not a residue of the premodern but, let us say, its displacement). Though a more general freedom of agency and vocalization can be found in any number of literary texts (throughout the work of Philip K. Dick, for instance), his reimagination of the social is undergirded by narrative theory, by a semiotic formalization of agency within narrative as such. In particular, actor network theory redeploys A. J. Greimas's notion of the *actant*, an agential role without specific con-tent, enabling Latour to redescribe certain putatively inanimate objects (a key, a speed bump) as having agency (and no less agency than some human actor).[59] He then describes such actants (off the Greimassian grid) combining and recombining into various networks.[60] Once a student in Greimas's seminars, now an anthropologist who routinely teaches semi-otics, Latour considers Greimassian semiotics as "the organon, as a sort of tool box, if you wish . . . to treat questions of agency, questions of ob-jectiveness, questions of the careers of objects." It may be that "literature is the place where the freedom of agency can be regained," as he's said, but it would seem that, from his point of view, it is more precisely liter-ary theory that should be "to the social sciences what mathematics is to physics."[61]

As Greimas points out, though, narrative structures are "characteristic of the human imaginary in general."[62] The point is not just that "evene-mential syntax . . . is, whether we like or not, of anthropomorphic inspi-ration" (104), but also that the *actant* (however unhuman) as the subject of a *doing* has already been humanized. Indeed, Greimas maintains that doing is "doubly anthropomorphic": "As an activity it presupposes a sub-ject; as a message, it is objectified and implies the axis of transmission be-tween sender and receiver" (71). Critics of Latour who object to a "monist ontology of social actants" that remains anthropocentric—that fails to grant objects sufficient autonomy from the human—may simply have

stumbled into this infrastructural impasse within actor network theory: what Greimas recognized as the inescapable anthropomorphism of the actant as such.[63] Latour himself has belittled the "accusation of anthropomorphism" while pointing out, no less, that it is "inanimism that is the queer invention" within modernity.[64]

Thus, far from wishing to spend energy ferreting out human remainders in Latour's effort to think beyond the human, I'm interested in the way that the human has returned—differently—in his work, and the way in which that return sheds light—the light of history—on various efforts to do without the human-unhuman binary, as on the current attraction to ontology. It is as though his political ecology has come to clarify the content of a material unconscious that expresses itself in the attention (however various) to objects across the disciplines and arts. In obvious contrast to Hannah Arendt's experiment in reasserting classical distinctions, he has always experimented by discarding modern distinctions, with full and vibrant explanations of why the experiment should be undertaken and what he expects the practical payoff to be. He stands out among object-oriented scholars because he has pursued his radical de-taxonomizing in behalf of establishing new epistemological norms (and ontological claims, and political possibilities) by which to apprehend the distribution of agency in concrete cases—to understand, for instance, why a transit system wasn't implemented in Paris. He begins the *Politics of Nature* (1999) by arguing that those two concepts have "developed in such a way as to make any juxtaposition, any synthesis, any combination of the two terms *impossible*" (PN, 3–4). This is because what we know about nature has been mediated by science; it is a "scientific production"; and it is thus within (never outside) the cultural and political field. For this reason, then, the "very core of political ecology" must have "*nothing to do with nature*" (PN, 4–5), just as it must jettison the fact-value distinction and the human-nonhuman distinction. As part of his dismissal of nature in this text, he humorously ruminates: "There can be a Gaia science, a Gaia cult, but can there be a Gaia politics?" (PN, 5). More recently, though, he has very seriously returned to Gaia (adopted from James Lovelock) as both figure and fact: not as any substitute for "nature," but as a scientific term, a cosmological term, a term by which to caption the earth's systems and the distributed agencies within them, to identify an entity that is at once "sensitive" to what humans are doing and utterly "indifferent" toward them.[65]

He has turned to Gaia in response to the notion of the Anthropocene, what he calls that "amazing lexical invention by geologists to put a label on our present period." As an epochal designation, the Anthropocene helps to convey the scale of an ecological crisis posing questions that are

"too big," but a crisis "of human, all too human origins": the human is the "collective *giant*" that "has become the main geological force shaping nature." Pointing to the irony that the geologic argument "comes just when vanguard philosophers were speaking of our time as that of the 'posthuman,'" Latour recognizes that the geologists confront us with "anthropomorphism on steroids." On the one hand, then, this hardly seems the hour to abandon the specificity of the human, for to do so elides the earthly actant that, like no other, has come to transform the planet. On the other, given the anthropogenic origin of climate change, it is increasingly difficult to distinguish *anthropos* from its environs, to distinguish the world from the earth. Although Latour does not put the matter this way, Gaia might be said to name the subject-object (which is no unified agent) of unhuman history, which is a history that, precisely by being unhuman, retains the human within it. This is the history in which *anthropos* comes to find itself (and now to recognize itself) relegated to the role of object within a vast assemblage.

However stridently Hannah Arendt reasserted her fundamental lexicon—her distinction between the world and the earth, for instance—her work makes it clear that she recognized how, in the middle of the twentieth century, that lexicon was losing its purchase. Human history had already produced an unhuman condition wherein political ontology had begun to lose its footing. She believed that "experiences of worldliness," for instance, had been increasingly denied to "ordinary human experience," and thus that the faculties of "making, fabricating, and building" were increasingly "restricted to the abilities of the artist" (323). Increasingly, the artist alone served to illustrate and to embody *homo faber*. This is why she adds an extraordinary final note in *The Human Condition*, a non sequitur in which she aggressively specifies that the "inherent worldliness of the artist" is unaffected by the nonfigurative turn in art that dispenses with the "representation of things": "to mistake this 'nonobjectivity' for subjectivity, where the artist feels called upon to 'express himself,' his subjective feelings, is the mark of charlatans, not of artists." The objective of the artist remains "reification": "The artist, whether painter or sculptor or poet or musician, produces worldly objects" (323n87). But just as her account of the stability that things grant man necessarily elides the instability of things themselves (and the vacillation between the object and the thing), so too her claim that art *is* reification would seem to foreclose the access that art gives to reification, to the dynamics of thingification itself, as to the thingness disclosed by those dynamics. Sculpture is not an object but "the study of objects," as Michael Heizer insisted; it is "also a study of materials."[66] And aesthetic experience, as Hans Ulrich Gumbrecht has argued, is a matter of "getting lost" in "the oscillation be-

tween presence effects and meaning effects."[67] The artwork is not just a "worldly object"; it is also an object that discloses a world, even when the world can no longer quite distinguish itself from the earth.

About a decade after Arendt published her lectures as *The Human Condition*, Heizer and Robert Smithson produced those iconic earthworks, *Double Negative* (1969–70) and *Spiral Jetty* (1970), with which I began this section of the book. Both works are legible as the expressions of a kind of egomania, the American artist's phallic assertion of his will on the face of the earth. From Arendt's perspective, the point about them would be, rather, that they are acts of reification, the production of worldly objects. Yet the independent worldliness of the objects—art understood as "the most intensely worldly of all tangible things" (167)—is not easy to fathom because of their integration with the earth: indeed their material and phenomenological presence as earth. "I think the earth is the material with the most potential because it is the original source of material," Heizer explained, but not without addressing the world, describing a "sensibility" founded "on a feeling that we [are] coming close to the end of the world." In 1972, when he began to construct *City*, the massive complex in the Nevada desert, he did so on the edge of a nuclear testing site, which is to say on the edge of history as we know it: "We're probably living at the end of civilization."[68] Such site specificity transforms the work as such into one of what Smithson designated "sites of time."[69] Alongside that designation he makes an insistent (though unconceptualized) distinction between the object and the thing. He objects to the way that the market necessitates the "art object," whereas the artist produces "*things* in a state of arrested disruption" (112, 106, his emphasis). As though in oblique response to Arendt's celebration of the artwork's stability, he considers "objects" and "shapes" to be "convenient fictions" (112). When instead "a *thing* is seen through the consciousness of temporality," it discloses an "uncertain disintegrating order" (112, his emphasis). By his light, the work of the work of art is to "explore the pre- and posthistoric," to "go into places where remote futures meet remote pasts" (113).[70] If it is not in some unconscious and unanticipated tribute to Gaia, such a work of art nonetheless anticipates our current striving to think unhuman history.[71]

Six

Object Relations in an Expanded Field (Myla Goldberg/ Harold Searles)

For Barbara Johnson

It seems to me that, in our culture, a conscious ignoring of the psychological importance of the nonhuman environment exists simultaneously with a (largely unconscious) overdependence upon the environment.

HAROLD SEARLES, *The Nonhuman Environment* (1960)

Under the spell of shape-changing, anything can become anything at any moment, and the world around us may contain the ghosts of the stories that we no longer know. The relation between persons and things grows more uncanny.

BARBARA JOHNSON, *Persons and Things* (2008)

I ended the previous chapter by hearing the artist's voice from the sixties as an adumbration of a current concern with unhuman history. This is a history that, on the one hand, means to suspend the distinction between human and nonhuman, subject and object, earth and world, as it extends the chronological frame beyond that of the species (but which, on the other, marks *history* as a necessarily human perception). Of course, art as such, and particularly modern art, has been said to depend on blurring distinctions, on dissipating boundaries. Anton Ehrenzweig, for instance, developing a psychoanalytic perspective on artistic creativity (which he used pedagogically), describes a "'manic-oceanic' phase in creative work," a requisite "dedifferentiation," which he defines as "the dynamic process by which the ego scatters and represses surface imagery."[1] Contesting gestalt psychology's emphasis on form, he focused on a deform-

ing process in *The Hidden Order of Art* (1967): "Creativity can almost be defined as the capacity for transforming the chaotic aspect of undifferentiation into a hidden order that can be encompassed by a comprehensive (syncretistic) vision" (127). The "aggressive fragmentation" of modern art amounts to "outright attacks on conscious order and reason" (70); it exemplifies the "extreme de-differentiaton in lower levels of the ego which occurs during creative work" (294).

Though he believed, in 1967, that "modern art [was] dying" (69), younger artists welcomed the book as a confirmation of their own insights and ambitions. Publishing "A Sedimentation of the Mind: Earth Projects" the following year, Robert Smithson made repeated reference to Ehrenzweig's overarching concept as a way to recaption the fragmentation, erosion, and entropy that were the focus of his own attention: the "'primary process' of making contact with matter ... called by Anton Ehrenzweig 'dedifferentiation.'"[2] "At low levels of consciousness," Smithson transposes, "the artist experiences undifferentiated or unbounded methods of procedure," wherein tools are "undifferentiated from the material they operate on, or they seem to sink back into their primordial condition" (102). To convey the idea, he recounts his visit to a slate quarry in Pennsylvania, where "all boundaries and distinctions lost their meaning," with the present falling "forward and backward into a tumult of 'dedifferentiation'" (110).

Smithson distinguishes art from the "mere object"; he distinguishes the "*thing*" from the mere art object, "the object get[ting] less and less but exist[ing] as something clearer" (112); and he considers "the mind and things of certain artists" to be "not 'unities,' but *things* in a state of arrested disruption" (106). Nonetheless, his account of the quarry points to a dedifferentiating experience beyond the generally recognizable bounds of art. And Ehrenzweig acknowledged that the process is hardly restricted to the artistic imagination, to the endeavor of art, even if it typically "occurs only in deeply unconscious levels and so escapes attention" (295). For him, teaching art was a matter of encouraging students to gain access to those levels.

This chapter focuses on a kind of dedifferentiation, at once exhilarating and chilling, that unfolds within the subplot of Myla Goldberg's *Bee Season* (2000), where a woman experiences a kind of intimacy with objects so strong that the subject-object boundary seems to disappear. Her life can be read as a retreat into objects—a retreat provoked by her childhood encounter with one object, a kaleidoscope. It can be read as an illustration of dedifferentiation within everyday life. But though Ehrenzweig's account of the creative imagination could be used to understand some aspects of the character (and though she becomes a kind of art-

ist), I turn instead to the work of Harold Searles, a psychoanalyst who breaks the paradigm of object-relations theory as developed by Melanie Klein. He expands the theory by insisting that an object of cathexis need not always be, nor stand in for, a human subject. Helping to disclose the limits of traditional psychoanalysis, he also helps to clarify the dynamics by which an object can assert strange power over a human psyche. In the case of Goldberg's novel, this is an object—the kaleidoscope—that has enjoyed a long history as a powerful trope; within the pages of her world it becomes some thing else.

1. Novel Objects

When David Brewster invented the kaleidoscope in 1816 (originally de-signed to produce theatrical phantasmata), he could hardly have pre-dicted the impact. Two years later, though, reporting on the "univer-sal mania for the instrument," Roget, the physician and lexicographer, remarked that "no invention, and no work, whether addressed to the imagination or to the understanding, ever produced such an effect."[3] Brewster had in fact hoped that his invention, producing a "magical union of parts" (as he put it) would offer more than a means of enjoying "rational amusement" or of assisting in the "ornamental arts."[4] He hoped it would become a "philosophical instrument" (6).

It became such an instrument in the hands of Charles Baudelaire, one means of getting at the psychology of modern life. He likens the "perfect flâneur," who takes joy in the urban masses, to a "kaleidoscope gifted with consciousness," responding to each movement "by reproducing the multiplicity of life and the flickering graces of all the elements of life." The kaleidoscope figures the way a certain cosmopolitan "I" absorbs and refracts the "non-I."[5] ("C'est un moi insatiable du non-moi.") Henri Berg-son used the kaleidoscope to figure the point of perception—the body— in the midst of a system of images that shift utterly with the slightest change in that point; and for Marcel Proust, "the shifting kaleidoscope of the darkness" forms part of Marcel's sleeping/waking/dreaming state.[6] Walter Benjamin, writing about Baudelaire, considered the kaleidoscope to be an invention that could—like the telephone, the camera, and film— both provoke and figure the experience of modernity as a sequence of shocks.[7]

For Claude Lévi-Strauss, though, it was not modern life but *la pensée sauvage*, not flânerie but bricolage, that could be best understood with the kaleidoscope's help. Recharacterizing "the thought we call primitive" as a "thirst for objective knowledge" that orders the world systematically,

and eager to imagine this "science of the concrete" as concretely as pos-sible—to emphasize how, as he goes on to write, "savage thought" is char-acterized both "by a consuming symbolic ambition . . . and by scrupulous attention directed entirely toward the concrete"—he epigrammatically maintains that the bricoleur "speaks not only *with* things . . . but also through the medium of things."[8] He soon gets his hands on a thing to speak with and through. The kaleidoscope, an "instrument" that "con-tains bits and pieces by means of which structured patterns are realized" (36), is an apparatus, a medium, that figures not only mythical thinking but his own thinking about the mythical, his own fragmentation and re-organization of mythemes into a recognizable system.

Yet, even as the kaleidoscope provides a concrete illustration of mythi-cal and magical and anthropological thinking, it nonetheless might be said to illustrate a dematerializing operation: it shows how "concrete logic" can dissolve material properties. The fragments, which "can no longer be considered entities in their own right," form a "new type of entity" where "signs assume the status of things signified" (36). In other words, the pattern, the design, the specular form—this has become the content; the simulacrum has become the object. That particular shard of glass—cobalt blue—is, in itself, beside the point.

Regardless of how well the kaleidoscope explains *la pensée sauvage*, the figure of the kaleidoscope helps to metaphorize why structural-ism has been repeatedly charged with effecting a transition in French thought, circa 1960, away from an engagement with material culture. Kristin Ross's account of this transition in the work of Roland Barthes (a transition marked by the difference between *Mythologies* [1957] and *La système de la mode* [1967]) is, in a word, kaleidoscopic: "Structural man takes the real, decomposes it, then recomposes it in view of creating the general intelligibility underlying the object; he creates the object's simulacrum."[9] The operation of the kaleidoscope helps to dramatize the urgency with which more recent anthropology has worked so hard to prevent us from "overlook[ing] the material properties of things" and to recognize how those properties complicate or compromise "semiotic deployment."[10] You might simply call this the persistence of some post-structuralist attention to the materiality of the signifier, but the differ-ence lies, of course, in the fact that such attention is no longer restricted to the word; this is no longer, to borrow a phrase from one of Derrida's descriptions of Paul de Man, "materialism without matter."[11]

This "new materialism," as it is sometimes called, has by now taken hold not just in anthropology but also in the history of science, art his-tory, literary criticism and literary history, sociology and political theory. But rather than charting these recent trajectories, I'd like to keep hold

of the kaleidoscope, which reappears as a different kind of philosophical instrument in Myla Goldberg's *Bee Season* (2000). When a little girl named Miriam peers into her new kaleidoscope, she suddenly "forgets to breathe." She is "prepared to spend the rest of her life holding the cylinder to her face"; she "wishes she could squeeze through the eye-hole and into the tube, joining the flawless symmetry." Her seventh birthday ends, then, as an overwhelming success. "By the time Miriam goes to bed, the kaleidoscope clutched to her chest, she has decided that where there is a window there has to be a door."[12] Through such a window she can perceive a world of exquisite arrangement, a world where any fragment achieves its self-transcendence. This is no mirror-stage, wherein a toddler, identifying with the image, mistakes *its* coherence for his own fragmented self. Instead, Goldberg dramatizes some kind of kaleidoscope-stage, when a child discovers just how perfect the object-world can be. But when the window becomes a door, she enters no kaleidoscopic world. Rather, she begins to inhabit a kaleidoscopic worldview: a view of the world as ill-arranged, awaiting its recomposition, awaiting its perfection, what Brewster had called the "magical union of parts."

I'd like to read this novel—or rather, this subplot from the novel—as a way of engaging another field that, like anthropology, seems to embrace objects only to let them go. And yet, within that field—psychoanalysis—there is one figure, Harold Searles, who devoted one book, *The Nonhuman Environment* (1960), to "the significance of the nonhuman environment in man's psychological life," a significance that had been ignored in favor of the inter- and intra-personal.[13] I'm wondering, as my title suggests, what a theory of object relations could accomplish if, as in much recent anthropological work, it turned its attention to things. Thus, after addressing the elision of artifactual objects from object relations, I'd like to pursue their recuperation in Searles's aberrant line of thinking, and to preserve the aberrance of that thinking when it comes to understanding why Miriam, the child thrilled by a kaleidoscope, grows up to live a secret life of longing, a life of longing *for* things and for a perfection achieved *through* things, a life that her family cannot comprehend. On the one hand, this appears as a pathological desire to be absorbed within the unhuman, the inanimate object world, and thus to eschew human responsibility. On the other, it appears as the responsible recognition that "inanimism" is, as Bruno Latour puts it, a singularly odd modern invention; hers is a fulsome apprehension of the composite character of subject and object both.[14]

2. Object Relations

Of course, the novel as a genre, the novel as such, has been perennially understood as a written relation to the nonhuman environment. John Richetti reasserts a familiar point, a point of Allen Tate's and Ian Watt's, in his introduction to a recent edition of *Robinson Crusoe*, arguing that "realism derives much from the Latin word *res* (thing, object, matter), and [that] *Robinson Crusoe* is a pioneering work of modern novelistic realism because Defoe renders for much of the narrative the force and feel of Crusoe's material and phenomenal world with an unprecedented density and fine-grained immediacy and intricacy."[15] One of the great mysteries of literary history (literary history tout court) is why, almost three hundred years later, most novels still assume this burden of rendering the force and feel of the material and phenomenal world.

Even a novelist responsible for redirecting the genre away from realistic poetics, "away from the observed object toward the observing subject, away from exterior description toward inner apprehension," to borrow Alex Woloch's formula for what happens in the modernist novel,[16] even Virginia Woolf famously found herself mesmerized by Defoe's reality effects, as I pointed out in chapter 2. Writing about *Crusoe* in the 1920s, and clearly bored by sociological accounts of the rise of the novel, she admitted that we *could* say that prose "accommodated itself" to the demands of the eighteenth century's new middle class, "able to read and anxious to read."[17] But our responsibility as readers, in her view, is to "gaze through [the individual novelist's] eyes until we, too, understand in what order he ranges the large common objects upon which novelists are fated to gaze" (52). Her particularizing point about *Crusoe*, then, is that instead of poetic "sunsets," we find, "on the contrary, staring us full in the face nothing but a large earthenware pot. . . . Reality, fact, substance is going to dominate all that follows. . . . Nothing exists except an earthenware pot" (54–55). Defoe's "genius for fact" also enables him to dignify the common: "To dig, to bake, to plant, to build—how serious these simple occupations are; hatchets, scissors, logs, axes—how beautiful these simple objects become" (57).

Dignifying both the act and the product of his labor, Crusoe reports extensively on the difficulty he had making pots: two months it took him to produce "two large earthen ugly things" (96), with which he was overjoyed. But Woolf is far less concerned with these pots then she is with the *figure* of the pot, the way the pot figures Defoe's whole materializing enterprise, his science of the concrete: "By believing fixedly in the solidity of the pot and its earthiness, he has subdued every other element to his design; he has roped the whole universe into harmony" (58). The

realist commitment, the belief in things, grants him his organizational authority, the power of the novelistic art.

It is difficult to read Woolf's rumination on the pot without being reminded of Heidegger's rumination on the jug (*Krug*) and the more contemporaneous rumination on the pitcher (*Krug*) with which Ernst Bloch begins his *Sprit of Utopia* (written in 1915 and 1916, published in 1918, revised in 1923). "I could probably be formed like the pitcher," Bloch writes, and "see myself as something brown, something peculiarly organic, some Nordic amphora, and not just mimetically or simply empathetically, but so that I thus become for my part richer, more present, cultivated further toward myself by this artifact that participates in me."[18] If Defoe, by Woolf's light, organizes the universe through his commitment to common objects, then Bloch, committing himself to one object, means to reorganize himself. Within an isolated and meditative register, Bloch enacts an anthropological and psychological fact: the constitution of the human subject through the nonhuman object: indeed their mutual constitution, their mutual animation.

Together, Woolf and Bloch help to mark a proliferation of the discourse on objects in the 1920s, a new effort to think about things, to think with them, to think through them. That discourse included a great range of well-known work: Malinowski's study of the Kula in the archipelagoes of eastern New Guinea; Marcel Mauss's account of the *life* of objects outside Western modernity; Piaget's first attempt to write about the child's relation to objects; Heidegger's initial efforts, within *Being and Time*, to think through "equipmental-being"; André Breton's flea-market flânerie; and Benjamin's materialist phenomenology that includes his redescription of the surrealist project, in 1929, as an archaeological and anthropological—and not a psychoanalytic—endeavor. This attention to the nonhuman environment, which I engaged in the first section of this book, took place when Karl Abraham and Melanie Klein were developing a theory of object relations and when (following Freud's analysis of the fort/da in 1920) Klein developed her play technique for children, making use of toys to facilitate the work of analysis.

Of course, within psychoanalysis, "object relation" denotes only an intersubjective relationship, not the human relation to the inanimate object world. One synthetic textbook, *Object Relations in Psychoanalytic Theory*, makes it clear that this effort to interpret psychodynamic content is the exclusive effort to map the internalization of interpersonal relations.[19] In other words, the words of Laplanche and Pontalis, "'Object,' within 'object relations,' is to be taken . . . in the special sense which it has for psychoanalysis in such expressions as 'object-choice' and 'object-love.' . . . [A] person is described as an object in so far as the [drives] are

directed toward him."[20] The object, whether constituted through projection or introjection, is never not another human subject. In Klein's work, external objects (the mother, the father) or part objects (the breast, the penis) are ambivalently internalized and split (the good breast and the bad breast) just as feelings are externalized through acts of projection (onto the mother or the father). The child's interaction with the inanimate object world becomes a symbolic drama, staging fantasy relations to those other (proper) objects.[21]

Thus, in the analytical play-technique, about which she began to generalize in 1926, Klein understands the child's interaction with toys according to the logics of fantasy, projection, and displacement. She does so because in children the conscious and unconscious operate "side by side," enabling the analyst to "reach the deepest repressed experience and fixations."[22] Although champions of Klein, such as Julia Kristeva, insist that it's unfair to accuse her of mere sexual symbolism, that accusation has often been made, by Anna Freud, among others: the toy train is always "Daddy's genital," the toy oven is always "Mummy's genital"; the story is always, as Deleuze and Guattari liked to say of psychoanalysis, the story called "daddy-mommy-[and]-me."[23]

Bloch wrote, in his 1963 afterword to *The Spirit of Utopia*, that it was a "book entrenched and carried out by night, against the War" (279); and it was this war, as I showed in chapter 2, that provided much of the matter of modernism. The subsequent world conflict frames Klein's most aggressive act of vaporizing context from her analytical work. Her *Narrative of a Child Analysis*, which remains the longest published case study we have (at 450-plus pages), reports her treatment of a precocious, hypersensitive, hypochondriacal and antisocial boy of ten, named Richard. Klein conducted the treatment in Pitlochry, Scotland; it lasted four months, ninety-three sessions, April to August 1941. (She quite desperately hoped to write and publish the narrative in 1942, but she was in fact correcting proofs shortly before her death in 1960.) Throughout the narrative, Richard keeps talking about the war and about Hitler; about England, France, and Russia; about planes and bombs and U-boats. Klein keeps talking about part objects and the familial dynamic.

In the third session, to take an early example, Klein writes that Richard "soon turned to the map and expressed his fears about the British battleships being blockaded in the Mediterranean if Gibraltar were taken by the Germans. They could not get through the Suez. He also spoke of injured soldiers and showed some anxiety about their fate. He wondered how the British troops could be rescued from Greece. What would Hitler do to the Greeks; would he enslave them?" "Mrs K.," Klein then writes, "interpreted that he also worried unconsciously about what might hap-

pen to Daddy when he put his genital into Mummy."[24] Klein, an Austrian Jew who'd left Berlin to work in London, and who'd left London to escape danger there, is treating a boy who, with his German mother, has been evacuated from his own London home. Richard's brother, eleven years older, is serving in the British army. Richard himself is overwhelmingly worried about air raids.[25] In her introduction to the narrative, Klein writes that Richard "followed the news closely and took a great interest in the war situation, and his preoccupation came up again and again during the course of his analysis" (16). Despite those circumstances and this prefatory acknowledgment, war, within the analytical imagination, serves only an allegorical function.

Klein's acts of transcoding approach the level of caricature, with Hitler symbolizing the father, bombs symbolizing feces, the city of Brest representing the breast. In the sixteenth section, Richard and Mrs. K turn their attention to Drawing 5 (fig. 6.1). "She interpreted," Klein writes, "that the four British planes might represent the family," and he supposed that the "crossed-out German bomber also represented himself." When he added that he had "soiled" his trousers the night before, she "added that his 'big job' was felt to be the bombs." She explained that the drawing expressed "his fear lest he might bomb his family with his feces." Moreover, "in the drawing the ack-ack gun had destroyed the German bomber, which represented the bad part of himself which had stolen Daddy's genital (the gun) and attacked Daddy with it" (74). (When Klein's biographer spoke with Richard decades later, his recall of the analysis was very vague, but he predictably remembered "her angle": "She would often talk about the 'big Mummy genital' and the 'big Daddy genital,' or the 'good Mummy genital' or the 'bad Daddy genital.' I can't remember what other things she had to say. It was very much a strong interest in genitalia.")[26] Here, the psychoanalytic content-context divide disables any insight into the extrafamilial psychodynamics that are likely at play: above all, the use of the family to process anxieties about the war, the use of the father to understand Hitler, the use of the mother to work through an ambivalent relation to the nation-state Germany that is at once bad and good. The general point must amount to the fact that Klein can only imagine how war serves to allegorize the family, not how the family might serve to allegorize the war. But my more particular point concerns the way in which the traditional script of object relations fails to permit a subject to have intense relations to objects—the U-boat, the plane, blockades, the bomb—that signify themselves.

This is why, from the proliferating discourse on things following World War I, Benjamin's *One-Way Street* (written between 1923 and 1926) provides such an arresting contrast to the emerging paradigm of object re-

6.1 "Drawing 5," from Melanie Klein, Narrative of a Child Analysis: The Conduct of the Psycho-Analysis of Children as Seen in the Treatment of a Ten-Year-Old Boy (New York: Basic Books, 1961). Reproduced by permission from the Melanie Klein Trust.

lations. He addresses the play of children as a case for inhabiting, differently, the nonhuman environment: children, he writes, "are irresistibly drawn by the detritus generated by building, gardening, housework, tailoring, or carpentry. In waste products they recognize the face that the world of things turns directly and solely to them. In using these things, they do not so much imitate the works of adults as bring together, in the artifact produced in play, materials of widely differing kinds in a new, intuitive relationship."[27] Unrestricted by a mode of analysis that is determined to script the waking dreamwork as a family romance, Benjamin goes in search of some model for reconstructing the waste of the world—modernity's detritus—but for reconstructing it as something other than

it was. Bloch had lamented that "we have unlearned how to play," and thus that we must "kill the cold machinery" to "see what still remains to be generously warmed up again" (10). Benjamin sought in play a human mode for reenergizing the nonhuman environment. "Warmth is ebbing from things," he goes on to write in *One-Way Street*: "We must compensate for their coldness with our warmth if they are not to freeze us to death" (453–54). Seized by the "menace" of a "refractory material world," he sensed the urgency of positing our relation to things as a primary relation to think and work through, the dynamics of which are no less subject to unconscious fantasy, individual and collective (454).

For Benjamin the point is not only that children "produce their own small world of things within the greater one" (450), and not only that anything they happen to find "is already the start of a collection" (465). They also enjoy a lover's relation to food, from the hand's "tactile tryst with comestibles" to the mouth's "passionate meeting" with currants and honey and strawberry jam in the absence of any mediating spoon (464). And they inhabit the object world mimetically: "Behind a door, he himself *is* the door—wears it as his heavy mask, and like a shaman will bewitch all those who unsuspectingly enter" (465). As Miriam Hansen has shown at length, for Benjamin "children pioneer a model of mimetic innervation," a model not of interjecting the good or bad object that is the mother or father, but of incorporating objects themselves into the psyche, into the sensorium.[28] In the account of his childhood in Berlin, Benjamin writes of becoming similar to objects, and of how the artist effects such similarity, not representing the Chinese vase, but "resembl[ing] the porcelain which I had entered in a cloud of colors."[29]

And yet, just as Klein's work was clarifying for Lacan ("the Kleinian doctrine places the mother's body there," where "the question of what we call the Thing is raised");[30] just as her work has been crucial to feminism because it highlights originary psychodynamics that structure the child's relation to its mother; so too, by shifting attention away from the father's penis and to the mother's breast, and by describing the ambivalent fragmentation (good and bad) of the internalized object, her work allows us to perceive modes of separation from, attachment to, and aggression toward objects, which are part objects (and not really subject or object), and which, as Deleuze and Guattari insist, need not be derived from some original whole. Bitter as they are that Klein, "the analyst least prone to see everything in terms of Oedipus," did not in fact "shatter the iron collar of Oedipus," they nonetheless grant that she was responsible for the discovery of partial objects, and thus of "that world of explosions, rotations, vibrations" which they transform into the world of desiring machines (44–45).[31] What if, as they insist, "*the unconscious is an orphan*, and

produces itself within the identity of nature and man" (49)? Indeed, one might read the very ubiquity of the Oedipus in Klein as a compensatory mark of its superfluity (any indication of which would have cost her her place in the field), if not the mark of some kind of analytical anxiety. Were the object relations of the waking dreamwork so overwhelming that she had to contain them, each and all, with Oedipus?

3. Words and Things

"The relation to the nonhuman environment" is "also a function of object relations, since in psychoanalytic terminology 'object' refers to the 'object of the drives,' regardless of whether human or nonhuman." And yet, as Harold Searles goes on to lament, "in actual practice . . . 'human' has almost become equated with 'object.'"[32] Psychoanalysis assumes that the significance of nonhuman objects amounts to a displacement of cathexis (65).

Bee Season can be understood as outlining a "concrete logic" that preserves the specificity of things and provides a case study explicable (to a certain degree) according to object-relations-as-usual, but the novel is rendered more far powerful when explained in engagement with Searles, as with Benjamin. This drama takes place, though, as a tangent to the central plot, in which Miriam appears as the mother of an eleven-year-old girl, Eliza Naumann, who has always been a mediocre student, who has always suffered the humiliation of being in the slow class, but who suddenly discovers, during the first fifth-grade spelling bee, that she's a whiz of a speller. She wins the class bee, the school bee, and the divisional bee with a mystical capacity to see and to feel words. "She hears the word and suddenly it is inside her head, translated from sound into physical form. . . . She knows when a word has reached its perfect form, SCALLION and BUTANE and ORANGUTAN blazing pure and incontrovertible in her mind" (40). This success occurs outside the familiar order of the sign: rather than words murdering things (as the familiar formula goes), they become like things, their signifying function beside the point. Eliza has no trouble spelling words she's never heard and does not know: "Ay-reer" (a unit of Icelandic currency): "E-Y-R-I-R" (62).

Eliza's father, Saul, the temple cantor and a self-absorbed, passionate scholar, has never had much time for his daughter. He's paid attention to his son, Eliza's older brother Aaron, a good student who has aspirations of becoming a rabbi. But Eliza's spelling success captivates her father; he begins to study with her, to coach her, to travel with her, recognizing that her untraditional, intuitive, mystical capacities might enable

her to achieve the kind of success he himself has never enjoyed. "Both spelling bees and Torah scribes," he explains to her, "share the idea that a word should be constructed perfectly or not at all" (81). He directs her to begin studying the Kabbalists, to follow the ladder prescribed by Abulafia, who believed (as he recorded in the late thirteenth century) that by focusing on letters and permuting words, "the mind could loose itself from its shackles to commune with a presence greater than itself," to achieve *shefa*, the influx of the divine (172). Abulafia prescribed a technique of meditation wherein the mystic could transcend the sensuous world by focusing on an "absolute object"—"something not merely abstract but also not determinable as an object in the strict sense," as Gershom Scholem put it.[33] The regimen, Saul explains to his daughter, is a mode of overcoming the barrier between the self and "the larger stream of life, the Divine Intellect" (172). But the very human revelation that Eliza finally does achieve enables her only to recognize that she must lose her next contest, must wrest herself away from her father's grip, must assert herself (rather than losing herself) by putting an end to the bee season that has utterly disrupted the domestic existence of this family of four. The novel ends with her triumphant failure: She spells "O-R-I-G-A-M-Y" with a final "Y."

Goldberg devotes much of the novel to recounting Eliza's extraordinary relation to words, which the girl herself originally experiences in intensely physical terms. Not only does she picture "words lining her stomach, expanding with each stretch of her lungs"; she also experiences the letters as "magnets, her brain a refrigerator door"—content to experience herself as a different object form (44). This imbrication of word and thing (outside the semiotic relation of word and thing) unfolds between two antithetical subplots—one adamantly antimaterialist and one hypermaterialist—which fill out the story of the Naumann family. Abandoning his faith and his family by joining a Krishna temple, her brother Aaron announces his newly found truth to his father: "The material body is a heap of ignorance and the senses are a network of paths to death," he insists; "The body is part of the material world, which is an illusion" (249). Saul, as though neglecting the correspondences between Eastern mysticism and Prophetic Kabbalism, and as though forgetting the rebellion of his own 1960s youth (his discovery of LSD and Jewish mysticism), can make no sense of his own son's rebellion.

Over the course of the bee season, Eliza's mother Miriam, the woman transformed as a girl by the kaleidoscope gift, begins to indulge her passion for the material world, for the objects of that world, for the world of things she makes within the world of things. Her kleptomania becomes irrepressible. A lawyer with more than enough money to afford retail-

therapy-as-usual, instead she inhabits department stores propelled by an overwhelming drive but unaware of what object, or which kind of object, might appease her longing.

> Miriam sometimes spends hours combing through floor after floor, intent as a pig sniffing truffle. She's seeking what she is meant to find, the singular item waiting for her swift hand. She and this object are intimately joined, its discovery a matter of attuning herself to her body, sensing the size and shape of the internal gap meant to be filled. Miriam treasures this inevitable moment of communion. Nothing is as certain as the instant the object reveals itself. She can practically feel the click as the internal dislocation is corrected. . . . She is no petty thief. She is compelled by a force superior to material gain. (77)

Although Miriam might be said to inhabit the traditional role of the bourgeois female kleptomaniac, and although her acts of theft could be explained by the "female castration Complex" described by Abraham in 1920, the "moment of communion" described here, the intense intimacy of human subject and inanimate object, evokes the kind of "subjective oneness" described by Searles.[34] And if consumer culture has made her apprehension more convenient, so too, as Searles would have it, that culture has made her antimaterialist materialism more intense.

4. The Nonhuman Environment

Overlooked in the subsequent history of psychoanalytic thinking, Searles's book on the nonhuman environment provides a significant resource for imagining how relations to the inanimate object world contribute to the psychic self. By now, he is known—if known at all—for his elaborations of the countertransference.[35] But his work with schizophrenics (at Chestnut Lodge, in Maryland), reported in *Nonhuman Environment*, alerted him to "the multitude of inanimate objects lying, so to speak, in our unconscious" (49) and thus to the profound need for developing some account of how the nonhuman impresses itself on the human psyche, how phantasms of it linger within the unconscious. He understood Freud's case of Dr. Schreber (1911) and the essay "On Narcissism" (1914) to have initiated a theory of object relation that object relations per se (as developed by Klein and Ronald Fairbairn) compromised by positing a structure (subject-object, internal-external) for the infant libido. Searles's *Nonhuman Environment* helps to fill the gap (however anachronistically) between, on the one hand, the object-relations theory

of the 1920s and, on the other, that decade's proliferating discourse on things. Moreover, it contributes to a sense of how, in the sixties, a handful of psychoanalytic perspectives were approaching questions that have resurfaced in the twenty-first century—questions about the divide between subject and object, human and nonhuman.

Both his personal and his clinical experience demonstrated that relations to the nonhuman are characterized by a "dual level": occasioned on the one hand by the transference of interpersonal attitudes or the projection of unconscious feelings, but, on the other, elicited by the nonhuman itself, by "the tree *as being a tree*" (19). In what could be understood as an expansion of Klein's notion of the primary attachment to the breast, he posits a primary attachment to the nonhuman environment, an attachment that in fact erases the human-nonhuman distinction: an originary infant-being, before any ego formation, that does not and cannot differentiate itself from its environment, that is in some fundamental way at one with its environment, that *is* its environment. This unity of world and ego—wherein there is neither world nor ego—he describes as a state of undifferentiation or of syncretism, the evidence for which he finds in stages of childhood development described by Werner, Inhelder, and Piaget (as I summarized in chapter 1); in non-Western philosophy and Western mythology; in the hallucinogenic experience triggered by LSD; and in schizophrenic patients—from the woman who dreams of being a "bombed-out building" to the man who treats a telephone as "a piece of his former life" to those more simply unable "to distinguish clear boundaries between the self and the nonhuman environment" (51, 147, 163). In other words, instead of developing the psychodynamics described by Klein, he compiles an archive that shows how "subjective oneness with the environment" persists unconsciously "long after differentiation on a purely perceptual and conscious level has been effected" (37). He is willing to write in concert with the claim that "it is [the] separation in the primitive ego, the formation of the external world, which, properly speaking, is the primitive castration" (145). This primitive castration is the "event" that goes unacknowledged, disavowed through, say, the fetishization of the human subject.

However intriguing and complicating Searles's case histories are, the understanding of "subjective oneness with the environment" enables us to describe Bloch's effort to contemplate a syncretic imbrication with the pitcher as the effort to recuperate from that originary rupture by which the human and its environment become distinct—a rupture reenacted and intensified by the modernity described by Latour. More obviously, Searles's convictions read like an emergent impulse that characterizes what we call the sixties, including the work of Anton Ehrenzweig. More

famously, accompanying R. D. Laing's effort to show the nonpathologi-
cal productivity of ego loss—the access it grants to "all mankind," to "pri-
mal man," and to the "beings of animals, vegetables, and minerals"—he
imagined a future that would realize how "what we call 'schizophrenia'
was one of the forms in which . . . the light began to break through the
cracks in our all-too-closed minds."[36] Intensifying that light in the form
of schizoanalysis, the *Anti-Oedipus* (decidedly deferential to Laing),
transformed psychiatric description into methodological prescription
and a call to recognize "the real inorganization of desire" and the "order
of dispersion," over and against the structuring work of the phallus (*Anti-
Oedipus*, 328, 323).

Searles himself never risks romanticizing psychosis, although he uses
the schizophrenic to point out what we overlook (and must rediscover)
in our own neurotic lives. And like the Bloch he unevenly recalls and the
Laing he squarely anticipates, Searles comes to frame his argument with
a lapsarian account of Western culture: the "psychological estrangement
from the nonhuman environment" has been effected by the advance of
technology, the abstraction of the material world into exchange values,
and a culture of overabundance and disposability (316).[37] Were you to his-
toricize this work (and its elision) within the American postwar era, you
might understand *The Nonhuman Environment* as some kind of response
to—a critique of, or some compensation for—the unprecedented pro-
liferation of objects (the toasters, the refrigerators, those kitchen gad-
gets that Nixon celebrated in his explanation of American life to Khru-
shchev, for instance). Were you to historicize it (no less) within a broad
discursive context, you would hear resonances beyond the bounds of
psychoanalysis. When Siegfried Kracauer subtitled his *Theory of Film*
(1960) "The Redemption of Physical Reality," he was pointing to the ob-
ject world that constitutes the nonhuman environment. Because film is
"uniquely equipped to record and reveal physical reality and hence gravi-
tates toward it," Kracauer writes, film can prompt "psychophysical cor-
respondences," some kind of "fluid interrelations between the physical
world and the psychological dimension."[38] He describes a version of what
Searles (and Ehrenzweig) called syncretism, which, when it comes to
cinema conceptualized as a "sensory-perceptual matrix of experience,"
becomes a description of discovery: because cinema "clings to the sur-
face of things," it "assists us in discovering" what he calls "hidden aspects
of the world about us."[39] To amplify his point, he turns to the 1920s—not
to his own earlier work on consumer objects, nor to Benjamin's efforts to
rethink the object world, but to Alfred North Whitehead's *Science and the
Modern World* (1925), where Whitehead describes how science and tech-
nology have benumbed the human sensorium with "abstractness." Only

by developing "habits of aesthetic apprehension," says Kracauer, can we overcome "our all but compulsive indulgence in abstractions" (296). He argues, of course, that even if we have acquired "the habit of abstract thinking . . . under the reign of science and technology"—a reign from which "things continue to recede," a reign that "eliminate[s] the qualities of things"—nonetheless cinema (that product of science and technology) enables us to rediscover "the material world with its psychophysical correspondences" (300). *Bee Season* imagines that film is not the only such technology.

5. The Kaleidoscope

The objects that Miriam serendipitously collects on her surreptitious adventures have something of the character of the transitional object as D. W. Winnicott describes it. That is, they are characterized by the same paradox he underscores: The baby creates the object, but the object was there waiting to be created, to become a cathected object."[40] But for Miriam no object actually effects a *transition* that would enable her to recognize the object's—and the object world's—autonomy. Quite the reverse: every discovery seems to augment her desire and her failure to distinguish herself from the objects she seeks. In her next stage of obsession, Miriam finds herself abandoning stores and breaking into houses to find the unforeseen objects she overwhelmingly desires.

> Miriam knows, technically, that she doesn't belong here, but neither does the object she has come to rescue. As long as it stays in this house, the world will remain slightly misaligned. By reclaiming it and becoming more whole, she is working toward the correction of a larger imbalance. She knows the instant she sees it that she is here for the blue ceramic dish holding spare change beside the kitchen telephone. (111)

In this case, as in others, the object she steals is ludicrously worthless, valuable by no criteria but her own. As she understands this preoccupation, performed secretly yet certainly, Miriam is carrying out Tikkun Olam (110), the reordering of the world. Saul explained to her, one night in bed before they were married, that the mystics believed that God's Divine Light, enclosed in sacred vessels, had shattered them into countless pieces, leaving us with the job of fixing the world. Saul's explanation enables Miriam to sacralize her kaleidoscopic worldview; she comes to personalize the narrative, thinking of herself as "a broken vessel, pieces of her scattered everywhere. She has been finding these pieces, in their

many forms, and bringing them together so that she can be whole again" (87). The world's unrealized wholeness and her unrealized wholeness — these are one and the same. Both remain unrealized.

The extent of Miriam's ambition becomes clear when Saul suddenly discovers what his wife has been up to, when the police phone to say that his wife has been arrested, when an officer takes him to the lot of a "U-Store-It," a group of "squat, windowless buildings with sliding metal doors," and when that officer opens one unit, "a storage room the size of a small gym," and flicks on the bright white lights to reveal Miriam's collection. For as it turns out, she has been stealing objects for eighteen years; she has left her law firm; she has devoted her days to finding objects, to being found by part-objects, by finding other things. She has committed herself to the creation of some new total work of art, "meticulous constructions" that add up to "a landscape of unending shape and pattern" (223).

> A spiral of shoes of decreasing heel heights cycles from brown to orange as it winds its way to a center of earrings whose shapes and colors form a pattern of stripes and circles in sparkling metal and rhinestone. The shoes are framed by pens and pencils stacked at careful angles to form a free-standing fence of contrasting colors and shapes, the curve of a pen's tip set off by the blunt end of an unused pencil. An arrangement of pink erasers becomes the flesh of a creature governed by the laws of geometry. (223)

A novel that has eschewed superfluous description suddenly becomes as detailed as anything from Dickens or Balzac.

> The transition from shoe to wineglass is barely perceptible, the shoes as they stretch toward the glasses actually assuming shapes that reflect or contain a wineglass within them. The perimeter is composed of glasses lying lengthwise on the floor, but with the aid of marbles, beads, and shot glasses, the line arches upward in a graceful curve to join a column of stacked wineglasses, brandy snifters, and champagne flutes reaching higher than Saul's head. (225)

Miriam's concrete logic (where one recognizes, say, the shoe-ness of the wineglass and vice versa) has abandoned consistent taxonomy; its order is sensuous, not conceptual; the magical union of parts is neither complete nor incomplete. Her *assemblage* is the culmination of no *bricolage*, both because of the specifying energy of her cathexis and because, however magically the shape of one object assumes the shape of another, her

work depends on accumulation rather than abstraction, on accretion rather than refraction.

Objects are not shattered into a multiplicity that is whole, but each becomes—as Saul comes to sense—something other than it was.

> All around him, each object presents itself redefined, this its true function, this the reason for its creation. Looking back the way he came, Saul sees a swath of motion carved by his path, innumerable objects twisting and twirling in response to his passage through the room. This space is not a passive object to be observed and left behind. It is interactive. Every person who steps inside becomes an object in its perfect order, associating with it in infinite, beautifully balanced ways. . . . When Saul starts to cry, it is out of this sense of supersaturation as well as having arrived at a new level of understanding. (225)

The description begins by drawing attention to the inadequacy of the exchange-use binary, captioning the "true function" of these objects (their productive *misuse*) as their aesthetic function. But the affective climax appears in the universalizing claim that "every person" within this collection of objects becomes an integral component of the aesthetic achievement, enters the object-space as a thing among things that have been granted their place in the perfect order that they themselves produce. A drama replete with psychophysical correspondence, it stages the overwhelming subjective oneness with the environment that amounts to the dedifferentiation of subject and object, human and nonhuman.

Although the novel luxuriates in its long description of this inadvertent work of art, I hasten to add that there are many reasons why Miriam's behavior had become so "pathological" that she could produce it: her parents died in a car accident when she was in college; she and her husband no longer have sex; she derives little satisfaction from her children in a household where her husband has assumed the stereotypical maternal functions: buying and cooking food, organizing the life of the family. Yet the novel specifies that the primal scene in Miriam's psychic life was her chance to witness the "magical union of parts" disclosed by the kaleidoscope. On the one hand, when Searles draws evidence from experiments with LSD, he describes the subjects as "overwhelmed by a kaleidoscope of fantastic images," a kaleidoscope exposing "something of the multitude of inanimate objects lying, so to speak, in our unconscious" (49). On the other, in Goldberg's novel, the kaleidoscope has finally been dislodged from the tropological register: it does not metaphorize the psyche; it might be said to shape the psyche, which then externalizes itself. The police tell Saul, "Your wife . . . called this place her kaleidoscope"

(226). Miriam's passion crystallizes (and her stealing begins) when she receives the kaleidoscope gift, which serves as some kind of antitransitional object, mediating the refusal to recognize objects as "not-me," the refusal to adopt a path toward decathexis, the refusal to accept what we call "reality," to accept the object world as it is. Within Maurice Merleau-Ponty's somatic phenomenology, although the body is "a thing among things" that is "caught in the fabric of the world," its mobility and vision enable it to hold "things in a circle around itself."[41] In Miriam's kaleidoscope, the circle collapses in on itself.

It is still important to say that the novel, which clearly denigrates all the excesses prompted by mystical aspiration (even as it highlights the ironic convergence of antipathetic aspirations), pathologizes Miriam and abandons her. As the novel closes, we know only that she remains in hospital, unwilling to have visitors, unwilling to see her family. From a Kleinian perspective, it's obvious what has gone wrong: in the rivalry between mother and daughter for the father, the daughter has captivated her father's attention, she has idealized the second object, the father, while abandoning the breast. One might say that Miriam's collecting obsession is both an effort to restore her own mother to her and an effort to compensate for her daughter's rejection of her—of her part object. Here too, the kaleidoscope (as object rather than metaphor) mediates the final mother-daughter rupture when Eliza can make no sense of the gift that Miriam offers in celebration of her child's spelling triumph, the gift she has decided to pass on. When Eliza "uncovers the old kaleidoscope, she mistakes it for one of those fancy tubes that tights are sometimes sold in, maybe ones that aren't so scratchy," and Miriam immediately recognizes her humiliating failure. "It doesn't come apart," she explains, "It's a kaleidoscope. It was mine when I was a girl." Despite Eliza's efforts to appear interested and grateful, "Miriam already envisions its internment on a dusty shelf in Eliza's room, never to be used again" (67). You could say that such rejection gradually provokes a psychotic break; it triggers something like a latent schizophrenia. But as Deleuze and Guattari put it, "a schizophrenic out for a walk is a better model than a neurotic lying on a couch" (2).

A model of what? The novel might be understood as disclosing the insufficiency of the attack on Balzac, stretching from Willa Cather's "The Novel *Démeublé*" to, say, Georges Perec's *Les choses* (1960), generally read as the French novel's having done with the Balzatian paradigm. But in Miriam's collecting habit, and in her sequestered collection, Goldberg more impressively seems to disclose an allegory of the work of narrative prose fiction itself, from, say, 1719—the effort, as Woolf put it, to "rope the whole universe into harmony." Moreover, her elaborate assemblage

of *objets trouvés* evokes the poetics of accumulation that are so essential to outsider art, from Simon Rodia's *Watts Towers* to James Hampton's *Throne of the Third Heaven of Nations Millennium General Assembly*, the reassembled, foil-covered collection of detritus discovered in the garage where Hampton secretly worked on the throne for the final fourteen years of his life, the throne now housed in the Smithsonian. Those poetics have come to inform a host of contemporary art practices, from the work of Sarah Sze to that of Theaster Gates.

Above all, like Woolf's own "Solid Objects" (which I addressed in chapter 2), Miriam's story, within the story of *Bee Season*, would seem to challenge the psychology of collecting. For what if the collector's ambitions are in fact driven by some effort not to represent the self or to collect the self, but to dissolve the self into its nonhuman environment, to become an object, a thing among things, in the collection's perfect order? What if that object you long for is simply the object-cause of a more profound desire to achieve some thing that amounts to subjective oneness with your nonhuman environment? And what if that object is—at the same time—precisely an impediment to that desire, perpetuating the desire simply by being apperceived as nonhuman? It is easy to recognize that Goldberg's novel, which patently criticizes mystical fanaticism tout court, shows a host of oppositions—between word and thing, subject and object, the spiritual and the material, the animate and the inanimate—in various states of creative collapse. As Benjamin parenthetically mentioned in his essay on the magic of language, "there is also a magic of matter."[42] However devoted to the mysterious work of words, the words of *Bee Season* speak no less profoundly of how mystical materialism can be.

How can a gift transform a child's life? If the first steps in answering such a question amount to expanding the field of object relations, then the case I've presented here—the case of a novel refracted through the lens of Searles's *Nonhuman Environment*, itself adjusted between the work of Klein and Benjamin—is a case that intimates an expansive field indeed, the boundaries of which, from the department store to the mysterious and mystical collection, from consumer-desire-as-usual to a de-ontologizing longing, have been very readily traversed. It is within that field, though, where we might formulate answers to familiar questions about our everyday lives, and where we may find questions that we haven't been willing to ask, questions about materialist desires—not for objects but for other things—formed not outside the order of consumer culture, perhaps, but in some desperately different relation to it.[43]

Seven

Objects, Others, and Us
(Brian Jungen)

For George Stocking

Amnesiacs that we are, we believe that they adored the god
or goddess sculpted in stone or wood. No: they were giving to the
thing itself, marble or bronze, the power of speech, by conferring
on it the appearance of a human body endowed with a voice.

MICHEL SERRES, *The Natural Contract*

However much Robert Smithson simply took wide-eyed pleasure in New York's Museum of Natural History as a child, it became for him an important institutional site: a site through which to consider questions of nature, time, and history. Familiarly, he argues that "there is nothing 'natural' about the Museum of Natural History." Less familiarly, he explains that this is because *nature* was an eighteenth-century and nineteenth-century invention—one that accompanied the imposition of "the temporality of time" on art, itself accompanied by deference to the Renaissance and by the birth of the museum as such. But the natural history museum has the habit of rupturing such temporality by bringing the "distant future (post-history)" and the "distant past (pre-history)" into a kind of proximity that, you might say, denaturalizes history. And the natural history museum effectively overlooks the Renaissance, though it "does show 'art' from the Aztec and American Indian periods."[1] However aggressive its own taxonomizing impulse, it challenges certain inherited taxonomies.

George Stocking, the historian of anthropology, edited and published *Objects and Others* in 1985. That was the year after New York's Museum

of Modern Art staged its blockbuster show *"Primitivism" in 20th-Century Art: Affinity of the Tribal and the Modern,* which provoked a steady, indeed roaring, stream of commentary. The essays Stocking collected on "museums and material culture" were historical, "institutionally oriented studies, focusing on what has been called the 'Museum Period' in the history of anthropology" (1880–1920) while raising decidedly broader issues—about the "relationship of humanist culture and anthropological culture, and of ethnic artifact and fine art; and most generally the representation of culture in material objects."[2] The Stocking collection asked how the West has represented "other" cultures, and the otherness of other cultures, through the display of artifacts—a question that, as he himself later put it, "caught a wave of rising interest."[3] MoMA's *Primitivism* exhibit asked how artifacts from "other" cultures became integral to the Western aesthetic imagination and its understanding of the aesthetic tout court. In sum, such questions precipitated subsequent exhibitions, conferences, graduate seminars, and new essay collections on the history and theory of museum practice, most paradigmatically, perhaps, three formidable collections coedited by Ivan Karp, each based on conferences (involving art historians, anthropologists, and folklorists, as well as curators and museum directors), the first two held at the Smithsonian, all three funded by the Rockefeller Foundation. The first, *Exhibiting Cultures: The Poetics and Politics of Museum Display* (1991), testified to the new "contestability of museum exhibitions," as to the ways that "museums attempting to act responsibly in complex, multicultural environments are bound to find themselves enmeshed in controversy."[4] The most recent, *Museum Frictions: Public Cultures/Global Transformations* (2006) provided an international set of cases for understanding how globalization presents new possibilities and problems for museum and heritage practice—how, as the editors put it, "museum-based processes and globalizing processes come together."[5] Important specialized monographs also appeared within this time span, most relevantly, for my inquiry here, *The Storage Box of Tradition: Kwakiutl Art, Anthropologists, and Museums, 1881–1981* (2002), in which Ira Jacknis tracks the changing aesthetic status and epistemological status of so-called tribal artifacts. What "anthropological encounters" and "social networks" led to the preservation of specific objects and to their metonymic value? What histories of taste led to their institutionalization as artworks? Museums and museum studies—the new museology—may no longer be enduring (or enjoying) that frisson of crisis from the 1980s, but the field has continued to respond to the histories presented and the questions posed in that decade.[6]

My questions, while no less responsive, are differently lodged and obliquely formed. For one thing, I focus on contemporary work pro-

duced in one of those "othered" cultures and draw attention to the ways that an individual artist—working on and within the many logics that animated museum history—recycles certain "ubiquitous" global consumer products (in itself a customary practice, within and beyond the art market) in behalf of dilating a spectator's sense of time, and in behalf of expanding any understanding of cultural systems and cultural space. Indeed, Brian Jungen represents a new wave of First Nation artists whose sophistication predictably locates their work at the very edge, or beyond the edge, of the analytic grids deployed to understand the dynamics of collection, institutionalization, and display. Second, I want to think of this work as part of the ongoing artistic extension of what André Breton called (in a lecture he delivered in Prague in 1935) "the fundamental crisis of the object," a crisis meant to be provoked by the surrealist dismissal of "reasonable" beings and objects, as by the surrealists' work as *amateur* ethnologists (as William Rubin put it), as by their passion for objects from Africa, Australia, the American Southwest, and the Pacific Northwest.[7] It was the impact of these objects from elsewhere that helped to provoke, to legitimate, and to generalize this destabilization of the object. Third, I'm eager to imagine Jungen's work itself as practicing an archaeology of the present, and a kind of anthropology in plastic form—what Wayne Booth might call the rhetoric of things, what Kenneth Burke might call the symbolic action of objects. And finally, I'm interested—in this case as in others—in what works of art teach us about the apparent otherness of objects as such, the differentiation between subject and object, as between human and nonhuman, serving what I take to the be the phenomenological infrastructure on which an apprehension of alterity as such is built. All told, then, while Stocking's anthology of essays addressed the ways that objects have been used to represent "others," I'm interested in how particular objects dramatize the problematic of otherness, which is to say the uncertainties that inhere in any identification of sameness or difference, be it argued or experienced or acted out. But before I engage the work of Brian Jungen, with a focus on production (more specifically, on refabrication), I want to begin, with a focus on consumption (or, say, perception: the scene of spectatorship) by following C. L. R. James on his trip to two museums in London—a trip establishing the nodes that organize my subsequent engagement.

1. Time and the Object

C. L. R. James titled one of his first "letters from London" for the *Port of Spain Gazette*, written during his inaugural trip to England in 1932, "Visit

to the Science and Art Museums." He begins the article with a sight by which he was "knocked silly"—the "sight of the airplane in which Lieutenant Stanforth won the Schneider Trophy at a speed of 407 miles an hour; that is to say from Port of Spain to St. Joseph in one minute." "The plane," he goes on to say, "is the most beautiful thing in the museum and one of the most beautiful I have seen in London ... nothing superfluous, all cut and line ... it looks so light ... the body is like nothing so much as a long fish ... the whole thing looks like a toy, and it is a thing for photographers to think about, that what has been built solely for utility turns out to be so beautiful."[8]

His fascination with the object has little to do, finally, with this moment of Corbusian appreciation. It has to do, rather, with a recognition of how "scientific knowledge goes forward" provoked by competitiveness and the seemingly irrational dedication to "mere speed," for instance. It has to do with his estimation of how such public displays—the museum's combination of historical artifacts and elaborate models—can serve to inspire a next generation of inventors. "So Galileo must have looked at the pendulum," James writes, "noting how evenly it swung" (9). And it has to do, too, with a sense of lack and of longing: "Why haven't we got such a place at home"? (1) "We, in Trinidad, know what the answer to any such effort ... [would] be. No money, and probably a hint that, 'Oh, the people will not be interested,' the people this and the people that" (10). To his readers back in the West Indies, James describes a perverse projection (of what "the people" can't appreciate), just as he describes the distinction between wealth and poverty, extraordinary access ("Everything free") and inaccessibility (10), center and periphery, metropole and colony. My interest lies in the way that—for a writer who was to become one of the twentieth century's best-known analysts of "civilization" and its colonial, class, and race relations—a particular and particularized object occasions this cultural comparison and charged complaint. The Stanforth plane embodies technological sophistication and passion, *and* it serves as an allegorical object that stands for those opportunities presented by the twentieth century, and those denied.

As a point of departure in his account of this foreign yet familiar land, James registers the importance of objects—indeed, their hyperpresence—within the psychological, social, and political dynamics among modern human subjects. The account of Stanforth's plane is a brief yet theatrical example of how objects mediate our sense of ourselves, as individuals and as collectivities, and our sense of others. Spotlighting the role of the inanimate object world within culture, as culture, and as a means for apprehending culture, James has found (if I may paraphrase Lévi-Strauss), a thing to think with.[9]

How might we describe this thinking—this field of thought? James produces as his object of address and analysis the *object culture* of London. By *object culture* I mean to designate the objects through which a culture constitutes itself, which is to say, too, culture as it is objectified in material forms. A given object culture entails the practical and symbolic use of objects, and thus both the ways that inanimate objects mediate human relations and the ways that humans mediate object relations (generating differences of value, significance, and permanence among them), thus the systems (material, economic, symbolic) through which objects become meaningful, or fail to.[10] Although the phrase may not be common (however commonsensical), in fact the analysis of *object culture* has multiple genealogies. Among those who heard or read Georg Simmel on the material everyday (as we'd now put it) in the first decades of the twentieth century, Ernst Bloch, Walter Benjamin, and Siegfried Kracauer each in his way pursued the engagement with object culture, that pursuit achieving its most compressed and celebrated realization in Benjamin's exposé of the *Passagen-Werk*, "Paris, Capital of the Nineteenth Century" (1935), where he imagines how object culture, "from enduring edifices to passing fashions," stores "the unconscious of the collective."[11] Whereas Marx recognized a history of human labor that lay congealed in every human artifact (accounting for its value), Benjamin recognized multiple histories congealed there together: a history of production but also of circulation and consumption and use, thus also a history of collective fascination, apprehension, aspiration.

Still, insofar as ethnology developed the culture concept as such through the rearrangement of objects on exhibition (displaying a given basket not within an evolutionary history of basket weaving but within a contextualizing scene of use), the field of cultural anthropology remains (historically and currently) the privileged site in which object culture becomes visible.[12] From the museum work of Franz Boas (c. 1900) to Mauss's work on the gift (1923–24), Lévi-Strauss's analysis of masks (1975) to Arjun Appadurai's collection of essays on the "social life of things" (1986) and Nicholas Thomas's history of "entangled objects" (1995), anthropology has repeatedly centralized objects. Nonetheless, shortly after World War I, while some anthropologists "sustained to some extent an object orientation insofar as they conceived of culture as a collection of easily transportable thinglike 'elements,'" Boas himself had abandoned museum work in 1905, and in both Britain and the United States the field lost faith in objects: "While 'others' themselves might in a metaphoric sense still be objectified by the scientizing orientation that long survived the demise of evolutionary anthropology," Stocking argues, "in both countries 'objects' as such" could no longer "provide a focus for

the unity of anthropology."[13] And though objects have consistently re-surfaced, the study of object culture persistently begins by expressing frustration about the fate of the object within the academy: Why have objects "consistently managed to evade the focus of the academic gaze"? Why have the social sciences "ignored" the "ceaseless and varied inter-action among people and myriad kinds of things"? "Why has the 'thingly' component of our past and present being become forgotten or ignored to such an extent in contemporary social research?"[14] The "very materi-ality of objects," Webb Keane argued, in 2001, "means that they are not merely arbitrary signs." He meant that objects get caught up, *analytically*, in economic systems or sign systems that prevent us from attending to their material specificity and that specificity's semantic ramifications.[15]

But even as it makes obvious sense to track the analytic history of ob-ject culture within anthropology, archaeology, and, say, material culture studies (Jules Prown in the United States, Daniel Miller in the United Kingdom), I don't want to pretend that there is anything genuinely ethnographic about James's essay; indeed, as his *aesthetic* attention to the Stanforth plane adumbrates, he concludes his letter on the museums not with inventions (culture) but with a work of art (Culture), not with some metonymically or metaphorically English piece, but with a sculpture by Rodin: *John the Baptist*—"a statue of a naked man walking, that's all" (12). "I was dreadfully tired out but the thing made me fresh again" (13). The refreshment prompts (if it is not prompted by) a brisk proliferation of other affiliations, identifications, interpellations. Suddenly James writes about what "we" of the twentieth century will be able to say to the ancient Greeks—to the ancient Greek who could sit with James and stare at the statue "with much the same eyes and feelings" as would in fact "a wan-derer from the West Indies" seeing the statue of the man walking "three thousand years from now." While the Stanforth plane would be "mean-ingless" to the Greek, and dismissed by the future West Indian "as one of a crowd of obsolete designs," the Rodin "cannot grow old. It cannot go out of date. It is timeless" (14). The object prompts an unanticipated sequence of first-person plurals—*we* moderns, *we* humans, *we* West Indi-ans present and future—and it is as though the object suddenly releases James from the confines of modernity, including its colonialist history, to provoke a very differently imagined "us." The "timelessness" that James projects onto the object is in fact a timelessness he himself seems to ex-perience, at one with the ancient Greek and the future West Indian. How-ever scripted this experience may be by the science-art binary, by aes-thetic ideology, by a particular class *habitus*, I think it's worth noting that Jacques Rancière might say, echoing Schiller, that James here occupies a "region of being" where the asserted equivalence of experience eventu-

ates in an inevitable, if unexpressed, afterthought in behalf of the material realization of a common humanity.[16]

The acts of identification elicited by London's object culture—the Rodin statue and the Stanforth plane—occur within that more general dynamic by which human subjects depend on inanimate objects to establish their sense of identity, a dynamic described not just by anthropologists, but by philosophers. John Locke, among others, imagined that identity was an effect of remembering thoughts and actions, but Hannah Arendt, as I detailed at length in chapter 5, came to argue that our sense of ourselves and what we call identity stabilize foremost in relation to concrete objects. The "things of the world have the function of stabilizing human life," she writes, "and their objectivity lies in the fact that—in contradistinction to the Heraclitean saying that the same man can never enter the same stream—men, their ever-changing nature notwithstanding, can retrieve their sameness, that is, their identity, by being related to the same chair and the same table."[17] But most things of this world—food and clothes, computers and cars—are eminently consumable, fungible, disposable; far from interrupting the transience of our lives, they illustrate ephemerality at its most banal. This is why Arendt distinguishes between labor and work, between human effort that disappears without a trace (consumed commodities) and that which results in reification, some more enduring product, a material externalization of an imagined product, as Marx would put it, differentiating between human and animal architecture.[18] Arendt underscores the "outstanding permanence" of artworks as the quality that makes art such a significant part of the human condition. "Nowhere else," she argues, does the "thing-world reveal itself so spectacularly as the non-mortal home for mortal beings. It is as though worldly stability had become transparent in the permanence of art" (168).

However challenged by the art of her era (and not least by Smithson), Arendt helps to elucidate the case of James in London and productively specifies the role of particular objects (what we call art, what we understand or experience as art) within object culture, even though this particularity is (of course) a historical product of the same systems (material, economic, symbolic) that particularize other kinds of objects (as food, kitsch, trash, &c.). Her assertion helps to dramatize the oddity of any emergent "new materialism" that proceeds by isolating one very distinct kind of object (an art object) within an object culture in order to render that object culture (other objects within that culture) newly apprehensible. But such an oddity could also precipitate the coding of an object that concerns itself with other objects as a *meta-object*—the work of art, say, that isn't satisfied with just being an object and seems to in-

sist instead on taking other objects or object culture as its object of address.[19] This would seem to be one of the attractions of Pop, be it Claes Oldenburg's soft monumentalization of everyday objects, or Andy Warhol's participation in mass manufacture, or John Chamberlain's refabrication of waste.

Much of the art of the twentieth century renders the Arendtian binary and its predecessors obsolete, in two ways: by appropriating ephemeral objects into the artwork, and by making art that is itself ephemeral, as though redramatizing worldly instability (if not simply entropy, as in Smithson's case). But I want to deploy Arendt's binary, heuristically, to highlight a paradox within James's essay: for the Stanforth plane *has been preserved*, after all, that act of preservation having conferred upon it a spectatorial temporality within which its art can be appreciated: "one of the most beautiful" things that James has "seen in London . . . [the] body . . . like nothing so much as a long fish." The paradox closely relates to one that Stocking describes: objects preserved from the past within the museum "are at the same time timeless—removed from history in the very process of embodying it."[20] Humans have a certain penchant for preserving their things, all kinds of things. We don't just preserve "art"; we also preserve quotidian artifacts, which is why we have science museums, and space museums, and technology museums, and craft museums, and Rock and Roll museums, and natural history museums, and why certain objects—an Aldo Rossi tea kettle or a Haida mask, a Tupperware bowl or a ritual bronze Chinese ding—end up in different kinds of museal sites. Above all, I'm interested in the *metaleptic effect whereby institutions don't preserve art but rather, through the act of institutional preservation, create art.*

The temporal coordinates narrated by James and conceptualized by Arendt played a central role in the acquisition and definition of so-called primitive or tribal art. The very act of stabilizing ephemeral objects has the effect of stabilizing cultural identity, be this English identity or Haida identity. When full-size Haida totem poles began to be collected in the 1870s, it became clear to the collectors that they were ephemeral objects. Preserving them—and thus interrupting the local habit of letting the poles be subject to decay—generally meant producing a new concrete base, replacing rotten parts, and repainting.[21] Those acts of preservation helped to establish the allochronic character of the cultural artifacts— both conferring a timeless tradition on the poles that were in fact a rather recent addition to Haida sculpture, and locating Haida culture outside the present tense.[22] The preservation also helped to recode such "tribal artifacts" as art objects: *the arrested time of cultural coherence became the universalized timelessness of art.* By the time the Burlington Fine Arts Club presented *Objects of Indigenous Art* in London in 1920, it did so by accept-

ing the most accomplished work of the Haida nation as "the outcome of inherent genius"; in 1927, the National Gallery of Canada described the work of the Haida, the Tsimsyan, and the Tlingit as "works of art that count among the outstanding creations of mankind in the sphere of plastic decorative beauty," "mankind" serving here as a temporal marker.[23] MoMA's *"Primitivism"* exhibition located itself within the narrative where "tribal art," like "all great art" comes to be recognized as showing "images of man that transcend the particular lives and times of their creators," transcending, in other words, the life and the time of a particular culture.[24] But as James Clifford put it (in 1985), anthropology and art come to coexist as "two domains that have excluded and confirmed one another, inventively disputing the right to contextualize, to represent these objects."[25] The "aesthetic-anthropological object systems of the West," in his phrase, made it possible, in the winter of 1984–85, to view "tribal art" at more than seven different kinds of institutions.[26] The specter of such systems animates the work of Brian Jungen as he sets out to preserve, however perversely, the ephemera of North American consumer culture.

2. Misuse Value and Unhuman History

Jungen, a Swiss-Aboriginal member of the Doig River band of the Dane-zaa (or Dunne-za) nation (or Beaver people, a small Dene population living in the Peace River area of eastern British Columbia and northwestern Alberta), has come to rely on the act of redeploying, refabricating, and recirculating (within the art system) some of the most globally familiar objects: baseball bats and soccer balls and cafeteria trays and wooden pallets and plastic coolers and sports jerseys and red plastic gas cans and backpacks. Of course, these days, the artistic redistribution of consumerist object culture (fully formed or ravaged) has become a major mode of production within the contemporary art world, from the work of Thomas Hirschhorn to that Dan Peterman to that of Sarah Sze. Such artists evoke the long and global history of how things are absorbed into the field of cultural production.[27] Within that field, there is something disarming about Jungen's work, in large measure because the artist's act of recycling (often humorous and serious) takes place within what James Clifford termed, back in the 1980s, "the predicament of culture," by which he meant the predicament of ethnographic modernity wherein one finds oneself "off center among scattered traditions" and in the midst of literal and figurative mobilities that effect "a kind of rootlessness." The anthropologist's concept of culture makes less sense once cultures have been dislodged from specific locales, rendering the location of culture an im-

probable accomplishment. Clifford was one of the first anthropologists to be explicit about not seeing "the world as populated by endangered authenticities," about recognizing that "people and things are increasingly out of place," while still understanding the importance of asking "geopolitical questions" of "every inventive poetics of reality."[28] Critical ethnography, the new museology, postcolonial theory—these have each in its way worked to stage this predicament of culture, as has a considerable body of art.

In the case of Jungen, you might think of yourself as facing not only the predicament of culture but also the predicament of nature: the predicament of their mutual entanglement that irritates the history of museums and material culture. For Jungen's work, appearing in galleries and museums of art, *situates itself* at the intersection of art museums and natural history museums, whose iconic artifacts and traditional logics of display he repeatedly evokes even as he works with untraditional materials, such as the stacking white plastic chair, a globally ubiquitous object (see fig. 7.1). These monobloc polypropylene objects, which have become, as one reporter adroitly dubbed them in 2007, "the everychair of chairs," were "invented" in the 1960s and began to be mass manufactured in the early 1980s (polypropylene as such having been polymerized in 1954). The reporter asks her readers to contemplate just how familiar the chairs have become: "Just think about how many there are in schools, bars, hospitals, parks, beaches, sports stadiums and retirement homes. And how often they appear as props in global dramas. Floating in the debris of the tsunami and Hurricane Katrina. Seating thousands of people at Cuban political rallies. Lurking in the hideout where Saddam Hussein was captured, and in Abu Ghraib prison."[29] So, while one analyst of material culture has argued that "in some respects artifacts are like new species that reproduce themselves alongside biological ones," where one can see "an evolutionary process tending toward greater and greater complexity of function," the stacking white plastic chair would seem to be the result of a devolutionary process, leaving us with chairness at its most generic, at its most "primitive" or "natural," where economic and aesthetic minimalism converge in a kind of coarse yet clean vernacular modernism.[30]

In 2000 Jungen began to produce his first chair-dependent sculptures, such as *Bush Capsule*, made from a circle of plastic chairs covered by plastic wrap, the capsule illuminated from within (plate 9). It is a structure that brings to mind the geodesic dome or some kind of lunar domestic pod. More particularly, the construction reenacts, differently, the work that went into the makeshift shelters built by farm workers, or temporary "winter houses" made annually by some First Nation people of the Northwest, or the permanent houses discovered in an ancient village

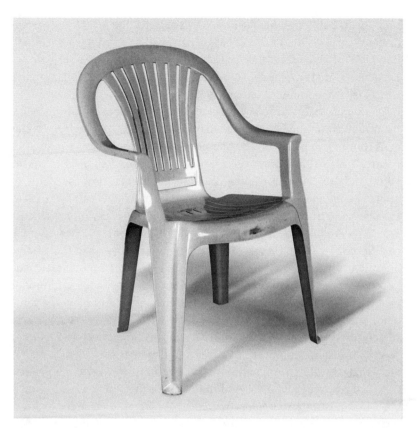

7.1 White plastic chair.

during the Thule expeditions of the 1920s, an especially productive chapter in the history of material anthropology.[31] The structures were constructed with driftwood or whalebone supports and covered by skins, then by sod and by rock. In his reenactment, Jungen has replaced the whalebone with the plastic chairs and the sealskins with plastic wrap. He has taken ready-to-hand materials that are at once local (they're simply around) and representative of an Americanized global culture (that's everywhere) to represent a highly specific, local and traditional culture, substituting an especially "unnatural" substance for skin and bone.

Jungen intensified the relay between traditional and contemporary domesticities in *Furniture Sculpture*, constructed for his first comprehensive retrospective at the Vancouver Art Gallery in 2006 (plate 10). He made the huge tepee from eleven 2006 Natuzzi leather sofas, discarding the guts of the sofas (that is, the stuffing), and using the wood infrastructure for the internal supports of the tepee. In a video that accompanies the display of the piece, you see Jungen theatrically taking a sort of hunting knife to the sofas, slicing them open, ripping out the guts, and skin-

ning them. (Although he had hoped to slaughter the sofas "more tradi-
tionally" by pitching them off a balcony, the gallery did not permit him to
do so.)[32] Dislodged from the domestic fashion system (where leather has
become the material of choice within the "casual comfort" paradigm),
the sofas, at the moment of regutting, might be said to experience a re-
becoming animal, a process that places the contemporary furniture in-
dustry within an object culture where man's mere subsistence, or ele-
gant comfort, depends on the ongoing (however occluded) conquest of
nature. The intensity of his re-creative imagination lies not least in his
willingness to confer (or, more dramatically, to disclose) the status of
animal on inanimate, manufactured objects. This could be understood as
the playful performance of a kind of animism (classically interpreted by
E. B. Tyler among others to be the ur-form of religion), an unwillingness
to differentiate what we call spirit and matter, what we call the organic
and the inorganic. This is to argue, then, that Jungen's mode of artistic
production, his radical misuse, transforms a characteristic of "premod-
ern" culture into a characteristic of "postmodern" Culture; but the value
emerging from the misuse, as I understand it, is to identify the singleness
of a culture for which "home" continues to depend on stretched hide.

That transformation thus involves not just what we call culture, but
also what we call nature, and it is to the natural world—to the paleon-
tological recovery and display of that world—that Jungen establishes a
citational relation in a sequence of works known as his "cetology series"
(2000–2003), room-size skeletons made from plastic chairs, the chairs
now replicating whale bone in behalf of representing a complete whale
skeleton (see plate 11). Cut up, the chairs (less than $5.00 CAD each at the
time of production) have been reconstellated, riveted segment upon riv-
eted segment forming the vast spinal column and tail, the rib cage, the
skull and massive jaw. The most extensive of the figures is fifty feet long.

Of course, there is considerable modernist precedent for transform-
ing common manufactured objects into the figure of an animal, as in
Picasso's not-quite-readymade, *Tête de taureau* (1942), composed of a bi-
cycle seat and handlebars. But Jungen monumentalizes the gesture and
means to equate the final product with a familiar sight from natural his-
tory museums all over the world. Even as the hovering figures resemble
the sea monsters from the Pliocene era that hang from the ceilings of
those museums, so too the evident creativity and craftsmanship fore-
ground the *constructedness of prehistory* (that is, the history of unhuman
history). But the formal simplicity of the bright white creatures expresses
a kind of purity, especially when they are exhibited in a white gallery
space that evokes a white-on-white modernism.[33] You could argue that
these are full-scale representations of the killer whale or of Wasgo, the

mythological "sea-wolf" that is part wolf and part whale, but the creatures are in fact generic, neither naturally nor mythologically specific; the replication—more an evocation—is iconic and gestural, not grounded in any measured correspondence to a model.

In some respects, then, Jungen might seem to fit within the crowd of anthropologists (say, Lévi-Strauss) and artists (say, Robert Smithson) for whom the natural history museum serves as the site of some primal scene. Smithson, as an example of his more widespread investment in "origins and primordial beginnings," described himself, as an eight-year-old interested in collecting "naturalist things, looking for insects, rocks and whatever," visiting the Museum of Natural History and making "very large paper constructions of dinosaurs which in a way, I suppose, relate right up to the present in terms of the film I made on *The Spiral Jetty*—the prehistory motif runs throughout the film."[34] His assertion that contemporary art must "explore the pre- and post-historic mind [and] go into the places where remote futures meet remote pasts," like his equation of dinosaurs and modern technology, can be traced to his fascination with the convergence, or exchangeability, of the temporalities he experienced within the museum: "This sense of the extreme past and future has its partial origin with the Museum of Natural History; there the 'cave-man' and the 'space-man' may be seen under one roof. In this museum all 'nature' is stuffed and interchangeable."[35] But unlike Smithson, of course, Jungen eschews rocks and dirt in favor of the substance that is indissociable from contemporary culture. Although exhibits of this work have pointed out how the skeletons recall the threat of extinction as it has been faced by First Nation people, it is the ambition of Jungen's work, as I understand it, to at once mark and transcend "the currency of tribal art, culture, and politics."[36] (He himself has said in an interview that "serious political correctness" doesn't interest him.)[37] A materialist approach to art that understands materialism temporally could perceive a generalized dialectical drama of permanence and change: the relation between, on the one hand, bones that remain because they have been fossilized and, on the other, the nonbiodegradable polypropylene chairs that will remain in our garbage dumps long after we ourselves are gone: *the nonmortal remains of mortal being.* The cetology series theatricalizes the ubiquity of white plastic not in space, but in time. In Arendtian terms, the drama begins with the question of what identity is being stabilized in relation to *the same chair,* which is at once cheap and disposable and yet undisposable.

Because, at a certain distance, the skeletons become recognizable as fragments of the white chairs, the metamorphosis of human products into natural creatures remains incomplete. This is not an accretion of

outmoded cultural fragments conjured into some language of the fossil. Rather, it is an effort to prehistoricize the present, as though history (real human history) were an event yet to come, or an effort to posthistoricize the present, as though history were over and we simply linger, however unconsciously, in the state of our extinction. It is an effort to dramatize the chronological extent of the Anthropocene. By divesting the chairs—in these acts of misuse—of their exchange value and their use value, freeing them "from the drudgery of being useful,"[38] Jungen can reconfigure the chairs into sublime objects that relocate them within unhuman history—the history not of the world, but of the earth.

Or, you might say, some new history of the *earth* as *world*, given the discovery in 1997 of what has been dubbed a new "Leviathan," found in the North Pacific subtropical gyre: the Great Pacific Garbage Patch, a slowly rotating mass of debris—90 percent of which is plastic—a mass estimated to be twice the size of Texas.[39] Charles Moore made the discovery when, sailing from Hawaii to Long Beach, he took a shortcut through a region assiduously avoided because of the lack of current and wind, the constant high pressure that creates an "oceanic desert": "As I gazed from the deck at the surface of what ought to have been a pristine ocean, I was confronted, as far as the eye could see, with the sight of plastic. It seemed unbelievable, but I never found a clear spot. In the week it took to cross the subtropical high, no matter what time of day I looked, plastic debris was floating everywhere: bottles, bottle caps, wrappers, fragments."[40] As one polymer chemist put it, "every little piece of plastic manufactured in the past 50 years that made it into the ocean is still out there somewhere . . . because there is no mechanism to break it down."[41] Plastics do break down (they photodegrade) to a point: to the point of becoming confetti-like bits and then microscopic particles mimicking plankton and consumed by fish and birds, the toxicity of the plastic itself supplemented by the toxins it has absorbed. This is why one oceanographer, a marine debris specialist who has worked with Moore, insists that "if you could fast-forward 10,000 years and do an archaeological dig . . . you'd find a little line of plastic. . . . What happened to those people? Well, they ate their own plastic and disrupted their genetic structure and weren't able to reproduce. They didn't last very long because they killed themselves."[42] The becoming plastic of the human.

But my point is not that the cetology series argues for some specific ecological consciousness. Rather, it provokes the experience, however momentary, of a temporality and a natural history wherein such a consciousness might develop; it means to shock our "historical metabolism" into some dilation that registers a more totalizing *durée*.[43] The misuse of

the chairs, which draws attention to their material specificity, on the one hand, and to the constructedness of the icons and emblems of the pre-historical, on the other, enables the cetological products to become dialectical objects, the compressed temporalities (present, past, and future) dramatizing some dialectic of transience and transcendence.[44] The art confronts the spectator with another region of being where man-in-the-world, in the midst of nothing more than these silly chairs, is minimized in the before and after of man, the pre- and the posthistoric.

3. The Re-creation of Things

A series of twenty-three works that Jungen produced between 1998 and 2005, his celebrated "Prototypes for New Understanding," seem to return the focus to human history. This is a series of "inauthentic/authentic" Northwest-coast artifacts meant to evoke Haida masks but made from Air Jordans, the sneakers unstitched and recomposed into a variety of iconic forms, to which, in some instances, Jungen attaches human hair— the reminder, perhaps, that the human body is a thing among things. The strange, surreal masks are meta-objects that congeal three highly identifiable object cultures (plates 12, 13).

The first, of course, is the traditional art of the Haida, whose masks, representing spirits of the woods or spirits confronted by their ancestors, were used during potlatch performances, and whose object culture was originally best known beyond Canada in the form of the Haida Gwaii totem poles, written about by Tylor and Boas and cherished by major institutions—the Pitt Rivers Museum, the American Museum of Natural History, the Smithsonian, &c. The traffic in Haida artifacts has played a prominent role in anthropology, in ethnographic display, and in tourism, the tourist literature of the late nineteenth century identifying the Indians of the Northwest Coast as "the artistic savages of the world."[45] As Stocking puts it, "the very materiality of the objects of material culture" meant that they could be dislodged, exchanged, or stolen, readily entering "Western economic processes of the acquisition and exchange of wealth."[46] He goes on to argue that "the objects of 'material culture'— which in traditional contexts often had spiritual value—are respiritualized (in Western terms) as aesthetic objects, at the same time that they are subjected to the processes of the world art market," a market that always threatens to compromise their authenticity (6).[47] There was already a market, in the first half of the nineteenth century, for seamen, traders, and tourists, who purchased argillite carvings and masks (made for the

market); by the 1860s model totem poles became the favorite souvenir; and by the end of the century (small pox having reduced the population to twelve hundred, and that population having left its traditional home), well-known artists (notably Charles Edenshaw, whose transformation mask from 1890 resides in the Pitt Rivers Museum) worked very self-consciously to learn and preserve traditional techniques and designs. These days, when the work of Haida artist Bill Reid appears on the back of the Canadian twenty-dollar bill (the aboriginal in Canada and elsewhere having come to function as a sign of the national), the high-end market includes artists such as Robert Davidson (Edenshaw's great-grandson), Jim Hart, and George Storry, well known throughout the province and beyond it (see plate 14). The low-end market amounts to tourist trinkets that you can pick up at several shops in Vancouver, just one dimension of what Charlotte Townsend-Gault has termed "the polymorphous proliferation of First Nation designs, images, and motifs over the last 15 to 20 years."[48] Prototypical Haida design, known nationally and internationally, appears on all sorts of objects: scarves and serving trays and sweatshirts and skateboards (plate 15). All this is to say that, from the 1840s to the 2010s, both Haida objects and "Haida" objects have become part of many object cultures. The very ubiquity of the design makes Jungen's masks recognizable at a glance as "Haida" (which is not to say that one or another doesn't suggest, more precisely, a Kwakwaka'wakw or Tlingit analogue).[49]

The second object culture evoked by the pristine display of Jungen's masks (which he insists on) is that moment in the history of European aesthetic sensibility—primitivism—when "tribal artifacts" became re-designated as art, their further recontextualization exerting a new "power over viewers," but, as Stocking says, "a power not simply inherent in the objects, but given to them by the museum as an institution within a particular historical sociocultural setting."[50] Within the history of European art, that new power was mediated most famously by the Museum of Ethnology at the Trocadéro, which provided Picasso with the formal inspiration to complete the large canvas he had been struggling with in 1907, *Les demoiselles d'Avignon*, the premiere exhibit of the MoMA "Primitivism" show and, arguably, the painting in which Picasso "discovered modernism." In 1903 the new decoration for the ballroom of the governor's mansion in Victoria included Haida motifs; in 1927, a gallery in Paris exhibited the paintings of Yves Tanguy with carvings from the Northwest coast;[51] and during that decade two books (one published by a school of art and design) appeared in Europe that were based on museum collections of Northwest Coast specimens.[52] African artifacts have had a more famous art-historical presence in European art history, but

work from the Northwest coast became no less aesthetically respected, ultimately the subject of "ethnocentric awe" and "escalating markets."[53]

The third object genealogy is located neither on the Northwest Coast nor in Europe, but in the United States, where Nike's production of Air Jordan sneakers, originally designed by Peter Moore, began in 1985 (plate 16). Banned at first by the NBA because the dramatic color scheme violated the association's design code, and originally disliked by Jordan, who said of the first designs that they looked like "devil shoes," Air Jordans have since become the marketing triumph of the sportswear industry, by now famous and infamous for their expense—Air Jordan VI's sold for $125 in 1991—and for their status as collector's items.[54] Indeed, Nike itself reproduces earlier models in their Retro and Retro Plus editions: retros of the Air Jordan VII, originally on the market in late 1991, were released again in 2002 and 2004. (Of course, illegal copies have also been manufactured.) The sneakers themselves have always relied on complex, citational design—one inspired by the Stealth Fighter F-117 used in Desert Storm; many incorporating Jordan's number 23 (or his Olympic number 9) into the stitching or the design of the shoe itself; and the Air Jordan XXI, released in February 2006, making use of the grill design from the Bentley as inspiration for its side vents. Increasingly the objects themselves approach the status of meta-objects.[55]

Jungen has commented at some length on the initial stages that led him to the Prototype refabrications. He describes being in New York and visiting the Museum of Natural History, the Metropolitan Museum of Art, and then Niketown, "where they also present their products in big, hermetically sealed vitrines." "I went to the sports store and purchased a number of pairs of Air Jordan sneakers and began to dissect them, which in itself was interesting—in that it was almost a sacrilegious act: cutting up and 'destroying' these iconic, collectible (and expensive) shoes."[56] The emphasis on the iconicity of the shoes is of particular importance because it helps to dramatize what you might call a rival act of recontextualization and appropriation, within which the sneakers attain new value, or within which the exhibition value of Nikes has been disclosed as having (as always having had) greater priority than any exchange or use value. "It was interesting to see how by simply manipulating the Air Jordan shoes you could evoke specific cultural traditions whilst simultaneously amplifying the process of cultural corruption and assimilation. The Nike 'mask' sculptures seemed to articulate a paradoxical relationship between a consumerist artifact and an 'authentic' native artifact."[57] Rather than Western art being rejuvenated by the incorporation of "primitive forms," First Nation art is rejuvenated through the incorporation of the Western commodity, but a product that has much of the totemic potency

we associate with "tribal art." Moreover, the Prototypes enact a counter-appropriation from the North American sports world that has consistently used Native American imagery for its emblems.[58]

Michael Jordan and the Nike swoosh achieved an international recognizability in excess of Haida iconography. Air Jordans could well serve as the paradigmatic object for apprehending a global object culture just as Nike often serves as the paradigmatic global corporation; the title *Michael Jordan and the New Global Capitalism* makes immediate sense; Jordan was (and perhaps still is) the most recognizable individual worldwide.[59] There are college courses offered on the Jordan phenomenon: on Nike's work to turn Michael Jordan into "everybody's All-American commodity sign," at once catering to the fascination with the black male athlete and transcending race; and on the "intertextual corporate coalition that engineered Jordan's global ubiquity": "Michael Jordan's commodified image can be confronted with startling regularity when strolling through the commercial hyperspaces of the world's major cities, deindustrialized urban wastelands, excessively affluent suburban fortresses, or even rural hinterlands."[60] Originally signing Jordan in 1984 (for $2.5 million over five years), Nike aired the "Jordan Flight" commercial in 1985 and sold $100 million of its new Air Jordan line that year, the demand ultimately outstripping the supply. Nike was also one of the first U.S. corporations to depend on outsourcing (in the 1980s); it established factories in Taiwan and South Korea, then China and Indonesia and Vietnam, and found itself entangled in labor disputes and subject to frequent publicity for its exploitation of foreign labor.[61] The Prototypes have a timeliness the way the cetology series does not: "I think in 50 years people won't know what exactly Air Jordans were. They'll see these objects and it'll be like how the Surrealists used contemporary products in the 30s and 40s; you look at them now as an arrangement of antiques."[62] But given how Air Jordans have depended on the global system for their production, marketing, and distribution, the Prototypes might be said to defy any specificity of place. The first sneakers that Jungen patiently unstitched were probably stitched, less patiently, in Vietnam.

For me it's useful—however traditionally anthropological—to think about Jungen's "cultural corruption" (his term) with the help of Lévi-Strauss's work on the masks of the Northwest Coast: *La voie des masques*, the way of the masks and the voice of the masks. Lévi-Strauss was trying to resolve the discrepancies in form between a particular Salish mask and a Kwkiutl (now Kwakwaka'wakw) mask and concluded that, within distinct origin myths for the masks, there are transformational relations that, from a purely plastic point of view, prevail among the masks themselves, thus explaining why the sunken eyes *here* reappear as the pro-

truding eyes *there*. His ultimate claim was that the masks from differ-
ent tribes and different locales within the region are "parts of a system
within which they transform each other."[63] My sense of Jungen's work is
that it means, say, to *expand the region under anthropological scrutiny* and
to expose other systems in which artifacts appear as transformations of
one another. Which systems?

Most obviously, within a gallery, the art system, where the Prototypes
invert and recode that appropriative act by which Western art made use
of "other" cultures. Like the "tribal artifacts" recontextualized as art, the
Air Jordans have been dislodged from their original scene (of display,
consumption, and use). Second, the system of conspicuous display, the
process of creating and preserving cultural capital: the Prototypes high-
light the ways in which Northwest artifacts and Air Jordans look like ver-
sions of one another in their iconicity and sign value, indeed even their
value on the market. That is, they appear as one another not just plasti-
cally but structurally: their exhibition, sign, and economic value seems
to minimize their use value. (Indeed, Air Jordans are often not worn be-
cause of the threat of violent theft.) Third, the international "traffic in
culture," from the anthropologist's traffic in artifacts of the nineteenth
century to the global marketing enabled by new networks of commu-
nication.[64] Fourth, the systems of fetishism through which inanimate
objects "are not perceived as inert matter but as quasi-living power ob-
jects."[65] All this is to say, more epigrammatically, that in these acts of re-
fabrication Jungen transforms the sneakers into what they already are.

Of course, the confrontation—or, better, simply the conflation—of
these three object cultures and these four systems provokes some new
predicament of culture. Attention has been drawn, successfully, to how
Jungen's work relies on cultural misunderstandings and stereotypes to
complicate and criticize the modes by which things mediate people. Jun-
gen himself has spoken eloquently, both of the influence of growing up
in a household where "improvisatory recycling was born out of both
practical and economic necessity" and of his attempt, with the Proto-
types, to transform these objects into a new "hybrid object, which both
affirms and negates its mass-produced origin and charts an alternative
destination to that of landfill." But his creations also work to disclose a
certain thingness derived from what Webb Keane calls the "very materi-
ality of the object."[66]

In Heidegger's famous account of Van Gogh's painting of peasant
shoes, he works to discover the equipmental quality (the equipmental
being) of equipment, the reliability of "a pair of peasant shoes and noth-
ing more. . . . From the dark opening of the worn insides of the shoes
the toilsome tread of the worker stares forth. . . . In the shoes vibrates

the silent call of the earth, its quiet gift of the ripening grain and its un-
explained self-refusal in the fallow desolation of the wintry field."[67] But
shoes as Jungen has reconfigured them disclose a different being, a dif-
ferent thingly feature, a certain uncanniness that unsettles the thing as
formed matter for human use. Not at first glance, perhaps, but with some
concentration, a viewer finds these works so arresting because they are
neither one thing nor the other, which is to say, by my light, that their
thingness emerges from a kind of oscillation: neither plastic chairs nor
whale skeleton, yet both skeleton and chairs.[68] Neither sneakers nor
mask. Both mask and sneakers. The relays between these object forms
might finally disclose the life and longing of the constituent materials:
the oscillation enchants dyed leather into a thing that drifts in excess of
any object form. It allows us to imagine, I think, a world in which the
material around us—the denim of your jeans, the glass of your watch
crystal, the wood of your chair seat—has, as the object of its desire, per-
haps, the desire to be some other object. It is as though Jungen's work
begins to expose a newly animate world, a secret life of things that is ir-
reducible to the object forms with which we have constructed and con-
stricted our world. And it is the recognition of that life, I think, that holds
some promise for transforming life as we know it.

Kitsch Kulchur

About the art with which chapter 7 concluded—Brian Jungen's "Proto-types for New Understanding," his "Northwest Coast masks"—about these you might say that there's something kind of kitschy . . . depen-dent as they are on a caricatured image of "primitive art," as on the fe-tishization of Air Jordans and the mass marketing of Jordan himself. You would be pointing at a low cultural bar: sham sophistication, ease of comprehension, witty diversion. Appreciating that ease while none-theless sensing the disturbance that Jungen means to effect depends on a doubled temporality: both glance and dilating inquiry. The work means to catalyze a kind of double vision—something akin to what emerges, persistently and profoundly, in Walter Benjamin's analytic: a capacity to witness anguish and aspiration, disabled past and enabled future, in the same instant, the same image, the same object. The object is what it is; it is also something else. Within his *Arcades* project, which he began as he worked on the surrealists, Benjamin concurs with the established conten-tion that kitsch is "irreconcilably opposed" to art by being "nothing more than art with a 100 percent, absolute and instantaneous availability for consumption."[1] The trick, then, is to retard that instantaneity—to make kitsch available instead for consternation. Or: the trick is to shake kitsch loose from its oneiric habitat, the diorama of the everyday. In 1928, as Benjamin began to develop the idea for his collecting project on the Paris Arcades, he imagined releasing kitsch from "the realm of dream": "We construct here an alarm clock that rouses the kitsch of the previous cen-

tury to 'assembly'" (*Arcades Project*, 883). But how can the kitsch of our own time be roused?

Of course, these days, if something is *kitsch*, it could be that it's tasteless in a way that makes it kind of cool, if not camp. Could be it's so kitsch that it's dope. The likes of Warhol, Barbara Kruger, Jeff Koons, and Paul McCarthy have made it clear how aggressively artists are willing to deploy kitsch to evade an aesthetic system for distributing value, just as architects have made it clear that kitsch can be deployed to humanize a built environment sterilized by modernism.[2] There was a time, though, within the (modernist) American art scene, when the bite of kitsch lay in its having been posited by Clement Greenberg not just as the antithesis of art but also as "the epitome of all that is spurious in the life of our times."[3] He was willing to grant that "superior culture is one of the most artificial of all human creations" and that the "great mass of the exploited and poor," unable to appreciate "genuine culture," remain "hungry nevertheless for the diversions that only culture of some sort can provide" (19, 17, 12). Still, the "virulence of kitsch," its "irresistible attractiveness," and its "potency" lay in the effortlessness with which the "predigest[ed]" can be consumed, eliding any "discontinuity between art and life" (14–15). The danger of kitsch, as Greenberg saw it in 1939, was twofold: it served as the medium for perpetuating the status quo (life as it is within the system of Capital), and it served as the medium by which totalitarian regimes (in Germany, Italy, and Russia) "ingratiate themselves" to the masses (19–22).

Engaged as he was by the "genuine culture" exemplified by Baudelaire, Proust, and Kafka, for instance, Benjamin recognized that this irresistibility of kitsch, like that of film, made it the necessary locus for apprehending some collective desire to live life otherwise. That kitsch merits serious attention (rather than dismissive demonization) is a lesson ultimately learned by his friend and harshest critic, Theodor Adorno, who was finally willing to explore the "kernel of truth" within kitsch, the degree to which it responds to a legitimate desire within the carceral capitalism of the twentieth century.[4] He was willing, moreover, to locate the anticipation of kitsch in the novels of James Fennimore Cooper, in Hellenistic arts and crafts, in Attic comedy: in cultural forms that both depend on the "structure of invariables" and insist that "nothing must change."[5] He continued to believe that kitsch serves the "dual nature" of so-called progress, which maintains oppression while ceaselessly pointing to the possibility of freedom (M, 146).[6] But he was also willing to assert that kitsch "incurs hostility because it blurts out the secret of art"— its "rational purposefulness" as something made—and because it reveals

the "affinity of culture to savagery" (M, 226). In his memorializing "Portrait of Walter Benjamin," he points to "Dream Kitsch" as the short article in which to perceive not simply Benjamin's concern with the surrealists' ability to produce "shocklike flashes" from "obsolete" objects, but also his longing "not merely for philosophy to catch up to surrealism, but for it to become surrealistic."[7] On the one hand, such philosophy sees through the "ideologies of the 'concrete'" as "the mere mask of conceptual thinking at its wits end" ("WB," 231); on the other, "an essay on the Paris Arcades is of greater interest philosophically than are ponderous observations on the Being of beings" ("WB," 232).[8] What Benjamin himself called the "materialist toxins" in his thought curbed any impulse toward ontological speculation ("WB," 235).

In "Dream Kitsch" (1927), he fuses the surrealist invigoration of cultural debris with the movement's own invigoration from "tribal artifacts." He describes them seeking "the totemic tree of objects within the thicket of primal history. The very last, the topmost face on the totem pole, is that of kitsch." Though his image visualizes the animation projected onto (or into) the "outlived world of things," he concludes by describing the process in reverse, explaining how "in kitsch, the world of things advances on the human being" and "ultimately fashions its figures in his interior."[9] Adorno recognized that much of the power of Benjamin's work derived from his willingness to permit "thought to get, as it were, too close to its object" and his refusal "to accept as ineluctable the threshold between consciousness and the thing-in-itself": a non-Hegelian refusal—familiar today among speculative realists and object oriented ontologists—to abide by Kant ("WB," 240). But Benjamin's historical point in "Dream Kitsch" is, more radically, that such a threshold no longer exists. You might have asserted, once, that subjects constitute objects, but things—the things we call kitsch—have now installed themselves within the human psyche.

The following chapters track that installation (in the psyche) but they do so very differently, and within very different cultural sites. In a chapter on Shawn Wong's fiction, I concentrate on a boy's misuse of a Charlie McCarthy doll, which enables him to productively confuse history and dream, dream and history—the history of immigrant labor. I then turn to the "black collectibles" within Spike Lee's *Bamboozled*, a film that discloses a "kernel of truth" within them—the truth of the ontological ambiguity suffered by American slaves. Finally, chapter 10, "Commodity Nationalism and the Lost Object," focuses on the 9/11 collectibles that appear as an example of the materializing ambitions that worked not just to memorialize that tragedy but also to compensate for the loss of the Twin

Towers. All told, then, scrounging around the dregs of a recent U.S. object culture, I end up fixating on particular objects that powerfully congeal some of the worst episodes of U.S. history; that power appears in the oscillation between the object and the thing.

Eight

How to Do Things
with Things:
A Toy Story
(Shawn Wong)

What fallacy do you risk when you pause to grant a text some extratextual dimension? What hazards do you chance (naïveté, banality, empiricism, humanism?) when you read a literary text to write a history of the referent? What fetishism do you commit? Or, more important, what fetishism are you trying to overcome? For only an unseemly, rear-guard investment in the object of reference, perhaps, can explain that object as the precipitate of other investments. Perhaps only an analytic overvaluation of the object allows literature to teach not just a history of things but also the history *in* them.

If the history *of* things can be understood as their circulation, the commodity's "social life" through diverse cultural fields, then the history *in* things might be understood as the crystallization of the anxieties and aspirations that linger there in the material object. And such a history might yet be explored, however provisionally and problematically, between two critical formations where things (very differently) disappeared: between a poststructuralist epistemology that insisted on dispensing with "things" and a marxian phenomenology that insisted that we have no things to dispense with, that the "thingness of things" is precisely what modernity and its aftermath deny us.[1] Here, then, as throughout the course of this book, *things* will come to designate less the unalterably given material object world than that which becomes visible or palpable only in (or as) its alteration—the alteration between the object and the thing. Things and the history in things become conspicuous in

the irregularities of exchange—in the retardation of the primary circuit of exchange wherein man establishes objects insofar as he is established by them.[2] The question of things, even the question of whether they are, is inseparable from a question about what they do, or what can be done with them. For things compel our attention and elicit our questions only in their animation, their alternation between one thing and another, between the object and the other thing. Literature, as I've tried to show in preceding chapters, can serve as a mode of rehabilitative reification: a resignifying of the fixations and fixities of thing-ification that will grant us access to what remains obscure (or obscured) in the routines through which we (fail to) experience the inanimate object world.

Consider what follows a materialist dream. It is a dream about the 1950s, the point of which is all but magical: if not to hear things speak for themselves, then to imagine a history of things as something other than the exiled other of language.

1. An Object Lesson

In Shawn Wong's first novel, *Homebase* (1979), Rainsford Chan lives his life longing to be recognized as American, not as Chinese, and to "find a place in this country."[3] In his childhood, though, that desire is temporarily arrested when he confronts an American icon, Charlie McCarthy, in the form of a doll. Among the mass-cultural debris that helps construct this novel's image of the 1950s, the toy prompts a kind of blockage, the occasion for a more extended engagement with the products of consumer culture.

When his father brings home "a tattered Charlie McCarthy puppet," the seven-year-old bluntly asserts that he doesn't play with dolls. "But this is not a doll," his father tells him.

> "His name is Charlie McCarthy and he talks." His father puts his hand through the back of the puppet, spins the head around, and pulls the string that moves the mouth.
>
> "Hi, my name is Charlie McCarthy. I'm glad to meet you." The mouth claps open and shut. The arm pushes out to shake hands. The head spins all the way around. The kid shakes his hand. (*H*, 70)

The doll then participates in the family meal, and Rainsford, learning to talk as an amateur ventriloquist with his "teeth clamped down into a pasted grin," learns to play with dolls (*H*, 71). He adopts the doll and adapts it, changing its name from Charlie to Freddy, despite his friends'

objections. Although China as a political, cultural, or geographic entity is something that Rainsford has "never seen, never been to, never dream[ed] about, and never care[d] about" (*H*, 66), nonetheless his act of willful misnaming prompts Charlie McCarthy's assimilation into Chinese culture. "Freddy" becomes Charlie's "Chinese name," and the boy's mother makes the tattered doll a suit out of red Chinese silk (*H*, 71).

Wong's account of how the subject reconstitutes the object—the boy's ludic transformation of the doll into the bright red Chinese figure of Freddy—attests to how the act of consumption can itself be productive (or re-productive), to how objects remain fungible outside the commodity form.[4] Rainsford's transformation of the discarded cultural object confers new value on it: the tattered doll becomes the only "Charlie McCarthy doll on the island that could speak Chinese" (*H*, 71). *Homebase* thus offers a basic lesson in how, despite the purported mass-cultural homogenization of America in the 1950s, some products, significantly recoded, could become the ground from which to express ethnic individuation. This scene is stored in the imaginative archive that enables the narrator to perpetuate contact with his family. Named after the town (Rainsford, California) where his great-grandfather settled to work on the Central Pacific Railroad, he narrates the history of Chinese labor as a history he intermittently lives in the present tense; but though *homebase* names an idealized correspondence of object, place, and concept, the boy's name marks a disjuncture, for Rainsford, California, has disappeared from the map. Literally and figuratively displaced, the boy accumulates scenes of lost filial intimacy, his father having died when the boy was seven, his mother when he was fifteen. But 1956, the year before his father's death, the year his parents moved from Berkeley to Guam, assumes retrospective status as the best year of his life: he lives in "a boy's paradise" (*H*, 3) made up of aircraft carriers and submarines, a paradise where, accompanying his father on his building inspecting rounds, the boy rides shotgun, sporting a Superman shirt and a toy Colt, proudly exhibiting familiar emblems of U.S. culture (see *H*, 11).

No such familiarity characterizes his interaction with the doll. Freddy soon serves as the facilitator for the boy's education in a language neither he nor his father knows.

> "*Yi*," said Mother.
> "*Yi*," said Freddy.
> "One. *Yi*!" I said.
> "*Er*."
> "Ergh." It came up through the teeth from the throat, like a cough.
> "Two. Er," I said. Freddy nodded. (*H*, 71)

As Freddy and Rainsford learn their numbers through ten, the scene extends as a vertiginous accretion of ventriloquist acts: Rainsford, in the voice of Freddy, teaches himself the "native" language he does not know.

A kind of recontextualized readymade, the doll thus emerges as the requisite mediating object, a pedagogic tool, without which the boy wouldn't bother with his mother's native tongue. It functions as a belated transitional object with which he negotiates his relation to his mother. The doll occupies a familiar role in the dynamic whereby the child as subject deploys material objects in the construction of the self. In other words, the scene literalizes the process of what psychoanalysis calls projection and introjection. And it literalizes, no less, the process of what anthropology calls objectification and internalization. The animate object in *Homebase* externalizes a psychosemiotic process of cultural negotiation, wherein the boy manifests—identifies with and as—the identity he seems to project and construct. The magic of this animation is comparable to the paradox of the transitional object as D. W. Winnicott originally described it: created by the subject, it was just waiting there to be created.[5]

If the scene literalizes those processes, it has also erased them. For the protagonist's narrative (the novel's first-person narration) simply confers agency and voice on the doll, doubling the narrator's own ventriloquist act. "Freddy looked at me with his mouth open, 'Are you ready for this one kid? Here goes, *ba'*'" (*H*, 72). In anticipation of a trip to Hong Kong, Freddy and Rainsford learn more than numbers: "Me and Freddy learned all the necessary words to get by, including ngoh m'sickg ong tong hua [I don't speak no Chinese]" (*H*, 73). Whatever the dynamics of projection, introjection, identification—these assume material form in the movement, the dynamism, of the object itself.

When the subject-object relation is temporalized to the point of becoming recognizable as a negotiation, when the object reappears as a thing assuming a life of its own, this is when we discover the uncanniness of everyday life. Though the very temporality of narrative can prompt that discovery, it can do so only if we unlearn some familiar habits of reading. By this I mean merely that, from a formalist point of view, it doesn't quite make sense to say that the doll, as a narrative object, can be "no more than a pretext, a locus of value investment, an elsewhere mediating the relationship between the subject and himself," for the subject seems to appear here, no less, as a pretext for the object.[6] And from a materialist point of view, even if we agree that there can be in literature no "intensive life of things" independent of man, it doesn't quite make sense to consider the doll just another concrete medium for "concrete human relationships."[7] *Homebase* delays and distorts the regularities of

mediation, which is how it preserves the object from disappearing into (and thereby confirming) the history we already know (the story of homogenous consumer culture), how it uses the psychosemiotic to disrupt the sociosemiotic register, how it defamiliarizes the object into an other thing that can attain a new kind of presence in our understanding of the American 1950s. *Homebase* is explicable as a narrative of mass-mediated ethnic subjectivity, but the irregularities of that mediation also expose what we might call a narrative of objectivity—a narrative in which an object, Charlie McCarthy, becomes differently intelligible, and intelligible not least as an object through which a new relation to things was being voiced, in a decade when the topic of mass culture assumed new urgency.

2. Hybrid Objects and the Life of Things

If, like so much American fiction in the closing decades of the twentieth century, *Homebase* returns to the 1950s, it does so not to luxuriate in a stable and prosperous America, nor to recover the decade as some lost object of desire. Rather, Wong depicts a character who manages the tragic chaos of his life by desperately naming places and by learning how desires can be channeled through and lodged in material objects.

This is why the novel reads like an extended act of accretion. The encounter between Rainsford and "a tattered Charlie McCarthy puppet" is just a brief episode in an obsession with the material world and an obsessive rematerialization of the world. Things like his mother's "dark green jade bracelet" command a talismanic potency in the boy's memory: "I can hear her working around the house when she has it on because it knocks against everything she touches. I've felt it touching my skin many times" (*H*, 93). The memory of the (whole) object comes to substitute for the fragmenting memory of the mother herself: "My sleep tore me apart, and gave her flesh back to me in pieces, her voice with no substance, and finally nothing but a hollow sound would wake me, her jade bracelet knocking against the house as she moved around, cleaning, cooking, writing. It had become for me, in those dreams, the rhythmic beating of her heart" (*H*, 40). His sense of the immigrant struggle becomes most impassioned when he reads words scratched into the walls of Angel Island, the material traces of an anguish that he relives.[8] And he completes his archaeological mission by rematerializing his ancestry within the landscape: "We are old enough to haunt this land like an Indian who laid down to rest and his body became the outline of the horizon. This is my father's canyon. See his head reclining! That peak is his nose, that cliff his chin, and his folded arms are summits" (*H*, 98). Psychic survival depends

on saturating the object world with significance. The anthropomorphization of the land is the final act in a drama of projective incarnation in which artifacts and the artifactual serve as the mode of keeping the past proximate, and of keeping it distant, of turning the imagoes of the psychic life into physical objects. Though Rainsford announces his project as centripetal—"trying to pull all of my past together" (H, 67)—his success depends on the centrifugal possibility of dislodging one's past from oneself.

The act of projecting his father onto and into the landscape works to stabilize the past, to materialize an unruly ghost, just as it seems to satisfy Rainsford's quest for American authenticity and, indeed, aboriginal identity. In contrast, then, Charlie McCarthy, neither an impressive monument nor an exquisite fetish, appears as a kind of unstable element. His/its facile assumption of a Chinese identity might be understood as part of his/its hybridity, part of an uncanny transmutation between identities—the animate and the inanimate, object and subject, person and thing.[9]

When Gaston Bachelard defined hybrid objects in 1957, he was imagining how built space constructs the human psyche. He described how drawers and chests and wardrobes exist as "veritable organs of the secret psychological life," how they serve as a kind of phenomenological prosthesis, providing "images of intimacy" without which "our intimate life would lack a model." These are the things he called "objects-subjects."[10] He understood their hybridity to result from their capacity as objects to produce subjects, for without a sense of the secretness of our secrets, we would hardly be who we are. But because he considers objects only prosthetically—as material ground for imaging the subject as such—Bachelard in fact forecloses any consideration of our intimacy with things: the way we finger watches, rosary beads, cigarettes, a favorite pen; the way toys become the interlocutors with whom children share their secrets; or the way the car or the toaster assumes an ugly personality. In various appropriations of J. L. Austin's How to Do Things with Words (1955), his point is taken to be that language functions perfectly well irrespective of any extralinguistic foundation, irrespective of things. But things can nonetheless, in the ventriloquism of everyday life, people the world we address, the world that addresses us.[11] The hybrid object, then, may be figured as a participant in the intersubjective constitution of reality.[12] In Homebase Rainsford re-produces himself as subject, triangulated between the object and himself.

Indeed, the popularity of ventriloquism as such, like the power of the ventriloquism scene in the novel, may result from its capacity to literalize—indeed, to vocalize—"the interior structure of the artifact," the human animation of the material object world with autonomous agency,

with human powers and weaknesses.[13] And it may result from the clarity with which it materializes the way any human "act" arises from the performance of multiple selves, in concert or in conflict. Yet the instability of any talking doll, ventriloquist's dummy, or engineer's automaton (its fluctuation between the animate and inanimate, person and thing) makes it the object of a fascination that approximates apprehension. Like Hoffmann's tales from the early nineteenth century, any number of horror films from the 1950s or any number of Twilight Zone episodes attest to how persistently the dummy or doll-come-to-life figures in our personal, if not our cultural nightmares. Even when we wish to dispense with any talk about things, they may still be talking about us, sharing a secret life in which they slowly conspire against us.

Such possibilities help to explain why, alongside a story where one dispossessed individual in the 1950s actively transposed some mass-cultural debris, a "tattered" puppet, into a good object (successfully idealized), we can produce another story in which the 1950s cultural mainstream had begun to figure Charlie McCarthy as a bad object, recalcitrant and persecutory.[14] That explanation would make little sense without recognizing how a decade's concern with mass culture, notably marked by Bernard Rosenberg and David Manning White's *Mass Culture* (1957), attended to the status, role, and activity of things.[15] Indeed, while the effort to check mass culture borrows liberally from the Cold War rhetoric of ideological containment, the very problem of ideological containment could be rendered as a problem with the autonomous object, the problem of action without retrospection: Russia, George Kennan had explained in 1947, is "a toy automobile wound up and headed in a given direction."[16] A new attention to the physical, beyond the visual, recast arguments about mass culture and high culture. Just as Reuel Denney was arguing, in 1957, that advertising had widened "the sensuous range of product appeal to include greater variety in the tactile and kinesthetic, as contrasted with the visual, aspect of products," so too Clement Greenberg, in the 1958 revision of his essay "The New Sculpture," was describing the denigration of "the tactile and its associations, which include that of weight as well as impermeability."[17] Art, by Greenberg's light, withdraws from an aesthetics wherein the tactility and kinesthesis of things have become increasingly public.

On the one hand, as the story goes, consumerism became the touted locus of American happiness and the ideological battleground for the Cold War; on the other, mass culture became anathematized by the intellectual Left.[18] Within the less predictable, more ambivalent record of the mass media, though, there appears an account of Charlie McCarthy that reads as an allegory about the power of material objects in postwar

America. The single trajectory of Charlie McCarthy's success, from radio and film in the thirties to his television debut in the fifties, was not accompanied by a single trajectory of appreciation for Edgar Bergen's theatrical accomplishments. In the 1930s Bergen counted foremost as the self-made American: by 1938 he had his own show on NBC (*The Chase and Sanborn Hour*) and made $75,000 a year from Hollywood.[19] By 1950 Charlie McCarthy comics, tie tacks, watches, bubble gum, and peashooters, along with the ubiquitous dolls—"millions of miniature Charlies padd[ing] into homes all over the world"—contributed to an annual retail business of $400,000.[20] Having enjoyed the largest radio audiences in history, Bergen and McCarthy debuted on television, with Coca-Cola spending a record $50,000 to underwrite the half-hour show.[21] The whole enterprise, the ongoing success of the enterprise, the very familiarity of McCarthy as an icon and a household object began to seem symptomatic of a curiously pathological presence. By then McCarthy had received votes in New York mayoral elections; he had become "so living a personality in the imaginations of Americans that Eleanor Roosevelt, upon being introduced to him, reflexively reached for his hand to shake"; and he himself had a private life chock full of the amenities of postwar living.[22] (Candice Bergen, in her autobiography, records her intense sibling rivalry with Charlie McCarthy in the Bergen household: "I wondered if there was a chance my father might leave him in that trunk, might forget him or lose him or something. Then I would have to fill in.")[23] We might say that Charlie McCarthy lived "the social life of things" all too literally, demonstrating not how things constitute everyday life, but how they come to have everyday lives of their own—even that, as Bachelard tried to explain, they possess a "great wealth of intimacy"[24] (fig. 8.1).

Dean Jennings, writing for *Collier's* in 1950, described a "titanic psychological conflict which in recent years has become so acute that [Edgar Bergen] consciously rejects Charlie and is jealous of him." The "intimate and mysterious relationship with his rasping alter ego" had become an intimacy that Bergen seemed unable to bear, not least because he recognized that he was nobody without his prop ("CM," 13). Jennings's account shares something of the logic with which mass culture was being villainized as "an instrument of domination" by the likes of Dwight McDonald and C. Wright Mills, under the influence, not least, of Adorno;[25] but its focus on a particular subject-object relation personalizes and intensifies the sense of oppression. Bergen's intimate relationship with McCarthy, literalizing the increasing use of objects to speak for and with us, was becoming unbearable. "In these dark moments Bergen, like Frankenstein, undoubtedly considers ways and means of killing the thing he created. . . . But Charlie is ubiquitous and indestructible because he is really Bergen's

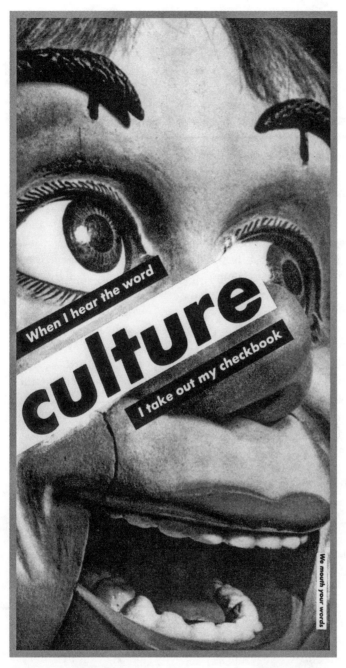

8.1 Barbara Kruger, *Untitled (When I hear the word culture I take out my checkbook)* (1985). © Barbara Kruger. Photograph, 138 × 60 in. Photograph: Courtesy Mary Boone Gallery, New York.

subconscious" ("CM," 14).[26] Such claims, however excessive, express something of the horror some Americans faced with the recognition that their subjectivity increasingly lay elsewhere, outside themselves, in the objects that surrounded them.

McCarthy thus appears as an object of media projection, conveniently materializing the hyperpresence and hyperactivity of things that come to dwarf the human subject. Tracing the "Freudian consequences" of McCarthy's longevity, Jennings described a "ruthless intracranial battle" between Bergen and the doll, citing Heywood Broun's conclusion that "psychologically, it is Bergen who sits in the lap of McCarthy" ("CM," 14). Though the mass culture of this era repeatedly displays and sutures the ruptures of the individual psyche (the double lives of comic super-heroes of the 1950s are exemplary), Charlie McCarthy seems to manifest a psychic split that has no resolution. To say that Bergen sits in the lap of his doll is to say not just that objects mediate our intersubjective re-lations but that objects ventriloquize us. The point is less that the object assumes priority over the subject, and more that the humiliated subject has become a kind of subject-object; it is as though the human being has become the object's *sujet petit a*, perceived and longed for as the miss-ing/completing component of itself. The simple inversion of the subject-object relation both expresses a kind of horror at the monstrosity of the material world and suppresses the dialectical disintegration and reinte-gration of the subject in its object relations.

3. How Things Disappear

Bachelard's argument, written before signs or discourse emerged as the privileged object of critical attention, portrays the material object world as another medium through which we are constructed, by which subjects are, say, silently interpellated. And the degree to which modern subjec-tivity has been structured by the interior-exterior binary (and the degree to which this aligns the private-public and unconscious-conscious bina-ries) is the degree to which his hybrid objects—drawers and chests and wardrobes—might be said to serve as the material condition for subjec-tivity as such. Yet Bachelard's very choice of objects further stabilizes the stasis implied by such a formulation—which can't perceive such interpel-lation as an act of exchange and as an activity riddled by the dynamics of projection and introjection. Indeed, rendered in their abstract specificity, drawers and chests and wardrobes ("le tiroir, les coffres et les armoires") are precisely what lend a bourgeois provinciality, a kind of quaintness and spareness, to Bachelard's argument, offered as it was when France

had begun to experience the abundance of mass modernity: a new prolif-
eration of things, a newly Americanized consumer culture, an accumula-
tion of suddenly indispensable durables within the house—refrigerators,
blenders, washing machines.[27] If Bachelard records the constitutive im-
pact of everyday objects on the postwar subject, he does so only by exor-
cising the everyday of its new American ghost, by displacing that impact
outside the frame of metropolitan modernity. His fixation on the armoire
begins to feel like a kind of cultural fetishism, a memorializing disavowal
of the eradication of the French *interior* as it once was.

Moreover, this particular concentration on things takes place through
his concentration on poetic language.[28] And as Daniel Miller has ob-
jected, other texts about things—Roger Brown's *Words and Things* (1958)
and Ernest Gellner's *Words and Things* (1959)—have virtually nothing
to say about things, much as they have to say about words.[29] In obvious
contrast, Foucault's well-known methodological meditation from the *Ar-
chaeology of Knowledge* (1969) argues that the point of his *Les mots et les
choses* (1966) was to abandon both words and things, above all to forego
any "history of the referent," and to "substitute for the enigmatic trea-
sure of 'things' anterior to discourse, the regular formation of objects
that emerge only in discourse," discourse understood not as "the sign of
something else" but as a practice "that systematically form[s] the objects
of which [it] speak[s]."[30] Discourses and objects must replace words and
things.

And, yet, if one genealogical task is, as Foucault elsewhere describes
it, to preserve the "singularity of events outside of any monotonous fi-
nality" and "in the most unpromising places," then it may well be that
the irregular formation of things—the other thing understood as irregu-
larity—can intrude on the regular formation of objects to provide some
access to what counts as countermemory.[31] Post-Foucauldian historiog-
raphy has cautioned against adding new "experiences" to the historical
record, because such additions will never generate a sufficiently new his-
tory, failing as they do to problematize the very notion of experience
on which history-as-usual has been grounded.[32] We might yet imagine,
nonetheless, that only an untoward and excessive compilation of new
"experiences" will ever be able to alter what we understand by experi-
entiality.

4. How Things Reappear

Rainsford Chan repeatedly describes his narration as a dream, indeed, a
dream embedded in a dream. He tells a "dream girl"—"named after an

American doll . . . a name like Becky or Nancy Ann" (*H*, 64, 73)—all his "dreams about my grandfathers, my father and mother": "In the dream about me I get the girl I wanted when I was fifteen. . . . I tell her about a kid on Guam whose father brings home a tattered Charlie McCarthy puppet" (*H*, 68, 70). The oneiric coding serves not to distinguish the story from "experience" but rather to preserve and expand "experience" beyond familiar historiographical and autobiographical frames and to insist on other modes by which we come to know the past as the past, and the past in and as the present.

This novel's account of the 1950s begins to introduce the personal, cultural, and political stakes of understanding dreams as a valid form of experience. It thus, in a very different register, intersects with the work of what we might call the pre-Foucauldian Foucault, writing in the fifties about dreams as a form of knowledge. In his extended introduction (1954) to Ludwig Binswanger's "Dreams and Existence" (1930), Foucault joins the effort to discount any psychologizing account of dreams in order to respect the dream phenomenon as a specific form of "experience" and of "knowledge," meaningful without reference to the otherwise produced biography of the dreaming subject, and meaningful as a world that is irreducible to language. Foucault charts a history of dreams wherein, for some, dreams offer "an immediate return to objects without passing through the mediation of the organs," for others a penetration into the "intimacy of things"; this history "teaches us that [the dream] both reveals the world in its transcendence and modulates the world in its substance, playing on its material character."[33]

It is easy enough to read Foucault's essay as the mark of his attraction to a phenomenology (Husserl, Heidegger, and Sartre, but also Bachelard) that he overcame in a historical/archaeological mode (what Deleuze calls "Foucault's major achievement: the conversion of phenomenology into epistemology").[34] But the functioning of the dream—understood not as the sign of something else, but as a self-sufficient practice that forms the object (*Existenz*) of its own address—anticipates the functioning of a discourse that forms the object (Man) of its own address. If it might thus be said that Foucault learned from dreams how to write a history that dispensed with things, postmodern fiction dreams the things with which to elaborate other histories, in the least promising places. Whereas Foucault understood dreams as disclosing "the primary moment of existence where the original constitution of the world is achieved,"[35] Frank Chin's *Donald Duk* (1991), more adamantly than *Homebase*, understands dreams as disclosing the potential reconstitution of the world. What the eponymous boy in *Donald Duk* dreams—a specific event excised from the historiography of nineteenth-century America—is an event he helps to per-

form as a fully embodied laborer, part of the Chinese labor force racing to complete a U.S. cross-continental railway.

In *Donald Duk*, as in *Homebase*, oneiric drama does not foretell the future, it does not register a familiar erotic allegory, and it does not mediate between individual desire and collective symbology. Rather, dreams foretell the past, in the sense of adumbrating what, in the future, might yet come to count as history; they develop an underexposed scene and render it available for current inhabitation. There is nothing erotic in this unless we understand the longing for history as experienced with something like the ache of physical desire. This is the ache to make fantasy physical, to transform the material of the unconscious into matter, to make the dreamwork count as the cultural work of precipitating countermemory. "Donald Duk dreams he's sleeping at night and wakes up dreaming, and wakes up from that dream into another, and wakes up into the real."[36] The real here is not the unsymbolizable. And dreaming is, as Cornelius Castoriadis would put it, representation that must be understood as something other than "representation of"—which is to say representation constituted (not by lack but) by plenitude.[37] Donald Duk's father transforms the pain the boy feels about the discrepancy between dream and history, between one history and another, into a historiographical responsibility: "They don't want our names in their history books. So what? You're surprised? If we don't write our history, why should they, huh?" (*DD*, 123).

5. Misuse Value

Winnicott differentiated his original work on the transitional object (1951) from the work of Melanie Klein by emphasizing not the internal object but the material object (and the materiality of the object) as a possession. But when it came to the child at play, his use of dreams to make sense of the child's manipulation of objects followed one of Klein's insights from the 1920s. She showed how play—where children employ "the same language, the same archaic, phylogenetically acquired mode of expression as we are familiar with from dreams"—could be appreciated with the same hermeneutic intensity as the dreamwork.[38] When, in the same decade, Benjamin coupled playing and dreaming, he did so not to align their interpretability, but to point to how the mimetic mode that they share might grant access to a new materialism, and a new materialist history. In the child's intuitive remaking of the material world lay the reversal of the fate of the object within capital, as Marx understood it, where the "sensuous characteristics" of the product of labor are "ex-

tinguished" once it becomes a commodity,[39] or as Simmel described it in the dialectic of proximity and distance, where our very capacity to accumulate things around us stands in inverse proportion to our capacity to experience them as things.[40]

Benjamin's perceptions become clearest, then, in the context of what Lukács defined as reification. Amplifying both Marx and Simmel, Lukács describes reification not just as the rationalization of the human (within the hegemony of the calculable) but also as the alienation from things. Once the commodity form saturates society, reification "conceals above all the immediate-qualitative and material-character of things as things"; it destroys their "substantiality"; it alienates their "individuality."[41] To imagine the substantial character of things, Lukács necessarily and implicitly posits (as Marx explicitly does) an existentially satisfying subject-object relation destroyed by capital's advance.[42]

Adorno, audibly following Benjamin's lead, still caught a glimpse of this relation in the play of the child who "sides with use-value against exchange value"; within a game, toy trucks become "allegories of what they are specifically for."[43] Though he resists Lukács's humanist history, he seems trapped within the same binary of exchange and use; this utopian moment in the otherwise dyspeptic *Minima Moralia* (1951) acknowledges only a rematerialization that is reducible to preconceived utility. Child's play becomes an act of restitution, of returning the object to its proper place in an allegory of practical reason, in the mirror of utilitarian consumption. The scene is rendered against Adorno's better judgment: "Not least to blame for the withering of experience is the fact that things, under the law of pure functionality, assume a form that limits contact with them to mere operation, and tolerates no surplus, either in freedom of conduct or in autonomy of things, which would survive as the core of experience, because it is not consumed by the moment of action."[44] Adorno isn't willing to imagine how the very impropriety of a child's sensuous practice, the sort of catachrestical reobjectification that can take place in play—the reproduction of the truck as a table, or a table as a truck—might produce a surplus into which the "character of things as things" irrupts. Misuse frees objects from the systems to which they've been beholden. Common sense may tell us that the thing exists anterior to (the corresponding) object, that the thing is the substance out of which the subject, discourse, or the economic system constitutes an object. But we might instead imagine—as I tried to make clear with my chart in chapter 1—the thing (its very thingness, its "substantial character," its "individuality," its "autonomy") as a kind of remainder—what's left over after a routinized objectification has taken place, what's palpable in and as irregular exchange.

To respond to the familiar charge against poststructuralism—that it denies material existence—the question then becomes how to perceive or produce materiality.[45] And the answer would seem to lie, as the surrealists understood so well, in the deformation of the object or in its dislocation from one system into another. If you try to use the English football in an American football game, its substantial individuality becomes manifest as though for the first time. To use a spoon as a knife, a knife as a screwdriver, a helmet as a soup bowl, a newspaper as an umbrella, a pencil as a shoehorn, a sock as a change purse, a dictionary as a pillow—these irregular reobjectifications deform the object, however momentarily, into a thing. The object assumes materiality, as it were, not because of its familiar designated function but during a re-creation that renders it other than it was. The sensuous praxis is inextricable from the resignifying praxis. And, thus, what dawns on us when we confront Man Ray's metronome (in *Object to Be Destroyed*) or a practice like camp—the untoward appropriation of the everyday, the reanimation of cultural detritus, the recoding of icons—is both the object defamiliarized (as physical thing) as well as the codes and cathexes by which it has long been trapped (the history in the thing). All but needless to add, the reformation of an object (a result of its decontextualization and recontextualization) exposes its prior formation.[46]

If, then, we begin to understand a thing as both excess matter and meaning, made manifest in the time of misuse, we might nonetheless follow Adorno's intuition that children are adept at exposing the secret life of things. Whereas child psychology and cultural anthropology have described how the object world produces the subjects by which it is produced, Benjamin, captivated by children's books and children's toys, prepares the way for understanding the child at play—the child's interaction with the material world—not culturally or psychologically but politically and historically, not as the production of the self in the subject-object dynamic, but as a highly charged reproduction of the material world.

For him, it is not the child's past but society's future that is at stake. "In waste products children recognize the face that the world of things turns directly and solely to them. In using these things they do not so much imitate the works of adults as bring together, in the artifact produced in play, materials of widely differing kinds in a new, discontinuous relationship."[47] Such spontaneous assemblage, bricolage, collage, camp—this is what promotes children, throughout Benjamin's work, as the representatives of radical difference, able as they are to reappropriate a technologically produced world away from the utilitarian telos of instrumental reason. Indeed, though at times it seems to be the child's "cognitive mode" that arrests Benjamin's attention, at others it is more exclusively the re-

constellating practice itself, the technics pursued passionately and auto-telically. When he himself deployed such technics, accreting the frag-ments of the *Passagen-Werk* to compose an alternative history lodged in the tattered refuse of an emergent mass culture (as though objects might possess an unconscious, as though things themselves might be made to speak), he thought of himself as achieving the kind of "concreteness" that children achieve in games.[48] One must imagine that within the child's "tactile tryst," the substantiality of things emerges for the first time, and that this is the condition for reshaping the material world we inhabit.[49] One must imagine that this experience in the everyday foretells a differ-ent human existence. If the use value of an object amounts to its precon-ceived utility, then its misuse value should be understood as the unfore-seeable potential within the object, part of an uncompleted dream.

6. Icons, Objects, and the Material Unconscious

Such potential is indistinguishable from the hope of overcoming the op-pression of everyday life, which is no more sociological or ideological than it is iconological, experienced as the pressure of a culture's domi-nant images. And literary texts, reapproached as objects of knowledge about objects, teach us that the first task in wresting oneself from the metaphysical potency of an icon is to wrestle it into three-dimensional form. The lesson is axiomatic in the opening pages of Toni Morrison's *The Bluest Eye* (1970), where Claudia's affective understanding of what it means to be black, which is what it means to be not-white, erupts in her Depression-era confrontation with Shirley Temple and the Temple-like dolls she receives as gifts. Claudia is "bemused with the thing itself, and the way it looked." While "all the world had agreed that a blue-eyed, yellow-haired, pink-skinned doll was what every girl child treasured," her resentment builds to the point where she destroys the dolls she re-ceives, ripping them apart to unearth "the desirability that escaped [her], but only [her]."[50] Morrison's scene of destruction produces particularity as the effect of the child's power: just as the doll is dismembered, so too it as though the American icon is figuratively fractured into its body parts: yellow hair, pink skin. Morrison records the subject's interpellative fail-ure as the unwillingness to identify with a dominant icon. Rather than providing an ideal and idealized body, Shirley Temple becomes the alien/ alienating body to which Claudia's psyche produces what we might call destructive and self-destructive antibodies. But this moment of failed identification deforms the icon itself by charging it as a corporeal posi-tivity. In other words, if the icon provides Claudia no relief from her

body, the child's refusal to subject herself to its potency reveals a singular embarrassment: the child star has a body. Shirley Temple (or any other icon) is always a coincidence of part objects. She's adored not for her "self" but because she foregrounds a set of part objects sacred to the culture.

When the twelve-year-old hero of Chin's *Donald Duk* turns Shirley Temple into an object of fun, his sister mockingly objects: "Now, don't disparage Shirley Temple. She was the Candlewick Fairy of my progressive all-American childhood" (*DD*, 166). The ease and humor with which the folkloric metaphor provides the explanatory paradigm here for the attractions of mass culture is precisely not an ease her younger brother shares in his private nationalist quest. For him, American mass culture provides both an embarrassing problem and a sublime possibility. With his room full of posters and glossy stills, he longs to become the next Fred Astaire, to be loved the way Fred Astaire is still loved, to be American the way Fred Astaire is American. (Astaire changed his name from Frederick Austerlitz, which he shared with his father, who emigrated in 1894 from the Austro-Hungarian Empire to Omaha, Nebraska.) Alongside this planned impersonation, which includes weekly dancing lessons, Donald Duk, in order to palliate the bullying of gangs, is forced to ventriloquize himself as the homonymous Disney character: "His own perfect Donald Duck voice cries for help in perfect Cantonese Gow meng ahhhh! and they all laugh" (*DD*, 6). While acts of transethnic impersonation—Connie Chung "'doing her impression of Annette Funicello' . . . 'doing her impression of Shirley Temple'"—provide Donald Duk's sisters with amusement (*DD*, 105), his experience of his own inflicted impersonation is inseparable from ethnic self-hatred: "'Only the Chinese are stupid enough to give a kid a stupid name like Donald Duk,' Donald Duk says to himself" (*DD*, 2). But his self-ventriloquized Chinese "cartoon" participates in the novel's defamiliarization of the Disney character. While the aural equivalence of *duk* and *duck* questions the authority of writing, the misreferent confers corporeal specificity on the cartoon character, most clearly exemplified when Donald Duk's uncle, Donald Duk, objects to his nephew's name: "All the bok gwai, the white monsters, will think he is named after that barebutt cartoon duck in the top half of a sailor suit and no shoes" (*DD*, 7). Just as Shirley Temple becomes "yellow-haired" in *The Bluest Eye*, here Donald Duck becomes a bare butt and bare feet.

Both novels, just as they confer physical status on those icons, refuse to imagine a history without them, outside the waking reality of the dreamworld of mass culture. *Donald Duk* manages the boy's bitterness, over the fifteen-day course of the Chinese New Year celebration in San Francisco, by establishing a clear trajectory for Donald Duk's acculturation

into his Chinese heritage: from dancing like Fred Astaire to running the dragon in the New Year's parade, from American mass culture to Cantonese popular culture, from hating Chinese to hating white people who have suppressed the history of the Chinese in the United States. Within this trajectory, his personal production of Chinese history in America effects and marks his assimilation into Chinese culture. But that production unfolds in an explicitly oneiric and cinematic mode—"The dream comes on like a movie all over his eyes"—wherein he becomes his great-great-grandfather, laboring on the transcontinental rail lines (*DD*, 25).

Within the dreamwork of *Homebase*—in the scene in which Rainsford, playing with dolls, transforms Charlie McCarthy into Freddy the Chinese doll—lies a question about the icon's own ethnic history. An answer to the question begins with Bergen, born Edgar Berggren, son of Swedish immigrants, a self-taught ventriloquist who paid thirty-five dollars in 1922 to have a dummy's head "modeled after an impish Irish newsboy" carved out of wood.[51] With McCarthy, Bergen performed his way through three years of Northwestern University before making a living on the national Chautauqua circuit and in the nightclubs of Chicago and New York. By the late thirties, Bergen was living the quintessential ethnic American success story made possible by the entertainment industry. Famous for his recalcitrance—"unforgivably insolent with the most distinguished list of guest stars ever heard on radio"[52]—Charlie McCarthy, dislodged from any family structure, is an orphan whose pedigree is traceable to the likes of Horatio Alger's tough and spunky heroes. Though television trafficked in the images of American domestic normalcy, ameliorating the stress and suffering of a wartorn nation, the Irish bad boy was licensed to make audible, aggressively, the sort of topics (sex, money, looks) that lay otherwise suppressed in the televisual culture of the 1950s.[53]

If literary texts possess a material unconscious—whereby the history in things, however unacknowledged by the text, seems to overdetermine their textual presence—then we might say that lurking within the cultural transaction in *Homebase* is some other motivating transaction that lies somewhere in the history of the object. Just as the scene dramatizes an American boy's Chinese appropriation of the Irish object, so too the deep genealogy of the Irish doll, as Bergen and others understood it, curiously returned—and returns us—to China. The history of "talking dummies" returns to ancient history: "Thousands of years ago" they were used by Chinese priests who "would hold them against their stomachs" and ask them questions, whereupon "the dummies would answer in deep sepulchral tones."[54] In his own explanation of the "very old art" of ventriloquism, Bergen traced the practice to medicine men and to

divine philosophers and finally to contemporary Chinese practice: "Not long ago in Shanghai a Chinese woman made a lot of money by charging ten cents to those who wanted to hear her unborn child talk. Thousands of credulous Chinese went to her convinced that she was touched with some divine spark. The authorities stopped her. She, of course, was a natural ventriloquist."[55] To be a natural ventriloquist in Chinese culture, it seems, is to dupe the masses; to be a ventriloquist in American culture is simply to entertain them. But the point I want to emphasize is how Bergen and others imagine China as the place where ventriloquism assumes the form of listening to oneself. *Homebase*, then, does not just tell the story of a boy for whom a doll mediates his biculturality. The novel tells the story of a Chinese American boy making use of an Irish American instantiation of what was taken to be an ancient Chinese practice of enabling some other self (or the body itself) to attain audibility.

You might say, further, that this ethnic negotiation marks and manages a nineteenth-century history of ethnic confrontation that appears nowhere in *Homebase* but can be found elsewhere in Wong's fiction.[56] In Wong's second novel, *American Knees* (1995), a romantic comedy of the 1990s, the Chinese-Irish conflict in America appears as a set piece in the "romantic search for identity" that could be satisfied by as little as some "momentary acknowledgment" of the story of immigrant Chinese labor: "the completion of the transcontinental railroad built by Chinese workers from west to east, and from east to west by Irish workers—though no Chinese were allowed in the historic photo of two locomotives meeting at Promontory Point, Utah."[57]

In *Donald Duk*, the central event of the oneiric drama is a track-laying contest between the Irish working for the Union Pacific, "big and strong" boys with "fire in their bellies and a glint in their eye," and the Chinese working for the Central Pacific, denigrated by the Irish as "smaller and poop[ing] out sooner" (*DD*, 28). Led by a foreman named Kwan, the name of the "god of fighters, blighters and writers" (*DD*, 159), who stands as the mythic embodiment of aggressive potency, the young Chinese labor force both shakes up the Crocker management and establishes a world track-laying record of more than ten miles in a day. The dream provokes a set of archival confrontations. Discovering an account of the track-laying feat in the books of the public library, Donald Duk can find no record of the twelve hundred Chinese, only the names of eight Irishmen, only the sort of reference that perpetuates the history of the railroad as the history of "white men. White dreams. White brains and white brawn" (*DD*, 131).

Donald Duk's self-realization depends on his own counterpedagogical practice, a presentation of his newly produced history within the public

sphere of the classroom where he has been humiliated by a narrative of Chinese passivity. As the class and the teacher grant the scene of show-and-tell the status of authorized history, one of the novel's lessons, as it circulates the history that its protagonist dreams, is that history is perpetually subject to revision, and (as Faulkner's *Absalom! Absalom!* and Doctorow's *The Book of Daniel* established) to reinhabitation. *Homebase* shares this lesson: Rainsford records the history of Chinese labor as a history he seamlessly lives: "In 1866 I discovered the sound of granite breaking away. We had reached a solid granite buttress and we chipped, blasted, and drilled at the rock day after day" (*H*, 17). But rather than attending to how this history was suppressed in favor of the Irish, Wong shows his protagonist recoding the material embodiment of Irish spunk, the doll, as Chinese. The redesignation of the Irish boy with a Chinese identity seems like a kind of revenge against the displacement of the Chinese, but a revenge accomplished through an unconscious identification with the other minoritized immigrant subject. In the "tattered Charlie McCarthy puppet," the cultural detritus of the 1950s, Rainsford finds access to something other than his longed-for American identity.

Coda: Toy Story

Periodizers in search of postmodernity might diagnose the recent interest in a newly materialist knowledge of culture, as well as the very capacity to think about objects and the vitality of matter, as a symptom that in a postindustrial society things are no longer primary.[58] In other words, the academic attention to things and the ontological amplitude conferred upon them may nostalgically preserve them from their disappearance along another horizon: not one where the object as substance has been supplanted by the object as sign (the simulacrum with no original), but one where the universe has become "a screen and network," effecting a transparency in which we experience, in Baudrillard's words, "the absolute proximity, the total instantaneity of things." Proximity such as this displaces any "tactile tryst" beyond the horizon of possibility. In a note, however, Baudrillard uncharacteristically admits the nonsynchronicity of the culture he describes: "This does not mean that the domestic universe—the home, its objects, etc.—is not still lived largely in a traditional way"; it means, rather, that "the stakes are no longer there."[59] This should mean, moreover, that the stakes (in a hypervisual culture) hardly reside in the literary. And you might thus suppose that literature has achieved the specific autonomy known as obsolescence. There can be no postmodern novel, because the form belongs to modernity. Literature's power

as an obsolescent form of cultural production resides not least in its capacity to make legible the disjuncture between life lived in a traditional way (which includes the tradition of reading novels) and the way of postmodernity (which novels can diegetically, stylistically, or symptomatically record). This is why, without ever supposing that "the true being of things becomes accessible precisely in their linguistic appearance," as Gadamer would have it,[60] you might nonetheless imagine that in the time and space of reading you have the chance to reexperience opacity and to think about the thingness of an object that might otherwise disappear. Moreover, any book of poetry or prose fiction clearly illustrates the way that an object can be "bigger" on the inside than on the outside: the way that an object can be some other thing.

Before the end of the twentieth century, though, the secret life of things had itself been rendered proximate in a kind of dream dislodged from the discursive register and from any oneiric coding. If Adorno and Benjamin once imagined toys as a repository where children could discover the autonomy of things, it hardly seems surprising that autonomous toys attracted Hollywood precisely when things were beside the point. Disney's *Toy Story* (1995) was the first full-length film to be generated wholly by computer (by Pixar Animation Studios).[61] It abandons any cinematographic indexicality and dispenses with two-dimensional cell animation. At the same time, within a Disney tradition that begins with *Fantasia* and crystallizes in *The Brave Little Toaster*, it visualizes the Marxian drama where "grotesque ideas" evolve out of "wooden brain[s]" and where "the fantastic form of a relation between things" supplants the relation between humans.[62] By now that visualization feels like the routinization of the uncanny. Though the film personifies the tension between novelty and obsolescence as the tension between the latest battery-operated space ranger (Buzz Lightyear) and the pull-string cowboy (Woody), what makes the film feel so anachronistic and nostalgic is that, for preadolescent boys in the 1990s, video games and computer games (for instance, Disney Interactive's own Toy Story CD-ROM game) threatened to render the toys depicted (including piggy banks and toy soldiers, Mr. Potato Head and Etch-A-Sketch) all but obsolete. Let's face it: the uncanniness of the everyday in postmodernity has more to do with the autonomy achieved through computational technology.

The well-known climactic moment of fetishism, as rendered in *Capital*, appears when commodities speak for themselves, exhibiting a social life of things that occults the social life of humans. By 1995 the life that the life of American toys occults begins with a story of their international production. *Toy Story* gesturally and comically marks the geoindustrial facts; it also significantly displaces them. The Piggy Bank asks the new

toy, the space ranger, "Where you from, Singapore, Hong Kong?" And the space ranger, Buzz Lightyear, finally succumbs to recognizing himself as a mere toy when he reads, inside his wrist monitor, "Made in Taiwan." To be an American toy in the 1990s is to have come from elsewhere. As the U.S. International Trade Commission began to explain at the outset of the 1980s, the variety required to successfully market dolls and toys precludes automation and requires the vast and intense manual labor that has all but disappeared from the U.S. scene of production.[63] More specifically, just as the economic success of America in the nineteenth century (the materialization of its "manifest destiny") depended on an immigrant Chinese labor force, so too in the closing decades of the twentieth century it came to depend on the Chinese labor force living in the Republic of China.

Whereas Rainsford Chan imagines himself at work on the transcontinental railway, and works to reproduce the American-made Irish doll for himself, Shawn Wong published his novel at the moment of transition, when the U.S. toy industry was about to become utterly dependent on China. The first signs of China's economic emergence became visible in 1979, in the contract signed with the British firm of Dunbee-Combex-Marx; by 1980 the Republic was granted most-favored-nation status by the United States, to be followed by the Chinese government's opening of special economic zones (SEZs). The 1950s witnessed the height of U.S. toy production. After steadily declining U.S. employment in the industry (from 20,000 to 13,000 jobs between 1986 and 1990), some U.S. companies eliminated all domestic manufacturing capacity; both because of low wages and because of unregulated overtime (enabling a twenty-four-hour production schedule to correspond with the very uneven, seasonal demands of toy consumption), China supplied the manufacturing needs not only of the United States but also of Japan and Hong Kong. China was responsible for 6 percent of the U.S. toy imports in 1985, for 44 percent in 1990 (followed by Korea, with 12 percent). Taiwan, Hong Kong, and Singapore lost their GSP (Generalized System of Preferences) status in 1989.[64] The story of such staples as Star Wars characters and Cabbage Patch dolls, as well as the story of such seasonal successes as the Power Ranger (for Christmas 1994), is the story of specifically Chinese productivity. As Steven Mufson put it on the front page of the *Washington Post* on Christmas Eve 1995, in "Santa Finds a Bargain in China": "To find Santa's workshop, start at the North Pole and point your reindeer south—way south, until you arrive at the paved-over rice paddies of southern China. Here you'll find Santa's helpers: about 300,000 low-paid Chinese migrant workers, virtually all of them women in their late teens and early twenties."[65]

```
breathbreathbreathbreathbreath
breathbreathbreathbreathbreath
breathbreathbreathbreathbreath
breathbreathbreathbreathbreath
breathbreathbreathbreathbreath
breathbreathbreathbreathbreath
breathbreathbreathbreathbreath
breathbreathbreathbreathbreath
breathbreathbreathbreathbreath
breathbreathbreathbreathbreath
breathbreathbreathbreathbreath
breathbreathbreathbreathbreath
breathbreathbreathbreathbreath
breathbreathbreathbreathbreath
```

1 Carl Andre, *One Hundred Sonnets (I . . . Flower)* (1963). © Carl Andre/Licensed by VAGA, New York.
Photograph: Permanent Collection, the Chinati Foundation, Marfa, Texas.

2 Carl Andre, *18 Small Field* (2001). © Carl Andre/Licensed by VAGA, New York. Steel magnets, 0.6 × 4.2 × 5.4 cm. From *Words and Small Fields*. Photograph: Courtesy of Sadie Coles HQ, London.

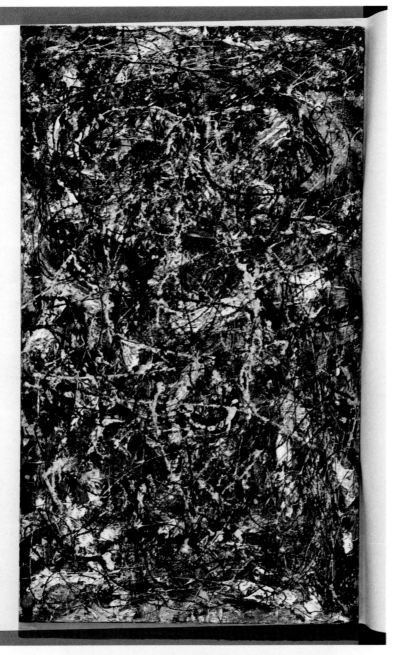

3 Jackson Pollock, *Full Fathom Five* (1947). © 2015 Pollock-Krasner Foundation/Artists Rights Society, New York. Oil on canvas with nails, tacks, buttons, key, coins, cigarettes, matches, etc., 129.2 × 76.5 cm. Photograph: Gift of Peggy Guggenheim, Museum of Modern Art, New York, © The Museum of Modern Art/Licensed by SCALA/Art Resource, New York.

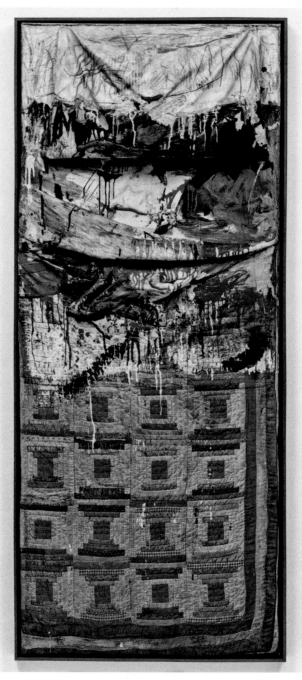

4 Robert Rauschenberg, *Bed* (1955). © Robert Rauschenberg Foundation/Licensed by VAGA, New York. Oil and pencil on pillow, quilt, and sheet on wood supports, 191.1 × 80 × 20.3 cm. Photograph: Gift of Leo Castelli in honor of Alfred H. Barr Jr., Museum of Modern Art, New York, © The Museum of Modern Art/Licensed by SCALA/Art Resource, New York.

5 Lee Bontecou, *Untitled* (1959). © 2015 Lee Bontecou. Welded steel, canvas, black fabric, soot, and wire, 147.5 × 148.5 × 44 cm. Photograph: Gift of Mr. and Mrs. Arnold H. Maremont, © The Museum of Modern Art/Licensed by SCALA/Art Resource, New York.

6 Lee Bontecou, *Untitled* (1961). © 2015 Lee Bontecou. Welded steel, canvas, black fabric, copper wire, and soot, 203.6 × 226 × 88 cm. Photograph: Kay Sage Tanguy Fund, © The Museum of Modern Art/ Licensed by SCALA/Art Resource, New York.

7 Andre Breton, *Poem-Object* (1935). © 2015 Artists Rights Society, New York/ADAGP, Paris. Photograph: Scottish National Gallery of Modern Art.

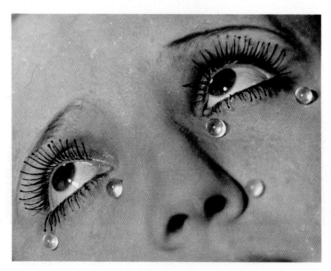

8 Man Ray, *Tears* (1930–32). © 2015 Man Ray Trust/Artists Rights Society, New York/ADAGP, Paris. Gelatin silver print, 9 × 11¾ in. Photograph: J. Paul Getty Museum, Los Angeles.

9 Brian Jungen, *Bush Capsule* (2000). Plastic chairs, plastic, fluorescent lights, dimensions variable. Courtesy Catriona Jeffries Gallery, Vancouver.

10 Brian Jungen, *Furniture Sculpture* (2006). Eleven leather sofas, 619.8 × 589.3 × 721.4 cm. Collection of the Vancouver Art Gallery, purchased with significant financial support from the Audain Foundation and additional contributions from Rick Erickson and the Vancouver Art Gallery Acquisition Fund. Photograph: Tomas Svab, Vancouver Art Gallery.

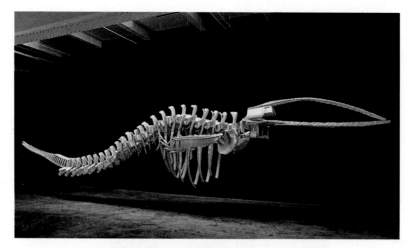

11 Brian Jungen, *Cetology* (2002). Plastic chairs, 161.54 × 1,260.40 × 168.66 cm. Collection of the
 Vancouver Art Gallery, purchased with the financial support of the Canada Council for the Arts
 Acquisition Assistance Program and the Vancouver Art Gallery Acquisition Fund. Photograph:
 Trevor Mills, Vancouver Art Gallery.

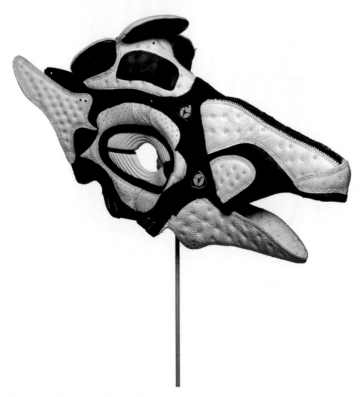

12 Brian Jungen, *Prototype for New Understanding #7* (1999). Nike Air Jordans. Collection of Joe Friday,
 Ottawa. Photograph: David Barbour, Courtesy of Carleton University Gallery.

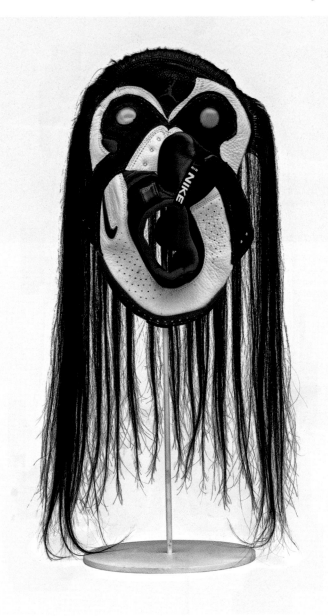

13 Brian Jungen, *Prototype for New Understanding #9* (1999). Nike Air Jordans, human hair. Collection of Greg and Lisa Kerfoot, West Vancouver. Photograph: Trevor Mills, Vancouver Art Gallery.

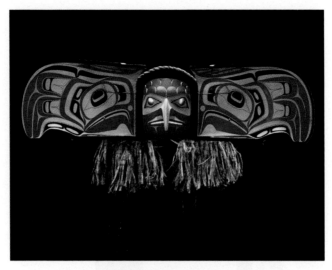

14 Robert Davidson, *Eagle Transformation Mask* (2002). Courtesy of the artist.

15 Thomas Edstrand, "The Chief" (c. 2010). Landyachtz longboard. Courtesy of the artist and
 Landyachtz Skateboards, Vancouver.

1-800-305-2185

16 Advertisement for Nike Air Jordans, *Sports Illustrated* 85.27
(December 30, 1996–January 6, 1997): 119.

17 Christopher Radko,
"Heroes All" (c. 2001).
Private Collection.
Photograph:
Michael Tropea.

18 Christopher Radko,
"Brave Heart" (c. 2001).
Private Collection.
Photograph:
Michael Tropea.

19 Minoru Yamasaki/Emery Roth & Sons, World Trade Center, scenic skyline view from the south (1964–74). © 2015 Scott Gilchrist Photograph: Archivision.

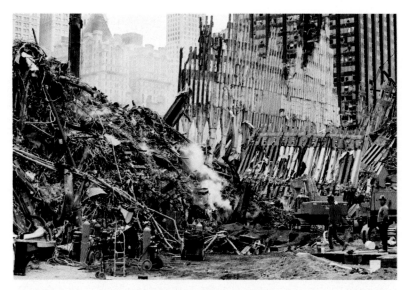

20 FEMA/Bri Rodriguez. Rescue and recovery operations continue at the site of the collapsed World Trade Center, New York (September 26, 2001). Photograph: FEMA.

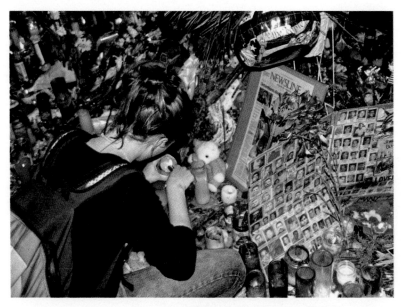

21 Douglas Potoksky, "A young woman keeps candles burning at a Union Square memorial" (2001). Photograph: National Museum of American History, Smithsonian Institution, Washington, DC. Photographic History Division.

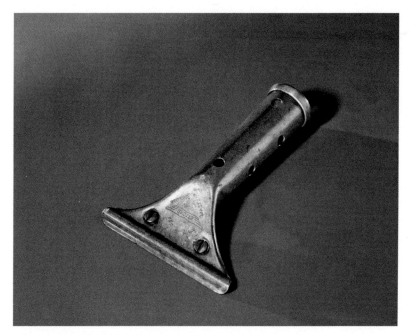

22 Window washer's squeegee handle (2001). Photograph: National Museum of American History, Smithsonian Institution, Washington, DC. Department of Military History and Diplomacy. Gift of Jan Demczur.

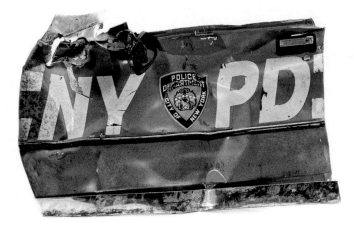

23 NYPD patrol car door (2001). Photograph: National Museum of American History, Smithsonian Institution, Washington, DC. Department of Military History and Diplomacy. Gift of New York Police Department.

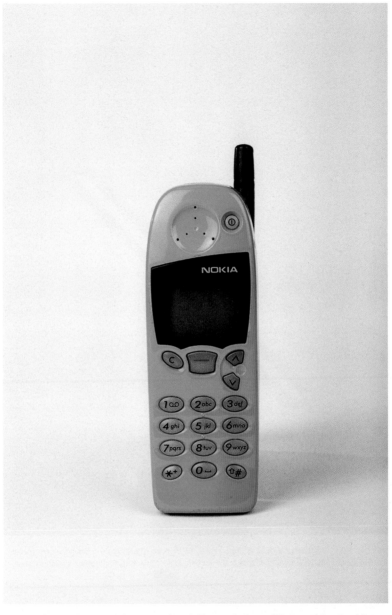

24 Cell phone used by New York commuter (2001). Photograph: National Museum of American History, Smithsonian Institution. Division of Work and Industry. Gift of Roe Bianculli-Taylor.

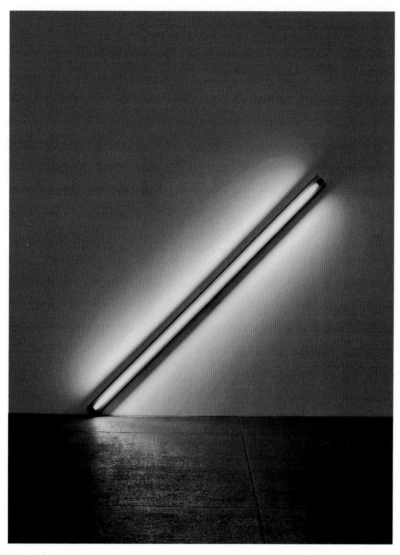

25 Dan Flavin, *Diagonal of May 25, 1963 (to Constantin Brancusi)* (1963). © 2015 Stephen Flavin/Artists Rights Society, New York. Photograph: Dia Art Foundation, New York. Photograph by Cathy Carver.

26 Tara Donovan, *Untitled (Styrofoam Cups)* (2008). © Tara Donovan. Styrofoam cups and glue, dimensions variable. Photograph: Courtesy of Pace Gallery, New York.

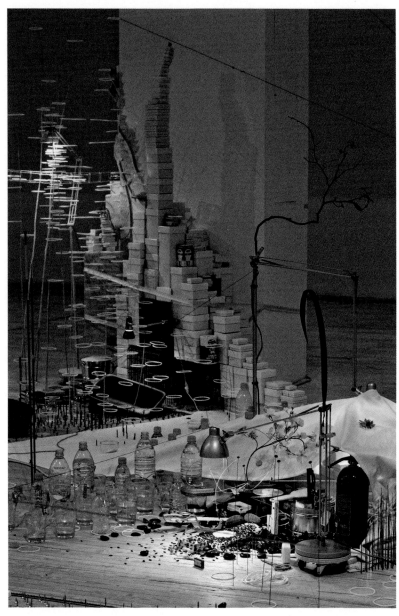

27 Sarah Sze, detail from *Tilting Planet* (2006). Mixed media, dimensions variable. Installed at *Sarah Sze: Tilting Planet*, Malmö Konsthall, Malmö, Sweden (December 1, 2006, to February 18, 2007). Courtesy of the artist and Tanya Bonakdar Gallery, New York. Photograph by Helene Toresdotter.

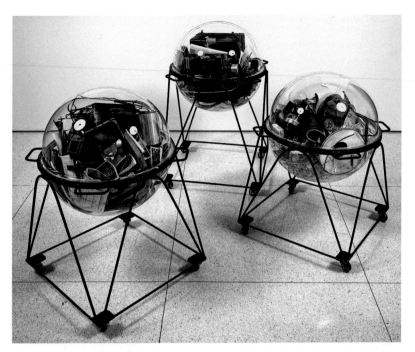

28 Dan Peterman, *Excerpts from the Universal Lab (travel pod #1, #2, and #3)* (2005). © Dan Peterman, courtesy of the Andrea Rosen Gallery. Mixed media encased in Plexiglas spheres with wheeled metal supports, overall approx. 36 × 120 × 36 in. Photograph: © 2011 The David and Alfred Smart Museum of Art, University of Chicago; Purchase, Paul and Miriam Kirkley Fund for Acquisitions. Photograph © 2011, courtesy of the David and Alfred Smart Museum of Art, University of Chicago.

29 Marie Krane and Cream Co., *Blue Studio Wall* (2010). Courtesy of the artist.

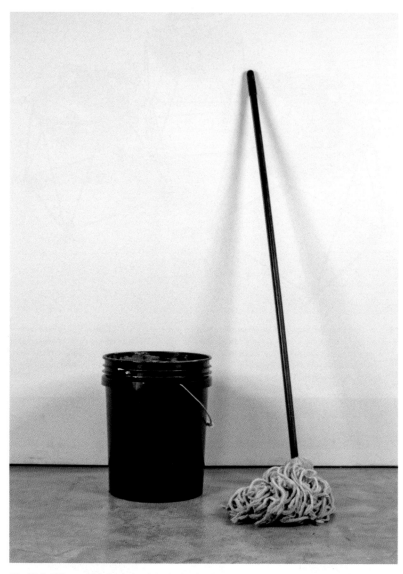

30 Michael Brown, *Elvis (bucket)* and *Aretha Franklin (mop)* (2008). Courtesy of the artist and
Mike Weiss Gallery, New York.

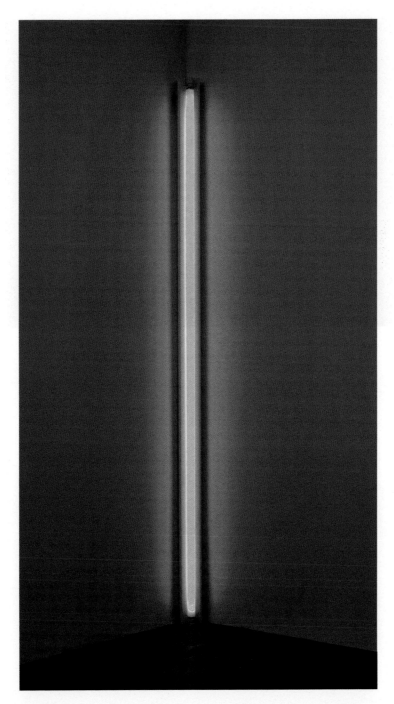

31 Dan Flavin, *Pink out of a corner (to Jasper Johns)* (1963). © 2015 Stephen Flavin/Artists Rights Society, New York. Fluorescent light and metal fixture, 8 ft. × 6 in. × 5⅜ in. Photograph: Gift of Philip Johnson, Museum of Modern Art, New York, © The Museum of Modern Art/Licensed by SCALA/Art Resource, New York.

32 Dan Flavin, *Monument 4 those who have been killed in an ambush (to PK, who reminded me about death)* (1966). © 2015 Stephen Flavin/Artists Rights Society, New York. Assemblage. Red fluorescent light, 166.4 × 345.4 cm. Photograph: National Gallery of Canada, Ottawa.

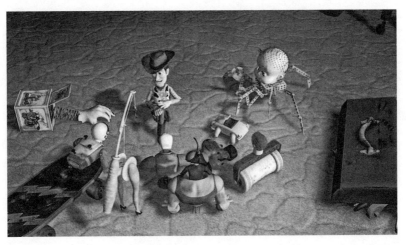

8.2 Still from *Toy Story*, John Lasseter, dir. (1995; Burbank: Walt Disney Studios Home Entertainment, 2010), DVD.

Toy Story, depicting the complex negotiations between toys, predictably obscures the complex negotiations about toys between nations, or between global corporations and local worker constituencies. The film also has a more immediate relevance to the scene with which this chapter began. Whereas the battle for the boy Andy's affections generates the basic plot of the film, it is the toys' fear of the neighbor Sid, the "psycho," that provides the most tension. Sid is thoroughly demonized as a Dr. Moreau figure who experiments with toys, torturing them and producing speechless mutants, bodies and things, body parts jumbled together as frightening composites: a one-eyed baby's head on an erector-set spider, a pair of Barbie legs attached to a miniature fishing pole (fig. 8.2). The moral of the story for the ultimately defeated Sid is, as Woody tells him, "Take good care of your toys." In other words, the film instructs its viewers against misuse—against irregular exchange—as though the toy industry should have the final say on the shape of the world and of the world to come. And yet the eerie mutants—peering out from beneath the bed, and speechless, we might say, because they have no exchange value—are not just benign. They are captivating, and captivating because the awkward, curious composites—surreal assemblages from the very late twentieth century—represent and embody those other things that materialize an otherwise unexpressed wish to transfigure things as they are.

Nine

Reification, Reanimation, and the American Uncanny (Spike Lee)

Only film can detonate the explosive stuff which the
nineteenth century has accumulated in that strange
and perhaps formerly unknown material which is kitsch.

WALTER BENJAMIN

1. Ontologies

Things quicken.

What you took to be the inanimate object-world slowly but certainly wakes.

Signs of new life can be read at a glance—in the titles of essays, exhibitions, and books.

The Tears of Things, Things That Talk, Ideas in Things, The Things Things Say, Alien Phenomenology; or, What It's Like to Be a Thing.[1] The titles alone perform some anthropomorphizing work. They mark an underacknowledged postmodernity: the confusion of object and subject, animate and inert, overcoming what's known now, in the political philosophy of science, as modernity's artificial distinction between persons and things.[2] At the very least, objects have become, say, somewhat different objects of knowledge.

As I have remarked in the preceding pages, within the field of anthropology Arjun Appadurai considerably renewed and revised the engagement with things by proposing a kind of "methodological fetishism": a

focus on the object exchanged rather than on the exchange system and its social functions.[3] The anthology he edited, *The Social Life of Things* (1986), enlivened the study of objects (within and beyond the field), and one essay in that volume, Igor Kopytoff's "The Cultural Biography of Things: Commoditization as Process," illustrated the collection's point with particular clarity and with considerable audacity.

Like Appadurai and the other contributors, Kopytoff wanted to establish a more complicated, extramercantile understanding of the commodification and circulation of objects, to insist that the commodification of an object involves a cognitive and cultural element;[4] he also emphasizes how a commodity object is unambiguously a commodity only during the course of transaction, after which it is individualized, leading a concrete life outside the commodity structure, beyond the abstraction on which exchange depends.[5] This is why you can imagine writing a life story of objects, beginning with prototypically biographical questions: "What has been its career so far, and what do people consider to be an ideal career for such things? What are the recognized 'ages' or periods in the thing's 'life,' and what are the cultural markers for them?"[6] He provides a "typical biography of a hut" among the Suku of Zaire: its original life as a home, then its gradual dilapidation and redeployment as a kitchen, a guest house, and a chicken coop, until the natural world, in the form of termites, reclaims the structure. Such biographies can elicit considerable pathos: "A biography of a painting by Renoir that ends up in an incinerator is as tragic, in its way, as the biography of a person who ends up murdered." "That," Kopytoff adds, "is obvious" ("CB," 67).

Although a Suku hut and a Renoir painting may seem remote (each in its own way, from us, as from each other), they're meant to illustrate a fully proximate and ubiquitous fact. For even when the commodity form saturates society (even when, that is, we are dealing with capitalism), culture works to singularize objects; however homogenous an object is, qua commodity, the process of singularization (the decommodification effected individually or collectively) returns the object-world to its heterogeneity, where the lives of things are variously differentiated.[7] The "autonomous cognitive and cultural process of singularization" might thus be said to supplement the life of things as conceptualized in Marx's account of the fetish character of the commodity. Kopytoff calls attention to the temporality of the bifurcation Marx demonstrated (use value–exchange value–use value); he provides a clarifying binary of his own (commoditization-singularization); and he allows us to speak of the commodity's afterlife—or its several afterlives—within multiple singularized dimensions (none of which can wholly arrest the potential for further commodification).

The calm audacity of the essay resides in the way that Kopytoff deploys the term *biography* so confidently and imagines "biographical possibilities" so clearly ("CB," 66), which he does by beginning his argument about the commodity—the object abstracted through commodification but subsequently individualized—with the example of the slave. However aberrant we take the commodification of humans to be, that process becomes exemplary of commodification itself, although the example shows how commodification, as an explanatory genre, never tells the whole story. Whereas Appadurai begins by writing of the "conceit that commodities, like persons, have social lives," Kopytoff begins with a literal instantiation of the trope.[8] Kopytoff, who works on slavery indigenous to Africa, describes how the slave has moved away "from the simple status of exchangeable commodity and toward that of a singular individual occupying a particular social and personal niche." His argument participates in the "shift away from [the] all-or-none view" of the slave as exchangeable property and toward a "processural perspective" that discloses the ambiguous status of the slave, which underlies her or his social identity ("CB," 65).[9] Anyone familiar with *The Interesting Narrative of the Life of Olaudah Equiano, or Gustavus Vassa, the African* (1789) will concede that designating Equiano a slave discloses very little about him—about his circulation through various regions of the world and occupations in the world and his circulation in and out of slavery. Indeed, to describe Equiano as a commodity object alone would amount to effecting the very abstraction accomplished by commodification itself.

Although Kopytoff's gambit, implicitly, is that we will not recognize the life of things without focusing on those things that have lives, he recognizes full well that "the conceptual distinction between the universe of people and the universe of objects" is axiomatic in the West, rooted in classical antiquity and Christianity, integral to European modernity ("CB," 84). Because this is an axiom by which his readers live their daily lives, he patiently points out not only that the "conceptual polarity of individual persons and commoditized things is recent and, culturally speaking, exceptional" but also that the contemporary traffic in human organs and ova as well as debates over adoption and surrogate motherhood demonstrate that the boundary between person and thing may be more permeable than we're inclined to believe ("CB," 64; see 84–87). Of course, the ethical challenges provoked by such permeability have their own history; the long-standing conceptual distinction between person and thing riddled the institution of slavery. As David Brion Davis explains, for Roman law it was generally "convenient to regard the slave as a *res*," but jurists also recognized that "the slave was both a person and a thing."[10] The contradictory legal status of the American slave—

both human and thing—provoked obvious questions about the criminal culpability of slaves (which depended on granting them autonomy and agency) and of the slaveholders' treatment of them (which depended on granting slaves some basic rights).[11] And yet, for instance, a Kentucky court ruled (in 1828) that, "whether it be politic or impolitic, a slave by our code is not treated as a person, but (*negotium*) a thing."[12]

For Harriet Beecher Stowe, of course, this ontological confusion, regardless of whatever legal quandary it provoked, crystallized the moral horror of slavery; or, rather, the slippage between person and thing efficiently captioned the moral fact that the institution of slavery enacted an ontological scandal. Though the history of that scandal may be most apparent in the law, it casually informs all sorts of discursive acts. An advertisement for an estate sale in 1777 reads: "PUBLICK AUCTION, At the house of the late Richard Colden, Esq., in Smith-Street, corner of King-Street, ... the sale of all his neat and elegant household and kitchen furniture, consisting of mahogany desks and book cases, buroes, chest drawers, card, dining and dressing tables, beds and bedsteads, plate, china, an elegant Axminster carpet, etc. etc. A valuable iron chest, with a handy young negro girl, about 13 years old. Also, a neat riding Chair."[13] The "handy young negro girl," more implement than child, remains ontologically undifferentiated from the chest or chair. Stowe's original subtitle for *Uncle Tom's Cabin* (1852)—"The Man Who Was a Thing"— advertises such a scandal, fully dramatized by her depiction of the kind, loving, Christian man who makes it clear, page after page, how human he is. Thus Stephen Best explains Stowe's understanding of the effect of slavery as "an everyday animism that cuts across the founding difference between persons and property";[14] and thus Phil Fisher describes the sentimental work of the abolitionist novel as the work of "making a thing into a man."[15] In Kopytoff's terms, the biographical dilemma suffered by any slave—the dilemma dramatized so poignantly by Stowe—is that the "singular individual" could become a commodity again, suddenly sold without warning, suffering the "social death," as Orlando Patterson termed it, that vitiates any social life of the American slave.[16] Indeed, the status of the "singular individual" hardly makes ideological sense—not, at least, from a Lockean perspective—given the loss of self-determination.[17] This is one reason why slave narratives, to the degree that they foreground self-determination—say, Douglass's work learning to read, his decision to battle Covey, his decision to speak and to write publicly—depict the very singular individuality that in itself (and regardless of any articulated plea) stages the crime of commodity homogenization.

Still, this ontological scandal does not depend on a slave economy—at least not according to Marx's conceptualization of the effects of capital.

For the spectral completion of commodity fetishism (where things appear to have lives of their own) is human reification (where people appear to be no more than things). The point is not just that social relations appear to the producers as "material [*dinglich*] relations between persons and social relations between things" (the latter phrase inspiring Appadurai's title); the commodity form itself depends on "the conversion of things into persons and the conversion of persons into things
. . . [*Personifizierung der Sachen und Versachlichung der Personen*]"; and the very fact that the worker is subject to the conditions of labor, rather than those conditions being subject to him, "entails the personification of things and the reification [*Versachlichung*] of persons."[18] The claim is at once formal (inherent in the calculus of value) and phenomenological (part of the generalizable experience of the laborer). The irony of the claim, of course, lies in its anachronistic redeployment of the ontological scandal effected by the institution—slavery—that Marx understood to be upended by capitalism, depending as it does on the transformation of the value of labor-power into wages (see *C*, 3:121). Just as commodity fetishism unveils the persistence of a kind of enchantment in the modern world, so too reification discloses the invisible persistence of the ontological effects of slavery. And just as Kopytoff points out the incompleteness of slavery even during its institutionalization, so Marx suggests the ineliminability of slavery even after the institution has been abolished.

Of course, in its U.S. manifestation, the institution of slavery proved something of a historical conundrum for Marx. On the one hand, it was clear that the capitalist mode of production and its accompanying technology were the preconditions for abolishing slavery (as the British government did throughout the empire in 1833). In a passing comment in *The German Ideology* about the incapacity of philosophy or theology to liberate man, he insists that "slavery cannot be abolished without the steam-engine and the mule and the spinning-jenny."[19] Likewise, the success of moral arguments against the institution appears as an epiphenomenon of the economic shift: "Slavery, on the basis of the capitalist mode of production, is unjust" (*C*, 3:461). On the other hand, Marx was well aware that the difference between "patriarchal slavery" and the "plantation system" was the latter's focus beyond the household economy—its focus on a "world market" (*C*, 3:940). This is why he designates plantation owners as "anomalies" within that market (a market "based on free labour"). Despite the anomaly, though, "we now not only call the plantation owners in America capitalists, but [also] they are capitalists."[20] All told, the persistence of slavery—its persistence *within* capitalism and as constitutive *of* the capitalism of the American South—appeared as a denial of history.

However perplexing the slave-dependent mode of production proved

to be within the history of capital, Marx too was certain about the onto-
logical confusion perpetrated by the institution, in the ancient and in
the modern American world, which he gleans from Frederick Law Olm-
sted's *A Journey in the Seaboard Slave States* (1856). Differentiated from
the *instrumentum mutum* as the *instrumentum vocale*, the speaking instru-
ment neglects and mistreats the mute instrument of his labor in order
to "give himself the satisfaction of knowing that he is different," which
is why slaves are provided with particularly rude and heavy tools, how-
ever inefficient (C, 1:303–4n18).[21] The psychological point, however dubi-
ous, is that the proximity to things provokes the act of differentiating
abuse toward things. (The completion of such psychology would address
the abuse of slaves as a comparably differentiating act.)[22] It may be dif-
ficult to determine the place of slavery within economic history, but it
is not difficult to sense the ambiguous personhood of the slave within,
say, ontological history—that is, perceived from the purview of histori-
cal ontology.

Historical ontology, a concept developed by Foucault, now names a
field of inquiry defined by Ian Hacking as, most generally, the study of
the possibility of certain objects coming into being, which includes the
historical study of the kinds of person it becomes possible to be: a per-
vert, a child, a homosexual, a heterosexual, a psychopath.[23] Within such
a field (heuristically hijacked), even as you point to a certain moment in
a certain place when and where it is no longer possible for a person to
be a slave (to be someone else's property, to be [*negotium*] a thing), you
nonetheless find, in the posthistory of that moment, residues of precisely
that possibility—in other words, an ongoing record of the ontological
effects of slavery, not marked by such terms as *slave wages* (which makes
no ontological point), but fully elaborated in Marx's account of *Versach-
lichung*.[24] I myself want to draw attention to how such a residual ontology
persists—figuratively or obliquely at times, at times theatrically—within
material, visual, and literary culture. Although it is the history of sci-
ence, psychology, and philosophy that have produced the groundbreak-
ing work in historical ontology, "pop culture," as Hacking says, is "full of
object-making, and there is a lot to be learned there."[25]

Which is where I am headed: not to trace the emergence of new kinds
of persons it is possible to be (say, a hacker or a geek), but to bring these
ontological residues into focus as, say, the incompleteness of history
(what Habermas, in a different register, would call the incompleteness
of Western modernity). The context for this, at the close of the twenti-
eth century, not only included the climate of ambiguity and uncertainty
of the sort prompted, as Kopytoff says, by the contemporary traffic in
organs and ova, and so on; it also involved the posthumanism (in the

anthropology of science, in feminism, in new media studies) that made modernity's distinction between human subjects and inanimate objects appear increasingly artificial.[26] By now, that climate change has intensified with the wide-ranging impact of Bruno Latour's use of the narratological "actant" to perceive and describe human and nonhuman agency within various assemblages and networks, which I addressed in chapter 5. This would seem to be an auspicious moment for rethinking that binary—and efforts to avoid it—within the complicating context of the United States. I would like to do this not by tracking the biography *of* things but by considering, say, the ontology *in* things, by which I mean the historical ontology congealed within objects.

2. Cultural Archaeologies

How does such a history become visible? It becomes visible when an object becomes something else, emerges as a thing dislocated from the circuits of everyday life or singularized by the doting mediation of lyric or fiction or film, textualized (retroprojectively produced) in a microethnographic operation that (consciously or unconsciously, and no matter how realistic or fantastic) provides access to the complex and ambiguous nature of objects and to the cultures of objects whereby they become meaningful, or fail to.

As an example, let me take Spike Lee's *Bamboozled*, that controversial film, within a career of controversial films, that bombed at the box office in 2000 while thriving in the academy: the object of extensive analysis, political commentary, and debate. However provocative the politics of Lee's recirculation of the minstrel show and its black stereotypes (curiously hard to distinguish from his protagonist's reinvention of minstrelsy), I want to draw attention to those objects in the movie that are generally designated Sambo art, Negro memorabilia, or black collectibles: the Aunt Jemima cookie jars, the Jocko hitching posts, the canisters and salt and pepper shakers, the hot-pad holders, most infamously the Jolly Nigger bank (figs. 9.1–2).[27] Such objects represent, in Patricia Turner's words, "one of the most deplorable and least well documented impulses in American consumer history," now provoking the kind of outrage provoked by the (well-documented) institution of blackface minstrelsy.[28] Whereas the minstrel show animates the stereotype of the "plantation darky," these objects might be said to deanimate it, to arrest the stereotype, to render it in three-dimensional stasis, to fix a demeaning and/or romanticizing racism with the fortitude of solid form.

Different arguments have been made to explain the sudden popu-

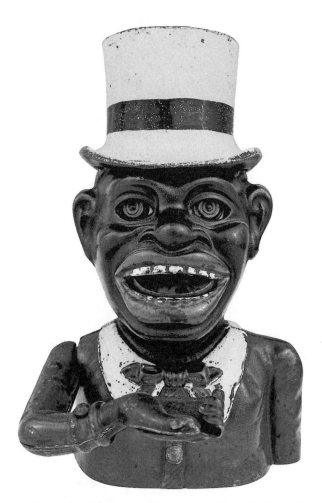

9.1 Butterfly Tie Jolly Nigger bank. John Harper & Co., England (c. 1890s–1920s).
Courtesy Dan Morphy Auctions.

larity of these objects in the post-Reconstruction era. "Such objects of material culture," Kenneth Goings writes, "gave a tangible reality to the idea of racial inferiority. They were the props that helped reinforce the new racist ideology that emerged after Reconstruction."[29] Steve Dubin reads the objects as inverted totems, enhancing the solidarity of the white population through "the convenient identification of who was beyond" the social boundary.[30] They could be read, likewise, as fetishes—as the embodiment of a specific type of fetishism: as the memorializing disavowal of the sameness effected by universal male suffrage; as the defense against the knowledge that the equation of physical features and behavior makes no sense; as, most simply, the denial of history.[31] The fixity of the stereotype, rendered in ceramic or iron or aluminum,

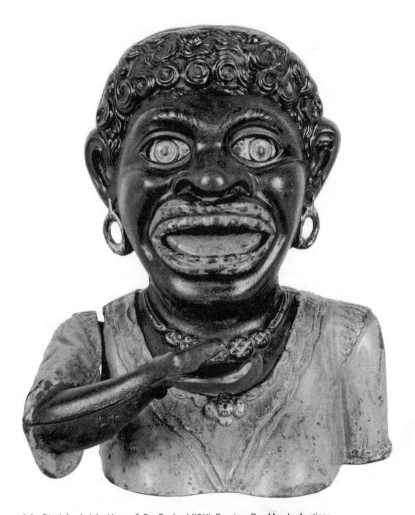

9.2 Dinah bank. John Harper & Co., England (1911). Courtesy Dan Morphy Auctions.

compensates for the new heterogeneity of black America; the nostalgic embodiment of some phantasmatic past compensates for uncertainties about the future place and role of African Americans in the United States.[32] Of course, in this respect, these household objects participated in the nostalgic, late-nineteenth-century romanticization of the plantation South, the literary version of which we find in Joel Chandler Harris's *Nights with Uncle Remus* (1883) and Thomas Nelson Page's *In Ole Virginia* (1887), for instance, and the theatrical version of which we find in the perpetuation of the minstrel show, notably in what Robert Toll takes to be the culmination of the black minstrel troupes' increasing use of plantation material. The *Black America* show, staged in Brooklyn's Ambrose Park in 1895, was a full-blown re-creation of slave life, featuring log

cabins, spirituals, watermelons, cakewalks, and more than five hundred "genuinely southern negroes," cheerfully enslaved.[33]

Thus, it might be simpler to argue that in a world without slavery, these objects enabled their owners to possess and control miniaturized black faces and black bodies (in a world of "symbolic slavery," as Dubin calls it). As Turner contends, "they are about the ways in which even after the institution of slavery was over, American consumers found acceptable ways of buying and selling the souls of black folk."[34] In other words, it is possible to imagine consumer culture offering white Americans some phantasmatic perpetuation of the system that capitalist modernization had helped to undo. And yet, the vast majority of these objects were produced in the North; there was a considerable European market for them; and manufacturers in Germany, France, and especially England found significant domestic markets for their own black objects.[35] Thus, the point might be, more precisely, that "by operating at the level of humor, satire, and caricature, these objects," as Jacqueline Najuma Stewart puts it, "support one fantasy of Blackness in the white imagination—that it is fixed, is visually familiar, and can be placed safely under white control."[36] The objects would seem to satisfy something other than the longing for slavery's persistence—perhaps no more than the longing for a simplicity and stability most conveniently achieved through the "synchronic essentialism" that arrests history.[37] The point is certainly not that the racist objects aren't racist, but rather that the racism, serving as a means rather than an end, is especially pernicious. American racial typology proves to be a convenient way, throughout the West, of securing such allotemporal stability. At the same time, we might consider the objects as sites of projection, where the human condition within the capitalist mode of production—reification—becomes externalized and historicized: the condition of other people at another time.[38] *Bamboozled*, though, characterizes and conceptualizes these objects very differently.

Within the film, the ambitious, pretentious, Harvard-educated Pierre Delacroix (Damon Wayans) suddenly succeeds as a television writer when he produces *Man Tan and the New Millennium Minstrel Show*, originally meant as a biting satire—à la Mark Twain, as he says—meant to be "so negative, so offensive, so racist" that he would offend his boss, Thomas Dunwitty (Michael Rapaport), and put an end to the job he has grown to hate.[39] But his boss (whose office is decorated with African art, Afro-American folk art, and photographs of iconic black athletes) loves the show, the network loves the show, and audiences "turning out by the millions" love the show. Delacroix continues to insist that his new mode of entertainment has a social message, that his aim is to "destroy

these stereotypes." Instead, he has licensed the public to forgo its political correctness and to embrace those stereotypes—first anxiously, then gleefully—all over again. He is caught between, on the one hand, a conscience that recognizes the mass-cultural horror he has loosed upon the world and, on the other, the financial, artistic, award-winning success that accompanies his new TV hit (B).

In the midst of this success, his unambivalent female assistant and onetime lover, Sloan Hopkins (Jada Pinkett Smith), presents Delacroix with a satiric gift, a "Jolly Nigger Bank," not a "repro," as she says, but "circa turn-of-century." "I love these black collectibles," she goes on to say: "It reminds me of a time of our history in this country when we were considered inferior, subhuman, and we should never forget" (B). The bank is meant to snap him out of his reverie, to refocus his attention on the tragic and grotesque history of black caricatures, and to put a stop to the show; it is meant, no less, to prod him into recognizing his self-humiliating greed.

To perform this feat, Sloan chooses the most notorious—and most widely produced and purchased—of the iron bust banks, the operation of which is simple: after a coin is placed in the outstretched hand of the character, and after the lever at the back of the bank is depressed, his arm lifts and his hand drops the coin in his mouth as his tongue recedes, and his eyes roll backward. The humor of the mechanical bank industry depended on circulating such caricatures, easily aligned with minstrelsy.[40] The caricaturing did not focus exclusively on African Americans: Paddy and His Pig depicts an Irishman, astraddle a large hog, who's willing to lick a penny from the animal's snout; the operation of the Reclining Chinaman exposes the four aces stealthily held in his poker hand. The great majority of the caricaturing, though, exploited black stereotypes, depicting a wide range of cartoonish incidents.[41]

The manufacture of the mechanical cast-iron banks began just after the Civil War; the first patent was taken out in 1869; and they enjoyed their widest popularity in the 1880s and 1890s, although they continued to be manufactured until World War II depleted the supply of iron.[42] The J. & E. Stevens Company (Cromwell, Connecticut), a foundry that had specialized in hardware, both inaugurated the (manual) mass production of the banks and commanded the field, which was extensive; there were manufacturers in Trenton, Baltimore, Chicago, and Philadelphia, among other cities, and the banks sold through the pages of Sears and Roebuck and Marshall Field's catalogs in the 1890s. By the turn of the century, the banks had become part of middle-class daily life. Although England served as an export market for J. & E. Stevens, the United States imported

few English banks, even though English manufacturers (especially Stark-ies) and French manufacturers made considerable use of American themes, including their own versions of the Jolly Nigger bank.[43]

In the 1930s and 1940s, the banks were still relished for the pedagogical work they supposedly once performed. "Many a child," one commentator wrote, "would put his pennies in a bank that afforded him the amusement of seeing a mule kick his master, or an elephant lift a small negro boy from the ground. This same child would not be easily persuaded to save his pennies from a sense of duty, but once started, the saving habit grew."[44] Another insisted that "these so-called Penny Banks really did more toward instilling the idea of thrift in the mind of the youngster than any other one idea of the time, and many financiers can look back and attribute part of their first ideas of thrift and economy to the Mechanical Bank of their childhood days."[45] Call it the material culturalist's version of the Weber thesis, where the black caricature has been deployed in behalf of saving. In contrast, you could argue no less persuasively that the practice of childhood thrift, mediated by the banks, instilled a demeaning racism—naturalizing adult myths, as Barthes would contend about toys, before the child could think about them.[46]

The Jolly Nigger bank was understood as the materialization of an actual practice—catching coins in the mouth—that Herman Melville, for one, portrays in the third chapter of *The Confidence-Man* (1857). "Not the least attractive object" on the Mississippi steamboat, the narrator explains, "was a grotesque negro cripple, in tow-cloth attire and an old coal-sifter of a tambourine in his hand, who, owing to something wrong about his legs, was, in effect, cut down to the stature of a Newfoundland dog." By "making music, such as it was" and "raising mirth," he attracts a crowd for whom he becomes "a singular temptation at once to diversion and charity": for "now and then he would pause, throwing back his head and opening his mouth like an elephant for tossed apples at a menagerie," at which point "people would have a bout at a strange sort of pitch-penny game, the cripple's mouth being at once target and purse, and he hailing each expertly-caught copper with a cracked bravura from his tambourine." The name of the crippled beggar—"Der Black Guinea dey calls me, sar"—not only fuses person and thing (which, once the reader discovers his identity as the novel's eponymous character, might be said to mark him as circulating counterfeit coin).[47] It also evokes the object-narratives of the eighteenth century, many of which (say, Charles Johnstone's *Chrysal; or, The Adventures of a Guinea* [1765]) appeared as biographies or autobiographies of specie. Published on the heels of the English consumer economy's expansion, the autobiographies (of a coach, a rupee, a banknote, shoes, a pen, and so on) certainly register a literal

version of commodity fetishism.[48] But, as Jonathan Lamb has made clear, these narratives also seriously investigate the boundary between things and what Locke called "that conscious thinking thing," the self.[49] To the degree that, as Lamb points out, "slave narratives closely follow the narrative pattern laid down by things,"[50] we should add, to Kopytoff's demonstration of how the slave narratives exemplify the life of objects outside the commodity structure, that some of those narratives themselves seem to inhabit the genre of the object autobiography. "You know," the preface reads, in *The Adventures of a Rupee* (1782), that "the limits of taste are not precisely ascertained—this will make you diffident in deciding on my merit. . . . By you I will be judged who have natural taste with acquired knowledge; whose commerce with mankind has not destroyed every sense of benevolence for your fellow-creatures."[51] The kind of mechanical bank that Sloan gives to Delacroix might be said to compress that literary history within a single object. Indeed, Kenneth Goings hints at such compression in the preface to his book on black collectibles: "I have personified these collectibles, and in doing so I earnestly tried to listen to the stories that Aunt Jemima and Uncle Mose and their kin told me."[52] Goings's cultural analysis, in other words, aspires to the generic status of the object autobiography.

Less remotely, though, Sloan means to provoke the kind of outrage that Ralph Ellison depicts in *Invisible Man*:

> Then near the door [of the boarding house] I saw something which I'd never noticed there before: The cast-iron figure of a very black, red-lipped and wide-mouthed Negro, whose white eyes stared up at me from the floor, his face an enormous grin, his single large black hand palm up before his chest. It was a bank, a piece of early Americana. . . . For a second I stopped, feeling hate charging within me, then dashed over and grabbed it, suddenly . . . enraged by the tolerance or lack of discrimination, or whatever, that allowed Mary [the house proprietor] to keep such a self-mocking image around.

In a fit of anger, he breaks the bank against a pipe, the iron head crumbling and flying apart in his hand, coins flying over the room like crickets. "I kneeled, picking up a piece of the bank, a part of the red-shirted chest, reading the legend FEED ME in a curve of white iron letters. . . . The figure had gone to pieces like a grenade, scattering jagged fragments of painted iron among the coins. I looked at my hand; a small trickle of blood showed."[53]

But unlike Ellison's protagonist, Delacroix experiences no such rage. And he not only becomes more obsessively involved in the success of

the show but also, no less obsessively, begins to accumulate Sambo art, his office filling up with antiques: Aunt Jemima cookie jars, Jocko hitching posts, canisters, salt and pepper shakers, and so on. By doing so, he mimics famous contemporary black Americans—Oprah Winfrey, Henry Louis Gates, Jr., Magic Johnson, Spike Lee himself, who kept the bank and an Aunt Jemima cookie jar on his desk while he worked on the film.[54] The psychology of this particular collecting impulse has itself been the topic of speculation and debate.[55] Kopytoff's analysis enables us to speculate that the point here is to decommodify the collectibles and to assert semiotic control over this concrete record of the production and distribution of black stereotypes—now representing not African Americans but U.S. racism. Whereas Baudrillard insists that the "magic" of collection is that collecting always amounts to collecting the self,[56] in this case you can imagine collecting, in concert with Sloan, as a memorializing act, marking "a time of our history in this country when we were considered inferior, subhuman," but also manifesting your distance from that history. But in Delacroix's case, as his office shelves mysteriously become ever more stuffed with this Americana, he seems to have little relation to the collection—less a collection, it seems, than a self-predicating accumulation.

But the camera itself establishes an increasingly intense relationship to the objects, providing both close-ups of individual figures and slow pan shots that grant the objects an eerie life of their own. Shot on high-definition digital tape with handheld cameras, the film provides multiple angles in a consistently high resolution. The cinematography effects the kind of "film magic" that Vachel Lindsay, in the early years of film, associated with the capacity of the medium to enliven the inanimate object world: "While the actors tend to become types and hieroglyphics and dolls, on the other hand, dolls and hieroglyphics and mechanisms tend to become human."[57] Jean Epstein called this magic *photogenie*: "Those lives it creates, by summoning objects out of the shadows of indifference into the light of dramatic concern, have little in common with human life. These lives are like the life in charms and amulets, the ominous, tabooed objects of certain primitive religions."[58] In the case of the black collectibles, of course, their cinematic animation has everything to do with human life, with human lives, which is why their smiling sadness seems to haunt the story so ominously, lined up and packed into the shelves, reflecting not so much the commodity's life, standing in some shop, but life on the middle passage.[59] The collectibles become a mute chorus, sitting in judgment and pained by the recapitulation of the history they're witnessing in the new millennium.

9.3 Still from *Bamboozled*, Spike Lee, dir. (New Line Productions, 2000), DVD.

9.4 Still from *Bamboozled*, Spike Lee, dir. (New Line Productions, 2000), DVD.

But even if the cinematography effects an aura of animation—scenes in which the objects stare back, in which the objects stare past (or all but stare through) the characters to establish contact with the cinematic spectator—*Bamboozled* goes on to literalize the animation. The establishing shot for the moment of psychological transition—after Delacroix, chastised by a phone call from his mother, finally begins to face up to the ramifications of his unanticipated success—provides a view from the floor of the ominously shadowed objects that now crowd the room. At his desk, Delacroix desultorily deposits a few coins in the bank, working its mechanical hand. Then the bank works itself. In a voice-over we hear: "When I thought or imagined that my favorite Jolly Nigger bank, an inanimate object, a piece of cold cast iron, was moving by itself, I knew I was getting paranoid" (*B*) (figs. 9.3–4). Such paranoia derives from the

apprehension that the animate object may be a witness to some crime; when Equiano first arrives in Virginia, "the first object that engaged [his] attention was a watch, which hung on the chimney, and was going. [He] was quite surprised at the noise it made, and was afraid it would tell the gentleman any thing [Equiano] might do amiss."[60] In *Bamboozled*, the jump cut from the office scene to a close-up of the blacked-up face of a new minstrel star intensifies the object-subject equation; it also intimates that the collectibles have some preternatural access to events beyond the confines of Delacroix's office.

As the film draws to a close, Delacroix's dreamlike success erupts into a nightmare. Enraged anarchists publicly execute the star of his show. The bank returns to life. Delacroix crumbles in a fit of despair and frustration, soon to be shot himself, by Sloan. In his despair, blacked-up, he cradles his bank—at once an emblem of his greed and of the degradation he himself has perpetuated. The film rehearses the ways in which capitalism continually offers up examples of sudden rises and falls, of the animation of things and the deanimation of humans. Above all, though, I want to understand this revenge of the black-collectible-come-to-life as the recollection of the ontological scandal perpetrated by slavery, as the reanimation of the reified black body: not some literalization of the commodity fetish, but the reenactment of the breakdown of the person-thing binary, a compressed filmic figure that encapsulates a long biography of things—the "relentless objectification" that reappears as the personification of objects.[61] Such reanimation constitutes the American uncanny.

3. The Uncanny

Freud can be read using the term *uncanny* as a rather casual synonym for *fearful*, describing something that bears "some relation to danger."[62] But of course his 1919 essay on the topic has become the *locus classicus* for apprehending a more highly specified kind of dread. In particular he was concerned to move beyond one claim made by Ernst Jentsch—who, in "Zur Psychologie des Unheimlichen," had ascribed the essential factor in the production of the feeling of uncanniness to intellectual uncertainty, an especially good instance of which is those "doubts whether an apparently animate being is in fact alive; or, conversely, whether a lifeless object might not in fact be animate." He mentions E. T. A. Hoffmann's tales and describes the way that wax figures, dolls, and life-size automata are especially prone to provoke the emotion of uncanniness. "A particularly favorable condition for awakening uncanny sensations," he writes, "is

created when there is intellectual uncertainty whether an object is alive or not, and when an inanimate object becomes too much like an animate one," and he points out how regularly literature uses this device to "invoke the origin of the uncanny mood in the reader."[63]

For Freud, routing an argument both through etymology and through his own reading of Hoffmann, the essential aspect of the uncanny is, first, the degree to which the unfamiliar is suddenly disclosed as the familiar. Famously: *das unheimliche* is *das heimliche*. The uncanny is "nothing new or alien, but something which is familiar and old-established in the mind and which has become alienated from it only through the process of repression." He quotes Schelling, for whom the uncanny names that which "ought to have remained secret and hidden but has come to light"— in other (psychoanalytic) words, the return of the repressed. And, for Freud, reading *The Sandman* as an oedipal drama, focusing on the eyes of Olympia (the automaton) and her creator's destruction of them, what gets repressed (and symptomatically expressed by the uncanny) is the threat of castration.[64]

Freud's essay has become one of those celebrated sites in psychoanalysis that attract extensive commentary, within which Jentsch has suffered the fate of being most familiar as a dismissive note.[65] Even Stanley Cavell, mentioning Freud's reference to "an article from 1906 by a certain Jentsch," working to preserve uncanniness from the hegemony of the Oedipus and to refocus attention on "the recognition of an uncertainty in our ability to distinguish the animate from the inanimate," does not return to Jentsch's essay and its interest in the animate-inanimate object world. Hardly concerned with dolls or automata, Cavell draws attention to "the sense of the human as inherently strange, say unstable, its quotidian as forever fantastic." The uncanny emerges from an individual's confrontation with the otherness-sameness of others, with the other's "automatonity" that "shows itself as a form of the skeptical problem concerning the existence of (what Anglo-American philosophy calls) other minds." Thus, while Cavell intriguingly points out how symptomatically Freud repudiates Jentsch "no fewer than four times," a denial he takes "to be itself uncanny," he himself never speculates that the repression at work may be the repression of the unhuman object world itself, which psychoanalysis compulsively translates into the human.[66] *The Interpretation of Dreams*, like *The Introductory Lectures on Psycho-Analysis*, may be chock full of objects, but each is a symbol for the human body, in whole or in parts.[67] Indeed, you might say that the degree to which psychoanalysis translates the unhuman into the human is the degree to which *uncanniness appears as the objective of psychoanalysis itself*. Which is

precisely why psychoanalysis can hardly begin to explain the uncanny, ontological ambiguity of objects like the mesmerizing, haunting Egyptian coffin mask of the Roman period (FM no. 4823) that was one of more than three thousand objects in Freud's collection of antiquities. While Freud quietly dismissed the importance of the collection, Lacan did so shrilly.[68] Here, I simply want to reassert the specificity of Jenstch's interest in the ambiguously animate object and to imagine that uncanniness can be precipitated by cultural history precisely because law, politics, and ideology so patently contribute to untoward and ambiguous ontologies, to the riddle of person or thing. As I've tried to suggest, for U.S. law the slave becomes the source of uncanny anxiety.

The animation of the lifeless object, in the case of the black collectible, reinstates Jentsch's argument, fully leavened by part of Freud's. For the point is not only that the inanimate comes to life but that the history of this ontological ambiguity—human or thing—is precisely what remains repressed within U.S. culture (or symptomatically expressed, say, in the law's contradiction). The point isn't just that the coming-to-life-of-the-black-object within *Bamboozled* is an expression of this uncanniness. Rather, in what one might call the material unconscious of the film, we can apprehend the uncanniness of the mechanical bank itself—the very ontological instability expressed by the artifact itself, the oscillation between animate and inanimate, subject and object, human and thing, that has no doubt made it such an iconic emblem of racism within American material culture, that has made it the most despised and most prized object of black memorabilia, simultaneously the object of repulsion and fascination.

The history of this uncanniness unsurprisingly plunges us back into the nineteenth century, as does the imbrication of minstrelsy and so-called Sambo art. In "The Mantle-Piece Minstrels," a story published by John Kendrick Bangs in 1896, Jimmieboy witnesses the fortnightly meeting of the Toy Club, where the objects on a mantel put on a minstrel show.

> Jimmieboy looked up as the rag-baby spoke, and what should he see on the mantel-shelf but a long row of pieces of bric-a-brac, blacked up to look like darkies, the clock in the middle looking for all the world like the middleman at the regular minstrels, and at the ends were the grotesque little Chinese god holding clappers in his hands and the dragon-handled Royal Worcester jar holding a tambourine. Between these two were ranged the antique silver match-box Jimmieboy's papa had bought in Italy, the Delft cat, three or four small vases, a sandstone statuette dug up from some old ruined temple in Cyprus, and various other rare objects of art which Jimmieboy Senior was very fond of.[69]

The point here, of course, is that for these objects to come to life, for them to violate their status as mere things, they must black up, they must perform within, or as, the ontological ambiguity expressed by minstrelsy itself.

In contrast, objects assume life in Charles Chesnutt's fiction in the mode of, say, residual enchantment—the sort of "animism" he traced back to "African fetishism," back to the life of things beyond commodity culture.[70] "Po' Sandy" narrates the tale of a slave's wife, a conjurer, who transforms him into a pine tree in order to keep him from being exchanged back and forth between plantations. But the tree is chopped down, and the milled boards are used to construct a kitchen. There the other slaves keep "hear[in] sump'n moanin' en groanin' . . . in de nighttime, en w'en de win' would blow dey could hear sump'n a holler'in en sweekin' lack it wuz in great pain en sufferin'." Rendered useless by being "ha'nted," the kitchen is torn down, the boards used to build a schoolhouse.[71] By telling the story—and intimating that the wood remains alive with Sandy's spirit—Uncle Julius happily prevents the new owner from tearing down the schoolhouse to make new use of the lumber. Instead, Julius makes use of it to house the meeting for the Colored Baptist Church. Insofar as such a tale reports the power of animism (actual or fabricated) to interrupt the northern appropriation of southern property, it would seem to tell the story—even as Chesnutt dramatizes the literal reification endured by slaves—of how the animate object world can interrupt human action.

For a very different example from the nineteenth century, I'd like to turn to some Twainian satire, to the pages of *The Gilded Age*, which Mark Twain published with Charles Dudley Warner in 1873. This rollicking tale of speculation and corruption also contains an uncanny scene of gothic proportions. Ruth Bolton, determined to buck her Quaker family and to study medicine, attends the Woman's Medical College in Philadelphia, where, like anyone in her trade, she begins "her anatomical practice upon detached portions of the human frame," that is, on cadaverous body parts. As the narrator puts it, remarking on the nursing work women did among the "scenes of carnage" during "the late war," "custom inures the most sensitive persons to that which is at first most repellant." But the uncustomary can reassert itself within any custom. To complete her studies, one night she must return to the dissecting room of the college. She brings a friend, and the two girls, candles in hand, climb the stairs to the room where, as the janitor has told them, "there's a new one." They approach the long table in the middle of the room, and Ruth tentatively lifts the sheet. "Both the girls started. It was a negro. The black face seemed to defy the pallor of death, and asserted an ugly life-

likeness that was frightful. . . . Perhaps it was the wavering light of the candles, perhaps it was only the agony from a death of pain, but the repulsive black face seemed to wear a scowl that said, 'Haven't you yet done with the outcast, persecuted black man, but you must now haul him from his grave, and send even your women to dismember his body?'"[72] This is the example with which Jentsch closes his essay—"the horror which a dead body" causes, the horror provoked by those "thoughts of latent animatedness [that] always lie so close to those things."[73] In *The Gilded Age*, the narrator adds a scolding commentary: "Who is this dead man, one of thousands who died yesterday, and will be dust anon, to protest that science shall not turn his worthless carcass into some account."[74] But of course, as with the animate bank that torments Delacroix in *Bamboozled*, this act of reanimation congeals a history with which it confronts the rattled young woman. The startling, unfamiliar event in the novel discloses the horror of the familiar. Different as these examples are, they uncannily reproduce an uncanny effect that has its roots in the condition of slavery itself, in the repressed fact of the ontological ambiguity that U.S. slavery sustained.

4. The Matter of Modernism

Modernism may have once seemed most familiar—in Proust or Joyce or Woolf, as in Braque and Picasso—as the story of the psychological or apperceiving subject. But it is no less the story of objects, as the first section of this book worked to dramatize at some length. In the case of *Invisible Man*, the scene of the smashed bank is simply one episode within Ellison's elaborate organization of both plot and character as a series of object relations, beginning with the narrator's disgust at the eviction he witnesses during his first day in Harlem, the scene of dispossession, with the "clutter of household objects" strewn on the sidewalk. "This junk, these shabby chairs, these heavy, old-fashioned pressing irons, zinc wash tubs with dented bottoms—all throbbed within me with more meaning than there should have been."[75] This excess of meaning gets discharged in the extemporaneous speech he delivers in the street, drawing a crowd and the attention of the Brotherhood. Within the Brotherhood, Brother Trap gives him an object similarly saturated with significance—"a kind of luck piece," an "oily piece of filed steel that had been twisted open and forced partly back into place," a chain link that serves as a memento of the nineteen years that Trap spent as a prisoner in the South. "I think it's got a heap of signifying wrapped up in it," Trap explains as he gives the "keepsake" to his fellow Brother; "It might help you remember what

we're really fighting against" (*IM*, 293). Preserving the object in his front pocket, the Invisible Man can keep the cause proximate while providing himself with a weapon. By the end of the novel, the keepsake shares space with another object, one of the paper dolls he picks up on Forty-Third Street, one of the dolls that seems to precipitate the final turning point of the action, a thing for which the Invisible Man "fe[els] a hatred as for something alive" (*IM*, 336).

When he's downtown, across the street he spots Clifton, a Brother who's been missing and who, it turns out, has become an apostate from the Brotherhood. He has become a vendor, selling dancing Sambo dolls: "I'd seen nothing like it before. A grinning doll of orange-and-black tissue paper with thin flat cardboard disks forming its head and feet and which some mysterious mechanism was causing to move up and down in a loose-jointed, shoulder-shaking, infuriatingly sensuous motion, a dance that was completely detached from the black, mask-like face. . . . [The] doll [was] throwing itself about with the fierce defiance of someone performing a degrading act in public, dancing as though it received a perverse pleasure from its motions." "Beneath the chuckles of the crowd," the Invisible Man can hear Clifton's accompanying "spiel": "*Shake him, shake him, you cannot break him. For he's Sambo, the dancing, Sambo, the prancing, Sambo, the entrancing, Sambo Boogie Woogie paper doll.*" The Invisible Man simply stares, "held by the inanimate, boneless bouncing of the grinning doll and struggl[ing] between the desire to join in the laughter and to leap upon it with both feet" (*IM*, 326). On the one hand, the dance of the doll recapitulates prior, dehumanizing episodes in the novel: when the protagonist, one of the black boys turned into toys, frantically lunges for coins on an electrified rug ("My muscles jumped, my nerves jangled, writhed" [*IM*, 22]); and when, on the verge of death, he has to endure shock therapy: "The pulse came swift and staccato, increasing gradually until I fairly danced between the nodes." At this point he overhears bits of a conversation: "Look he's dancing," "They really do have rhythm, don't they?" (*IM*, 180–81). The Invisible Man himself has endured a kind of ontological ambiguity. But, on the other hand and above all, on Forty-Third Street, he is shocked that a former Brother could have descended into caricature-mongering.

The year before *Invisible Man* appeared, a very different doll had become integral to the discussion of race relations in the United States. Kenneth and Mamie Clark's study of black children (ages six to nine) disidentifying with black dolls was presented as psychological evidence, in *Briggs v. Elliot*, of the devastating psychological effects of the discrimination perpetrated by segregated schooling.[76] The study depended on an axiomatic understanding of how objects contribute to the animation of

a self-image. One might speculate, beyond the confines of their study, that this disavowal of the black doll (however benign and realistic) was precipitated by the perpetuation of black caricatures in the form of dolls, bust banks, toys . . . objects of fun, not subjects in history. Indeed, Ellison's narrator recodes the uncanny as a relation to history, as the indecent persistence of the past in the present. He understands the lapsarian Clifton as having made the choice "to fall outside of *history*" (*IM*, 328). And after Clifton has been shot and killed, his former Brother continues to think: "Why should a man deliberately plunge outside of history and peddle an obscenity?" (*IM*, 331). That obscenity, which is itself the obscenity of anachronism, goes on to inform his perception of the history he's a part of; he thinks of the Negroes coming down from the train platform as "those of us who shoot up from the South into the busy city like wild jacks-in-the-box broken loose from our springs" (*IM*, 332). In other words, black life in the South is the static life of a windup toy; life in New York provides a kinesthetic alternative and the chance to become historical. For the Invisible Man, being-in-history is the precondition for overcoming what Cavell calls the other's "automatonity."

Pierre Delacroix, however privileged and however emblematic of a new African American class, has become, according to Ellison's scheme, one of the "men outside of historical time" (*IM*, 333), not a man who remembers "a time of our history in this country when we were considered inferior, subhuman" (as Sloan insists), but a man who reenacts that history. Convincing the rappers to black up as minstrels, he has led them to some place "outside, in the dark with Sambo, the dancing paper doll" (*IM*, 333). For the Invisible Man, staring at the doll from his pocket, "the political equivalent of such entertainment is death" (*IM*, 337). The Harvard-educated black man, circulating his own version of "'obscene dolls'" (*IM*, 353), succeeds, then, by commodifying not history, but the plunge outside of history. By telling the story of a televisualized minstrel show succeeding in the new millennium, Spike Lee works to produce a different kind of uncanniness: not ontological ambiguity but historical ambiguity, the incapacity to differentiate the present from the past, despite history, because, despite change over time, there's been too little change.

In the "sho 'nough race riot" with which the novel concludes, in the "crash of men against things" in Harlem that becomes the "crash of men against men," the Invisible Man runs east in the moonlight along 125th Street, avoiding the "distorted objects" within the river of glittering, shattered glass (*IM*, 417, 419). He then stops abruptly: "Ahead of me the body hung, white, naked, and horribly feminine from a lamppost . . . and now there was another and another, seven—all hanging before a

gutted storefront. . . . They were mannequins—'Dummies!' I said aloud."
Their status remains in doubt: "But are they unreal, I thought; are they?"
(*IM*, 419–20). Here it is no longer the black man's body that appears un-
canny, but, from the black man's perspective, the white woman's body.
It makes some sense to understand the scene as Ellison's effort to stage
the coalescence of the exploitation of black men and white women.[77]

But I want to conclude by emphasizing how, even as the scene records
Ellison's experience of the 1943 riot, this scene of the mannequins invokes
and refunctions the iconic source of uncanniness within modernity, the
mannequins that made it clear—for Zola, for Eugene Atget, for Aragon,
among others—that modernity was not the experience of disenchant-
ment but of reenchantment by other means.[78] Once Man Ray persuaded
Atget to contribute his photographs to *La révolution surréaliste* in 1926,
Atget's shop-window photographs from the Avenue des Gobelins (1910–
20) became integral to the surrealist imagination and contributed, along
with de Chirico's mannequin paintings (begun before World War I), to
the modernist apotheosis of the mannequin, as evident in Aragon's *Le
paysan de Paris*, where a "human form . . . swim[s] among the various
levels of the window display," as it is in Hans Bellmer's *La poupée* series,
his photographs of the mechanical and increasingly distorted dolls, ob-
jects of libidinal cathexis.[79] Breton and Eluard generated a famous mod-
ernist event when they produced their Surrealist Street, a line of female
mannequins (dressed by Duchamp, Dalí, Arp, Man Ray, Masson, and so
on) propped up outside the Galerie des Beaux-Arts for the 1938 *Exposition
Internationale du Surréalisme*. This life of things on the Paris street then
reappears as the life of things above the streets of Harlem—or the violent
death of the life of things, an uncanny uncanniness, the residue of the
violent attack on modernity, which becomes, in Ellison's text, the disloca-
tion of modernism and the question of whether Enlightenment moder-
nity has ever really happened. If the displaced mannequins in Paris are
meant to register the uncanny effects of consumer culture, then the dis-
placed mannequins in Harlem register, instead, an ongoing threat to life,
provincializing modernism within the context of U.S. racial conflict.[80]

Georges Bataille, while elaborating his alternative, surrealist political
economy, makes a point about the status of things that has always struck
me, and stuck with me, prompting and sustaining my own efforts to en-
gage the complex and ambiguous nature of objects. In "The Bourgeois
World," from the first volume of *The Accursed Share*, he argues that "at
the origin of industrial society, based on the primacy and autonomy of
commodities, of *things*, we find a contrary impulse to place what is essen-
tial—*what causes one to tremble with fear and delight*—outside the world of
activity, the world of *things*. But however this is shown it does not contro-

9.5 Still from *Bamboozled*, Spike Lee, dir. (New Line Productions, 2000), DVD.

9.6 Still from *Bamboozled*, Spike Lee, dir. (New Line Productions, 2000), DVD.

vert the fact that in general a capitalist society reduces what is human to the condition of a *thing*."[81] The retreat into the subject in modern Western thought, the dismissal of object-based epistemology, the declarations about the overthrow of matter—these refusals to accept and address the inanimate object world were precipitated, Bataille would argue, by the very centrality of that world in and for capitalist culture. But the American uncanny, as I've tried to describe it, might alert us to another dynamic as well: the possibility that a reluctance to think seriously about things may have resulted from a repressed apprehension: the apprehension that within things we will discover the human precisely because our

history is one in which humans were reduced to things, however uneven or incomplete that reduction.

As the closing credits for *Bamboozled* roll up the screen, Lee offers an extensive parade of black collectibles in the form of serial close-ups: an array of windup toys (Alabama Coon Jigger, Struttin' Sammy, &c.) along with two banks (Dark Town Battery, Always Did 'Spise a Mule), each shown against a blank, blue backdrop, performing full steam, as Bruce Hornsby sings "Shadowlands" (figs. 9.5–6). According to Lee himself, the visual catalog is meant to display the "hatred of the minds that made this stuff."[82] But the extraordinary, exhausting sequence registers more than such hatred. Multiply animated—by their own mechanism, by the film, by the music—each figure, whether gorgeous or grotesque, seems caught, frantically dancing or fiddling, bouncing or swinging, swallowing pitched balls, grinning and smiling, unable to stop. No longer part of that mute chorus witnessing the repetition of history, the individuated objects bespeak a life of things—of the other thing, of the thingness of objects—that is no social life, only the past's hyperactive persistence.

Ten

Commodity Nationalism and the Lost Object

However distinct their modes of inquiry, the realist metaphysics of ob-
ject oriented philosophy shares a certain passion for the real that is mani-
fest, no less, in one or another new materialism in literary studies, as
in, for instance, the materialist phenomenology now used as a mode
of research by archaeologists, and several other new materialisms.[1] At
the end of my overture, and again in chapter 5, I made some effort to
historicize this passion, considering it in relation to the new hegemony
of the digital, to the current state of ecological emergency, and to the
threat of human obsolescence posed by any number of new technologies
(from 3-D printing to advanced robotics). Before the end of the twenti-
eth century, Fredric Jameson had summed up, vehemently, some of the
risks entailed by any such critical cathexis on concrete objects. He did
so in an essay on Georg Simmel, curiously (but importantly) titled "The
Theoretical Hesitation: Benjamin's Sociological Predecessor." Jameson
points out how Georg Simmel's work from the turn of the previous cen-
tury, his "phenomenological commitment to the concrete"—to particu-
larity and empiricity—"forestalls concept-formation" and results in an
inability to move "towards the absolute of universal or abstract ideas."[2]
As Jürgen Habermas put it in an analogous formulation, Simmel "was
a creative although not systematic thinker—a philosophical diagnosti-
cian of the times with a social-scientific bent rather than a philosopher or
sociologist."[3] Most precisely, from Jameson's point of view (shared also
by Theodor Adorno), the limit of Simmel's thought, which becomes the
limit of Benjamin's thought, is, in a phrase, the unwillingness to theo-

rize, by which he means the unwillingness to totalize, to move out from the microethnographic level of analysis.[4] For Jameson, of course, the plea to "always historicize," as he put it, is the plea to totalize, which means to allegorize: to transcode the phenomena at hand into the terms of the modes-of-production and stages-of-capital narrative, the barely perceptible telos of which is the democratic socialization of the means of production. But it is precisely the translation of the object at hand into those terms that threatens *not only* to deny it phenomenal specificity (in behalf, say, of diagnosing a dominant spatiality or temporality) *but also* to forestall other (not necessarily alternative) accounts of how object culture forms and transforms human life, of how (for one subject or another) the object becomes a thing, of how the inherent doubleness of the object (the object-thing) becomes appropriated by the structure of the commodity form (exchange value–use value). The whole point of thinking about things—or, say, of thinking with them—is a matter of posing and responding to questions that a given master narrative cannot pose in an empirically or conceptually satisfying way. But the empirical (the commitment to the concrete) must never succumb to the merely empiricist, or to an antiquarian investment in recuperating a thingness of things that amounts to no more than their coarse materiality and their historical specificity. The present chapter tries to situate itself on some edge of that most overwhelming of master narratives—the history of capital—looking out at times, while at other times looking in. It does so in light of my conviction, spelled out in chapter 1, that Heidegger's tireless effort to fathom the thingness of things is (not least) a response to Lukács's claim that the character of things as things has been lost in an era saturated by the commodity form. For the time being, the exploration of thingness (like any new materialism or any object oriented philosophy) must be conducted within the phase of the history that Lukács had just begun to survey, and within which we continue to live.

1. Commodity Nationalism

Now let me juxtapose two scenes.

The first scene comes from a chapter of Svetlana's Boym's *The Future of Nostalgia*, "Immigrant Souvenirs," where she describes the decorating habits of Soviet immigrants living in Boston and New York. Although these homes have clearly become "memory museums," as she puts it, they're not quite what we expect. "Their collections of diasporic souvenirs tempt us at first glance with a heart-wrenching symbolism of the abandoned mother country." And yet, as she goes on to clarify, the col-

lections are not meant to compensate for some original (aboriginal) loss; they do not participate in the "Russian melodrama of insufferable nostalgia."[5] Rather, the collections metonymically narrate the Russian-America life as the émigré, the political refugee whose hybrid identity and multicultural milieu are expressed by the objects themselves. Each collection turns out to be a curious assemblage: matryoshka dolls and clay bowls, but also treasures from American yard sales and Thai lions and Chinese ducks and disposable objects rescued from a hyperconsumerist culture. Such an assemblage is explicable by Baudrillard's still-powerful account of collecting: "The particular value of the object, its exchange value, is," he writes, "a function of cultural and social determinants. Its *absolute singularity*, on the other hand, arises from the fact of being possessed by me—and this allows me, in turn, to recognize myself in the object as an absolutely singular human being. This is a grandiose tautology, but one that gives the relationship to objects all its density" (my emphasis).[6] Baudrillard's point is a decidedly post-Marxian and post-Freudian account of object relations in an expanded field, where objects are not simply substitutes for human subjects or for parts of the human body: daddy's genital, mummy's genital, the good breast and the bad. (See chapter 6.) In Baudrillard's version of self-possession, we collect objects in order to collect ourselves, to constitute ourselves; that is what these Russian immigrants have done, in a way that seems to express (or reflect) the very different dimensions of their recent past.

The second scene comes from the old State Street Marshall Field's store in Chicago, where, in early December 2002, I was in the "Christmas Shop," somewhat nervously looking for an ornament to take to someone's party, and then confronting Christopher Radko's "Heroes All" ornament, a bright miniature of the World Trade Towers (plate 17). The accompanying advertisement explained that "this inspiring patriotic design is a meaningful reminder of the supreme importance of our nation's freedom"; net profits from the sale of the ornament (sold for thirty-five dollars each) were being directed to the Twin Towers Fund. Of course, as someone who has spent time reading about and thinking about consumer culture, I should hardly have been surprised to see the Twin Towers ornament glistening there, dangling between a snowman and a reindeer. But in fact I was caught off guard; I *was* surprised. In fact, I was pretty disgusted. I left the Christmas Shop empty-handed, determined to arrive at the Christmas party with nothing more seasonal than a bottle of scotch.

Now the Radko enterprise, founded in 1983 and currently a multimillion-dollar business, is itself a product of nostalgia. When Christopher Radko's family's Christmas tree collapsed, shattering their collection of vintage glass ornaments, Radko went to Poland in search of

someone willing and able to blow ornaments in the traditional, "authentic" way. The hit of these heirloom replacements inspired a business venture that came to employ more than three thousand workers in Poland, Germany, Italy, and the Czech Republic, preserving the old-world European caché, no matter how patriotically American the design.[7] This "czar of the Christmas present," as the *New York Times* once called him, has contributed more than anyone else to the Christmas-collecting mania, which depends not only on the materialization and commodification of sentiment, but also on a particular logic of "souvenirism," by which I mean to name the dynamic by which objects retroprojectively create the event—the eventfulness of the event—they are meant to record and recall.[8] The ornament emblazoned "Christmas 1998" differentiates *that* Christmas from all the rest; these are souvenirs more of time than of place. Of course, Christmas as such is a kind of memory machine: Christmas is always "about" Christmas past, about what is now lost, about loss. You might thus argue that the vast accumulation of things (ornaments, decorations, gifts) serves some compensatory function.

But my irritation with this particular ornament—*a Twin Tower ornament?*—prompted me to discover what I should have already known: that in the year following 9/11, a new market had emerged, the market in high-end 9/11 collectibles, not just flags and ground-zero T-shirts and NYPD pins and WTC plastic snow globes. When, on December 15, 2001, Kyra Phillips interviewed Robyn Spizman for CNN's *Saturday Morning News*, she began by saying, "It seems September 11 has changed the way people are decorating and what we want to buy." Spizman responded cheerfully: just by googling, she had identified more than seventy-four thousand "patriotic gifts," including, as she put it, many "wonderful collectibles," and she noted that one designer was creating some of "the *most* collectible items."[9] This imbrication of grief, patriotism, and collectibility seemed to mark some unforeseen moment in the history of the commodification of affect, in some respects on a par with the Royal Wedding memorabilia, but with a far more durable market niche, and one that required the absence of all irony (the very irony with which Royal kitsch could be recoded as camp and thus legitimately accumulated by the British, Australian, Canadian, and American bourgeoisie).

There is nothing ironic about the figurines, statues, pins, ornaments, and plates that depict the twin towers, the fire fighters, the patriotic heart itself. Radko's "Brave Heart" ornament, decorated with stars and stripes, was meant to "Keep the Heart of Freedom Beating" (plate 18). Bradford Exchange's "We Will Never Forget" collector's plate offered the savvy collector the opportunity to display a vigilant memory while investing in a limited edition that would quickly increase in value. For, of course, what

makes these collectibles especially collectible is their staged symbolic connection to an event, to *the* event, to an utterly singular, personal and collective *moment* in history. The symbolic connection is merely symbolic, of course, without the metonymic matrix through which the souvenir becomes meaningful. Or you might say that such collectibles are meant to serve as souvenirs from an emotional place and time—that they're meant to record a specific chronotope within the psychogeography of the nation. I say "souvenirs" only while recalling Susan Stewart's epigrammatic differentiation between the relic and the souvenir: relics "mark the horrible transformation of meaning into materiality," whereas souvenirs mark "the transformation of materiality into meaning."[10] You could choose among "America's Bravest Ornament" (a fireman marching on parade) and "Santa Salutes America's Firefighters" and a personalized "America's Bravest Fire Escape." The "Always With You" figurine manifested such sentiment at its most saccharine. The description reads: "The angels wings enfold the tired, discouraged firefighter as she reaches out to him with the touch and hope of comfort. We expect a very strong demand for this affecting collectible. Please reserve yours now to avoid disappointment."[11]

It is easy to make fun of these sentimental objects (the way it is easy to make fun of Catholic kitsch—the St. Christopher or the Virgin Mary hanging from the rear-view mirror) but if there's one thing that postcritical theory has taught us, and indeed one thing 9/11 taught us, it is that making light of the affective register does not get us far in our apprehension of how capital's consumer culture works. Still, at this point I'd like to say, reflecting on the two scenes with which I began, that the hypernationalist kitsch is characterized by the very insufferable melodrama that Boym's immigrant collections seem to eschew and that, by Baudrillard's measure, these collectibles, however passionately purchased, accumulated, and displayed, *are not really being collected*. They evade the tautology that constitutes collecting; the collectible's value is culturally, not personally, determined; and it reflects back not personal identity but collective identity. Indeed, that would seem to be part of the marketing logic at work: by externalizing your grief in the form of the Twin Tower ornament, you exhibit your participation in a national act and prosthetically partake of the local scene, no matter how distant from it. The object form of recollection provides an etherealized, aestheticized participation in what Mark Seltzer has termed "the pathological public sphere," the sphere, generated by violence and spectacle, that, by his light, has become the sole form of our being-together.[12]

The aestheticization of grief, which is also its homogenization, would seem to complicate (but also to confirm) liberal defenses of the culture

of consumption. Anne Norton, in her study of the liberalism of everyday life, makes the familiar but important point that, in America, consumption appears as the realm of "self-determination"; consumer goods provide a common language that serves "to reveal the self to itself, carrying ideas that, apprehended in the object, will be internalized."[13] But staring at a shelf or a website stuffed with patriotic and memorializing ornaments, with "*affecting collectibles*," I find it difficult not to respond with the very arguments that Norton argues against, those arguments of Adorno's about the pseudo-individuality promised by the culture industry, wherein "everyone amounts only to those qualities by which he or she can replace everyone else: all are fungible."[14] Rather than giving expression to individual experience, consumer culture contains that experience with the freedom to choose only what is the same. But it is precisely that sameness—the interchangeability not of the objects but of the subjects—that would seem to catalyze this "purchase" of the nation formation itself, an imagined community of consumers purchasing mass-produced patriotic ornaments. To buy the Radko ornament is to participate in the feel of being national, which is really the feel of *being* American by way of *doing* what other Americans are doing and of *having* what they have, producing, as it were, a nationalized mass subject.[15]

But such a claim—not only about these ornaments but about all the 9/11 kitsch—overlooks the seriousness that even Adorno, confronting Thorstein Veblen with a decidedly Benjaminian move, was able to bring to bear on kitsch culture. Veblen, he wrote, does not "grapple with the historical necessity of kitsch, which represents the futile but compulsive effort to avoid the loss of experience" perpetrated by abstract equivalence. "Men prefer to deceive themselves with illusions of the concrete rather than abandon the hope that clings to it. Commodity fetishes are not merely the projection of opaque human relations onto the world of things. They are also the chimerical deities which originate in the exchange process but nevertheless represent something not entirely absorbed in it."[16] In other words: reification always leaves a residue.

What is it, in Adorno's terms, that remains unabsorbed in the exchange process; what loss of experience is being compensated, however phantasmatically? The dialectic that invigorates capital's consumer culture, and that strikes me as especially visible in the aftermath of 9/11, is simply the extent to which the proliferation of objects and the obsessive accumulation of objects compensates for what Lukács (following Marx) called the loss of the "character of things as things," a loss marked not by the absence of the Twin Towers so much as by their presence—or, say, a loss merely literalized by their absence.[17] One historian of the World Trade Center, Eric Darton, has argued that the antihumanist, utterly ab-

stract design of the Towers enabled them to serve as a terrorist target.[18] Whether or not you accept the argument, it is important to recognize that the U.S. government itself has been thrilled by the dematerializing capacities of our culture, about our "information age." "The central event of the 20th century," Alvin Toffler reported to Newt Gingrich, "is the overthrow of matter."[19] More generally, insofar as the twenty-first century has witnessed collecting tout court as having attained a new kind of urgency—fueled by decorating magazines, craft shows, television hits like *The Antiques Road Show*, and new consumer systems like eBay—you might want to argue that our culture is struggling to bring this overthrow of matter to a halt. The market in 9/11 collectibles simply made that struggle newly visible.

2. The Lost Object

The Towers literally and symbolically stood at the center around which other objects, literal and virtual, ceaselessly circulated. Their massive stability was the more important and impressive because they were emblems of the system of trade in which all things are fungible, in which all things—in the contemporary economy—seem above all virtual, with no solidity at all (plate 19). I want to speculate that this august stability in the midst of (or as the midst of) a no-less-august lability had a great deal to do with *why* the emotional response to the loss of built space, a human artifact, almost instantly exceeded the response to the loss of human lives. In diluted Heideggerian terms, an ontic tragedy (that involved beings) soon became ontological (a tragedy about being). It was clear that America plunged into a state of mourning for the lost objects themselves—or, perhaps more precisely, into a state of melancholia, not really knowing what had been lost, the towers having become emblems of something like the Lost Object as such, the materialization of what is always missing. In this respect, Giorgio Agamben's amplification of Freud is useful: the point isn't only "that a loss has occurred, without its being known what is lost"; moreover, "melancholia offers the paradox of an intention to mourn that precedes and anticipates the loss of the object."[20] If an intention to mourn may be said to have preceded the catastrophe, was it perhaps the intention to mourn the actual and seemingly perpetual absence of any stabilizing entity?[21]

More plainly, the tragedy changed not only our sense of U.S. fortitude; it changed—perhaps it simply revealed—our relation to the physical world as such. In the year following the attack on the towers—and still, perhaps—who looked at a skyscraper as a "a proud and soaring

thing," the way Louis Sullivan had, instead of as a fragile thing expressing an untoward ambition, our hubristic architectural imagination? Among the lessons learned from 9/11, you could learn more about how subjects strive to secure themselves with objects, more about the power we invest in objects, more about the way we fetishize particular objects to fill in the gaps in our physical and our psychic lives, more about the mutual constitution of the human subject and the nonhuman environment.[22] As I detailed in chapter 5, Hannah Arendt describes this striving with particular eloquence, arguing that "the things of the world have the function of stabilizing human life." It is her argument that works of art, to which I would add monumental architecture, have a particular kind of permanence: "Nowhere else does the sheer durability of the world of things appear in such purity and clarity, nowhere else therefore does this thing-world reveal itself so spectacularly as the non-mortal home for mortal being."[23]

In very broad strokes, then, I want to argue that the commemorative 9/11 commodities were part of an effort to organize—to reprocess, to sanitize, to discipline—a suddenly chaotic object culture and the psycho-ontological ramifications of that chaos. But this was only one such effort. In the immediate aftermath of 9/11, there were discursive efforts that turned our attention to everyday objects, as though compensating for the discursive inability to characterize the scene or the sense of demolition. The *New York Times* cataloged objects that were once within the depths of the towers: "A quarter mile below the spectacular vistas from the towers was the upside-down attic dropping 70 feet below ground, a strange world with enough room for fortunes in gold and silver, for Godiva chocolates, assault weapons, old furniture, bricks of cocaine, government vehicles, CIA files." There were several accounts of the storm of paper: "Personal and official, all shapes and sizes, bits of paper blanket lower Manhattan with the mundane poetry of office life. They drifted from the sky Tuesday and fell to earth miles away in Brooklyn, sheets and scraps that document the 28-year life and abrupt death of the World Trade Center."[24] Attention was paid to the seemingly trivial physical ramifications of the collapse: "the hundreds of high-heeled shoes left lying on the streets, shed by women running for their lives; . . . the collection of clocks at the Tourneau watch store, stopped in their tracks."[25] Such a list, wittingly or not, draws attention to the oddity of our imbrication in the physical world: our reliance on objects to tell us the time, our utter saturation with paper, our fascination with disabling fashion. The abandoned shoes—not simply metonyms for the people who left them but emblems of a moment of terror and the moment of abandoning the worldly goods by which we define ourselves in order to preserve the physical self—this repeated image of the abandoned high heels could

itself become the next chapter in the iconicity of shoes. "Now memories orbit around small things," Jim Dwyer wrote, in a series of articles "on workaday objects that resonate in unusual ways in the aftermath of Sept. 11."²⁶ The articles testified to a thorough defamiliarization, in which these objects became things, attaining a value in excess of any kind of exchange or use, reorganized within a new and unanticipated semantic field.

But even as these things depend on what you might call an aberrant economy (a different system of evaluation), the economy-as-usual was quick to foreclose this object lesson with a different discourse of materiality provoked by the disaster. Dominique Browning, for instance, editor of *House and Garden* magazine, published an essay in the November issue that began, "As I sit down to write this column, it is impossible to think about anything besides the devastation from the terrorist attacks on New York and Washington"; but the essay concluded somewhat differently: "Of course, no one is thinking about chintz, or blueprints, or birdbaths this week," she writes, but "people are thinking about home, about getting home, and about the homes that now suffer from the excruciating absence of a family member." You realize that "unreasonably trivial" things advertised in the magazine are really "all we have," "the little things of everyday life, the mundane details that pile up into whatever larger sense we make of our days."²⁷ I have no quarrel with this essay as an emotional response to the tragedy, but as an aesthetic response, it seems singularly unproductive, retreating into an object world of familiarity rather than inhabiting the interruption that provides some access to the dynamics by which the thingness of objects—the other thing—becomes visible.

By now, the prose fiction provoked by 9/11 has helped to draw attention to the individual and collective seismic shifts. The plot of Jonathan Safran Foer's *Extremely Loud and Incredibly Close* (2006) is structured as the quest for a missing object: an eight-year-old boy's mission, searching all over New York, to find the lock that fits the key he has found in his father's bedroom, the father whose body has disappeared without a trace in the wreck of the World Trade Center. In the opening pages of Don DeLillo's *Falling Man* (2007), a cut and dust-covered survivor runs, and then walks, from the epicenter of the chaos: "In time he heard the sound of the second fall. He crossed Canal Street and began to see things, somehow, differently. Things did not seem charged in the usual ways, the cobbled street, the cast-iron buildings. There was something critically missing from the things around him. They were unfinished, whatever that means. They were unseen, whatever that means, shop windows, loading platforms, paint-sprayed walls. Maybe that is what things look like when there is no one here to see them."²⁸ *Seeing things, somehow, dif-*

ferently (seeing the thingness of objects) became part of the immediate 9/11 legacy, for better and for worse.

Shortly after the 11th, objects had become part of the survival stories that circulated to remind us, in the midst of our weakness, of our strength; indeed, objects themselves were heroized. A twenty-dollar pair of handcuffs (prominently pictured) was used as a chisel to scrape against concrete toward freedom; a squeegee was used by a window-washer to dig himself and others out of an elevator, caught between floors.[29] I read these accounts as exemplifying something more than the prototypical way in which trauma focuses our attention on small, physical details. For just as our attention was repeatedly directed to survivors—to people who just barely escaped one tower or another before its collapse—so too was our attention drawn to the surviving objects, and thus to the fact that *some* human artifacts, *some* manufactured things, withstood the devastation. I want to describe the fascination with these objects, the emotional investment in these objects, as a kind of nonerotic fetishism that nonetheless, as Freud would have it, both marks and disavows an unendurable absence. In other words, the object of intense interest serves as a memorial *and* as a substitute; it is a token of triumph. The usefulness of Freud's model has nothing to do with the supposedly phallic character of the towers; it has everything to do with the fact that the handcuffs and the squeegee came, say, to occupy some space in the epicentric void of lower Manhattan. It is not their objectivity but what Laplanche would call their objectality—their relation to a drive—that calls for our attention.[30] These were contingent objects that had become things—attaining new value, dislodged from one or another quotidian scene—in large measure because they were standing in for, and thus obscuring, some phantasmatic object of a drive that is ontological or mnemonic, a drive that seeks the structure of duration and the presence of the durable.

In the spring of 2001, Philippe de Montebello, director of the Metropolitan Museum of Art, found himself declaring that his institution would fund the removal and relocation of the colossal Bamiyan Buddhas, 230 kilometers from Kabul, carved from the sandstone cliffs in the fifth century in the heart of the fabled Silk Road, their durability threatened by the Taliban's declaration that the sculptures would be destroyed as un-Islamic icons.[31] By fall, long after dynamite, tanks, and antiaircraft weapons had been used to destroy the Buddhas, Montebello argued in behalf of preserving "the searing fragment of ruin" of the World Trade Center as a memorial, "the searing fragment of ruin already so frequently photographed and televised that it has become as familiar to us as the buildings that once stood there."[32] He did so with a barely perceptible but important act of personification that granted the fragment a kind of

interiority, a kind of consciousness: the emotional fortitude of the steel "that still stubbornly stands" came to signify not ruin but endurance, the endurance of the physical world, of the built, of human artifice (plate 20).

However intensely the World Trade Center once symbolized change, abstraction, consumption, and commodified labor, it had come to symbolize, *after its destruction*, the endurance of human work, the permanence of human works. Hidden within Montebello's proposal is, among other things, a new chapter in Alois Riegl's account of the "cult of monuments," for we were now faced with the unintentional monument that was above all a monumental absence, rather than a presence, a missing portion of a skyline. As a missing object — an object missed — the towers became a Thing, a metaphysical presence more massive than they ever really were. This is why, even while being remembered as the out-of-scale, uncomfortable buildings that interrupted the city grid and blocked the light of the sun, they now, like the sun itself, still shone somewhere despite the darkness at hand. As Jean Baudrillard put it, "Their end in material space has borne them off into definitive imaginary space. . . . The World Trade Center has become the world's most beautiful building."[33]

In Baudrillard's "Requiem for the Towers," which was his contribution to the debate on 9/11 (February 2002), you can read an exaggerated version of what was already legible in the daily press: the inexorable animation of the object: "Seeing them collapse themselves, as if by implosion, one had the impression that they were committing suicide in response to the suicide of the suicide planes" (47). More sentimentally: "So the towers, tired of being a symbol which was too heavy a burden to bear, collapsed, this time physically, in their totality. Their nerves of steel cracked" (48). All but needless to say, the aggressive fetishism, granting the buildings consciousness and agency, functions here to hide the history of human labor congealed within the buildings, as well as the labor of destruction, and the labor invested in rendering the absence real — that is, in cleaning up the apocalyptic scene. Beside William Langewiesche's book on the "unbuilding" of the World Trade Center — his effort to record the massiveness of the refuse and the massiveness and complexity and politics of the rescue operation — Baudrillard's requiem reads like an offensive sleight.[34] And yet Baudrillard's act of prosopopoeia, his indulgence in the pathetic fallacy, participated in what seems to be the instinct to mourn this loss of built space by granting the Towers an afterlife that enables inanimate matter to live as it never did.

Of course, the Towers were always more than artifacts, more than facts. They were also expressions of a fantasy: Balthazar Korab, who worked as Yamasaki's photographer when Yamasaki was awarded the World Trade Center commission in 1962, explained, post-9/11, that "the

heroic dimensions were adopted after long soul searching, projecting a symbolic monument for a new millennium that was to lead to world peace through global trade."[35] Less sublimely, while Guy Tozzoli insisted that the new center provide 10 million square feet of rentable space, David Rockefeller insisted that whatever was built had to be a symbol of New York's global economic preeminence.[36] The dialectic of the physical and the metaphysical—or, if you will, the material and the symbolic— produced the energy for the original construction, just as it produced the energy for the posthumous lamentation. Andreas Huyssen wrote about the towers as the representation of global capital, but he was also quick to move beyond (or beneath) this act of representation to address the way that, in New York, "their monumental size crowded out other land-marks," so that "monumentality itself"—monumentality as such—"is at the core of their after image and its effects."[37]

3. Matter and Memory

As Radko's ornament makes clear, it is not only an afterimage, but also an objectified image, an afterobject, let us say, that will continue to circu-late. Indeed, one might argue that the proliferation of 9/11 objects serves to compensate for the spectacle that 9/11 became, its status as endlessly repeated footage. The attraction of objects—and the new attention to ob-jects—may reside in their capacity to rectify the insufficiencies of image culture. Such a dynamic of compensation or rectification occurs no less obviously in the extraordinary museal response to 9/11, the official efforts to collect and preserve the detritus from the disaster. These stand over and against the initial, unofficial acts of accumulation, the first of which, in Union Square, came to an abrupt end on September 20. Writing for the *New York Times*, Andrew Jacobs reported that

> just before rain arrived yesterday morning, New York City Parks Depart-ment workers gingerly collected the poems, paintings and missing per-sons fliers that had turned Union Square Park into a sprawling outdoor shrine to grief, remembrance and peace. Although the department said it was storing the items with an eye toward a future memorial or museum, some visitors said they were saddened to find large sections of the park cleared of candles, bouquets and notices about upcoming marches and meetings. As rain doused the hundreds of tiny flames and scattered the crowds, some of those who have been living in the park said they felt a historic moment was drawing to a close. (plate 21)

In their place appeared the vendors selling bears and snow globes and pendants and caps and jackets and T-shirts and key chains. Jacobs interviewed one twenty-year-old who described those initial acts of collection and display as "an incredible time": "There was such a feeling of community. Now it seems like New York is getting back to its old self."[38] The clutter was displaced by the clarity of consumer culture.

Another effort to attain some clarity was already being pursued through the Herculean effort to sort through the wreckage of 9/11 to find and preserve artifacts that could serve in behalf of memorializing the event—an effort that came to be spearheaded by the Port Authority, the Smithsonian, the New York Historical Society, and the New York State Museum, among other institutions. Let us call this the *race to curate disaster*. (This race has an ugly private dimension, a scramble for authentic souvenirs that was disclosed by John Solomon in 2004: FBI agents illegally secured fragments from the crash sites for Secretary of State Donald Rumsfeld and the FBI's executive assistant director for terrorism, Pasquale D'Amuro, among others.)[39] *Relics from the Rubble*, a documentary for the History Channel that first aired in September 2002 ("This Week in History") provides the simplest record of the aspirations, the clearest symptoms for diagnosing this case in the history of U.S. object relations. In some instances, within the documentary, there is the return of the heroized object, such as the brass squeegee holder, now accompanied by stories with the air of Ripley's Believe or Not: the story of Lisa Lefler's briefcase, for instance, which fell 103 stories but remained intact, a story framed to provide affective access to the daily working lives of the friends who worked with her but failed to escape the inferno. What the documentary calls the "quest to find relics," this particular American passion for the real, becomes saturated with significance because "artifacts are the way we touch the past" and are what we can offer "future generations" to install the event within collective memory. The artifacts are valuable because of what they will teach other people in another time. Because, as both Marx and Simmel emphasized, things or ideas only become valuable within a social relationship, we need to recognize that the act of evaluation here amounts to the projection of a social relationship with the future, as it were, one that fairly well depends on that future culture being just as "obsessed with memory" as ours is, as ours had already become in the closing decades of the twentieth century.[40]

Within the documentary David Shayt explains that the Smithsonian was granted a $5 million appropriation for securing artifacts from among the original wreckage, estimated to weigh 6 million tons and constituting a seven-story mound of debris, with the "cathedral like skeletal walls of

the twin towers standing above the mound." Mark Wagner became the Port Authority official who was responsible for "uncover[ing] objects and symbols that will resonate for future generations," leading the search for something "truly emblematic of the iconic status of those buildings." The crumpled steel was taken to JFK and carefully covered, the most remarkable piece being an eight-ton steel I-beam that, within the heat of the disaster and under the weight of the collapsing towers, bent into "the shape of a horseshoe." The remainder of the debris was carted to the Freshkills landfill on Staten Island, where Port Authority workers and curators from the Historical Society sifted through the rubble in search of meaningful artifacts: watches, rings, credit cards, but also crushed fire trucks and a crumpled bicycle stand, also a chunk of the granite memorial for the victims of the 1993 bombing. The documentary might be said to recognize itself as being in medias res, in more ways than one: in the midst of an overwhelming chaos of things and in the midst of the search for some adequate "piece of history," the most "powerful symbol" for the thousands of dead. The drama of the documentary derives from the melodramatized enigma of wondering which object will become *the* relic—which object will, in Susan Stewart's formulation, turn meaning into matter.

It is reasonable to imagine, I think, that this impulse to collect and preserve the artifacts from 9/11 participates in the fascination with memory that took particular hold in the 1990s (generally understood as a response to the world-transforming events of 1989, but clearly in accord with the architectural and literary-critical historicisms that thrived in the 1980s). As Andreas Huyssen put it, at the outset of *Twilight Memories* (1995), the "obsessions with memory" were inseparable from "the reproach that our culture is terminally ill with nostalgia," the result of which seemed to be the "resurgence of the museum, monument, and the memorial as major modes of aesthetic, historical, and spatial expansion."[41] At the time, the Jewish Museum in Berlin was under construction; the year before, the United States Holocaust Memorial Museum had opened in Washington (now accompanied by Holocaust museums in Huston, Florida, Virginia, Maryland, California, &c.). The role of objects within these memorial sites would seem to have set a contemporary standard for the power of inanimate matter to become—as the dominant trope would have it—a mute witness to history. Of course, the job of the museum is to give such witnesses voice, and thus to effect a social relation between humans and things, or between humans as mediated by things. The most powerful exhibition within the Washington museum has been the mound of four thousand shoes, given voice by the engraving on the wall that reads, "We are the shoes, we are the last witnesses. We are shoes from grandchildren

and grandfathers from Prague, Paris, and Amsterdam," the shoes taken off before stepping into the showers. The metonymic power of the shoes exists as a contact point with a particular place and time, with a particular yet departicularized person. The museum everywhere manifests what Michael Berenbaum, the museum director, calls an "incarnational theology" that means to personalize the experience of suffering.[42]

The memorial museum also displays—in Washington and on its website—a tiny embroidered dress worn by a Polish girl, Lola Rein Kaufman, who spent seven months hiding, with three other Jews, in a four-by-six-foot hole dug beneath a barn.[43] The dress, sewn by the mother who was killed by the Nazis, just as the father had been, was given to the museum in 2002. The exhibit is entitled *Silent Witness*. The dress, you read, "embodies not only a mother's love and a grandmother's courage and foresight, but also the world's abandonment of a little girl" (who, after the Russian liberation, wandered the countryside as an orphan). "It symbolizes the tragic experience of Jewish children during the Holocaust, and survives as a silent witness to their lives. It is a testament to resilience and survival, yet also a memorial to the up to one million and a half Jewish children who, unlike Lola, perished in the Holocaust." The silent witness becomes compelling insofar as it is an incitement to discourse and can be located very precisely within multiple narratives that the memorial museum has painstakingly reconstructed and authenticated.

There are many obvious and important differences between the Holocaust museum projects and the 9/11 museum projects. The difference I want to underscore lies in the fact that the Holocaust was an event that was insufficiently documented, passively repressed, or actively suppressed. The ambition to represent the event—on television, on film, in museums, in print—took hold as the last generation of survivors reached old age. In other words, the primary work of the Holocaust museums is the work of making sure that the Holocaust becomes historical (in 2007, for instance, the national memorial museum was "denounc[ing] the ongoing denial of the Holocaust in Iran"), which means documenting the Jewish communities that were destroyed, and the life of the refugees, and the life in the camps, and the life of those who perpetrated the crimes. The silent witnesses are meant to recover these lives from obscurity; the accumulation of objects—everyday objects, ritual objects—means to grant those lives and their destruction *objectivity*; and the objects are meant, one might go on to say, to withstand the widespread Nazi destruction of Jewish artifacts, the erasure of Jewish culture along with the Jewish population.

In obvious contrast, few events seem less obscure than 9/11, documented and redocumented in so many different media, collectively wit-

nessed on television—by a nation and by a world—the way no other event has been witnessed. Why does such a hypervisualized tragedy seem to require all these objects meant to serve as "powerful symbols" and "pieces of history"? Why have they become part of what Erika Doss has called the "memorial mania" that has overtaken the United States?[44] Who in the future, trying to learn about this tragedy, would turn to objects rather than to the image archive?

On September 11, 2002, the Smithsonian opened its 9/11 exhibit, explaining that "soon after September 11, the National Museum of American History began collecting objects to document the attacks and their aftermath."[45] The Institution also offered the public *Bearing Witness to History*, a traveling exhibit, which closed permanently in January 2006, after completing a two-year national tour. Among the objects on display were a helmet worn by the first fire chief to arrive at the World Trade Center on 9/11; a stairwell sign from the 102nd floor; the firefighter's pry bar used by Lt. Kevin Pfeifer, who was one of the 343 firefighters killed during the collapse, and the remains of the heroic squeegee (plate 22).

As its strategy of display, the museum supplemented each object with a plain-spoken description and with some narrative context for making sense of the artifact, for example, a car door from a police vehicle (plate 23):

NYPD patrol car door
 Description: This door panel was removed from a New York Police Department patrol car crushed by the falling debris of the World Trade Center.
 Context: New York City police officers immediately responded to the attack on the World Trade Center. With the collapse of the buildings, the NYPD lost both officers and vehicles. This door panel was removed from a crushed patrol. Many fire trucks, squad cars, taxis, delivery vehicles, and private automobiles were destroyed as the World Center collapsed. Twenty-three NYPD officers were killed in their attempts to save World Trade Center tenants.

How are we to imagine the psychodynamics that are meant to transform meaning into matter, to transform waste into relics, to project specific value onto these fragments? These relics—the squeegee, the fire hat, the crumpled car door—seem to stand in for the human remains that disappeared; the account of the "context" oscillates between the human (officers) and the unhuman (vehicles). Moreover, the incredible efficiency with which the Port Authority and the city cleaned up ground zero has to

be thought—or felt—in relation to the incapacity of the city and the nation to protect itself. Likewise, our national museum seemed to display all the competence the federal government seemed to lack, and the mere accumulation, organization, and exhibition of the relics represented a return to order, however phantasmatic. But the relics, and the passion for the real they register, should also be located within a paradigm that emerged from the later nineteenth century—most notably at the 1876 World's Fair, which witnessed the first display of the George Washington relics, arranged in a scene where, as the fairgoers put it, the general's spirit seemed all but palpable. The same fair saw the inauguration of the period room. (In the same decade, though in a different culture, Nietzsche complained of the "repulsive spectacle of a blind rage for collecting, a restless raking together of everything that has ever existed.")[46] The idea in these institutions of the palpable was to come close to touching what had been touched: to make some metonymic contact with the dead. Such metonymic contact—in the case of the 9/11 exhibits—focuses on the individual and interpellates the spectating subject in the dimension of affect and memory, not reason and history. The exhibits thus seem to mimic not just the new collecting passions, but also, in some sense, the new materialist turns within the academy, an interest in the microethnographic at the expense of perceiving any totalizing narrative.

But such a materialism could also isolate one object from the Smithsonian that seems like a less predictable object of museal attention: an intact bright green Nokia cell phone, the peculiarity of which might be measured by the fact that the description *of* it is in fact a narrative *about* it (plate 24):

Nokia cell phone

Description: Roe Bianculli-Taylor used this cell phone to learn about the September 11 attacks as she commuted to work on the Long Island Railroad.

Context: The use of cell phones has reduced people's isolation while traveling. New York City commuter Roe Bianculli-Taylor first learned of the attack on the World Trade Center when a fellow passenger on her train began sobbing in the middle of a cell phone call. The woman worked in the World Trade Center and had just learned that it had been hit by an airplane. Quickly everyone in the car who had a cell phone began contacting others to try to learn what was going on. These phone calls, plus a single portable radio, were their only connection to the outside world. As they approached Manhattan, the passengers could see the towers burning through the train window.

There is something uncanny about this "context," or perhaps something simply awkward about anticipating a future audience for what is, among other things, a museum of the present recently passed (which closed in January 2006). But the Nokia certainly seems like a satisfactory emblem of the telephonic culture, and the more general communication culture, that helped to make this event the object of worldwide attention. The trauma for the boy in *Extremely Loud and Incredibly Close* derives not just from the absence of his father but from the presence of the messages his father left on the home voice mail. One character in *Falling Man* describes the way that cell phones "spread the word . . . intimately," with an intimacy that is itself uncanny once the private act of communication becomes public—indeed, attains publicity as the contested telephonic record—gradually released over the course of the next decade.[47]

But the Nokia phone, which seems so ludicrously generic, gains considerable specificity as a displayed object if you imagine it registering, in fact memorializing, some supplement to the Smithsonian's understanding of 9/11. For the phone, produced by the Finnish corporation that became the world leader in mobile phones in 1998, is perhaps the most obvious contemporary marker of the "global," as opposed to the merely "national," given the ubiquity of phones in, say, China, Kenya, and Iraq. This is to say that the phone provides access to a "context" not addressed by the exhibit, and thus underscores the obsolescence of the geographical imagination that informs the display of artifacts (or, say, the geographical obsolescence of this political imagination) even as it might be said to mark the communication technologies that have enabled "globalized informal violence" to be so successful.[48] The phone—not as the object represented in the exhibit, but as an other thing—provides access to a more totalizing theorization of the event.

It is also, more simply, the piece of technology (the machine object) meant to help us in a state of emergency, meant to offer us contact with someone somewhere else. In "The Black Box," a chapter from her *Telephone Book*, Avital Ronnell, reading the "Emergency Care Guide" from the New York Telephone Company (1986), writes that "the telephone puts you at risk, or it figures the language of risk. It produces a safeguard against disaster—*Survival Guide*—which, however, puts you in touch with your own risk."[49] The cell phone is the emergency equipment that makes emergency (theirs or yours) perpetually proximate, lingering there in your pocket or your purse. And finally, the cell phone is perhaps the best example of a different proximity, the newly compressed temporality in which novelty and obsolescence seem simultaneous: your cell phone, like your computer, will not survive the decade . . . unless, that

is, it ends up in a museum. It is this compressed temporality—the emergency of the present becoming the past before it ever seems fully present—that might begin to suggest that this memorializing passion for the real had, and has, no more to do with remembering "them" than it has to do with the longing for someone, somewhere, to remember us.

Coda

A Little History of Light (Dan Flavin/ Gaston Bachelard)

The preceding chapters, I hope, have illustrated (and at times compli-cated or amplified) four overarching points.

The first point is that the object-thing distinction, dislodged from fundamental ontology (Heidegger) and from psychoanalysis (Lacan), can become a way to caption, and a tool for apprehending, the unanticipated force of an object, no matter how banal that object may be (a piece of glass, a pot, a doll, a cell phone). I've been engaged here more by the ontic than the ontological, and by captivations that are more psychological than psychoanalytic, but this formulation itself is meant to retain the productive slippage between those registers. The book as a whole (and not just chapter 6) can be read as a story of object relations in an expanded field—a field where objects are not simply substitutes for human subjects but a field shaped by desires and drives nonetheless. Heidegger (ultimately) understood the Thing as that which gathers deities and mortals, sky and earth. But the thing—indeed the thing that the object at once registers and obscures, as Lacan would have it—is a historical phenomenon; the thingness of an object cannot be abstracted from the field of culture. If I may now extend the work of my title: this book has addressed *other things*—a different thingness—from those things thought by Heidegger and Lacan.

Within the field of culture, objects aren't always what they seem; they don't always behave the way they "should." When Hannah Arendt wrote her influential account of how the object world sustains mankind, she did so in response, not least, to her recognition that certain objects were

destabilizing the human condition. But for Benjamin and the surrealists, acts of deforming and reforming the artifacts of culture held out the possibility of transforming the world tout court. The surrealist object can be dismissed as an amusing distraction; it can also be relished as the product of a materialist imagination, as evidence that the imagined can become concrete. The object's inherent instability, registered intentionally or inadvertently through its misuse, enables it to become a thing; that difference itself marks the prospect that the material structure of society might yet be other than it is. My second point, then, is that the field of culture, including the field of material culture, is most productively seen with a clarifying double vision.

As I made clear at the start of chapter 1, the *thing* in my lexicon names a subject-object relation. When I was working on the earliest of these essays many years ago, I could not have predicted making this third point—that it is not yet time to abandon the subject: that insofar as the current, lively concern with objects becomes a retreat into the object, it fails (just like the retreat into the subject) to provide any purchase on the world (in its Heideggerian sense, shared by Arendt). Getting *over* the subject (as an exclusive concern) does not mean getting *rid* of the subject. A flat ontology—where subject and object, human and nonhuman, animate and inanimate become indistinct—can neither explain the shock of the uncanny nor register the difference between life and death. This is why, within the sort of networks that Bruno Latour has mapped so convincingly, I remain interested in particular phenomenological nodes: in the synapse that emerges from the subject-object, human-unhuman encounter . . . the chemist and a test tube, say, when the test tube breaks . . . even if the thing that emerges from that encounter comes to disclose, above all, the operations of the network in which it takes part. Indeed the object qua thing is (as Latour himself has shown) the best access point to the network.

This book has ranged over an idiosyncratic and disparate assortment of objects, from the exquisite (Achilles' Shield) to the banal (a Charlie McCarthy doll), the simple (a piece of sand glass) to the complex (a cell phone). But that range, of course, is entirely deceptive because, by and large, my attention has been shaped by art and literature and film, which (my fourth point) provide particularly salient sites for redemptive reification: the retrieval of thingness from the blur of habit and the haze of consumer culture. Inhabiting those sites productively requires what Arjun Appadurai dubbed (in the field of anthropology) "methodological fetishism." Only such fetishism makes it clear that literature and the visual and plastic arts exist to teach us about objects and our relation to them: not just about object culture, but about the capacity of an object within any

culture to become something else. Art teaches us that the doubleness of the commodity (its use value and exchange value) prevents us from seeing the doubleness of the object as such (the object and the thing). The casualty of modernity was—and remains—not simply the loss of the character of things, but the loss of the character of other things.

Back in the mid-1990s, when I had settled into this topic of things and published a book on the "material unconscious," I got to know Sidney Nagel, a physicist who works on the physics of everyday life: on coffee stains and tendrils of honey, on small piles of sand and piles of dried peas.[1] He and his team focus on disordered systems; they work to describe the behavior of far-from-equilibrium processes. One day, over lunch, Sid confronted me with an unwelcome query: "If you're interested in things," he said, "I don't see why you're not working on light." To which I responded, "Light? Sid, I'm finding it hard enough to work on toasters."[2]

Taking the end of this book as an occasion to respond to Sid at long last, while having no thoughts to share from the perspective of physics, I want to offer instead a history of light. Yet, ill-equipped to provide a history of light as such—which would have to begin in one cosmogony or another, with some god's declaration, "Let there be light"—I want instead to focus on a historical convergence that occurs in 1961. This is the year when Gaston Bachelard (at age seventy-seven) published his last work, *The Flame of a Candle* (*La flamme d'une chandelle*); and it is the year when the American artist Dan Flavin (at age twenty-eight) jotted down in his notebooks a short poem that adumbrates his future career as one of the best known of the minimalists. The poem reads:

Fluorescent
 poles
 shimmer
 shiver
 flick
 out

 dim

 monuments

 of
 on
 and
 off

 art[3]

The poem speaks to the condition of art as we have come to know it in the museal regime—the condition of art that, far from being autonomous, depends on the systems that provide for its illumination (along with its preservation and organization). The poem anticipates what became Flavin's most famous piece of art, *Diagonal of Personal Ecstasy*, as titled in a preliminary sketch. He soon renamed the work *Diagonal of May 25, 1963 (to Constantin Brancusi)* and exhibited it that year (plate 25). On the one hand, the famous historian and philosopher of science anachronistically (in 1961!) bemoans the loss of candle and lamp light in the modern world, doggedly pursuing his "candle romanticism," as he calls it.[4] On the other, a struggling American artist transposes an increasingly familiar part of the industrial and commercial landscape, fluorescent tube lighting, into a work of art. (By dedicating the work to Brancusi, and not Duchamp, he means to locate the work not within a genealogy of readymades but within the tradition of abstract sculpture.) Engaging Flavin from Bachelard's point of view, my little history simply stages a particular play between matter and form, thingness and objecthood, object and thing, and indeed matter and spirit. The drama speaks both to *materiality* as such (materiality recognized as a process and as a problematic) and to the role of light within that process. Flavin's sculpture calls for a poetics not of fire but of commercial lighting.

Fifty years after this coincidence—the publication of a short book by a philosopher committed to the "imagination of matter" and the composition of a poem that foreshadows the role of tube lighting within the realm of "specific objects"—the art world has been revitalized by objects and the object world, material culture and materiality. Indeed, though there may be "a new fascination with the material stuff of life" across the disciplines, that fascination can hardly hope to keep up with the work going on between and beyond the disciplines—in the arts.[5] Any number of exhibitions make this clear: *Modernstarts: People, Places, Things*; *Thing: New Sculpture from Los Angeles*; *Unmonumental: The Object in the 21st Century*; *What Is a Thing?*; *Specific Objects without Specific Form*; *Seeing Things*.[6] Even if you understand the art world to be (by definition) a world of things, there is no denying this new emphasis and the extensive use of assemblage, reconstellation, and installation to rethink and rework the objects of daily life, not least to stage some character of things as things that has yet to be fathomed, yet to be grasped. The character, say, of other things. Tara Donovan amasses vast numbers of everyday utensils (toothpicks, straws, scotch tape, paper plates, buttons, rubber bands, &c.) and reconstellates them into sublime objects, geomorphic or biomorphic, in which the serial sameness of mass production gets dislodged into a dialectic of quantity and quality. The styrofoam cups gathered and hung

from the gallery ceiling become at once an eerie cloudscape and a hovering cellular organism, both beautiful and threatening (plate 26). Sarah Sze creates immense and obsessively intricate object ecosystems with a heterogeneous array of household products: Q-tips, tea bags, paper towels, fans, thread, lightbulbs, clamps, water bottles, twist ties, dried beans, ladders, houseplants, pencils, desk lamps, sponges, plastic cutlery, duct tape, pens, &c. The movement within the assemblages (which sprawl both horizontally and vertically) and the play of shadow and light seem to signal the vitality of some other network (other than consumption, other than domesticity), in some new scale, through which these bits and pieces attain a kind of mesmerizing coherence (plate 27). Dan Peterman, practicing a reconstitutional archaeology, converts industrial detritus into newly useful objects: he transforms plastic waste into tables, closed-cell foam into rooms, shopping carts into chairs, and (in an act and allegory of recycling) old dumpsters into kiosks. In *Excerpts from the Universal Lab (Travel Pod 1, 2, and 3)* he has gathered discarded bits of technology, preserving them in time capsules that seem to hold the promise for some future life (plate 28). And the practice of painting seems no less drawn by the materialist experiment. Marie Krane Bergman, having made a career of painting nearly monochromatic large canvases (composed in fact of thousands of distinct, individuated marks of imperceptibly different hues of acrylic), has released paint from the canvas support, conducting "pours" that are subsequently scraped off of a flat surface and hung on a nail, turning painting into the "matter-movement" of paint that continues to alter its shape, however slightly, as it hangs. She now drips paint down hundreds of strings that are hung from the ceiling to form broad columns; she licenses her paintings to assume three-dimensional object form while still asserting themselves as paintings (plate 29). Whether it is Theaster Gates amassing the refuse from a construction site (fragments of lath and plywood) into monumental thrones, or Danh Vo distributing fragments of a replicated monument (the Statue of Liberty), or Ai Weiwei lining up row after row of artifacts (glass bubbles or ceramic pots), the object world has summoned artists to its attention. Or: artists at work both *in* that world and *on* that world have shown how reconfiguring the artifactual environment can provide sensory-affective access to reconfiguration—difference—as such.

A quiet, straightforward, and patently sentimental version of these dynamics could be seen in Michael Brown's *An Object Is Just Material*, his 2009 exhibition at the Yvon Lambert Gallery in New York (plate 30). Like much contemporary art, this work depends on the magic of refabrication: in this case the conversion of vinyl records into household tools. He melts down stacks of records and recasts the molten vinyl into

forms such as broom handles, mop handles, fan blades, buckets. More-over, he chooses iconic records—by Aretha Franklin, by Elvis, by the Ramones—part of the collection he began to amass as a teenager. What-ever sentiment he means to evoke, the interest of the project lies in his demediation of the acoustical medium and his remediation of it as "just material"—the point being that the substance from which objects are made (the wood of a table, the marble of a column, the ceramic of the pot) has always had some other life in some other object form.[7] The exhibit also involves the most casual spectator in a dialectic of form and matter, for the degree to which you care about the vinyl of the handle, you cease to care about (or even to see) the mop itself; the degree to which you ex-perience the mop as a mop, its materiality is effectively beside the point. Hegel would say that the object is the medium through which various properties—blackness, roundness, length—congeal. No less, the vinyl is the medium through which the object congeals. Object and material tug at one another despite their mutual support, the fact that they medi-ate each other. Whatever: an object is not just material because material alone never amounts to an object. Indeed, if you believe Levinas, then material can be disclosed—or *exposed*—only at the expense of the object that, in his trope, is clothed with form.[8]

The imagination of matter as Bachelard pursued it (in a kind of alter-nating step with his historical epistemology) lay foremost in poetry, but not only there. He understood Van Gogh's use of color to be "stimulat-[ing] matter sufficiently to turn it into a new light"; "things are no longer simply painted or drawn," for there is instead "a *generation* of new mat-ter."[9] When he turned his attention to Eduardo Chillida, thinking about the monumental works in forged iron, Bachelard considered the artist to be a blacksmith dreaming of "a kind of sculpture that would stir up matter in its innermost being." As though casting Chillida in the role of Hephaestus, the philosopher describes him creating a "cosmos of iron." But whereas the vibrant matter of Achilles' Shield serves to animate the world of men and women, in Chillida's work the material draws atten-tion only to itself, to its own rights and its own agency. "Iron, like paint, has the right to originality," Bachelard writes; "Chillida evokes a dream of iron set free"; in all his works "iron asserts initiatives of its own."[10] Though art may have once served to grant its spectators access to one or another spiritual truth, it was summoned by twentieth-century philoso-phy to provide access to truths about matter and materiality.

And yet Bachelard, in *The Flame of a Candle*, writes against matter. He writes in favor of the flame that "liberates the forces of light impris-oned in matter."[11] The candle or the lamp provides in the flame "a being that lacks substance; in opposition to gross matter, it purifies matter."

Intimately tracking Novalis, Bachelard argues that "fire receives its real existence only at the conclusion of the process of becoming light, when through the agonies of the flame, it has been freed of all its materiality" (43). The flame achieves its significance by attaining the supposedly immaterial status of light. Insubstantial yet strong, the flame of the candle provides an "invitation to dream"; "long ago, in a long ago even dreams themselves have forgotten, the flame of a candle made wise men think" (13, 9, 13). But the curtain has dropped on such a drama, which Bachelard understands as the inevitable drama of everyday meditation, of reverie before the flame. "Ours is no longer the era of tapers and candle sticks," he writes (4). "Dreamer of words that I am, the word 'lightbulb' makes me laugh. Who can say 'my electric light bulb' in the same way that he once said 'my lamp.' The electric light bulb will never provoke in us the reveries of this living lamp which made light out of oil. We have entered the age of administered light. Our only role is to flip a switch. We can no longer become, with legitimate pride, the subject of the verb 'to light'" (64).

But imagine yourself as the guard, in one or another museum of modern art, who is responsible every morning (at 9:45) for walking up to the Dan Flavin light installation (*untitled [to Henri Matisse]*, 1964) and turning it "on." Your anticipation and the legitimate pride you might take — as the subject of the verb "to light" — convey something of the stakes of Flavin's transposition of administered light into art. Flavin himself worked as a guard at New York's MoMA, where he met Sol LeWitt and other minimalists. In 1961, when he was working as a guard for the American Museum of Natural History in New York, he began making sketches for sculptural constructions that included electric lights. He wrote the poem then. He stumbled upon the idea of a diagonal — "a common eight foot strip with fluorescent light of any commercially available color" — in the midst of making his series of icons, monochromatically painted masonite squares to which he affixed lightbulbs, fluorescent or incandescent. In his studio he tried out the other experiment he had sketched: "The radiant tube and the shadow cast by its supporting pan," he wrote, seemed "iconic enough to hold alone It seemed to sustain itself directly, dynamically, dramatically, on my workroom wall — a buoyant and insistent gaseous image which, though brilliant, somehow betrayed its physical presence into approximate invisibility."[12] Within the quotation, certain words and phrases — "system," "gaseous image," "physical presence," and "approximate invisibility" — suggest how much more significant his insight was than that suggested by early commentators, who simply focused on the simplicity with which Flavin had appropriated the unadorned fixtures, as though this were a Duchampian gesture once again.[13]

Instead, the act of appropriation generates a kind of *misuse value* that is multidimensional. Given a new role, the fixture is at once an object and an other thing that foregrounds the thingness of administered light — no longer light that is ignored while being used as equipment and *seen through* (while you stare at your work on the bench or the desk, or stare at the merchandise in a department store, or talk to a group around a conference table) but light set free, its qualities (color, intensity, breadth) no longer serving in behalf of something else. When, in book 6 of *The Republic*, Socrates works at differentiating the visible from the intelligible, he explains that seeing (unlike hearing, for instance) depends not just on vision and the visible, but on light: "Surely sight may be present in the eyes and its possessor may try to use it, and colors may be present in things; but unless a third kind of thing is present, which is naturally adapted for this specific purpose, sight will see nothing and the colors will remain unseen."[14] Light, relegated to being this "third kind of thing," the thing that manifests things in the visible, reappears in Flavin's work asserting itself as that which needs to be seen.[15]

This is especially true of the colored light with which he continued the project. In *Pink out of a corner (to Jasper Johns)* (1963) (plate 31), it is less the object than the light cast by the object — the cast light that assumes extent and shape while remaining essentially formless — that commands attention. In his response to the Vietnam War, *Monument 4 those who have been killed in an ambush (to PK, who reminded me about death)* (1966) (plate 32), Flavin arranges three tubes to flood one corner of the exhibition space with the color of blood or the color of wartorn sky; he aggressively invites some recognition of proximity, some step within the color field, some willingness to share the stain of calamity. In 1968 he began to install room-size environments, at times seeming to extend space, more often dividing space and thus creating new space. In *untitled (to you, Heiner, with admiration and affection)* (1973), a wall of 4 × 4 foot modules segregates a room, preventing access from one side to the other. The green light infuses the whole space while the infrastructure denies the wholeness of the space (110 feet long when it spanned the atrium on the National Gallery in Washington in 2004). The concreteness of the infrastructure, though, never denies light its own materiality. Flavin has granted the medium opacity — as a thing not to be *looked through* but to be *looked at*, the way a philosopher might stare at the flame of a candle.

In 1949, in *Applied Rationalism (Le rationalisme appliqué)*, Bachelard used the electric lightbulb as his example of an abstract-concrete object, the kind of object in which two distinct ontologies of physical reality converge, one grounded in science and the other grounded in "unreflective common sense." A barely noticed part of our quotidian lives, the light-

bulb would have been an object of wonder to Newton, something incomprehensible. The object lives a double life, irreducible to its phenomenological relation to a subject because it is also an object of scientific knowledge, constituted in a network of theoretical relations.[16] Whether or not Bachelard's choice of the lightbulb was determined by the duality of light itself—the wave-particle duality (first described by Einstein) of the electromagnetic radiation that we call visible light—in Flavin's project the abstract-concrete status of the lightbulb resurfaces as the oscillation between the material and (what you might find yourself calling) the spiritual.

He emphasizes the concreteness of the object by working with a relatively new, cheap, and widely recognized component of postwar life in America. While the General Electric Company of England (Osram-GEC) first made fluorescent light in a practical form in 1934, it was the American GE corporation that first engineered a commercially viable product in 1938. Because of its longevity, efficiency, and minimal surface luminance (which diminishes glare), fluorescent light came to dominate institutional spaces (factories and schools) by the end of the 1970s, but in 1960 it was still a relatively new, if widely used, invention. Flickering remained (and remains) a problem. It is a characteristic shared with the candle light that Bachelard describes, fascinated as he is by the twitch of the flame. Because the tubes remain so crude, the light sculpture evokes the platform of the medium in its broadest sense: the material support that is not just the fixture but also the material network, the electrical grid. Beyond the perceptual experience, then, you are incorporated into the broader system.

And yet, for all their obdurate concreteness and their embeddedness within the network, Flavin's sculptures evade their object forms. Indeed, they literalize the evasion that constitutes the thingness of objects in both the physical and the metaphysical register—the light spreading far beyond the object (that is its source), and the light serving a symbolic function, perhaps serving as the symbol of symbolism itself.[17] Flavin told Carl Andre that his work was inspired by Ralph Ellison's *Invisible Man* (1952), where, in the prologue, the unnamed narrator describes his life in an abandoned basement, which he has lit with 1,369 lightbulbs from the Monopolated Light Co.: "I doubt if there is a brighter spot in all New York than this hole of mine." If the location in New York and the protagonist's obsessive installation are clearly germane to Flavin's understanding of his project, so too is the simple symbolic potency of light itself: "Light is the truth."[18] And despite Flavin's denial that there is anything specifically spiritual about his work, reviews of the Flavin retrospective at the National Gallery (Washington) in 2004 could not resist documenting the

spiritual penumbra. Writing for the *New York Times*, Michael Kimmelman insisted that "spirituality and mystery are precisely what many people extract from his work."[19] Writing for *Art Forum*, Caroline Jones concentrated on the dialectic by which, through the most austere technique, "'aura' seems to pulse directly from his fluorescent tubes."[20] While the title of the icon series straightforwardly evokes a metaphysical dimension of the sculpture, the subsequent work is bold and bright enough to require no titular assistance. "Light was *light* afterall," Jones writes, "and it could be literalized and ironized while still covertly holding onto its philosophical and spiritual connotations. In the place of uplift, sublimity, and glory, in the spot where Bernini put his God rays, Flavin screwed his readymade bulbs" (158). Through this dialectic of the industrial and the spiritual, Dan Flavin reenchants the world of the present. You could say of the tube what Bachelard says of the flame: that it illustrates "every form of transcendence" (41). It is as though Flavin's experiment came into being precisely to arrest Bachelard's historiography—to insist that administered light has a romance of its own.

But this novel enchantment, spirituality, romance—these are now contingent; they depend on the electrical grid. The vitalism depends on the switch. Flavin underscores how the permanence of art, as Hannah Arendt described it, depends on the permanence of attention, of preservation, on Heidegger's "preservers."[21] Art as it is customarily known in the modern era is not autonomous; its being depends on electricity. It is the occasional, momentary flickering of the fluorescent tube that manifests the fragility of that permanence, and of that being. Writing about Flavin's work as part of the "new monuments" in 1966, Robert Smithson understood that rather than "causing us to remember the past," the works "cause us to forget the future," emphasizing the present, with artists deploying materials of the present day, no one more obviously so than Flavin, who purchased his materials for *Monument 7 for V. Tatlin* (1966–69) at the Radar Fluorescent Company. In a barely comprehensible flourish, Smithson writes that "Flavin turns gallery-space into gallery-time," making us ask "Where is the time?" He goes on to say that "Flavin's destruction of classical time and space is based on an entirely new notion of the structure of matter."[22] What is this structure other than the dependence of the work on the network that supports it? If the literalist objecthood of the diagonal amounts to the fixture and luminous tube itself, what exceeds the object (what, in Flavin's words, "betrayed the object's physical presence") is, on the one hand, the spread of light and the spread of its spiritual connotations, and, on the other, the electrical system on which its vitality depends. Considered not as an object of perception but as a philosophical object, the *Diagonal of May 25* shares just a hint of

what Bachelard senses in the flicker of the flame: "Everything trembles when the light trembles" (22). This is art that, far from insisting on its autonomy, dramatizes the eventfulness of museal materiality: the world of *no touching* where sight alone secures the very existence of the work of art—on and off, off and on.

Notes

1 Homer, *The Iliad*, trans. Robert Fitzgerald (New York: Farrar, Straus and Giroux, 2004), 444. Unless otherwise stated, references to the poem will be to the Fitzgerald translation, cited by book and line number.

2 In Richard Neer's dazzling account of the "effects of sculpture" in ancient Greece, he turns to this passage from Homer as a way to address the effect of wonder: "The audience sees the depiction and its material at once, and that simultaneity, that twofoldedness, is cause for wonder (*thauma*)." *The Emergence of Classical Style in Greek Sculpture* (Chicago: University of Chicago Press, 2010), 59. In the terms I establish in this book, you could call that "twofoldedness" the oscillation between the object and the other thing.

3 James A. W. Heffernan, *Museum of Words: The Poetics of Ekphrasis from Homer to Ashbery* (Chicago: University of Chicago Press, 1993), 3, emphasis in the original.

4 Paul Friedländer, quoted and translated by Andrew Sprague Becker, *The Shield of Achilles and the Poetics of Ekphrasis* (Lanham, MD: Rowman & Littlefield, 1995), 10.

5 G. E. Lessing, *Laokoon: On the Limits of Painting and Poetry*, trans. E. A. McCormick (Baltimore: Johns Hopkins University Press, 1984), chs. 16–19, quotations on 99.

6 As Heffernan argues, "Exactly what Hephaestus wrought on the shield is ultimately impossible to visualize. . . . Homer's account of the shield is an extreme specimen of 'notional ekphrasis'—the representation of an imaginary work of art. All we can see—all that actually exists in this passage—is Homer's language, which not only rivals but actually displaces the work of art it ostensibly describes and salutes." *Museum of Words*, 14.

7 Andrew Becker, *Shield of Achilles*, 21.

8 Heffernan, *Museum of Words*, 4–5.

9 W. J. T. Mitchell, *Picture Theory* (Chicago: University of Chicago Press, 1994),

178. I should add that Mitchell has gone on to address the dynamism of other objects in *What Do Pictures Want: The Lives and Loves of Images* (Chicago: University of Chicago Press, 2005), part 2, "Objects," 111–200. Elsewhere, with regard to the *Iliad*, the elision of the object qua object can be gleaned quickly from an uncertainty that approximates an uncertainty that concerns me here: "One is not sure whether the pictures on the shield are static or alive," Cedric Whitman writes, as though the shield were canvas. *Homer and the Homeric Tradition* (Cambridge, MA: Harvard University Press, 1958), 205.

10 E. T. A. Hoffmann, "Der Sandmann" (1816); Fritz Lang, *Metropolis* (1927); Philip K. Dick, *Do Androids Dream of Electric Sheep* (1968); Disney/Pixar, *WALL-E* (2008). For an extensive genealogy, see George L. Hersey, *Falling in Love with Statues: Artificial Humans from Pygmalion to the Present* (Chicago: University of Chicago Press, 2008), ch. 8, "New Races of Automata."

11 Becker, *Shield of Achilles*, 80.

12 George Chapman, *Achilles Shield* (1598), reprinted in *Chapman's Homer: The Iliad*, ed. Allardyce Nicoll (Princeton, NJ: Princeton University Press, 1998), 543. Subsequent references to Chapman's translations, made in the text, will be to this edition.

13 Georg Simmel, "Rodin" (1911), translated and abridged as "Rodin's Work as an Expression of the Modern Spirit" in *Rodin in Perspective*, ed. Ruth Butler (Englewood Cliffs, NJ: Prentice-Hall, 1980), 128. To compensate for my implicit simplification here, let me direct attention to an important account of Simmel's "distance from the vitalist philosophy of his time": Todd Cronan, "Georg Simmel's Timeless Impressionism," *New German Critique* 36.1 (Winter 2009): 83–101. In Simmel's reading of Rodin, the movement animating the sculpture is certainly "spiritual," and it is specified as the movement of modernity. The movement is in no sense narrative, as Rosalind Krauss has argued at length. See *Passages in Modern Sculpture* (Cambridge, MA: MIT Press, 1981), 7–38. Indeed, reading Krauss's account of Rodin's *Gates of Hell* might be the best way of appreciating how Achilles' Shield denotes action, but not action that resolves into coherent narrative form.

14 Gilles Deleuze and Félix Guattari, *A Thousand Plateaus*, trans. Brian Massumi (Minneapolis: University of Minnesota Press, 1987), 410 (hereafter cited parenthetically).

15 For the French, see Gilles Deleuze and Félix Guattari, *Capitalisme et Schizophrénie 2: Mille Plateaux* (Paris: Les Editions de Minuit, 1980), 507.

16 Krauss, *Passages in Modern Sculpture*, 5. On Henry Moore's vitalism, see chapter 4 of the current volume.

17 Tony Smith, "Talking to Tony Smith," *Artforum* 5 (December 1966): 14–19. Smith is quoted by Michael Fried on his way to accusing minimalism of a "latent or hidden naturalism, indeed anthropomorphism," that distinguishes it from the "authentic art of our time." "Art and Objecthood" (1967), in *Art and Objecthood* (Chicago: University of Chicago Press, 1998), 157, 167. On Fried and what I am designating the other thing, see chapter 3 of the current volume.

18 Within the argument of the present book I do not include nature, *phusis*, within the "object world," generally sustaining a distinction between world and earth from Heidegger and Arendt, the significance of which becomes clear, I trust, in chapter 1. For attention to nature that aligns with the kind of work I mean to accomplish here, see Mary Jacobus, *Romantic Things: A Tree, a Rock, a Cloud* (Chicago: University of Chicago Press, 2012).

19 Stanley Cavell uses the phrase to caption the inherent strangeness of the human in "The Uncanniness of the Ordinary," in *In Quest of the Ordinary: Lines of Skepticism and Romanticism* (Chicago: University of Chicago Press, 1988),

153–78. He has borrowed the phrase from Heidegger, who, in "The Origin of the Work of Art," insists that "at bottom, the ordinary is not ordinary; it is extra-ordinary, uncanny." *Poetry, Language, Thought*, trans. Albert Hofstadter (New York: Perennial Classics, 2001), 53.

20 "Commodities are simply congealed quantities of human labour." Karl Marx, *Capital*, trans. Ben Fowkes (New York: Penguin, 1991), 1:141.

21 *Iliad* 18.436–38, in *Chapman's Homer*, 384. Compare the 1598 translation: "In it was earthe's greene globe, the sea and heaven,/Th'unwearied Sunne, the Moone exactly round/And all the stares with which the skie is crownd" (554). And compare the Fitzgerald translation, cited above.

22 Heidegger, who pursues this etymology, might say that "in thinging" the Shield "stays earth and sky, divinities and mortals." "The Thing," in *Poetry, Language, Thought*, 75. Bruno Latour deploys the etymology to different ends in "Why Has Critique Run Out of Steam?: From Matters of Fact to Matters of Concern," in *Things*, ed. Bill Brown (Chicago: University of Chicago Press, 2004), 156–62. I have used the etymology as a way of discussing contemporary assemblage practice in "Redemptive Reification (Theaster Gates, Gathering)," in *Theaster Gates: My Labor Is My Protest*, ed. Honey Luard (London: White Cube, 2013), 36–40.

23 Michel Serres explains that the quasi-object "is more a contract than a thing" in *Genesis* (Ann Arbor: University of Michigan Press, 1995), 87–88. See also his chapter "The Theory of the Quasi Object," in *The Parasite*, trans. Lawrence R. Schehr (Baltimore: Johns Hopkins University Press, 1982), where, in conjunction with "quasi-subject," the term helps to signal the perpetual transfer between the object and subject positions. Latour adopts the term and uses it extensively. The prehistory of the term resides in the work of Gaston Bachelard (with whom Serres studied), with his notion of the subject-object hybrid, which I deploy in chapter 10.

24 Bruno Latour, *Pandora's Hope: Essays on the Reality of Science Studies* (Cambridge, MA: Harvard University Press, 1999), 305 (hereafter cited parenthetically as *PH*). See also, for a nonsemiotic, action-based approach to art, Alfred Gell, "'Things' as Social Agents," in *Art and Agency: An Anthropological Theory* (New York: Oxford University Press, 1998), 17–19.

25 His narration of Frédéric Joliot's work on fission (1939–40) shows how the history of science can hardly be sequestered from other histories, how national independence and nuclear chain reaction came to look like one and the same achievement, how "politics, law, economics, institutions, and passions" become utterly integrated with "ideas, principles, [and] knowledge procedures" (*PH*, 84). The history of fission in France is a history of the "imbroglio of things and people": things such as uranium oxide and heavy water, people such as industrialists, scientists, and ministers of war (*PH*, 87). And as for the American question of whether guns kill people, Latour insists that the question as posed makes no sense: neither gun nor person is what the question takes each to be. "You are another subject because you hold the gun; the gun is another object because it has entered into a relationship with you" (*PH*, 179).

26 Bruno Latour, *Reassembling the Social: An Introduction to Actor-Network-Theory* (New York: Oxford University Press, 2005), 82.

27 Clifford Geertz, *The Interpretation of Cultures* (New York: Basic Books, 1973), 208–9; and see 213n30. See also *Local Knowledge: Further Essays in Interpretive Anthropology* (New York: Basic Books, 1983), chs. 1, 2. The subsequent impact of Geertz on the study of literature—above all on new historicism—would thus seem somewhat circular.

28 Jane Bennett, *Vibrant Matter: A Political Ecology of Things* (Durham, NC: Duke University Press, 2010), 31, 63; Lorraine Daston, introduction to *Things That Talk: Objects Lessons from Art and Science*, ed. Daston (New York: Zone, 2004), 9 (quotation), 11.

29 Miguel Tamen, *Friends of Interpretable Objects* (Cambridge, MA: Harvard University Press, 2001), 117.

30 Bruno Latour, *We Have Never Been Modern*, trans. Catherine Porter (Cambridge, MA: Harvard University Press, 1993), 142.

31 The quotations are from Bruno Latour, "Where Constant Experiments Have Been Provided," interview, *Arch* 2 (Spring 2009), http://artsci.wustl.edu/~arch word/interviews/latour/interview.htm. For an account of how literature exposes the suppressed dynamics of sociology (including Latour's rethinking of the social), see David Alworth, "Supermarket Sociology," *New Literary History* 41.2 (Spring 2010): 301–27.

32 W. H. Auden, "The Shield of Achilles," in *Collected Shorter Poems, 1927–1957* (New York: Random House, 1967), 294.

33 Maurice Merleau-Ponty famously described the body as a "thing among things," but he did so as a way of addressing how the thinking subject differentiates itself from the world of things: "As a meditating Ego I can clearly distinguish from myself the world and things, since I certainly do not exist in the way in which things exist. I must even set aside my body understood as a thing among things, as a collection of psycho-chemical processes." *Phenomenology of Perception* (1945), trans. Colin Smith (London: Routledge, 2002), xiv. Subsequently, though, Merleau-Ponty emphasized the elusiveness of any such differentiation. See "The Intertwining—The Chiasm" (1961), in *The Visible and Invisible*, trans. Alphonso Lingis (Evanston, IL: Northwestern University Press, 1968), 130–55.

34 See Wanda Corn, *The Great American Thing: Modern Art and National Identity, 1915–1935* (Berkeley: University of California Press, 2001), 73–75.

35 One could go on to address (as Corn does) the humanoid, madonnaesque outline of the tipped urinal, and then to imagine that outline (as she does not) as the mark of the object as actant, but that would require a more complex argument than I am willing to make here.

36 Ezra Pound, *Guide to Kulchur* (New York: New Directions, 1970), 8.

37 Modernists must thus be sharply distinguished from the moderns, as Bruno Latour has described them in *An Inquiry into Modes of Existence: An Anthropology of the Moderns*, trans. Catherine Porter (Cambridge, MA: Harvard University Press, 2013). As will be clear across the following pages, I am often ferreting out what could be understood as fragments of a counterhistory to the history of modernity, thus fragments of a prehistory of the current interest in the vitality of matter and object agency, in dismissing the subject-object divide, and in effacing distinctions between the human and nonhuman. It will be no less clear that I remain (strongly) ambivalent about that current interest—an ambivalence clarified, I hope, by chapter 5.

38 Bachelard also plays a crucial role in chapter 3.

39 Georg Lukács, *History and Class Consciousness: Studies in Marxist Dialectics*, trans. Rodney Livingstone (Cambridge, MA: MIT Press, 1971), 92; Georges Bataille, *The Accursed Share: An Essay on General Economy*, 3 vols., trans. Robert Hurley (New York: Zone Books, 1988), 1:136, 129.

40 For an elaboration of the concept (and its distinction from the literary unconscious imagined by Pierre Macherey and Fredric Jameson), see Bill Brown, *The Material Unconscious: American Amusement, Stephen Crane, and the Economies of Play* (Cambridge, MA: Harvard University Press, 1996), 13–19.

41 See Bill Brown, *A Sense of Things: The Object Matter of American Literature* (Chicago: University of Chicago Press, 2003), 13–14.

42 Bill Brown, introduction to *Things*, 13. In this book edition of the special issue, the introduction has been slightly revised; it also includes additional essays — by Bruno Latour, Jessica Riskin, Charity Scribner, and Alan Trachtenberg.

43 On art history, see Jennifer Roberts, *Transporting Visions: The Movement of Images in Early America* (Berkeley: University of California Press, 2014); on anthropology, see Webb Keane, *Signs of Recognition: Powers and Hazards of Representation in an Indonesian Society* (Berkeley: University of California Press, 1997), 32; on history, see Leora Auslander, "Beyond Words," *American Historical Review* 110.4 (October 2005): 1015–45; on philosophy, see Graham Harman, *Tool-Being: Heidegger and the Metaphysics of Objects* (Chicago: Open Court, 2002).

44 Colin Renfrew, *Figuring It Out* (London: Thames and Hudson, 2003), 185–86. I hasten to add that, in direct response to such claims, a host of scholars have been at work addressing various materialities of the digital domain.

45 As one Boeing news release put it in 2005, field experiments showed that "once alerted to the first threat, the X-45As *autonomously* determined which vehicle held the optimum position, weapons and fuel load to properly attack the target." Boeing, "Boeing X-45As Reach 50th Flight with First Simulated Combat Mission" (February 14, 2005), www.boeing.com/news/releases/2005 /q1/nr_050214s.html (my emphasis). Though Boeing no longer hosts this press release on its website, an archived version is available: http://web.archive.org /web/*/http://www.boeing.com/news/releases/2005/q1/nr050214s.html.

46 P. W. Singer, *Wired for War: The Robotic Revolution and Conflict in the 21st Century* (New York: Penguin, 2009).

47 See Michel Serres, *Le retour au contrat naturel* (Paris: BNF, 2000). In this key, of course, nature, *phusis*, returns and the world-earth distinction is undone, as Hannah Arendt anticipated. See chapter 5.

48 Geoffrey Harpham, "Things and Theory," *Raritan* 25.2 (Fall 2005): 144.

49 Frank Trentmann, "Materiality in the Future of History: Things, Practices, and Politics," *Journal of British Studies* 48 (April 2009): 283.

50 See, for instance, Steven Henry Madoff, "Why Curator Carolyn Christov-Bakargiev's Documenta May Be the Most Important Exhibition of the 21st Century," *Blouin Artinfo*, July 5, 2012, www.artinfo.com/news/story/811949 /why-curator-carolyn-christov-bakargievs-documenta-is-the-most-important -exhibition-of-the-21st-century. On object oriented philosophy, see chapter 5.

51 Don DeLillo, *Underworld* (New York: Simon & Schuster, 1997), 83 (hereafter cited parenthetically).

52 The scene has been imagined in relation to the "boneyard" for decommissioned planes under the auspices of the AMARC (Aerospace Maintenance and Regeneration Center).

Chapter One

1 Don DeLillo, *Falling Man* (New York: Scribner, 2007), 5.

2 Martin Heidegger, *What Is a Thing?*, trans. W. B. Barton Jr. and Vera Deutsch (Chicago: Henry Regnery, 1967), 4–5, quotation on 7. Within this chapter I make use of a more literal translation of the German title, *Die Frage nach dem Ding*. In his prefatory note, Heidegger explains that the work was presented as a course of lectures in 1935–36 entitled "Basic Questions of Metaphysics" (vii).

3 Jean-Paul Sartre, *Being and Nothingness: An Essay on Phenomenological*

Ontology, trans. Hazel E. Barnes (1943; New York: Philosophical Library, 1956), 8–9.

4 Maurice Merleau-Ponty, *Phenomenology of Perception* (1945), trans. Colin Smith (London: Routledge, 2002), 353.

5 John Mullarkey, "'The Very Life of Things': Thinking Objects and Reversing Thought in Bergsonian Metaphysics," his introduction to Henri Bergson, *Introduction to Metaphysics*, trans. T. E. Hulme (London: Palgrave, 2007), xxviii; Bergson, *Introduction*, 40.

6 Alfred North Whitehead, *Adventures of Ideas* (1933; New York: Free Press, 1961), 176.

7 Jean Piaget, *The Construction of Reality in the Child* (1954; London: Routledge, 2001), xii, 3–96 (hereafter cited parenthetically). For his account of the process, see 3–96.

8 Apprehended perhaps as part of a me-not-me network—"sustaining relations of interdependence with the universe"—but one that depends on distinctions, xii.

9 William James, *Essays in Radical Empiricism* (Lincoln: University of Nebraska Press, 1996), 4. See also ch. 2, "The World of Pure Experience," 39–91; and ch. 3, "The Thing and Its Relations," 92–122.

10 Roland Barthes, *Camera Lucida: Reflections on Photography*, trans. Richard Howard (New York: Farrar, Straus and Giroux, 1981), 49, 55. In general, then, Barthes's exquisite distinction between what we are supposed to see and what instead arrests our attention is a distinction that applies to our interaction with the object world no less than our interactions with the photographic image. To press this point too far, though, would be to deny Barthes the specificity of his personal encounters.

11 Alphonso Lingis, *The Imperative* (Bloomington: Indiana University Press, 1998), 74, 121, 77. Among its many accomplishments, Lingis's book is an extended, aggressive, and beautiful refunctioning of the imperative in Kant. See, for instance, 64.

12 For Hegel, of course, "thinghood" names the "medium" that keeps the properties of the thing together. His useful example of the object showing itself to be a *"thing with many properties"* is salt: "The salt is a simple Here and at the same time manifold: it is white, and *also* pungent, *also* cubicle in shape, *also* of specific weight, and so on." As he goes on to say, "I must take the objective entity as a *community (Gemeinschaft)*." See G. W. F. Hegel, "Perception: Or Things and Their Deceptiveness," in *The Phenomenology of Mind*, trans. J. B. Baillie (New York: Harper, 1967), 161–78.

13 The same can be said for any value: symbolic value ("This was my grandfather's chair"), sign value ("You notice that this is a one-of-a-kind Philippe Starck ensemble"), or price ("$15,000").

14 Such a thing-theoretical emphasis on ambiguity *and* particularity has enabled Wendy Chun to characterize "software as a thing [that is] inseparable from the externalization of memory, from the dreams and nightmare of an all-encompassing archive that constantly regenerates and degenerates, that beckons us forward and disappears before our very eyes." Wendy Hui Kyong Chun, *Programmed Visions: Software and Memory* (Cambridge, MA: MIT Press, 2011), 11.

15 Lucien Goldmann, *Lukács and Heidegger: Towards a New Philosophy*, trans. William Q. Boelhower (London: Routledge & Kegan Paul, 1977), ch. 2, 27–39; Martin Heidegger, *Being and Time*, trans. John Macquarrie and Edward Robinson (New York: Harper & Row, 1962), quotations on 72 (hereafter cited parenthetically as *BT*). Goldmann also points to the final page of *Being and Time*, where Heidegger asks, "What is the positive structure of consciousness which sees to it that reification is not adequate to it?" (or, in the standard English

translation, "What *positive* structure does the Being of consciousness have, if reification remains inappropriate to it?" [487]). In the brief intellectual and institutional history with which Goldmann begins the book, he notes the impact of Husserl on Lukács, who, along with Jaspers (and of course Heidegger), studied with him. The Lukács quotation appears in *History and Class Consciousness: Studies in Marxist Dialectics*, trans. Rodney Livingstone (Cambridge, MA: MIT Press, 1971), 92.

16 Indeed, phenomena frequently surface in Heidegger's work, though they do so within a resolute emphasis on integration, as when he objects to any thing-concept according to which a thing is the unity of distinct sensations: but "we hear the storm whistling through the chimney," he writes, "we hear the three-motored plane, we hear the Mercedes in immediate distinction from the Volkswagen." No sound can be disaggregated from its aural drama nor extracted from the abiding intimacy of things. "The Origin of the Work of Art," in *Poetry, Language, Thought*, trans. Albert Hofstadter (New York: Perennial Classics, 2001), 25 (hereafter cited parenthetically as "WA").

17 In Jacques Derrida's formulation of the limits of Husserl's project, he emphasizes that phenomenology "is always phenomenology of perception": contrary to what it "has tried to make us believe, contrary to what our desire cannot fail to be tempted into believing, the thing itself always escapes." *Speech and Phenomena and Other Essays on Husserl's Theory of Signs*, trans. David B. Allison (Evanston, IL: Northwestern University Press, 1973), 104.

18 To be concerned (*besorgen*) includes the sense of procuring, providing for, and looking after; it is an involvement, Heidegger dilates, that can be understood as "having to do with something, producing something, attending to something and looking after it, making use of something, giving something up and letting it go, undertaking, accomplishing, evincing, interrogating, considering, discussing, determining" (*BT*, 83).

19 This is to say that the thing necessarily disappears from *theory*, given that theory is a view that requires distance. For Alfonso Lingis's different account of the hammer and hammering, see *Imperative*, 75.

20 As he epigrammatically puts it in the "Work of Art" essay, "the more handy a piece of equipment is, the more inconspicuous it remains" ("WA," 63).

21 The standard English translation appears as Martin Heidegger, *What Is a Thing?*, trans. W. B. Barton Jr. and Vera Deutsch (Chicago: Henry Regnery, 1967) (hereafter cited as *WT*). The German appeared as *Die Frage nach dem Ding* (Tübingen: Max Niemeyer Verlag, 1962).

22 I return to this episode at the conclusion of chapter 7.

23 Martin Heidegger, "The Thing," in *Poetry, Language, Thought*, 178 (hereafter cited parenthetically as "T").

24 Hannah Arendt, *The Human Condition* (Chicago: University of Chicago Press, 1958), 137. See chapter 5. To track Heidegger's insistence about how this standing against—*Gegenstand*—compromises any search for the thing, see *WT*, 137, 140, 184, 190.

25 Georg Simmel, "The Handle," trans. Rudolph H. Weingartner, in *Georg Simmel, 1858–1918: A Collection of Essays, with Translations and a Bibliography*, ed. Kurt H. Wolff (Columbus: Ohio State University Press, 1959), 267–75.

26 Ernst Bloch, *The Spirit of Utopia*, trans. Anthony Nassar (Stanford, CA: Stanford University Press, 2000), 2, 7–9.

27 Theodor Adorno, "The Handle, the Pot, and Early Experience," *Notes to Literature*, ed. Rolf Tiedeman, trans. Shierry Weber Nicholson (New York: Columbia University Press, 1992), 2:218. In contrast, Adorno was skeptical of the "cult of things" that he associated above all with Rilke. He considered Rilke's effort "to bring the alien objects into subjectively pure expression" to be a thoroughly

unconvincing compensation. The "aesthetic weakness" of the poet's mixture of "religion and decorative handicraft" lies in the fact that "the genuine power of reification" cannot be "painted over with a lyric aura." Theodor Adorno, "Lyric Poetry and Society," trans. Bruce Mayo, in *Critical Theory and Society*, ed. Stephen Bronner and Douglas Kellner (London: Routledge, 1989), 158. I do not mean, of course, to be endorsing Adorno's dismissal of Rilke's poetry; my interest lies, rather, in Adorno's sense of the range of engagement with the object world, and the need for that engagement. For a brief account of the lyric redemption of objects, see chapter 2. *Krug* would generally be translated as *jug*, and *pot* would appear in German as *Topf*; this is significant in the argument I'm making here because Heidegger "removes" any handle from the *Krug*.

28 Despite his touted interest in handicraft, Heidegger evacuates his inquiry, in its final stage, of both potter and pot, concentrating instead on the void around which the jug is formed. The ethnographic glimpse of the potter and the pot might be said to serve as a kind of alibi.

29 Duchamp anticipates this move with the first readymade, the bottle-rack. Given the ease with which pottery becomes an art object, Duchamp had to find a clunkier piece of equipment, and equipment that was not hand-crafted.

30 Ray Brassier, *Nihil Unbound: Enlightenment and Extinction* (New York: Palgrave Macmillan, 2007), 68. In contrast, Peter Bürger, for one, emphasizes the way that Heidegger "thinks the theological thought of salvation purely within the world." *The Thinking of the Master: Bataille between Hegel and Surrealism*, trans. Richard Block (Evanston, IL: Northwestern University Press, 2002), 103.

31 Karl Marx, *Capital*, trans. Ben Fowkes (New York: Penguin, 1990), 1:163.

32 Jacques Derrida, *Specters of Marx: The State of the Debt, the Work of Mourning and the New International*, trans. Peggy Kamuf (London: Routledge, 2006), ch. 5, 156–222. Derrida reads *Capital* through a hauntology (as opposed to an ontology) inspired by Shakespeare, focusing on Marx's depiction of the mystical character of the commodity. By Derrida's light, Marx's image of the transformation of the phenomenal object into a "sensuous-nonsensuous" thing, the commodity, neglects the way that an object of use (its use value as opposed to its exchange value) has already been subjected to idealizations and mystifications in a prior phantasmagoria in which the thing has already lost its self-identity. The character of things as things cannot be stabilized. For an extended account of Derrida's engagement with the topic, see Michael Marder, *The Event of the Thing: Derrida's Post-Deconstructive Realism* (Toronto: University of Toronto Press, 2009). My own sense that any object can become a thing (for a subject) shares Derrida's resistance (replaying Heidegger's resistance) to the idea that an object is simple and stable before it becomes a commodity, but of course the very distinction between object and thing would be unsustainable from a deconstructive point of view.

33 Lingis, *Imperative*, 64.

34 Here I mean to invoke (and revise) Emmanuel Levinas, *Existence and Existents* (1947), trans. Alphonso Lingis (Pittsburgh: Duquesne University Press, 2001), 52–60. See also my coda and my engagement with Levinas below.

35 Jacques Lacan, *The Ethics of Psychoanalysis 1959–1960*, trans. Dennis Porter (New York: Norton, 1992), 125 (hereafter cited parenthetically). For the French, page references are to *Le Séminaire de Jacques Lacan, livre VII, L'éthique de la psychanalyse*, ed. Jacques-Alain Miller (Paris: Editions du Seuil, 1986).

36 In a different cultural register, Lacan sees Harpo Marx as illustrating the enigmatic "dumb reality which is *das Ding*" (55). This vacillation between that which cannot be imagined and that which can nonetheless be particularized has made the Thing available for innumerable commentaries in which the

unsymbolizable Thing comes to designate the abstract threat that is nonetheless real in literature and film. Slavoj Žižek is the commentator who repeatedly renders such designations particularly productive. See, for instance, "The Thing from Inner Space—on Tarkovksy," *Angelaki* 4 (December 1999), where his point is that the Thing in fact closes the gap between the Symbolic and the Real. Žižek repeatedly clarifies Lacan's point in *Séminaire VII*: "The Thing can appear only in its retreat, as the obscure Ground which motivates our activity, but which dissipates the moment we endeavor to grasp it in its positive ontological consistency." *Interrogating the Real* (London: Continuum, 2005), 192. It will not go unnoticed by any reader of Shakespeare (as Wayne Booth reminded me long ago) that *thing* can also serve as slang for penis (dick or cock); Lacan suppresses such slang connotations.

37 Jacques Lacan, "Remarks on Daniel Lagache's Presentation," in *Ecrits*, trans. Bruce Fink (New York: Norton, 2007), 550.

38 More precisely, *Vorstellungen* designates the creation of a mental image or notion.

39 Lacan's exaggeration can be measured by the way he restricts the denotation and connotation of *Sache*, which can mean simply *matter*, concrete or abstract; *sachlich* can mean cool or objective, as in the *neu sachlichkeit*.

40 See chapter 6.

41 Jacques Lacan, "The Function and Field of Speech and Language in Psychoanalysis," in *Ecrits*, 229. See also Lacan's account of the lectern in "The Freudian Thing," in *Ecrits*, 351.

42 On Hannah Arendt, see chapter 5.

43 For instance, Duchamp shot painted matchsticks from toy canons at the Large Glass. And see Picabia, *Untitled (Match-Woman I)* (1920).

44 The Irwin quotation is from Lawrence Weschler, *Seeing Is Forgetting the Name of the Thing One Sees: A Life of Contemporary Artist Robert Irwin* (Berkeley: University of California Press, 1982), 68.

45 Gaston Bachelard, *The Poetics of Space* (1958), trans. Maria Jolas (Boston: Beacon Press, 1964), 78.

46 Theodor W. Adorno, *Negative Dialectics*, trans. E. B. Ashton (New York: Continuum, 1997), 33. For a brief account of American modernism, see the introduction to my previous book: "The Idea of Things and the Ideas in Them," in *A Sense of Things: The Object Matter of American Literature* (Chicago: University of Chicago Press, 2003), 1–19.

47 Graham Harman, "On the Horror of Phenomenology: Lovecraft and Husserl," *Collapse IV: Concept Horror* (May 2008): 6. My point is not to object to Harman's philosophical account of objects, and I certainly concur with his assessment that "we are never really sure what an object is. Whether we define it as nothing more than electrons, or as just a shape present in consciousness, we replace the fathomless reality of things with an intellectual model of what their underlying reality ought to be" (34). Still, the thingness of objects, in my account, has a distinct trajectory because the thing names a subject-object relation (of the sort that Harman specifically elides). This does not foreclose the possibility that there are moments when the thing about an object seems to name the object's inherent strangeness, though I consider the assessment of strangeness as such to be a judgment made by a subject (individual or collective, unhuman or human). As the fields of history and anthropology have demonstrated, what is weird for one culture may be the norm for another. Although in this book I spend very little time engaging the new metaphysics (or speculative realism) that focuses on objects and things, particular points often resonate, as when Tristan Garcia argues that "reductionism consists in refusing to consider the irreducibility of a what which is a thing to that which

it is." *Form and Object: A Treatise on Things*, trans. Mark Allen Ohm and Jon Cogburn (Edinburgh: Edinburgh University Press, 2014), 118.

48 See Bruno Latour and Steve Woolgar, *Laboratory Life: The Construction of Scientific Facts* (1979; Princeton, NJ: Princeton University Press, 1986). There are references throughout to *Le nouvel esprit scientifique* (1934) and to *Le matérialisme rationnel* (1953), especially the section titled "The Phenomenotechnique" (63–72).

49 Gaston Bachelard, *Earth and Reveries of Will: An Essay on the Imagination of Matter*, trans. Kenneth Haltman (Dallas: Dallas Institute, 2002), 5, 31, 29. His rendering of dynamic existence here could be understood as a recasting of Marx's existential materialism from the 1844 manuscripts.

50 André Bazin, "Ontology of the Photographic Image," in *What Is Cinema*, trans. Timothy Barnard (Montreal: Caboose, 2009), 8–9. Bazin is addressing the "irrational power of photography, in which we believe without reservation" (8).

51 Walter Benjamin, "The Work of Art in the Age of Its Technological Reproducibility" (1936), trans. Edmund Jephcott and Harry Zohn, in *Walter Benjamin Selected Writings*, vol. 3, *1935–1938*, ed. Howard Eiland and Michael Jennings (Cambridge, MA: Harvard University Press, 2002), 117–18.

52 Siegfried Kracauer, *Theory of Film: The Redemption of Physical Reality* (1960; Princeton, NJ: Princeton University Press, 1997), 28, 48, 58.

53 Miriam Bratu Hansen, *Cinema and Experience: Siegfried Kracauer, Walter Benjamin, and Theodor W. Adorno* (Berkeley: University of California Press, 2012), 259. This helps to explain Kracauer's investment in the "nonanthropocentric tendency of early cinema, its relative indifference to hierarchies between human and nonhuman, people and things" (261).

54 Levinas, *Existence and Existents*, 49.

55 DeLillo, *Falling Man*, 12 (hereafter cited parenthetically).

56 Janet Abramowicz, *Gorgio Morandi: The Art of Silence* (New Haven, CT: Yale University Press, 2004), 213–17. For the one extensive (and delightful) account of the Morandi in Fellini's film, see Mauro Aprile Zanetti, *La natura morta de la dolce vita: A misterioso Morandi nella rete dello sguardo di Fellini* (New York: Istituto Italiano di Cultura di New York, 2008).

57 Lacan, *Ethics of Psychoanalysis*, 55.

Introduction to Part One

1 Emmanuel Levinas, *Existence and Existents*, trans. Alphonso Lingis (Pittsburgh: Duquesne University Press, 1978), 46.

2 This relation between the world and the thing can be recast as the distinction that William James makes between perception and sensation. See chapter 2.

Chapter Two

This chapter began as a talk that I gave at the "Aesthetic Subjects" conference sponsored by the Interdisciplinary Group for Humanities Studies, Texas A&M University, in 1998. The argument appeared as an essay, "The Secret Life of Things (Virginia Woolf and the Matter of Modernism)," in *Modernism and Modernity* 6 (Summer 1999): 1–28; and in *Aesthetic Subjects*, ed. Pamela Matthews and David McWhirter (Minneapolis: University of Minnesota Press, 2003), 397–430, copyright 2003 by the Regents of the University of Minnesota. Noel Jackson assisted me with the research, and I owe a par-

ticular debt to four friends who were generous readers: Homi Bhabha, Robert Kaufman, Janel Mueller, and Lesley Stern.

1 Jean Baudrillard, *Fatal Strategies*, trans. Phillip Beitchman and W. G. J. Niesluchowski (New York: Semiotext[e], 1990), 111–13.

2 Theodor W. Adorno, *Negative Dialectics*, trans. E. B. Ashton (New York: Continuum, 1997), 140, 193, 185 (hereafter cited parenthetically as *ND*). At the close of his career, Adorno writes an impassioned plea on behalf of the fullness of the "somatic moment" that grants us access to things (193).

3 See Arjun Appadurai, "Introduction: Commodities and the Politics of Value," in *The Social Life of Things: Commodities in Cultural Perspective*, ed. Appadurai (New York: Cambridge University Press, 1986), 57; and Victoria de Grazia, introduction to *The Sex of Things: Gender and Consumption in Historical Perspective*, ed. de Grazia and Ellen Furlough (Berkeley: University of California Press, 1996), 10.

4 As I explained in chapter 1, another object can also serve as a catalyst. In other words, an inanimate object can occupy the subject position, though that will not be a focus of my attention in this book.

5 Tristan Tzara, "Highway Single Sun," trans. Charles Simic and Michael Benedikt, in *The Poetry of Surrealism: An Anthology*, ed. Benedikt (Boston: Little, Brown, 1974), 92; Louis Aragon, "Tercet," trans. Michael Benedikt, in ibid., 155.

6 In "Plus-que-raisons" (More than reasons) (1930), Ponge had argued that there is "no possible compromise between taking the side of ideas or things to be described, and taking the side of words. Given the singular power of words, the absolute power of the established order, only one attitude is possible: taking the side of things all the way." Francis Ponge, *Nouveau recueil* [New collection] (Paris: Gallimard, 1967), 32; quoted and translated by Beth Archer, introduction to *Francis Ponge: The Voice of Things*, ed. Archer (New York: McGraw-Hill, 1972), 5. The history of such claims in their relation to the dicta of Ezra Pound (the "direct treatment of the *thing*") and William Carlos Williams ("no ideas but in things") has yet to be written, to my knowledge. The standard account of the postromantic, Anglo-American effort to disclose the sensuous proximity of the object world outside the subject opposition remains J. Hillis Miller, *Poets of Reality: Six Twentieth-Century Writers* (Cambridge, MA: Harvard University Press, 1966). Such an effort is not confined to poetry, of course. Samuel Beckett's trilogy certainly conveys a fixation on objects, but elsewhere, as Elaine Scarry has shown, he means to minimize the significance of the intentional object. See "Nouns: The Realm of Things—Six Ways to Kill a Blackbird or Any Other Intentional Object in Samuel Beckett," in *Resisting Representation* (New York: Oxford University Press, 1994), 91–100.

7 Rainer Maria Rilke, *The Letters of Rainer Maria Rilke 1892–1910*, trans. Jane Bannard Greene and M. D. Herter Norton (New York: Norton, 1969), 102.

8 Rainer Maria Rilke, *Where Silence Reigns: Selected Prose*, trans. G. Craig Houston (New York: New Directions, 1978), 131, 132.

9 Rainer Maria Rilke, *Duino Elegies and the Sonnets to Orpheus*, trans. Stephen Mitchell (New York: Vintage, 2009), 13.

10 Walter Benjamin, *One-Way Street*, trans. Edmund Jephcott, in *Selected Writings, Volume 1, 1913–1926*, ed. Marcus Bullock and Michael W. Jennings (Cambridge, MA: Harvard University Press, 1996), 453–54. Thomas Mann's *Magic Mountain* (1924), trans. John E. Woods (New York: Alfred Knopf, 2005), provides a fair example of the problem. As a boy, the protagonist Hans Castorp is fascinated by the objects that his grandfather shows him in the "rococo china cabinet made of rosewood, with yellow silk curtains pulled across the inside of its

windowpanes," but the objects there are lifeless: "All sorts of objects had fallen out of use, which made them all the more captivating ... a pair of sinuous candlesticks; a broken barometer, its wooden case carved in figures; an album of daguerreotypes; a cedar chest for liqueurs; a little Turk in a bright silk costume, whose body was rigid to the touch but contained a mechanism that, though it had long since fallen into disrepair, had once enabled him to run across the table" (23). Life has gone out of this object world. Even the family baptismal bowl and plate, while providing the boy with the sense of generational continuity, gives him the feeling of "dizzying, everlasting sameness" (26).

11 Emmanuel Levinas, *Existence and Existents*, trans. Alphonso Lingis (Pittsburgh: Duquesne University Press, 1978), 46.

12 Hannah Arendt and Gunther Stern, "Rilke's *Duino Elegies*," in *Reflections on Literature and Culture*, ed. Susannah Gottlieb (Stanford, CA: Stanford University Press, 2007), 7.

13 Fernando Pessoa, *The Keeper of Sheep*, trans. Edwin Honig and Susan M. Brown (Riverdale-on-Hudson, New York: Sheep Meadow Press, 1997), 97 (hereafter cited parenthetically as *KS*).

14 William Carlos Williams, *Spring and All* (1926), in *Imaginations*, ed. Webster Schott (New York: New Directions, 1970), 102.

15 William Carlos Williams, *A Novelette* (1932), in *Imaginations*, 295.

16 William Carlos Williams, *The Collected Earlier Poems* (New York: New Directions, 1966), 260.

17 Virginia Woolf, "Solid Objects," in *A Haunted House and Other Stories*, collected by Leonard Woolf (New York: Harcourt Brace, 1944), 82 (hereafter cited parenthetically as *HH*).

18 See, for instance, Robert A. Watson, "'Solid Objects' as Allegory," *Virginia Woolf Miscellany* 16 (Spring 1981): 3–4; Dean R. Baldwin, *Virginia Woolf: A Study of the Short Fiction* (Boston: Twayne, 1989), 19–20; Panthea Reid, *Art and Affection: A Life of Virginia Woolf* (New York: Oxford, 1996), 241; and Hermione Lee, *Virginia Woolf* (New York: Knopf, 1997), 370. Douglas Mao interrupts this consensus in a chapter on Woolf that reads the story in order to introduce a wideranging account of Woolf's place in the genealogy of Victorian, aestheticist, and modernist attention to material objects. See Douglas Mao, *Solid Objects: Modernism and the Test of Production* (Princeton, NJ: Princeton University Press, 1998), 26–89.

19 Clive Bell, "Art and Politics," in *Since Cézanne* (New York: Harcourt Brace, 1922), 198. The topic of "things," when it comes to Woolf's fiction, has traditionally been rendered as the topic of "things in themselves," and has been pursued foremost through *The Waves*. See, for instance, Frank D. McConnell, "'Death among the Apple Trees': *The Waves* and the World of Things," *Bucknell Review* 16 (December 1968): 23–39; and Igor Webb, "'Things in Themselves': Virginia Woolf's *The Waves*," *Modern Fiction Studies* 17 (Winter 1971): 570–73.

20 Virginia Woolf, *The Diary of Virginia Woolf*, ed. Anne Olivier Bell (New York: Harcourt Brace Jovanovich, 1977), 1:173 (hereafter cited parenthetically as *D*).

21 Bell, "Art and Politics," 198.

22 Miriam Hansen, "T. E. Hulme, Mercenary of Modernism; or, Fragments of Avantgarde Sensibility in Pre–World War I Britain," *English Literary History* 47 (Summer 1980): 379. Michael Levenson, in *A Genealogy of Modernism: A Study of English Literary Doctrine, 1908–1922* (New York: Cambridge University Press, 1984), 120–23, traces the schism between Bloomsbury and the movements with which Hulme's ideas are associated, futurism and vorticism. If in the following pages I seem to imply that within Woolf's story we can detect some transcen-

dence of that schism, I hardly mean to suggest that this is anything but inadvertent, and my use of William James, Georg Simmel, Benjamin, and Adorno is meant to avoid domesticating Woolf's text too readily.

23 On the distinction between the souvenir and the collection, see Susan Stewart, *On Longing: Narratives of the Miniature, the Gigantic, the Souvenir, the Collection* (Baltimore: Johns Hopkins University Press, 1984), 132–69.

24 Virginia Woolf to Vanessa Bell, January 17, 1918, in Virginia Woolf, *The Letters of Virginia Woolf*, ed. Nigel Nicolson (New York: Harcourt Brace Jovanovich, 1976), 2:210.

25 In the early modern subfield of literary studies, for instance, there are distinct waves of what can be called "new materialism." In 1996 a group of essays anthologized in *Subject and Object in Renaissance Culture* pointed out how assiduously the field had elided objects as a way of representing the early modern era as the period that gives birth to the modern subject, that "long and monotonous history of the sovereignty of the subject": "Renaissance studies have been doubly instrumental in sustaining this obsessive teleological history," the editors wrote in their introduction, "by keeping the subject out of touch with the object and by staging this exclusion as the beginning of the Modern." Concerned to show "how objects have a hold on subjects," how "material things—land, clothes, tools—might constitute subjects who in turn own, use, and transform them," they imagined provisionally reversing the Aristotelian form-matter relation: "It is the material object that impresses its texture and contour upon the noumenal subject." Margreta de Grazia, Maureen Quilligan, and Peter Stallybrass, introduction to *Subject and Object in Renaissance Culture*, ed. de Grazia, Quilligan, and Stallybrass (Cambridge: Cambridge University Press, 1996), 5–11. A second wave of criticism, frustrated with the emphasis on material culture, has asked what "material" or "things" or "substance" might have meant within the historical moment. See, for instance, Jonathan Goldberg, *The Seeds of Time: Theorizing Sexuality and Materiality in Renaissance Representation* (New York: Fordham University Press, 2009); Jonathan Gil Harris, *Untimely Matter in the Time of Shakespeare* (Philadelphia: University of Pennsylvania Press, 2011); and Bradin Cormack, "Lyric Substance: Shakespeare's Sonnets," unpublished manuscript in author's collection.

26 Georg Simmel, *The Philosophy of Money*, trans. Tom Bottomore and David Frisby (New York: Routledge, 2004), 509 (hereafter cited parenthetically as *PM*).

27 William James, *Principles of Psychology* (Cambridge, MA: Harvard University Press, 1983), 891 (hereafter cited parenthetically as *P*). One could homologize this claim to the idea that regulative discursive iteration effects materiality, but part of my point in this chapter, of course, is to begin elsewhere, to suppose that there is an elsewhere that can regulate or interrupt discourse.

28 Claude Lévi-Strauss, *The Savage Mind* (Chicago: University of Chicago Press, 1966), 21, 36. By quoting this use of the kaleidoscope image, I mean, further, to intimate just how prevalent glass has been in the modernist imaginary. In "Between Walls," William Carlos Williams shows how the particular quality of glass allows a broken object—

> the broken
> pieces of a green
> bottle

—to assume greater luminosity than a whole one. *Collected Poems*, 381. For a further exploration of the figure of the kaleidoscope, see chapter 6.

29 Otto Wagner, *Moderne Architektur*, quoted in Sigfried Giedion, *Space, Time, and Architecture* (Cambridge, MA: Harvard University Press, 1941), 318; Donald Judd, "Specific Objects," in *Complete Writings, 1959–1975* (New York: New York University Press, 1975), 187. For a discussion of Marinetti (and indeed an invaluable account of the materials of modernism and modernity), see Jeffrey T. Schnapp, "The Fabric of Modern Times," *Critical Inquiry* 24 (Autumn 1997): 191–245. See also Jessica Burstein, *Cold Modernism: Literature, Fashion, Art* (University Park: Pennsylvania State University Press, 2012).

30 Roger Fry, "Wedgwood China" (1905), in *A Roger Fry Reader*, ed. Christopher Reed (Chicago: University of Chicago Press, 1996), 192.

31 Virginia Woolf, *Orlando: A Biography* (1928; New York: Harcourt Brace Jovanovich, 1956), 208, 23.

32 Roger Fry, "The Ottoman and the Whatnot," *Athenaeum*, June 27, 1919, 529–30. To specify further the difference between "social emotions" and "aesthetic feelings," Fry developed the notion of the "opifact," an object meant to gratify certain social desires (in Thorstein Veblen's sense) that falls short of being an art object. Roger Fry, *Art and Commerce* (London: Hogarth Press, 1926), 8.

33 Walter Benjamin, "Paris, Capital of the Nineteenth Century," trans. Howard Eiland, in *Selected Writings, Volume 3, 1935–1938*, ed. Howard Eiland and Michael W. Jennings (Cambridge, MA: Harvard University Press, 2002), 33.

34 John Ruskin, *The Seven Lamps of Architecture* (1849; New York: Dover, 1989), 56.

35 On such temporal structures in historiography, see Siegfried Kracauer, *History: The Last Things before the Last* (Princeton, NJ: Marcus Wiener, 1995), 139. The topic is of course central in the work of Benjamin. See, for instance, Beatrice Hanssen, *Walter Benjamin's Other History: Of Stones, Animals, Human Beings, and Angels* (Berkeley: University of California Press, 1998).

36 Georg Lukács, *History and Class Consciousness: Studies in Marxist Dialectic*, trans. Rodney Livingstone (Cambridge, MA: MIT Press, 1971), 92; Martin Heidegger, *Being and Time*, trans. John Macquarrie and Edward Robinson (New York: Harper & Row, 1962), 72; Benjamin, *One-Way Street*, 449–50.

37 Walter Benjamin, "Surrealism," trans. Emund Jephcott, in *Selected Writings, Volume 2, 1927–1934*, ed. Michael W. Jennings, Howard Eiland, and Gary Smith (Cambridge, MA: Harvard University Press, 1999), 210; Benjamin, "Dream Kitsch," trans. Howard Eiland, in *Selected Writings, Volume 2*, 3. On Benjamin's sense of the possible mimetic appropriation of the material world, which he called "innervation," see Miriam Bratu Hansen, *Cinema and Experience: Siegfried Kracauer, Walter Benjamin, and Theodor W. Adorno* (Berkeley: University of California Press, 2012), 132–47. For my own focus on childhood play as a refunctioning of the material world, see *The Material Unconscious: American Amusement, Stephen Crane, and the Economies of Play* (Cambridge, MA: Harvard University Press, 1996), 167–98.

38 Roger Fry, "The Artist's Vision," *Athenaeum* (July 11) 1919, 594.

39 Virginia Woolf, "The Cinema," in *Collected Essays* (New York: Harcourt Brace, 1950), 2:268. From Woolf's point of view, the cinema offers a temporality that might enable the English to engage a reality "more real, or real with a different reality from that which we perceive in daily life," but she goes on to imagine the surreal possibility that the cinema will offer "abstractions," "visual emotions," some way of visualizing "thought in its wildness" (2:271). In "Solid Objects" John's tactile engagement with material is coupled with a new sensitivity to abstract form: "He was often astonished, as he came to go into the question more deeply, by the immense variety of shapes to be found in London alone" (*HH*, 84).

40 Benjamin, "Paris," 39.

41 Woolf, "The Lady in the Looking Glass," in *HH*, 89.

42 Virginia Woolf, *Night and Day* (New York: Harcourt Brace, 1920), 22; Woolf, *Between the Acts* (1941; New York: Harcourt Brace, 1970), 70.

43 Virginia Woolf, "Street Haunting: A London Adventure," in *Collected Essays* (New York: Harcourt Brace, 1967), 4:155–56.

44 Virginia Woolf, *Jacob's Room and The Waves* (New York: Harcourt Brace, 1980), 9, 10 (hereafter cited parenthetically as *JR*).

45 Virginia Woolf, "Robinson Crusoe," in *Collected Essays* (1950), 1:75. For the best discussion of Woolf's essay, see Daniel Ferrer, *Virginia Woolf and the Madness of Language*, trans. Geoffrey Bennington and Rachel Bowlby (London: Routledge, 1990), 141–48. For an account of Woolf's novel in the context of object relations theory, see Elizabeth Abel, *Virginia Woolf and the Fictions of Psychoanalysis* (Chicago: University of Chicago Press, 1989). For a discussion of objects in Woolf's novels that emphasizes how they "hang loose" without ever comprising a "whole world of which the objects are parts" (in other words, performing an antithetical function to the pot in *Robinson Crusoe*), see Rachel Bowlby, *Virginia Woolf: Feminist Destinations* (Oxford: Basil Blackwell, 1988), 117–27. For an account of how the subjective apperception of objects in Woolf's novels corresponds with G. E. Moore's psychology, see Harvena Richter, *Virginia Woolf: The Inward Voyage* (Princeton, NJ: Princeton University Press, 1970), 67–69. For an account of Woolf's most explicit engagement with Hume's questions about the separation of subject and object, see Gillian Beer, "Hume, Stephen, and Elegy in *To the Lighthouse*," in *Virginia Woolf: The Common Ground* (Ann Arbor: University of Michigan Press, 1996), 29–47. For an account, prefaced with a reading of Woolf's essay, of Defoe in relation to the eighteenth-century china trade, see Lydia H. Liu, "Robinson Crusoe's Earthenware Pot," *Critical Inquiry* 25 (Summer 1999): 728–57.

46 It would be possible to call attention to how Woolf's realist mode, with its verisimilar rendering of decor, transforms into a modernist mode where objects no longer have an identifiable relation to humans or to one another. Such schematic narratives, however, erase the very instability that characterizes Woolf's objectifications even in her role as fictional chronicler. In "Solid Objects," John's relation to the things he collects seems more like the sort of relation described in Leonard Woolf's novelistic account of Hambantota life in Ceylon, *The Village in the Jungle* (1926), where Silindu's profound intimacy with the jungle provokes his isolation both from his fellow villagers and from the British officials.

47 See Paul Fussell, *The Great War and Modern Memory* (New York: Oxford University Press, 1975), 325–26. For discussions of Woolf's novels in relation to war, see the essays collected in Mark Hussey, ed., *Virginia Woolf and War: Fiction, Reality, Myth* (Syracuse, NY: Syracuse University Press, 1991).

48 Writing to Lytton Strachey before his visit to Asheham, Woolf explains, "You'll have to bring whatever cards for meat, sugar, butter you possess as we are strictly rationed here," or, alternatively, "get your cook at Belsize to get you a week's rations of butter, sugar and meat which you pack in your bag and bring with you," March 24, 27, 1918, in *Letters*, 227, 228.

49 Woolf's interest in glass extends from the material to the rhetorical. In her *Diary*, she explains of *Electra* that "traditional plots which have been made & improved & freed from superfluities by the polish of innumerable actors & authors & critics" become "like a lump of glass worn smooth in the sea" (*D*, 184). And when Orlando is frustrated by the way familiar metaphors encumber any thought or expression of love, Woolf uses the metaphor of the thing of glass: "Every single thing, once he tried to dislodge it from its place

in his mind, he found thus cumbered with other matter like the lump of glass which, after a year at the bottom of the sea, is grown about with bones and dragon-flies, and coins and the tresses of drowned women" (*Orlando*, 101).

50 See T. C. Baker, *The Glassmakers: Pilkington, the Rise of an International Company, 1826–1976* (London: Weidenfield and Nicolson, 1977), 242–47; and Pilkington Brothers, *Now Thus—Now Thus, 1826–1926* (London: Joseph Coaston, 1926), 59–63. On the significance of glass to the Victorian imagination, see Isobel Armstrong, *Victorian Glassworlds: Glass Culture and the Imagination, 1830–1880* (New York: Oxford University Press, 2008).

51 "Glass-Famine in Britain," *Literary Digest* 51 (October 16, 1915): 836.

52 See "British Glass-Sands," *Geographic Journal* 51 (May 1918): 335–36; and Great Britain Board of Trade, *Hand Blown Domestic Glassware* (London: HMSO, 1947), 24.

53 See C. E. N. Bromehead, "Natural Resources in Relation to the Arts," *Geographical Journal* 63 (June 1914): 488–89.

54 See R. J. Chesterton, *English Glass and the Glass Used in England, circa 400–1940* (London: George Allen and Unwin, 1984), 230; and Great Britain Board of Trade, *Hand Blown Domestic Glassware*, 21, 24.

55 As the architect Charles Downes originally emphasized, the construction was modular and the materials were "not of such a nature as to restrict the construction of similar buildings to any particular country." Charles Downes and Charles Cowper, *The Building Erected in Hyde Park for the Great Exhibition of the Works of Industry of All Nations, 1851* (London: John Weale, 1852), ii.

56 Leonard Woolf, *Imperialism and Civilization* (New York: Harcourt, Brace, 1928), 41, 44. He goes on to specify that the manufacturers, who were "the harbingers of imperialism in the hills and plains of Asia and the forests of Africa," went there to obtain "tin or iron or rubber or tea or coffee" (49).

57 See D. L. Burn, *The Economic History of Steelmaking, 1867–1939* (Cambridge: Cambridge University Press, 1940), 369.

58 Y., "Coal and Iron in War: The Importance of Alsace and Lorraine," *Fortnightly Review* 108 (November 1917): 709. The German memorandum reads, for instance, "For cast-iron shells alone, which are an inferior substitute for those in steel, an average production of 4,000 tons of iron per day has been necessary. If the production of pig-iron and steel had not been doubled, the war could not have been continued" (700).

59 Sir John French, quoted in *The Times History of the War*, October 12, 1915, 5:309. To track the control of glass and iron production and distribution, see N. B. Dearle, *An Economic Chronicle of the Great War for Great Britain and Ireland* (London: Oxford University Press, 1929). For a general account of munitions manufacturing, see Sir Llewellyn Woodward, *Great Britain and the War of 1914–1918* (London: Methuen, 1967), 453–67.

60 See W. Cunningham, *Western Civilization in Its Economic Aspects* (Cambridge: Cambridge University Press, 1900), 2:227–28; and J. Stephen Jeans, *The Iron Trade of Great Britain* (London: Methuen, 1940?), 150, 139.

61 See T. H. Burnham and G. O. Hoskins, *Iron and Steel in Britain, 1870–1930* (London: George Allen and Unwin, 1943), 46; and Burn, *Economic History*, 393–448. For a contemporaneous, international overview, see Edwin C. Eckel, *Coal, Iron, and War* (New York: Henry Holt, 1920). For details, see the *Iron and Coal Trades Review* (London), an illustrated weekly that began publication in 1866.

62 See Great Britain Board of Trade, *Report on Iron and Steel Products* (London: HMSO, 1920), 3–5.

63 From a poster quoting Sir Douglas Haig, quoted in *The Times History of the War*, May 14, 1918, 15:461.

64 Louis Aragon, "Drinking Song," trans. Michael Benedikt, in Benedikt, *Poetry of*

Surrealism, 154. One way to read Woolf's story, then, would be to understand John himself as a militaristic figure—increasingly strategic, goal-focused, and obsessive—as someone whose senses have been transformed by war's engulfing transformation, by its capacity to conscript even those who appear uninvolved.

65 Benjamin, "Surrealism," 179. This is hardly to argue that there is not a more explicit, more vibrant, and more politically fraught connection between Benjamin's investment in the surrealists and his depiction of the war. See Miriam Hansen, *Cinema and Experience: Siegfried Kracauer, Walter Benjamin, and Theodor W. Adorno* (Berkeley: University of California Press, 2012), 141–46.

66 Bronislaw Malinowski, *Argonauts of the Pacific* (Prospect Heights, IL: Waveland Press, 1984), 9. The "simple action—this passing from hand to hand of two meaningless and quite useless objects (the arm-shells and necklaces)—has somehow succeeded in becoming the foundation of a big inter-tribal institution" (86).

67 Marcel Mauss, *The Gift: Forms and Functions of Exchange in Archaic Societies*, trans. Ian Cunnison (New York: Norton, 1967), 74.

68 Thus William Pietz, in his influential history of the concept of fetishism, explains that the "worship of haphazardly chosen material objects" became the "paradigmatic illustration of what was *not* enlightenment." William Pietz, "The Problem of the Fetish, IIIa: Bosman's Guinea and the Enlightenment Theory of Fetishism," *Res* 16 (Autumn 1988): 106. See also his "The Problem of the Fetish I," *Res* 9 (Spring 1985): 5–17; "The Problem of the Fetish II: The Origin of the Fetish," *Res* 13 (Spring 1987): 23–45; and "Fetishism and Materialism: The Limits of Theory in Marx," in *Fetishism as Cultural Discourse*, ed. Emily Apter and William Pietz (Ithaca, NY: Cornell University Press, 1993), 119–51.

69 Woolf narrativizes such a development in "The Mark on the Wall"; the ambiguous, abstract mark turns out to be a snail. Insofar as the story represents an attraction to "the impersonal world which is proof of some existence other than ours," an attraction satisfied by the "solidity" and "reality" of materials ("Wood is a pleasant thing to think about"), "The Mark on the Wall" can be reasonably paired with "Solid Objects" (*HH*, 45). But the latter utterly differentiates itself by fixating on the fragment, the specifically cultural remainder that will never assume coherence as a familiar object, animate or inanimate.

Chapter Three

I presented an early version of this paper as a talk at the Art Institute of Chicago in 2011. For their responses to the essay form of the inquiry, I'd like to thank Rachel Kyne and Matthew Hunter.

1 Pierre Bourgeade, *Bonsoir, Man Ray* (Paris: Maeght, 2002), 62. The book records the conversations that Bourgeade had with Man Ray in 1972.

2 Roland Penrose, *Man Ray* (Boston: New York Graphic Society, 1975), 186. Penrose served as the founder-director of the Institute for Contemporary Art in London, where the New York retrospective traveled later in the year.

3 For instance: *Surreal Things* (the Guggenheim Museum, Bilboa, February 29–September 7, 2008); *The Erotic Object: Surrealist Sculpture from the Collection* (the Museum of Modern Art, New York, June 24, 2009–January 4, 2010); *Surreal Objects: Three-Dimensional Works from Dalí to Man Ray* (Schirn Kunsthalle, Frankfurt, February 11–May 29, 2011). To this, one should add *Man Ray, African Art, and the Modernist Lens* (the Phillips Collection, Washington, DC, October

10, 2009–January 10, 2010), curated by Wendy A. Grossman, whose subsequent book with the same title (Washington, DC: International Arts and Artists, 2011) does an especially adept job of documenting how, after the exhibit of African artifacts at 291 in 1914, photography brought African objects more widespread aesthetic attention. See also Janine Mileaf, *Please Touch: Dada and Surrealist Objects after the Readymade* (Hanover, NH: Dartmouth College Press, 2010). Hal Foster, in his foundational work on surrealism, *Compulsive Beauty* (Cambridge, MA: MIT Press, 1993), begins by pointing out how "surrealism has returned with a vengeance" (xi).

4 Theodor W. Adorno, *Aesthetic Theory*, trans. Robert Hullot-Kentor (Minneapolis: University of Minnesota Press, 1997), 229.

5 Walter Benjamin, "Surrealism: The Last Snapshot of the European Intelligentsia," trans. Edmund Jephcott, in *Selected Writings, Volume 2, 1927–1934*, ed. Michael W. Jennings, Howard Eiland, and Gary Smith (Cambridge, MA: Harvard University Press, 1999), 215.

6 André Breton, "The Crisis of the Object," in *Surrealism and Painting*, trans. Simon Watson Taylor (Boston: MFA, 2002), 275. My two poles could of course be complicated—see the overture.

7 Man Ray identified with both the Dadaists and the surrealists, without ever signing on to the latter's full script, composed by Breton. Breton claims Man Ray in behalf on surrealism, just as Tristan Tzara claims him in behalf of Dada. *Cadeau*, for instance, cannot properly be called a surrealist object because it was made (in 1921) before the first "Manifesto of Surrealism" (1924).

8 Maurice Blanchot, "Reflections on Surrrealism," in *The Work of Fire*, trans. Charlotte Mandell (Stanford, CA: Stanford University Press, 1995), 85, 97. I am skewing Blanchot's actual point, which has to do with writers—with the surrealist foundation of the writer's imagination. Scholarship is slowly overcoming its own embarrassment, belatedly willing to recognize how seriously surrealism permeates French thought in the second half of the twentieth century (Bataille, Lacan, Deleuze, Foucault) and slowly willing to recognize the importance of Bachelard, without whom Foucault, Serres, and Latour are unthinkable.

9 Lucy Lippard and John Chandler, "The Dematerialization of Art," *Art International* 12 (February 1968): 31.

10 The textualization of the material object soon found its specular completion in, say, the materialization of the text: in object-texts that enjoyed their own market niche. Moreover, by 2009, Weiner, one of the language artists who kept at it and who enjoyed a career retrospective (*As Far as the Eye Can See*) at the Whitney and the Los Angeles County Museum of Art in 2007–8, explained that since the 1960s he had been "trying to show that it's possible to accept the fact that art is the carrier place within society of the relationship between people and objects." The obsolescence of the object wasn't the point at all. "Lawrence Weiner in Conversation with Adam E Mendelsohn," *Saatchi Art* (October 22, 2009), http://magazine.saatchionline.com/spotlight/behind-the-canvas/lawrence_weiner_in_conversatio (accessed August 16, 2014).

11 Martin Jay, "Drifting into Dangerous Waters: The Separation of Aesthetic Experience from the Work of Art," in *Aesthetic Subjects*, ed. Pamela R. Matthews and David McWhirter (Minneapolis: University of Minnesota Press, 2003); François Julien, *The Great Image Has No Form; or, On the Nonobject through Painting*, trans. Jane Marie Todd (Chicago: University of Chicago Press, 2009), 1–15; Georges Didi-Huberman, "The Order of Material: Plasticities, *Malaises*, Survivals," in *Sculpture and Psychoanalysis*, ed. Brandon Taylor (London: Ashgate, 2006), 195; Klein is quoted by Sidra Stich in *Yves Klein* (Stuttgart: Hatje Cantz, 1994), 133. My list could have a much broader range of refer-

ence, of course: it could include, say, the Zen focus on *ma*—the empty space between objects—within one Japanese painting tradition.

12 Arthur Danto, *After the End of Art: Contemporary Art and the Pale of History* (Princeton, NJ: Princeton University Press, 1997), 77. The Warhol quotation is from Danto, "The Philosopher as Andy Warhol," in *Philosophizing Art: Selected Essays* (Berkeley: University of California Press, 1999), 74. For Danto, the Stable Gallery's exhibition of Warhol's *Brillo Box* in 1964 marked the end of art history understood as a history of perception.

13 Arthur Danto, *The Philosophical Disenfranchisement of Art* (1986; New York: Columbia University Press, 2004), 111.

14 "Art=Idea + the Object: Talking with Mel Bochner, 18 April 1972," reprinted in Ellen Johnson, *Modern Art and the Object* (New York: Harper & Row, 1976), 209–10.

15 Donald Judd, "Specific Objects," in *Donald Judd Complete Writings, 1959–1975* (Halifax: Press of Nova Scotia College of Art and Design, 2005), 181–90. Subsequent quotations appear across these few pages.

16 Michael Fried, "Art and Objecthood" (1967), reprinted in *Art and Objecthood* (Chicago: University of Chicago Press, 1998), 149, 151. Fried is also responding to Robert Morris's "Notes on Sculpture" (66) and to the interview of Tony Smith conducted by Samuel Wagstaff, "Talking to Tony Smith" (170). James Meyer does a particularly good job of analyzing the impact of Fried's essay. Meyer, *Minimalism: Art and Polemics in the Sixties* (New Haven, CT: Yale University Press, 2001), 229–43.

17 Michael Fried, "Shape as Form: Frank Stella's Irregular Polygons" (1966), reprinted in *Art and Objecthood*, 80.

18 As Fried puts it in his introduction to *Art and Objecthood*, he was offering a critique of Greenberg in the recognition that the minimalists had, in their way, realized the end game of Greenberg's logic of modernist painting: "Precisely with respect to his understanding of modernism Greenberg had no truer followers than the literalists" (36). (Hereafter, *Art and Objecthood* will be cited with the abbreviation *AO*.)

19 Rosalind Krauss, *The Optical Unconscious* (Cambridge, MA: MIT Press, 1994), 13.

20 Fried does list precursors in two footnotes—a point to which I'll return.

21 Kazimir Malevich, *The Non-Objective World: The Manifesto of Suprematism* (New York: Dover, 2003), 68.

22 Frank Stella, in response to Bruce Glaser, "Questions to Stella and Judd," *Art News* 65.5 (September 1966): 58–59. The conversation has been reprinted in *Minimal Art: A Critical Anthology*, ed. Gregory Battcock and Anne Wagner (Berkeley: University of California Press, 1995), 148–64. Fried himself does address Judd's interest in Stella and what he understands as Stella's temptation by the literal before his recommitment to painting. See "Shape as Form," 95.

23 Williams, *Spring and All*, in *Imaginations* (New York: New Directions, 1970), 117, 112.

24 William Carlos Williams, "The Work of Gertrude Stein," in *Imaginations*, 347. In *A Novelette*, he pleads on behalf of "Writing" that would be "actually itself." *Imaginations*, 296.

25 Gertrude Stein, *Tender Buttons*, in *Selected Writings of Gertrude Stein*, ed. Carl Van Vechten (New York: Vintage Books, 1962), 464.

26 Quoted by Liz Kotz, *Words to Be Looked At: Language in 1960s Art* (Cambridge, MA: MIT Press, 2007), 145.

27 Interview by Liz Kotz, April 10, 2005, quoted in ibid., 151. Stein is also invoked by Vito Acconci, for whom the "page has to be narrowed in on, treated as a chamber space separated from its surroundings," which means using "lan-

guage to cover a space rather than [to] uncover meaning." Quoted in ibid., 164, 167. It is customary, when addressing either language artists or the language poets, to say that they mean to foreground the "materiality of the signifier," which seems less than helpful, given the history of the phrase in deconstruction.

28 Liz Kotz develops this argument at length; see *Words to Be Looked At*, 140–53.

29 Peter Bürger, *Theory of the Avant-Garde*, trans. Michael Shaw (Minneapolis: University of Minnesota Press, 1984).

30 Clement Greenberg, "Sculpture in Our Time," in *The Collected Essays and Criticism*, ed. John O'Brian (Chicago: University of Chicago Press, 1993), 4:56. From Man Ray's point of view, "the violation of the medium employed is the most perfect assurance" of the artist's "convictions." "Age of Light," in *Man Ray — Photographies 1920–1934*, by Man Ray, ed. James Thrall Soby (Paris: Cahiers d'Art, 1934), v.

31 Clement Greenberg, "Picasso at Seventy-Five," in *Collected Essays*, 4:30.

32 Clement Greenberg, "Recentness of Sculpture," in *Collected Essays*, 4:256. Fried's attitude, expressed in 1966, was that "the 'traditional avant-garde' was done with, and [he] had little sympathy for what had taken its place." *AO*, 34.

33 *Bicycle Wheel* — the wheel mounted on a stool — is the not-quite-readymade that Duchamp constructed in 1913.

34 Claes Oldenburg, *Store Days* (New York: Something Else Press, 1967), 8.

35 Of course, this is precisely what Greenberg would dismiss as mere "novelty."

36 Tracey Emin's *Bed* (1998) is the second-generation child of this move, completely emancipated from painting, wholly comprised of objects and exhibited horizontally (as a bed).

37 Leo Steinberg, *Other Criteria: Confrontations with Twentieth-Century Art* (New York: Oxford University Press, 1972), 90.

38 This is the essay's note 22. In a prior note (13), Fried has said that "theatricality . . . links all these artists to other figures as disparate as Kaprow, Cornell, Rauschenberg, Oldenburg, Flavin . . . the list could go on forever." *AO*, 170. With the exception of Cornell (underscoring my point, perhaps), it is a list of contemporaries.

39 In her very different account in *Modern Art and the Object* (1976), Ellen Johnson writes that "the surrealist artist acts as a kind of medium, releasing the mysterious power of things" (36), a point I would revise to read "releasing the mysterious thingness of objects."

40 This is not to say that Greenberg expresses any enthusiasm for surrealism. See, for instance, "Surrealist Painting" (1944), in *The Collected Essays and Criticism*, vol. 1, *Perceptions and Judgments, 1939–1944*, ed. John O'Brian (Chicago: University of Chicago Press, 1986), 225–31. I should point out, too, that Fried is not dismissing surrealism tout court; indeed, he does not wish "to be understood as saying that because they are theatrical, all Surrealist works . . . fail as art; a conspicuous example of major work that can be described as theatrical is Giacometti's sculpture." *AO*, 171. All but needless to add, alternative histories of twentieth-century art (e.g., Krauss's *Optical Unconscious*) reposition surrealism to the center of the story.

41 Elizabeth A. T. Smith, "All Freedom in Every Sense," in *Lee Bontecou: A Retrospective*, ed. Smith (Chicago: Museum of Contemporary Art, 2003), 173.

42 Donald Judd, "Lee Bontecou," in *Complete Writings*, 178–80. Further quotations come from these pages.

43 For this reason Judd advocates greater simplicity: "If the secondary elements are numerous and complex, as in a relief done in 1962 which is ferocious in too literal a way, the work nearly lapses into ordinary imagery." Ibid. This is the

place to note (but not to address) the competing semantic values of "literal" in Judd's and Fried's work.

44 Quoted in Smith, "All Freedom in Every Sense," 174. For cultural referents, see Mona Hadler, "Lee Bontecou's Worldscapes," in Smith, *Lee Bontecou*, 202–9.

45 For an account of this intensifying interest in both the journals and galleries, see Christopher Green, *Art in France: 1900–1940* (New Haven, CT: Yale University Press, 2000), 128–32.

46 Breton's grounds for differentiating Joyce have to do with his effort, however experimental, to convey reality. Breton, "On Surrealism in Its Living Works," in *Manifestoes of Surrealism*, trans. Richard Seaver and Helen R. Lane (Ann Arbor: University of Michigan Press, 1972), 298–99.

47 Ibid., 299; André Breton, "Manifesto of Surrealism," in *Manifestoes of Surrealism*, 41, 3.

48 André Breton, *Soluble Fish*, in *Manifestoes of Surrealism*, 80.

49 Walter Benjamin, *The Arcades Project*, ed. Rolf Tiedemann, trans. Howard Eiland and Kevin McLaughlin (Cambridge, MA: Harvard University Press, 1999), 883. For accounts of the impact of surrealism on Benjamin's thought — and the inspiration that Aragon's work provided for *Das Passagen-Werk*, see Rolf Tiedemann, "Dialectics at a Standstill," trans. Gary Smith and André Lefevre, in Benjamin, *Arcades Project*, 929–45; Margaret Cohen, *Profane Illumination: Walter Benjamin and the Paris of the Surrealist Revolution* (Berkeley: University of California Press, 1995); and Susan Buck-Morss, *The Dialectics of Seeing: Walter Benjamin and the Arcades Project* (Cambridge, MA: MIT Press, 1989), 32–34.

50 See also Michel Leiris, *Le sacré dans la vie quotidienne: Notes pour le sacré dans la vie quotidienne* (1938; Paris: J-M Place, 1994), which combines the ethnographic and the psychoanalytic.

51 Walter Benjamin, "Dream Kitsch," trans. Howard Eiland, in *Selected Writings, Volume 2*, 3.

52 Benjamin, "Surrealism," 209 (hereafter cited parenthetically).

53 André Breton, *Nadja*, trans Richard Howard (New York: Grove Press, 1994), 52. Among other accounts of Breton and objects, see Haim N. Finkelstein, *Surrealism and the Crisis of the Object* (Ann Arbor: University of Michigan Press, 1979); and, in particular, Foster, *Compulsive Beauty*, 29–42.

54 While the explicit reference is to Breton, the claim is more appropriate to Aragon's *Paysan de Paris*, one of the main sections of which is "Passage de l'Opéra" (1926). At points in the essay, Benjamin effectively fuses the two surrealist texts (among others), a fact about which Miriam Hansen and I had long conversations in the midst of teaching the essay and the relevant surrealist texts in a course we taught together, "Modernity and the Sense of Things."

55 André Breton, "The Surrealist Situation of the Object," in *Manifestoes of Surrealism*, 263.

56 Octavio Paz, preface to *Je vois, j'imagine: Poème-objets*, by André Breton, quoted by Keith Aspley, "André Breton: The Crisis of the Object and the Object-Poem," in *From Rodin to Giacometti: Sculpture and Literature in France, 1880–1950*, ed. Keith Aspley, Elizabeth Cowling, and Peter Sharratt (Amsterdam: Rodopi, 2000), 147.

57 This is the point at which Benjamin had given up hope that the "public esteem" of the movement could ever correlate with "any profounder impact on society." See Benjamin, "The Present Social Situation of the French Writer" (1934), trans. Rodney Livingstone, in *Selected Writings, Volume 2*, 759–61.

58 André Breton, "What Is Surrealism?", in *What Is Surrealism? Selected Writings*, by Breton, ed. Franklin Rosemont (New York: Pathfinder Press, 1978), 184.

59 Breton, "Surrealist Situation," 258.

60 *Cahiers d'art* 11.1–2 (1936).

61 Breton, "Crisis of the Object," 275 (hereafter cited parenthetically as "CO").
 Breton published *Le surréalisme et la peinture* in 1928 (Gallimard); that text was
 incorporated into the subsequent edition of the book, which appeared in 1965
 (Gallimard).

62 André Breton, "Limits Not Frontiers of Surrealism," in *Surrealism*, ed. Herbert
 Read (London: Faber and Faber, 1937), 101–2. On Heidegger, see chapter 1.

63 Gaston Bachelard, *The New Scientific Spirit* (1934), trans. Arthur Goldhammer
 (Boston: Beacon Press, 1984), 39–40.

64 Gavin Parkinson, *Surrealism, Art and Modern Science: Relativity, Quantum
 Mechanics, Epistemology* (New Haven, CT: Yale University Press, 2008), 62–63.

65 Bachelard went on to publish an essay entitled "Le surrationalisme," his con-
 tribution to *Inquisitions* (June 1936), the postsurrealist review inaugurated by
 Tzara and Roger Caillois. Bachelard allies himself with the impulse of surreal-
 ist experimentation: "If, in any experience, one does not risk one's reason, that
 experience is not worth while attempting." Gavin Parkinson quotes the line
 in *Surrealism, Art and Modern Science*, 100, and discusses the correspondence
 leading up to the essay's publication.

66 In the "Work of Art" lecture, Heidegger describes how the "unpretentious
 thing evades thought most stubbornly," making it all but impossible to gain
 any access to "the thingly character of the thing." Martin Heidegger, "The Ori-
 gin of the Work of Art," in *Poetry, Language, Thought*, trans. Albert Hofstadter
 (New York: Harper Collins, 2001), 31. See chapter 1.

67 Man Ray, *Self-Portrait* (New York: Penguin, 1963), 368 (hereafter cited paren-
 thetically as *S-P*). On Man Ray's work with the models, see Parkinson, *Surreal-
 ism, Art and Modern Science*, 72–88. And see Isabelle Fortuné, "Man Ray et les
 objets mathématiques," *Etudes photographiques* 6 (May 1999): 1–11. For a brief
 mention of Max Ernst's and Man Ray's work in the context of art's response
 to mathematical models, through to digital art, see Iorfida Vincenzo, Lorenzi
 Giulia, and Francaviglia Mauro, "Algebraic Varieties in the Art of Nineteenth
 Century: From the Concept of Hyperspace to 'Exact' Rational Art," *Journal of
 Applied Mathematics* 4.4 (2011): 197–203.

68 André Breton, "Crise de l'objet" (1936), in *Surréalisme et la peinture* (Paris:
 Gallimard, 1965), 280.

69 See Parkinson, *Surrealism, Art and Modern Science*, 77–88. On the general
 importance of photography, see Rosalind E. Krauss, *The Originality of the
 Avant-Garde and Other Modernist Myths* (Cambridge, MA: MIT Press, 1986),
 98–99. By phrasing my point this way I mean to refrain from any number of
 arguments in which photography is said to dematerialize the object.

70 Man Ray's photographic transformation of these models should be considered
 part of the object portraiture that has played a crucial (though insufficiently
 acknowledged) role in the history of plastic modernism and the avant-garde
 (and thus the history of modernist sculpture). Alex Potts writes of the photo-
 graphs that Man Ray took of Duchamp's readymades (subsequently cropped by
 Duchamp): "In viewing such photographs, the double bind between an imagi-
 native projection of the work as a resonant form or shape, and the blocking of
 that through one's awareness of what it actually is, really comes into its own."
 The decontextualizing and defamiliarizing photograph gives the object "a cer-
 tain aura, partly through the calculated cropping and shading and simplifying
 that makes the shape stand out"; thus readymades "as displayed in a gallery
 suffer in comparison with their photographic representation." Potts, *The Sculp-
 tural Imagination: Figurative, Modern, Minimalist* (New Haven, CT: Yale Uni-
 versity Press, 2000), 115–16. See also Sarah Hamill, *David Smith in Two Dimen-*

sions: Photography and the Matter of Sculpture (Berkeley: University of California Press, 2014).

71 Soupault "discovered" *Les chants* in a bookshop in 1919. In 1913, before they were married, Adon Lacroix read French literature to Man Ray, including *Maldoror*. See Neil Baldwin, *Man Ray: American Artist* (New York: Clarkson N. Potter, 1988), 37.

72 Comte de Lautréamont, *Les chants de Maldoror*, trans. Guy Wernham (New York: New Directions, 1965), 263.

73 Quoted by Breton, "Surrealist Situation," 275.

74 Salvador Dalí, "The Object as Revealed in Surrealist Experimentation," in *The Collected Writings of Salvador Dalí*, trans. Haim Finklestein (Cambridge: Cambridge University Press, 1998), 237.

75 This is to say that the photograph of the assemblage can also be read as a kind of illustration from the novel, in obvious violation of the sort of medium specificity described by Lessing (see my overture, above) and championed by Greenberg in his defense of abstraction in "Towards a Newer Laocoon," *Partisan Review* 7.4 (July–August 1940): 296–310, and in distinction from Duchamp.

76 Clement Greenberg, "Towards a Newer Laocoon" (1940), in *Clement Greenberg: The Collected Essays and Criticism*, vol. 1, *Perceptions and Judgments, 1939–1944*, ed. John O'Brian (Chicago: University of Chicago Press, 1986), 32.

77 Arturo Schwartz, *Man Ray: The Rigour of the Imagination* (New York: Rizzoli, 1977), 158. See also the exchange with Pierre Bourgeade in Bourgeade, *Bonsoir, Man Ray*, 59.

78 Thierry de Duve, *Kant after Duchamp* (Cambridge, MA: MIT Press, 1998), 159–66. De Duve extrapolates from Duchamp's emphasis on the act of choosing — choosing one tube of paint or another, thus choosing a ready-made thing — to develop his account of "pictorial nominalism." He goes on to quote Duchamp, from a 1961 interview, asserting, "Since the tubes of paint used by the artists are manufactured and ready-made products we must conclude that all paintings in the world are 'readymades aided' and also works of assemblage" (163). This is an important comment in the conceptual history of the *object-from of painting*. See also de Duve, *Pictorial Nominalism: On Marcel Duchamp's Passage from Painting to the Readymade*, trans. Dana Polan (Minneapolis: University of Minnesota Press, 1991); and de Duve, "The Readymade and the Tube of Paint," *Artforum* 24 (1986): 110–21.

79 Marcel Mauss, *The Gift: The Form and Reason for Exchange in Archaic Societies*, trans. W. D. Halls (New York: Norton, 1990), 48–49, 76.

80 Although I disagree with Arturo Schwarz (among others) when he generalizes that "for Man Ray the title is as important as the object itself" (*Man Ray*, 153), in the case of *Le cadeau*, the title does add the dimension I develop here.

81 Nelson Goodman, *Languages of Art* (Indianapolis: Hackett, 1976), 113–22. See also Gérard Genette, *The Work of Art: Immanence and Transcendence*, trans. G. M. Goshgarian (Ithaca, NY: Cornell University Press, 1997), 16–19.

82 Man Ray, *Objets de mon affection* (New York: Hacker Art Books, 1983), 158. As Rosalind Krauss put it in the early 1980s, aligning his work with Baudrillard's interest in the order of the simulacrum, Man Ray's photographic record usurped the object, and in the many cases of the disassembled, lost, or destroyed object, "the remainder, this photographic trace, was then used by Man Ray as a process that for him had an internal logic: the creation of copies of copies, that is, the making of multiple versions of these objects after the photograph whose status had become a copy without an original." "Objects of My Affection," in *Man Ray: Objects of My Affection* (New York: Zabriskie Gallery, 1985), n.p. As Krauss says elsewhere, surrealist photography "achieved some of [the movement's] supreme images — images of far greater power than

most of what was done in the remorselessly labored paintings and drawings that came increasingly to establish the identity of Breton's concept of 'surrealist painting.'" Krauss, "Photography in the Service of Surrealism," in *L'amour fou: Photography and Surrealism* (New York: Abbeville Press, 1985), 19. On the aesthetic impact of Man Ray's photography on the surrealist enterprise tout court, see, also from *L'amour fou*, Jane Livingston, "Man Ray and Surrealist Photography," 115–54.

83 As Man Ray narrates the story, Tzara returned that night: "We made some Rayographs together, he disposing matches on the paper, breaking up the matchbox itself for an object, and burning holes with a cigarette in a piece of paper, while I made cones and triangles and wire spirals, all of which produced astonishing results" (*S-P*, 129).

84 Cocteau's comment comes from a later essay, quoted in the *Vanity Fair* issue discussed below.

85 Christian Schad is the most notable predecessor, and László Moholy-Nagy began producing photograms in 1922.

86 Quoted by Elizabeth Hutton Turner, "Transatlantic," in *Perpetual Motif: The Art of Man Ray*, ed. Merry Foresta (Washington, DC: National Museum of American Art, Smithsonian Institution, 1988), 145.

87 For an exacting account of how the rayographs do and do not resemble painting and photography, see Susan Laxton, "*Flou*: Rayographs and the Dada Automatic," *October* 127 (Winter 2009): 25–48. Her comment about the photogrammic method merits quoting at length: "Photograms are extremely concrete, to the point that they literalize the indexical paradigm that has been central to theorization of photographic representation from its inception. In this sense, it could be said that in the rayographs photography *itself* appeared for the first time, photography in its very 'difference from' the material world it represented" (29).

88 Man Ray, in an interview by Jean Vidal in 1929, quoted by Sandra S. Phillips, "Themes and Variations: Man Ray's Photography in the Twenties and Thirties," in Foresta, *Perpetual Motif*, 179.

89 Benjamin translated the essay for *G* in 1924 and subsequently quoted from it in his essay on photography, with no mention of the rayographs. For him, the photogrammic method would violate photography's capacity to disclose reality while eliminating the object's aura. See "Little History of Photography," in *Selected Writings, Volume 2*, 523.

90 The Tzara essay, reprinted in *Man Ray/Photographies/1920–1934*, subsequently appears in *Man Ray: 60 anni di libertà/60 ans de libertés/60 years of liberties*, ed. Arturo Schwarz (Paris: Eric Losfeld, 1971), 104–8. The quotation comes from 108.

91 Georges Ribemont-Dessaignes, *Man Ray* (Paris: Gallimard, 1924), excerpted in Arturo Schwarz, *Man Ray: 60 anni*, 90, translated by Rodney Stringer.

92 Man Ray, "Forty Years Ago . . ." (1963), reprinted in Arturo Schwarz, *Man Ray: 60 anni*, 25. Whereas in this case Man Ray is making specific reference to the rayographs, he had used the imagery previously to describe his photographic work tout court. See his "Age of Light," v.

93 *Little Review* 9.1 (Autumn 1922): 100; "A New Method of Realizing the Artistic Possibilities of Photography: Experiments in Abstract Form, Made without a Camera Lens, by Man Ray, the American Painter," *Vanity Fair* 19.3 (November 1922): 50. During the 1920s, *Vanity Fair*'s circulation numbers exceeded ninety thousand. In Man Ray's version of the story, "An editor of a literary and art magazine took some prints for publication" (*S-P*, 131). The *Little Review* continued to publish rayographs over the course of the next few years.

94 For the best general assessment of *Vanity Fair* in the field of cultural pro-
duction, see Faye Hammill, "In Good Company: Modernism, Celebrity, and
Sophistication in *Vanity Fair*," in *Modernist Star Maps: Celebrity Modernity Cul-
ture*, ed. Aaron Jaffe and Jonathan Goldman (Surrey: Ashgate, 2010), 123–35.
Hammill quotes and corrects the characterization of the magazine that schol-
ars of modernism have perpetuated. For the most sophisticated reading of
modern fashion in the context of modernism, see Jessica Burstein, *Cold Mod-
ernism: Literature, Fashion, Art* (University Park: Pennsylvania State University
Press, 2012). See also Amy Fine Collins, "Vanity Fair: The Early Years, 1914–
1936," *Vanity Fair*, July 7, 2011, www.vanityfair.com/magazine/vintage
/earlyyears (accessed August 16, 2014). And for several references to *Vanity
Fair* in an account of modernism, see Michael North, *Reading 1922: A Return
to the Scene of the Modern* (New York: Oxford University Press, 2001).
95 Tristan Tzara, "News of the Seven Arts from Europe," *Vanity Fair* 19 (Novem-
ber 1922): 51, 88. In the same year, see also, from Tzara, "What We Are Doing
in Europe—Some Account of the Latest Ballets, Books, Pictures and Literary
Scandals of the Continent," *Vanity Fair* 18 (September 1922): 68; and "Some
Memoirs of Dada," *Vanity Fair* 18 (July 1922): 70).
96 Man Ray had explained in a letter to the dean of Dada in Zürich: "Cher Tzara—
dada cannot live in New York. All New York is dada, and will not tolerate a
rival,—will not notice dada." Quoted by Mason Klein, *Alias Man Ray: The Art
of Reinvention* (New Haven, CT: Yale University Press, 2009), 14. Nonetheless,
he and Duchamp went on to publish *New York Dada* (just one issue, in 1919). In
Man Ray's words, "In 1919, with the permission and with the approval of other
Dadaists, I legalized Dada in New York." "Who Made Dada?" (1958), reprinted
in Arturo Schwarz, *Man Ray: 60 anni*, 16.
97 Benjamin, "Present Social Situation," 760. His term is in fact "haute bourgeoi-
sie," which doesn't translate into the American context. My argument here
very seriously elides the politics of surrealism, for an account of which see
Helena Lewis, *The Politics of Surrealism* (New York: Paragon House, 1988). Man
Ray himself made repeated pleas, after *la crise de 1929*, in behalf of desire as the
means of uniting a fractured society.
98 See *Vanity Fair* (July 1922): 52.
99 Bernard Barryte with Graham Howe and Elaine Dines, "Paul Outerbridge:
A Singular Aesthetic," in *Paul Outerbridge: A Singular Aesthetic*, ed. Elaine K.
Dines-Cox (Laguna Beach, CA: Laguna Beach Museum of Art, 1981), 16.
100 Benjamin, *Arcades Project*, 68. Nonetheless, Benjamin points elsewhere to
the limits of object portraiture—and thus to a very different kind of "crisis
of the object." For when photography becomes more experimental, the "cre-
ative" becomes a "fetish, whose lineaments live only in the full illumination
of changing fashion"; this is a "posture of a photography that can endow any
soup can with cosmic significance but cannot grasp a single one of the human
connections in which it exists, even when this photograph's most dream-laden
subjects are a forerunner more of its salability than of any knowledge it might
produce." "Little History of Photography" (1931), trans. Edmund Jephcott and
Kigsley Shorter, 526. On fashion and modernism, see Burstein, *Cold Modernism*.
101 See Jennifer Marshall, *Machine Art, 1934* (Chicago: University of Chicago Press,
2012).
102 *291* 7–8 (1915–16).
103 Rainer Maria Rilke, letter from 1925, quoted by Heidegger, "What Are Poets
For?", in *Poetry, Language, Thought*, trans. Albert Hofstadter (New York: Harper
and Row, 2001), 111. On Rilke's lyricization of objects, see chapter 2.
104 Cited by William Bozaitis, "The Joke at the Heart of Things: Francis Picabia's

Machine Drawings and the Little Magazine *291*," *American Art* 8 (Fall 1994): 46. Pepe Karmel convincingly argues that Picabia's attraction to machinery was the product of his 1913 visit to New York, although 1915 inaugurates his more objective style. "Francis Picabia, 1915: The Sex of a New Machine," in *Modern Art and America: Alfred Stieglitz and His New York Galleries*, ed. Sarah Greenough (Washington, DC: National Gallery of Art, 2000), 203–19.

105 For a summary of interpretations, see Barbara Zabel, *Assembling Art: The Machine and the American Avant-Garde* (Jackson: University Press of Mississippi, 2004), 89–91. For a particularly persuasive account of the gender politics that underlie this portrait and other mechanomorphic work, see Caroline A. Jones, "The Sex of the Machine: Mechanomorphic Art, New Women, and Francis Picabia's Neurasthenic Culture," in *Picturing Science*, ed. Jones and Peter Galison (New York: Routledge, 1998), 145–80.

106 Henri Bergson, *Laughter: An Essay on the Meaning of the Comic*, trans. Cloudesley Brereton and Fred Rothwell (New York: Macmillan, 1914), 29.

107 André Breton, "Convulsionnaires," foreword to Man Ray, *La photographie n'est pas l'art* (Paris: GLM, 1937), n.p.

108 Klein, *Alias Man Ray*, 58.

109 Quoted by Baldwin, *Man Ray*, 65.

110 In his book on Man Ray's early work, Francis Naumann simply rechristens the painting *Filter*. Even such a designation doesn't resolve the oddity of the offset top of the metal tube, which makes the basket alone look more like a grinder. Man Ray thought highly enough of the work to include *Percolator* in both his New York and Paris shows. See Francis M. Naumann, *Conversion to Modernism: The Early Work of Man Ray* (New Brunswick, NJ: Rutgers University Press, 2003), 181–82.

111 Francis Naumann explains that Man Ray would have seen two of Duchamp's chocolate grinders, if not exhibited in New York galleries, then in the apartment of Walter Arensberg. Ibid., 182.

112 For biographical details I'm relying chiefly on Baldwin, *Man Ray*.

113 Man Ray, "Object of Destruction," *This Quarter* 5.1 (September 1932): 55.

114 Tristan Tzara, "Dada Manifeste sur l'amour faible et l'amour amer" (1920), from Gérard Durozoi, *History of the Surrealist Movement*, trans. Alison Anderson (Chicago: University of Chicago Press, 2002), 4.

115 "After you have settled yourself in a place as favorable as possible to the concentration of your mind upon itself, have writing materials brought to you. Put yourself in as passive, or receptive, a state of mind as you can." André Breton, "Manifesto of Surrealism," 29. The best-known example of the genre is no doubt Jacques Prévert's poem "Pour faire le portrait d'un oiseau" (1949).

116 Reported conversation in Schwarz, *Man Ray: Rigour*, 205.

117 Surrealist eyes are too numerable to name, but important instances include Max Ernst's *Système de monnaie solaire* (1925, from *Histoire Natuerelle*), a graphite frottage of nothing but enucleated eyes, which looks forward to Lee Bontecou's many untitled drawings filled with eyes. Among its other horrors, Bataille's novel *The Story of the Eye* (1928) includes scenes of violent enucleation. Shortly after the opening of Dalí and Louis Buñel's *Un chien andalu* (1929), the film depicts a woman's open eye being sliced by a razor.

118 Rainer Maria Rilke, *New Poems*, trans. Edward Snow (Berkeley, CA: North Point Press, 2001) 183.

119 G. W. F. Hegel, *Aesthetics: Lectures on Fine Art*, trans. T. M. Knox (Oxford: Clarendon Press, 1975), 1:153–54.

120 "To experience the aura of an object we look at means to invest it with the ability to look back at us." Walter Benjamin, "On Some Motifs in Baudelaire," trans. Harry Zohn, in *Selected Writings, Volume 4, 1938–1940*, ed. Howard Eiland

and Michael W. Jennings (Cambridge, MA: Harvard University Press, 2003), 338.

121 Rosalind E. Krauss, *Passages in Modern Sculpture* (Cambridge, MA: MIT Press, 1981), 123.

122 The sequence of problems posed by the most memorable protodadaist, proto-surrealist assemblage in literature, Franz Kafka's *Odradek*, helps to clarify this point. First off, the problem with the object is its physical incomprehensibility—a "creature" that "looks like a flat star-shaped spool for thread, and indeed it does seem to have thread wound upon it," "old, broken-off bits of thread, knotted and tangled together," with "a small wooden crossbar" sticking "out of the middle of the star, and another small rod is joined to that at a right angle." The next problem is its ubiquity in space, "lurk[ing] by turns in the garret, the stairway, the lobbies, the entrance hall" with no apparent aim in life. But the ultimate problem is its *duration*: "The idea that he is likely to survive me I find almost painful." Kafka literalizes the other thing *in* object form, which is so ill-formed or unformed and "extraordinarily nimble" that it "can never be laid hold of." "The Cares of a Family Man," trans. Willa Muir and Edwin Muir, in *Collected Stories* (New York: Knopf Doubleday, 1993), 183. Fried lists a number of surrealist painters who thematize time.

123 Bürger, *Theory of the Avant-Garde*, 27.

124 Quoted by Schwarz, *Man Ray: Rigour*, 206. He repeats the entry in the hand-made album he produced in Hollywood in 1944, *Objects of My Affection*; pages from the album are reprinted by Phillip Prodger, *Man Ray/Lee Miller: Partners in Surrealism* (London: Merrell, 2011), 108–9.

125 The quotation comes from the interview with Arturo Schwarz (*Man Ray: Rigour*, 206), as does this basic history of the object's reproduction. See also Man Ray, *S-P*, 389–92.

126 Jacques Lacan, *The Seminar of Jacques Lacan, Book XI: The Four Fundamental Concepts of Psychoanalysis*, trans. Alan Sheridan (New York: Norton, 1998), 95.

127 You need not look at the *Object to Be Destroyed* for long to see how the metronome figures the letter A. It does so as *l'Objet Grand A*, displacing all the *objets petit a*'s that circulate through Lacan's work as the object cause of desire, to insist on the object's own capacity to elicit fear, anxiety, &c.

128 Benjamin, "Surrealism," 218.

Chapter Four

This chapter was originally delivered as a talk in May 2008 at a conference for Fredric Jameson sponsored jointly by Columbia University and New York University; the decision to speak about Philip K. Dick was prompted by my having found Jameson to be, over and over again, Dick's most convincing expositor. I subsequently presented portions of the evolving essay as the Gunn Lecture at the University of Kansas, and at Brown University, UCLA, the University of Ottawa, Yale, the Sterling and Francine Clark Institute, the University of California (Riverside), and Princeton University. I owe a considerable debt to those audiences for the questions that helped to shape the argument.

1 "Philip K. Dick on Philosophy: A Brief Interview," in *The Shifting Realities of Philip K. Dick: Selected Literary and Philosophical Writings*, by Philip K. Dick, ed. Lawrence Sutin (New York: Vintage Books, 1995), 45–46; Philip K. Dick, *VALIS* (1981; New York: Vintage Books, 1991), 23 (hereafter cited parenthetically).

2 Fredric Jameson, "History and Salvation in Philip K. Dick" (2000), in *Archaeologies of the Future: The Desire Called Utopia and Other Science Fictions* (New York:

Verso, 2005), 366. For Jameson, historicizing has a different horizon—say, the stages of capital and the history of the human senses in modernity and post-modernity.

3 I'm borrowing the term "vernacular modernism" from Miriam Hansen, who uses it to recharacterize the place of film within the modern history of art and aesthetics. See, for instance, "The Mass Production of the Senses: Classi-cal Cinema as Vernacular Modernism," *Modernism/Modernity* 6.2 (April 1999): 59–77; "Vernacular Modernism: Tracking Cinema on a Global Scale," in *World Cinemas, Transnational Perspectives*, ed. N. Durovicova and K. Newman (New York: Routledge, 2010), 287–314.

4 Louis Althusser, "Preface to *Capital* Volume One," in *Lenin and Philosophy and Other Essays*, trans. Ben Brewster (New York: Monthly Review Press, 1971), 71–77. On "la coupure épistémologique," see Althusser, *For Marx*, trans. Ben Brewster (New York: Verso, 2005), ch. 2.

5 Louis Althusser, "Avertissement aux lecteurs du livre I du *Capital*," in Marx, *Le capital*, Livre I, trans. J. Roy (Paris: Garnier Flammarion, 1969), 10.

6 I find it hard, while making this point, to resist pointing out the narrative bra-vado with which Althusser, writing for the French communist journals of the early 1960s (*La pensée*, above all), pits the early Marx against the mature Marx, describing Marx "on the threshold of becoming himself." Of the *1844 Manu-scripts*, Althusser posits Marx as one of those "prisoners of a philosophy that is exercising its last prestige and power over them": "the Marx *furthest from Marx* is this Marx, the Marx on the brink, on the eve, on the threshold—as if, before the rupture, in order to achieve it, he had to give philosophy every chance, its last, this absolute empire over its opposite, this boundless theo-retical triumph, that is, *its defeat*." *For Marx*, 159–60. Livy's speculations about Alexander are considered an early version of alternate history, and Philip K. Dick was inspired by Ward Moore's *Bring the Jubilee* (1953), his account of the South's having won the Civil War. See Lawrence Sutin, *Divine Invasions: A Life of Philip K. Dick* (New York: Citadel Press, 1991), 113. The difference—when it comes to Wells, Dick, and Althusser—lies in the image of simultaneous reali-ties, neither of which can be discounted.

7 Philip K. Dick, "Precious Artifact" (1964), in *Selected Stories of Philip K. Dick* (New York: Pantheon Books, 2002), 298.

8 Philip K. Dick, *Time Out of Joint* (1959; New York: Carroll & Graff, 1987), 110. More generally, Dick wrote that "we live in a society in which specious realities are manufactured by the media, by governments, by big corporations, by reli-gious groups, political groups—and the electronic hardware exists by which to deliver these pseudo-worlds right into the heads of the reader, the viewer, the listener." "Introduction: How to Build a Universe That Doesn't Fall Apart Two Days Later," in *I Hope I Shall Arrive Soon* (New York: St. Martin's, 1987), 4.

9 Philip K. Dick, *The Exegesis of Philip K. Dick*, ed. Pamela Jackson and Jonathan Lethem (New York: Houghton Mifflin Harcourt, 2011), 337. What Dick always referred to as the *Exegesis* consists of the journals he kept, which ran to eight thousand unpublished pages, after he began to experience visions in 1974.

10 Ibid., 397, 275; Dick, "Joe Protagoras Is Alive and Living on Earth," in *Shifting Realities of Philip K. Dick*, 140.

11 Dick, "Dick on Philosophy," 45–46.

12 See Peter Byrne, *The Many Worlds of Hugh Everett III: Multiple Universes, Mutual Assured Destruction, and the Meltdown of a Nuclear Family* (New York: Oxford University Press, 2013).

13 Philip K. Dick, *Flow My Tears, the Policeman Said* (1974; New York: Vintage Books, 1993), 209 (hereafter cited parenthetically).

14 Philip K. Dick, *Time Out of Joint* (New York: Mariner Books, 2012), 50.

15 N. Katherine Hayles, *How We Became Posthuman: Virtual Bodies in Cybernetics, Literature, and Informatics* (Chicago: University of Chicago Press, 1999), 61. While I may seem to be overdrawing the connection between American cybernetics and French structuralism, this connection has now been fleshed out. See Lydia Liu, "The Cybernetic Unconscious: Rethinking Lacan, Poe, and French Theory," *Critical Inquiry* 36.2 (Winter 2010): 288–320. And see Bernard Dionysius Geoghegan, "From Information Theory to French Theory: Jakobson, Lévi-Strauss and the Cybernetic Apparatus," *Critical Inquiry* 38.1 (Autumn 2011): 96–126.

16 Niklas Luhmann, *Social Systems*, trans. John Bednaz Jr. and Dirk Baeker (Stanford, CA: Stanford University Press, 1996), 77. Luhmann is audibly objecting to the Aristotelian account of things in the *Categories*. For Heidegger's very different objection, see chapter 1.

17 Philip K. Dick and Roger Zelazny, *Deus Irae* (New York: Collier Books, 1976), 42, 23 (hereafter cited parenthetically).

18 Aleksandr Rodchenko, quoted by Christina Kiaer, "Rodchenko in Paris," *October* 75 (Winter 1996): 3.

19 David Gill, "'O Ho' on sale at Ebay," http://totaldickhead.blogspot.com/2008/07/oh-ho-on-sale-at-ebay.html (accessed February 15, 2014). In *VALIS*, Fat's friends discuss the object: "How'd Fat get that ceramic pot? Some broad gave it to him?" "Made it, fired it and gave it to him, around 1971 after his wife left him" (154).

20 Dick, "Joe Protagoras Is Alive," 143.

21 Kristin Ross, *Fast Cars, Clean Bodies: Decolonization and the Reordering of French Culture* (Cambridge, MA: MIT Press, 1996), 13 (hereafter cited parenthetically).

22 "Rather than theorizing the liquidation of the historical," Ross writes, "structuralism enacted and legitimated that liquidation. After all, structuralism's concern was the ordering of objects, not the criticism of their function" (177). The first of these claims seems overdrawn to the extent that it elides the very public Sartre–Lévi-Strauss debate about history. On that debate and the problematics of literary historicism, see James Chandler, *England in 1819: The Politics of Literary Culture and the Case of Romantic Historicism* (Chicago: University of Chicago Press, 1998), 34–100.

23 And yet, as Ross importantly adds, "from all the pages of the New Novelist prose Barthes read in the early 1960s, what seems to stay with him, almost nostalgically, are the objects, the eyeglasses, eraser, coffeemakers, prefab sandwiches, and cigarettes" (184). This helps to explain Barthes's "fall" from structuralism and semiotics in his later work.

24 See Jean Baudrillard, "Simulacra and Science Fiction," in *Simulacra and Simulation*, trans. Sheila Faria Glaser (Ann Arbor: University of Michigan Press, 1995), 121–28. On Baudrillard's materialism, see Ross, *Fast Cars, Clean Bodies*, 5.

25 Quoted by Elaine Tyler May, *Homeward Bound: American Families in the Cold War Era* (New York: Basic Books, 1990), 11.

26 Lizabeth Cohen, *A Consumer's Republic: The Politics of Mass Consumption in Postwar America* (New York: Basic Books, 2004), 113.

27 Quoted in ibid., 261. On the economic theory that funds such visions of consumption, see Regenia Gagnier, *The Insatiability of Human Wants: Economics and Aesthetics in a Market Society* (Chicago: Chicago University Press, 2000). For the ways in which American marketing discourse deployed such theory, see Bill Brown, "Now Advertising: Late James," *Henry James Review* 30.1 (Winter 2009): 10–21.

28 Thomas Pynchon, *The Crying of Lot 49* (1965; New York: Perennial Classics, 1999), 25; Vladimir Nabokov, *Pnin* (1953; New York: Vintage, 1989), 13–14. Nabokov's novel provides an exemplary scene of redemptive reification:

Despite Pnin's sad academic fate, he derives enormous satisfaction from an aquamarine glass bowl, in which he serves Pnin's punch. It is "one of those gifts whose first impact produces in the recipient's mind a colored image, a blazoned blur, reflecting with such emblematic force the sweet nature of the donor that the tangible attributes of the thing are dissolved, as it were, in this pure inner blaze, but suddenly and forever leap into brilliant being when praised by an outsider to whom the true glory of the object is unknown" (153). Jackson Lears distinguishes himself as a historian who does take the time to summarize an artistic effort to interrupt the status quo of consumer culture, just as he points out how marketing strategies within that culture appropriate avant-garde techniques. See *Fables of Abundance: A Cultural History of Advertising in America* (New York: Basic Books, 1994), chs. 10–12. For a thorough discussion of objects in Nabokov's fiction, especially *Pnin*, see Babette Bärbel Tischleder, *The Literary Life of Things: Case Studies in American Fiction* (Frankfurt: Campus Verlag, 2014), ch. 4, "Object Trouble."

29 *The Collected Stories of Philip K. Dick* (New York: Citadel Press, 1990), 1:350. Dick's comment about the "ultimate in paranoia" was made in reference to this story. "Afterthoughts by the Author," in *The Best of Philip K. Dick* (New York: Ballantine, 1977), 447.

30 Philip K. Dick, *Ubik*, in *Four Novels of the 1960s* (New York: Library of America, 2007), 629 (hereafter cited parenthetically). On animate objects in the American 1950s, see also chapter 8.

31 Philip K. Dick, *Now Wait for Last Year*, in *Five Novels of the 1960s and 70s* (New York: Library of America, 2008), 667. "Autonomic cab" is the designation offered in *The Three Stigmata of Palmer Eldritch*, in *Four Novels of the 1960s*, 224 (hereafter cited parenthetically).

32 Philip K. Dick, *Do Androids Dream of Electric Sheep*, in *Four Novels of the 1960s*, 464 (hereafter cited parenthetically).

33 Bruno Latour, *The Politics of Nature: How to Bring the Sciences into Democracy*, trans. Catherine Porter (Cambridge, MA: Harvard University Press, 2004), 71, 76. See also "Objects Too Have Agency," *Reassembling the Social: An Introduction to Actor-Network Theory* (Oxford: Oxford University Press, 2005), 63–82. And see also, for my engagement with Latour, this book's overture and chapter 5.

34 Jacques Derrida, "Typewriter Ribbon: Limited Ink (2) ('within such limits')," trans. Peggy Kamuf, in *Material Events: Paul de Man and the Afterlife of Theory*, ed. Tom Cohen, Barbara Cohen, J. Hillis Miller, and Andrzej Warminski (Minneapolis: University of Minnesota Press, 2001), 350.

35 Henri Bergson, *Creative Evolution*, trans. Arthur Mitchell (New York: Dover, 1998), 5.

36 Gilles Deleuze, *Bergsonism*, trans. Hugh Tomlinson and Barbara Habberjam (New York: Zone, 1991), 71 (hereafter cited parenthetically).

37 Walter Benjamin, *The Arcades Project*, trans. Howard Eiland and Kevin McLughlin (Cambridge, MA.: Harvard University Press, 1999), 206.

38 Philip K. Dick, *Martian Time-Slip* (New York: Vintage, 1995), 206.

39 Philip K. Dick, "Schizophrenia and *The Book of Changes*," in *Shifting Realities of Dick*, 176–77.

40 Walter Benjamin, "On Some Motifs in Baudelaire," trans. Harry Zohn, in *Selected Writings, Volume 4, 1938–1940*, ed. Howard Eiland and Michael W. Jennings (Cambridge, MA: Harvard University Press, 2003), 314–16.

41 Philip K. Dick, "My Definition of Science Fiction," "Notes Made Late at Night by a Weary SF Writer," in *Shifting Realities of Philip K. Dick*, 100, 19.

42 Jacques Rancière, "The Politics of Literature," *SubStance* 33.1, issue 103 (2004): 12.

43 P. W. Singer, *Wired for War: The Robotic Revolution and Conflict in the 21st Century* (New York: Penguin, 2009), 150–69, quotation on 86.

44 Philip K. Dick, "Autofac," in *Selected Stories of Philip K. Dick* (New York: Random House, 2002), 213, 204 (hereafter cited parenthetically).

45 Fredric Jameson, *Archaeologies of the Future*, 345–46 (hereafter cited parenthetically). On objects in Dick's fiction, see also Alexander Star, who describes the novelist's "sure feel for the detritus and debris, the obsolescent object-world, of postwar suburbia." "The God in the Trash," *New Republic*, December 6, 1993, 34. Quoted by Lawrence Sutin, introduction to Dick, *Shifting Realities of Philip K. Dick*, xxi.

46 Fredric Jameson, *Postmodernism; or, The Cultural Logic of Late Capitalism* (Durham, NC: Duke University Press, 1991), 285. Beyond such "nostalgia for outmoded forms of production," Andrew Hoberek has shown how Dick engaged in assessing and reimagining white-collar work in the context of those major arguments of the 1950s (in C. Wright Mills's *White Collar* and William Whyte's *The Organization Man*) that considered the change in middle-class work to have effected a new culture. See "The 'Work' of Science Fiction: Philip K. Dick and Occupational Masculinity in the Post–World War II United States," *Modern Fiction Studies* 43.2 (1997): 374–404.

47 William Morris, *News from Nowhere; or, An Epoch of Rest Being Some Chapters from "A Utopian Romance"* (1896; New York: Dover, 2004), 82.

48 MoMA held a solo exhibit of Eva Zeisel's work in 1946.

49 Philip K. Dick, *The Galactic Pot-Healer* (New York: Vintage Books, 1994), 132, 35.

50 In the final scene of the novel, Fenwright takes a chance throwing—not simply repairing—a pot. The results (reported in the novel's last line) are "awful." The episode underscores the specificity and dignity of repair work, but it also draws attention away from making and toward the appreciation of the already made—aesthetic experience rather than artistic production.

51 On Dick's work within Anne Dick's jewelry business, see Lawrence Sutin, *Divine Invasions*, 111–12.

52 Rob Barnard, "Paradise Lost? American Crafts' Pursuit of the Avant-Garde," in *Objects and Meaning: New Perspectives on Art and Craft*, ed. M. Anna Fariello and Paula Owen (Lanham, MD: Scarecrow Press, 2005), 60.

53 M. Anna Fariello, "Regarding the History of Objects," in Fariello and Owen, *Objects and Meaning*, 16–18; Paul Greenhalgh, curator at the Victoria and Albert Museum, quoted by Fariello (3).

54 Bernard Rackham and Hebert Read, *English Pottery* (1924; Yorkshire: EP, 1972), 1–7.

55 On the impact of Read's thinking on considerations of craft in the twenties and thirties, see Julian Stair, "Reinventing the Wheel—The Origins of Studio Pottery," in *The Persistence of Craft*, ed. Paul Greenhalgh (London: A & C Black, 2002), 49–60.

56 Herbert Read, *The Meaning of Art* (1931; London: Faber & Faber, 1972), 41–42. Read goes on: "Historically it is among the first of the arts. The earliest vessels were shaped by hand from crude clay dug out of the earth, and such vessels were dried in the sun and wind. Even at that stage, before man could write, before he had a literature or even a religion, he had this art, and the vessels then made can still move us by their expressive form" (41).

57 Herbert Read, *Art and Industry* (Bloomington: Indiana University Press, 1961), 41, 36 (hereafter cited parenthetically).

58 Philip K. Dick, *The Man in the High Castle*, in *Four Novels of the 1960s*, 7, 155 (hereafter cited parenthetically).

59 Gilles Deleuze and Félix Guattari, *A Thousand Plateaus*, trans. Brian Massumi (Minneapolis: University of Minnesota Press, 1987), 410. See my overture.

60 Two decades later, in *VALIS*, Horselover Fat's analyst reads to him from Lao Tzu's *Tao Te Ching*: "This is called the shape that has no shape,/The image that is without substance" (59).

61 Quoted by Herbert Read, *Henry Moore, Sculptor* (London: A. Zwemmer, 1934), 30. For Moore, then, "material can take its part in the shaping of an idea" (29).

62 Isamu Noguchi, *A Sculptor's World* (New York: Harper and Row, 1968), 18.

63 Quoted by Rosalind E. Krauss, *Passages in Modern Sculpture* (1977; Cambridge, MA: MIT Press, 1981), 141. While historians of modernist sculpture inevitably quote Hepworth's response to her visit to Arp's studio, Krauss's description of Arp's vitalism is especially poignant in relation to the jewelry: "The gentle bulges and twists in the smooth surfaces of the objects suggest that inorganic substance, such as marble or bronze, is possessed from within by animate force" (141). This is an appropriate place to emphasize that the "formless form" I am tracking should be differentiated from *informe* as conceptualized by Georges Bataille. For the latter, see Yve-Alain Bois and Rosalind E. Krauss, *Formless: A User's Guide* (New York: Zone, 1997).

64 Herbert Read, *The Philosophy of Modern Art* (1952; London: Faber & Faber, 1979), 203.

65 Bergson, *Creative Evolution*, ix.

66 Jack Burnham, *Beyond Modern Sculpture* (New York: George Brazilier, 1968), 67, 70, 79.

67 Leela Gandhi, "After Virtue: Notes on Early-Twentieth-Century Socialist Anti-materialism," *English Literary History* 77.2 (Summer 2010): 413.

68 Henri Bergson, *An Introduction to Metaphysics*, trans. T. E. Hulme (London: Palgrave, 2007), 40. John Mullarkey's introduction to this new edition, "'The Very Life of Things': Thinking Objects and Reversing Thought in Bergsonian Metaphysics," ix–xxxii, is particularly enlightening with regard to the recent philosophical context in which to be rereading Bergson. It will no doubt be clear to those familiar with the various neovitalisms of the twenty-first century that I mean to be sharing an earlier chapter in vitalist thought (philosophical and artistic) that has suffered serious neglect.

69 Rackham and Read, *English Pottery*, 7. For an intellectual biography of Read—which goes far toward answering the question of just what he read when—see David Thistlewood, *Herbert Read: Formlessness and Form* (London: Routledge & Kegan Paul, 1984). On the impact of a vitalist aesthetic on postwar American sculpture, see Burnham, *Beyond Modern Sculpture*, 100–109. The work of Theodore Roszak, Ibram Lassaw, and Seymour Lipton, I should say, seems to bear no resemblance to the descriptions of the jewelry in Dick's novel.

70 My use of the word "field" here derives from Pierre Bourdieu, *The Field of Cultural Production*, ed. Randal Johnson (Cambridge: Polity Press, 1993). All but needless to say, a literary history of the pot in English and American literature (Virginia Woolf's celebration of the pot in *Robinson Crusoe*, Willa Cather's attention to Anasazi pottery in *The Song of the Lark* and *The Professor's House*, &c.) could also inform my account of pottery in Dick's fiction. I suspect it would dilute the point I am trying to make about Read.

71 Herbert Read, *Art and the Evolution of Man* (London: Freedom Press, 1951), 34.

72 Herbert Read, *The Art of Sculpture* (London: Faber & Faber, 1956), 71.

73 Clement Greenberg, "Polemic against Modern Art: Review of *The Demon of Progress in the Arts* by Wyndham Lewis" (1955) and "Roundness Isn't All: Review of *The Art of Sculpture* by Herbert Read" (1956), in *The Collected Essays and Criticism*, vol. 3, *Affirmations and Refusals, 1950–1956*, ed. John O'Brian (Chicago: University of Chicago Press, 1993), 253, 272.

74 Herbert Read, *A Concise History of Modern Sculpture* (New York: Praeger, 1964), 76–77.
75 The formulation approximates Marcel Mauss's description of a gift economy in which the thing itself possesses a soul—the "spirit of the thing given," the hau of the taonga—that he posited as an alternative to Western utilitarianism and the "economic animal" that Western man had become. See chapter 3.
76 The alternative between words and things so pervades Dick's fiction that it becomes routine: "Stephanie . . . made the little ceramic pot Oh Ho and presented it to Fat as her gift of love, a love she lacked the verbal skills to articulate" (*VALIS*, 67). In his reading of *Dr Bloodmoney*, Fredric Jameson describes the "basic event envisaged" by the novel to be "the substitution of the realm of language for the realm of things, the replacement of the older, compromised world of empirical activity, capitalist everyday work and scientific knowledge, by that newer one of communication and of messages of all kinds with which we are only too familiar in this consumer and service era." "After Armageddon: Character Systems in *Dr. Bloodmoney*," in *Archaeologies of the Future*, 360.
77 See Jean Baudrillard, *The System of Objects* (1968), trans. James Benedict (New York: Verso, 1996), 74–76; Jameson, *Archaeologies of the Future*, 346.
78 Fredric Jameson, "Progress versus Utopia; or, Can We Imagine The Future," in *Archaeologies of the Future*, 295. On "presence," see Hans Ulrich Gumbrecht, *Production of Presence: What Meaning Cannot Convey* (Stanford, CA: Stanford University Press, 2003). On the "drastic," see Carolyn Abbate, "Music—Drastic or Gnostic," *Critical Inquiry* 30.3 (Spring 2004): 505–37.
79 Lawrence Sutin quotes the interview in which Dick says that he used the *I Ching* to plot the novel. *Divine Invasions*, 112.
80 The discrepancy between *Grasshopper* and historical events is addressed in the unpublished chapters of the sequel to *The Man in the Highcastle*, where, in *Nebenwelt*, for instance, "communism has spread throughout the Orient; specifically into China." "The Two Completed Chapters of a Proposed Sequel to *The Man in the High Castle*," in *Shifting Realities of Philip K. Dick*, 124.
81 On the politics of objects within the Chinese context, see Rey Chow, "Fateful Attachments: On Collecting, Fidelity, and Lao She," in *Entanglements; or, Transmedial Thinking about Capture* (Durham, NC: Duke University Press, 2012), ch. 3.

Introduction to Part Two

1 The geologists' case for the identification of a "formal epoch," distinct from the Holocene is made on the grounds that, "since the start of the Industrial Revolution, Earth has endured changes sufficient to leave a global stratigraphic signature," which includes "biotic, sedimentary, and geochemical change." See Jan Zalasiewicz, et al., "Are We Now Living in the Anthropocene?" *GSA Today* 18.2 (February 2008): 4, www.see.ed.ac.uk/~shs/Climate%20change/Geo-politics/Anthropocene%202.pdf. For a representation of the Anthropocene within the popular press, which includes different dates for the onset of the epoch (such as 1945), see Howard Falcon-Lang, "Anthropocene: Have Humans Created a New Geological Age?" *BBC News: Science and Environment* May 11, 2011, www.bbc.co.uk/news/science-environment-13335683. For the original use of the term, see Paul Crutzen and E. Stoermer, "The Anthropocene," *Global Change Newsletter* 41.1 (2000): 17–18; and see Paul Crutzen, "Geology of Mankind," *Nature* 415 (January 3, 2002), 23. Above all, on the historiographical ramifications of climate change—and the distinct temporal scales through which it must be apprehended—see Dipesh Chakrabarty, "Climate and Capital: On Conjoined Histories," *Critical Inquiry* 41.1 (Autumn 2014): 1–23.

2 Robert Smithson, ". . . The Earth, Subject to Cataclysms, Is a Cruel Master"
 (1971), in *Robert Smithson: The Collected Writings*, ed. Jack Flam (Berkeley:
 University of California Press, 1996), 256.

Chapter Five

This chapter was delivered as a talk at the University of Nevada (Reno), at Prince-
ton University, and as the Petrou lecture at the University of Maryland. I shared por-
tions of it at the "Cultures of Obsolescence" conference at the University of Göttingen
in a talk called "The Obsolescence of the Human." My thanks to those audiences for
responses that have helped me to clarify particular points.

1 See, for instance, "Autofac" (1955), discussed in chapter 4.
2 This isn't to say that Latour does not make metaphysical propositions, but he
 does so as an anthropologist, not as a philosopher. See *An Inquiry into Modes of
 Existence: An Anthropology of the Moderns*, trans. Catherine Porter (Cambridge,
 MA: Harvard University Press, 2013).
3 Hannah Arendt, *The Human Condition* (Chicago: University of Chicago Press,
 1958), 1 (hereafter cited parenthetically).
4 *New York Times*, October 5, 1957.
5 Georg Simmel, *The Philosophy of Money* (1900, 1907), trans. Tom Bottomore
 and David Frisby (London: Routledge, 1990), 450, 449. Here, as elsewhere,
 Simmel sounds as though he is recasting arguments made by Marx (argu-
 ments about alienation and about the fetishization of objects), but of course he
 does so as a sociologist, not as a political economist, all the while bracketing
 economic determinants.
6 Arendt subsequently focuses on another object-event, the invention of the
 telescope, whose "objective novelty" outstripped the significance of any idea;
 she considers it the momentous origin of the "astrophysical world view," one
 of "three great events [that] stand at the threshold of the modern age" (259,
 261, 249). For a discussion of the object, see Mark Coeckelbergh, "The Public
 Thing: On the Idea of the Politics of Artefacts," *Techné* 13.3 (Fall 2009): 175–81.
7 All but needless to add, the very stability of things—or things insofar as they
 are durable—could very well dramatize the alteration in and of "the unstable
 and mortal creature which is man" (136). In Bruce Chatwin's *Utz* (New York:
 Penguin, 1988), where a collector has amassed an unrivaled collection of Meis-
 sen porcelain and protected it during World War II and the Stalinist era in
 Czechoslovakia, the object world frames human deterioration. "I have said
 that Utz's face was 'waxy in texture,' but now in the candlelight its texture
 seemed like melted wax. I looked at the ageless complexion of the Dresden
 ladies. Things, I reflected, are tougher than people. Things are the changeless
 mirror in which we watch ourselves disintegrate. Nothing is more ageing than
 a collection of works of art" (113).
8 John Locke, *An Essay Concerning Human Understanding*, ed. Roger Woolhouse
 (1706; New York: Penguin Books, 1997), 302.
9 William James, *Principles of Psychology* (1890; Cambridge, MA: Harvard Uni-
 versity Press, 1983), 279.
10 See, for instance, Karin Knorr Cetina, "Sociality with Objects: Social Relations
 in Postsocial Knowledge Societies," *Theory, Culture, and Society* 14.1 (1997):
 1–30; Leora Auslander, *Taste and Power: Furnishing Modern France* (Berke-
 ley: University of California Press, 1996); Thorstein Veblen, *The Theory of the
 Leisure Class* (1899; New York: Penguin Press, 1994); Mihaly Csikszentmiha-

lyi and Eugene Rochberg-Halton, *The Meaning of Things: Domestic Symbols and the Self* (Cambridge: Cambridge University Press, 1981); Anne Norton, *Republic of Signs: Liberal Theory and American Popular Culture* (Chicago: University of Chicago Press, 1993); Dick Hebdige, *Subculture: The Meaning of Style* (London: Methuen, 1979); Wolfgang Fritz Haug, *Critique of Commodity Aesthetics: Appearance, Sexuality, and Advertising in Capitalist Society*, trans. Robert Bock (Minneapolis: University of Minnesota Press, 1986); Paul Betts, *The Authority of Everyday Objects: A Cultural History of West German Industrial Design* (Berkeley: University of California Press, 2004). Before developing their account of the symbolic role of objects, Csikszentmihalyi and Rochberg-Halton make reference (15–16) to Arendt's argument. See below.

11 Alain Robbe-Grillet, "A Future for the Novel," in *For a New Novel*, trans. Richard Howard (New York: Grove, 1965), 19, 21, 22. For the French: "Une voie pour le roman futur," in *Pour un nouveau roman* (Paris: Les Editions de Minuit, 1956), 18, 20–21. Robbe-Grillet is making use of Roland Barthes's notion of the "suspect interiority" of objects. Howard identifies Barthes in the translation; the original refers to him as "un essayiste." For what I'm calling the postwar object world, see David E. Nye, *Narratives and Spaces: Technology and the Construction of American Culture* (New York: Columbia University Press, 1997); David E. Nye, *Consuming Power: A Social History of American Energies* (Cambridge, MA: MIT Press, 1998); Elaine Tyler May, *Homeward Bound: American Families in the Cold War Era* (New York: Basic Books, 1988); Victoria de Grazia, *Irresistible Empire: America's Advance through Twentieth-Century Europe* (Cambridge, MA: Harvard University Press, 2005); Lizabeth Cohen, *A Consumers' Republic: The Politics of Mass Consumption in Postwar America* (New York: Knopf, 2003).

12 On Lukács and reification, see chapter 1. For an extended account of the concept within the Marxist tradition, see Timothy Bewes, *Reification; or, The Anxiety of Late Capitalism* (New York: Verso, 2002). I return to Arendt's definition of art in chapter 7.

13 Jaspers to Arendt, December 2, 1945, in *Hannah Arendt/Karl Jaspers Correspondence, 1926–1969*, ed. Lotte Kohler and Hans Guner, trans. Robert Kimber and Rita Kimber (New York: Harcourt, 1992), 25–26.

14 Arendt to Jaspers, January 29, 1946, in ibid., 28. As Bradin Cormack notes (in conversation), what Arendt remembers—as though in response to *his* solicitation that she remember the chair and desk as "hers," jostling with him about how to hold the past—is his *body* in space and time.

15 Ibid., 29.

16 Jaspers to Arendt, October 28, 1945, in ibid., 22.

17 Hannah Arendt, "Europe and the Atom Bomb," in *Essays in Understanding, 1930–1954* (New York: Schocken Books, 1994), 419, 422. For an important account of how global warming collapses the distinction between natural history and human history, and how it necessarily provokes thinking of humans in (and on) a different scale—as a form of life, as a species in the general history of life—see Dipesh Chakrabarty, "The Climate of History: Four Theses," *Critical Inquiry* 35 (Winter 2009): 197–222. For an objection to the gender politics of Arendt's generalized subject in *The Human Condition*, see Adrienne Rich, "Conditions for Work: The Common World of Women," in *On Lies, Secrets, and Silence* (New York: Norton, 1979). For a subsequent response to Rich's objections, see Seyla Benhabib, *The Reluctant Modernism of Hannah Arendt* (Lanham, MD: Rowman & Littlefield, 2003), 2–4.

18 Hannah Arendt, *Between Past and Future* (New York: Penguin, 1968), 278.

19 Csikszentmihalyi and Rochberg-Halton, *Meaning of Things*, x, 227. Similarly having quoted Arendt in his history of advertising, Jackson Lears argues

that the problem is "not materialism, but the spread of indifference toward a material world where the things [are] reduced to disposable commodities." *Fables of Abundance: A Cultural History of Advertising in America* (New York: Basic Books, 1994), 6. And in the prologue to *The Craftsman* (New Haven, CT: Yale University Press, 2008), Richard Sennett responds to Arendt both as his former teacher and as the theorist of *homo faber* (1–8).

20 Arendt to Jaspers, April 7, 1956, in *Correspondence*, 283.

21 Wolfgang-Rainer Mann, *The Discovery of Things: Aristotle's Categories and Their Context* (Princeton, NJ: Princeton University Press, 2000), 179.

22 This is a question currently posed within the metaphysics of persistence. See Katherine Hawley, *The Persistence of Things* (Oxford: Oxford University Press, 2001).

23 José Ortega y Gasset, "An Essay in Esthetics by Way of a Preface," in *Phenomenology and Art*, trans. Philip W. Silver (New York: Norton, 1975), 127–60, quotation on 135. The essay was originally a preface for what he calls a "slim volume of poems," *The Traveler* (1914), by Moreno Villa.

24 Alfred North Whitehead, *The Concept of Nature* (1920; Ann Arbor: University of Michigan Press, 1957), 32. Quoted by Arendt, *Human Condition*, 283.

25 Within the following pages I restrict myself to very few figures, but the "turn to science in Post-Continental philosophy," as John Mullarkey calls it, has "rekindled faith in the possibility of philosophy as a worldly and materialist thinking." The science that has sparked this faith is wide ranging, from mathematics to biology. Mullarkey concentrates on Gilles Deleuze, Michel Henry, Alain Badiou, and François Laruelle. *Post-Continental Philosophy: An Outline* (London: Continuum, 2006), quotations from 2–4.

26 Quentin Meillassoux, *After Finitude: An Essay on the Necessity of Contingency*, trans. Ray Brassier (London: Continuum, 2008), 3, 112. Meillassoux was a student of Alain Badiou's; Badiou writes a preface to the book (hereafter cited parenthetically as *AF*).

27 All but needless to add, from a Kantian perspective such knowledge remains limited by being merely *our* knowledge, achieved through human instruments such as math. Though Meillassoux would grant such a response, the scandal as he sees it is more extreme: *"Science can think a world wherein spatio-temporal givenness itself came into being within a time and a space which preceded every variety of givenness* (22, emphasis in the original). I am not here concerned with assessing Meillasoux's philosophy, but see Ray Brassier's "The Enigma of Realism," in *Nihil Unbound: Enlightenment and Extinction* (New York: Palgrave Macmillan, 2007), ch. 3, 49–96. I will say here that it is a caricatured Kant that provokes the antipathetic energy of much recent realist thinking.

28 Latour does isolate thinkers, especially Williams James and Whitehead, who did not succumb to the phantasm.

29 Bruno Latour, *Pandora's Hope: Essays in the Reality of Science Studies* (Cambridge, MA: Harvard University Press, 1999), 3–6 (hereafter cited parenthetically as *PH*). He also points to an "added insult": the effort (deconstruction's effort) to "destroy—in slow motion—anyone who reminds them that there was a time when they were free and when their language bore a connection with the world" (8). With something of Arendt's spirit, Latour has more recently fulminated against the way in which "critique" has rendered itself superfluous. See "Why Has Critique Run Out of Steam? From Matters of Fact to Matters of Concern," in *Things*, ed. Bill Brown (Chicago: University of Chicago Press, 2004), 151–73.

30 For the precise way in which he is using the term *network*, see Bruno Latour, *Reassembling the Social: An Introduction to Actor-Network Theory* (Oxford: Oxford University Press, 2005); on the agency of objects, see 63–86.

31 Graham Harman, *Bruno Latour: Prince of Networks* (Melbourne: Re.press, 2009), 208, 159.
32 Graham Harman, *Tool-Being: Heidegger and the Metaphysics of Objects* (Chicago: Open Court, 2002), 233.
33 On Heidegger's objection to this formulation of the object, see chapter 1.
34 Martin Heidegger, "The Origin of the Work of Art," in *Poetry, Language, Thought*, trans. Albert Hofstadter (New York: Perennial Classics, 2001), 31.
35 Graham Harman, *Guerrilla Metaphysics : Phenomenology and the Carpentry of Things* (Chicago: Open Court, 2005), 154; see also *Bruno Latour*, 215.
36 Ian Bogost, *Alien Phenomenology; or, What It's Like to Be a Thing* (Minneapolis: University of Minnesota Press, 2012), 19.
37 Andrew Cole, "The Call of Things: A Critique of Object Oriented Ontologies," *Minnesota Review* 80 (2013): 106–18.
38 Alfred North Whitehead, "Objects and Subjects," in *Adventures of Ideas* (New York: Free Press, 1967), 176. Above all, the subject-object relation need not be reduced to any kind of Cartesian paradigm. See chapter 1, where I specify (in concert with William James as with Gilles Deleuze) that we are better off not positing some subject who experiences *x* or *z*, but recognizing that the subject is an effect of experience.
39 Daniel Miller, "Materiality: An Introduction," in *Materiality*, ed. Daniel Miller (Durham, NC: Duke University Press, 2005), 14. Miller has been an especially important figure for drawing attention to objects within anthropology. See, for instance, *The Comfort of Things* (Cambridge: Polity, 2008); and *Stuff* (Cambridge: Polity, 2010).
40 Lynn Meskell, "Objects in the Mirror Appear Closer than They Are," in Miller, *Materiality*, 51–71, quoted 57, 53. See also Meskell, *Object Worlds in Ancient Egypt: Material Biographies Past and Present* (Oxford: Berg, 2004).
41 Marcel Mauss, *The Gift*, trans. W. D. Halls (New York: Norton, 1990), 44; Wu Hung, *Monumentality in Early Chinese Art and Architecture* (Stanford, CA: Stanford University Press, 1996), 7; Caroline Walker Bynum, *Christian Materiality: An Essay on Religion in Late Medieval Europe* (New York: Zone, 2011), 125.
42 Alfred Gell, *Art and Agency: An Anthropological Theory* (Oxford: Clarendon Press, 1998), 9.
43 Bruno Latour, *We Have Never Been Modern*, trans. Catherine Porter (Cambridge, MA: Harvard University Press, 1993), 142.
44 For an anticipation of such quandaries, see Timothy Lenoir, "Was That Last Turn a Right Turn: The Semiotic Turn and A. J. Greimas," *Configurations* 2 (1994): 199–36.
45 Michael Hardt and Antonio Negri, *Empire* (Cambridge, MA: Harvard University Press, 2000), 362. On "additive manufacturing," see the print edition of the *Economist* 21 (2012); and see John Naughton, "Is 3D Printing the Key to Utopia?" *Guardian*, May 12, 2012, www.guardian.co.uk/technology/2012/may/13/3d-printing-digital-manufacturing-industry. For the most arresting prefiguration of 3-D printing, see Philip K. Dick, "Pay for the Printer" (1956), in *The Philip K. Dick Reader* (New York: Citadel Press, 1987), 239–52.
46 Bruno Latour, *Aramis; or, The Love of Technology*, trans. Catherine Porter (Cambridge, MA: Harvard University Press, 1996), viii.
47 Latour, *Inquiry*, 290–91.
48 The question is posed by Bjørnar Olsen, "Material Culture after Text: Re-Membering Things," *Norwegian Archaeological Review* 36.2 (2003): 87.
49 Latour, *We Have Never Been Modern*, 52.
50 Latour, *Reassembling the Social*, 70. He goes to write that "much like sex during the Victorian period, objects are nowhere to be said and everywhere to be felt" (73).

51 Latour, *We Have Never Been Modern*, 11.
52 Boris Arvatov, "Everyday Life and the Culture of the Thing (Toward the Formulation of the Question)" (1925), trans. Christina Kiaer, *October* 75 (Winter 1996): 3.
53 Latour, *We Have Never Been Modern*, 79; *Reassembling the Social*, 54. In his notes to the latter, he references Samuel Butler's *Erewhon* (1872), Francis Ponge's *The Voice of Things* (1942), and Richard Powers's *Galatea* 2.2 (1995), along with theoretical work by A. J. Greimas, Louis Marin, and Thomas Pavel.
54 Bruno Latour, *Politics of Nature: How to Bring the Sciences into Democracy*, trans. Catherine Porter (Cambridge, MA: Harvard University Press, 2004), 69 (hereafter cited parenthetically as *PN*). He goes on to argue, in the subsequent sentence: "To limit the discussion to humans, their interests, their subjectivities, and their rights, will appear as strange a few years from now as having denied the right to vote of slaves, poor people, or women" (69). In what remains Latour's most "literary" experiment, *Aramis; or, The Love of Technology*, he grants a voice to a designed but abandoned transit system.
55 Jacques Rancière, "The Politics of Literature," *SubStance* 33.1 (2004): 7. See also Rancière, *The Future of the Image*, trans. Gregory Elliott (New York: Verso, 2007), 11–17.
56 For a consideration of the riddles, see, for instance, Daniel Tiffany, "Lyric Substance: On Riddles, Materialism, and Poetic Obscurity," in Brown, *Things*, 72–98. On object autobiographies, see Jonathan Lamb, *The Things Things Say* (Princeton, NJ: Princeton University Press, 2012); and the essays collected in *The Secret Life of Things: Animals, Objects, and It-Narratives in Eighteenth-Century England*, ed. Mark Blackwell (Lewisburg, PA: Bucknell University Press, 2007).
57 Helenus Scott, *The Adventures of a Rupee: Wherein Are Interspersed Various Anecdotes Asiatic and European* (London: J. Murray, 1783), 1–2.
58 George Santayana, *Three Philosophical Poets: Lucretius, Dante, and Goethe* (Cambridge, MA: Harvard University Press, 1910), 63.
59 Algirdas Julien Greimas, "Actants, Actors, and Figures" (1973), in *On Meaning: Selected Writings in Semiotic Theory*, trans. Paul J. Perron and Frank H. Collins (Minneapolis: University of Minnesota Press, 1987), 106–20. His original use of the term *actant* appeared in his effort to reschematize Vladimir Propp's morphology of Russian folktales. What is significant for the argument at hand is that, for instance, among the oppositional actants paired along three axes, the *content* of the "helper" actant (which stands in binary opposition to the "opponent" actant) can be human (the wise man), animate but unhuman (the horse), inanimate (the sword), or abstract (courage), and each of them assists the Prince in attaining his goal. See A. J. Greimas, "Reflections on Actantial Models" (1966), in *Structural Semantics*, trans. D. McDowell, R. Schleifer, and A. Velie (Lincoln: University of Nebraska Press, 1983), ch. 10. On the speed bump, see Latour, *Pandora's Hope*, 190; on the key, see "The Berlin Key; or, How to Do Words with Things," in *Matter, Materiality and Modern Culture*, ed. P. M. Graves-Brown (London: Routledge, 2000), 11–21.
60 Thus, in *The Pasteurization of France* (1988), trans. Alan Sheridan and John Law (Cambridge, MA: Harvard University Press, 1993), Latour writes, "No actant is so weak that it cannot enlist another. Then the two join together and become one for a third actant, which they can therefore move more easily. An eddy is formed, and it grows by becoming many others" (159).
61 Bruno Latour, "Where Constant Experiments Have Been Provided," interview, *Arch* 2 (Spring 2009), http://artsci.wustl.edu/~archword/interviews/latour /interview.htm. See also Latour, "Pasteur on Lactic Acid Yeast: A Partial Semiotic Analysis," *Configurations* 1 (1993): 129–46.

62 Greimas, *On Meaning*, 115. Further references to Greimas, made parentheti-
 cally, will be to this text.

63 Mark Hansen, *Embodying Technesis: Technology beyond Writing* (Ann Arbor:
 University of Michigan Press, 2000), 45–47. Hansen is interested in the
 "experiential impact" of technology (47), which is why his subsequent work
 becomes particularly invested in phenomenology, which has its own limits,
 the positing of "my" experience as "your" experience or as "one's" experi-
 ence—universalizing the subject. Latour's extraordinary success in the realm
 of social epistemology, I would argue, has everything to do with his success as
 a narrator: he is nothing if not a good storyteller, the teller of tales in which,
 in the paradigmatic dimension, objects have been substituted for persons.
 The nonphenomenological approach has the further advantage of being able
 to describe interactions between objects. I say this while recognizing that my
 own approach to the question of the other thing is fundamentally phenome-
 nological and not sociological.

64 Bruno Latour, "An Attempt at a 'Compositionalist Manifesto,'" *New Literary
 History* 41 (2010): 481–82.

65 Bruno Latour, "Waiting for Gaia: Composing the Common World through
 Arts and Politics," www.bruno-latour.fr/sites/default/files/124-GAIA-LONDON
 -SPEAP_0.pdf (accessed February 2, 2012). This was Latour's lecture at the
 French Institute, London, November 2011, part of his introduction to the Arts
 and Politics program at Sciences Po, inaugurated in 2010. Subsequent quota-
 tions about Gaia will be from this source. Among James Lovelock's books on
 Gaia, see *The Revenge of Gaia: Earth's Climate Crisis and the Fate of Humanity*
 (New York: Basic Books, 2007). For an intellectual history of Gaia, see Michael
 Ruse, *The Gaia Hypothesis: Science on a Pagan Planet* (Chicago: University of
 Chicago Press, 2013).

66 "Interview: Julia Brown and Michael Heizer" (1983), in *Michael Heizer: Sculp-
 ture in Reverse*, ed. Julia Brown (Los Angeles: Museum of Contemporary Art,
 1984), 31.

67 Hans Ulrich Gumbrecht, *Production of Presence: What Meaning Cannot Con-
 vey* (Stanford, CA: Stanford University Press, 2003), 116. He goes on to write
 that "aesthetic experience can give us back at least a feeling of our being-in-
 the-world, in the sense of being part of the physical world of things" (116). His
 formulation of this claim doesn't include the point, as John Dewey does, that
 art shows us (or convinces us) that it compensates for a loss. For Dewey, art is
 an "incomparable organ of instruction" because it teaches us, while providing
 us with *an* experience, just what experience is—teaches us ("gives us back," in
 Gumbrecht's words) what we are missing, what we have missed. John Dewey,
 Art as Experience (1934; New York: Perigree, 2005), 360–61.

68 Michael Heizer, interview by Julia Brown, in *Michael Heizer: Sculpture in
 Reverse*, ed. Brown (Los Angeles: Museum of Contemporary Art, 1984), 14,
 11, 15.

69 Robert Smithson, "A Sedimentation of the Mind: Earth Projects" (1968), in
 Robert Smithson: The Collected Writings, ed. Jack Flam (Berkeley: University
 of California Press, 1996), 105 (hereafter cited parenthetically).

70 Though my emphasis here is on the way that Smithson's work provides
 access to the before-and-after of the human, I want to acknowledge Jennifer
 Roberts's important point that *Spiral Jetty* emphasizes the duration of both
 creative and erosive process over and against the phenomenological instanta-
 neity demanded by the art criticism of Clement Greenberg and Michael Fried.
 She makes the point by addressing the *Jetty*'s proximity to the Golden Spike
 National Historic Site, where the history of Western railroading is compressed
 into the object itself. Her reading provides the best way of understanding *Spi-

ral Jetty as a work situated between human and unhuman history. See Jennifer
L. Roberts, *Mirror-Travels: Robert Smithson and History* (New Haven, CT: Yale
University Press, 2004), 1–11, 114–39.

71 It is important to add that a tribute to Gaia is in no sense a tribute to Nature
(a term that is effectively effaced by Gaia). Moreover, *nature*—a name "which
anyone associated with Earthworks dared not utter," as Suzaan Boettger puts
it—can hardly be said to name a topic of concern for Smithson. See Boettger,
Earthworks: Art and the Landscape of the Sixties (Berkeley: University of Califor-
nia Press, 2002), especially ch. 9, "Nature and Nurture." The quotation comes
from 207.

Chapter Six

For their objections, suggestions, and enthusiasms, I owe a considerable debt to audi-
ences who heard preliminary versions of this essay at the University of Pennsylvania
(as part of Comparative Literature's "Theorizing" series in 2004), Vanderbilt Univer-
sity, Princeton University, Stanford University, the University of Illinois (Urbana-
Champagne), and Columbia University. A version of the chapter appeared as an essay
in a special issues of *differences* (17.3 [2006]: 88–106) in honor of Barbara Johnson.
Copyright 2006, Brown University and *differences*. Reprinted by permission of the
present publisher, Duke University Press.

1 Anton Ehrenzweig, *The Hidden Order of Art* (1967; Berkeley: University of Cali-
fornia Press, 1971), 294, 19 (hereafter cited parenthetically).

2 Robert Smithson, "A Sedimentation of the Mind: Earth Projects" (1968), in
Robert Smithson: The Collected Writings, ed. Jack Flam (Berkeley: University of
California Press, 1996), 103 (hereafter cited parenthetically). Along with his
own work, Smithson makes extended reference to the work of Iain Baxter,
Carl Andre, Michael Heizer, and Dennis Oppenheim, and to the words of Tony
Smith.

3 For an account of the "mania," see Cozy Baker, *Kaleidoscope Renaissance*
(Annapolis, MD: Beechcliff, 1993), who quotes P. M. Roget (writing for *Black-
wood's Edinburgh Magazine* in 1818), 14. For an overview of the impact of the
kaleidoscope on artists and writers, see Helen Groth, "Kaleidoscope Vision
and Literary Imagination in an 'Age of Things': David Brewster, *Don Juan*, and
'A Lady's Kaleidoscope,'" *English Literary History* 74.1 (Spring 2007): 217–37.

4 David Brewster, *A Treatise on the Kaleidoscope* (Edinburgh: Archibald Constable,
1819), 3, 7, 6. Brewster published a revision of the treatise as *The Kaleidoscope:
Its History, Theory, and Construction* (London: J. Murray, 1858).

5 Charles Baudelaire, "The Painter of Modern Life," in *The Painter of Modern Life
and Other Essays*, trans. and ed. Jonathan Mayne (New York: Phaidon, 1964),
9–10.

6 Henri Bergson, *Matter and Memory*, trans. N. M. Paul and W. S. Palmer (New
York: Zone, 1988), 2; Marcel Proust, *Remembrance of Things Past: Swann's Way*,
trans. C. K. Scott Moncrieff and Terrence Kilmartin (New York: Random
House, 1981), 4.

7 Walter Benjamin, "On Some Motifs in Baudelaire," trans. Harry Zohn,
in *Selected Writings, Volume 4, 1938–1940*, ed. Howard Eiland and Michael
Jennings (Cambridge, MA: Harvard University Press, 2003), 328.

8 Claude Lévi-Strauss, *The Savage Mind* (Chicago: University of Chicago Press,
1966), 10, 3, 220, 21 (hereafter cited parenthetically).

9 Kristin Ross, *Fast Cars, Clean Bodies: Decolonization and the Reordering of French
Culture* (Cambridge, MA: MIT Press, 1996), 161. On Barthes's abandonment of

the object world, see also 180–84. Ross's more particular concern is the way that structuralist thought, denying historical change and the extradiscursive, occluded the politics of the present. Her book brings both those politics and the contemporary object world into full view.

10 Fred R. Meyers, "Introduction: The Empire of Things," in *The Empire of Things: Regimes of Value and Material Culture*, ed. Meyers (Santa Fe, NM: School of American Research Press, 2001), 22.

11 Jacques Derrida, "Typewriter Ribbon: Limited Ink (2) ('within such limits')," trans. Peggy Kamuf, in *Material Events: Paul de Man and the Afterlife of Theory*, ed. Tom Cohen, Barbara Cohen, J. Hillis Miller, and Andrzej Warminski (Minneapolis: University of Minnesota Press, 2001), 350.

12 Myla Goldberg, *Bee Season* (New York: Anchor Books, 2000), 64 (hereafter cited parenthetically).

13 Harold F. Searles, *The Nonhuman Environment in Normal Development and in Schizophrenia* (New York: International Universities Press, 1960), 5.

14 Bruno Latour, "An Attempt at a 'Compositionalist Manifesto,'" *New Literary History* 41 (2010): 481–82.

15 John Richetti, introduction to Daniel Defoe, *Robinson Crusoe* (1719; London: Penguin, 2001), xvii. References to the novel will be to this edition.

16 Alex Woloch, *The One vs. the Many: Minor Characters and the Space of the Protagonist in the Novel* (Princeton, NJ: Princeton University Press, 2003), 28.

17 Virginia Woolf, "Robinson Crusoe," in *The Common Reader (Second Series)* (London: Hogarth, 1932), 51 (hereafter cited parenthetically).

18 Ernst Bloch, *The Spirit of Utopia*, trans. Anthony A. Nassar (Stanford, CA: Stanford University Press, 2000), 9. See chapter 1 for a more extensive account of Bloch's rumination (hereafter cited parenthetically).

19 J. R. Goldberg and A. Stephen, *Object Relations in Psychoanalytic Theory* (Cambridge, MA: Harvard University Press, 1983).

20 J. Laplanche and J.-B. Pontalis, *The Language of Psycho-Analysis*, trans. Donald Nicholson-Smith (New York: Norton, 1973), 278.

21 Melanie Klein, "The Role of the School in Libidinal Development of the Child" (1923), in *The Writings of Melanie Klein*, vol. 1, *Love, Guilt, and Reparation and Other Works, 1921–1945* (New York: Free Press, 1971), 59–76.

22 Melanie Klein, "Psychological Principles of Early Analysis" (1926), in *Writings of Melanie Klein*, 1:135, 138.

23 Julia Kristeva, *Melanie Klein*, trans. Ross Guberman (New York: Columbia University Press, 2001); Gilles Deleuze and Félix Guattari, *Anti-Oedipus: Capitalism and Schizophrenia*, trans. Robert Hurley, Mark Seem, and Helen R. Lane (Minneapolis: University of Minnesota Press, 1983), 23 (quotations) (hereafter cited parenthetically).

24 Melanie Klein, *Narrative of a Child Analysis: The Conduct of the Psycho-Analysis of Children as Seen in the Treatment of a Ten-Year-Old Boy* (New York: Free Press, 1961), 27–28 (hereafter cited parenthetically).

25 Some of these details become clear from reading the *Narrative* itself. Others can be found in Phyllis Grosskurth, *Melanie Klein: Her World and Her Work* (Cambridge, MA: Harvard University Press, 1986), 264.

26 Klein's biographer, Phyllis Grosskurth, met "Richard" when he was in his fifties, unaware that that he had become the subject of one of Klein's most-discussed books. Ibid., 273.

27 Walter Benjamin, *One Way Street*, trans. Edmond Jephcott, in *Selected Writings, Volume 1, 1913–1926*, ed. Marcus Bullock and Michael W. Jennings (Cambridge, MA: Harvard University Press, 1996), 449–50 (hereafter cited parenthetically). For an account of the work of the play concept throughout Benjamin's work, and its relation to the function of *Spiel* within Western aesthetics, see Miriam

Hansen, "Play-Form of Second Nature," in *Cinema and Experience: Siegfried Kracauer, Walter Benjamin, and Theodor W. Adorno* (Berkeley: University of California Press, 2012), ch. 7, 185–204.

28 Hansen, *Cinema and Experience*, 150 (hereafter cited parenthetically).

29 Walter Benjamin, *Berlin Childhood around 1900*, trans. Edmond Jephcott, in *Selected Writings, Volume 3, 1935–1938*, ed. Howard Eiland and Michael W. Jennings (Cambridge, MA: Harvard University Press, 2002), 392–93. For the deployment of Benjamin's book on Berlin to think through contemporary art practices, see Bradin Cormack, "Walking Form, Commanding Example: Seven Notes on Helen Mirra," in *Helen Mirra: Edge Habitat Materials* (Chicago: Whitewalls, 2014), n.p.

30 Jacques Lacan, *The Seminar of Jacques Lacan, Book VII: The Ethics of Psychoanalysis, 1959–1960*, trans. Dennis Porter (New York: Norton, 1992), 117.

31 From their perspective, "the unconscious is totally unaware of persons as such. Partial objects are not representations of parental figures or of basic patterns of family relations; they are parts of desiring machines, having to do with a process and with relations of production that are both irreducible and prior to anything that may be made to conform to the Oedipal figure" (46).

32 Searles, *Nonhuman Environment*, 34 (hereafter cited parenthetically).

33 Gershom Scholem, *Major Trends in Jewish Mysticism* (New York: Schocken Books, 1974), 132.

34 On female kleptomania and Abraham's concept, see Adela Pinch, "Stealing Happiness: Shoplifting in Early Nineteenth-Century England," in *Border Fetishisms: Material Objects in Unstable Places*, ed. Patricia Spyer (New York: Routledge, 1988), 122–49.

35 See, for instance, Howard Searles, *Countertransference and Related Topics: Selected Papers* (1979; New York: International Universities Press, 1981).

36 R. D. Laing, *The Politics of Experience* (New York: Pantheon Books, 1967), 126, 129.

37 In formulating his cultural argument, Searles makes considerable use of Erich Fromm, Paul Tillich, and Gregory Bateson, among others.

38 Siegfried Kracauer, *Theory of Film: The Redemption of Physical Reality* (Princeton, NJ: Princeton University Press, 1997), 28, 68–69. For an account of what Kracauer means by "reality," see Hansen, *Cinema and Experience*, ch. 9 (253–279), where she uses Kracauer's earlier Marseille Notebooks to dilate the concept and to respond to previous charges leveled against Kracauer's supposedly naive realism.

39 Kracauer, *Theory of Film*, 285, 300, 48. This definition of what Kracauer means by *cinema* comes from Hansen, *Cinema and Experience*, 255.

40 D. W. Winnicott, *Playing and Reality* (1971; London: Routledge, 1991), 89. Winnicott carefully distinguishes his concept of the transitional object from the Kleinian internal object: "The transitional object is *not an internal object* (which is a mental concept)—it is a possession. Yet it is not (for the infant) an external object either" (9).

41 Maurice Merleau-Ponty, "Eye and Mind," trans. Carleton Dallery, in *The Primacy of Perception: And Other Essays on Phenomenological Psychology*, ed. James A. Edie (Evanston, IL: Northwestern University Press, 1964), 163.

42 Walter Benjamin, "On Language as Such and on the Language of Man," trans. Edmund Jephcott, in *Selected Writings, Volume 1*, 67.

43 In the face of the European emergency and writing near the end of his life, Benjamin gave up on using the child's imagination to reimagine the material world. At that point he used the figure of the kaleidoscope only to figure the ongoing simulacrum of order: "The course of history, seen in terms of the concept of catastrophe, can actually claim no more attention from the think-

ers than a child's kaleidoscope, with which every turn of the hand dissolves the established order into a new array. There is profound truth in this image. The concepts of the ruling class have always been mirrors that enabled an image of 'order' to prevail. — The kaleidoscope must be smashed." Walter Benjamin, "Central Park," trans. Edmund Jephcott and Howard Eland, in *Selected Writings, Volume 4*, 164. See also Benjamin, *The Arcades Project*, ed. Rolf Tiedemann, trans. Howard Eiland and Kevin McLaughlin (Cambridge, MA: Harvard University Press, 1999), 339.

Chapter Seven

I'd like to express my appreciation to the Vancouver Art Gallery for the invitation to speak in conjunction with the Brian Jungen retrospective survey (2006), curated by Daina Augaitis. For their responses to versions of my argument, I am indebted to audiences at Rochester University; the University of Iowa; Duke University; the Bard Graduate Center of Design; Institute for the Doctoral Study of Art: York University; the University of Wisconsin (Madison); the California College of Arts & Crafts (San Francisco); Boston College; the University of Colorado (Boulder); the University of Virginia; Michigan State University; the University of Ottawa; and Stanford University. Thanks in particular to Janet Berlo, Brian Jungen, Liz Magor, Laura Tanner, Charlotte Townsend-Gault, Anne Wagner, Barry Katz, and Ian Hodder. An essay version of the chapter appeared in *Critical Inquiry* 36.2 (Winter 2010): 183–217.

1 Robert Smithson, "A Museum of Language in the Vicinity of Art" (1968), in *Robert Smithson: The Collected Writings*, ed. Jack Flam (Berkeley: University of California Press, 1996), 84–85.
2 George W. Stocking, "Essays on Museums and Material Culture," in *Objects and Others: Essays on Museums and Material Culture*, ed. Stocking (Madison: University of Wisconsin Press, 1985), 3. The dating of this "museum period" varies according to the historian, and Stocking reviews several possibilities; still, "in the Anglo-American tradition, the shift toward a more behaviorally oriented anthropology . . . had by the outbreak of . . . World War II left museum anthropology stranded in an institutional, methodological, and theoretical backwater" (7). See also another contribution by Stocking to the volume: "Philanthropoids and Vanishing Cultures: Rockefeller Funding and the End of the Museum Era in Anglo-American Anthropology," 112–45. For the shadow history of the argument I make in the present chapter, the point is that *as the anthropological interest in artifacts waned (from 1905 to 1940), the aesthetic interest in them grew*; indeed, two dramatic and emblematic events occurred within two years of each other: Franz Boas's resignation from the American Museum of Natural History, which accompanied his decision to abandon museum work (1905), and Picasso's incorporation of the African-mask motifs in *Les demoiselles d'Avignon* (1907). On such aesthetic interest, within the Stocking volume, see Elizabeth Williams, "Art and Artifact at the Trocadero: *Ars Americana* and the Primitivist Revolution," 146–66. And see William Rubin, "Modernist Primitivism: An Introduction," in *"Primitivism" in 20th Century Art: Affinity of the Tribal and the Modern*, ed. William Rubin (New York: Museum of Modern Art, 1984), 1:1.
3 George W. Stocking Jr., *The Ethnographer's Magic and Other Essays in the History of Anthropology* (Madison: University of Wisconsin Press, 1992), 9.
4 Steven D. Lavine and Ivan Karp, "Introduction: Museums and Multiculturalism," in *Exhibiting Cultures: The Poetics and Politics of Museum Display*, ed. Karp and Lavine (Washington, DC: Smithsonian Institution Press, 1991), 1, 5.
5 Corrine A. Kratz and Ivan Karp, "Museum Frictions: Public Cultures/Global

Transformations," in *Museum Frictions: Public Cultures/Global Transformations*, ed. Karp, Kratz, Lynn Szwaja, and Tomás Ybarra-Frausto (Durham, NC: Duke University Press, 2006), 26.

6 Among the many catalyzing arguments from the decade, three historical essays (which are now canonical) have been particularly influential: Douglas Crimp, "On The Museum's Ruins" (1980), in *The Anti-Aesthetic*, ed. Hal Foster (Seattle: Bay Press, 1983), 43–56; Donna Haraway, "Teddy Bear Patriarchy: Taxidermy in the Garden of Eden, 1908–1936," *Social Text* 11 (Winter 1984–85): 19–64; Tony Bennett, "The Exhibitionary Complex," *New Formations* 1 (1998): 73–102. All but needless to add, within the same decade the field of anthropology began to undergo significant self-scrutiny. See, for instance, George E. Marcus and Michael M. J. Fischer, *Anthropology as Cultural Critique: An Experimental Moment in the Human Sciences* (Chicago: University of Chicago Press, 1986). Moreover and more important, the decade's cultural politics and politicized institutional histories helped to publicize, if not to facilitate, the repatriation of ceremonial objects. George Bush signed the Native American Graves Protection and Repatriation Act in November 1990. On the repatriation of Northwest Coast objects, see Ira Jacknis, *The Storage Box of Tradition: Kwakiutl Art, Anthropologists, and Museums, 1881–1981* (Washington, DC: Smithsonian Institution Press, 2002), chs. 7–9; and James Clifford, "Four Northwest Coast Museums: Travel Reflections," in *Routes: Travel and Translation in the Late Twentieth Century* (Cambridge, MA: Harvard University Press, 1997), 107–47. For an overview of the topic and a bibliography, see the third edition of Jeanette Greenfield's *The Return of Cultural Treasures* (Cambridge: Cambridge University Press, 2007).

7 André Breton, "Surrealist Situation of the Object," in *Manifestoes of Surrealism*, trans. Richard Seaver and Helen R. Lane (Ann Arbor: University of Michigan Press, 1969), 257; Rubin, *"Primitivism,"* 1:1. On Breton's understanding of the "crisis of the object," see chapter 3.

8 C. L. R. James, *Letters from London*, ed. Nicholas Laughlin (Port of Spain, Trinidad and Tobago: Prospect Press, 2003), 3–4 (hereafter cited parenthetically).

9 Claude Lévi-Strauss, *The Savage Mind* (Chicago: University of Chicago Press, 1966), 26.

10 Of course, the term *object relations* comes from the field of psychoanalysis, where (in the work of Melanie Klein, for instance) the object has the habit of standing for a human subject, or a human body part. Within this chapter I deploy the phrase without psychoanalytic connotations. In chapter 6, though, I suggest how the concept might be expanded within a psychoanalytic paradigm.

11 Walter Benjamin, "Paris, Capital of the Nineteenth Century," trans. Howard Eiland, in *Selected Writings, Volume 3, 1935–1938* (Cambridge, MA: Harvard University Press, 2002), 34. As Adorno said of Simmel, he "was the first, despite all psychologistic idealism, to accomplish the return of philosophy to concrete objects, which remained canonical for all who were not drawn to the banging of the critique of knowledge and of spiritual history." Quoted by Jürgen Habermas, "Georg Simmel on Philosophy and Culture: Postscript to a Collection of Essays," trans. Mattieu Deflem, *Critical Inquiry* 22.3 (Spring 1996): 403–14.

12 The key document for understanding how the critique of evolutionary ethnology leads to an understanding of culture, and for understanding how this critique was mediated by objects, see Franz Boas, "The Principles of Ethnological Classification" (1887), in *A Franz Boas Reader: The Shaping of American Anthropology, 1883–1911*, ed. George W. Stocking, Jr. (Chicago: University of Chicago Press, 1974), 61–67. See also Stocking's preface, 3–6. And see Ira Jacknis, "Franz

Boas and Exhibits: On the Limitations of the Museum Method in Anthropology," in Stocking, *Objects and Others*, 75–111.

13 Stocking, *Ethnographer's Magic*, 182.

14 Daniel Miller, *Material Culture and Mass Consumption* (Oxford: Blackwell, 1987), 217; Michael Schiffer, *The Material Life of Human Beings: Artifacts, Behavior, and Communication* (New York: Routledge, 1999), 2; Bjørnar Olsen, "Material Culture after Text: Re-Membering Things," *Norwegian Archaeological Review* 36.2 (2003): 87. In 1998, though, Daniel Miller was willing to declare, moving to a "second stage" of material culture studies, that "the point that things matter can now be argued to have been made." "Why Some Things Matter," in *Material Cultures: Why Some Things Matter*, ed. Daniel Miller (Chicago: University of Chicago Press, 1998), 3.

15 Webb Keane, "Money Is No Object: Materiality, Desire, and Modernity in Indonesian Society," in *The Empire of Things: Regimes of Value and Material Culture*, ed. Fred R. Myers (Santa Fe, NM: School of American Research Press, 2001), 71. In sharp contrast, and despite his august capacity to explain the modes by which artifacts achieve semantic plenitude, Lévi-Strauss, for one, insisted that no "empirical properties of beings or things" could interrupt the system of knowing. *Savage Mind*, 217.

16 Jacques Rancière, *The Politics of Aesthetics: The Distribution of the Sensible*, trans. Gabriel Rockhill (London: Continuum, 2004), 24–27. See also "Thinking between Disciplines: An Aesthetics of Knowledge," trans. Jon Roffe, *Parrhesia* 1 (2006): 1–12, where Rancière responds to Bourdieu's attack on Kant.

17 Hannah Arendt, *The Human Condition* (Chicago: University of Chicago Press, 1958), 137 (hereafter cited parenthetically).

18 See ibid., 99.

19 The term *meta-object* is most familiar within the field of computer science, where it designates a base object that generates or manipulates other objects. See Gregor Kiczales, Jim des Rivieres, and Daniel G. Bobrow, *The Art of the Metaobject Protocol* (Cambridge, MA: MIT Press, 1991). My own use of the term has been derived from Ira Jacknis, who uses "meta-objects" to caption the way that Kwakwaka'wakw artifacts, collected, institutionalized, and photographed by anthropologists, can continue to have an artistic impact on the production of new Kwakwaka'wakw objects. *Storage Box of Tradition*, 5. I also mean the term to square with W. J. T. Mitchell's deployment of "metapicture," in *Picture Theory* (Chicago: University of Chicago Press, 1994), ch. 2. For (many) other examples of meta-objects, see chapter 3.

20 Stocking, "Museums and Material Culture," 4.

21 Gloria Cranmer-Webster, "Conservation and Cultural Centres: U'Mista Cultural Centre, Alert Bay, Canada," in *Symposium 86: The Care and Preservation of Ethnological Materials*, ed. R. Barclay, R. M. Gilberg, J. C. McCawley, and T. Stone (Ottawa, ON: Canadian Conservation Institute, 1986), 77–79.

22 On the allochronism within anthropology and ethnography, see Johannes Fabian, *Time and the Other: How Anthropology Makes Its Object* (New York: Columbia University Press, 1983). On the relatively recent production of totem poles within Haida culture, see Aldona Jonaitis, "Northwest Coast Totem Poles," in *Unpacking Culture: Art and Commodity in Colonial and Postcolonial Worlds*, ed. Ruth B. Phillips and Christopher B. Steiner (Berkeley: University of California Press, 1999), 104–21.

23 Quoted by Jacknis, *Storage Box of Tradition*, 120.

24 Rubin, *"Primitivism,"* 1:73. MoMA crystallized its representation of transcultural aesthetics with the term *affinity*, which incited considerable criticism because it elided cultural context and collapsed non-Western history (where

the modern seems not to exist). A decade later, Charlotte Townsend-Gault wrote of "the gaffe embedded in the . . . spectacular exhibition": "the pegging of the formalist view just as the richness of this approach and its interpretations was widely perceived to have exhausted itself." "If Art Is the Answer, What Is the Question?—Some Queries Raised by First Nations' Visual Culture in Vancouver," *Revue d'Art Canadienne/Canadian Art Review* (RACAR) 21.1–2 (1994): 102.

25 James Clifford, "Histories of the Tribal and Modern," *Art in America* 73.4 (1985): 171, republished in *The Predicament of Culture: Twentieth-Century Ethnography, Literature, and Art* (Cambridge, MA: Harvard University Press, 1988), 200.

26 Clifford, *Predicament of Culture*, 209. See also Clifford, "Objects and Selves—An Afterword," in Stocking, *Objects and Others*, 243.

27 They also make it clear that the "new materialism," or "object studies," or "thing theory" that now informs various academic fields has, say, a longer and broader history in the field of cultural production. On the current state of object studies, see *The Object Reader*, ed. Fiona Candlin and Raiford Guins (New York: Routledge, 2009).

28 James Clifford, "The Pure Products Go Crazy," in *Predicament of Culture*, 1–18.

29 Alice Rawsthorn, "Celebrating the Everychair of Chairs, in Cheap Plastic," *International Herald Tribune*, February 4, 2007, www.iht.com/articles/2007/02/04/features/design5.php.

30 Mihaly Csikszentmihalyi, "Why We Need Things," in *History from Things: Essays on Material Culture*, ed. Steven Lubar and W. David Kingery (Washington, DC: Smithsonian Institution Press, 1993), 21. On the concept of "vernacular modernism," see Miriam Bratu Hansen, "The Mass Production of the Senses: Classical Cinema as Vernacular Modernism," *Modernism/Modernity* 6.2 (April 1999): 59–77. For an account of how a modernist aesthetic informed the production and marketing of everyday objects, and a sense of how design and art converge, see Alison J. Clarke, *Tupperware: The Promise of Plastic in 1950s America* (Washington, DC: Smithsonian Institution Press, 1999).

31 For an account of the expedition, see Knud Rasmussen, *Across Arctic America: Narrative of the Fifth Thule Expedition* (1927; Fairbanks: University of Alaska Press, 1999); for his account of the houses, see 113. For a recent excavation, see James M. Savelle and Juno Habu, "A Processural Investigation of a Thule Whale Bone House, Somerset Island, Artic Canada," *Artic Anthropology* 41.2 (2004): 204–21. In an interview with Terrence Dick, without reference to his *Bush Capsule*, Jungen supplied a biographical referent for the first of my analogues: "When I was a kid, especially when I was a teenager, I used to work on farms and I'd hang around with my cousins and we'd hang around in the bush with my aunties and uncles who would build these amazing summer shacks, and they were fantastic. I wish I took pictures of them back then. Not many people do it anymore." *C Magazine* 89 (March 22, 2006): 36.

32 Brian Jungen, in conversation with the author, March 2006.

33 In dialectical contrast, much of Jungen's work infuses minimalist form with narrative, social, and political content. See Trevor Smith, "Collapsing Utopias: Brian Jungen's Minimalist Tactics," in Vancouver Art Gallery, *Brian Jungen* (Vancouver: Douglas and McIntyre, 2006), 81–89.

34 "Interview with Robert Smithson for the Archives of American Art/Smithsonian Institution" (1972), in Smithson, *Collected Writings*, 271, 286. For an account of Smithson's engagement with dinosaurs, see W. J. T. Mitchell, *The Last Dinosaur Book* (Chicago: University of Chicago Press, 1998), 270–75.

35 Robert Smithson, "A Sedimentation of the Mind: Earth Projects" (1968), in *Collected Writings*, 113; Smithson, "Entropy and the New Monuments" (1966), in *Collected Writings*, 15. See also Smithson, "Museum of Language," 78–94.

36 Clifford, "Four Northwest Coast Museums," 120.

37 Jungen, interview by Jessica Morgan (2009), www.tate.org.uk/download/file
 /fid/21411.

38 Benjamin, "Paris," 39.

39 Susan Casey, "Plastic Ocean: The Great Pacific Garbage Patch," *CDNN*, Novem-
 ber 4, 2007, www.cdnn.info/news/article/a071104.html. In "Leviathan," Clint
 Burnham considers Jungen's cetology series in relation to Melville's white
 whale. Burnham, "Leviathan," in *Brian Jungen*, ed. Nicolaus Schafhausen
 (Rotterdam: Witte de With Center for Contemporary Art, 2006), 69–77.

40 Charles Moore, "Trashed," *Natural History Magazine*, November 2003, www
 .naturalhistorymag.com/htmlsite/1103/1103_feature.html.

41 Anthony L. Andrady, as quoted by Kenneth R. Weiss, "Plague of Plastic Chokes
 the Sea," *Los Angeles Times*, August 2, 2006, www.latimes.com/news/local
 /oceans/la-me-ocean2aug02,0,3130914.story.

42 Curtis Ebbesmeyer, quoted in Casey, "Plastic Ocean."

43 The phrase is Fredric Jameson's: "We remember the archeological as a
 sequence in Disney's *Fantasia*; . . . This is because our historical metabolism
 has undergone a serious mutation; the organs with which we register time
 can handle only smaller and smaller, and more and more immediate, empiri-
 cal segments; the schematism of our transcendental historical imagination
 encompasses less and less material, and can process only stories short enough
 to be verifiable via television." *Late Marxism: Adorno, or, the Persistence of the
 Dialectic* (New York: Verso, 1990), 95.

44 Readers familiar with the importance of "natural history" in Frankfurt School
 thought will recognize the derivation of some of these thoughts. See Theodor
 W. Adorno, "The Idea of Natural-History" (1932), trans. Robert Hullot-Kentor,
 in *Things beyond Resemblance: Collected Essays on Theodor W. Adorno* (New York:
 Columbia University Press, 2006), 252–69. See also Hullot-Kentor's introduc-
 tion to Adorno's lecture, 234–51. And see Walter Benjamin, *The Origin of Ger-
 man Tragic Drama*, trans. John Osborne (London: NLB, 1977). Beatrice Hans-
 sen clarifies Adorno's particular understanding of Benjamin's concept in the
 Trauerspiel book, *Walter Benjamin's Other History: Of Stones, Animals, Human
 Beings, and Angels* (Berkeley: University of California Press, 1998), ch. 1; and
 Susan Buck-Morse tracks the work of the concept in Benjamin's *Arcades* project
 in *The Dialectics of Seeing: Walter Benjamin and the Arcades Project* (Cambridge,
 MA: MIT Press, 1989), ch. 3.

45 Quoted by Aldona Jonaitis, "Northwest Coast Totem Poles," 104. On the traffic
 in Haida art, see Jonaitis, "Traders of Tradition: The History of Haida Art," in
 Robert Davidson: Eagle of the Dawn (Vancouver: Vancouver Art Gallery, 1993),
 3–23. On totem poles and museum culture, see Jonaitis, *From the Land of the
 Totem Poles: The Northwest Coast Indian Art Collection at the American Museum
 of Natural History* (Seattle: University of Washington Press, 1988).

46 Stocking, "Museums and Material Culture," 5.

47 Ruth Phillips points out that "a central contradiction [runs] like a fault line
 through standard museum representations of Native art and culture. This
 contradiction arises directly from unresolved conflicts between the roman-
 ticized, dialectical notion of the modern and the primitive, and a persistent
 discomfort with the logical consequences of commoditization." A cruder way
 to put the point, circa 2000, is that "authentic" artifacts were stolen; anything
 legitimately purchased is part of modernity and can't exude the aura and
 appeal of externality, of otherness, that aboriginal objects should have.
 Ruth B. Phillips, *Trading Identities: The Souvenir in Native North American Art
 from the Northeast, 1700–1900* (Seattle: University of Washington Press, 1998),
 49–50.

48 Charlotte Townsend-Gault, "Circulating Aboriginality," *Journal of Material Culture* 9.2 (2004): 187.

49 Specialists will probably object to my specification of Haida design as the source for the masks, and certainly many spectators would more simply recognize the masks as Northwest Coast forms or, more generically, "tribal" forms. My specification simply follows that of many reviews of the Proto-types while seeking to add, however gesturally, an historical dimension. Still, it is important, I think, to sense the dynamics of citation and recirculation (let alone interpellation) among the First Nation cultures of the Northwest, especially given that the Dane-zaa are not coastal.

50 Stocking, "Museums and Material Culture," 5.

51 Jacknis, *Storage Box of Tradition*, 119, 127.

52 Christian F. Feest, "From North America," in Rubin, *"Primitivism,"* 1:95.

53 Townsend-Gault, "If Art Is the Answer," 102. See Jackson Rushing, *Native American Art and the New York Avant Garde: A History of Cultural Primitivism* (Austin: University of Texas Press, 1997).

54 Jungen speaks of finding Air Jordans at Niketown for "almost $300." Interview by Danielle Egan, "Aboriginal Art Turned Inside Out," *Tyee*, January 26, 2006, http://thetyee.ca/Photo/2006/01/26/AboriginalArtInsideOut/). On eBay, June 29, 2009, the "Buy It Now" price of a pair of Nike Air Jordan IVs White/FireRed, size 12, was $2,000.

55 In 2007, Nike released the Air Native N7, specifically designed for Native Americans, wider and with a broad tip. The Associated Press report (September 26, 2007) explains, "The N7 name is a reference to the seventh generation theory, used by some tribes to look to the three generations preceding them for wisdom and the three generations ahead for their legacy. . . . The design features several 'heritage callouts' as one product manager described it, including sunrise to sunset patterns on the tongue and heel of the shoe. Feather designs adorn the inside and stars are on the sole to represent the night sky." Response to the Nikes has been mixed. The report is available at www.msnbc.msn.com/id/20980046/. My thanks to Jonathan Berliner for news of this new design.

56 Jungen, interview by Jessica Morgan.

57 Jungen, interview by Matthew Higgs, in *Brian Jungen: 18.9.2003–16.11.2003*, by Jungen (Vienna: Secession, 2003), 25.

58 In Jungen's words: "If it's OK for North American sporting teams to use imagery and language and even some crude ceremonial practices of Native Americans, then I feel like I have every right to use sports equipment. What sport fulfills in contemporary North America is this kinship ritual among fans." Interview by Terrence Dick, 36.

59 Walter LaFeber, *Michael Jordan and the New Global Capitalism* (New York: Norton, 1999).

60 Ben Carrington, David L. Andrews, Steven J. Jackson, and Zbigniew Mazur, "The Global Jordanscape," in *Michael Jordan, Inc.: Corporate Sport, Media Culture, and Late Modern America*, ed. David L. Andrews (Albany: State University of New York Press, 2001), 181. The authors go on in their essay to address the reception of Jordan in New Zealand, Poland, and Britain.

61 Sixty-five hundred factory workers went on strike in Indonesia in 1992, eventually gaining a wage increase from $1.20 to $1.80 a day. Douglas Kellner, "The Sports Spectacle, Michael Jordan, and Nike: Unholy Alliance?," in *Michael Jordan, Inc.*, 55. For details on Nike's early outsourcing, see Robert Goldman and Stephen Papson, *Nike Culture: The Sign of the Swoosh* (London: Sage, 1998), ch. 1. Jungen most explicitly addresses the sport-labor nexus in *Court* (2004),

an installation piece in which 224 sewing tables make up a small-scale basket-ball court.

62 Interview by Terrence Dick.

63 Claude Lévi-Strauss, *The Way of the Masks*, trans. Sylvia Modelski (Seattle: University of Washington Press, 1988), 93.

64 I'm borrowing the "traffic in culture" from Fred R. Meyers, *Painting Culture: The Making of an Aboriginal High Art* (Durham, NC: Duke University Press, 2002), ch. 12.

65 Cuauhtémoc Medina, "High Curios," in Vancouver Art Gallery, *Brian Jungen*, 33.

66 Interview by Matthew Higgs, 29; Keane, "Money Is No Object," 71.

67 Martin Heidegger, "The Origin of the Work of Art," in *Poetry, Language, Thought*, trans. Albert Hofstadter (New York: Harper & Row, 1971), 33.

68 Jungen told Alexander Varty, "Someone once told me that when they look at the whales it kind of hurt their eyes, because they were jumping back and forth between the chairs and the skeleton. . . . It was kind of like looking at an optical illusion." Varty, "Culture Shock," *Georgia Straight*, February 2, 2006, www.straight.com/article/culture-shock.

Introduction to Part Three

1 Walter Benjamin, *The Arcades Project*, ed. Rolf Tiedemann, trans. Howard Eiland and Kevin McLaughlin (Cambridge, MA: Harvard University Press, 1999), 394.

2 Writing about Warhol in the context of abstract expressionism and Clement Greenberg's essay "Avant-Garde and Kitsch," Arthur Danto writes that "pop affirmed the reliable symbols of everyday life as against the magical, the shamanistic, and the arcane. The pop artists cherished the things that abstract expressionists found crass beyond endurance." *Philosophizing Art* (Berkeley: University of California Press, 1999), 77. On architecture, see Colin Rowe and Fred Koetter, *Collage City* (Cambridge, MA: MIT Press, 1978); Rem Koolhaas, *Delirious New York: A Retroactive Manifesto for Manhattan*, new ed. (1978; New York: Monacelli Press, 1997); and see, for instance, Robert Venturi, Denise Scott Brown, and Steven Izenour, *Learning from Las Vegas* (Cambridge, MA: MIT Press, 1972).

3 Clement Greenberg, "Avant-Garde and Kitsch" (1939), in *The Collected Essays and Criticism: Perceptions and Judgments, 1939–1944*, ed. John O'Brian (Chicago: University of Chicago Press, 1986), 12 (hereafter cited parenthetically). As I suggested in chapter 3, surrealism is never far from such a charge, and Greenberg considered it an impediment to the imperative to keep culture moving: by restoring "'outside' subject matter" instead of being preoccupied with its own medium, surrealism marks a "reactionary tendency" (9).

4 Theodor W. Adorno, "Veblen's Attack on Culture," in *Prisms*, trans. Samuel Weber and Sherry Weber (Cambridge, MA: MIT Press, 1981), 85.

5 Theodor Adorno, *Minima Moralia* (1951), trans. E. F. N. Jephcott (London: Verso, 1985), 147 (hereafter cited parenthetically as *M*).

6 For an updated version of this dynamic, see Lauren Berlant, *Cruel Optimism* (Durham, NC: Duke University Press, 2011), where she describes how people cling to fantasies of the good life as the sole mode of continuing in a present devastated by neoliberalism; such attachments—such objects of desire—are in fact impediments to any such life.

7 Theodor Adorno, "A Portrait of Walter Benjamin," in *Prisms*, trans. Samuel

Weber and Sherry Weber (Cambridge, MA: MIT Press, 1967), 237, 239 (here-
after cited parenthetically as "WB").

8 To this Adorno adds the claim that "philosophy appropriates the fetishization
of commodities for itself: everything must metamorphose into a thing in
order to break the spell of things" ("WB," 233).

9 Walter Benjamin, "Dream Kitsch," trans. Howard Eiland, in *Selected Writings,
Volume 2, 1927–1934* (Cambridge, MA: Harvard University Press, 1999), 4–5.

Chapter Eight

The present chapter originally appeared, in essay form, in *Critical Inquiry* 24 (Summer
1998): 935–64.

1 Needless to say, all sorts of things (let alone things in themselves) appear to
have been disappearing for a very long time. They've done so in different ways
within different analytics, where either the lingering presence of things is
regretted or the loss of things is lamented. In a Heideggerian lament, Gadamer
complained that "talk of a respect for things is more and more unintelligible in
a world that is becoming ever more technical. They are simply vanishing." His
effort to recover the thing's autonomy, its "unalterable givenness" discovered
only when we "suspend any consideration of persons," is an effort to sense
"the nature of things" in language: to hear how things bring themselves to
expression in the language of the poet. Hans-Georg Gadamer, "The Nature of
Things and the Language of Things," in *Philosophical Hermeneutics*, trans. and
ed. David E. Linge (Berkeley: University of California Press, 1976), 71, 70. The
following pages, which do not ask the Heideggerian question (about how the
thing things, and how it things the world), address not the "nature of things"
but the "culture of things," however much the latter may be thought to domes-
ticate or neutralize the former. The original date of Gadamer's essay (1960),
though, locates it squarely within the chronological frame of my argument.
On Heidegger, see chapter 1.

2 See Karl Marx, *Economic and Philosophic Manuscripts*, in *Early Writings*, trans.
Rodney Livingstone and Gregor Benton (New York: Penguin, 1992), 389.

3 Shawn Wong, *Homebase* (1979; New York: Plume, 1991), 11 (hereafter cited par-
enthetically as *H*).

4 On consumption as "another production," see Michel de Certeau, *The Prac-
tice of Everyday Life*, trans. Steven Rendall (Berkeley: University of California
Press, 1984), xii. For a review of changes in the historiographical assessment
of consumption, see Jean-Christophe Agnew, "Coming Up for Air: Consumer
Culture in Historical Perspective," in *Consumption and the World of Goods*,
ed. John Brewer and Roy Porter (New York: Routledge, 1993), 19–39. For an
overview of the anthropological literature, see Daniel Miller, "Consumption
Studies as the Transformation of Anthropology," in *Acknowledging Consump-
tion: A Review of New Studies*, ed. Miller (New York: Routledge, 1995), 264–95.
On the development of material culture studies, see Miller, "Why Some Things
Matter," in *Material Cultures: Why Some Things Matter*, ed. Miller (Chicago:
University of Chicago Press, 1998), 3–21. On the metamorphosis of commodity
objects outside the structure of exchange, see chapter 9.

5 See D. W. Winnicott, *Playing and Reality* (1971; New York: Basic Books, 1991), 89.

6 A. J. Greimas, "A Problem of Narrative Semiotics: Objects of Value," in *On
Meaning: Selected Writings in Semiotic Theory*, trans. Paul J. Perron and Frank H.
Collins (Minneapolis: University of Minnesota Press, 1987), 86.

7 Georg Lukács, "Idea and Form in Literature" (1949), *Marxism and Human Lib-*

eration: Essays on History, Culture and Revolution, ed. E. San Juan Jr. (New York: Dell, 1973), 122.

8　"After the riot of blood, a man was beaten and thrown into isolation. And beaten again and again until I could hear his flesh break like glass, cutting him deeper and the salt of his sweat moved like dark worms in his wound" (*H*, 93). The hypermateriality of the account renders glass as the metaphorizing object and agent, which satisfies not just the longing to establish material contact with the tragic and violent past but also the need to relive that past rather than accumulating a collection of fragments. "On days like today, the glass is merely under my feet and I pick the pieces up like I'm collecting bones" (*H*, 94).

9　The suggestion that uncanniness is prompted by automata and our more general doubts about "whether a lifeless object might not be in fact animate" is made by Jentsch in an article (1906) famously quoted by Freud in "The 'Uncanny.'" Freud, "The 'Uncanny'" (1919), in *The Standard Edition of the Complete Psychological Works of Sigmund Freud*, trans. and ed. James Strachey (London: Hogarth Press, 1953–74), 17:226. See chapter 9.

10　Gaston Bachelard, *The Poetics of Space*, trans. Maria Jolas (Boston: Beacon, 1964), 74, 78, translation modified. See Bachelard, *La poétique de l'espace* (Paris, 1970), 83.

11　At the close of Austin's eleventh lecture, when the constative-performative distinction breaks down, it is clear that a facticity-effect cannot reside unproblematically outside the speech situation: "We cannot quite make the simple statement that the truth of statements depends on facts as distinct from knowledge of facts. . . . Reference depends on knowledge at the time of utterance." J. L. Austin, *How to Do Things with Words* (Cambridge, MA: Harvard University Press, 1975), 144. The book is based on Austin's William James Lectures of 1955, a version of his "Words and Deeds" lectures, delivered at Oxford, 1952–54. What seemed interesting about Austin's claim within literary studies of the 1970s (see Stanley Fish, below) was the purchase it provided, over and against a deconstructive elaboration of the indeterminate, on the institutional frame that conditions determination (or its absence). What seemed compelling about Austin's claim in the 1990s was, not least, the transition it provided from attention to the human body toward the question of how bodiliness is produced. The "performative" is translated from a term that designates a subject's illocutionary act (the success of which is inseparable from the specificity of the speech-act situation) into a term that designates the more general capacity for "discourse to materialize its effects." Judith Butler, *Bodies That Matter: On the Discursive Limits of "Sex"* (New York: Routledge, 1993), 2.

12　When it comes to what can be said or what can be thought, objects are characterized by no substantiality of their own; they attain their referential substance triangulated between subjects. In Stanley Fish's exaggerated summary of Austin, "reality [a slippage from 'facticity'] is a matter of its public specification." Stanley Fish, "How to Do Things with Austin and Searle: Speech-Act Theory and Literary Criticism," in *Is There a Text in This Class? The Authority of Interpretive Communities* (Cambridge, MA: Harvard University Press, 1980), 204, 198. Cornelius Castoriadis understands "things" not as prima facie given, but as emerging psychogenetically and sociogenetically, "in the history of the subject," and thinkable only from "a koinogenetic (koinos, common, shared) perspective." Cornelius Castoriadis, *The Imaginary Institution of Society*, trans. Kathleen Blamey (1975; Cambridge, MA: MIT Press, 1987), 333, 334. The propositions I am pressing here are, first, that we may "share" a perspective with things no less than with persons, and, second, that such a shared perspective may help to constitute persons. Talking with a doll, a child may determine both who and what the child's new sister is.

13 On the "interior structure of the artifact," see Elaine Scarry, *The Body in Pain: The Making and Unmaking of the World* (New York: Oxford University Press, 1985), esp. 256–57. On fiction's mimetic psychology, the mode by which it seeks to render the world as material form, see Scarry, "On Vivacity: The Difference between Daydreaming and Imagining-under-Authorial-Instruction," *Representations*, no. 52 (Fall 1995): 1–26. And on intentional objects in fiction, see Scarry, "Nouns: The Realm of Things," in *Resisting Representation* (New York: Oxford University Press, 1994), 91–100.

14 Melanie Klein's clearest formulation of the "bad object" appears in "A Contribution to the Psychogenesis of Manic-Depressive States" (1935), in *"Love, Guilt, and Reparation" and Other Works, 1921–1945*, vol. 1 of *The Writings of Melanie Klein*, ed. Roger Money-Kyrle, Betty Joseph, Edna O'Shaughnessy, and Hanna Segal (New York: Free Press, 1975), 262–89.

15 See *Mass Culture: The Popular Arts in America*, ed. Bernard Rosenberg and David Manning White (Glencoe, IL: Free Press, 1957).

16 George Kennan, "The Sources of Soviet Conduct," *Foreign Affairs* (July 1947); reprinted in Walter Lippmann's *The Cold War: A Study in US. Foreign Policy* (1947; New York: Harper, 1972), 65.

17 Reuel Denney, *The Astonished Muse* (Chicago: University of Chicago Press, 1957), 209; Clement Greenberg, "The New Sculpture" (1948; rev. 1958), in *Art and Culture: Critical Essays* (Boston: Beacon, 1961), 144. Meanwhile, other cultural analysts lamented the loss of contact with objects at the site of production. According to C. Wright Mills, as the manipulation of "people and symbols" supplants the manipulation of "things" in white-collar work, the worker is denied any contemplative pleasure in the object of his production. C. Wright Mills, *White Collar: The American Middle Classes* (1951; New York: Oxford University Press, 1981), 65. And Albert Roland believed that Thoreauvian hobbies would foster "individual realization . . . through the confrontation with things-specific and concrete things . . . that help us define ourselves at least at a simple, biological level." Albert Roland, "Do-It-Yourself: A Walden for the Millions?" (1958), in *The American Culture: Approaches to the Study of the United States*, ed. Hennig Cohen (Boston: Houghton Mifflin, 1968), 281.

18 See, for instance, Andrew Ross, *No Respect: Intellectuals and Popular Culture* (New York: Routledge, 1989), ch. 2; Elaine Tyler May, *Homeward Bound: American Families in the Cold War Era* (New York: Basic Books, 1988), ch. 1; and George Lipsitz, *Rainbow at Midnight: Labor and Culture in the 1940s* (Urbana: University of Illinois Press, 1994), ch. 11.

19 See "Four-Year Sensation in Wood," *Newsweek*, May 19, 1941, 60.

20 Dean Jennings, "Charlie McCarthy: The Double Life of Edgar Bergen," *Collier's*, April 29, 1950, 13–14 (hereafter cited parenthetically as "CM"). Charlie McCarthy dolls and other objects began to appear in the 1930s. This was part of a transition in the American toy industry that also witnessed the proliferation of Mickey Mouse and Shirley Temple dolls and novelties. The production of celebrity toys, which is to say the toy industry's reliance on the new mass media of radio and talking pictures, was part of a new marketing strategy that responded to the Depression by creating desires that could not be satisfied by generic toys (hence by hand-me-downs or cheap imitations); see Gary Cross, *Kids' Stuff: Toys and the Changing World of American Childhood* (Cambridge, MA,: Harvard University Press, 1997), 100–108.

21 See "Bergen Debut," *Newsweek*, December 4, 1950, 50.

22 "The Durable Dummy," *Newsweek*, May 14, 1956, 114.

23 Candice Bergen, *Knock Wood* (New York: Simon & Schuster, 1984), 68. On May 10, 1946, *Variety* announced that "wooden-bodied Charlie McCarthy . . . today had a flesh and blood rival for the affections of Edgar Bergen since the arrival

of a 7 lb. 13 1/2 oz. daughter last night at Hollywood Presbyterian Hospital" (quoted in ibid., 43). This is to say that if Candice Bergen experienced intense jealousy regarding Charlie McCarthy, she was also scripted into the role of the jealous sibling by Hollywood and the national press.

24 Bachelard, *Poetics of Space*, 81.

25 Dwight MacDonald, *Against the American Grain* (New York: Random House, 1962), 14. On Adorno's impact, see Peter U. Hohendahl, "The Displaced Intellectual? Adorno's American Years Revisited," *New German Critique* 56 (Spring–Summer 1992): 76–100.

26 Jennings, "Woman Trouble in Charlie McCarthy's Future: More about the Double Life of Edgar Bergen," *Collier's*, May 6, 1950, 22.

27 See Kristin Ross, *Fast Cars, Clean Bodies: Decolonization and the Reordering of French Culture* (Cambridge, MA: MIT Press, 1995).

28 His "materialism" appears within the overarching logocentricity of his own poetics: "I believe that everything specifically human in man is logos." Bachelard, *Poetics of Space*, xix.

29 See Miller, *Material Culture and Mass Consumption* (Oxford: Blackwell, 1987), 85.

30 Michel Foucault, *The Archaeology of Knowledge*, trans. A. M. Sheridan Smith (New York: Harper & Row, 1972), 47, 49. It is important to add that "words are as deliberately absent as things themselves; any description of a vocabulary is as lacking as any reference to the living plenitude of experience" (ibid., 48). In the obviously speculative and spectral history that underwrites this chapter, one reads Perec's *Les Choses* exactly in between *Les mots et les choses* (1966) and *The Archaeology of Knowledge* (1969) as the record of the things Foucault wished to dispense with.

31 Foucault, "Nietzsche, Genealogy, History," in *Language, Counter-Memory, Practice*, trans. Donald E. Bouchard and Sherry Simon, ed. Bouchard (Ithaca, NY: Cornell University Press, 1978), 139.

32 See Joan W. Scott, "The Evidence of Experience," in *Questions of Evidence: Proof, Practice, and Persuasion across the Disciplines*, ed. James Chandler, Arnold I. Davidson, and Harry Harootunian (Chicago: University of Chicago Press, 1994), 363–87.

33 Foucault, "Dream, Imagination, and Existence," trans. Forrest Williams, *Review of Existential Psychology and Psychiatry* 19 (1984–85): 43, 44, 48, 49. The effort to reassess the specificity of the act of dreaming is exemplified by Jean-Paul Sartre, whose analogue for the dream, however, is fiction; see Jean-Paul Sartre, *The Psychology of Imagination*, trans. Bernard Frechtman (New York: Philosophical Library, 1948), 231–55. When Foucault turns to Artemidorus's oneiro-criticism in *The History of Sexuality*, his project has clearly changed, his object of attention being Artemidorus's taxonomy of pleasures, not dreams per se. To imagine some bridge between the projects, see Walter Seitter, "Oneirocriticisms," in *Michel Foucault, Philosopher*, ed. and trans. Timothy J. Armstrong (New York: Routledge, 1992), 142–47. Any extended account of Foucault and the phenomenon of dreaming would address his debate with Derrida over the function of dreams in Descartes.

34 Gilles Deleuze, *Foucault*, trans. Sean Hand (Minneapolis: University of Minnesota Press, 1988), 109.

35 Foucault, "Dream, Imagination, and Existence," 73.

36 Frank Chin, *Donald Duk* (Minneapolis: Coffee House Press, 1991), 118 (hereafter cited parenthetically as *DD*).

37 Castoriadis, *Imaginary Institution of Society*, 329.

38 Klein, "Psychological Principles of Early Analysis," 1:134. For more on Klein, see chapter 6.

39 Marx, *Capital*, trans. Ben Fowkes, 2 vols. (New York: Vintage, 1990), 1:128.

40 See Georg Simmel, *The Philosophy of Money*, trans. Tom Bottomore, David
 Frisby, and Kaethe Mengelberg (New York: Routledge, 1990), 470–79.

41 Georg Lukács, *History and Class Consciousness: Studies in Marxist Dialectics*,
 trans. Rodney Livingstone (Cambridge, MA: MIT Press, 1971), 92.

42 Thus Heidegger complains: "The Thinghood itself which such reification
 implies must have its ontological origin demonstrated if we are to be in a
 position to ask what we are to understand positively when we think of the
 unreified Being of the subject, the soul, the consciousness, the spirit, the per-
 son. All these terms . . . are never used without a notable failure to see the need
 for inquiring about the Being of the entities thus designated." Heidegger, *Being
 and Time*, trans. John Macquarrie and Edward Robinson (New York: Harper,
 1962), 10, 70. On Lukács and Heidegger, see chapter 1.

43 Theodor Adorno, *Minima Moralia: Reflections from Damaged Life*, trans. Jeph-
 cott (New York: Verso, 1978), 228.

44 Ibid., 40.

45 See Ernesto Laclau and Chantal Mouffe, "Post-Marxism without Apologies,"
 in *New Reflections on the Revolution of Our Time* (New York: Verso, 1990), 100.

46 Recent scholarship on Duchamp's *Fountain*, for instance, charts how the
 readymade was understood not just as part of an anti-aesthetic argument but
 also as an effort to disclose the aesthetics of the urinal; see William A. Cam-
 field, "Marcel Duchamp's Fountain: Its History and Aesthetics in the Context
 of 1917," in *Marcel Duchamp: Artist of the Century*, ed. Rudolph E. Kuenzli and
 Francis M. Naumann (Cambridge, MA: MIT Press, 1989), 64–94. For one clas-
 sic account of the camp dynamic, see Richard Dyer, "Judy Garland and Gay
 Men," *Heavenly Bodies: Film Stars and Society* (New York: St. Martin's Press,
 1986), 141–94.

47 Benjamin, "'Old Forgotten Children's Books,'" trans. Rodney Livingstone,
 in *Selected Writings, Volume 1, 1913–26*, ed. Marcus Bullock and Michael W.
 Jennings (Cambridge, MA: Harvard University Press, 1996), 408; quotation
 modified to accord with Jennings, *Dialectical Images: Walter Benjamin's Theory
 of Literary Criticism* (Ithaca, NY: Cornell University Press, 1987), 87. Benjamin's
 claim (repeated in *One-Way Street*) has become the crucial site for under-
 standing his investment in the "magical force" of the "child's world," as Ger-
 shom Scholem described it in *On Jews and Judaism in Crisis: Selected Essays*,
 ed. Werner G. Dannhauser (New York: Schocken Books, 1976), 175; Scholem
 is quoted in Susan Buck-Morss, *The Dialectics of Seeing: Walter Benjamin and
 the Arcades Project* (Cambridge, MA: MIT Press, 1989), 262. See also Buck-
 Morss's commentary on 263: "Imagery of the child's world appears so persis-
 tently throughout Benjamin's opus that the omission of a serious discussion
 of its theoretical significance in practically all commentaries on Benjamin is
 remarkable—a symptom, perhaps, of precisely the repression of childhood
 and its cognitive modes which he considered a problem of the utmost political
 significance." Accounts of Benjamin in the 1990s, though, have partially recti-
 fied that neglect; see, for example, Jeffrey Mehlman, *Walter Benjamin for Chil-
 dren: An Essay on His Radio Years* (Chicago: University of Chicago Press, 1993),
 and Graeme Gilloch, *Myth and Metropolis: Walter Benjamin and the City* (Cam-
 bridge: Polity, 1996), ch. 5. The most informative place to begin remains Buck-
 Morss's juxtaposition of his politics of childhood to Piaget's child psychology
 of the twenties.

48 In a letter to Kracauer, Benjamin wrote that his "Paris study [. . . stood] very
 near to [his] interest in children's toys"; and to Scholem he wrote, "[The
 Passagen-Werk] has to do with . . . achieving the most extreme concreteness
 for an epoch, as appears now and again in children's games." Quoted in Buck-
 Morss, *Dialectics of Seeing*, 457n40, 262.

49 Benjamin, *One-Way Street*, 464.
50 Toni Morrison, *The Bluest Eye* (New York: Washington Square Press, 1970), 20. Claudia's dolls are not Shirley Temple dolls per se, but the account of them is framed by her antipathy to the child star. For an account of the scene, see Susan Willis, *A Primer for Daily Life* (New York: Routledge, 1991), 108–32. For an account of how black women's writing becomes the work "that promises resistance and integrity, the utopian supplement to [Willis's] own 'deconstruction of commodities,'" see Elizabeth Abel, "Black Writing, White Reading: Race and the Politics of Feminist Interpretation," *Critical Inquiry* 19 (Spring 1993): 494. I myself have previously read the scene in relation to Benjamin's work in the introduction to *A Sense of Things: The Object Matter of American Literature* (Chicago: Chicago University Press, 2003).
51 "Four-Year Sensation in Wood," 60. See also Bergen, *Knock Wood*, 17–42.
52 "Durable Dummy," 114.
53 See Lynn Spigel, *Make Room for TV — Television and the Family Ideal in Postwar America* (Chicago: University of Chicago Press, 1992), 2–3, and ch. 2; and Lipsitz, *Rainbow at Midnight*, 270–73.
54 Meyer Berger, "Bergen's Brazen Blockhead," *New York Times Magazine*, November 7, 1937, 11.
55 Quoted in Quentin Reynolds, "The Man Who Talks to Himself," *Collier's*, March 20, 1937, 88.
56 I mean for this reading to align with other efforts to recover the sediments of history that lie within comparable scenes of interethnic appropriation; see Bill Brown, "Global Bodies/Postnationalities: Charles Johnson's Consumer Culture," *Representations* 58 (Spring 1997): 24–48.
57 Wong, *American Knees* (New York: Simon & Schuster, 1995), 23.
58 Thus Arthur and Marilouise Kroker, in a recognizably *fin-de-millennialist* strain, argue that the "intense fascination with the fate of the body" may well result from the fact that "the body no longer exists." Arthur Kroker and Marilouise Kroker, "Theses on the Disappearing Body in the Hyper-Modern Condition," in *Body Invaders: Panic Sex in America*, ed. Kroker and Kroker (New York: St. Martin's Press, 1987), 20. And thus Sylvere Lotringer, as Baudrillard's interlocutor, argues in an interview that "you can only reveal a phenomenon if it is already disappearing." Baudrillard, "Forget Baudrillard," interview by Sylvere Lotringer, trans. Phil Beitchman, Lee Hildreth, and Mark Polizzotti, in *Forget Foucault* (New York: Semiotext(e), 1987), 72.
59 Baudrillard, "The Ecstasy of Communication," in *The Anti-Aesthetic: Essays on Post-modern Culture*, ed. Hal Foster (Port Townsend, WA: Bay Press, 1983), 126, 133.
60 Gadamer, *Philosophical Hermeneutics*, 70–71.
61 *Toy Story* (Buena Vista: Walt Disney Pictures, 1995) is a full-length version of a concept director John Lasseter tried out in "Tin Toy" (1988), an animated short that won an Academy Award. For an account of the computer graphics, see Burr Snider, "The Toy Story Story," *Wired* 3 (December 1995): 147–50, 212–15; Gregory Solman, "Babes in Toy Land," *Millimeter* (October 1995): 38–66; and Barbara Robertson, "Toy Story: A Triumph of Animation," *Computer Graphics World* 18 (August 1995): 28–34.
62 Marx, *Capital*, 1:163, 165. On the Frankfurt School confrontation with Mickey Mouse and Donald Duck, see Miriam Bratu Hansen, *Cinema and Experience: Siegfried Kracauer, Walter Benjamin, and Theodor W. Adorno* (Berkeley: University of California Press, 2012), ch. 6, "Micky-Maus," 163–82. On the world of things coming to life in a different historical moment, see Stuart Culver, "What Manikins Want: *The Wonderful Wizard of Oz* and *The Art of Decorating Dry Goods Windows*," *Representations* 21 (Winter 1988): 97–116.

63 See U.S. International Trade Commission, Summary of Trade and Tariff Information, USITC publication 841, July 1980, 2.
64 For statistics, see ibid. and USITC, Industry and Trade Summary, Toys and Models, USITC publication 2426 (GM-1), November 1991. On the industry in Hong Kong, see Jenny Walden, "Toying with China," *Far Eastern Economic Review*, December 17, 1987, 126; and Carl Goldstein, "Turnaround in Toytown," *Far Eastern Economic Review* 25 (January 1990): 44. This shift in the sourcing of production has made China the globe's largest toy producer and exporter, the match for the largest toy market, the United States, with Congress in a state of "hysteria" over a trade surplus. Andrew Tanzer, "China's Dolls," *Forbes*, December 21, 1992, 250.
65 Steven Mufson, "Santa Finds a Bargain in China," *Washington Post*, December 24, 1995, A1. For the history of Shenzhen as an SEZ, see J. C. M. Chan, D. Sculli, and K. Si, "The Cost of Manufacturing Toys in the Shenzhen Special Economic Zone of China," *International Journal of Production Economics* 25 (1991): 181–90. In 1997 the packaging of the stuffed Animal Pal that accompanied a McDonald's Happy Meal explained: "Contents made in China. Contenu fabriqué en Chine. Contenido fabricado en China." The United States becomes the conduit through which Chinese products are distributed throughout the world.

Chapter Nine

This chapter originally appeared, in essay form, as a belated response to a question posed by Jay Fliegelman about my work on the object culture of the United States, in *Critical Inquiry* 32 (Winter 2006): 175–207. For their responses to previous versions of the argument, I am grateful to audiences at Dartmouth College, the University of Iowa, the University of Toronto, the University of Arizona, Stanford University, Princeton University, Columbia University, the University of Michigan, the University of Bonn, the National Central University (Taiwan), Northwestern University, Texas A&M University, and Yale University. I am grateful in particular to Sara Blair, Eduardo Cadava, Edgar Dryden, Jacqueline Goldsby, Scottie Parrish, Jacqueline Stewart, and Christina Zwang.

1 See Peter Schwenger, *The Tears of Things: Melancholy and Physical Objects* (Minneapolis: University of Minnesota Press, 2006); Lorraine Daston, ed., *Things That Talk: Object Lessons from Art and Science* (New York: Zone Books, 2004); Elaine Freedgood, *Ideas in Things: Fugitive Meaning in the Victorian Novel* (Chicago: University of Chicago Press, 2006); Jonathan Lamb, *The Things Things Say* (Princeton, NJ: Princeton University Press, 2012); Ian Bogost, *Alien Phenomenology; or, What It's Like to Be a Thing* (Minneapolis: University of Minnesota Press, 2012).
2 See Bruno Latour, *We Have Never Been Modern*, trans. Catherine Porter (Cambridge, MA: Harvard University Press, 1993). See also Latour, *Pandora's Hope: Essays on the Reality of Science Studies* (Cambridge, MA: Harvard University Press, 1999). For instance: "I am struggling to approach the zone where some, though not all, of the characteristics of pavement become policemen, and some, though not all, of the characteristics of policemen become speed bumps. . . . I want to . . . follow how Daedalus folds, weaves, plots, contrives, finds solutions where none are visible, using any expedient at hand, in the cracks and gaps of ordinary routines, swapping properties among inert, animal, symbolic, concrete, and human materials" (190). I should add that Latour would adamantly object to being characterized as a postmodernist, preferring instead the term *nonmodernist*. See Latour, *Politics of Nature: How to Bring*

the Sciences into Democracy, trans. Catherine Porter (Cambridge, MA: Harvard University Press, 2004), 244. On Latour, see also chapter 5.

3 Arjun Appadurai, "Introduction: Commodities and the Politics of Value," in *The Social Life of Things: Commodities in Cultural Perspective*, ed. Appadurai (Cambridge: Cambridge University Press, 1986), 5. Although the study of literature did not at first share this attention to objects, two notable exceptions appeared in the 1980s: Philip Fisher, *Hard Facts: Setting and Form in the American Novel* (New York: Oxford University Press, 1985); and Susan Stewart, *On Longing: Narratives of the Miniature, the Gigantic, the Souvenir, the Collection* (Baltimore: Johns Hopkins University Press, 1984). Indeed Stewart, cited by Appadurai and other anthropologists, continues to have considerable influence beyond literary studies. Over the course of the past decade and a half, in contrast, the study of literature has devoted considerable attention to objects and the life of things within and beyond literary texts.

4 Whereas Appadurai and the contributors to his volume use the verb *commoditize* and the noun *commoditization*, I've reverted (unless quoting) to *commodify* and *commodification*. The slight semantic loss is, I think, compensated for by the aural gain.

5 A related, subject-oriented version of this point, which proved especially important for cultural studies, was advanced by Michel de Certeau, who argues that what we've traditionally called "consumption" entails "another production." Michel de Certeau, *The Practice of Everyday Life*, trans. Steven Rendall (Berkeley: University of California Press, 1984), xii.

6 Igor Kopytoff, "The Cultural Biography of Things: Commoditization as Process," in Appadurai, *Social Life of Things*, 66–67 (hereafter cited parenthetically as "CB").

7 Such a formulation, while true to this part of Kopytoff's schema, depends on understanding culture and commodification as antithetical, whereas culture (even what we call traditional culture) can itself be mediated by the commodity form. Moreover, as I've already paraphrased, Kopytoff is no less concerned with the cultural preconditions for the commodification of any object.

8 Appadurai, "Introduction," 3. Moreover, while an object's "social life" might be understood as its circulation, Kopytoff is interested in focusing attention on the object's biography outside of circulation—or outside the circulation mediated by commodity exchange.

9 See, for instance, Kopytoff and Suzanne Miers, "African 'Slavery' as an Institution of Marginality," in *Slavery in Africa: Historical and Anthropological Perspectives*, ed. Miers and Kopytoff (Madison: University of Wisconsin Press, 1977), 1–81; and Kopytoff, "Indigenous African Slavery: Commentary One," in *Roots and Branches: Current Directions in Slave Studies*, ed. Michael Craton (Toronto: Pergamon Press, 1979), 62–77.

10 David Brion Davis, *The Problem of Slavery in Western Culture* (Ithaca, NY: Cornell University Press, 1966), 33.

11 See Eugene D. Genovese, *Roll, Jordan, Roll: The World the Slaves Made* (1972; New York: Vintage, 1976), 25–48, 87–96.

12 Quoted in ibid., 30. "But one year later," Genovese goes on to say, "we hear: 'A slave has volition, and has feelings which cannot be entirely disregarded'" (ibid). Saidiya V. Hartman has trenchantly summarized the paradoxical effects of the law's recognition of "slave personhood": "The weighing of person and property—the limited recognition of the slave as person, to the extent that it did not interfere with the full enjoyment of the slave as thing—endowed the enslaved with limited protections and made them vulnerable to injury, precisely because the recognition of person and the calibration of subjectivity were consonant with the imperatives of the institution." Saidiya V. Hartman,

Scenes of Subjection: Terror, Slavery, and Self-Making in Nineteenth-Century America (New York: Oxford University Press, 1997), 97–98.

13 *New York Gazette: And the Weekly Mercury*, October 6, 1777.

14 Stephen Best, *The Fugitive's Property: Law and the Poetics of Possession* (Chicago: University of Chicago Press, 2004), 2.

15 See Fisher, *Hard Facts*, ch. 2, "Making a Thing into a Man: The Sentimental Novel and Slavery," 87–127.

16 See Orlando Patterson, *Slavery and Social Death: A Comparative Study* (Cambridge, MA: Harvard University Press, 1985). On the "perpetual dread" of being resold, see Walter Johnson, *Soul by Soul: Life Inside the Antebellum Slave Market* (Cambridge, MA: Harvard University Press, 1999), 22–24.

17 See John Locke, *Two Treatises on Government*, ed. Peter Laslett (Cambridge: Cambridge University Press, 1988), 325.

18 Karl Marx, *Capital*, trans. Ben Fowkes, 3 vols. (1867–94; Harmondsworth, UK: Penguin Books in assoc. with New Left Review, 1990), 1:166, 209, 1054 (hereafter cited parenthetically as *C*). For the fuller (and now canonical) account of reification, see Lukács, *History and Class Consciousness: Studies in Marxist Dialectics*, trans. Rodney Livingstone (Cambridge, MA: MIT Press, 1971).

19 Marx, *The German Ideology*, trans. S. Ryazanskaya, in *The Marx-Engels Reader*, ed. Robert C. Tucker (New York: Norton, 1972), 169. For the classic argument insisting on the economic determination of the Civil War, see Charles A. Beard and Mary R. Beard, *The Rise of American Civilization*, 2 vols. (New York: Macmillan, 1931), 2:166–210. For a recent effort to reassert economic determinants, see James L. Huston, *Calculating the Value of the Union: Slavery, Property Rights, and the Economic Origins of the Civil War* (Chapel Hill: University of North Carolina Press, 2003).

20 Marx, *Grundrisse: Foundations of the Critique of Political Economy*, trans. Martin Nicolaus (Harmondsworth, UK: Penguin, 1993), 513.

21 For a discussion of Greek slaves within a hierarchy of objects, making reference to Aristotle's notion of the "animate tool," see Page Dubois, *Slaves and Other Objects* (Chicago: University of Chicago Press, 2003), 82–100.

22 Take, for instance, Douglass's account of how masters treated their own slave children; see Frederick Douglass, *Narrative of the Life of Frederick Douglass, an African Slave*, ed. Henry Louis Gates, Jr. (1845; New York: Penguin, 1987), 257. Douglass also belies the psychological point made by Marx (among others), recording that he "often wished [him]self a beast. I preferred the condition of the meanest reptile to my own. Any thing, no matter what, to get rid of thinking! . . . It was pressed upon me by every object within sight or hearing, animate or inanimate" (279).

23 See Ian Hacking, *Historical Ontology* (Cambridge, MA: Harvard University Press, 2002), 1–27.

24 In an argument about U.S. legal culture, Stephen Best demonstrates how the ontological ambiguity affected by slavery rendered the "the idea of personhood 'as such' increasingly subject to the domain of property." He draws attention to "how the relation between persons and things, and conceiving persons as things, becomes a varying preoccupation of the law in the aftermath of slavery." Best, *Fugitive's Property*, 270, 139.

25 Hacking, *Historical Ontology*, 26.

26 See, for instance, N. Katherine Hayles, *How We Became Posthuman: Virtual Bodies in Cybernetics, Literature, and Informatics* (Chicago: University of Chicago Press, 1999); Donna J. Haraway, "A Cyborg Manifesto: Science, Technology, and Socialist-Feminism in the Late Twentieth Century," in *Simians, Cyborgs, and Women: The Reinvention of Nature* (New York: Routledge, 1991), 149–81; Latour, *We Have Never Been Modern*; and *Pandora's Hope*. I should add

that Hacking seriously questions Latour's "intention to minimize the differ-
ences between the human and the nonhuman." Hacking, *Historical Ontology*,
17. The historical ontologist concerns himself with charting the very distinc-
tion that Latour (among others) has worked to undo. For Latour, though, only
our capacity to think beyond the human-nonhuman, person-thing binary will
enable us to perpetuate the habitability of the globe. See Latour, *Politics of
Nature*, ch. 2.

27 For an account of the minstrelsy within *Bamboozled*, see, for instance, Michael
H. Epp, "Raising Minstrelsy: Humor, Satire, and the Stereotype in *The Birth of
a Nation* and *Bamboozled*," *Canadian Review of American Studies* 33, no. 1 (2003):
17–35. For an account of the film as an ambivalent and ambiguous engagement
with the stereotype, see W. J. T. Mitchell, "Living Color: Race, Stereotype, and
Animation in Spike Lee's *Bamboozled*," in *What Do Pictures Want: The Lives
and Loves of Images* (Chicago: University of Chicago Press, 2005), 294–308. On
black stereotypes in American film, see Donald Bogle, *Toms, Coons, Mulattoes,
Mammies, and Bucks: An Interpretive History of Blacks in American Films* (New
York: Continuum, 1989). On the African American challenge to such stereo-
typing, see Jacqueline Najuma Stewart, *Migrating to the Movies: Cinema and
Black Urban Modernity* (Berkeley: University of California Press, 2005), 34–36,
48–49.

28 Patricia A. Turner, *Ceramic Uncles and Celluloid Mammies: Black Images and
Their Influence on Culture* (New York: Anchor Books, 1994), 11. Turner does not
address the bank, but she does describe a related game, Milton Bradley's Jolly
Darkie Target Game, first manufactured in 1890: the objective "was to score
'bull's-eyes' by throwing a ball into the gaping mouth of a black male figure"
(11).

29 Kenneth W. Goings, *Mammy and Uncle Mose: Black Collectibles and American
Stereotyping* (Bloomington: Indiana University Press, 1994), 14.

30 Steven C. Dubin, "Symbolic Slavery: Black Representations in Popular Cul-
ture," *Social Problems* 34 (April 1987): 132.

31 On the stereotype itself as a fetish, see Homi K. Bhabha, "The Other Question:
Stereotype, Discrimination and the Discourse of Colonialism," in *The Location
of Culture* (New York: Routledge, 1994), 66.

32 You could say that the objects play a part in what Grace Elizabeth Hale calls
"the ritualistic enactment of racial difference vital to the maintenance of white
supremacy." Grace Elizabeth Hale, *Making Whiteness: The Culture of Segregation
in the South, 1890–1940* (New York: Vintage, 1998), 284.

33 Robert C. Toll, *Blacking Up: The Minstrel Show in Nineteenth-Century America*
(New York: Oxford University Press, 1974), 262–63.

34 Turner, *Ceramic Uncles and Celluloid Mammies*, 11.

35 This is not to suppose that black stereotypes always functioned the same way
in different national spaces. See Jan Nederveen Pieterse, *White on Black: Images
of Africa and Blacks in Western Popular Culture* (New Haven, CT: Yale Univer-
sity Press, 1992), particularly ch. 10, "Popular Types," 152–65. For an encounter
with the contemporary French market, see Leora Auslander and Thomas Holt,
"Sambo in Paris: Race and Racism in the Iconography of the Everyday," in *The
Color of Liberty: Histories of Race in France*, ed. Sue Peabody and Tyler Stovall
(Durham, NC: Duke University Press, 2002), 147–84.

36 Stewart, *Migrating to the Movies*, 34.

37 Edward W. Said, *Orientalism* (New York: Pantheon Books, 1978), 71.

38 In the case of the banks, I understand them as a subset of the mechanical toys
I've discussed before: "The automaton's segmented, repetitive movement
reproduced, as a scene of delight, the rationalization of the worker at the site
of production, affirming, within the realm of childhood amusement, the frag-

menting rhythm of machine discipline and the automatization of the body.
. . . But if the modern toy thus enacted the rhythm of modernity, it most often
nostalgically represented traditional forms of entertainment—above all, circus and minstrel acts." Bill Brown, *The Material Unconscious: American Amusement, Stephen Crane, and the Economies of Play* (Cambridge, MA: Harvard University Press, 1996), 181.

39 *Bamboozled*, dir. Spike Lee (Los Angeles: New Line Cinema, 2000), DVD (hereafter cited parenthetically as *B*).

40 For a basic overview of the banks, see Don Duer, *A Penny Saved: Still and Mechanical Banks* (Atglen, PA: Schiffer, 2005). A collector of toys and banks for more than twenty-five years, Duer helped to organize the *A Penny Saved: Architecture in Cast Iron Toy Banks* exhibition at the Cooper-Hewitt Museum in New York. By now, an especially rich source for the history of toy banks is the "scrap book" website established by the Mechanical Bank Collectors of America, which provides articles dating from the 1930s through the 1980s, patent papers, and especially detailed information on the leading manufacturer, the J. & E. Stevens Company. See www.mechanicalbanks.org/scrapbook.htm (hereafter cited as MBCA scrapbook).

41 The bank in fact has several different instantiations (all associated with two patents): in some cases there is additional mechanical action (the ears also move); in some the figure is differently specified (Uncle Tom, Sambo, and so on); and in some it is differently gendered (Dinah). Other well-known racist banks (patented in the 1870s and 1880s) include I Always Did Spise a Mule, Darktown Battery, and Darkey and Watermelon. The minstrel cast from *Bamboozled* includes familiar stereotypes: Sambo, Aunt Jemima, Pickaninny, and so on.

42 The banks were eventually made in aluminum.

43 See F. H. Griffith, "Mechanical Bank Ramblings" (1962), MBCA scrapbook. Griffith wrote a monthly article (this is one of them), for *Hobbies* magazine for more than three decades.

44 Mrs. George Thompson, "Children's Banks of Other Days" (1937), MBCA scrapbook.

45 Ina Hayward Bellow, "Mechanical Banks" (1945), MBCA scrapbook. Bellows published the first book on the subject, *Old Mechanical Banks*, in 1940.

46 See Roland Barthes, *Mythologies*, trans. Annette Lavers (New York: Hill and Wang, 1972), 53.

47 Herman Melville, *The Confidence-Man: His Masquerade* (New York: Norton, 1971), 7–8. Such pitch-penny games were eventually marketed by Milton Bradley, among other manufacturers.

48 On the economic context for these object-narratives, see Deidre Lynch, *The Economy of Character: Novels, Market Culture, and the Business of Inner Meaning* (Chicago: University of Chicago Press, 1998); and Christopher Flint, "Speaking Objects: The Circulation of Stories in Eighteenth-Century Prose Fiction," *PMLA* 113 (March 1998): 212–26. On the new consumer culture, see, for instance, *Consumption and the World of Goods*, ed. John Brewer and Roy Porter (New York, 1993). For an account of the object culture of the long eighteenth century that focuses on the object narratives, see Jonathan Lamb, *The Things Things Say* (Princeton, NJ: Princeton University Press, 2011). And for the first anthology of the subgenre, see *British It-Narratives, 1750–1830*, 4 vols., ed. Mark Blackwell, Liz Bellamy, Christina Lupton, and Heather Keenleyside (London: Pickering and Chatto, 2012).

49 Quoted in Jonathan Lamb, "Modern Metamorphoses and Disgraceful Tales," in *Things*, ed. Brown (Chicago: University of Chicago Press, 2004), 207. And see Heather Keenleyside, "Of Locke and Lap-dogs: Things and Other Persons

in Eighteenth-Century Object-Narratives," unpublished manuscript, presented at the University of Chicago, March 2004.

50 Lamb, "Modern Metamorphoses," 218.

51 Helenus Scott, *The Adventures of a Rupee* (Dublin: W. Spotswood, et al., 1782), vi–vii.

52 Goings, *Mammy and Uncle Mose*, xi.

53 Ralph Ellison, *Invisible Man* (New York: Random House, 1952), 241–42.

54 See "Audio Commentary with Director Spike Lee," in *Bamboozled*.

55 For a personal account of this collecting aspiration, see David Pilgrim, "The Garbage Man: Why I Collect Racist Objects." Pilgrim is the founder and current curator of the Jim Crow Museum of Racist Memorabilia at Ferris State University (Grand Rapids, Michigan). His essay, information about the museum, and images from the collection can be viewed at the museum website, www.ferris.edu/htmls/news/jimcrow/collect. Lee's own collection appears as well in Judy's kitchen collection in *Girl 6* (1996).

56 See Jean Baudrillard, *The System of Objects*, trans. James Benedict (London: Verso, 1996), 91.

57 Vachel Lindsay, *The Art of the Moving Picture* (1915; New York: Liveright, 1970), 148–49, 161. Lindsay wanted "buildings [to] emanate conscious life" (144).

58 Jean Epstein, "On Certain Characteristics of *Photogenie*," in *French Film Theory and Criticism*, ed. Richard Abel, 2 vols. (Princeton, NJ: Princeton University Press, 1988), 1:317. For a full account of the interest in animate objects within early film theory, see Rachel O. Moore, *Savage Theory: Cinema as Modern Magic* (Durham, NC: Duke University Press, 2000).

59 Cumulatively, the objects demand a kind of pathos not unlike William Kentridge's *Shadow Procession* (1999, single-channel projection, 35 mm. film), which features beleaguered anthropomorphic objects that migrate over and over again across a blank landscape that is at once South Africa and no more than a white screen. In both instances, the objects elicit an especially strong emotional response because they so readily disclose the status of the evoked subjects as objects.

60 Olaudah Equiano, *The Interesting Narrative of the Life of Olaudah Equiano, or Gustavus Vassa, the African* (1789), in *The Classic Slave Narratives*, ed. Henry Louis Gates, Jr. (New York: Signet, 2012), 39.

61 The phrase is from Johnson, *Soul by Soul*, 15, who goes on to document how "human beings" were "broken down into parts and recomposed as commodities" (3). See esp. chs. 4–5.

62 Sigmund Freud, *Introductory Lectures on Psycho-Analysis*, trans. and ed. James Strachey (1917; New York: Norton, 1966), 399.

63 Ernst Jentsch, "On the Psychology of the Uncanny" (1906), trans. Roy Sellars, *Angelaki* 2.1 (1995): 12.

64 Freud, "The Uncanny" (1919), in *The Standard Edition of the Complete Psychological Works of Sigmund Freud*, trans. and ed. James Strachey, 24 vols. (London: Hogarth, 1953–74), 17:241, 225.

65 But see Françoise Meltzer, "The Uncanny Rendered Canny: Freud's Blind Spot in Reading Hoffmann's 'Sandman,'" in *Introducing Psychoanalytic Theory*, ed. Sander Gilman (Berlin: Brunner/Mazel, 1982): 218–39.

66 Stanley Cavell, "The Uncanniness of the Ordinary," in *In Quest of the Ordinary: Lines of Skepticism and Romanticism* (Chicago: University of Chicago Press, 1988), 155, 154, 156.

67 Thus, in two pages from the *Introductory Lectures*, Freud suggests that the following objects substitute for the "male organ": "sticks, umbrellas, posts, trees . . . knives, daggers, spears, sabers . . . rifles, pistols, and revolvers . . . water-taps, watering-cans, or fountains . . . hanging-lamps, extensible pencils . . .

pen-holders, nail-files, hammers . . . balloons, flying-machines . . . Zeppelin airships . . . hats and overcoats or cloaks" (190–91).

68 On Lacan's symptomatic dismissal, see chapter 6. For an analysis of the role of Freud's collection in his personal and professional life, see John Forrester, "'Mille e tre': Freud and Collecting," in The Cultures of Collecting, ed. John Elsner and Roger Cardinal (Cambridge, MA: Harvard University Press, 1994), 224–51.

69 John Kendrick Bangs, "The Mantle-Piece Minstrels," in "The Mantel-Piece Minstrels" and Other Stories (New York: R. H. Russell, 1896), 13–14.

70 Charles W. Chesnutt, "Superstitions and Folklore of the South" (1901), in Essays and Speeches, ed. Joseph R. McElrath, Jr., Robert C. Leitz III, and Jesse Crisler (Stanford, CA: Stanford University Press, 1999), 155.

71 Chesnutt, "Po' Sandy," in "The Conjure Woman" and Other Conjure Tales, ed. Richard H. Brodhead (Durham, NC: Duke University Press, 1993), 52. I have read this story in the context of regional fiction in Bill Brown, A Sense of Things: The Object Matter of American Literature (Chicago: University of Chicago Press, 2003), 117–18.

72 Mark Twain and Charles Dudley Warner, The Gilded Age (1873; New York, Penguin, 2001), 113–14.

73 Jentsch, "On the Psychology of the Uncanny," 15.

74 Twain and Warner, Gilded Age, 114.

75 Ellison, Invisible Man, 205, 207 (hereafter cited parenthetically as IM).

76 The appeal of the 1951 South Carolina case was combined by the Supreme Court with other school segregation cases under the umbrella Brown v. Board of Education. Just as Kenneth Clark had testified before the three-judge federal panel in South Carolina, so too he presented his research to the Warren court. The Clarks tested the sensitivity of black children to racial discrimination by presenting each child with identically formed dolls, one black and one white, and asking which was good or bad, which was a preferable toy, and which looked like the child. In both his original research (on more than two hundred children) and his local research for the case, a considerable majority of the black children preferred the white doll.

77 For a reading of the episode and its transposition of the riot into a lynching scene, in relation to both Ellison's and Baldwin's account of the 1943 Harlem riot, see Nicole A. Waligora-Davis, "Riotous Discontent: Ralph Ellison's 'Birth of a Nation,'" Modern Fiction Studies 50 (Summer 2004): 385–410, esp. 398.

78 When Denise Baudu witnesses her first shop window of the grand magasin, not only is she mesmerized by the mannequins—"the well-rounded neck and graceful figures of the dummies exaggerated the slimness of the waist, the absent head being replaced by a large price-ticket pinned on the neck . . . whilst the mirrors reflected and multiplied the forms without end, peopling the street with these beautiful women for sale"—but also the "stuffs became animated in this passionate atmosphere." Emile Zola, The Ladies' Paradise (1883, trans. 1886) (Berkeley: University of California Press, 1992), 8, 16. See Kristin Ross, "Introduction: Shopping," in ibid., xxii: and Anne Friedberg, Window Shopping: Cinema and the Postmodern (Berkeley: University of California Press, 1993), 41–44.

79 Sue Taylor, Hans Bellmer: The Anatomy of Anxiety (Cambridge, MA: MIT Press, 2000), esp. ch. 3, "Uncanny Automata," 56–68. Taylor makes a convincing case for the importance of Offenbach's Tales of Hoffmann in the development of Bellmer's particular treatment of the doll (and its difference from Kokoshka's fetish object, the life-size replica of Alma he had made in 1919). In Sara Blair's "Ralph Ellison, Photographer," she makes a far more specific point about the "logic of the mannequin" in work by photographers that Ellison knew well—

Henri Cartier-Bresson and Lisette Model—and about how such work "can be read as an analogue, if not a direct source, for Ellison's own." Blair also draws attention to the depiction of mannequins in the newspaper images of the looted streets in Harlem. Sara Blair, "Ralph Ellison, Photographer," *Raritan* 24 (Spring 2005): 36, 39; see also 41–42.

80 See Dipesh Chakrabarty, *Provincializing Europe: Postcolonial Thought and Historical Difference* (Princeton, NJ: Princeton University Press, 2000).

81 Georges Bataille, *The Accursed Share: An Essay on General Economy*, trans. Robert Hurley, 3 vols. in 2 (1967; New York: Zone Books, 1988–91), 1:129.

82 "Audio Commentary with Director Spike Lee."

Chapter Ten

I first shared the argument of this chapter about 9/11 as a talk at the Fannie and Allan Leslie Center for the Humanities at Dartmouth in March 2003. I am especially grateful for that audience's response, coming as it did with the emotional charge that accompanied the proximity to the tragedy. Although it has been impossible to keep up with the proliferating accounts of 9/11, I have learned a great deal from subsequent audiences who heard the talk, including those at Columbia University, the University of Virginia, the University of Oregon, the University of Colorado (Boulder), Michigan State University, the University of Iowa, Haverford College, Northwestern University, Yale University, Texas A&M University, Stanford University, and a conference organized by the Kennedy Institute of the Freie Universität (Berlin). A version of the chapter was published in *The Pathos of Authenticity: American Passions of the Real*, ed. Ulla Haselstein, Andrew Gross, and Maryann Snyder-Körber (Heidelberg: Universitätsverlag, 2010), 33–55. The arguments I make in the chapter could now be extended to (and somewhat complicated by) the rebuilt Ground Zero site and the National September 11 Memorial and Museum, but I have chosen to preserve the earlier chronological focus and frame of the argument (with some exceptions), regarding it as an occasional piece whose implications for a history of the present will be clear.

1 In the world of archaeology, see, for instance, Christopher Tilley, *The Materiality of Stone: Explorations in Landscape Archaeology* (London: Bloomsbury Academic, 2004). I should add that phenomenology per se is generally dismissed by object oriented philosophy because it preserves the embodied subject as the access point to objects. For a short list of work in other disciplines, see the overture to this book, and see, for just one example, *New Materialisms: Ontology, Agency, and Politics*, ed. Diana Coole and Samantha Frost (Durham, NC: Duke University Press, 2010).

2 Fredric Jameson, "The Theoretical Hesitation: Benjamin's Sociological Predecessor," *Critical Inquiry* 25.2 (Winter 1999): 269, 281, 271. All but needless to add, Jameson has elsewhere engaged the theoretical potential of Benjamin's work. See, for instance, Jameson, *Marxism and Form: Twentieth-Century Dialectical Theories of Literature* (Princeton, NJ: Princeton University Press, 1974).

3 Jürgen Habermas, "Georg Simmel on Philosophy and Culture: Postscript to a Collection of Essays" (1996), trans. Mathieu Deflem, *Critical Inquiry* 22.3 (Spring 1999): 405.

4 See Theodor Adorno, "Portrait of Walter Benjamin," in *Prisms* (Cambridge, MA: MIT Press, 1983): 227–42.

5 Svetlana Boym, *The Future of Nostalgia* (New York: Basic Books, 2001), 327–36.

6 Jean Baudrillard, *The System of Objects*, trans. James Benedict (New York: Verso, 2005), 96–97.

7 For biographical details, see Christopher Radko, *Christopher Radko: The First Decade, 1986–1995* (Dobbs Ferry, NY: Christopher Radko/STARAD, NY, 1995).

8 Marian Buros, "Tree Trimming With: Christopher Radko; The Czar of the Christmas Present," *New York Times*, December 11, 1997, www.nytimes.com /1997/12/11/garden/tree-trimming-with-christopher-radko-the-czar-of -christmas-present.html.

9 For a transcript, see CNN.com/Transcripts, http://transcripts.cnn.com/TRAN SCRIPTS/0112/15/smn.15.html.

10 Susan Stewart, *On Longing: Narratives of the Miniature, the Gigantic, the Souvenir, the Collection* (Baltimore: Johns Hopkins University Press, 1984), 140.

11 The description was part of the listing on a now-defunct website, www .ophetnet.com/Always-With-You-Figurine.html. A "vast selection" of 9/11 collectibles can still be found on the web.

12 Mark Seltzer describes the "pathological public sphere" in *Serial Killers: Death and Life in America's Wound Culture* (New York: Routledge, 1998), 109–17.

13 Anne Norton, *Republic of Signs: Liberal Theory and American Popular Culture* (Chicago: University of Chicago Press, 1993), 52.

14 Max Horkheimer and Thedor W. Adorno, *The Dialectic of Enlightenment*, trans. Edmund Jephcott (Stanford, CA: Stanford University Press, 2002), 117.

15 On the "mass subject," see Michael Warner, "The Mass Public and the Mass Subject," in *Habermas and the Public Sphere*, ed. Craig Calhoun (Cambridge, MA: MIT Press, 1992), 377–401.

16 Theodor W. Adorno, "Veblen's Attack on Culture," in *Prisms*, trans. Samuel and Sherry Weber (Cambridge, MA: MIT Press, 1981), 85.

17 Georg Lukács, *History and Class Consciousness: Studies in Marxist Dialectics*, trans. Rodney Livingstone (Cambridge, MA: MIT Press, 1968), 92.

18 Eric Darton, "The Janus Face of Architectural Terrorism: Minora Yamasaki, Mohammad Atta, and the World Trade Center," in Open Democracy, www .opendemocracy.net/conflict-us911/article_94.jsp.

19 Quoted by Katherine Hayles, *How We Became Posthuman: Virtual Bodies in Cybernetics, Literature, and Informatics* (Chicago: University of Chicago Press, 1999), 18.

20 Giorgio Agamben, *Stanzas: Word and Phantasm in Western Culture*, trans. Ronald L. Martinez (Minneapolis: University of Minnesota Press, 1993), 20.

21 Henry James recognized that "collective consciousness . . . grasps for a relation, as intimate as possible, to something superior"—some object—"around which its life may revolve." Moreover, that collective consciousness longs for "this object [to] have a heroic or romantic association." "The difficulty is, in these later times," he wrote in 1907, "that the central something, the social *point de repère*, has had to consist of the biggest hotel or the biggest common school, the biggest factory, the biggest newspaper office, or, for climax of desperation, the house of the biggest millionaire." With James's help, you might describe how the destruction of the Towers confronts us, finally, with the loss of anything *other* than these objects through which to experience loss on such a collective scale. Henry James, *The American Scene* (1907), in *Collected Travel Writings: Great Britain and America* (New York: Library of America, 1993), 593.

22 Nonetheless, as Lauren Berlant would have it, "an object of desire is not only a thing, scene, or person, but an affect: the affect associated with the pleasure of binding or attachment itself. The loss of a world is thus not only of a singular thing, but also the loss of the capacity to keep having the feelings that were represented by the ongoingness of the thing." *The Female Complaint: The Unfinished Business of Sentimentality in American Culture* (Durham, NC: Duke University Press, 2008), 266. The point to be emphasized, when it comes to the Towers, is how the ongoing attachment appears to be retroprojective and thus

seems to serve as a screen narrative of loss that veils some other (ongoing) loss.

23 Hannah Arendt, *The Human Condition* (Chicago: University of Chicago Press, 1958), 137, 167–68.

24 Jane Fritsch and David Rohde, "After the Attack: Relics; Trade Center's Past in Sad Paper Trail," *New York Times*, September 14, 2001, www.nytimes.com/2001 /09/14/us/after-the-attacks-relics-trade-center-s-past-in-a-sad-paper-trail .html.

25 Michiko Kakutani, "A Nation Challenged: Critic's Notebook; The Trivial Assumes Symbolism of Tragedy," *New York Times*, September 23, 2001, www .nytimes.com/2001/09/23/nyregion/a-nation-challenged-critic-s-notebook -the-trivial-assumes-symbolism-of-tragedy.html.

26 Jim Dwyer, "A Nation Challenged: Objects; Fighting for Life 50 Floors Up, with One Tool and Ingenuity," *New York Times*, October 9, 2001, www.nytimes.com /2001/10/09/nyregion/nation-challenged-objects-fighting-for-life-50-floors -up-with-one-tool-ingenuity.html.

27 Dominique Browning, "Welcome," *House and Garden*, November 2001, 16.

28 Don DeLillo, *Falling Man* (New York: Scribner, 2007), 5.

29 See for instance, Jim Dwyer, "A Nation Challenged: Objects; Beneath the Rubble, the Only Tool Was a Pair of Cuffs," *New York Times*, October 30, 200l, www.nytimes.com/2001/10/23/nyregion/a-nation-challenged-objects-from -the-rubble-a-picture-and-a-friendship.html.

30 Jean Laplanche, *Life and Death in Psychoanalysis*, trans. Jeffrey Mehlman (Baltimore: Johns Hopkins University Press, 1976), 12. His point is that the object of the drive can, and might essentially, be phantasmatic.

31 "U.N. Pleads with Taliban Not to Destroy Buddha Statues," *New York Times*, March 3, 2001, www.nytimes.com/2001/03/03/world/un-pleads-with-taliban -not-to-destroy-buddha-statues.html.

32 Philippe de Montebello, "The Iconic Power of an Artifact," *New York Times*, September 25, 2001, www.nytimes.com/2001/09/25/opinion/the-iconic -power-of-an-artifact.html.

33 Jean Baudrillard, "Requiem for the Towers," in *The Spirit of Terrorism*, trans. Chris Turner (New York: Verso, 2002), 52 (hereafter cited parenthetically).

34 William Langewiesche, *American Ground: Unbuilding the World Trade Center* (New York: North Point Press, 2002).

35 Balthazar Korab, "Celebration of a Forward-Looking Spirit," in *A New World Trade Center: Design Proposals from Leading Architects Worldwide*, ed. Max Protetch (New York: ReganBooks, 2002), 1–2.

36 For the history of the buildings, see Eric Darton, *Divided We Stand: A Biography of New York's World Trade Center* (New York: Basic, 1999). See also Rem Koolhaas, *Delirious New York: A Retroactive Manifesto for Manhattan* (1978; New York, Monacelli, 1997).

37 Andreas Huyssen, "Twin Memories: Afterimages of Nine/Eleven," *Grey Room* 7 (Spring 2002): 10. Reprinted in Huyssen, *Present Pasts: Urban Palimpsests and the Politics of Memory* (Stanford, CA: Stanford University Press, 2003), 158–63.

38 Andrew Jacobs, "A Nation Challenged: Notebooks; Dismantling a Memorial, Clearing a Camp Site," *New York Times*, September 21, 2001, www.nytimes .com/2001/09/21/nyregion/a-nation-challenged-notebooks-dismantling -a-memorial-clearing-a-camp-site.html.

39 John Solomon, "Rumsfeld Has Sept. 11 Souvenir Debris," *Associated Press Online*, March 14, 2004, www.highbeam.com/doc/1P1-92135457.html.

40 Andreas Huyssen, "Twin Memories," 9.

41 Andreas Huyssen, *Twilight Memories: Marking Time in a Culture of Amnesia* (New York: Routledge, 1995), 1, 3.

42 This is the phrase used by Berenbaum during his interview by Jonathan Rosen. Rosen quotes the comment in "The Trvialization of Tragedy," in *Best Contemporary Jewish Writing*, ed. Michael Lerner (New York: Jossey-Bass, 2001), 236.

43 See United States Holocaust Memorial Museum, www.ushmm.org/research /collections/.

44 Erika Doss, *Memorial Mania: Public Feeling in America* (Chicago: University of Chicago Press, 2010). Doss situates both the formal and informal memorials to 9/11 within this broad context. For other important efforts to think through the dynamics of monumental memorialization, see the essays in *Monuments and Memory, Made and Unmade*, ed. Robert S. Nelson and Margaret Olin (Chicago: University of Chicago Press, 2003).

45 For the website, see Smithsonian National Museum of American History, http://americanhistory.si.edu/september11/. The objects and the documentation that I go on to examine can be found through this website.

46 Friedrich Nietzsche, "On the Uses and Disadvantages of History," in *Untimely Meditations*, ed. Daniel Breazeale, trans. R. J. Hollingbroke (Cambridge: Cambridge University Press, 1997), 75.

47 One of the controversies emerged from the use of cell phone records, in the *9/11 Commission's Report*, to construct a detailed narrative of events that took place within the hijacked planes. See Michel Chossudovsky, "More Holes in the Official Story: The 9/11 Cell Phone Calls," Centre for Research on Globalisation, www.globalresearch.ca/articles/CHO408B.html.

48 I borrow the phrase from Robert O. Keohane, "The Globalization of Informal Violence," in *Understanding September 11*, ed. Craig Calhoun, Paul Price, and Ashley Timmer (New York: New Press, 2002), 77–91.

49 Avital Ronnell, *The Telephone Book: Technology, Schizophrenia, Electric Speech* (Lincoln: University of Nebraska Press, 1989), 350.

Coda

This coda emerged from a talk I gave at a conference, "Materialitäten: Herausforderungen für die Sozial- und Kulturwissenschaften," held at the University of Mainz, October 2011. My thanks to organizers for inviting me, and for the participants (philosophers and sociologists) for taking Dan Flavin's art so seriously as a contribution to the questions raised by the conference.

1 For an example, see Nagel's account of the physics of a drop. Sidney R. Nagel, "Shadows and Ephemera," in *Things*, ed. Bill Brown (Chicago: University of Chicago Press, 2004), 23–40.

2 The essay on toasters has been abandoned. I was interested in a history of the toaster (as object and icon) that would focus on the 1980s and the ways in which toaster design in that decade cites previous decades (the 1950s, above all). I meant to be relating this design strategy to a comic series that appeared in that decade—Stray Toasters—and to Disney's *Brave Little Toaster* trilogy, where old technology triumphs over new technology (computers) in a film that deployed only "old fashioned" animation techniques. All told, it was a project looking at the ways in which a particular object becomes a conduit through which to enact a recuperation of the past. I also meant to be in dialogue with the late Michael Rogin. See his *Ronald Reagan, the Movie: And Other Episodes in Political Demonology* (Berkeley: University of California Press, 1987).

3 Reprinted in Dan Flavin, "Writings," in *Dan Flavin: The Architecture of Light* (New York: Solomon R. Guggenheim Foundation, 1999), 48.

4 Gaston Bachelard, *The Flame of a Candle*, trans. Joni Caldwell (Dallas: Dallas Institute of Humanities and Culture, 1988), 78.

5 Frank Trentmann, "Materiality in the Future of History: Things, Practices, and Politics," *Journal of British Studies* 48 (April 2009): 283.

6 MoMA, New York, 2000; Hammer Museum, Los Angeles, 2005; The New Museum, New York, 2007–8; Princeton Art Museum, 2009; the Gonzalez-Torres exhibition premiered at WEILS, Brussels, 2010; "Seeing Things" was a yearlong series of talks and exhibitions at the Art Institute of Chicago in 2010. I should note, too, that with Peter Weibel, Bruno Latour curated *Making Things Public—Atmospheres of Democracy* in 2005 (ZKM [Center for Media and Art], Karlsruhe). See the book that accompanied the exhibition, *Making Things Public: Atmospheres of Democracy*, ed. Latour and Weibel (Cambridge, MA: MIT Press, 2005).

7 I mean to mark here (as in chapter 7) the importance of drawing attention not just to objects but to the materials from which they are made. See also Hans Peter Hahn and Jens Soentgen, "Acknowledging Substances: Looking at the Hidden Side of the Material World," *Philosophy and Technology* 24.1 (2010): 19–33.

8 Emanuel Levinas, *Existence and Existents* (1947), trans. Alphonso Lingis (Pittsburgh: Duquesne University Press, 2001); see also my introduction to part 1 of the present volume.

9 Gaston Bachelard, "The Painter Solicited by the Elements" (1954), in *The Right to Dream*, trans. J. A. Underwood (Dallas: Dallas Institute, 1988), 26.

10 Gaston Bachelard, "The Cosmos of Iron" (1956), in *The Right to Dream*, 39–41.

11 Bachelard, *Flame of a Candle*, 66 (hereafter cited parenthetically).

12 Dan Flavin, "'. . . in daylight or cool white.' an autobiographical sketch," reprinted in *Dan Flavin: A Retrospective*, ed. Michael Govan and Tiffany Bell (New York: Dia Art Foundation, 2004), 191.

13 See Donald Judd, "Aspects of Flavin's Work" (1969), reprinted in Donald Judd, *Complete Writings, 1959–1975* (Halifax: Press of the Nova Scotia School of Art and Design, 1975).

14 Plato, *Republic*, trans. G. M. A. Grube and C. D. C. Reeve (Indianapolis: Hackett, 1992), 181; book 6, 506c–508b.

15 For Levinas, it is the dark that establishes a kind of degree-zero materiality.

16 Gaston Bachelard, *Le rationalisme appliqué* (Paris: Presses Universitaires de France, 1975), 108–10.

17 See the essays collected in *The Presence of Light: Divine Radiance and Religious Experience*, ed. Matthew T. Kapstein (Chicago: University of Chicago Press, 2004); Jeffrey L. Kosky, *Arts of Wonder* (Chicago: University of Chicago Press, 2013); and Christoph Ribbat's chapter "Art from Tubes," in *Flickering Light: A History of Neon* (London: Reaktion Books, 2013), the English edition of his *Flackernde Moderne: Die Geschichte des Neonlichts* (Stuttgart: Steiner, 2011).

18 Ralph Ellison, *Invisible Man* (1952; New York: Vintage, 1995), 6, 7. See Jeff Wall's light box *After "Invisible Man" by Ralph Ellison, the Prologue* (1999–2001), Museum of Modern Art, New York. For a reading of the work that makes compelling use of Heidegger's distinction between the "ready-to-hand" and the "present-at-hand," see Michael Fried, *Why Photography Matters as Art as Never Before* (New Haven, CT: Yale University Press, 2008), 46–62.

19 Michael Kimmelman, "To Be Enlightened, You Pull the Switch," *New York Times*, October 1, 2004, www.nytimes.com/2004/10/01/arts/design/01KIMM.html.

20 Caroline A. Jones, "Light Speed: Dan Flavin at the National Gallery," *Art Forum*, February 2005, 156. Since Flavin's original experiment, several artists differ-

ently developed the medium of light sculpture, often working to "material-ize" light while nonetheless preserving its "spiritual" connotations. See, for instance, the work depicted in *Phenomenal: California Light, Space, Surface*, ed. Robin Clark (Berkeley: University of California Press, 2011).

21　Heidegger writes: "The preservers of a work belong to its createdness with an essentiality equal to that of the creators." "But," he goes on to say, "it is the work that makes the creators possible in their nature, and that by its own nature is in need of preservers." "The Origin of the Work of Art," in *Poetry, Language, Thought*, trans. Albert Hofstadter (New York: Harper Collins, 2001), 68–69.

22　Robert Smithson, "Entropy and the New Monuments" (1966), in *The Collected Writings*, ed. Jack Flam (Berkeley: University of California Press, 1996), 11.

Glossary

The **object**-**thing** distinction, described at length in chapter 1, vivifies the thinking throughout this book. Additional concepts—the **other thing**, the **material unconscious**, the **modernist object**, **unhuman history**, the **uncanny**, and **kitsch**—receive sufficient attention to make them clear. Still, along the way I make more passing use of concepts that merit gathering here (though they can also be traced in the index) as tools for describing the world we inhabit: the way we inhabit that world and the way it inhabits us.

Dialectical Object For Walter Benjamin the dialectical image is apprehensible through a figural (not temporal) relation between the past and the present, a convergence that interrupts any sense of history-as-usual. I use the term **dialectical object** as a way to name the experienced, irresolvable and contradictory, doubleness of a single object, the way it seems to oscillate between the poles of object and thing, which can be, as well, the poles of unhuman and human, the figural and the literal, then and now, proximate and distant.

Hybrid Object Within the computational sciences, a **hybrid object** is most often a composite of other (reusable) objects. Within the anthropology of science as practiced by Bruno Latour, the **hybrid object** designates the composite character of a particular object that cannot be isolated from the ideas and practices that enable it to appear as an object; this means that the object cannot be purified by traditional enlightenment binaries (nature-culture, subject-object, human-

unhuman). His anthropological insight has evolved from the notions of the quasi-object and the quasi-subject, developed by Gaston Bachelard and (Bachelard's student) Michel Serres. Within the book in hand, the **hybrid object** designates an imbrication or conflation of object and subject, the unhuman object assuming characteristics of human subjects (from animation to agency to consciousness). Such hybridity is one manifestation of the dialectical object. The art world, in its own argument with the Enlightenment, repeatedly stages such hybridity, most aggressively in the genre of the surrealist assemblage, most routinely in puppet theater.

Inanimate Object World Dish towels, desk lamps, skyscrapers, skateboards, pencils, coffee mugs, backpacks, sneakers, straws, driveway stone, cars, desks, chairs, windows, paper—these are the kinds of objects that make up the **inanimate object world**, a phrase that means to differentiate a class of objects from flora and fauna. Of course the inanimate character of such objects can be challenged analytically and historically: the cotton of the dish towel was once living; the towel makes no sense as an object outside a scene of its animation (its use); as with any object, there is incessant activity at the atomic and subatomic levels of scrutiny. The point of the phrase, though, is to describe a quotidian human perception, and thus to be able to describe the effects of a sudden change in status when, in the course of that perception, the inanimate object suddenly comes to life.

Materiality Effect In order to evade the unhelpfully general question of what should count as materiality, I use **materiality effect** as a term to argue in behalf of understanding materiality as a relational characteristic. Materiality counts as materiality from a particular perspective: the air you breathe seems immaterial until a smoggy day irritates your eyes. Although the argument makes sense most readily from a human point of view—the carpenter, the botanist, and the physicist can describe the materiality of a piece of wood very differently—that point of view can be expanded. Sunlight has a **materiality effect** on (or for) the elm tree that is not shared by a rock.

Meta-object An object that seems to investigate its own status as an object can be called a **meta-object**—so, too, an object that seems to reflect on objecthood or on the object world more generally. Although the **meta-object** appears most frequently in the art world, it appears as well in the world of architecture and domestic design—in the building that seems to defy the laws of gravity, for instance, or the teapot designed to look like a building, or any number of large- and small-scale objects that cite other objects.

Misuse Value Marx differentiates between an object's use value and its exchange value (as a commodity), the latter transforming the physical properties of the object into an abstraction. By **misuse value** I mean to designate the efficacy and the effects of some untoward deployment of an object—some new valuation emerging from the object's displacement from routine systems or networks of use. This expansion of use often includes the recognition of a different physical property of the object—the fact that the key is sharp enough to be used as a small knife, for instance. In a scene of misuse, you typically see and feel an object with a specificity that disappears when you're deploying it routinely. (And when your misuse of an object has ineffective results—when you yourself collapse along with the chair that you were using as a ladder—you also confront its physical specificity in a way that you don't when you grab a seat at the dinner table.) Within the art world, the misuse of found objects can have many effects, including an unanticipated appreciation of the formal (more broadly, the aesthetic) properties of the object, whether fragment or whole. More generally, **misuse value** captions the effectiveness of broken routine (the interruption of habit) as an unanticipated mode of apprehending the object world anew.

New Materialism Over the course of the past twenty years, many efforts have been launched—across the disciplines—to reengage the physical world, from a material cultural history that focuses on the circulation of objects, to a phenomenology that attempts to register the human body's encounter with that physical world (often the built environment), to an account of how physical objects assume agency within particular networks, to metaphysical speculations about what actually constitutes materiality. These materialisms are new insofar as they focus on the objects that have been overlooked by the critical attention to the subject, language, and the image, as by a highly textualist understanding of culture. These materialisms are also new insofar as they generally square neither with the materialist tradition within Western philosophy nor with the historical materialism practiced by Marx (although they are variously engaged with those materialisms). **New materialism** is hardly reducible to a single philosophy or methodology; there are distinct new materialisms that share neither the same presumptions nor the same objectives. As should be clear throughout this book, my own new materialist practice explicitly takes place within the frame established by historical materialism.

Object Culture To designate the objects of a particular culture or subculture (e.g., Bantu culture, Catholic culture, Hip Hop culture, French

culture), I use the term **object culture**, but in its broadest sense the term points as well to the systems (and not just the economic systems) within which those objects attain, retain, or lose value or significance.

Redemptive Reification The concept of reification, within the Marxist tradition, describes the effects of capitalism: conditions provoked by the saturation of society with the commodity form. On the one hand, humans are reduced to things within a rationalized system; on the other, the character of things as things withdraws. **Redemptive reification** describes a re-thingification that resuscitates the character of things as things—or the thingness of the object—although it is engaged not in recovery (retrieving some prelapsarian moment) so much as discovery (disclosing a heretofore unrecognized thingness). This process can be part of the eventfulness of everyday life, but it is most easy to see when an artist, producing an object, re-produces other objects (retrieving them, reworking them, recombining them, reframing them) in a way that interrupts reification-as-usual, granting one or another object the status of a thing, disclosing the thingness of the object, some thing about the object that can be (all at once) material, formal, historical, conceptual, &c.

Index